# On the Art of Fixing a Shadow

*One Hundred and Fifty Years of Photography*

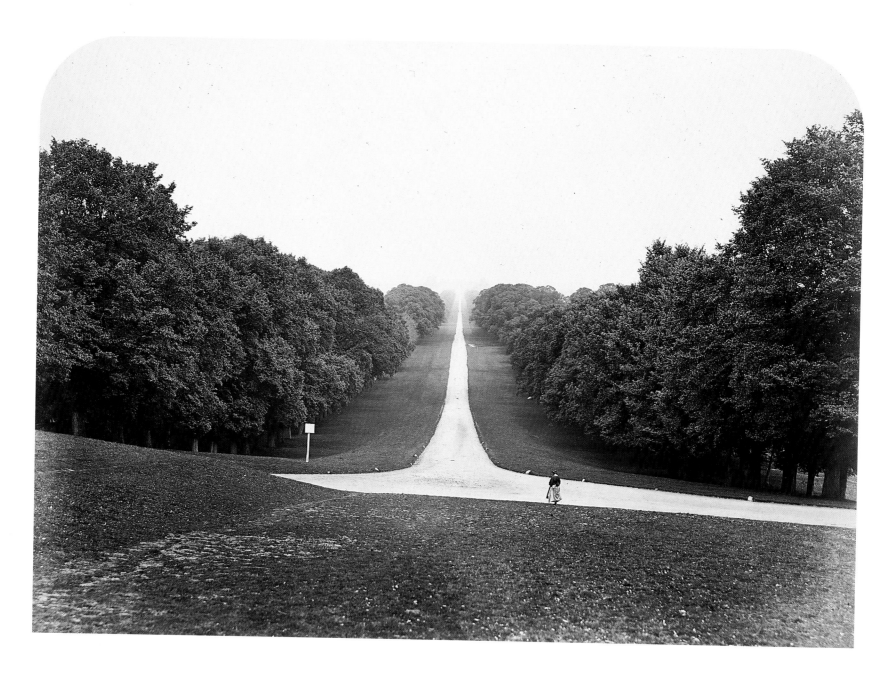

ROGER FENTON
*The Long Walk, Windsor*, 1860
albumen print from the wet collodion negative, 30.6 x 43.3 (12¹⁄₁₆ x 17⅛)
Royal Photographic Society (cat. 388)

# ON THE ART
# OF FIXING A SHADOW

*One Hundred and Fifty Years of Photography*

Sarah Greenough

Joel Snyder

David Travis

Colin Westerbeck

National Gallery of Art · The Art Institute of Chicago

IN ASSOCIATION WITH

Bulfinch Press / Little, Brown and Company

Boston    Toronto    London

This exhibition is made possible by a generous grant from Eastman Kodak Company

Exhibition dates:

National Gallery of Art
*7 May 1989–30 July 1989*

The Art Institute of Chicago
*16 September 1989–26 November 1989*

Los Angeles County Museum of Art
*21 December 1989–25 February 1990*

A hardcover edition of this book is published and distributed
by Bulfinch Press

Bulfinch Press is an imprint and trademark of Little, Brown
and Company (Inc.)

Published simultaneously in Canada by Little, Brown &
Company (Canada) Limited

Cats. 245, 246, 247, copyright G. Brassaï 1989
Cats. 200, 201, 202, 276 copyright the August Sander Archive

Cover: cat. 241   Back cover: cat. 383

FIRST EDITION

This book was produced by the editors office, National Gallery of Art
Editor-in-Chief, Frances P. Smyth
Senior Editor, Mary Yakush

Designed by Bruce Campbell, Stonington, Connecticut

Printed by Franklin Graphics, Providence, Rhode Island,
on Warren Lustro Offset Enamel Dull

Color separations by Image Processing, Branford, Connecticut;
duotone negatives by Image Processing and Franklin Graphics;
production supervision by Integraphix International, Inc.,
New Haven, Connecticut

Typeset by Columbia Publishing Company, Inc., Baltimore,
Maryland, in Linotype Walbaum

Library of Congress Cataloging-in-Publication Data

On the art of fixing a shadow: 150 years of photography /
Sarah Greenough . . . [et al.].
    p. cm.
    Catalogue of an exhibition held at the National Gallery of Art,
May 7–July 30, 1989, The Art Institute of Chicago, Sept. 16–
Nov. 26, 1989, and the Los Angeles County Museum of Art,
Dec. 21, 1989–Febr. 25, 1990.
    Bibliography: p.
    Includes index.
    ISBN 0–89468–127–3 softcover
    ISBN 0–8212–1757–7 hardcover
    1. Photography—History—exhibitions. I. Greenough, Sarah,
1951–    II. National Gallery of Art (U.S.). III. Art Institute of
Chicago. IV. Los Angeles County Museum of Art.
TR15.05   1989
779'.074'73–dc20
                                                    89–3275
                                                      CIP

# Contents

# Lenders to the Exhibition

AFGA FOTO-HISTORAMA, COLOGNE

AMON CARTER MUSEUM, FORT WORTH, TEXAS

THE ART INSTITUTE OF CHICAGO

ASSOCIATION DES AMIS DE JACQUES-HENRI LARTIGUE, PARIS

MR. RICHARD AVEDON

THE BALTIMORE MUSEUM OF ART

HILLA AND BERNHARD BECHER

MRS. EDWIN A. BERGMAN

BIBLIOTHÈQUE DES ARTS DÉCORATIFS, PARIS

BIBLIOTHÈQUE NATIONALE, PARIS

MARY BOONE GALLERY, NEW YORK

PETER BRAMS AND RHONA HOFFMAN GALLERY

CARSON COLLECTION

CENTER FOR CREATIVE PHOTOGRAPHY, UNIVERSITY OF ARIZONA, TUCSON

CENTRE CANADIEN D'ARCHITECTURE/CANADIAN CENTER FOR ARCHITECTURE, MONTRÉAL

HELEN CHADWICK AND MARK PILKINGTON

CHICAGO HISTORICAL SOCIETY

ÉCOLE NATIONALE DES PONTS ET CHAUSSÉES, PARIS

STEFAN T. EDLIS COLLECTION

EXCHANGE NATIONAL BANK, CHICAGO

FRAENKEL GALLERY, SAN FRANCISCO

LARRY FRANKEL

GERNSHEIM COLLECTION, HARRY RANSOM HUMANITIES RESEARCH CENTER, UNIVERSITY OF TEXAS AT AUSTIN

THE J. PAUL GETTY MUSEUM, MALIBU

GILMAN PAPER COMPANY COLLECTION, NEW YORK

HALLMARK PHOTOGRAPHIC COLLECTION, HALLMARK CARDS, INC., KANSAS CITY

HOCHBERG-MATTIS COLLECTION

HOCHSCHULE DER KÜNSTE, BERLIN

DAVID HOCKNEY

EDWARD STEICHEN
*The Pool—Evening: A Symphony to a Race
and to a Soul*, 1898
gum bichromate-platinum print
21.0 x 16.2 (8¼ x 6⅜)
Royal Photographic Society (cat. 389)

# *Foreword*

One hundred and fifty years ago William Henry Fox Talbot and Louis Jacques Mandé Daguerre announced to a startled world that they had discovered, quite independently of each other, two very different processes to fix the image of nature. Daguerre's method produced unique, mirrorlike gems that astounded his audience with their finely detailed precision. Talbot's results were rougher, less polished and resolved; however, because his process came to be based on a negative-positive structure, it contained seeds of future photography. Neither man, despite undeniable genius, could have predicted the profound impact this new medium would have on modern life. It is not simply that photography has pervaded our world, confronting us at every turn in our art, literature, entertainment, medicine, commerce, science, and industry. In an even more fundamental way it has challenged our assumptions and altered our basic understanding of who we are—in relation to our past and present, to other people, and to other cultures. To a very large extent, in the last 150 years we have come to see, define, and know our world through the medium of photography.

*On the Art of Fixing a Shadow* celebrates the development of the art of photography from 1839 to 1989. It has not been our intention to chart the growth of a technology or to pursue historical curiosities, but rather to examine the development of an understanding of how the tool of the camera and the medium of photography could be used for creative expression. One achievement of this exhibition is that it shows the art of photography to be an intricate, ever-changing dance. Like a dance, it relies on apparent ease and grace, while the seemingly effortless way in which the steps are performed belies the extraordinary skill, control, sensitivity, and intelligence that are required to master the art. It has been our goal to reveal photographers' creativity from the earliest, nascent markings of Talbot or Daguerre to the full-blown work of post-modern photographers; to explore what each decade perceived to be the art of photography; to examine the sources for their inspiration; and to describe the development of their ideas.

Conceived by the National Gallery in 1986, this exhibition has been put together jointly by the National Gallery of Art and The Art Institute of Chicago. The exhibition has been selected by David Travis, head of the department of photography at The Art Institute of Chicago, and Sarah Greenough, research curator at the National Gallery, with Joel Snyder, professor of humanities at the University of Chicago, and Colin Westerbeck, assistant curator at The Art Institute. The contributions of many of the staff at both institutions are detailed in the acknowledgments that follow. Suffice it to say that all three museums at which the exhibition will be seen are particularly grateful to the staff and to the authors of the catalogue.

For more than a century, the name of Eastman Kodak has stood for leadership and innovation in photography. The Professional Photography Division of Eastman Kodak has been not only an appropriate sponsor for *On the Art of Fixing a Shadow*, but also a very generous and enthusiastic one. We would especially like to thank Raymond DeMoulin, Vice President and General Manager, and Marianne Samenko, Director, Marketing Communications and Support Services.

Finally, we should note that the history of photography is a new field, and it is only within the last few decades that rigor and selectivity have been applied to the collecting of photographs. Many of the key images in the history of photography have been preserved by individuals and institutions who are lenders to our exhibition. We would like to extend our profound thanks to all those who have graciously enriched our exhibition with their knowledge and their photographic treasures.

J. Carter Brown, *National Gallery of Art, Washington*
James N. Wood, *The Art Institute of Chicago*
Earl A. Powell III, *Los Angeles County Museum of Art*

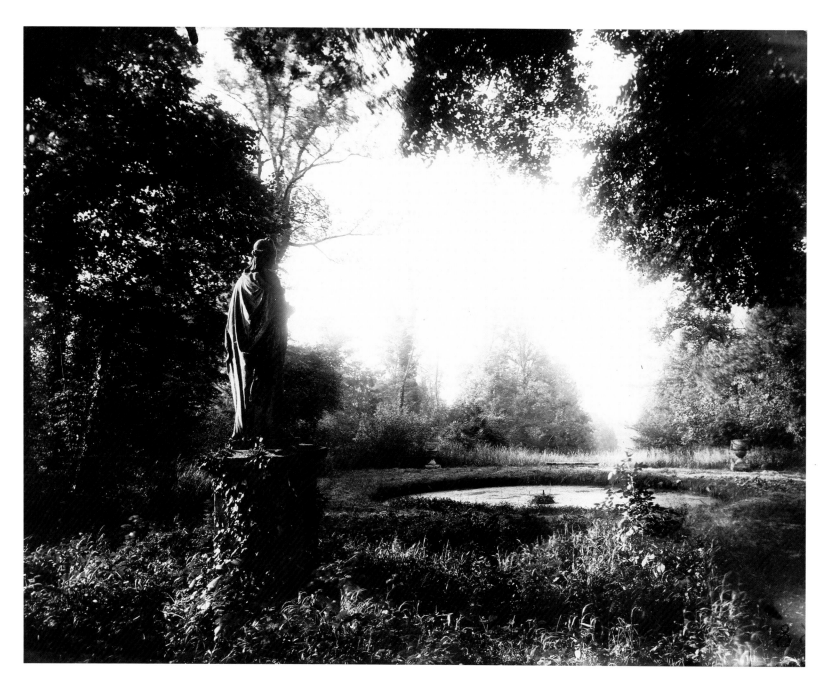

Eugène Atget
*Parc de Sceaux (68)*, 1925
albumen print, 17.6 x 22.5 (7 x 8⅞)
Collection, The Museum of Modern Art, New York, Abbott-Levy Collection,
Partial Gift of Shirley C. Burden (cat. 390)

# *Acknowledgments*

From its very inception, *On the Art of Fixing a Shadow* has been a team project. In 1986 when J. Carter Brown first spoke with David Travis and Sarah Greenough about organizing an exhibition to celebrate the 150th anniversary of photography, it was clear that the most effective way to accomplish this mission was to pool the ideas and creativity of several people. This was done not to minimize the amount of work of any one person, but rather because we believed that the time had passed when it was feasible or desirable for one person to shape our understanding of 150 years of the art of photography. In recent years, the field has benefited enormously from the infusion of different points of view, and we wanted our exhibition and catalogue to profit from this scholarship and insight. For that reason we assembled a team of curators and scholars, each responsible for one section of the exhibition, with Mr. Travis and Ms. Greenough acting as overall arbitrators of its scope and content: Joel Snyder, professor of humanities at the University of Chicago, selected the images for the earliest section of the exhibition, 1839 to 1879; Sarah Greenough, research curator at the National Gallery, was responsible for the turn of the century, from 1880 to 1918; David Travis, curator and head of the department of photography at The Art Institute of Chicago, worked on the period between the wars, from 1919 to 1945; and Colin Westerbeck, assistant curator at The Art Institute of Chicago, was responsible for the work done after World War II.

Our team quickly felt the need of more players. Megan Fox, exhibition assistant at the National Gallery, has worked on the exhibition from its very earliest stages. Her superb organizational skills have supported every crucial undertaking of this project from the creation and maintenance of the master list of photographs and loan letters to the coordination of all matting and framing. She has accomplished these duties with an efficiency and wit greatly appreciated by all those dependent on her efforts. In addition, Ms. Fox researched and prepared the artists' bibliographies published in this catalogue. Sandra Binion, chief assistant at The Art Institute of Chicago for *On the Art of Fixing a Shadow*, coordinated the activities of the three Chicago-based authors and curators and performed countless duties with diligence and thoroughness.

We are also indebted to many other crucial players. At every turn, each of us found colleagues eager to help and generous with their time, knowledge, and photographs. For their magnanimity we particularly wish to thank Phyllis Lambert, Richard Pare, and David Harris at the Centre Canadien d'Architecture/Canadian Centre for Architecture; James Enyeart, Terence Pitts, Amy Rule, and Victor Laviola of the Center for Creative Photography; Weston Naef, Judith Keller, Gordon Baldwin, Louise Stover, and Joan Gallant of the J. Paul Getty Museum; David Wooters of The International Museum of Photography at George Eastman House; Marie-Thérèse and André Jammes; Frank and Patti Kolodny; Maria Morris Hambourg and Ellen Handy of The Metropolitan Museum of Art; Bonnie Yochelson at the Museum of the City of New York; John Szarkowski and Susan Kismaric of The Museum of Modern Art; Brian Coe and Pam Roberts of the Royal Photographic Society; and Sandra S. Phillips and Diana Du Pont of the San Francisco Museum of Modern Art. These people answered innumerable complicated, and often last-minute requests, and we thank them for their patience and invaluable assistance. Special thanks are due to Robert Sobieszek of the George Eastman House, who, in addition to the assistance he gave through his institution, offered many detailed and constructive comments on the essays published in this catalogue.

In the course of planning and selecting this exhibition, we have visited or been in touch with many major European and American photography collections. Our colleagues at these institutions gave every assistance possible, and we

wish to thank Bodo von Dewitz at the Agfa Foto-Historama; Thomas Southall of the Amon Carter Museum of Art; Martine d'Astier de la Vigerie of the Association des Amis de Jacques-Henri Lartigue; Janos Freçot of the Berlinisches Galerie; Geneviève Bonté and Josianne Sarte of the Bibliothèque des Arts Decoratifs; Catherine Mathon of the Bibliothèque des Beaux-Arts; Jean-Claude Lemagny and Bernard Marbot of the Bibliothèque Nationale; Barbara Norfleet and Chris Burnett of the Carpenter Center, Harvard University; Alain Sayag of the Centre Georges Pompidou; Larry Viskochil of the Chicago Historical Society; Jane Livingston of the Corcoran Gallery of Art; M. B. Hirsch and Michele Yvon of the École Nationale des Ponts et Chaussées; Herbert Kahn of the Permanent Collection of Photography at the Exchange National Bank; Pierre Apraxine and Lee Marks of the Gilman Paper Company; Keith Davis of Hallmark Cards, Inc; Roy Flukinger of the Harry Ransom Humanities Research Center, University of Texas at Austin; Kenneth Finkel of the Library Company of Philadelphia; Stephen Ostrow, Bernard Riley, Barbara Brannan, and Mary Ison of the Library of Congress; Elizabeth Gallin of Magnum; Neal Prince and Susan Davidson of The Menil Collection; Antonin Dufek of the Moravska Galerie; Françoise Reynaud of the Musée Carnavalet; Françoise Heilbrun, Philippe Néagu, and André Lejeune of the Musée d'Orsay; Ute Eskildsen and Robert Knodt at the Museum Folkwang; Rüdiger Joppien of the Museum für Kunst und Gewerbe; Clifford Ackley and Theodore Stebbins at the Museum of Fine Arts, Boston; Anne Tucker at the Museum of Fine Arts, Houston; William Stapp at the National Portrait Gallery; Toshio Fujii at the Nojima Collection; Martha Chahroudi at the Philadelphia Museum of Art; Barbara Hitchcock of the Polaroid Collection; Peter Bunnell and Maria Pellerano of the Art Museum, Princeton University; Pool Andries of the Provinciaal Museum voor Fotografie; John Ward at the Science Museum; Sarah Stevenson at the Scottish National Portrait Gallery; Eugene Ostroff at the Smithsonian Institution; Zdeněk Kirschner and Kateřina Klaricová at the Uměleckoprůmyslové Museum; Mark Haworth-Booth, Chris Titterington, and Virginia Dodier at the Victoria and Albert Museum; Robert Lassam at the William Henry Fox Talbot Museum;

and Stephen Jareckie of the Worcester Art Museum.

Private collectors and many photographers whose work is in the exhibition have also been extremely generous, opening up their homes and offices to show us their most prized possessions. We extend our sincere appreciation to Roger Baugh; Hilla and Bernhard Becher; Werner and Anna Bockelberg; Marta Braun; Mrs. Joseph E. Carson; Helen Chadwick; Chuck Close; Jean Demachy; Stefan Edlis; Robert Heinecken; Judith Hochberg and Michael Mattis; Mark Klett; Kathleen Lamb; Richard Menschel; Joel Meyerowitz; Marcia and Kent Minichiello; Dr. Joseph Monsen; Joyce Neimanas; Mr. and Mrs. Hubert Neumann; Jeffrey Gilbert of the Nojima Estate; Anthony Penrose; David Pincus; Nicholas Pritzker; C. David Robinson; David and Sarajean Ruttenberg; Antoine Salomon; Richard Sandor; Joshua Smith; Holger Trülzsch; and Leonard and Marjorie Vernon. Many gallery owners were also extremely helpful, sharing information on the location of many key works. We wish especially to thank Petra Benteler; Henrik Berinsen; Michelle Chomette; George Dalsheimer; Carol Ehlers; Kathleen Ewing; Sylviane de Decker Heftler; Marvin Hoshino; Edwynn Houk; Jeffrey Fraenkel; Jennifer Flay of the Galerie Ghislaine Hussenot; Rudolf Kicken; Hans Kraus; Tom Jacobson; Janet Lehr; Gerard Lévy; Harry Lunn; Peter MacGill; Peter Opheim of Mary Boone Gallery; Laurence Miller; Howard Read and Susan Arthur of the Robert Miller Gallery; Gerd Sander; Jo Tartt; Stephen White; Elyse Goldberg of the John Weber Gallery; and Ann Lapides of the Zabriskie Gallery.

In the course of writing our catalogue essays and thinking about our selection and presentation of photographs, each of the authors has checked with scholars in the field. For their invaluable assistance, we wish to thank Jaroslav Andel; Juliet Bareau; Tom Beck; Gail Buckland; Jean-François Chevrier; Diane Dillon; Laura Gonzales; Mike and Barbara Grey; Manfred Heitung; Mary Ison; Valerie Lloyd; Pablo Ortiz Monasterio; Beaumont Newhall; Naomi Rosenblum; Jésus Sanchez Uribe; Maren Stange; and Gilles Tiberghien. Neil Allen provided invaluable editorial assistance. We would also like to thank David Ross of Ross-Ehlert Photo Labs for printing the negative supplied by the Jet Propulsion Laboratory and Doug Munson of the Chicago Albumen

Works for his excellent modern reprints of the Jacob Riis lantern slides and glass negatives from the collection of the Museum of the City of New York. We wish to thank the many individuals charged with administering the estates of photographers whose works are reproduced in this catalogue: Mary Alinder and Pamela C. Feld of the Ansel Adams Publishing Rights Trust; Mary Drugan of the Diane Arbus Estate; Gilberte Brassaï; John Hill of the Walker Evans Estate; Elizabeth Gallin of Magnum; Hattula Moholy-Nagy of the László Moholy-Nagy Estate; Gerd Sander of the August Sander Archive; Joanna Steichen of the Edward Steichen Estate; Juan Hamilton for the Alfred Stieglitz Collection.

At the National Gallery our team rapidly took on the appearance of a small army of people who have devoted much of their efforts to the realization of this exhibition and catalogue. John Wilmerding, former deputy director, and his successor Roger Mandle provided essential guidance throughout the project. D. Dodge Thompson of the exhibitions department, ably assisted by Deborah Shepherd, supervised much of the organization, securing all loans and insurance in addition to providing crucial support and advice. Frances Smyth and Mary Yakush, who accomplished the herculean task of producing and bringing order, clarity, and precision to the catalogue, are especially to be commended for their intelligence and patience. Numerous individuals including the late Edwin Higgins, Kurt Peterson, and Robert Hennessey provided advice and assistance in the course of producing the catalogue. We applaud Bruce Campbell for his elegant catalogue design and good humor in dealing with four authors scattered around the country. Robert Brown and the staff of Franklin Graphics deserve special thanks for their excellent work under tight deadlines. To Gaillard Ravenel, Mark Leithauser, Bill Bowser, Gordon Anson, and the staff of the department of installation and design, we extend our sincere thanks for the lucid, graceful design, installation, and lighting of this exhibition. In the department of photographic services, Barbara Bernard is to be thanked for securing transparencies and copy photographs of the images in the exhibition, as are Richard Amt and Dean Beasom in the photo laboratory for supplying many copy photographs and meeting impossible deadlines.

Hugh Phibbs and Virginia Ritchie efficiently coordinated the matting and framing of more than 400 photographs, working with other staff in the department of conservation, while Mary Suzor, registrar, supervised the complicated arrangements necessary to insure the prompt shipment of all the objects. Susan Arensberg and Will Scott contributed their expertise in museum education, and Elizabeth A. C. Weil, corporate relations officer, organized the funding. For additional assistance, we are indebted to Sharon Millman, Jennifer Kahane, Suzy Harris, Amelia Henderson, and Abigail Walker.

At The Art Institute of Chicago we wish to thank Dorothy Schroeder, assistant to the director, for her help in coordinating the responsibilities of the organizing institutions. In the department of photography we would like to commend Sylvia Wolf and J. Russell Harris, curatorial assistants; Claude Baillargeon, research assistant; Doug Severson, conservator; and James Iska, preparator, for the thorough assistance they provided at every stage of this exhibition. Alan B. Newman, Christopher Gallagher, Robert Hashimoto, Michelle Klarich, Paula Pergament, Tom Cinoman, and Mikhael Mogilmer of the department of photographic services are all to be thanked for their excellent work, as are Virginia Mann, registrar, Mary Solt, registrar for loans, and Kent Lydecker and Celia Marriott of the department of education. At the Los Angeles County Museum we were ably assisted by Kathleen Gauss and Sheryl Conkelton of the department of photographs and Elizabeth Algermisson of the exhibition division.

Finally, to our families and closest friends who have heard about this exhibition for the last three years, endured our long absences, and given wise and invaluable counsel, we extend our most sincere thanks.

Sarah Greenough
Joel Snyder
David Travis
Colin Westerbeck

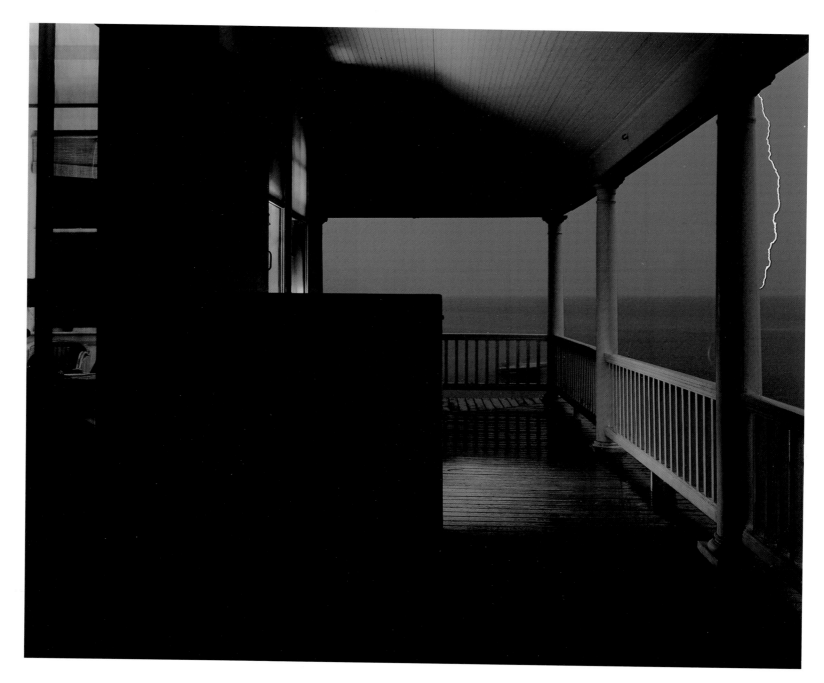

JOEL MEYEROWITZ
*Provincetown Porch*, 1977
chromogenic color print, 50.8 x 61.0 (20 x 24)
Joel Meyerowitz (cat. 391)

# Introduction

Anniversaries should be a time not only of celebration, but also of reflection on the past and contemplation of the future. Yet often they are hollow events, occasioned more by seemingly arbitrary dates than by any genuine milestone. This anniversary of the birth of photography, however, is not a manufactured occurrence, for one hundred and fifty years after its announcement by Louis Jacques Mandé Daguerre in France and William Henry Fox Talbot in England, photography and with it the study of the history of photography are at an obvious juncture. Fifty years ago at the centennial commemoration of Daguerre's and Talbot's inventions it was practically unheard of for art museums to collect or exhibit photographs as works of art; today it is commonplace. Fifty years ago there were no publicly-supported museums devoted exclusively to photography; today there are several. Fifty years ago the serious study of the history of photography hardly existed; today it is taught in most major universities in the United States and Europe, while countless books devoted to the subject are published annually. Fifty years ago there were few private collections of photography as an art; today hundreds are supplied by a new class of dealers who exclusively handle photographs. This massive institutionalization, occurring entirely within the last fifty years, has utterly transformed the history and appreciation of photography, and perhaps also the medium itself. But it should be equally clear that fifty years from now, at the bicentennial commemoration of photography's birth, the silver-based images included in this exhibition and discussed in this catalogue may be regarded as curious relics of another age—for photography as we know it today may not exist.

Over the course of the past fifty years several attempts have been made to write the history of photography and by so doing to define the medium as a whole. Addressing such issues as uniqueness, inherent characteristics, technology, and application, historians have endeavored to fashion an all-inclusive history that would establish the position of photography in relation to art, science, commerce, and society. When Beaumont Newhall published the first version of his seminal history of photography in 1937 to accompany an exhibition, it was a sorely needed study, for traditional art histories did not mention photography at all. It was then feasible to undertake construction of a framework that would encompass the entire known history of the medium. But as our knowledge has mushroomed in the last fifty years—and particularly in the last twenty—it hardly seems necessary to write *the* history of photography as a single, isolated chronology. It is not simply that we know more about French, German, Japanese, Mexican, or Russian photography—not that the information revolution of the last twenty years prevents us from assuming that the history of photography only consists of work from the United States and Europe—but rather that as the medium comes to maturity we admit and celebrate other points of view. Just as the study of American history has benefited enormously from the work of feminist, Marxist, socialist, and cultural historians, so too have these same approaches enriched our understanding of photography.

At this sesquicentennial celebration, it has been our intention in both the exhibition and the catalogue to present and analyze those photographs that, regardless of why they were made, seem the most visually significant. Limiting ourselves, for the most part, to American and European photographers, we have attempted to chart the development of an understanding of photography as a pictorial device. It is our contention that the invention of the technique of photography did not automatically endow its practitioners with an understanding of what photography was as an independent pictorial medium, or even what photographic pictures should or could look like; photography was not "born whole" with a unique visual syntax clearly evident. Rather, we believe that an understanding of the potential of photography

was and continues to be a process of discovery, at times stumbled upon in youth with blind good luck, at times painstakingly extracted at the end of a life's work. It is an understanding that is not fixed and immutable but which has had to be rethought and revised countless times, with each new technological improvement and each new cultural mandate.

These same technological improvements and cultural mandates have dictated the division of our exhibition into four sections. The first, from 1839 to 1879, encompasses the early years of the medium's discovery, both the initial invention and subsequent modifications to the processes announced in 1839 and the early attempts to discover how photography was different from other ways of making pictures. Sparked by the profound changes caused by the invention of dry plates and small hand-held cameras, the second period, from 1880 to 1918, saw a significant change not only in who could make photographs, but also in the subjects chosen and in pictorial structure. Unlike the first two periods, which were initiated by technological inventions and improvements, the third and fourth periods, from 1919 to 1945 and from 1946 to 1989, are bounded by the profound philosophical, political, economic, cultural, and emotional chaos caused by the two World Wars. The response of photographers after World War I was to search for a purity and order within the medium itself; those working after World War II have sought more to find an order or truth within consciousness itself.

Within these sections, we did not start out to define a set photographic syntax, but rather to see what images in 1989 emerged as the most visually innovative. That we have included many photographers who were also included in various other historical anthologies during the past fifty years points to the development of a consensus of historians and critics on which photographers are generally considered the most creative. That we have excluded some and included many others indicates a canon is still emerging. We should point out, however, that while we have included several images by a

dozen or so photographers, our intention has not been to dwell on personality or develop a profile of the master photographer, but rather to chart the evolution of certain ideas through the work of these photographers and that of other less well-known or even anonymous figures.

Some would argue that photographs are not art and should not be exhibited within the walls of an art museum. Motivated not by a desire to preserve the sanctity of painting or the other fine arts, these critics insist instead that photographs are more properly understood as artifacts, signs that when analyzed together have meaning only within a larger social context. While we acknowledge their point of view and often admire such ideas, in this exhibition and catalogue we have chosen to place emphasis on the image itself rather than a philosophical construct. For even now, at the end of the twentieth century, there is something about photography—which resides both in the act of making photographs and the images themselves—that strikes many of us as being undeniably personal, distinctive, and compelling.

In his first account of his discovery, written in 1839, Talbot included a subheading titled "On the Art of Fixing a Shadow," where he described what he believed to be the domain of photography. "The most transitory of things," he wrote, "a shadow, the proverbial emblem of all that is fleeting and momentary, may be fettered by the spells of our 'natural magic,' and may be fixed for ever in the position which it seemed only destined for a single instant to occupy." Talbot was the first to define photography and his own understanding of its potential and uses; *On the Art of Fixing a Shadow* traces the evolution of that understanding of photography as a distinct pictorial entity from 1839 to 1989.

Sarah Greenough
Joel Snyder
David Travis
Colin Westerbeck

# I
## 1839–1879

Fig. 1. Hippolyte Bayard, *Montmartre, Windmills*, 1839, direct positive print, 9.5 x 11.0 (3¾ x 4⁵⁄₁₆), Gilman Paper Company Collection (cat. 392)

# Inventing Photography

JOEL SNYDER

If the small, dark, and stained print of twin windmills on Montmartre, made by the French civil servant and inventor Hippolyte Bayard in 1839, had been inscribed with the motto *Festina Lente* ("Make haste slowly"), it would serve as a perfect emblem for an essay dealing with the foundations of photography. But even without a legend or text to furnish guidance or instruction, this experiment, made at the dawn of photography—before anyone could have guessed at what photography was or might become—this singular photograph offers grounds for speculating about the conditions of photography, musing about the passions of photographers, and reflecting on the power of light.

Bayard's picture, made in the year of photography's introduction, was produced on a sheet of "ordinary" letter paper prepared for an extraordinary purpose. The paper was dipped in two baths formulated according to Bayard's recipe and placed in bright sunlight until its white surface was covered with a uniform veneer of pure, black elemental silver. The ebony paper was then washed in yet another solution and placed while still wet into a camera that had been carefully focused on the windmills at the summit of the distant hill. The light from the sky entered the camera and, over the course of perhaps an hour, slowly etched away at the blackened silver, bleaching it to various shades of gray—separating the heavens from the earth, leaving the black shapes of the butte and the two windmills with the building set between them. After taking the sheet of paper from the camera and treating it with a final, stabilizing bath, Bayard must have been filled with conflicting emotions. Here, on the paper he had blackened with silver, the world was struggling to emerge from darkness, trying with the slightest success to secure itself on the paper and yet succeeding nonetheless in showing some certain mark of its presentness. The appearance on the paper of the unmistakable imprint of design—of a picture showing signs of life—must have given him cause for celebration; the meagerness and incompleteness of those signs provided him with grounds for judging this *essai*, and perhaps even himself, a failure.

Here, then, is nothing less than an origination, a beginning, a birthing. And like all births viewed retrospectively, it is intelligible, unsurprising, thoroughly ordinary, and entirely miraculous.

## PRELIMINARIES

The invention of the first photographic technologies was announced to an astonished world precisely a century and a half ago. Unanticipated by the public at large, its very possibility unsuspected, photography was immediately termed "marvelous," "prodigious," "a bit of natural magic." As a rule, prodigies mature quickly—yesterday's marvels rapidly come to age as tomorrow's unremarkable facts; yet the terms of amazement that greeted photography's announcement remain not merely appropriate today, they seem somehow inevitable. Anyone who has ever slipped a sheet of exposed photographic paper into a tray of developer and has watched a fully formed picture emerge in a matter of seconds knows the astonishment accompanying the appearance of the image (no matter how banal it might be), and knows why it seems so right to think of it as "a bit of natural magic." No matter how often a picture may be seen to inform itself and overwhelm the stark whiteness of the paper, the spectacle can still strike us as being at the same time both predictable and uncanny. There is an irony here, since calling a phenomenon "uncanny" is simply another way of saying it stands apart from our usual experience, apart from the routine course of nature. And

yet, photography not only plays a routine and indispensable role in our daily lives, it is generally thought to be a scientific technique, an expression of known and understood laws of nature, and is generally addressed as if it were exhaustively explicable in the terms of contemporary optics, physics, and chemistry. And yet, despite the assurance of its scientific identity, it never loses this tinge of enchantment. Having been assigned to the realms both of the natural and the magical at the moment of its announcement, photography has continued to inform, delight, and confound us to the present day.[1]

Most critics of photography, whether admirers or detractors, have addressed it in terms of its alleged special relation to what they generously and equivocally term "reality." Some have gone so far as to claim that a photograph is little more than a trace of the world, an inevitable "index" of an encounter between light-sensitive substances and things in the world.[2] In this view, a photographic picture is no different from a sunburn (which is, after all, the mark of an encounter between light-sensitive skin and the sun). But for all its painful indexicality, a sunburn is not a snapshot of the sun. A photograph is more than just the registering of light on a sensitive material: it is also a picture.

Beginning with its inventors, most commentators on photography have claimed that photographs are in some important sense *natural* pictures of the world. Thus characterized, they seem to fall between the ancient Greek categories of art and nature (categories we seem incapable of dismissing from our reasoning about pictures), between the productive capacities of human beings and the fundamental processes inherent in the universe. The terms in which photography is described and analyzed—the manner in which critics, historians, and even philosophers have attempted to formulate it—almost inevitably reconfirm the original pronouncement of its split personality and, in so doing, place it at the edge of our understanding. But there is no conceptual room, so to speak, between these two categories. A picture is preeminently a work of human ingenuity, an object fashioned by human choice and design, not by the laws of nature. Nature is neither a pictorial technique nor a medium of depiction. So we need to know in what way photographs may rightly

be thought of as being natural and perhaps more important, we need to know why it is they are pictures at all.

Photography was invented to do what illustrators and artists already could do quite successfully.[3] Human habits being what they are, the first photographic processes were immediately put to pictorially routine uses in attempts to achieve results that had already been well defined by picture makers in portraiture, architectural drawing, and travel illustration. It is not a trivial fact that the originators of the first photographic technologies, Joseph Nicéphore Niépce, Louis Jacques Mandé Daguerre, and William Henry Fox Talbot, were motivated by a desire to make pictures like those they were accustomed to studying in books or viewing on walls. Their dreams were dreams of pictures. These inventors were not motivated by a conception of an independent *medium* of photography; instead, they hoped to create something rather different—a non-manual technique for making pictures. Why else shall we suppose that Talbot named his first process "photogenic drawing?"[4]

In describing the pictures he published in *The Pencil of Nature*, the first book about photography illustrated with photographic prints, Talbot gives no hint that his process has resulted in a rupture with the aesthetics of the past. Commenting on *The Open Door*, he writes: "A painter's eye will often be arrested where ordinary people see nothing remarkable. A casual gleam of sunshine, or a shadow thrown accross his path, a time withered oak, or a moss covered stone may awaken a train of thoughts and feelings, and picturesque imaginings."[5] The pictures themselves make no attempt to declare their independence from existing practices of illustration, in terms either of subject matter or pictorial format.[6] Indeed, Talbot found it necessary to include a slip of letterpress in some copies of the book, advising the reader:

> The Plates of the present work are impressed by the agency of Light alone, without any aid whatever from the artist's pencil. They are the sun pictures themselves and not, as some persons have imagined, engravings in imitation.

Coming to terms with photography has been complicated by historians and critics who have attempted to write final,

once-and-for-all accounts of its invention and progress as a medium. In an important sense photography has been continually *reinvented* since its initial publication in 1839. The first photographic technologies constituted a mammoth but nonetheless only a preliminary step in the process of inventing photography. No matter how revolutionary a new picture-making process may be, it cannot constitute by itself a pictorial medium. At best it can only suggest the possibility of one. It took time for photographers to learn that the constraints and opportunities afforded by photography were not identical with those of the older, manual techniques of depiction. It also took time for them to come to value and insist upon the differences. Understanding the origination of photography can suggest, but cannot determine, possibilities. Although the inventors of the first photographic processes were motivated by a desire to produce pictures incorporating the values of existing pictorial practice, this tells us little about how later generations of photographers would come, in their diverse uses of photography (sometimes self-consciously, sometimes not), to adopt, modify, or subvert those practices.

## BEFORE PHOTOGRAPHY

Photography cannot be dissociated from the older graphic arts because it originates with them, but this is not to say that it is an outgrowth of what some might still choose to call "high" art. Photography doesn't stand in need of such legitimization. Its origins are in the broad practice of picture making taken as a whole; in functional illustration (medical, scientific, technical); in the illustration of popular journals and books; in various forms of commercial printmaking; as well as in artistic practice.[7]

How is it possible to account for the pictorial character of photography—to explain the remarkable fact that photographs are pictures? Beginning a history of photography with descriptions of the earliest experiments aimed at a practical system blocks examination of this question, because it forces the assumption that photography is somehow inevitably pictorial, and urges us to believe that an account of the chemical discoveries of photography's inventors is at the same time an explanation of why a photograph is a picture. The first pho-

Fig. 2. William Henry Fox Talbot, *The Open Door*, Plate VI, *The Pencil of Nature*, c. 1844, salted paper print from calotype negative, Gilman Paper Company Collection

tographic experiments were not merely concerned with eliciting changes in the constitution of certain chemicals by the action of light; they were aimed at the production of pictures through the agency of light. The first inventors sought to find ways of guiding chemical reactions in a way that would result in the formation of pictures, and their guiding mechanism was the camera. The reason most photographs are pictures at all is that they are made with cameras.[8]

We now accept cameras as little more than natural mechanisms for making images. They strike us as being natural machines because they seem to do their work with the inevitability of water rushing over a fall. We have lost the capacity to see that cameras are tools, or instruments designed to accomplish certain goals. But in fact they do not provide an in-

5

dependent, scientific corroboration of the pictorial values of illustrators and artists; nor do they coincidentally produce the sort of imagery we associate with them (say, through great good luck, or blind dumb chance). On the contrary, they were designed to incorporate or confirm the values of established pictorial practice.[9] Without an appreciation of the history of cameras, of the fact that they were painstakingly designed over a period of nearly three centuries to produce a certain kind of imagery, it is impossible to account for the fact that many photographs bear such a remarkable resemblance to prints, drawings, or paintings made long before the invention of photography.

## CAMERAS AND DEPICTION

The idea of designing a camera specifically for pictorial applications appeared first in late Renaissance Italy. It had been known since antiquity that an image of the sun forms in back of a minute hole, for example, one drilled in the wall or ceiling of a darkened room. This phenomenon, known today as "pinhole image formation," was used by ancient astronomers to observe solar eclipses. It was well known and thoroughly studied by natural scientists throughout the medieval period.[10] But it apparently never occurred to these students of pinhole imagery that it might have a pictorial application.[11] The first published suggestion that pinhole image formation might be adapted for a pictorial use appears in *Magia Naturalis Libri IIII*, published in 1558 by the Neapolitan nobleman and encyclopaedist Giovanni Battista Della Porta:

It is necessary to closely shut the windows and door [of a room] . . . lest even a little daylight should cause the demonstration to fail. The light should be admitted only through a single conical hole bored through the wall, the base of the cone being turned to the sun and the pointed end turned toward the interior. The wall opposite should be kept white or covered with a sheet of paper. One will then perceive everything that is lighted by the sun, and the people passing in the street will have their feet in the air and what is on the right will be on the left side. . . . The images will be much larger as the paper

will be farther away from the opening; but the nearer the paper is placed, the smaller they will become . . . anyone ignorant of the art of painting [can use the camera] to draw with a pencil or pen the image of any object whatever.[12]

Although it may seem that the camera obscura (literally, "dark room"), as described by Porta, merely adopts well-known laws of optics to pictorial purposes, it is easy to overlook the various design considerations already built into the instrument. For example, Porta requires that the wall onto which the imagery is to be projected will be at a right angle to the aperture. Moreover, he assumes that the surface receiving the image will be planar rather than concave or convex. These requirements are not dictated by optical laws—images will form equally well on a concave surface at a sixty degree angle to the aperture—but they will look rather different from the images formed in a device like Porta's. The problem then, is to determine the standard for an acceptable image—and laws of optics offer no guidance here. Porta clearly has as his goal an image that looks like a picture—the kind of picture already made by printmakers, sketchers, and painters.

Eight years before Porta published his remarks about the pictorial use of the camera, Girolamo Cardano had suggested the introduction of a lens at the aperture to increase the brightness of the projected image. This innovation introduced complications: with any particular lens, the resulting image will be in focus at a set distance from the aperture and only those illuminated objects at a mathematically determined distance in front of the camera could be well-delineated in the image.

Cameras that were minimally useful aids to illustrators and artists were not produced until well into the seventeenth century, and while it is probable that artists, particularly Dutch painters like Pieter Saenredam and Johannes Vermeer, were fascinated by the imagery produced by these instruments, it is highly unlikely that they ever depended on them as aids for drawing.[13] The reason for this is simple; lens making was still crude and lenses suffered from major aberrations that interfered with the production of acceptable images. Painters like Saenredam had no need for the kind of

Fig. 3. Pieter Saenredam, *Cathedral of St. John at s' Hertogenbosch*, 1646,
National Gallery of Art

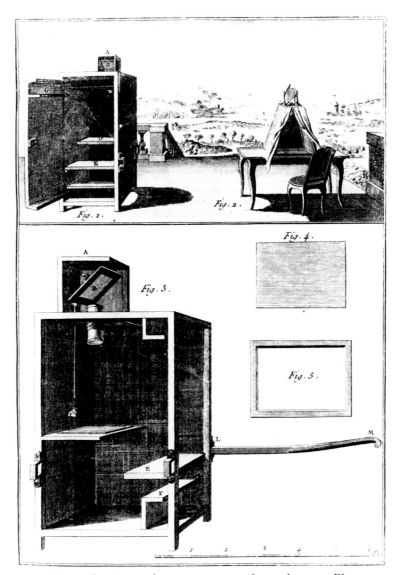

Fig. 4. Two early nineteenth-century cameras for outdoor use, Plate 4,
*Dessein, Chambre Obscure*, from *Dictionnaire des Beaux-Arts*, Paris,
1805, Department of Special Collections, Joseph Regenstein Library,
University of Chicago

assistance a camera might afford them; indeed, it would
have introduced more problems than it could solve.

By the late seventeenth century, reasonably portable cam-
eras were introduced and lens making had progressed suffi-
ciently that cameras were now able to provide reasonably
sharp imagery, but they remained difficult to use effectively.[14]

The creation of lenses of differing focal lengths was a *sine
qua non* for the use of the camera as a pictorial tool. Since
artistic practice required that painters stand at a set distance
(determined, in part, by the dimensions of the canvas) in order
to avoid exaggeration of the features of their sitters, specific
lenses were required for portraiture.[15] Further, a portrait

lens for a small camera could not function as a portrait lens for a large one. Likewise, special lenses for city and landscape painting had to be formulated and ground in relation to the size of the cameras they were intended to fit. By the middle of the eighteenth century, cameras and lenses had been specifically designed for use by picture makers, and manuals of instruction for their correct use were produced by lens makers and artists as well. The important point here is the relation of design to purpose: camera makers had to be told of the specific needs of picture makers before they could design cameras that would satisfy their needs. By the late eighteenth century, the mechanism of the camera was thoroughly conventionalized to meet the well-defined needs of the practices they were intended to aid. The camera did not sidestep the conventions of picture making, it incorporated them.[16] This is photography's birthright.

The development of the camera satisfied only one of three preconditions for the invention of photography. The other two were the idea of using the agency of light to make pictures from camera imagery and the availability of diverse and reasonably predictable chemicals. Some historians, who have maintained that these conditions had been met by the first third of the eighteenth century, find it mysterious that it took another century for its actual invention.[17] But there is no mystery here. The invention of photography was critically dependent upon the manufacture of reliable quantities of certain chemicals like silver nitrate and upon the discovery, investigation, and commercial production of new elements and compounds (in particular, iodine, bromine, and sodium thiosulfate). These materials were simply unavailable in reliable quality and quantity prior to the middle of the second decade of the nineteenth century. The invention of photography so soon after the discovery of some of its basic chemical materials is less mysterious than it is stunning.[18]

The chemical action of light is a quite unremarkable feature of our everyday experience. The darkening of pale human skin and the bleaching of fabric by sunlight are such common phenomena that they tend to escape our attention in discussions of photosensitivity—even though they provide clear proof of the agency of light. While the effect of light on various substances has been noted in the literature of the arts and sciences for more than two thousand years, the systematic study of the chemical action of light began in the late seventeenth century with the development of chemistry, which accompanied the growth of various manufacturing industries. During the 1700s, compounds of silver, in particular silver nitrate, were well investigated for their ability to dye feathers, leather, and furs to a deep, permanent black. But the idea or conception of making a picture by conjoining chemistry and the optics of cameras did not emerge until the close of the eighteenth century.

The first published account of photographic experiments aimed at making pictures with the camera obscura appeared in *The Journals of the Royal Institution* in 1802.[19] The essay, written by the young British chemist Humphry Davy, reported on a photographic invention by Thomas Wedgwood and summarized experiments carried on by both men. The actual results were modest and the working method was quite simple. A solution of silver nitrate was brushed on ordinary paper or white leather. The material remained white until exposed to sunlight, which turned it light blue, then dark purple, and finally black. Wedgwood devised a means of "pretty accurately represent[ing]" objects like "the woody fibres of leaves, and the wings of insects" by pressing them in contact with the photosensitive material and exposing them to sunlight.[20] Light penetrated the translucent parts of, for example, a leaf and darkened the areas beneath, while the opaque stem and veins blocked light and left the underlying photosensitive regions in their original white condition. Because the area beyond the leaf's periphery turned to a uniform black, these pictures, the first ever made by photographic means, were termed "profiles." (We would now call them "photograms.")

Beyond this point, the experiments were a failure. Neither Wedgwood nor Davy could find a means of desensitizing the pictures once they were made. Ironically, the agent responsible for creating the pictures—light—also destroyed them. Perhaps even more disappointing, attempts to make pictures by means of the camera were entirely unsuccessful.

These experiments are important not because of their results but because of the idea motivating them. According to Davy, "the first object of Mr. Wedgwood" was to "copy" the

images of the camera obscura, not in the usual manner of working by hand, but "by the agency of light upon nitrate of silver." Wedgwood conceived of optically crafted camera imagery in the same way an artist or illustrator would: as a complete, still picture to be copied. The novelty of his idea lies in the *method* of copying. He proposed to substitute the action of light for the agency of a hand tracing over the camera image. What we must be careful to note is that his idea involved the photochemical or mechanical "copying" of an *image* already constructed in the camera. The image itself is a given. The relation of the image to the objects in front of the camera seems to have been of no interest. This notion of the substitution of mechanical work for human labor is, of course, a major energizing force of the industrial revolution. Wedgwood's idea of using a natural agency for the copying of camera imagery and Davy's characterization of it within the context of the elegant, the utile, and the commonplace marks the idea of photography, at its birth, with the attributes of an emerging modernity.[21]

The history of the invention of the first successful photographic technologies actually comprises two separate and parallel stories leading to two entirely distinct processes.[22] The invention in France of the first—but entirely impractical—photographic system by Joseph Nicéphore Niépce leads directly to the daguerreotype, the first practical and commercially successful photographic process; the work of William Henry Fox Talbot in England leads to our modern system of photography. These processes need to be discussed as they were invented—in isolation from one another.

## JOSEPH NICÉPHORE NIÉPCE

The first complete photographic system was invented in France by Joseph Nicéphore Niépce. The experiments leading to the process (called "héliogravure") were begun by Niépce and his brother Claude in 1815 and came as a direct outgrowth of their work with lithography, the revolutionary process then known as "chemical printing," which had been invented in Germany in 1798.

Working at his estate in Gras, Niépce had first experimented with lithographic engraving in 1813. Since he was not adept at drawing, the designs were put down on the lithographic stone by his son Isidore. It was doubtless because of Isidore's departure for the army in 1814 that Joseph, along with his brother Claude, soon began their first experiments aimed at creating pictures "spontaneously" in the camera.

In 1817, after obtaining mixed results with salts of silver, Joseph turned to the materials of lithography itself as the foundation for a photomechanical printing process, that is, a procedure with which he could prepare a design by the action of light on a stone, and then produce prints by treating and inking the stone in the usual manner. His experiments finally led him to a popular lithographic varnish or resist made of asphaltum (naturally occurring tar pitch), dissolved in oil of lavender. Niépce discovered that when exposed to strong light the varnish hardens and loses its solubility in lavender oil. This allowed him to take an existing paper engraving, place it in contact with a varnished stone or plate, expose it to strong sunlight for roughly two hours, and "develop" it in a bath of petroleum and oil of lavender. Light passing through the paper hardened the varnish beneath, while dark areas of the engraving blocked the passage of light, leaving the underlying varnish in its original soluble form. Development in the solvent left a pattern of unvarnished and varnished areas on the plate corresponding to the light and dark portions of the engraving. (In modern terms, a latent image formed on the plate which, when developed, was a negative of the original print.) It could now be treated chemically and used to make prints in the usual manner. The general details of this procedure were well worked out by the summer of 1822.

In September 1824, Niépce succeeded for the first time in using the process for the production of a camera image (which he called a "point de vue") on a lithographic stone. He wrote Claude, who was now in London:

I have the satisfaction of finally telling you that having perfected my process, I succeeded in obtaining a *point de vue*. . . . [It] was taken from my workroom in Gras using my largest C[amera] O[bscura] and my largest stone. The image of the objects is represented with a clarity, an astonishing fidelity, complete with myriad

details and with nuances of extreme delicacy. To get the effect, one must look at the stone from an oblique angle . . . and I must say my dear friend, this effect is truly something magical.[23]

The *point de vue* was faint, very low in contrast, and extraordinarily difficult to view, but its effect was nonetheless "magical." The exposure in camera was on the order of eight hours. Unlike the images made by contact with engravings, camera images proved to be too fragile to withstand harsh chemical treatment, and thus could not be used for the production of prints in ink. Niépce ceased thinking of camera-made héliogravures as intermediate steps toward making prints and came to address them as single, unique images.

By the late 1820s, Niépce had revised the method for making héliogravures. He applied the varnish to pewter and silver-surfaced copper plates, which were exposed and developed as before. He then fumed the plates over iodine crystals, thus permanently blackening the exposed silver or pewter and leaving unaffected those areas still protected by the varnish.[24] Finally, he removed the varnish from the plate. The result was a unique positive picture that was difficult to view and time-consuming to make, and which suffered from excessive contrast and imperfect rendering of detail. Niépce understood that his process was in need of major improvement.

## L. J. M. DAGUERRE

Impoverished by the experiments and heartbroken by the death of his brother in 1828, Joseph Niépce entered into a partnership agreement with L. J. M. Daguerre in December 1829. Daguerre was a successful painter-entrépreneur with a quirky genius for creating extraordinary effects in the immense scenographic paintings that he exhibited in Paris. Niépce contributed the working details of the process and Daguerre brought funds for research, an excellent camera manufactured by Charles Chevalier, and an extraordinary amount of energy.[25] The men worked separately—Daguerre in Paris, Niépce in Gras—though they stayed in touch through a constant, coded correspondence.

In May 1831, Daguerre discovered that the iodized areas of the silvered metal plates were extremely sensitive to light and from that point on, he devoted most of his experiments to working with this combination of materials, eventually discarding the asphaltum varnish. Silvered plates, fumed in the dark over iodine crystals (thus producing silver iodide) and then placed in the camera, required relatively short exposures (about an hour in bright sun) to produce, without development, intense and highly detailed but tonally reversed (negative) images. The next three years (during which Joseph Niépce died and his son Isidore replaced him in the partnership) were devoted to finding a means of reversing the tonal structure of the image, and in the fall of 1834, for reasons no one has ever been able to explain, Daguerre began fuming his plates after exposure with the vapors of heated mercury.[26] The results were astonishing; a delicate, exquisitely detailed, and highly finished picture formed on the plate. The image consisted of a creamy white, fragile deposit of a silver-mercury amalgam on those areas of the highly polished surface of the silvered plate that had been exposed to light.[27] The mercurial development also reduced the exposure to about twenty minutes in bright sun.

Late in 1837 Daguerre discovered a simple means of stabilizing his pictures by bathing them in a strong solution of ordinary table salt. With this, the process was capable of producing pictures that were relatively resistant to the darkening effects of further exposure to light. The partners attempted to sell the invention by public subscription, but failed to find interested investors. In January 1839, Count François Arago, a brilliant and highly popular French scientist, succeeded in interesting the French legislature in considering an arrangement by which Daguerre and Niépce would receive lifetime pensions in return for the rights to their processes.[28] In July, the Chamber of Deputies and Chamber of Peers heard reports from separate commissions that had reviewed the processes. On 3 July 1839, Arago presented the enthusiastic report of his commission to the Chamber of Deputies, detailing the usefulness of the daguerreotype for archaeology, the fine arts, and the various sciences.

The report places special.emphasis on the great "economic

Fig. 5. Jacques Louis Mandé Daguerre, *Collection de coquillage et divers*, 1839, daguerreotype, Conservatoire Nationale des Arts et Métiers

advantages" promised by the invention; a single daguerreotypist, he argues, could copy the hieroglyphs on Egyptian monuments, which would otherwise require "decades of time and legions of draughtsmen." Moreover, the daguerreotypes would "excel the works of the most accomplished painters, in fidelity of detail and true reproduction of the local atmosphere."[29]

During the commission's hearings, the painter Paul Delaroche was asked by Arago if "art itself may expect further progress from the study of [daguerreotypes] drawn by nature's most subtle pencil." Arago quotes from the painter's response:

[Delaroche] states that Daguerre's processes 'are so far reaching in the realization of certain essential requirements of art that they will be the subject of observation and study, even by the most able painters.'[30]

Both chambers of the French legislature voted to support a bill giving the inventors a lifetime pension in return for the details of their processes. On 19 August 1839, Arago described the processes to a joint session of the Académie des Sciences and the Académie des Beaux-Arts, and within weeks people throughout the western world were using it to see (as Daguerre put it) "the imprint of nature reproduce itself. . . ."[31]

## WILLIAM HENRY FOX TALBOT

The commotion created in late 1838 by the rumors of Daguerre's invention struck the Englishman William Henry Fox Talbot with special force. During 1834 and 1835, Talbot had devised a process based on the light sensitivity of silver salts that allowed him to make photographs with a camera. Tales about Daguerre's process, while exceedingly vague, suggested to Talbot that the Frenchman had invented a procedure using the same principles he had discovered three years before. He quickly arranged to present a paper to the Royal Society, to which he belonged, in late January of the coming year in order to establish his priority as the discoverer of certain basic photochemical principles and their application to the production of pictures.

Talbot need not have been so concerned. His discoveries were quite different from Daguerre's and his pictures, which he called "photogenic drawing," were crude and incomplete by comparison with well-made daguerreotypes. Nonetheless, his method contained the seed of modern photography, for unlike Daguerre's, Talbot's was a primitive photographic printing process.

Talbot's interest in photography grew out of his inability to draw. In 1833, while on his honeymoon in Italy, he tried to sketch the scenery around Lake Como with the aid of a camera lucida—an optical drawing aid.[32] This brought to mind a previous failure at drawing in which he used a camera obscura:

And this led me to reflect on the inimitable beauty of the pictures of nature's paintings which the glass lens of the Camera throws upon the paper in its focus—fairy pictures, creations of a moment, and destined as rapidly to fade away.

It was during these thoughts that the idea occurred to me . . . how charming it would be if it were possible to cause these natural images to imprint themselves durably, and remain fixed upon the paper.[33]

Talbot's experiments began early in 1834, and he turned to silver nitrate as had Wedgwood and Niépce before him. His initial tests evolved into a procedure in which paper was coated with a solution of table salt, allowed to dry, and then re-coated with silver nitrate. Talbot discovered that the resulting silver chloride was more sensitive and more predictable than silver nitrate used alone. He used this "salted paper" successfully to make solar photomicrographs, photograms of botanical specimens and items like lace, and contact prints of engravings. He found that the prints could be stabilized successfully by bathing them in a strong solution of table salt or potassium iodide. Talbot's prints were tonally reversed, but in certain cases (with white lace), this worked to his advantage, while in most other cases (the botanical specimens) the reversal was unremarkable. In some cases, though, the problem is severe; a contact print from an engraving will produce a negative picture.

In February 1835, Talbot worked out a solution to this problem; to re-reverse the tonality of a print, the negative picture had only to be printed in contact with a fresh piece of sensitized paper. As it turned out, this procedure was correct in principle, but his photographic materials were most usually incapable of producing negatives with sufficient density to allow the successful printing of positives.

Talbot next devised a method of making specially "sensitive paper" by brushing and rebrushing it with repeated, alternate baths of salt water and silver nitrate, and then turned to experiments with the camera. His first camera negatives, which were quite small, took "an hour or two" to expose in bright sunlight. Talbot notes in his Royal Society lecture:

> I obtained [with the camera] very perfect, but extremely small [negative] pictures; such as without great stretch of the imagination might be supposed to be the work of some Lilliputian artist. They require indeed examination with a lens to discover all their minutiae.
>
> In the summer of 1835 I made in this way a great number of representations of my house in the country, which is well suited to the purpose. And this building I believe to be the first that was ever yet known *to have drawn its own picture.*[34]

Fig. 6. William Henry Fox Talbot, *Lace*, c. 1841, photogenic drawing negative, Hans P. Kraus, Jr., New York

In late January 1839, Talbot displayed at the Royal Institution a set of his prints made in 1834–1835 and delivered a paper to the Royal Society announcing his invention. Although no exact list of the exhibited prints remains, contemporary accounts indicate that there were photograms of botanical specimens, negatives made from engravings, camera negatives of buildings and sculpture, and some negative photomicrographs. He also showed two or three positive prints from negatives of engravings, but he showed none made from camera negatives, because they were too faint to be used in printing.[35]

Thus, by the autumn of 1839, two photographic processes had been made public; the daguerreotype, which gave astonishingly detailed, highly finished camera-originated pictures, and Talbot's photogenic drawing process, which allowed the production of photograms, camera-originated negatives, and positive prints from negatives of engravings.[36] In terms of its practical possibilities, the future of photography seemed entirely with the daguerreotype.

The crux of Talbot's problem lay with the character of his camera negatives; even after he substituted silver bromide for silver chloride to produce more "vigorous" negatives, they

were insufficiently dense to produce anything but dull gray positive prints. Moreover, camera exposures of photogenic drawing paper were prolonged and accordingly placed a strict limitation on what might serve as a possible object of photographic depiction—anything that could remain static for an hour or more.

By mid-1840, Talbot had devised an entirely new procedure for making negatives. He brushed paper with potassium iodide and silver nitrate to produce a bright yellow coating of silver iodide (the active compound in the daguerreotype), which was, however, quite insensitive to light. These sheets, called "iodized paper," could be made many months before they were needed. Just prior to making a camera negative, the iodized paper was brushed with "gallo-nitrate of silver" (a solution of silver nitrate, acetic, and gallic acids) and placed, while still moist, into the camera.

Depending upon the strength of the sunlight, exposures ran from a few seconds to a minute or two. The exposed sheet was brushed with more gallo-nitrate of silver in a darkroom until a vigorous negative was completely developed. Talbot now used this negative as a master from which positives were made on his photogenic drawing paper. The new process, named "calotype" (from the Greek words *kalos* and *tupos*, or "beautiful print"), was patented by Talbot in February 1841.

During printing, the fibrous structure of the paper negative diffuses the light passing through it to the printing paper and obscures the details in the negative. Talbot found he could increase somewhat the resolution of detail in his prints by waxing the negative after processing, making it more translucent. Although prints from his calotype negatives lacked the hard-edged precision of daguerreotypes, their overall effect was substantially closer to the naturalistic, suggestive mode of depiction favored by many illustrators and artists of the time.

## INVENTING PHOTOGRAPHY

The invention of the first photographic processes was virtually complete by 1841. Some details of the calotype process remained to be ironed out and Talbot completed them

within two years; at the same time, daguerreotypists discovered that using bromine in conjunction with iodine "quickened" daguerreotype plates and thus permitted exposures to be counted in seconds rather than minutes. But the future of photography remained unclear, the course of its practical use uncharted.

In some way, the new processes were disappointments. Neither one captured color. As illustrations for mass communication and education, both left much to be desired; each daguerreotype was unique, and while multiple prints could be made with the calotype process, the procedure was highly inefficient compared with methods such as wood and steel engraving and was, moreover, not compatible with type. The inventors and contemporary critics offered predictions of contributions to science and art that ranged from the prescient to the bizarre, but no breakthroughs were immediately forthcoming.[37] Perhaps photography would simply be a pastime for the rich and the artistically untalented—Daguerre suggested the possibility, and Talbot embodied it.[38]

Some of the pictorial characteristics we now take to be revolutionary and peculiarly photographic (such as randomness and a preoccupation with the singular and fragmentary) were mentioned by the earliest viewers of photographs, but were not seen as providing need for a special photographic aesthetic. True, at the time of its announcement, the daguerreotype was hailed as an innovation for its astonishing finish and resolution of detail and it became a kind of a game to observe the plates with a positivist's fascination, to count bricks on building facades or to use a magnifying glass to reveal minute, unsuspected details in puddles or window reflections. But popular interest in detail *qua* detail soon waned.[39]

For those evaluating the *pictorial* effects of the new processes, the wealth of detail was a revelation of a different sort. There is a note of genuine surprise, coupled with relief, in the reaction of Delaroche, as reported by Arago: "What he stresses most about photographic drawings [*les dessins photographiques*] is their 'unimaginable precision' of detail, which does not disturb the repose of the masses and does not detract in any way from the general effect."[40] Talbot made much the same point writing about his picture *The*

*Haystack* (cat. 12), which for him raised the possibility of using the calotype both to confirm and extend the picturesque mode. An artist, he notes, would not have taken the trouble "to copy faithfully from nature" all the minute details shown in the picture and would content himself with "a general effect." Nonetheless, the representation by the calotype process of these details and "every accident of light and shade . . . will sometimes be found to give an air of variety beyond expectation to the scene represented," and, of course, an "air of variety" is at the very heart of the picturesque.[41] What is "beyond expectation" (and clearly, he means the expectation of an audience well-acquainted with the devices of romantic depiction) is the contribution made by details to the general effect of random variety.

The contents and style of the pictures made by the inventors of photography were hardly revolutionary. In the period between June 1844 and April 1846, Talbot printed and published *The Pencil of Nature*, which was offered in six individual fascicles containing a total of twenty-four salt paper prints, most of which had been made from calotype negatives. The goal of publication was to introduce photographic pictures to an audience already familiar with the daguerreotype but unfamiliar with photographic prints and to provide some examples of the art, suggestive of a variety of future uses.

The categories into which the pictures fall are entirely conventional; there are ten architectural and travel pictures, four still life studies, three inventories (chinaware, glass, and books), two copies of handmade prints, one of a page from an ancient book, two of a plaster cast, a print of a leaf, and finally, a print of a bit of lace. In addition to the conventionality of the categories (curiously, portraiture is not included) the pictures themselves make no attempt to declare their independence from existing practices of illustration, in terms either of subject matter or pictorial format. Photography had been invented, but it was still undefined.

## ESTABLISHING PHOTOGRAPHIC PRACTICE

The scientific endorsers of the daguerreotype and its first critical reviewers failed to predict the first widespread use of the invention—the production of portraits. At the time it was made public, the daguerreotype required many minutes of exposure in bright sunlight. As news of the process reached across the world, a number of adventurous spirits became amateur daguerreotypists and many of them set out to put the process in the service of portraiture. Within two or three months of the announcement of the details of the process, daguerreotypists in America and England had constructed cameras and light-reflecting apparatus permitting the taking of small daguerrean portraits in sunlight, in just a few minutes.

The early, experimental, studio self portrait by Robert Cornelius of Philadelphia (cat. 8) was made within months of the publication of the daguerreotype, using a camera of his own manufacture. The self portrait is an emblem of photographic experimentation; it shows Cornelius off-center, hair disheveled and looking at his viewers, as if disbelievingly, out the corners of his eyes.[42] Late in 1839 Dr. Paul Goddard of Philadelphia discovered that exposure could be reduced considerably by fuming a previously iodized plate with the vapors of bromine. With a reasonably "fast" lens, it soon became possible to make large daguerreotype portraits with exposures ranging from ten to thirty seconds in a studio equipped with a skylight. By 1842, portrait studios had been established in cities throughout Europe and America, and the numbers increased throughout the 1840s, as itinerant teachers of the new process and local daguerreotypists offered lectures and classes on the latest techniques of the art to a growing audience of would-be photographers. Daguerreotype portraiture was initially understood by both its practitioners and its sitters as a replacement for painted miniatures.[43] Daguerreotypists (especially in America) were quick to advertise their plates as "miniatures by the daguerreotype process," and it is not surprising that many portrait daguerreotypes, particularly those made in the more fashionable studios, rely heavily upon formulas of pose, placement, and lighting derived from miniature painting as well as from portrait lithographs and steel engravings.

The portraits of Southworth and Hawes (cats. 16, 18, 30) of Boston, perhaps the most consistently beautiful and elegant made with the daguerreotype process, show a remarkable attention to the use of varied lighting schemes, careful consideration to posing, and a willingness to subordinate some

details in the service of an overall effect. These portraits are remarkable for their willingness to suppress precisely those properties we have come to think of as essential marks of the daguerreotype—transparency and precision, in favor of translucency and the relatively muted presentation of some planes or details requiring the viewer to fill in what is only suggested.[44] There is no suggestion that these photographers were attempting to produce portraits that might be mistaken for miniature paintings—they show no interest in painting over the surface of their portraits, or in otherwise producing daguerreotype-paintings. Rather, they were working within the well-established genre of portraiture, and the question of medium (which had hardly been posed yet for photography) was subordinated to the conventions of that genre.[45]

Southworth and Hawes' plates cannot be classified as simple "likenesses"—they are not limited to the superficies of their subjects. Neither are they precisely evocations of the personalities of their sitters. They seem adjusted on a knife edge between the two and may even risk blatant theatricality without turning to melodrama. At the same time, these photographers were able to produce informal, almost offhand portraits reminiscent (to a modern eye) of snapshots, which nonetheless maintain a graceful equipoise.

Soon after the establishment of a commerce in daguerreotypes a curious division began to appear in the work of American daguerreotypists. While the more socially prominent, expensive studios continued to make plates generally in keeping with the portrait conventions of other media, the less expensive studios and itinerant daguerreotypists tended to dispense with these formalities and developed a vernacular approach to portraiture. This approach may have originated in a conscious desire to do away with the older conventions of portraiture or may result from the lack of familiarity with those conventions on the part of the new and often poorly educated daguerrean entrepreneurs. It is not unreasonable to suppose that each of these reasons applies in some measure.

Vernacular portraiture aims at representing the superficial and frankly revels in it.[46] The vernacular is no less formulaic or rule-oriented than the more elevated modes of representation, but because it lacks "artfulness," it can seem entirely aconventional. In vernacular portraiture, lighting

Fig. 7. Southworth and Hawes, *Marion Augusta Hawes or Alice Mary Hawes*, c. 1850, daguerreotype, 10.8 x 8.3 (4¼ x 3¼), International Museum of Photography at George Eastman House, Gift of Alden Scott Boyer (cat. 393)

tends to be even, diffuse, nearly directionless; backgrounds are relatively uncluttered and are often an unvarying, unobtrusive gray; details are resolved everywhere, as if no probing eye or authorial consciousness seeks to direct our attention here rather than there; focus is maintained uniformly through all or most represented planes; sitters tend to confront viewers by looking straight at them, advertising their awareness of being beheld, or are shown somehow absorbed in studying the tools of their trades.

These two impulses—one toward established conventions of depiction and the other toward vernacular formulas insisting on the frank revelation of the commonplace—are fundamental to the development of the medium of photography. But they are tendencies in the rhetoric of photo-

15

Fig. 8. Unattributed, c. 1848, daguerreotype, Private collection

Fig. 9. Unattributed, c. 1850, daguerreotype, Private collection

graphic production and not the signs of ontological or ethical successes or failures. The daguerreotypes of Southworth and Hawes are no less causally related to the people they represent than are the plates by less conventional photographers.[47] That the vernacular formulas strike us today as being more accurate, natural, or honest—as being somehow appropriate to a medium—is undeniable and important. The tendency toward vernacular forms in photography is real, as Beaumont Newhall[48] has convincingly shown us, but it is not the only tendency, and is it not inevitably triumphant. These opposed impulses in portraiture characterize two approaches to photographic practice in general, which tend, by the 1860s

and 1870s, to merge into one another, only to be separated and recombined and separated again in later decades.

Although daguerreotype practice flourished throughout the 1840s and into the 1850s, Talbot's patents on the calotype process restricted its commercialization. But the failure of Talbot's process to establish itself as a commercial and genuinely competitive technology with the daguerreotype had less to do with legal restraints than it did with the process itself. Unlike the daguerreotype, the calotype process was awkward, unpredictable, and frustratingly difficult to work. Moreover, for an audience taken with the daguerreotype's smooth, metallic finish and finely resolved details, salt paper

prints from calotype negatives seemed too much like prints from manual, non-photographic mediums. Finally, negatives made in full sunlight often resulted in prints with high contrast and dense shadows showing little or no tonal variations or detail within them. But when negatives *were* exposed for shadow information, the resulting prints often displayed mottled, mid-toned patches containing few details. For all its charm, Talbot's print *The Open Door* is too high-contrast, its shadows too dense, to suggest the contents of the room. The density of the shadows works against the need to suggest both the space and the objects within the room, and the overall effect is one of flatness. Talbot's photographs are often as straightforwardly picturesque as his words about them indicate, but they also show the difficulty of employing the calotype in complete emulation of some of the values of established picture making.

As it left Talbot's hands, the calotype had little appeal for would-be commercializers and entrépreneurs, but it did establish itself in Great Britain during the mid-1840s with the circle of the inventor's friends and relatives, and with a small group of British amateurs who were mainly well-educated professionals—lawyers, physicians, and clergymen. Judging from their prints, the process appealed to them for the ease with which it could be used for the production of landscape and architectural views that remained, like Talbot's, very much within the tradition of the British picturesque and for its ability to produce, in the proper hands, remarkably suggestive portraits.

In 1843 the Scottish painter David Octavius Hill joined Robert Adamson, a young engineer, in using the calotype process to produce a remarkable group of prints—portraits and picturesque and architectural views made in and near Edinburgh. Hill originally adopted the calotype process as an aid to his painting; he conceived of producing a monumental group portrait of the 457 men and women who had recently formed the Free Church of Scotland and accordingly needed to take sketches of each. He turned to Adamson, who had learned photography from a friend of Talbot's, to assist him in producing photographic portrait sketches.

Shortly after entering into partnership in 1843, Hill and Adamson established an open air portrait studio on Carlton Hill in Edinburgh. They may at first have conceived of photography as an automatic shortcut for depiction but soon learned, as have all subsequent generations of photographers, that the responsibility for a poor photograph rests with the photographer and cannot be palmed off onto nature. Their portraits make intelligent use of the overall softness and suppression of details characteristic of early prints made from calotype negatives. But this softness of effect is assisted greatly by the use of selective focus and blurring caused by the slight movements of the subjects during the ten or twenty seconds it took to make exposures. When these elements are combined in group views like *John Henning and Female Audience* (cat. 26) the overall impression (and it aims at being understood *as* an impression) is one of relaxed spontaneity, while in *Highland Guard* (cat. 23), the effect produced is one of barely arrested motion. Hill and Adamson's *Life Study, Dr. George Bell* (cat. 21) cannot be viewed as an anatomical record; it is, rather, a study of the play of light and deep shadow on human flesh. This work, which comes so early in the history of photography, demonstrates the plasticity of photography and its easy dependence upon established modes of picture making. It shows that photography is not inherently and only a pictorial record-keeping procedure— something on the order of a photostat machine. Our interest in these photographs is not limited to what we might know independently about their referents, but begins with their effects as pictures. Hill and Adamson teach us the first essential lesson of photographic production; objects in front of a camera need not, and most often do not, constitute the subject matter of a photograph.

While there was a modicum of interest in paper processes from the moment photography was made public in France, the calotype process took some time to find an audience in Daguerre's homeland. By 1846, however, interest in photographic prints on paper was awakened in France by Louis-Desiré Blanquart-Évrard, a cloth merchant from Lille, who published some working modifications to Talbot's process, greatly increasing its predictability and the ease of its use.[49] In the next few years, Blanquart-Évrard made major contributions to the practice of photography on paper, both as an inventor and as a photofinisher-publisher of the work of others.

The modifications to the calotype suggested by Blanquart-Évrard provided only a point of departure for the French calotypists who followed his lead. Between 1849 and 1854, their improvements transformed the process from a hit-or-miss affair to one that was capable of giving consistent results, though consistency remained a highly personal achievement.

Gustave Le Gray, a student of the painter Delaroche, drifted into photography during the late 1840s, mastered Blanquart-Évrard's modified calotype process, and then devised a set of brilliant working modifications of his own that further simplified the production of paper negatives. Le Gray's mastery of photographic technology was entirely engaged in making pictures and was not a technical devotion to the chemistry of photography. His dry, waxed-paper technique permitted him to photograph with relative ease out of doors—producing landscapes in the forests of Fountainebleau, or working on commission in the Loire Valley, photographing ancient and medieval architecture.

Le Gray's dry waxed-paper process allowed the paper to imbibe the aqueous chemicals in a uniform manner. His negatives have a rich and unblemished tonal structure with a remarkable translucency permitting the production of prints with even, unmottled shadows. Le Gray's photograph of the *Cloister at Moissac* (cat. 31) is a technical and aesthetic *tour de force*—a triangular sweep of columns, each composed of highlights and shadows, situated in an environment of dense shadows and the highlights of the sweep of arches. The overall effect of the picture is one of sharply etched lines, but upon examination this is achieved entirely by the abrupt separation of light from shade.

The use of paper negatives in France received an official standing of a sort in 1851 when the Commission des Monuments Historiques, which was charged with producing an inventory of France's rich architectural heritage, formed the Missions Héliographiques, to photograph ancient structures throughout the country. The commission chose five photographers, each assigned to a specific region of the country: Le Gray, Hippolyte Bayard, Édouard-Denis Baldus, Henri Le Secq, and Mestral (whose first name remains a mystery). Unfortunately, the commission made no use of the remarkable negatives and prints made by this small group of photographers; they were consigned indifferently to obscurity (as were commissioned works made by illustrators using other media).

Attempts to professionalize the practice of photography on paper proved to be especially difficult since, given the public taste of the time, daguerreotypists had a nearly exclusive monopoly on portraiture and there was little interest in purchasing photographic prints. In Great Britain, the practice was confined, for the most part, to amateurs who had sufficient leisure time to devote to their craft. Talbot attempted to establish a professional basis for photography on paper (and perhaps to give would-be photographers a model for their own professional aspirations) with the Reading Establishment, a photographic printing and publishing firm operated for him by Nicolaas Henneman and Thomas Malone. But, while the venture proved the feasibility of photographic publication, it was a financial failure. Moreover, Talbot's control of the calotype patent and his demand for a costly licensing fee added an additional and impossible burden for photographers who hoped to earn a living as professionals.

One means of supplementing a livelihood as a photographer using the paper negative process was through public commissions, like the Missions Héliographiques, or through private assignments. Roger Fenton, an Englishman who had trained with Paul Delaroche in Paris and who had also taken a degree in law, traveled to Russia in 1852 on assignment from the engineer Charles Vignoles to photograph the construction of a bridge over the Dnieper River at Kiev. But such commissions could not be counted upon as a reliable source of income. In France, the small band of professional photographers who were devoted to the paper negative processes were forced to devise multiple sources of income. In addition to the relatively infrequent public and private commissions, they attempted with some small success to sell prints to the public through print and stationery shops and also devoted considerable energy to teaching photography. Some, like Le Gray and Édouard-Denis Baldus, also wrote practical treatises on photography, both for the income they could derive from the sale of books and also to keep their names and accomplishments before the public.

In addition to photographing the ancient architecture of their own countries with the paper negative processes, photographers—many who were professionals in other fields—archaeologists, civil engineers, painters, and writers—traveled to Italy, Greece, and the Middle East, producing a remarkable photographic inventory of the monuments of classical civilization. The polymath, journalist, poet, painter, and professional traveler Maxime Du Camp (cat. 42) took a few lessons in the use of paper negatives from Gustave Le Gray[50] and traveled throughout the Middle East from 1849 through 1851 (accompanying Gustave Flaubert), producing more than two hundred negatives of the area, of which 125 were published by Blanquart-Évrard in 1852 under the title of *Egypte, Nubie, Palestine et Syrie*.[51] These prints were the first published photographs of the Middle East. Du Camp's views are intelligent, workmanlike, informative. By and large, they are formulaic, and make little attempt to challenge the well-established schema for composing views that typify the travel and archaeological illustrations of the time.

The Middle Eastern photographs of the painter and archaeologist Auguste Salzmann are, by contrast with Du Camp's, anything but characteristic of the archaeological illustration of the time. Salzmann traveled through Egypt, Syria, and Palestine in 1854 on a commission from the Ministry of Public Instruction, photographing ancient sites as well as various buildings and monuments dating from the time of the Crusades. While photographing in Jerusalem, Salzmann was asked by F. Caignart de Saulcy, the numismatist and dilletante archaeologist, to photograph a number of architectural remains that he believed were datable to the time of Solomon. The results of this trip were published in 1854 by Blanquart-Évrard (in three volumes containing 178 plates).[52]

While the purpose of Salzmann's photographic commission was educational in character, his photographs are exceptional for their suggestiveness and for the way in which broad patches of light and dark are used to define the shapes of structures. There is a simplicity and pictorial boldness in his *Temple Wall: Triple Roman Portal* (cat. 44), which is not usually associated with archaeological illustration. The harshly-lit wall with its three portals seems to rest on a jagged hill made of deep, featureless shadows. To be sure, the picture provides information of use for instructional purposes, but it is at the same time a remarkable study of patterns, textures, and the random play of light and shadow. Salzmann was, after all, trained as a picture maker, and his archaeological views show the mark of an elegant, pictorial sensibility.

John Beasely Greene was arguably the most pictorially inventive of all the photographers who used paper negatives in the Middle East. The son of an American businessman who managed a banking house in Paris, Greene trained as an archaeologist and made his first trip to Egypt in 1853, at the age of twenty-one. Ninety-four prints from this trip were published by Blanquart-Évrard in 1854 as *Le Nil—Monuments—Paysages—Explorations photographiques par J. B. Greene*. The photographs in this album are divided into two categories—landscapes and monuments. Greene's landscapes seem like exercises in attenuation—as if his goal is to determine a means of maximizing pictorial effect by minimizing pictorial data. The stunning view titled *The Nile* (cat. 45) is not intended to convey discrete bits of information—everything it presents is vague, distant, and featureless. It suggests a glimpse of an evanescent scene in which the weight of the blank sky pressing against the amorphous Nile is balanced precisely on the thin slip of shoreline and its centered mass of buildings and trees.

The roots of the practice of photography as a printmaking medium were established in the paper negative period (ranging from 1843 through roughly 1855), but the impact of photographic prints on the evolving popular culture was minimal. It is true that printing paper negatives was a slow and tedious process (even as practiced by Blanquart-Évrard's printing house at Lille), but it is similarly true that photographic prints were not particularly costly. The problem seems to have been one of finding a popular use for photographic prints. Albums of photographs were produced in relatively small editions and found their audience among archaeologists and dilettantes interested in archaeology, scholars, print and book collectors, and, finally, among lovers of the visual arts. Individual prints were sold to travelers (in relatively small numbers) as souvenirs, but there was no large-scale demand for such pictures. As late as 1853 only a small market existed for photographic prints because the mem-

bers of the rapidly expanding middle class were, as yet, ignorant of them and unaware of how these pictures might fit into their lives. The photographic print explosion that began in the mid-to-late 1850s required the creation of a new audience—one that rapidly became accustomed to seeing itself depicted in sepia tones and which was soon demanding to see everyone and everything represented on sheets of glossy paper.

## WET PLATE PHOTOGRAPHY

By the mid-1840s, some photographers and experimenters had seen the future of photography in the combination of what they took to be the virtues of the daguerreotype and the paper negative processes. They aimed at finding a means of preparing negatives on glass, which would provide photographers with a way of making multiple prints from sharply detailed negatives. Claude F. A. Niépce de St. Victor, a cousin of Joseph Niépce, invented a means for doing this in 1847, by depositing photosensitive silver salts in and on a thin film of albumen (the whites of eggs) coating a piece of glass.[53] Exposures with the process were exceedingly long (on the order of half an hour in bright sun), but prints taken from the negatives demonstrated the possibilities for securing fine detail and remarkable chiaroscuro with glass-based processes.

Then, in 1851, Frederick Scott Archer published the details of a process based on Talbot's chemistry, but which used collodion, a mixture of ether, alcohol, and nitrated cellulose (often called guncotton, because of its explosive properties) as an invisible vehicle to hold the photosensitive salts to a sheet of glass. The plates had to be exposed while still wet and returned immediately to a darkroom for development and fixation.

The introduction of the wet plate heightened a controversy that had already been brewing as various procedures had been explored to add sharpness and tonal richness to the paper negative. As early as 1848, D. O. Hill had identified the artistic virtues of the calotype—though some saw them as technical shortcomings: "The rough and unequal texture throughout the paper is the main cause of the calotype failing in details before the Daguerreotype . . . and this is the

very life of it. They look like the imperfect work of man and not the very much diminished work of God."[54] Much the same point was raised in an ongoing debate at the 1853 sessions of the Photographic Society of London, initiated by one of its three vice presidents, the painter William J. Newton. In a paper principally addressing the pictorial consequences of various improvements in the technology of photography, Newton drew a distinction between chemical and artistic beauty. The former, he claimed, was a question of natural science and addressed the increasing power of negatives (on paper and glass) to produce "pictures still more minute and perfect in detail."[55] Newton's major concern was to show artists how they could adapt photography to their own ends— "producing a broad and general effect . . . the suggestions which nature offers." Accordingly, he advised a means of defeating the uniform sharpness that was becoming increasingly characteristic of prints produced by the members of the society by putting "the whole subject a little out of focus."[56]

At the following meeting, a photographer named Shadbolt responded by claiming that Newton's advice had created angry feelings and had divided the membership of the society: "There is a very strong party feeling between the two classes of members, whom I may call the Pre-Raphaelites and the Modern School. I confess that I am a Pre-Raphaelite myself."[57] Shadbolt saw no opposition between art and science when it came to the sharp rendering of detail and went so far as to suggest that artists who avoided precise delineation did so out of a desire to avoid the enormous amount of time it would take to execute it. The implication was clear: since it took no special effort to get all the details rendered sharply in a photograph, photographers ought to emphasize them. This division of opinion was not to be worked out in theoretical disputations between the opponents and proponents of photographic naturalism, but was decided in practice. The values of transparency and precision, related as they were to popular conceptions of both art and science, would soon come to overwhelm the practice of photography.

Scott Archer wrote that his experiments with collodion and his invention of the wet plate process resulted from his unhappiness with "the imperfections of paper photography"

and with his desire for a negative material possessing "fineness of surface [and] transparency. . . ."[58] The issue of "imperfection" is a pivotal one and needs to be understood as Archer put it—in terms of transparency and the flawless, glasslike surface of a collodion negative. His point is that paper negatives fail in certain respects when judged against the pictorial characteristics of well-resolved daguerreotypes made with sharp lenses (as well as, perhaps, prints from other media—scientific illustrations, or architectural views made by means of steel engraving). Archer spoke for many photographers who were frustrated by the difficulty of obtaining prints from paper negatives with smooth and uniform tonal structures, rich, dense yet open shadows, and highly articulated details. Thus, the motivation for the invention concerned, among other matters, the values of resolution, chiaroscuro, and transparency.[59]

But it is not unreasonable to take the notion of "transparency" to its limit. What seemed at first a technical problem—reducing the graininess and muddiness of calotype prints—would end as an aesthetic ideal: providing the viewer with an "unmediated" view of the subject of a photograph. To be transparent is, in effect, to be understood as invisible or unmediated and it is ironic that some of the photographers who were most successful at simulating transparency were often in fact the most rule-bound and conventional practitioners.[60] Thus transparency, which over the years came to be seen as a hallmark of photography, did not necessarily produce a relaxation of pictorial conventions—in the case of most photographers it simply brought about the wholesale adoption of a new set of rigid pictorial rules. On the other hand, transparency did not bring an end to originality in photography, but it did mean that photographers had to learn to apply their inventiveness within the constraints of photography defined in terms of the transparent.

The interest in producing negatives on glass, associated as it is with an evolving opposition between pictorial suggestion and what for want of a better term might best be called "pictorial articulation," signals the beginning of a profound change in both professional and popular attitudes toward photography.[61] Although photographs had never been accorded co-equal status with works made in traditional pictorial media,

the subject matter and formulas of depiction routinely employed in those works were thought to be appropriate to photographic practice. The ideology of suggestion and its associated naturalism is ultimately established upon the conception of representation as being expressive of the appearance of the world, in particular, of the visual impressions of an artist. The growing insistence upon transparency in photographic depiction and upon the subordination of suggestion in favor of articulation marks a change in photographic practice—a transition toward pictorial formats that now seem somehow especially appropriate to photography. The domain of photography came increasingly to be thought of as "reality" or as "the physical world" and not the way the world appears to an artist. The issue for photographers was to chart the consequences of a process that could, when used in a certain way, provide extraordinary transparency and clarity across and through all represented planes. The challenge to photographers was to create photographs that gave pictorial coherence to a vast amount of information.

These issues rarely were presented to any working photographer in a pristine form. The practical advantages of the wet plate were extraordinary, and by 1856, nearly all photographers, save a few die-hards committed to the older processes, had adopted its use. The wet plate was far more predictable than the various paper negative processes and, on average, more sensitive to light. Moreover, glass negatives printed more quickly than their counterparts on paper, which was an important consideration for photographers who were interested in making large numbers of prints from single negatives. While collodion was initially more cumbersome and less predictable than the daguerreotype, this was balanced by the cheapness of its materials and the ease with which multiple prints could be made.

Collodion negatives, together with improvements in print production, permitted the unprecedented commercialization of photography. The preparation of prints from paper negatives was necessarily a time-consuming and painstaking procedure that resisted the introduction of mass production techniques. Since collodion negatives could be printed quickly and easily by relatively unskilled workers, they offered the opportunity for the production of immense numbers of

cheap prints. This led, in turn, to a division of labor within photographic studios in which one or two skilled managers directed the activities of many unskilled printers. And it was this division of labor that brought photography into the rapidly evolving industrial culture of the nineteenth century. It became possible for travel and architectural photographers to produce tens of thousands of inexpensive prints and stereographic cards a month—some firms employed three or four hundred low-salaried workers, whose sole job was to produce prints for sale to the public. The wet collodion negative introduced photographic prints into popular culture.

One way of appreciating how the conflicting values of "transparency" and "artistry" worked themselves out in the 1850s can clearly be seen in what at first might seem to be a trivial matter—the surface structure of photographic prints. Prior to 1850, prints from paper negatives were made on fine writing paper or on papers used in engraving or for drawing. These prints are matte and have a surface character very much like lithographs or engravings. The openness of the paper weave, however, prevents the resolution of fine details. As the resolving power of paper negatives increased, owing to the modifications of the calotype, some photographers began searching for ways of registering more details in their prints. In 1850, Blanquart-Évrard published a procedure for closing the open weave of printing papers by filling their pores with salted albumen. In his description of the technique, Blanquart-Évrard notes that prints made on albumenized paper are far richer and more detailed than those made on plain, salted paper.[62] The use of egg white, however, imparts a distinct gloss to the prints, which he calls a "vulgar varnish," adding that the albumen ought to be diluted with salt water in order to reduce the gloss to a nearly invisible luster.[63] For photographers interested in staying within the tradition of printmaking as it was then understood, the gloss was anathema, constituting an unwanted and immediately apparent difference between photographs and other kinds of prints.

But as the use of collodion negatives became routine, many photographers began using undiluted albumen paper to register all the detail in their negatives and to increase the contrast of their photographs; prints took on a distinct luster. During the 1860s some photographers (and then commercial

manufacturers of photographic paper) began to double-coat their papers with albumen in order to achieve a genuinely glossy surface for their prints. Moreover, as the surface of the prints became increasingly glossy, their hues, which had been a matter of personal choice for the photographers in the paper negative period, came increasingly to be standardized within a limited range of sepia, purple, and steely brown-black tones.

The changing surface structure of photographs and the change in the variety of their hues has a dual effect; it draws attention to the photographic origins of the picture—other print forms in this period were rarely glossy—and it produces the impression in the viewer that the prints are machined, exactly reproducible, rather than handmade. It brings photography into a new world.[64]

Portrait daguerreotypists were quick to see the commercial advantages of photography on wet plates. Whereas daguerreotypes had to be sold one at a time, a photographer could now take orders for multiple prints. Portraiture remained the sole interest of most professional photographers and in their hands the genre came increasingly to conjoin the idea of likeness to one of public display. Here the adoption of new materials was accompanied by an increasing "standardization," this time of pictorial treatment. Photographic portraits came increasingly to rely on stock poses and general formulas of presentation, which often included the addition of stage props like painted backgrounds, Greek columns, or garden fences. These trappings, together with formulaic poses and lighting, have the effect of distancing a viewer from the sitter—they block all but the most routine communication. Moreover, the near-total adoption of this rigid portrait practice resulted in prints that are stylistically indistinguishable from each other. Thus the impression was created that all photographic portraits were essentially the same and that they differed only because the subjects differed, or because the same subject was shown in different (formulaic) poses. Under such conditions of production, it was easy to conclude that photography could deal only with the surface or superficial aspects of a sitter and could not evoke either the spiritual, moral character of the sitter or the attitudes of the photographer toward the sitter.

Fig. 10. Lock and Whitfield, c. 1876, *Sir Garnet Wolseley*, woodbury-type from wet collodion negative, Private collection

Two photographers, however, developed startling approaches to portraiture that differed as much from one another as they did from the general background of competent but indifferent practice. The wet plate portrait studies by the Parisian caricaturist and photographer Gaspard Félix Tournachon, known as Nadar, have been aptly compared to the portraits of Ingres and the lithographs of Achille Devéria.[65] Nadar's portraits, especially those made at the height of his powers in the mid-to-late 1850s (cats. 75, 77, 78, 79), rely almost entirely on the use of light, his careful attention to pose, and his willingness to make as much or as little use of the ability of the wet plate to delineate details as the occasion required. His portraits often convey an odd fragility—the

sitter appears to be left on his or her own, with nothing to fall back upon (no props, no comfortable, formulaic public poses) in what sometimes seems to be a communion and sometimes a confrontation with the beholder. Nadar was committed to the production of "the most familiar and favorable resemblance, the intimate resemblance" by means of a "moral understanding" of the subject.[66] There is at times something disquieting about his portraits—because they often refuse, steadfastly, to flatter his sitters, but more often because they show us the nervousness and intimate the secretiveness of Flaubert's Paris.

The British photographer Julia Margaret Cameron set out in 1863–1864 quite self consciously and with the full force of her extraordinary will to make photography consonant with the aims of art: "My aspirations are to ennoble photography and to secure for it the character and uses of High Art by combining the real & Ideal and sacrificing nothing of Truth by all possible devotion to Poetry and *beauty*. . . ."[67] Her aims echoed those of her good friend the painter G. F. Watts, as well as the thriving naturalism of her time. Cameron's majestic portraits of the major figures of British intellectual society often aim at evocation and attempt to represent idealized types. She worked by the denial of the entire structure of routine photographic portraiture; where commercial portrait makers emphasized clarity and detail, she worked by suggestion and approximation; while they rarely varied from using even, soft lighting, she often turned to harsh, raking light. For Cameron, suggestion was everything. The portrait of her friend Sir John Herschel (cat. 90) makes no attempt at delineating his outward appearance; it is not meant as a likeness. The harsh illumination from above that makes his eyes into mesmerizing holes also rims the top of his head with bright light. The overall effect of the blur of his face together with the sharply contrasting light and shade is one of energy and motion. This is a photograph of cerebration, of intellectual energy, and certainly Mrs. Cameron expected us to understand that the light on Herschel's head came from within and brought clarity out of darkness.

Although Cameron sold her prints through print and book sellers and created a stir among the stuffy community of portrait photographers, her manner of addressing photography

denied everything they and most of their audience had come to take for granted. It would come in later years to be seen as exemplary by a handful of photographers who had just been born.

## THE INDUSTRIAL LANDSCAPE

The introduction of the wet plate and glossy papers offered new possibilities for photographers working out of doors, removed from the stifling constraints of studio practice. Photographers like Gustave Le Gray varied their choice of negative material, sometimes using the paper processes and at other times using collodion, depending upon the overall effect they hoped to produce. Le Gray utilized the new material to produce moody seascapes and pictures of battlefield maneuvers that tended to suppress detail in preference to an overall effect. Some photographers who had produced extraordinary work with the paper processes—E.-D. Baldus and Charles Marville in France and Robert Howlett and Roger Fenton in England—made entirely successful transitions to wet collodion and in so doing helped to transform the pictorial character of photography. It is misleading, though, to seek an explanation of this pictorial transformation simply in terms of the new photographic materials; the idiosyncratic responses of these photographers to the challenge of new subject matter (which increasingly embodied a new world) and the evolving definition of the values appropriate to photography provide a more coherent basis for understanding the change.

The progressive industrialization of both urban and suburban Europe and America in the mid-nineteenth century provided an interesting and increasingly unavoidable problem for the generation of photographers who made the transition from paper negatives to collodion. The initial response to depicting industrial settings was to envelop them in the trappings of the picturesque, to soften their elements, establish points of view eliminating or reducing their symmetry and, in short, to bring them within the scope of the genres of romantic picture making.[68] Although Gustave Le Gray's photograph of the new railroad yard at Tours (cat. 64), made with his waxed paper negative process in 1851, was taken from above the yard and fails to establish an easy "footing" from

which the viewer can imaginatively enter into the scene (thus departing from an important picturesque convention), it emphasizes the snaking asymmetries of the boxcars and the apparently random placement of the buildings, clearly aiming at a softened, general effect. Likewise, Victor Regnault's photograph of the porcelain manufactory at Sèvres (cat. 35) naturalizes the buildings and provides us with a glimpse, or an impression, of the facility at peace in its environment.

Baldus' photograph of the train station at Toulon (cat. 65) is an example of the new and evolving means of addressing an industrial setting. The placement of the camera emphasizes the geometry of the rails and the building and drives the viewer's eye down the tracks, through the station, and to the vanishing point where the rails converge. Baldus avoids selective focus, giving all planes equal clarity. The print values range from deep blacks of the shadows within the station through the pure white of the featureless sky. The surface of the print is glossy. There is nothing suggestive about the picture; everything seems to be given, nothing held back. While avoiding the naturalizing devices of the picturesque, Baldus utilizes pictorial schemes drawn from various modes of handmade illustration (for example, architectural renderings by trained draftsmen, perspective views of cityscapes), which were common in books of the time. While he rejects the picturesque as appropriate for this kind of picture, he cannot therefore be thought of as working free of convention, or without precedent. The importance of a photograph like this one, quite aside from its elegance and success as a picture, is that it shows a clear break with photography's recent past and a turning toward less elevated and apparently more utilitarian modes of depiction by a painter-turned-photographer who had been an acknowledged master of the older form.

Some photographers of the 1850s and 1860s worked unabashedly in a variety of genres. P. H. Delamotte's photographs of the construction of the Crystal Palace in 1852 and 1853 (cats. 62, 63), like the exhibition within the palace itself, is a peculiarly Victorian conglomeration of the new and the old. Delamotte's view of craftsmen in their workshop is a remarkable play of highlights and deep shadows based on a well-established theme. His photograph of the upper gallery

during construction, however, is distinctly more modern, with its interest focused on the regular geometry of the building and on the repeated shapes of the circular ironwork played against the rhythms of the arched framework of the roof. Here Delamotte, joining with other photographers of his time, begins with great grace to establish a new genre of photographs aimed at the depiction of modern engineering feats, for which there were no well-established formulas in other media. While Delamotte addresses both the old and the new, his work is whole cloth—neither erratic nor incoherent. The same use of deep shadows played against distant, bright highlights and the ease with which numerous details are resolved into the unified views is central to his variation on the old picturesque theme, titled *Evening* (cat. 57). Here, rather than insisting on a structure of tonal values emphasizing the middle tones, he permits foreground trees to go into deep, black shadows and leads the eye toward the background by means of the path of pure white reflection on the lake. The delicate aerial perspective of the backlit scene (a technical *tour-de-force* at this time) and the whiteness of the sky join the lower path of light in the far distance, creating a rough hour-glass shape.

The British photographer Robert Howlett shows a pronounced tendency to produce prints in different genres as if they were crafted in separate media. His *In the Valley of the Mole* (cat. 58) is an evocative view, reminiscent of paintings by John Constable, and was surely intended to stimulate aesthetic pleasures, unrelated to any utilitarian purpose. His photographs of the huge ship *Leviathan* (cat. 68), made for the legendary engineer I. K. Brunel, are another matter entirely. They are quite frankly work photographs, the pictures of a photographer doing the work he was paid to do. Howlett responded to his assignemnt with an audacity equal to his subject. He might have moved far away from the hull to show all of it and then pay the inevitable consequence—the loss of its majestic proportions to the sea and shoreline. Instead, he chose to work close-in, chopping off a major part of the hull, and tilted his camera upward, metaphorically placing his viewers into the same position as the camera. The monstrous size of the titling ship looms above us, the two backlit figures dwarfed by the bow, almost disappearing in the light. How-

lett's photograph establishes only a small part of the ship, but by purposely failing to provide a pictorial framing element to keep the viewer's eye from running off the right-hand edge of the picture, the hull is not atomized into a single, self-sufficient element, but is left to suggest the continuation of the immense vessel.

Roger Fenton photographed in Russia in the early 1850s using paper negatives and then distinguished himself by photographing the Crimean War with the wet plate process. It is, however, in his architectural and landscape work that he shows an increasing restlessness with conventional approaches to photography and seems to anticipate a modern inclination toward abstract design. Like Benjamin Brecknell Turner, Fenton found that moving away from a building, to show all of it, often leads to graphically uninteresting photographs. And so, like Turner, he often moved in close, to show some part, and devised ways to keep the viewer's eye from wandering past the picture's borders. In *Salisbury, The King's Gardens* (cat. 50), Fenton placed the silhouetted central tree against the lighter ground of the cathedral, providing a bull's eye that rivets the eye to the center of the picture.

Fenton's landscapes made during the period from 1855 to 1860 show an overwhelming interest in pattern and shape, his concerns moving beyond the picturesque toward the definition of a new genre of landscape. In *The Long Walk, Windsor*, he constructs the picture out of the inverted T-shaped path and allows the trees and bushes to mass into dark swells, again keeping the eye centered and driving it far off into the distance. The familiar serpentine line of the picturesque is absent again in Fenton's *The Double Bridge on the Machno* (cat. 60), transformed now into a corkscrew or vortex of motion drawing us into the center of the picture through repeated leaps of black and white—first in the black pool reflecting white, jagged shapes, then up to the highlights and shadows to the right, across the silhouetted tree and down to the water and up, across and down again.[69]

Photographs of the products of the revolution in engineering and architecture of the 1850s, 1860s, and 1870s are particularly worthwhile objects of study because they demonstrate the response of photographers to situations for which no ready formulas of depiction had yet been deter-

mined in other media. Curiously, all but the most gifted of the first generation of photographers were not terribly inventive about finding new approaches to old subjects, most often contenting themselves with fulfilling or approximating the demands of any given genre. But this was not possible when photographers were given the sort of assignment handed them by engineers, as in the case of A. Collard's view of the *Arches of the Pont de Grenelle* (cat. 107). The picture shows the steel framework of the completed bridge from beneath and looking upward. His wide-angle lens exaggerates the broad sweep of the curved girders and the interest of the picture is, again, in the geometry of the steelwork and the distinct unconventionality of the point of view. Alphonse Terpereau's incredible view of the new bridge over the Dordogne (cat. 69) similarly advertises an odd point of view from underneath a bridge, but it adds the eerie halation of highlights caused by backlighting. The strong light etches away at the structural elements of the ironwork, producing, at the same time, an aerial perspective on the distant shore that seems to situate the bridge in a reverie.

Perhaps the most complete expression of the extent to which photography had moved away from the devices of the older pictorial media and, through adaptation and invention, had fixed its own approach to depiction, can be found in the photographs of Paris made by Charles Marville during the 1860s and 1870s (cats. 70, 71, 73).[70] This work, done on commission (including a major survey of "old Paris" for Baron Haussmann), expresses a professional ideal for photographic picture making that remains central to the way many photographers work today. Like Baldus, Marville trained as a painter and distinguished himself in the use of paper negatives. Again, like Baldus, his work with the wet plate attempted successfully to break away from the older genres to establish new ways of picture making.

Marville was among the leading pioneers of a form in photography that has become so thoroughly accepted by picture makers and viewers alike that it often strikes us as being without style—artless, formless—in brief, transparent. The manner of working is so entirely seductive, so much now a part of our second nature, that it can seem that the interest of these pictures derives entirely from the objects portrayed.

Marville's approach depends upon a set of devices that work to insure a uniformity of presentation, extending from the tangible luster of the print surface and the restricted range of print hues to the incomparable richness of each print's tonal structure and the precision with which the surfaces of objects are rendered. The point of view established by these pictures is always straight ahead, never upward or downward. More often than not, focus is total and through all planes, but when areas are allowed to go out of focus, it is most often objects in the distance and not the foreground that lose precise delineation. The character of cool, detached professionalism and acute skills of observation and presentation that Marville's pictures convey is no small part of their rhetoric. They seem capable of presenting anything, no matter how trivial, or even indecorous, in a way that makes them objects worthy of our attention.

Beyond the rhetorical aspects of each photograph's presentation is Marville's willing acceptance of the world beyond the frame of the picture. Photographers had been struggling with the problem of dealing with the edges of their photographs from the first days of photography—a struggle that was necessitated by the demands for pictorial unity or coherence required by the genres in which they worked. Portrait photographers did not solve the problem so much as they sidestepped it—by using neutral backdrops and simply eliminating the world; by placing their photographs in vignettes or oval mounts that cropped it out; by crafting a unitary theatrical world within which their sitters could appear. Landscape and architectural photographers were forced to find other solutions to the problem of integrating or suppressing aspects of the world that fell at the edges of their pictures. Freely borrowing from landscape painters and sketchers, they placed silhouetted trees or deep shadows at the edges of their pictures, or allowed focus to fall off at the periphery. Architectural photographers often moved far from the buildings they photographed, allowing their subjects to be placed in natural settings. Marville's solution is to accept rather than suppress the world at the periphery of his pictures. He addresses the objects in front of his camera but does not present them in terms of autonomy or other-worldliness. His pictures are of this world. This is not to say that he ig-

nores the edges. On the contrary, their integration into his pictures constitutes part of his stunning success.[71] His use of elements of the pictorial frame to indicate (and not merely to suggest) the presence of the world beyond, while keeping the viewer's eye from wandering aimlessly in and out of the picture, is one of his greatest achievements. His choice of the artificial, physical limits of the size of his plate as the "natural" boundary of his compositions was an aesthetic judgment that would have a growing and profound importance for the development of photography in the twentieth century.

## The Civil War and the American West

In America, two great events shaped the development of photography. The Civil War brought photographers out of their studios and into the field to take the first, sometimes stumbling, steps toward what we now call "documentary" photography. The opening of the western American wilderness attracted photographers—many of them war-trained—to new challenges in depicting the landscape.

From the start, Americans had been a receptive audience for photography. American daguerreotypists were prolific and accomplished and made an easy transition to the wet plate. Foremost among these was Mathew Brady of New York City and Washington, D.C., who had established himself by the late 1840s as *the* photographer of the celebrated and the rich. Like other photographer-entrepreneurs of the period, Brady hired cameramen (then called "operators") to do most of the actual photographic work, while he saw to business and made himself available for especially important customers.

Brady filled the waiting rooms of his studios with ornately framed photographs of illustrious Americans and foreign dignitaries as a way of advertising his work and demonstrating his familiarity with the great and near-great. At the outset of the Civil War in 1861, he added photographs of leading military figures and began selling to the public the so-called *cartes-de-visite* and "cabinet card" portraits of these officers.

Brady was among the first photographers to conceive of photographing the Union Army in its camps around Wash-

ington and then to graduate to depictions of other aspects of the war. Again, these pictures were put into his galleries, but soon the views were being sold to magazines like *Harper's Weekly* (where they were copied as wood engravings) and to the public at large. Initially, Brady sent his own staff photographers—Alexander Gardner, George N. Barnard, and the young Timothy H. O'Sullivan most prominent among them— to accompany units of the Army of the Potomac, but he also relied constantly upon freelance photographers who sold him their own glass-plate negatives of important officers and battlefields and events of the war.[72] These pictures, as well as those taken by his own staff, were indifferently credited to Brady (following the well-established studio practice) and appeared on boards titled, *Brady's Incidents of the War in North America*, though, in truth, only a small handful of them actually were made by Brady himself.

Photographers worked under constantly trying conditions, pouring and processing their plates in cramped tents or special wagons fitted out for photographic purposes. The slowness of wet plates made it almost impossible to photograph scenes of combat, so battlefields were photographed as soon after the fact as possible. The response to battlefield photographs was immediate and intense. Upon seeing the dreadful photographs of the aftermath of the battle at Antietam, Oliver Wendell Holmes (who had been on the field looking for his son) wrote:

> It was so nearly like visiting the battlefield to look over these views, that all of the emotions excited by the actual sight of the stained and sordid scene, strewed with rags and wrecks, came back to us, and we buried them in the recesses of our cabinet as we would have buried the mutilated remains of the dead they too vividly represented.[73]

Although many thousands of photographs were made of various aspects of the war, only a relatively few of them possess an enduring *pictorial* interest.[74] We take photography for granted as a documentary medium and forget that its ability to provide us with relevant "facts" depends upon some reasonably well-defined notion of what constitutes the subject of depiction. The photographers of the Civil War were

among the first to grapple with the problem of defining photographic documentation.

This problem was major, as *Gardner's Photographic Sketch Book of the War* clearly demonstrates. The two-volume compilation of war-related photographs published in 1866 contains Alexander Gardner's choice of one hundred views selected from more than three thousand negatives (some of which were his own, almost all having once been credited to Brady). To a modern eye, many of the photographs do not seem to be about the primary subject matter of war at all. The first view in the book is of a rather mundane-looking hotel in Arlington, Virginia, in which (as the caption indicates) the first Union officer to die in the war was killed (two years before the photograph was made). Another photograph shows a quite ordinary-looking house that had the distinction, as the caption again points out, of being located a number of miles from the scene of a major battle.[75] By and large, these photographs do not work to engage the interest of their audience by means of compositional devices or other means; on the contrary, they assume the viewer will come to them already equipped with the interests of an informed and concerned citizen.

To a modern viewer, the interest of T. H. O'Sullivan's *Field Where General Reynolds Fell* (cat. 94), is in the anonymous dead who lie bloated on the field at Gettysburg, giving silent witness to the viciousness and stupidity of war. The title makes it clear that for O'Sullivan's audience, the interest of the picture was not located in the presence of these dead troops, or in any universal message about war, but in the identity of the patch of ground they lie on, known to the public through the accounts of General Reynolds' death on the first day of the battle.

John Reekie's *A Burial Party* (cat. 93), a similarly grisly picture, was calculated to inflame Northern resentment. The photograph shows a burial detail impassively gathering up the remains of the Union troops who had been left unburied on the field of battle for more than a year by the victorious Southern forces at Cold Harbor, Virginia. The irony of the picture—that it shows recently freed slaves engaged in the dirtiest business of war—apparently was lost on the audience for which the picture was made.

Defining the subject matter and practice of war photography remained an unsolved problem through the end. With very few exceptions, the photographers adopted a distant, straight-on view. It is tempting to think that this formulaic distance and bluntness is linked to the shortcomings of technology—to the slowness of the plates and the awkward size of the cameras—but the current technology did not force the use of these formulas. The sorts of significant details we have grown accustomed to seeing in photographs of war—and the use of interesting compositional arrangements or odd angles—were not precluded by the wet plate process. As a rule, these pictures deliberately work against the suggestion of an authorial presence directing the viewer's attention in one way or another. They don't stake out odd perspectives; their focus tends to be even across all planes; the viewer's eye is not directed by compositional devices to move in one direction rather than another. The pictures are not meant to be singular impressions; they work as a kind of "everyman's" view of the war, encouraging the viewer to believe that this is just what he or she would have seen from a place near the camera. At times, this practice works against the most basic goal of providing information. O'Sullivan's view of captured Confederate soldiers, for example, establishes a distance so far removed that it is impossible for a viewer to gauge the effects of battle on either the victors or the prisoners. The figures seem to melt into one another.

Andrew Joseph Russell's photographs of the war differ significantly from those of the great majority of his contemporaries. Russell was one of the few soldiers assigned by the War Department to work specifically as a photographer and his audience consisted entirely of the officers of the Corps of Engineers to which he was assigned. His routine work was to document the construction of new types of railroad and pontoon bridges (cat. 96), and these photographs were used, in turn, to instruct engineers unfamiliar with the novel technology—an assignment he fulfilled with uncommon grace and elegance. But he also received permission to photograph the fields of battle in the areas in which he was stationed. Unconstrained by the need to make saleable photographs, Russell produced unprecedented close-up views of the faces of dead soldiers and constructed poignant, though horrifying,

Fig. 11. Timothy H. O'Sullivan, *Group of Confederate Prisoners at Fairfax Court-House, Virginia, June 1863* (Plate 34 from *Gardner's Photographic Sketchbook of the War*, vol. 1, 1866), albumen print from wet collodion negative, The Art Institute of Chicago, Gift of Mrs. Everett Kovler

war landscapes. His photograph of the Confederate dead at Fredericksburg (cat. 95) combines elements of both the picturesque and the sublime. Russell uses the confluence of the irregular stone wall, the trench with its dead soldiers, and the road to its right to suggest an endless funnel of death.

In the war, photographers often worked side-by-side with sketch artists for popular newspapers and magazines, providing them with raw material. In the American West, photographers were thrown together with major landscape painters on their journeys of discovery. But the photographs of the American West were made for a considerably broader audience than the paintings of popular nineteenth-century landscape artists Albert Bierstadt and Thomas Moran. Those interested included professional scientists, teachers, businessmen, and mining engineers, as well as members of the eastern and far western middle class who purchased photographs in the form of stereographic cards and large, handsome views sold for framing and display. These pictures are not scientific documents, but photographic landscapes, intended sometimes as pictures for instruction or amusement and sometimes simply as items for aesthetic appreciation.

At the same time the Civil War was beginning in 1861, Carleton E. Watkins produced a set of stunning stereographic and mammoth plate views of Yosemite Valley, the recently discovered "garden paradise" about a two-day ride on horseback from San Francisco (cat. 104).[76] Watkins' mammoth plates, the first to be made at Yosemite, created a sensation both for their size and for their technical and aesthetic perfection, and he enlarged his reputation with a later series taken in 1866. Working in a manner that brings to mind some Western American landscape paintings of the period, Watkins fused the romance of Yosemite with aspects of its sublime grandeur. These photographs combine the variety of line and shape demanded by the picturesque with a sense of timelessness, immensity, and absolute silence borrowed from the sublime. Watkins' trees are still and sharply rendered; his rivers and ponds are deep, unruffled mirrors replaying the mountains and trees above, giving no signals of the passage of time; immense distances are deftly suggested by an exquisite control of aerial perspective. The uncommonly large size of the plates and the flawless technique—

both of negative making and print production—insured an extraordinarily broad and rich tonal configuration, from the dense shadows beneath trees and along mountain walls through subtle sepia-gray middle tones to the transparent highlights on the surface of high valued rock outcroppings. Watkins' views engage us as highly crafted photographs, not as would-be paintings, and while it is not incorrect to approach them equipped with the ideas they share with works in other landscape mediums, it is equally important to understand them in terms of their "photographicality." This unmistakably photographic character is not the inevitable consequence of their being made with photographic materials, but marks (as it does for Marville) Watkins' achievement as a photographer.[77]

In 1868 Watkins photographed along the northern Pacific Coast accompanied by the painter William Keith. Some of the mammoth views he made in Oregon are among his best photographs and one in particular, *Cape Horn near Celilo* (cat. 105), deserves special comment. Whereas Watkins' views of the Yosemite Valley celebrate a majestic garden, an unspoiled Eden, in this picture Watkins addressed the marks of industrialization upon a recently virgin landscape. It would be wrong to view the rails as an intrusion upon the land, but as they rush out of the foreground and quickly disappear from sight, as if swallowed back into the earth, they clearly divide the sheer, dark cliff on the right from the underbrush to the left of the tracks by means of a pair of polished, symmetrical lines that are at visual odds with the irregularity of all the other lines in the picture. The graphic sweep of this picture—the strong, dark, vertical plunge of the cliff interrupted by the outward-running lines of the rails that are joined by the horizontal sweep of middle grays to the left—is completed by the blank, featureless sky. The picture could be addressed in terms of the standard categories of landscape depiction, but the invocation of such categories no longer seems entirely relevent. Of course the picture aims at being breathtaking, broadly graphic, sublime, but its sublimity has been achieved by a photographer's response to this land through the adaptation of the means of depiction to something that suggests a distinctly new manner—a photographic manner.

Within months of Lee's unconditional surrender at Appomattox, the westward expansion of the United States

Fig. 12. William Henry Jackson, *The Mountain of the Holy Cross, Colorado*, 1873, albumen print from wet collodion negative, Department of Special Collections, Joseph Regenstein Library, University of Chicago

opened new fields for war-trained, open-air photographers. The railroad companies, rushing to complete a transcontinental line, hired some of the best photographers of the war to document construction and produce pictures of the barely explored western territories for eastern consumption.[78] Andrew Joseph Russell, whose value as a photographer of railroad construction had been well-established, was among the first photographers to go West, working on a commission to the Union Pacific Railroad.

Beginning in 1867, explorations to the West were directed by both the Army and civilian professionals, who brought a new spirit of inquiry to government expeditions. They also brought photographers with them. William Henry Jackson joined the Geographical and Geological Surveys of the Territories at the invitation of its chief, F. V. Hayden, in 1870, and by the time he left the expeditionary group in 1878 he was well on his way to becoming the most celebrated landscape photographer in America. Jackson spent his first two years with the surveys working with two prominent landscape painters (R. S. Gifford in 1870 and Thomas Moran in 1871) and his panoramas bear the unmistakable imprint of

the landscape concerns of these men. Jackson, like other survey photographers, was expected to produce pictures for various categories of use; part of the work was a sort of graphic inventory of noteworthy geological features (cat. 106) and the ethnographically diverse tribes of Native Americans, and part was landscape photography pure and simple. The photographs were sold to the public, given to congressmen, and incorporated into the reports of the survey. Jackson's reputation as a survey photographer was based to a great extent upon his numerous panoramic views of the Rocky Mountains and his remarkable studies of the area that became Yellowstone Park. The broad vista showing the Mountain of the Holy Cross in Colorado, made in 1873, which required a heroic effort to produce, was quickly absorbed into American popular culture. Jackson's photographs helped shape America's conception of the West as an immense, virgin, and yet ultimately hospitable paradise—filled with awesome marvels and yet always remaining benign.

Timothy O'Sullivan spent seven years in the West working for the U. S. Geological Exploration of the 40th Parallel under the direction of Clarence King (1867–1869 and 1872) and for Lieutenant George Wheeler's U. S. Geographical Survey of the Territory West of the 100th Meridian (1871, 1873–1874). O'Sullivan's visionary photographs chart a new, and for many years an unappreciated, direction in photographic landscape. His photographs show the West of the Great Basin as unforgiving, barren, God-forsaken. O'Sullivan's justly famous picture of his photographic wagon in the midst of a desert (cat. 98) was made shortly after he arrived in the West. The picture implies a topography of boundless sand dunes continuing in all directions and suggests that the photographer brought his photographic van to rest during a difficult, pathless journey through a bleak, untraveled wasteland. (In fact, O'Sullivan carefully constructed this picture by placing his van within an isolated, slight group of dunes surrounded by immense and visually uninteresting plains that are barely indicated at the edges of the picture.) The photograph reveals the setting of the photographer's work within a desiccated environment barely able to support the growth of a few scattered weeds. The rills put down by the photographic wagon can leave no lasting trace and neither

31

Fig. 13. Timothy H. O'Sullivan, *Fissure Vent of Steamboat Springs*, 1867, albumen print from wet collodion negative, 21.6 x 27.9 (8½ x 11), National Archives (cat. 394)

can the photographer's footsteps, impressed in the sand as he walked quickly from the van to the camera with the unexposed wet plate. The photograph thus centers on the job of a photographer (which O'Sullivan called "working-up a view") in this unknown, sterile land and could serve as an emblem of his photography in the West.

This theme of photographic activity, of a self-conscious concern with the materials and equipment of photography, appears throughout O'Sullivan's work. The photograph of the small boat resting on the shore of the Black Canyon (of the Grand Canyon of the Colorado) (cat. 101) is a variation on the theme established by the *Sand Dunes, Carson Desert, Nevada*. O'Sullivan shows a solitary, contemplative figure seated in his boat, *Picture*, next to the photographic tent in which the photographer poured the wet plate used to make this view. The surrounding cliffs and land are devoid of vegetation; the streaked river, its surface features obscured by a thirty- or forty-second-long exposure, is other-worldly. This haunting photograph of a man seeking salvation from an alien and overwhelming environment by absorbing himself in his work (in this instance, in the work of a photographer photographed in the *Picture*) is a modernist romance and one that appealed to O'Sullivan's chief on this survey, Lt. George M. Wheeler. The title pages of each of the volumes of the Final Reports of the Wheeler Survey carry a lithographic copy of this view in vignette.

O'Sullivan's photographs often deal with the static representation of force—for example, in the form of immense waters pouring over Shoshone Falls, or as scalding steam venting out of a fissure in the gound and obscuring a human figure engulfed by it. This simple photograph of steam rising out of a tear in the earth is more than a glimpse of the grotesque, freakish topography of the land explored by the geological survey under Clarence King's direction; O'Sullivan portrays the power of this natural, telluric force as overwhelming the figure, robbing it of its personhood, thus epitomizing the severity of the relationship between this man and this environment.

In the forty years between 1839 and 1879, the various practices of photography gradually came to define a medium.

The medium was not discovered by Niépce, Daguerre, and Talbot—it was painstakingly invented by the two generations of photographers who came after them. These forty years also define an era, though the photographers practicing at the time had no idea that a new photographic age was about to dawn. But with the invention of the gelatin dry plate and then of roll film in the 1880s, new possibilities would entice new practitioners to invent photography yet again.

The photographers of the first era were, overwhelmingly, professionals. They worked on commission, or at least with an eye on the market. They created their own negative materials through kitchen chemistry, and guarded their trade secrets. Although photography had been hailed as a boon to science at its birth, it had made few contributions to the sciences and was not itself the subject of intense scientific investigation. Although photography had been enmeshed since its invention in the problems of depiction shared by other arts, few photographers—Cameron being a notable exception— subscribed to an aesthetic of art for art's sake.

As practiced by the great majority of photographers, it was a humdrum medium, and it was the work of the majority that defined public perceptions. Millions of run-of-the-mill photographic portraits, which were formulaic in practically every detail and which aimed at the production of palpably bland public likenesses, came to be seen as defining the potentialities of photography for portraiture; similarly, the millions of indifferent travel and architectural views made and sold each year by commercial photographic houses were understood as expressive of everything the medium had to offer a viewer interested in such things. Even the truly innovative and interesting photographers discussed in this essay were rarely enmeshed in the same milieu or motivated by the same passions as painters such as Gustave Courbet, Édouard Manet, or Edgar Degas.[79]

In short, there was little in photography to attract the amateur with a flair either for picture making or for scientific investigation. But a brief glance at a picture made in 1883 by the French bio-physicist Étienne-Jules Marey gives some hint at what was to come. This "chronophotograph" bears little formal resemblance to O'Sullivan's photograph of the fissure vent, though it also addresses the issue of force. Marey

33

was a scientist first, a photographer second. He used the new gelatin-based material to show himself shaking a long glass rod and, for the first time, utilized photography to analyze force by arresting individual instants of time and mapping them against each other. Others would be attracted to the medium for its artistic, rather than scientific, potential. The entire issue of art versus science, which most practitioners had ignored or finessed since the invention of photography, was about to become a central concern.

O'Sullivan's picture of the fissure vents can stand as a token of the best in the first forty years of photography—it is

the forceful product of a master craftsman, unmistakably a photograph, unmistakably a picture, too. Marey's work hints at a new age and new concerns. It is clearly divorced from the conventional concerns of pictorial craftsmanship. If it is a picture, just *how* is it a picture, and just what is it a picture *of*? To anyone comfortably familiar with photography as practiced in 1879, this is a profoundly disturbing and unfathomable image. But the future of photography could not be seen from the vantage point of the present as given in 1879. There is no reason to suppose we can see its future today.

1. The characterization of photography as magical cannot be dismissed as the astonished response of the benighted, unenlightened, or unsophisticated. The impulse is both enduring and vexing, surviving, perhaps even flourishing in the current literature on photography and film. In his final statement on photography, Roland Barthes notes: "The realists, of whom I am one, and of whom I was already one when I asserted that the Photograph is an image without a code—even if, obviously, certain codes do inflect our reading of it—the realists do not take the photograph for a 'copy' of reality, but for an emanation of *past reality*, a *magic*, not an art" [author's emphasis], in *Camera Lucida* (New York, 1981), 88. In speaking of film (and its origins in photography), the philosopher Stanley Cavell writes: "How do movies reproduce the world magically? Not by literally presenting us with the world, but by permitting us to view it unseen. . . . movies arise out of magic; from beneath the world," in *The World Viewed* (Cambridge, Mass., 1979), 39.
2. See, for example, Rosalind Krauss, "Photography's Discursive Spaces," in *The Originality of the Avant Garde and Other Modernist Myths* (Cambridge, Mass., 1986), 131–150. An index, according to the philosopher Charles Sanders Peirce, is a sign that refers to an object because of a "dynamical connection" between the object and the "senses or memory of the person for whom it serves as a sign. . . . " Thus, smoke is a sign of fire, but so are demonstrative pronouns like "this" and "that." See "Logic as Semiotic: The Theory of Signs," in *Philosophical Writings of Peirce*, Justus Buchler, ed. (New York, 1955), 107.
3. I am speaking here about the professed motivations of the inventors of the first processes. In some respects, regarding, for example, the resolution of fine detail, the daguerreotype over-fulfilled the goals of its inventor Daguerre, while the photogenic drawing process fell considerably beneath the hopes of Talbot, its inventor.
4. The name means "drawing originating in light."
5. Unpaginated caption to plate VI, "The Open Door," in William Henry Fox Talbot, *The Pencil of Nature* (London, 1844–1846).
6. My point here is not that Talbot's prints are indistinguishable from prints made in the picturesque mode in other media. His still lifes like *The Open Door*, are not perfect embodiments of the conventions of picturesque depiction, but they attempt to be. If they fail at perfection in this respect, I suspect this has less to do with inherently photographic issues than with Talbot's self-admitted failures as a picture maker. For an alternative

view, see Eugenia Parry Janis, *The Art of French Calotype* (Princeton, 1982), 16–17.
7. The origins of photography are not to be found exclusively in one or another of these established practices, if only because each does not constitute a rigid category of production, appreciation, and use that is somehow hermetically sealed off from the others. Picture makers, like poets, novelists, and composers, are committed to building on and adapting the work of their predecessors and contemporaries; no matter how independent they may become, they begin as inveterate borrowers. This seems as true of commercial illustrators as it is of committed artists.
8. Some photographs, for example, X-rays of teeth, are not made with cameras. For all their obvious importance, X-rays do not interest or engage us in the way that camera-made photographs do.
9. I have used the expression "the camera" from time to time in this essay, for reasons of brevity. There is, in fact, no such thing as "the camera," rather, there are various kinds of cameras and their imagery varies from kind to kind. For example, while mass-marketed cameras produce imagery in accord with the rules of linear perspective (roughly or strictly depending upon their optics), some cameras do not (for example, panoramic cameras with pivoting lenses that produce pictures having an infinite number of vanishing points, rather than the single one required by the rules of linear perspective projection). Moreover, it is a simple matter to design and construct cameras incapable of producing the sorts of imagery we associate with photography.
10. The study of pinhole imagery forms a part of the medieval theory of optics or vision known as "perspectiva," which is both a physical and psychological account of vision. This study provided some of the geometric elements for the theory and artistic practice of linear perspective.
11. Medieval students of optics were concerned with the shape of the image formed by a pinhole and rarely with its content.
12. Giovanni Battista Della Porta, *Magia Naturalis Libri IIII*, book IV, chapter II; quoted in Georges Potonniée, *The History of the Discovery of Photography*, Edward Epstean, trans. (New York, 1946), 7. Porta has often been credited with the invention of the camera obscura, but such claims ignore the long history of the investigation of pinhole imagery and accounts of cameras obscura published prior to Porta's discussion. For a further discussion of the early history of the camera, see my essay, "Picturing Vision," in the *Language of Images*, W. J. T. Mitchell, ed. (Chicago, 1980), 219–246.

13. Claims that painters like Vermeer and Saenredam traced camera imagery and then transferred these tracings to canvas are made by historians of photography and painting, but are based entirely on judgments about the similarity of certain features of camera imagery to the effects found in selected paintings. These claims are not based upon textual evidence, X-ray analysis, or sketches or construction drawings for the paintings in question, and are entirely speculative. It is of course possible that Vermeer, Saenredam, and other painters also may have been interested in various effects found in camera imagery of the period and may well have incorporated these into their work. Readers interested in the literature on this topic should see A. Hyatt Mayor, "The Photographic Eye," *Bulletin of The Metropolitan Museum of Art* 5 (1946), 15–26; Charles Seymour, "Dark Chamber and Lightfilled Room: Vermeer and the Camera Obscura," *The Art Bulletin* 46 (1964), 323–331; Heinrich Schwarz, "Vermeer and the Camera Obscura," *Pantheon* 24 (1966), 170–180; Daniel A. Fink, "Vermeer's Use of the Camera Obscura—A Comparative Study," *The Art Bulletin* 53 (1971), 493–505. An excellent and balanced presentation of the pros and cons concerning the use of cameras by Dutch painters can be found in Arthur K. Wheelock, *Perspective, Optics, and Delft Artists around 1650* (New York, 1977).

14. And still, as aids to artists, they left much to be desired. If an illustrator wanted to trace the image in a camera, he had to confront a major practical problem; objects at varying distances from the lens could not be held in focus at the same time. Sketchers had to learn to trace one plane at a time, refocus, adjust for changes in magnification caused by moving the lens, and trace again. The work was tedious and constantly interrupted by slight movements of the camera or tracing paper, which required major readjustments in the entire apparatus. As an aid to artistic practice, the camera left a lot to be desired for an illustrator who could lay out, for example, the perspective lines in rapid fashion by the use of shortcut geometric construction techniques.

15. The focal length of so called "normal lenses" found on modern cameras is still calculated by means of a standard determined in the Renaissance. This is equally true of lenses made specifically for portraiture.

16. Despite these developments, artists and illustrators remained dissatisfied with cameras and felt it necessary to use their artistic training as a corrective to camera imagery. Writing late in the eighteenth century, the French landscape painter Pierre-Henri Valenciennes, who used a camera for making rough sketches, noted that cameras were entirely unreliable aids for the sketching of perspective and outlines in a picture. He claims, "all the lines [of the image], as given by the camera are false." Valenciennes remarks that painters who use the camera effectively for taking sketches are able to do so because they knew how to correct for the various lens-related errors in the image, and adds, "the camera can be very useful but not for the tracing of lines; rather for studying color and its effects." Pierre-Henri Valenciennes, *Elements de perspective practique à l'usage des artistes*... (Paris, c. 1800), 207–208, author's translation.

17. Helmut and Alison Gernsheim claim, "Considering that the knowledge of the chemical as well as the optical principles of photography was fairly widespread following Schulze's experiment [in 1727]... the circumstance that photography was not invented earlier remains the greatest mystery in its history," in *The History of Photography from the Camera Obscura to the Beginning of the Modern Era* (New York, 1969), 13. Peter Galassi cites this sentence approvingly, adding; "For Helmut and Alison Gernsheim... and for most other historians of photography, the mystery persists...." Galassi agrees that the scientific bases of photography had been in place long before its invention, but suggests that photography could not have been invented until a "fundamental transformation in pictorial strategy" was achieved by artists. He argues that photography "is capable of serving only the [new] artistic sense," and could not have been invented while the old artistic strategy dominated artists' practice, in *Before Photography* (New York, 1982), 11, 18. My disagreements with Galassi concern more than the factual issues regarding the chemistry of photography. As will soon become apparent, Galassi assumes what I shall explicitly deny—that the various technologies of photography and the medium of photography are the same thing. In my terms, the characteristics that Galassi finds to be definitive of photography are not essential to or givens of the medium; they are the results of certain historically addressable practices of photographers.

18. The history of photography is inextricably linked to the history of the commercial manufacture of various chemicals, which, in turn, is linked to the history of the commercial demand for them. This linkage between commerce and technology has not been well investigated in relation to the history of photography and deserves more attention than it has received.

19. Humphry Davy, "An Account of a method of copying Paintings upon Glass, and of making profiles, by the agency of Light upon Nitrate of Silver. Invented by T. Wedgwood, Esq. With Observations by H. Davy," *The Journals of the Royal Institution*, vol. 1 (1802), 170–174.

20. Pressing together an object like a leaf or a negative and a sheet of photosensitive paper came to be called "contact printing." In addition to making prints of leaves and insects, Wedgwood and Davy also made contact prints of paintings on glass.

21. Wedgwood and Davy's choice of the *Journals of the Royal Institution* for the publication of their report places the experiments and the idea motivating them in the context of the progressive social aims of the Institution, which was established in 1799 to teach "the applications of science to the common purposes of life."

22. Although both processes depend on the light-sensitive character of certain silver salts, Talbot's is a primitive print process while Daguerre's produces one of a kind images.

23. Letter from Joseph to Claude Niépce dated 16.7bre [Septembre] 1824, in *Dokumenty po istorii izobreteniya fotografii*, T. P. Kravits, ed. (Moscow, Academy of Sciences of the USSR, 1949), 148–149 [*Documents in the History of the Invention of Photography* (The Correspondences of J. N. Niépce, L. J. M. Daguerre, and Others)]. The pewter plate, discovered by Helmut Gernsheim in the early 1950s and now in the Collection of the Humanities Center at the University of Texas, is not, despite its great importance and interest, "the world's first photograph" as Gernsheim has claimed. The plate seems to have been made in June or July 1827.

24. The blackening of the silver was accomplished entirely by chemical means and was not dependent upon the action of light on the iodized silver.

25. The partnership agreement called for the establishment of a firm "under the commercial title of *Niépce-Daguerre*, for the purpose of perfecting [heliography] invented by Monsieur Niépce and [to be] improved by Monsieur Daguerre."

26. The procedures for fuming plates with various gases had been devised by Niépce in 1818–1819. Daguerre adapted this procedure; the use of mercurial vapors, however, seems to have been his own idea. See the appendix in this volume.

27. The quantity of silver-mercury amalgam formed is in direct proportion to the amount of exposure received on any particular area of the plate. Thus, heavily exposed areas show as a bright, creamy white, while moderately exposed areas are thinner and therefore grayer deposits of the amalgam.

28. In February 1839, the English astronomer and chemist Sir John Herschel read a paper to the Royal Society in London, in which he described the solvent action of sodium hyposulfite (now called "sodium thiosulfate") on salts of silver. Daguerre immediately adopted the use of "hypo," as it came to be called, to make the daguerreotype image permanent. The process was now essentially complete.

29. Louis Jacques Mandé Daguerre, *An Historical and Descriptive Account of the Daguerreotype and the Diorama* (London, 1839), 22. Arago was not entirely correct about the singularity of photography in regard to the copying of hieroglyphs. Archaeologists currently make photographic prints of hieroglyphic inscriptions and then draw over them with india ink, filling in effaced details and other information not provided by the photograph. They then remove all traces of the photograph by means of a bleaching bath. The final result is entirely drawn by hand.

30. Daguerre, *Daguerreotype and Diorama*, 23.

31. Daguerre patented his process in England and America at the same time that the French government made details of the process available to the world. According to a story, doubtless apocryphal (and of unknown origin, possibly British), a reporter asked Daguerre why, if he had given the process to the world, he instructed his agents to patent it. Daguerre supposedly replied; "I gave the daguerreotype to the civilized world— the French speaking world."

32. The camera lucida is not a camera at all, but is a prism mounted to a metal dowel.

33. William Henry Fox Talbot, "A Brief Historical Note on the Invention of the Art," unpaginated introductory remarks to the first fascicle of *The Pencil of Nature* (London, 1844).

34. William Henry Fox Talbot, *Some Account of the Art of Photogenic Drawing* (London, 1839).

35. One reviewer of Talbot's exhibit wrote, "At the Royal Institution, on Friday evening, were exhibited a variety of specimens of a process invented by Mr. Talbot, but which appears to differ from that of M. Daguerre, especially in this, that Mr. Talbot reverses the natural effect, representing dark objects light and light objects dark." He also noted, "His copying of engravings (there is a sweet one of Venice), by first getting them with the lights and shades reversed, and then copying from the reversed impression, as before, is singularly ingenious." Unattributed review, "The New Art," *The Literary Gazette and Journal of Belles Lettres* (2 February 1839), 73. Talbot was unable to make prints from his camera negatives until sometime in April or May 1839; "We should several weeks ago have announced to our readers that Mr. Talbot had succeeded in getting the lights and shades of his photogenic copies in the natural order. We have several specimens in our possession, which are perfectly accurate and quite beautiful." These remarks appear at the conclusion of an unattributed report titled "Daguerreotype," *The Literary Gazette and Journal of Belles Lettres* (13 July 1839), 444.

36. It is important to point out that Hippolyte Bayard invented a paper-based process in 1839 that was intermediate, so to speak, between the procedures of Daguerre and Talbot. Like the daguerreotype, Bayard's process produced a unique positive image, but like the photogenic drawing, the image appeared on paper. Bayard was, in fact, the first person to make positive images on paper by means of the camera. Unfortunately for him, his process was lost in the excitement created by the announcement of the two other processes.

37. When Edgar Allan Poe saw a small group of some of the first daguerreotypes made in America, he was struck by their "miraculous beauty" and the ability of the process to be "*infinitely* more accurate in its representa-

tion than any painting by human hands." Poe noted how ill advised it was to make predictions about the future of inventions like the daguerreotype:

> The results of the invention cannot, even remotely, be seen— but all experience, in matters of philosophical discovery, teaches us, that in such discovery, it is the unforeseen upon which we must calculate most largely. It is a theorem almost demonstrated, that the consequences of any new scientific invention will, at the present day exceed, by very much, the wildest expectations of the most imaginative.

But having given the best possible reason for being restrained about guessing at the future of invention, Poe incautiously suggested one of the "most obvious advantages of the daguerreotype"—its potential for taking (of all things) measurements of inaccessible elevations. He seemed to view the daguerreotype as a solution to an as yet undetermined set of scientific-technological problems and felt obliged to find a precise geometric problem for the process to solve. For all of its "miraculous beauty," he could see the future of the daguerreotype most obviously in the context of the disciplines of science and engineering, which, he believed, had engendered it. Edgar Allan Poe, "The Daguerreotype," *Alexander's Weekly Messenger* (15 January 1840), 27.

38. Daguerre proposed a very different future and a different audience for the daguerreotype from the one suggested by Poe:

> By this process, without any idea of how to draw, without any knowledge of chemistry and physics, it will be possible to take the most detailed views, the most picturesque scenery in a few minutes. . . . With the aid of the daguerreotype everyone will make a view of his castle or country-house . . . even portraits will be made. . . . This important discovery, capable of innumerable applications, will not only be of great interest to science, but it will also give a new impulse to the arts. . . . The leisured class will find it a most attractive occupation . . . the little work it entails will greatly please ladies.

Louis-Jacques-Mandé Daguerre, *Daguerreotype* (Paris, 1838–1839) (a broadsheet published by Daguerre in contemplation of a second public offering of his invention [the first, proposed in 1838, had failed]. The subscription was scheduled to be announced on 15 January 1839, but was cancelled once Arago brought the daguerreotype to the attention of the Chamber of Deputies.)

39. Our ability to pick out details in a photograph may account for our interest in some photographs, but our usual interest in photographs is not explicable in terms of detail location.

40. *Comptes rendus hebdomadaires des séances de l'Academie des Sciences* 8 (1839), 260.

41. Unpaginated caption to plate X, "The Haystack," in Talbot, *The Pencil of Nature*.

42. For an excellent and thorough account of the work of Robert Cornelius, see William F. Stapp, *Robert Cornelius: Portraits from the Dawn of Photography* (Washington, 1983).

43. It may be true, as some critics have claimed, that painting and photography have never been in competition. The truth of the claim is, however, contingent upon making "painting" coextensive with the activity of a small number of avant-garde painters who have been given the honorific title "artist." Miniature portrait painters were not only in competition with photography, they were made an endangered species by it.

44. Many of their plates have a faint opalescent cast, produced pehaps by a

rather longer sensitizing with bromine vapors than used by most portrait daguerreotypists.

45. This is not to say that the processes could be used to produce results physically *identical* with pictures from the older media. Both the daguerreotype and the calotype were incapable of matching, say, lithographic prints in every physically significant respect. One might conceive of these incapacities as "flaws" of the processes, or conversely, treat them as their defining features. For my purposes, it makes sense to address them as physical facts that do not define the processes, but which were suppressed or emphasized in accordance with the aims of the early photographers. In other words, I am prepared to grant that prints from say, calotype negatives, have on the whole certain features permitting us to recognize them for what they are. But so do lithographic prints and wood engravings. Lithography, the other revolutionary nineteenth-century print process, which is only forty years older than photography, was used for making portraits as soon as lithographic studios were established. While these portraits are not identical in their physical characteristics to steel engravings or aquatints, they maintain the conventions of depiction appropriate to the portrait genre.

46. I intend "superficial" without any pejorative connotations. I use it to mean "first surface," what is apparent and immediately recognized. Walker Evans, who is, in my estimation, one of the best photographers in the history of the medium, is devoted to the superficial. He saw the depth in first surfaces.

47. And photographers who use the vernacular are not necessarily more true to themselves, to the world, or to photography than are the others.

48. See Newhall, *The History of Photography*, 1982.

49. *Comptes rendus* 33 (1846), 639 and 1083; 24 (1847), 46–48, 117–123, 448, and 653; 30 (1850), 663–665, 779; 31, (1850), 864–866; see also, *Procédés employés pour obtenir les épreuves de photographie sur papier* (Paris, 1847) (published by the optician and photographic equipment manufacturer, Charles Chevalier).

50. Du Camp was taught the dry paper negative process by Le Gray, but the process proved useless for much of his work in the Middle East, most probably because of the heat and very low relative humidity. Du Camp was fortunate to meet a M. de Lagrange in Cairo, who instructed him in the use of Blanquart-Évrard's new wet albumen negative process, which worked quite well under the difficult climatic conditions.

51. In 1850, Blanquart-Évrard invented a photographic printing process allowing the printing of large numbers of prints in a short period of time. The process required the bathing of briefly exposed salted paper in a developer of gallic acid. In 1851 Blanquart-Évrard joined with his friend Hippolyte Fockedey in establishing Imprimerie Photographique, a photographic printing and publishing house in Lille. The firm printed work by leading French, British, and Belgian photographers, producing (according to Eugenia Janis) at least twenty-four portfolios in the five years of its existence. For further information on Blanquart-Évrard's publications, see Janis, *French Calotype*.

52. Auguste Salzmann, *Jerusalem, époques judaïque, romaine, chrétienne, arabe, explorations photographiques*, published by Blanquart-Évrard (Lille, 1854).

53. Niépce de St. Victor published the details of the process in *Comptes rendus* 16 (1847), 579 and 785.

54. D. O. Hill to Elhanan Bicknell, 17 January 1848, quoted in C. Ford and R. Strong, *An Early Victorian Album. The Photographic Masterpieces of David Octavius Hill and Robert Adamson* (London, 1976).

55. Sir Wm. J. Newton, "Upon Photography in an Artistic View, and in its Relations to the Arts," *Journal of the Photographic Society* vol. 1, no. 1 (London,

1854), 6. It is worth noting that this session was chaired by the president of The Photographic Society of London, Sir Charles Eastlake, who was a respected painter and president of The Royal Academy.

56. Newton, *Upon Photography*, 6–7.

57. Remarks of George Shadbolt, *Journal of the Photographic Society*, vol. 1, no. 1 (London, 1854), 77.

58. Frederick Scott Archer, "The Use of Collodion in Photography," *The Chemist* no. 2 (March 1851), 257.

59. Curiously, most of the photographers who were instrumental in the invention and early perfection of the wet collodion technology (including Scott Archer himself) had not been daguerreotypists, but came to collodion from the practice of paper negative photography. This suggests that while the values of transparency, high resolution, and tonal modeling were important to them, they were at least equally committed to the conception of photography as a print medium. Accordingly, the "imperfections" of the daguerreotype process (its failure to permit the production of prints together with the problems inherent in its highly reflective, positive/negative surface) were sufficient to drive away those photographers who saw the future of photography as a printmaking medium.

60. In other words, it required the application of various stringent formulas of depiction to create the apparently unmediated character of the photographs. This apparent absence of mediation might best be thought of as a pictorial effect, as part of the rhetoric of a picture.

61. I originally planned to use the term "pictorial assertion" in opposition to "suggestion," but was persuaded by the aesthetician T. E. D. Cohen that "articulation" is probably closer to the original intent of those who spoke of "suggestion" in visual art. In general, I do not defer to Cohen in these matters.

62. "Photographie sur papier. Moyen d'obtenir l'image à la chambre noire sur papier sec; par M. Blanquart-Évrard," *Comptes rendus* 30 (1850), 665. The production of albumen paper begins with the addition of common table salt to egg white, which is then whipped into a stiff meringue and allowed to settle overnight into a watery suspension. Sheets of paper are floated on the salted albumen and then clipped to a drying line. All further operations are essentially similar to the printing of plain salted paper.

63. I like the sound of "vulgar," although one reader has suggested it might be better translated as "common." As I read Blanquart-Évrard, however, the point is not that the varnish is common or ordinary, but that it would appeal to an audience with common taste.

64. The question of the surface character of photographic prints is a recurrent one in photography. The change from a matte to a glossy surface, which was nearly universal by the 1870s, was challenged by Peter Henry Emerson in the 1880s, thus initiating (for a group of photographers dedicated to demonstrating the artfulness of photography) a return to matte surfaced papers that lasted until the early 1920s, when photographers like Alfred Stieglitz, Paul Strand, and Edward Weston championed the use of glossy papers on the grounds that "photographs ought to look like photographs." The hegemony of glossy paper has relaxed considerably in recent times.

65. See Charles Rosen and Henri Zerner, *Romanticism and Realism* (New York, 1984), 100–101.

66. Quoted in the preface to *Nadar* by André Jammes (Paris, 1982).

67. Cameron in a letter to Sir John Herschel, 31 December 1864. This letter, along with others to Herschel and Sir Edward Ryan, are now in the collection of the Gilman Paper Company, New York City. I am indebted to Professor Joanne Lukitsh for bringing this material to my attention.

68. This was, of course, a problem for illustrators and artists as well, whose

response was a similar one—to impose familiar pictorial schemata upon new physical structures.

69. At first, Fenton was reluctant to use albumen paper, though he finally adopted its use for general purposes. His prints show great care in toning and avoid an overall uniformity of hue and surface appearance. It is highly instructive to view one of Fenton's own prints from his architectural negatives side-by-side with prints from the same negatives published by Francis Frith. The latter have a blue-black hue and a glossy surface and seem to have been carved out of steel, while Fenton's prints are most generally slightly lustrous and quite soft in their effect.

70. I do not mean to imply that Marville singlehandedly established the new form, but I do wish to urge that his photographs exemplify it.

71. There were always photographers who simply did not worry too much about the borders of their pictures, preferring instead to place the center of visual interest far from the edges and accept the consequences of whatever happened to fall along the perimeter. This lack of concern about the margins of their prints amounts to a failure of presentation and characterizes much of the indifferent travel and architectural photography of the 1860s and 1870s.

72. Years after the war, Brady claimed he had sent many well-equipped photographers into the field, but a study of passes issued by the Army of the Potomac to photographers throughout the duration of the war shows that of the more than three hundred photographers who were passed through the lines, only seven were employed by Brady. See Josephine Cobb, "Photographers of the Civil War," *Military Affairs* (Fall 1962), 127–135.

73. Oliver Wendell Holmes, Sr., "Doings of the Sunbeam," *The Atlantic Monthly* 12, (July 1863), 8.

74. We often do find an interest in the *details* provided by these pictures, say those relating to aspects of locale, ordnance, or costume. And it is of course impossible to remain unaffected by the gruesome pictures of the dead. My point, however, is that most of the Civil War photographs do not generally interest us as pictures, but engage us as presentations of disparate details of the war.

75. "The Yellow House on Weldon Railway," plate 71, Alexander Gardner, *Gardner's Photographic Sketchbook of the War* (Washington, 1866).

76. Since large camera sizes had not yet been standardized, so-called "mammoth plate" cameras varied in size from roughly $16 \times 18$ in to $22 \times 24$ in.

Prints from these plates were generally trimmed an inch in each dimension.

77. I want to emphasize the quotation marks around "photographicality." Anyone familiar with my work in photography knows that I have little patience with conceptions of *the essentially photographic*. By "photographicality" I do not mean anything essential to the photographic process, either in terms of connections it is said to establish between pictures and the world, or with an invariant set of pictorial features shared alike by all photographs (or, by all *good* photographs). My suggestion here is that what we take to be the "pure" characteristics of photography are not determined by the techniques of photography, but are determined, at any given moment in the history of the medium, by various established photographic practices and values.

78. The building of the Union Pacific Railroad was photographed by Russell and John Carbutt; Alexander Gardner was hired by the Union Pacific Railway, Eastern Division, to photograph important aspects of its construction.

79. In other words, they did not consider themselves to be artists—they were photographers. This obvious fact implies little, if anything at all, about judgments regarding the artfulness of their work. It is now generally recognized, for example, that some motion pictures made in the period ranging from the 1920s through the 1950s are rightly understood to be works of art, though their makers never thought of themselves as artists. The notion that the traditional visual arts (say, painting, sculpture, architecture, and certain kinds of printmaking) have a special and exclusive claim to art status is, today, less a considered opinion than an ingrained habit of mind, an expression of intellectual territoriality and as such, more of a mental reflex than a reasoned judgment.

I am indebted to a number of friends for their comments on various drafts of this essay. W. J. T. Mitchell provided me with a close, contentious, and enormously helpful reading of the first draft; Neil Allen gave crucial assistance in editing and restructuring the penultimate draft; Robert Sobieszek, Doug Munson, David Travis, and Marta Braun made numerous helpful comments on the character and details of the essay. Finally, discussions with T. E. D. Cohen were helpful in determining how best to address the more notorious tangles surrounding the concept of *photographic picture*.

1. Joseph Nicéphore Niépce
*Cardinal D'Amboise*, c. 1827
heliographic print from original engraving, 19.3 x 12.8 (7⅝ x 5¹⁄₁₆)
Royal Photographic Society

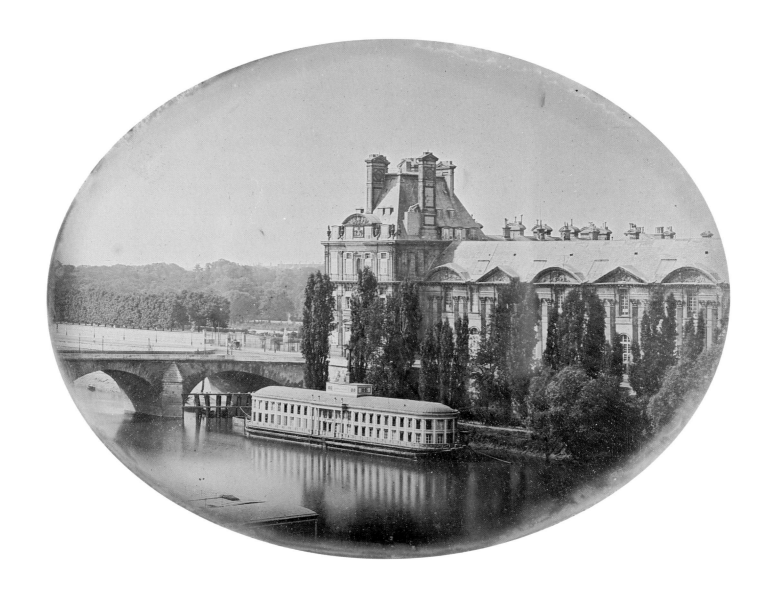

2. Louis Jacques Mandé Daguerre
*Première Épreuve fait par Daguerre devant ses Colleagues des Beaux-Arts*, 1839
full-plate oval daguerreotype, 14.5 x 19.3 (5¹¹/₁₆ x 7⅝)
Musée National des Techniques du CNAM–Paris

3. WILLIAM HENRY FOX TALBOT
*Flowers, Leaves, and Stem*, c. 1838
photogenic drawing, 22.1 x 18.1 (8¹¹⁄₁₆ x 7⅛)
The Art Institute of Chicago, In Memory of Charles L. Hutchinson by
his great friend and admirer Edward E. Ayer

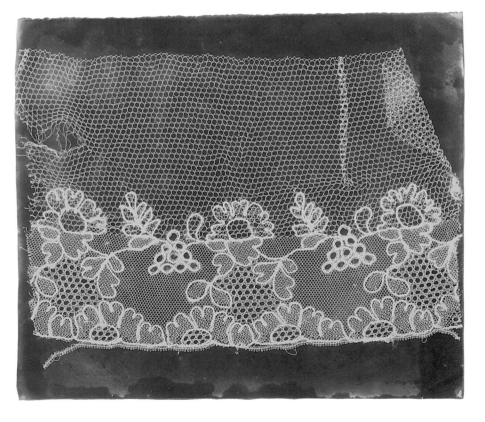

4. WILLIAM HENRY FOX TALBOT
*Lace*, c. 1844
photogenic drawing paper negative, 20.1 x 23.3 (7⅞ x 9⁵⁄₁₆)
The National Museum of Photography, Film and Television
(National Museum of Science and Industry)
Not in exhibition

5. WILLIAM HENRY FOX TALBOT
*Solar Photo-Micrograph Transverse Section Stem*, 1839
photogenic drawing,
The National Museum of Photography, Film and Television
(National Museum of Science and Industry)
Not in exhibition

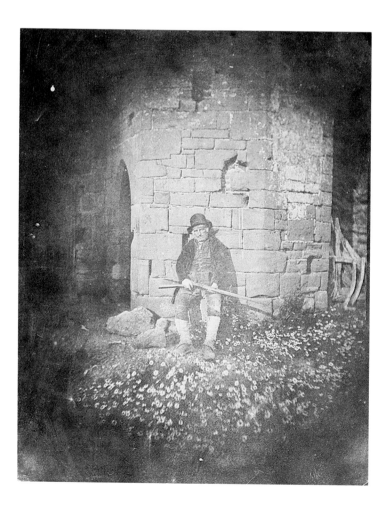

6. WILLIAM HENRY FOX TALBOT
*The Game Keeper*, c. 1843
salted paper print from calotype negative
18.1 x 14.6 (7⅛ x 5¾)
National Museum of American History,
Smithsonian Institution, Division of Photographic History

42

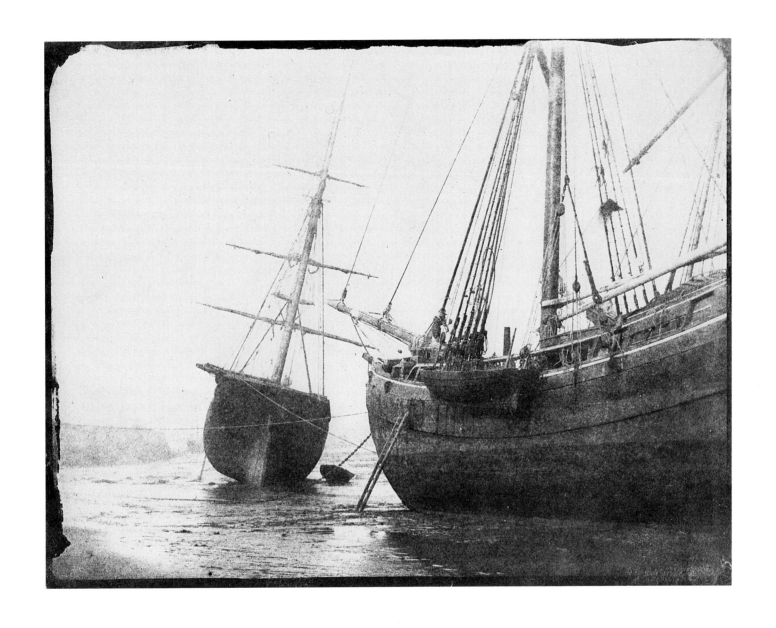

7. WILLIAM HENRY FOX TALBOT
*Ships at Low Tide*, c. 1844
salted paper print from calotype negative, 16.5 x 21.6 (6½ x 8½)
National Museum of American History,
Smithsonian Institution, Division of Photographic History

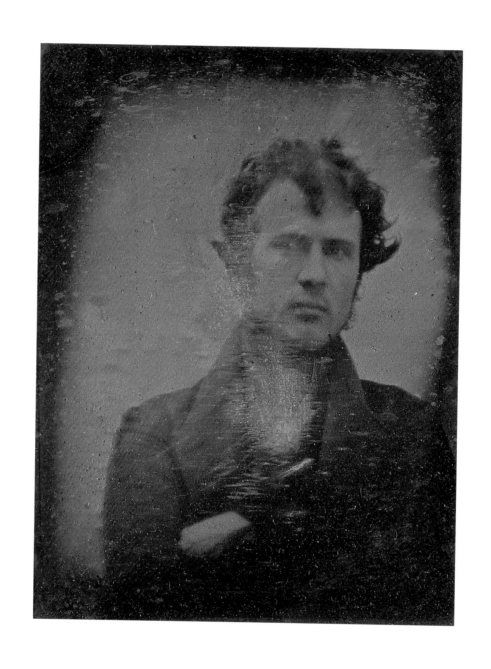

8. ROBERT CORNELIUS
*Self-Portrait*, 1839
daguerreotype, 12.0 x 9.4 (4¾ x 3¹¹⁄₁₆)
Private collection

9. William Henry Fox Talbot
*Courtyard Scene*, c. 1844
salted paper print from calotype negative, 14.9 x 19.7 (5⅞ x 7¾)
National Museum of American History,
Smithsonian Institution, Division of Photographic History

10. William Henry Fox Talbot
*Cloisters, Lacock Abbey*, 1843
calotype negative, 16.5 x 20.7 (6½ x 8⅛)
Royal Photographic Society

11. William Henry Fox Talbot
*Cloisters, Lacock Abbey*, 1843
salted paper print from calotype negative
16.5 x 20.7 (6½ x 8⅛)
Royal Photographic Society

12. WILLIAM HENRY FOX TALBOT
*The Haystack*, 1844–1845
salted paper print from calotype negative, 15.1 x 20.0 (6 x 7⅞)
The National Museum of Photography, Film and Television
(National Museum of Science and Industry)

13. NOEL-MARIE PAYMAL LEREBOURS
*Hôtel-de-Ville de Paris*, c. 1841–1843
hand-colored photomechanical print from
engraved daguerreotype plate, 13.7 x 19.1 (5⅜ x 7½)
Collection of the International Museum of Photography at
George Eastman House, Gift of Eastman Kodak Company,
ex-collection Gabriel Cromer

48

14. FREDERICK VON MARTENS
*Pont Neuf de Paris*, 1842
panoramic daguerreotype, 14.0 x 50.0 (6½ x 19⅝)
Musée National des Techniques du CNAM–Paris

49

15. Mathew B. Brady
*Thomas Cole*, c. 1845
half-plate daguerreotype, 13.8 x 10.4 (5⁷/₁₆ x 4⅛)
National Portrait Gallery, Smithsonian Institution, Gift of Edith Cole Silberstein

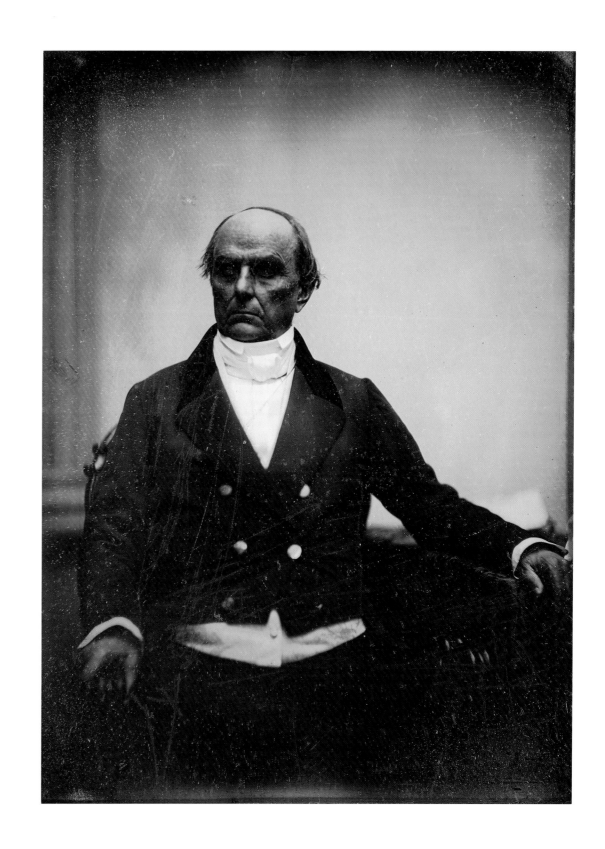

16. Albert Sands Southworth and Josiah Johnson Hawes
*Daniel Webster*, 1851
full-plate daguerreotype, 21.5 x 16.6 (8½ x 6⁹⁄₁₆)
The Metropolitan Museum of Art, Gift of
I. N. Phelps Stokes, Edward S. Hawes,
Alice Mary Hawes, Marion August Hawes, 1937

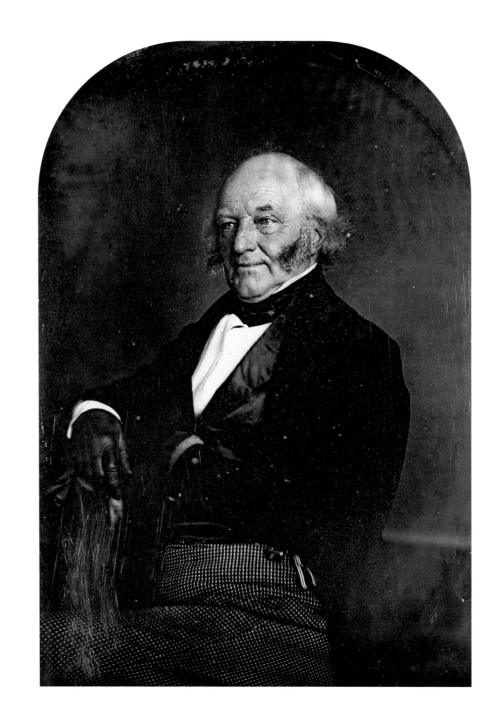

17. Photographer Unknown
*Martin van Buren*, c. 1845
full plate daguerreotype, 21.6 x 16.5 (5½ x 4½)
Chicago Historical Society

18. ALBERT SANDS SOUTHWORTH AND JOSIAH JOHNSON HAWES
*Copy Daguerreotype of Mother and Child*, c. 1850
sixth-plate daguerreotype, 8.2 x 7.0 (3¼ x 2¾)
Collection of the International Museum of Photography
at George Eastman House, Gift of Alden Scott Boyer

19. JOHN PLUMBE, JR.
*Untitled*, c. 1844
quarter-plate daguerreotype, 11.0 x 8.5 (4⁵⁄₁₆ x 3⅜)
The J. Paul Getty Museum

53

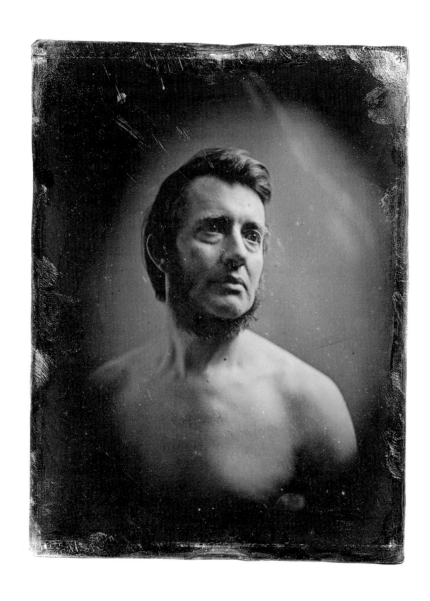

20. Josiah Johnson Hawes
*Albert Sands Southworth*, c. 1848
half-plate daguerreotype, 14.0 x 10.7 (5½ x 4¼)
Collection of the International Museum of Photography at George Eastman House,
Gift of Alden Scott Boyer

54

21. David Octavius Hill and Robert Adamson
*Life Study, Dr. George Bell*, c. 1845
salted paper print from calotype negative, 14.0 x 20.0 (5½ x 7⅞)
National Galleries of Scotland, Portrait Gallery

22. REVEREND CALVERT RICHARD JONES
*Scottish Clansmen*, c. 1845
salted paper print from calotype negative, 17.0 x 21.0 (6¹¹⁄₁₆ x 8¼)
Lacock Abbey Collection

23. DAVID OCTAVIUS HILL AND ROBERT ADAMSON
*Highland Guard*, c. 1844–1845
salted paper print from calotype negative, 15.3 x 19.4 (6¹/₁₆ x 7⅝)
Royal Photographic Society

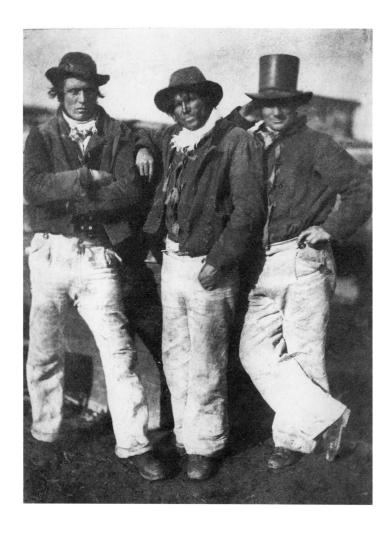

24. DAVID OCTAVIUS HILL AND ROBERT ADAMSON
*Alexander Rutherford, William Ramsay, and John Liston*, c. 1844–1845
salted paper print from calotype negative
18.2 x 14.0 (7³⁄₁₆ x 5½)
Royal Photographic Society

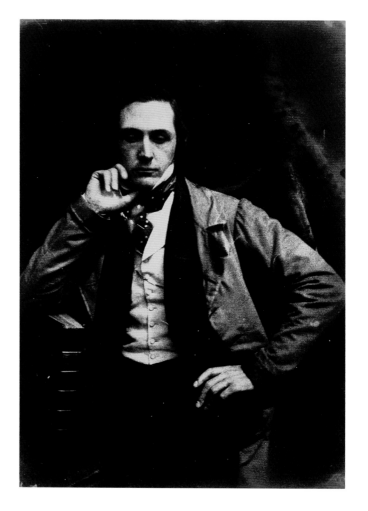

25. DAVID OCTAVIUS HILL AND ROBERT ADAMSON
*James Drummond*, c. 1846
salted paper print from calotype negative
14.0 x 20.0 (5½ x 7⅞)
National Galleries of Scotland, Portrait Gallery

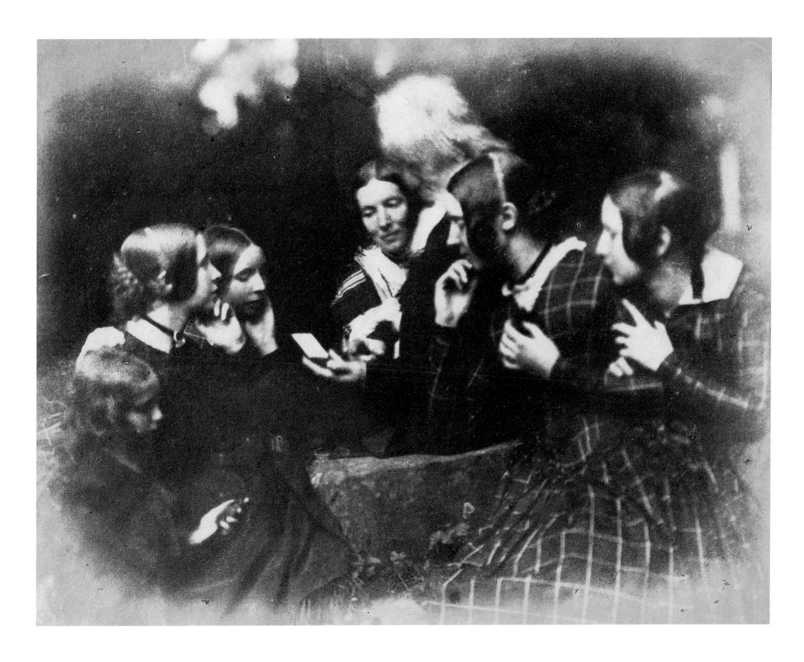

26. DAVID OCTAVIUS HILL AND ROBERT ADAMSON
*John Henning and Female Audience*, c. 1844
salted paper print from calotype negative, 15.6 x 20.2 (6⅛ x 8)
Royal Photographic Society

27. DAVID OCTAVIUS HILL AND ROBERT ADAMSON
*East Gable of the Cathedral and St. Rule's Tower,*
*St. Andrews,* 1846
salted paper print from calotype negative
19.4 x 14.0 (7⅝ x 5½)
Hochberg-Mattis Collection

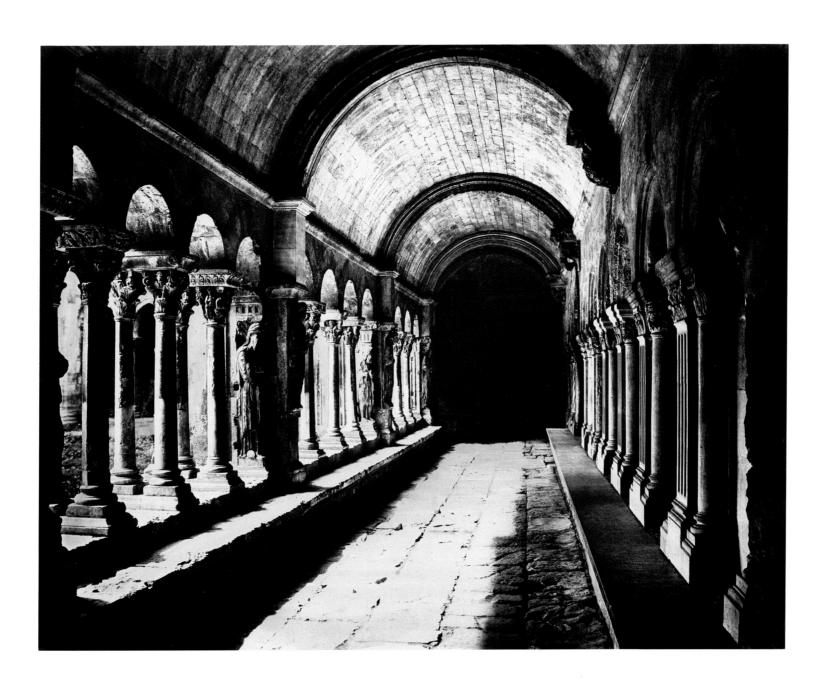

28. Edouard-Denis Baldus
*Cloister of St. Trophine, Arles*, c. 1855
dilute albumen print from paper negative, 33.9 x 43.0 (13⅜ x 17)
Collection Centre Canadien d'Architecture/Canadian Centre for Architecture, Montréal

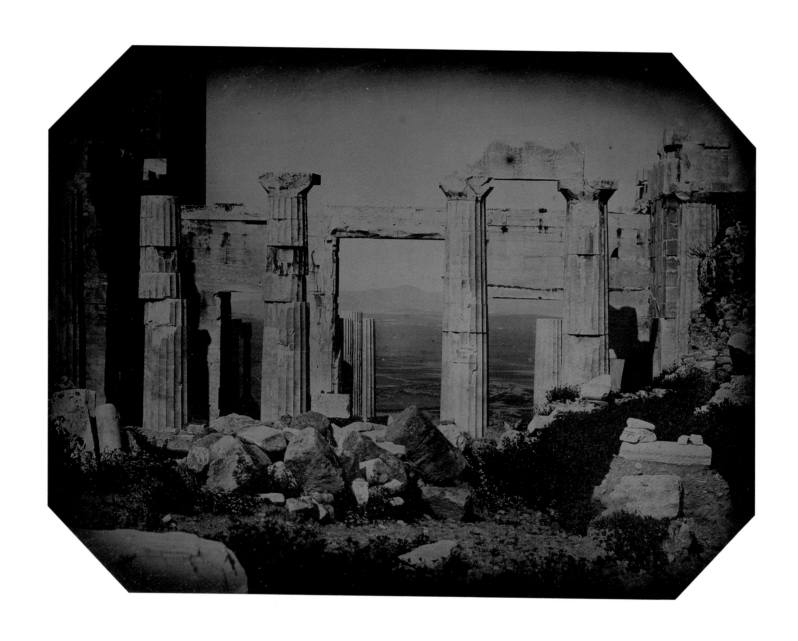

29. Jean-Baptiste-Louis Gros
*East Façade of the Propylaea, the Acropolis, Athens, 1850*
daguerreotype, 15.0 x 23.0 (5¹⁵⁄₁₆ x 9¹⁄₁₆)
Collection Centre Canadien d'Architecture/Canadian Centre for Architecture, Montréal

30. ALBERT SANDS SOUTHWORTH AND JOSIAH JOHNSON HAWES
*Winchester Family Tomb, Mount Auburn Cemetery*, c. 1850
full-plate daguerreotype, 21.5 × 16.6 (8½ × 6⁹⁄₁₆)
International Museum of Photography
at George Eastman House,
Gift of Alden Scott Boyer

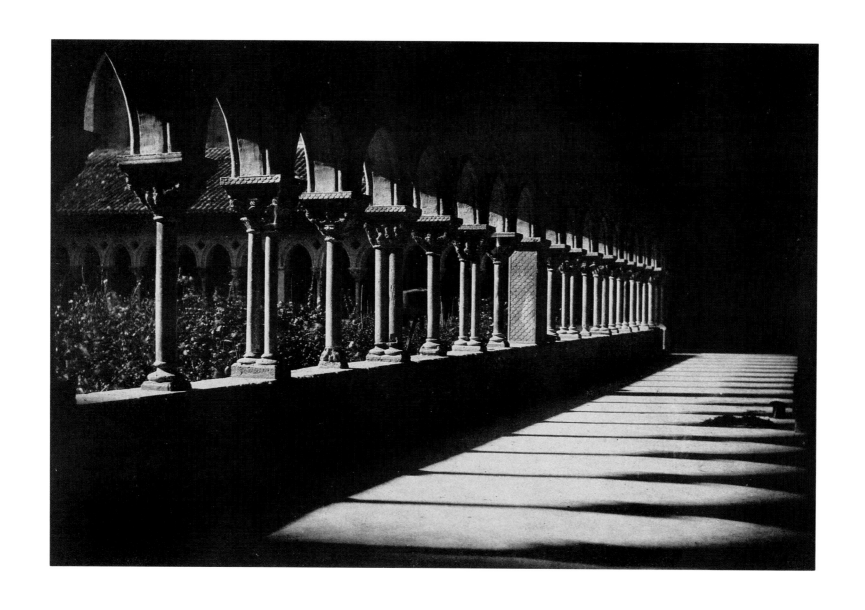

31. Gustave Le Gray
*Cloister of Moissac,* 1851
dilute albumen print from waxed paper negative, 23.0 × 34.3 (9⅛ × 13½)
Musée d'Orsay, Copyright Réunion des Musées Nationaux, Musée d'Orsay

32. PIERRE AMEDÉE AND EUGÈNE-NAPOLEON VARIN
*View of Flying Buttresses, Reims*, 1853–1854
dilute albumen print, 17.0 × 13.0 (6$^{11}$/$_{16}$ × 5$^{1}$/$_{8}$)
Musée d'Orsay, Copyright Réunion des Musées Nationaux, Musée d'Orsay

33. Louis Désiré Blanquart-Évrard
*Phare de Lantern des Mortes de l'ancien cimetière de Bayeux*, c. 1851–1855
dilute albumen print from paper negative, 25.9 × 20.2 (10⁹⁄₁₆ × 8)
International Museum of Photography at George Eastman House,
Gift of Eastman Kodak Company, Vincennes,
via the French Society of Photography, ex-collection Henri Fontan

34. Benjamin Brecknell Turner
*Whitby Abbey: North Transept*, 1852–1854
albumen print from waxed paper negative, 26.8 × 34.4 (10⁹⁄₁₆ × 13⅝)
By courtesy of the Board of Trustees of the Victoria and Albert Museum

35. VICTOR REGNAULT
*Sèvres et environs, bords de la Seine, usine*, c. 1852
salted paper print from paper negative, 44.0 × 33.5 (17⅜ × 13¼)
Musée d'Orsay, Dépot d'Archives de la Manufacture de Sèvres,
Copyright Réunion des Musées Nationaux, Musée d'Orsay

36. HENRI LE SECQ
*Carrière en Forêt cadré verticalement*, c. 1852
dilute albumen print from waxed paper negative, 51.3 × 37.0 (20¼ × 14⅝)
Bibliothèque des Arts Décoratifs, Paris

37. Edouard-Denis Baldus
*Le Moine*
dilute albumen print from paper negative, c. 1853, 32.0 × 40.7 (12⅝ × 16)
Exchange National Bank of Chicago

38. Henri Le Secq
*Ruisseau en Forêt cadré horizontalement*, c. 1852
dilute albumen print from waxed paper negative, 37.8 × 50.8 (14⅞ × 19⅞)
Bibliothèque des Arts Decoratifs, Paris

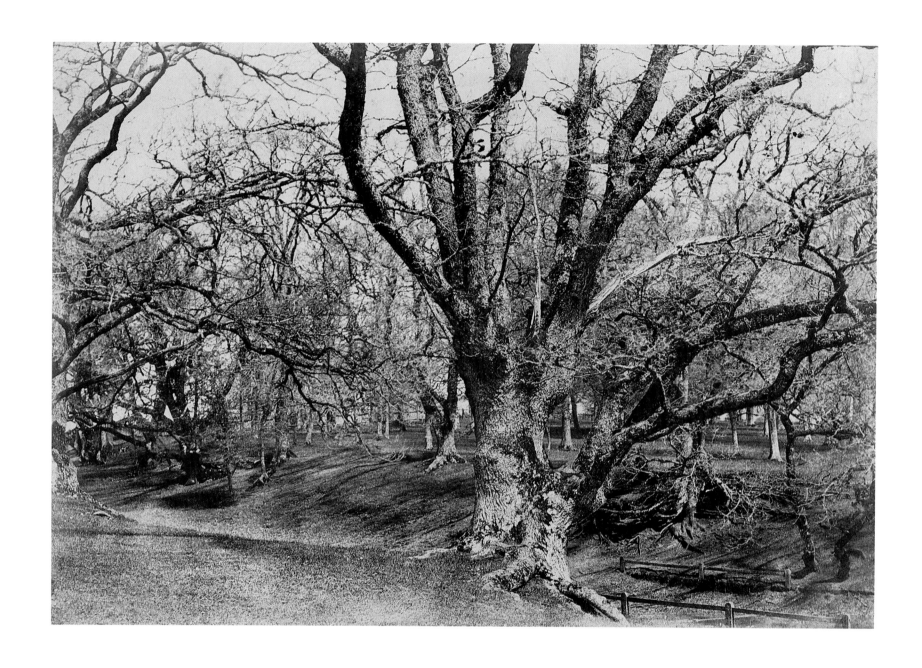

39. Benjamin Brecknell Turner
*Pepperharrow Park, Surrey*, c. 1853
albumen print from paper negative, 26.5×38.6 (10⁷⁄₁₆×15¼)
By courtesy of the Board of Trustees of the Victoria and Albert Museum

40. Adelbert Cuvelier
*Forest at Fontainebleau*, 1852
salted paper print from wet collodion negative, 16.2 × 14.5 (6⅜ × 5⁹⁄₁₆)
Gilman Paper Company Collection

41. Félix Teynard
*Nubie: Environs d'Ibrim*, c. 1854
salted paper print from paper negative, 23.9 × 32.5 (9⅜ × 12¹³⁄₁₆)
Gilman Paper Company Collection

42. Maxime DuCamp
*Égypte*, 1851
salt paper print from waxed paper negative, 16.5 × 21.0 (6½ × 8¼)
Gilman Paper Company Collection

43. Félix Teynard
*Capital, Shafts and Architrave, Temple of Knum, Esna, Egypt*, 1852
salted print by H. de Fonteny from paper negative, 24.9 × 39.8 (9¹³⁄₁₆ × 15⅝)
The J. Paul Getty Museum

44. AUGUSTE SALZMANN
*Jerusalem: Anciente du Temple, Triple port romaine*, 1855
developed-out salted paper print by Blanquart-Évrard from paper negative, 22.3 × 32.0 (8¹³/₁₆ × 12⅝)
International Museum of Photography at George Eastman House, Museum Purchase

45. John Beasely Greene
*The Nile*, 1853–1854
developed-out salted paper print by Blanquart-Évrard
from waxed paper negative, 23.1 x 30.3 (9⅛ x 12)
Gilman Paper Company Collection

46. JOHN BEASELY GREENE
*Statue, Egypt*, 1854
developed-out salted paper print by Blanquart-Évrard
from waxed paper negative, 29.6 x 21.5 (11 11/16 x 8½)
Janet Lehr, Inc., New York

47. LINNAEUS TRIPE
*The Elephant Rock, Madura*, c. 1858
dilute albumen print from paper negative
27.4 x 37.5 (10¾ x 14¾)
Royal Photographic Society

48. JOHN BEASELY GREENE
*Pyramid, Egypt*, 1853–1854
developed-out salted paper print by Blanquart-Évrard
from waxed paper negative, 22.9 x 28.5 (9½ x 11⅝)
Janet Lehr, Inc., New York

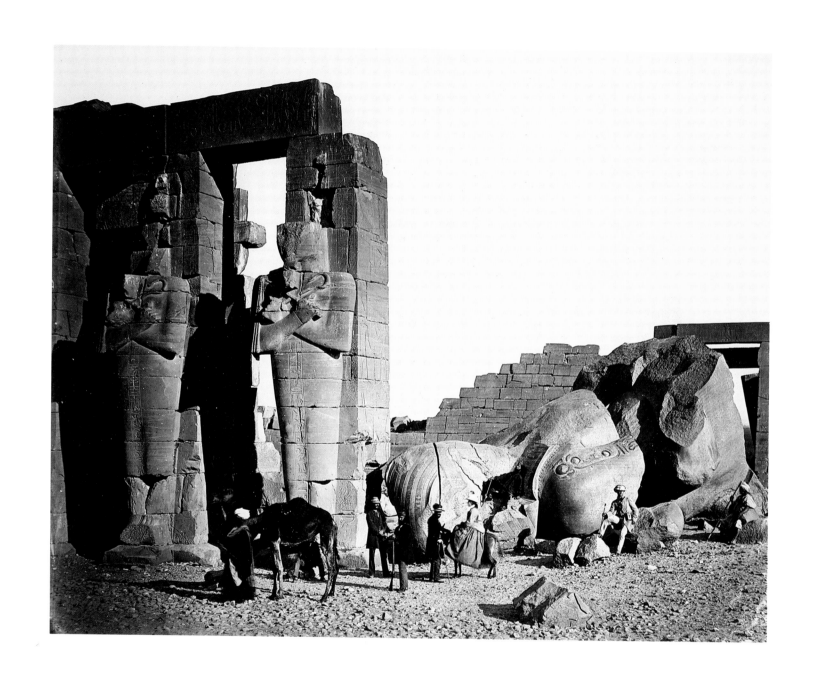

49. FRANCIS FRITH
*Fallen Colossus*, c. 1858
albumen print from wet collodion negative, 38.1 x 48 (15 x 18⅞)
Janet Lehr, Inc., New York

50. ROGER FENTON
*Salisbury, The Bishop's Gardens*, c. 1858
albumen print by Francis Frith from wet collodion
negative, 34.2 x 41.3 (13½ x 16¼)
Royal Photographic Society

51. CHARLES NÈGRE
*Chartres Cathedral, South Porch*, c. 1856
heliogravure, 51.8 x 72.0 (20⅜ x 28⅜)
Marie-Thérèse and André Jammes

52. FREDERICK SCOTT ARCHER
*Ante Room of Great Hall*, 1851
albumen print from wet collodion negative, 21.9 x 17.5 (8⅝ x 6⅞)
Royal Photographic Society

53. CHARLES CLIFFORD
*Puente del Diablo, Martorell*, c. 1856
albumen silver print from glass negative, 31.0 x 42.3 (12³⁄₁₆ x 16⅝)
The Metropolitan Museum of Art, Purchase, Joyce and Robert Menschel Gift, 1988,

54. CHARLES CLIFFORD
*Interior, Mosque of Cordova*, 1862
albumen print from wet collodion negative
38.8 x 28.7 (15⁵⁄₁₆ x 11³⁄₁₆)
The J. Paul Getty Museum

55. Eugène Cuvelier
*View of Fontainebleau Forest in the Mist,* 1859–1862
salted paper print from wet collodion negative, 19.6 x 25.6 (7¾ x 10¹⁄₁₆)
The Metropolitan Museum of Art, The Howard Gilman Foundation and
Joyce and Robert Menschel Gifts, 1988, All rights reserved, The Metropolitan Museum of Art

56. Gustave Le Gray
*Tree, Forest of Fontainebleau*, c. 1856
albumen print from wet collodion negative, 31.9 x 41.6 (12⁹/₁₆ x 16⅜)
The Art Institute of Chicago, Laura T. Magnuson Fund; Edward E. Ayer Fund in Memory of
Charles L. Hutchinson by his great friend and admirer, Edward E. Ayer; Maurice D. Galleher Fund
Wentworth Green Field Memorial Fund and the Samuel P. Avery Fund

57. PHILIP HENRY DELAMOTTE
*Evening*, 1856–1857
albumen print from wet collodion negative
21.0 x 17.0 (8¼ x 6¹¹⁄₁₆)
The Metropolitan Museum of Art,

58. ROBERT HOWLETT
*In the Valley of the Mole*, 1856
albumen print from wet collodion negative, 20.0 x 26.2 (7⅞ x 10⁵⁄₁₆)
The Metropolitan Museum of Art, Purchase, Harrison D. Horblitt and
Harriette and Noel Levine Gifts and David Hunter McAlpin Fund, 1988,

59. ROGER FENTON
*View on the Ribble*, 1858–1859
albumen print from wet collodion negative, 28.4 x 39.9 (11 3/16 x 15 5/8)
Royal Photographic Society

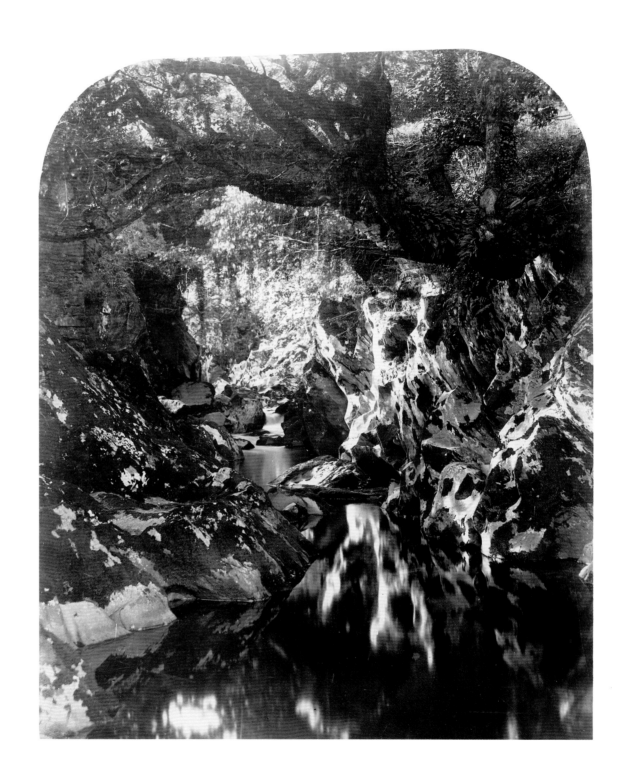

60. ROGER FENTON
*The Double Bridge on the Machno*, 1857
albumen print from wet collodion negative
40.3 x 33.6 (15⅞ x 13¼)
Royal Photographic Society

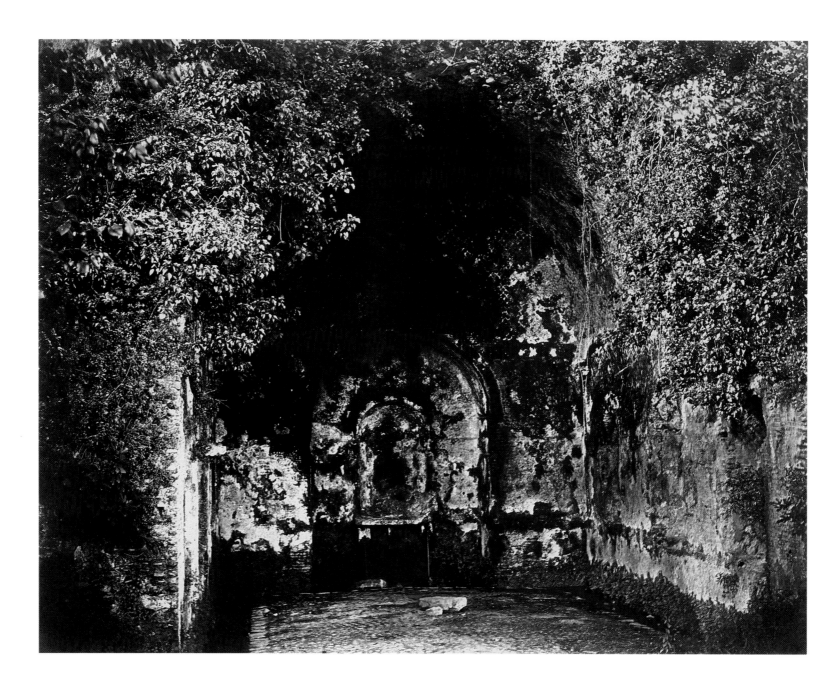

61. ROBERT MACPHERSON
*Grotto of Egeria*, c. 1855
dilute albumen print from wet collodion negative, 31 x 40.2 (12³⁄₁₆ x 15⁷⁄₈)
Hochberg-Mattis Collection

62. Philip Henry Delamotte
*The Upper Gallery, Crystal Palace*, 1852–1853
albumen silver print from wet collodion negative
23.0 x 28.0 (9¹⁄₁₆ x 11¹⁄₁₆)
The Metropolitan Museum of Art

63. Philip Henry Delamotte
*Storeroom with Artisans and Plaster Casts,
Crystal Palace*, 1852
albumen print from wet collodion negative
23.0 x 28.0 (9¹⁄₁₆ x 11¹⁄₁₆)
The Metropolitan Museum of Art,

64. GUSTAVE LE GRAY
*Railroad Yard, Tours*, c. 1851
dilute albumen print from waxed paper negative, 25.2 x 34.8 (10 x 13¾)
Collection Centre Canadien d'Architecture/Canadian Centre for Architecture, Montréal

65. Édouard-Denis Baldus
*Train Station, Toulon*, c. 1859
albumen print from wet collodion negative, 27.0 x 43.2 (10⅝ x 17)
Mr. C. David Robinson

66. Hyacinthe César Delmaet & Louise-Emile Durandelle
*Apollo Group (Construction of the Paris Opera)*, c. 1865
albumen print from wet collodion negative, 33.5 x 28.3 (13¼ x 11⅛)
International Museum of Photography at George Eastman House,
Gift of Eastman Kodak Company, ex-collection Gabriel Cromer

67. Hyacinthe César Delmaet & Louise-Emile Durandelle
*Opera Construction*, c. 1861
albumen print
International Museum of Photography at George Eastman House,
Gift of Eastman Kodak Company, ex-collection Gabriel Cromer
*Not in exhibition*

68. ROBERT HOWLETT
*Leviathan: Side View of the Hull*, c. 1857
albumen print from wet collodion negative, 28.6 x 35.9 (11¼ x 14⅛)
International Museum of Photography at George Eastman House, Museum Purchase

94

69. ALPHONSE TERPEREAU
*Pont du Gilet sur la Dordogne*, c. 1884
albumen print from wet collodion negative, 37.0 x 43.0 (14½ x 17)
École Nationale des Ponts et Chaussées, Paris

70. CHARLES MARVILLE
*Cul de sac at the Horse Market*, 1860–1870
albumen print from wet collodion negative, 26.2 x 37.2 (10⁵/₁₆ x 14⁵/₈)
The J. Paul Getty Museum

71. CHARLES MARVILLE
*Rue de l'Épée de Bois de la rue Mouffetard*, 1865–1875
albumen print from wet collodion negative, 30.4 x 27.1 (12 x 10¹¹/₁₆)
Musées de la Ville de Paris, Musée Carnavalet

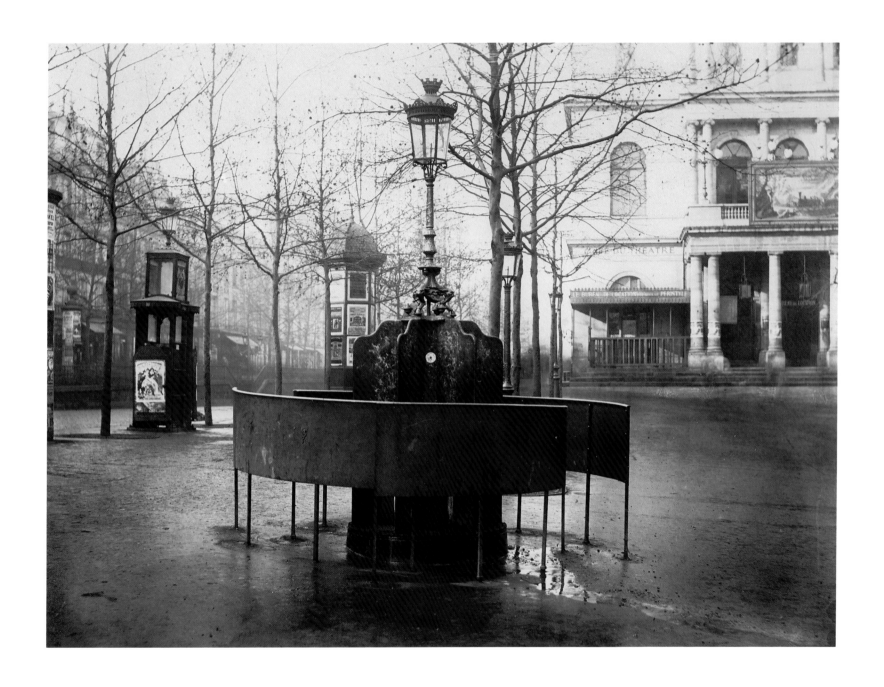

72. CHARLES MARVILLE
*No. 3, Urinoir (Système Jennings), Plateau de l'Ambiguë*, 1865–1875
albumen print from wet collodion negative, 26.6 x 36.2 (10½ x 14⅝)
Musées de la Ville de Paris, Musée Carnavalet

73. CHARLES AUBRY
*A Study of a Leaf (heracoeum longefolium)*, c. 1864
albumen print from wet collodion negative
47.0 x 39.1 (18⅝ x 15⅜)
By Courtesy of Fraenkel Gallery, San Francisco

74. Auguste Vacquerie
*Adele Victor Hugo's Hand*, c. 1853
dilute albumen print from wet collodion negative
9.4 x 7.1 (3¹¹⁄₁₆ x 2¹³⁄₁₆) Musée d'Orsay,
Copyright Reunion des Musées Nationaux, Musée d'Orsay

75. NADAR
*Théophile Gautier*, c. 1855
dilute albumen print from wet collodion negative
25.6 x 19.7 (10¹⁄₁₆ x 7³⁄₄)
The J. Paul Getty Museum

76. Étienne Carjat
*Charles Baudelaire*
albumen print from wet collodion negative
23.2 x 18.1 (9⅛ x 7⅛)
Collection of Mr. and Mrs. Harry H. Lunn, Jr.

77. Nadar
*Charles Baudelaire*, c. 1855
salted paper print from wet collodion negative
21 x 18.5 (8¼ x 7¼)
Marie-Thérèse and André Jammes

78. NADAR
*Auguste Luchet*, c. 1855
salted paper print from wet collodion negative, 21.5 x 15.5 (8½ x 6)
The J. Paul Getty Museum

79. NADAR
*Auguste Vacquerie*, 1855
salted paper print from wet collodion negative, 26.5 x 20.5 (10⁷/₁₆ x 8¹/₁₆)
The J. Paul Getty Museum

80. NADAR
*Paul Legrand, Mime*, c. 1855
salted paper print from wet collodion negative
24.0 x 17.7 (9⁷/₁₆ x 7)
Marie-Thérèse and André Jammes

103

82. LADY CLEMENTINA HAWARDEN
*Two Girls—Hand to Bosom*, c. 1862
albumen print from wet collodion negative, 24.0 x 27.5 ($9^{7}/_{16}$ x $10^{13}/_{16}$)
By courtesy of the Board of Trustees of the Victoria and Albert Museum

81. ROBERT CRAWSHAY
*Study in a Turkish Bath*, c. 1855
quarter-plate ambrotype, 10.5 x 7.9 ($4^{1}/_{8}$ x $3^{1}/_{8}$)
By courtesy of the Board of Trustees of the Victoria and Albert Museum

83. Lady Clementina Hawarden
*Girl at Mirror*, c. 1862
albumen print from wet collodion negative, 22.2 x 24.2 (8¾ x 9⁹⁄₁₆)
By courtesy of the Board of Trustees of the Victoria and Albert Museum

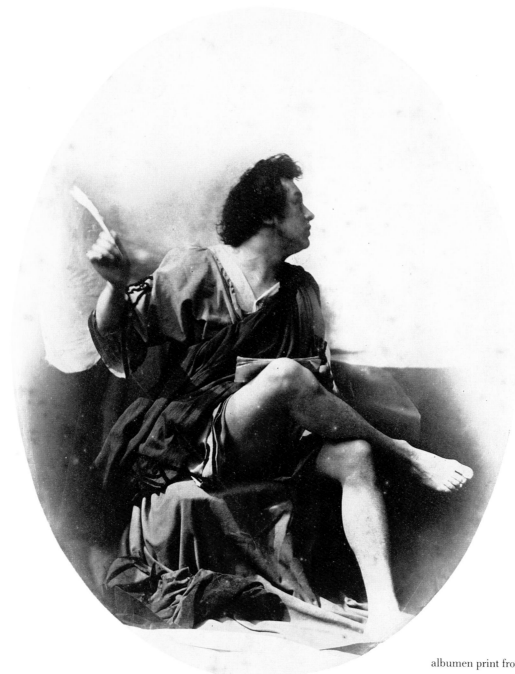

84. Oscar G. Rejlander
*The Poet*, 1856
albumen print from wet collodion negative, 18.2 x 14.1 (7³⁄₁₆ x 5½)
Royal Photographic Society

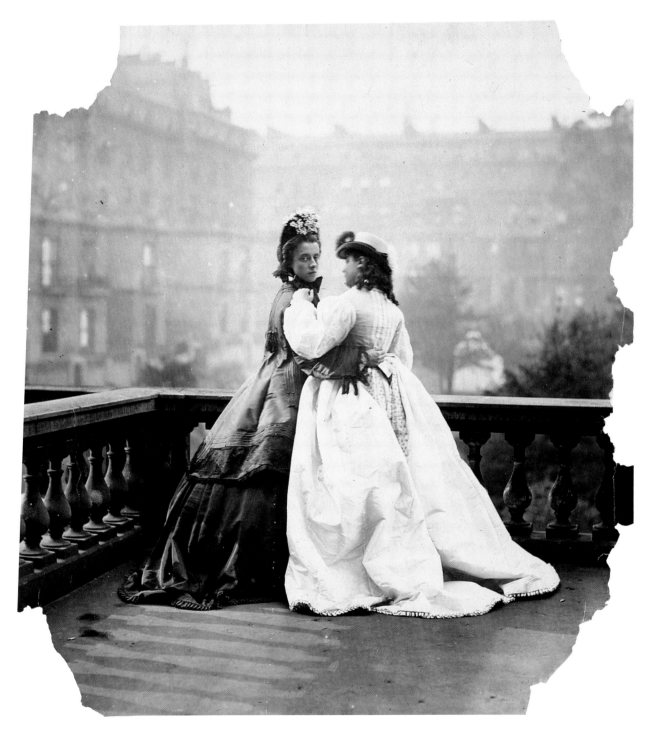

85. LADY CLEMENTINA HAWARDEN
*Two Women on Porch*, c. 1862
albumen print from wet collodion negative
23.1 x 21.3 (9¹⁄₁₆ x 8⅜)
By courtesy of the Board of Trustees of
the Victoria and Albert Museum

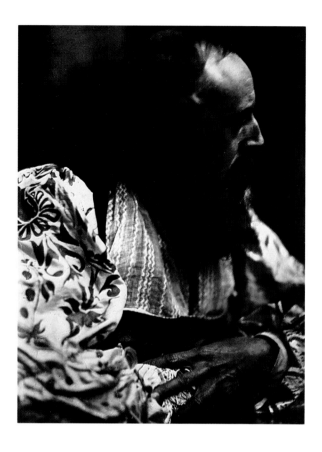

86. David Wilkie Wynfield
*G. F. Watts, O.M., R.A.,* 1862
albumen print from wet collodion negative
21.3 x 16.2 (8⅜ x 6⅜)
Royal Academy of Arts

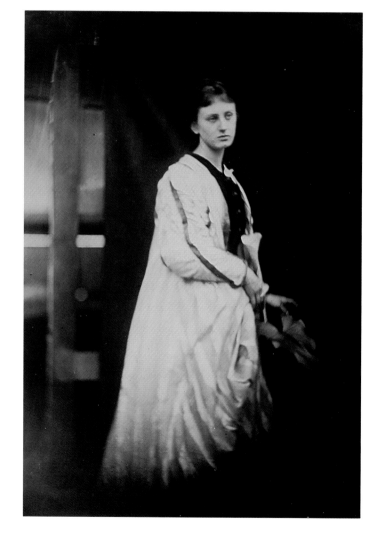

87. Julia Margaret Cameron
*May Prinsep,* c. 1865
albumen print from wet collodion negative
22.5 x 20.5 (8⅞ x 8¹⁄₁₆)
The Metropolitan Museum of Art, Harris Brisbane
Dick Fund, 1941, All rights reserved,
The Metropolitan Museum of Art

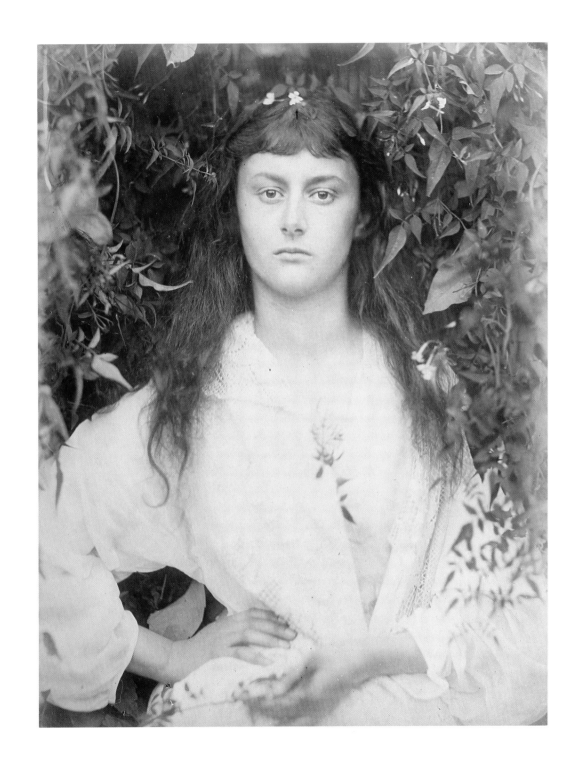

88. Julia Margaret Cameron
*Pomona*, 1872
albumen print from wet collodion negative
34.6 x 26.9 (13⅝ x 10⁹/₁₆)
Royal Photographic Society

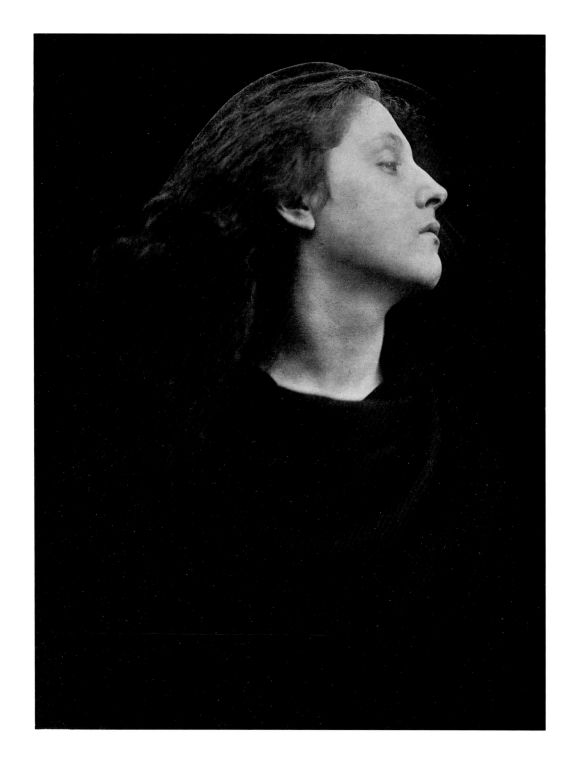

89. JULIA MARGARET CAMERON
*Call, I follow, I follow, let me die!* c. 1867
carbon print from wet collodion negative
36.3 x 28.0 (14¼ x 11¹¹⁄₁₆)
Royal Photographic Society

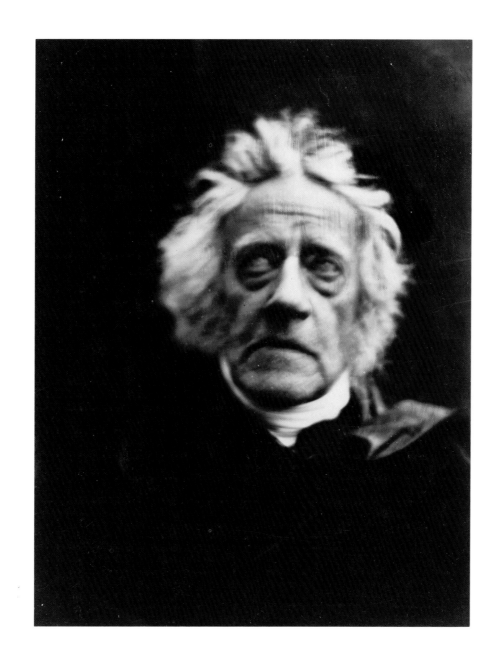

90. JULIA MARGARET CAMERON
*The Astronomer: Sir John Herschel*, 1867
albumen print from wet collodion negative, 30.2 x 23.2 (11⅞ x 9⅛)
Royal Photographic Society

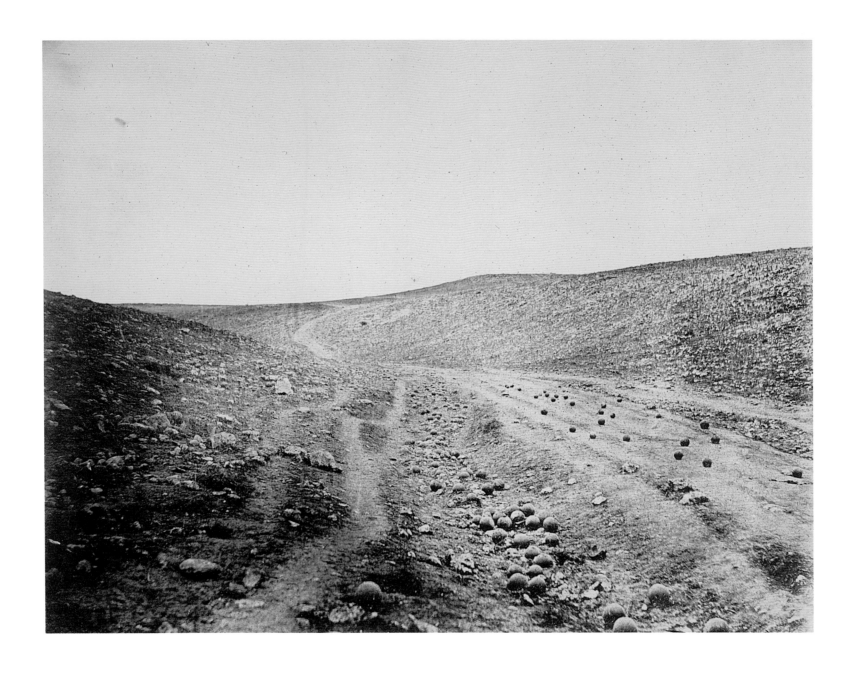

91. ROGER FENTON
*Valley of Death*, 1856
albumen print from wet collodion negative, 27.2 x 36.4 (10$^{11}$/$_{16}$ x 14$^{3}$/$_{8}$)
The Art Institute of Chicago, Photography Gallery, Restricted Gifts Fund

92. ALEXANDER GARDNER
*Home of a Rebel Sharpshooter, Gettysburg, 1863*
albumen print from wet collodion negative, 30.4 x 39.8 (12 x 15⅝)
Library of Congress, Prints and Photographs Division

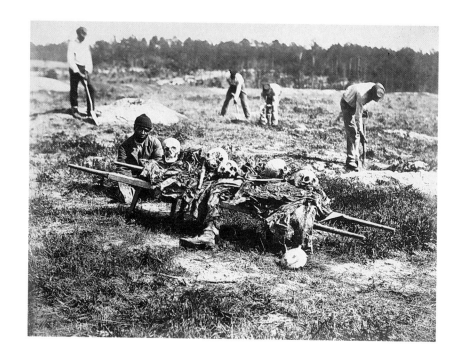

93. John Reekie
*A Burial Party, Cold Harbor, Virginia,* 1865
albumen print from wet collodion negative
30.4 x 39.8 (12 x 15⅝)
Library of Congress, Prints and Photographs Division

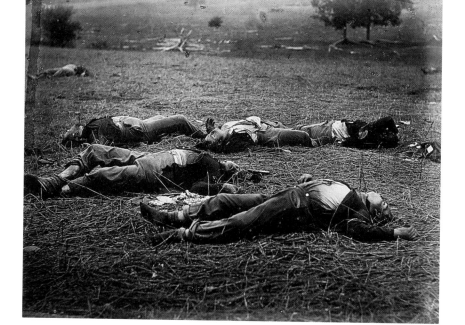

94. Timothy O'Sullivan
*Field Where General Reynolds Fell,* 1863
albumen print from wet collodion negative, 17.8 x 22.9 (7 x 9)
The Art Institute of Chicago, Gift of Mrs. Everett Kovler

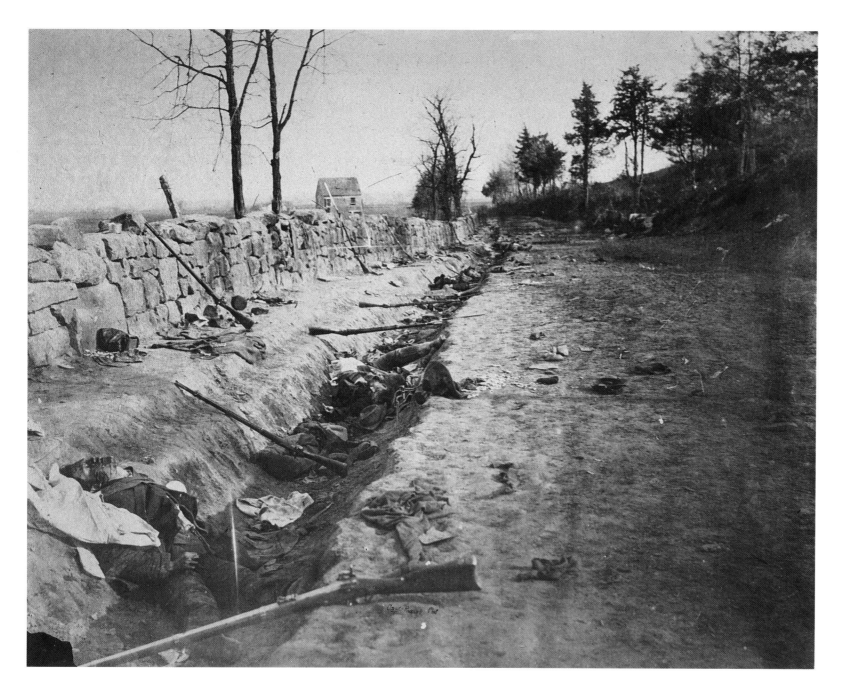

95. Andrew Joseph Russell
*Stone Wall, Rear of Fredericksburg, With Rebel Dead, 3 May 1863*
albumen print from wet collodion negative, 23.6 x 30.2 (9⁹/₁₆ x 11⁷/₈)
Library of Congress, Prints and Photographs Division

96. Andrew Joseph Russell
*Potomac Creek Bridge, Aquia Creek and Fredericksburg Railroad, 18 April 1863*
albumen print from collodion negative, 25.9 x 40.4 (10³⁄₁₆ x 16)
Library of Congress, Prints and Photographs Division

97. ANDREW JOSEPH RUSSELL
*Granite Canyon from the Water Tower*, c. 1865
albumen print from wet collodion negative
22.0 x 30.5 (12¾ x 18¼)
Janet Lehr, Inc., New York

98. TIMOTHY O'SULLIVAN
*Sand Dunes, Carson Desert*, 1867
albumen print from wet collodion negative
21.5 x 28.0 (8½ x 11¹⁄₁₆)
Records of the Office of the Chief Engineers,
No. 77-KS-5-160, National Archives

99. Timothy O'Sullivan
*Vermillion Creek Canyon*, 1867
albumen print from wet collodion negative, 20.3 x 26.0 (8 x 10¼)
Library of Congress, Prints and Photographs Division

100. William Bell
*Grand Canyon of the Colorado*, 1872
albumen print from wet collodion negative
27.2 x 19.8 (10$^{11}$/$_{16}$ x 7$^{13}$/$_{16}$)
Gilman Paper Company Collection

101. Timothy O'Sullivan
*Black Canyon, Colorado River, From Camp 8, Looking Above*, 1871
albumen print from wet collodion negative, 20.1 x 27.6 (8 x 10$^7$/$_8$)
The J. Paul Getty Museum

102. CARLETON WATKINS
*Cape Horn, Columbia River, Oregon*, 1867
albumen print from wet collodion negative
52.4 x 40 (20⅝ x 15¾)
Gilman Paper Company Collection

103. CARLETON WATKINS
*Multnomah Falls, Columbia River*, c. 1870
albumen stereograph from wet collodion
negatives, 8.0 x 7.8 (3³⁄₁₆ x 3¹⁄₁₆) each
The Art Institute of Chicago, Gift of Harold Allen

104. CARLETON WATKINS
*Mirror View, Yosemite Valley*, c. 1866
albumen stereograph from wet collodion
negatives, 7.9 x 7.9 (3¹⁄₁₆ x 3¹⁄₁₆) each
The Art Institute of Chicago,
Restricted gift of Kunstadter Family Foundation

105. CARLETON WATKINS
*Cape Horn near Celilo*, 1867
albumen print from wet collodion negative, 40.0 x 52.0 (15¾ x 20½)
Gilman Paper Company Collection

106. WILLIAM HENRY JACKSON
*The Royal Gorge, Grand Canyon of the Arkansas*, c. 1882
albumen print from wet collodion negative
52.0 x 40.0 (20½ x 15¾)
Janet Lehr, Inc., New York

107. ALBERT COLLARD
*Arche du Pont de Grenelle, Paris*, 1874
albumen print from wet collodion negative, 32.0 x 42.0 (12⅝ x 16⅝)
École Nationale des Ponts et Chausées, Paris

108. WILLIAM RAU
*Main Line and Low Grade Tracks at Parkersburg*, c. 1890
gelatin silver print, 44.0 x 54.6 (17 x 21½)
The J. Paul Getty Museum

109. ALBERT COLLARD
*Arcades des Lisses, A l'amont du chemin rural de Corbeil à Arpajon*, 1874
albumen print from wet collodion negative, 29.4 x 42.5 (11⁹⁄₁₆ x 16¾)
Musées de la Ville de Paris, Musée Carnavalet

# II
## 1880–1918

Fig. 1. Photographer unknown, *Untitled (Two Men and Two Women)*, c. 1889, gelatin silver print, 8.0 diam. (3¾₆ diam.), International Museum of Photography at George Eastman House, Gift of George P. Dryden (cat. 115)

# The Curious Contagion of the Camera

SARAH GREENOUGH

The years between 1880 and 1917 have often been referred to as photography's coming-of-age. Like a child maturing from adolescence to adulthood, the physique or structure of photography changed so markedly during this time that by 1917 it was difficult to recognize the youth in the adult. As with any puberty, it was a tumultuous and self-conscious time. The adolescent, in an attempt to gain better self-understanding, experimented with various theories and sought out new friends and allies. Some of the new-found ideas and colleagues were pleasant and congenial, some proved lasting, others incited great controversy. The basic process remained the same, of course, but the exterior and indeed much of the essential character and function of photography changed significantly—so much so that these years should be understood as a time when the practice of photography was re-invented.

In 1871 when Richard Leach Maddox invented the gelatin dry plate process he did far more than perfect the technique of photography—he laid the foundation for a revolution that would profoundly affect not just how photographs were made but who made them and what subjects were chosen. As his invention was improved in the next several years, emulsions became more sensitive and because cameras could have faster shutter speeds, they no longer required tripods but could be hand-held. An enormous and competitive industry developed around the manufacturing of prepared films and small, light-weight, inexpensive cameras. When George Eastman introduced the first Kodak camera in 1888, a box not much bigger than three by three by six inches with a roll of film that could be sent back to the manufacturer for development and re-loading, he added the final ingredient necessary to revolutionize the medium—the development of a photo-finishing industry. In a little less than fifty years photography had gone from being a complicated, laborious, messy process, practiced almost exclusively by the wealthy, professionals, or scientists who had the time to master its difficult technique, to something so simple and inexpensive that anyone who "could wind a watch," as the manufacturers promised, could master it. Of even greater importance, however, was the fact that with these inventions it was now possible for most middle-class people not only to own photographs of their friends and loved ones, but also to own cameras. For the first time the general public did not simply have to receive second-hand visual information, but could create photographs for themselves.

The legions of hand camera enthusiasts created new subjects, new criteria of pictorial structure and function, new theories, and a new critical vocabulary. In so doing they shook the very core of the medium, challenging the rules and assumptions that had been evolving for the past fifty years about who the photographer was, what a photograph should look like, how it should be made, and what its subject should be. The invention of the hand camera forever altered the photographer's self-image and mutated the relationship that had been established between both the photographer and the public, and the photographer and his subject.

The halftone process also contributed to the changing perception of photography. Although reproductive printing processes had been available for many years, they were of limited application because images could not be economically printed on the same page with type. First used in a New York newspaper on 4 March 1880, the halftone process supplied limitless numbers of cheap reproductions. By the turn of the century, photographic halftones regularly appeared in newspapers, periodicals, and books, establishing new de-

mands for objective visual data. Photographs now could not only be taken by anyone, but they were seen everywhere. With these two inventions photography completed its invasion of modern life; art, science, the social sciences, business, and all forms of communication all were affected by photography and all used photographs. This proliferation of photographic images profoundly changed cultural perceptions about the nature, use, and art of photography.

The 1880s and 1890s saw an evolution in the basic understanding of what photography was. The nineteenth century had long believed that the camera never lied or distorted reality and had equated photography with truth. However, technical innovations at the turn of the century altered this perception. The faster emulsions of the hand camera made it possible for even a novice to record a fraction of a second and freeze actions that the eye never really saw or that passed so quickly they could not be studied. With this improvement, photography evolved from being a secondary method of seeing, where the viewer re-examined what the photographer had already seen, to a primary one, where the viewer and the photographer alike could discover in the photograph things never before seen. In this way, the medium no longer functioned solely as something that re-presented facts, the memory aid that in 1859 Baudelaire said would "rescue from oblivion those tumbling ruins, those books, those prints and manuscripts which time is devouring . . . and which demand a place in the archives of our memory."[1] Instead it became equated with revelation and with primary knowledge. Emile Zola expressed the dominant belief of the period when he said in 1900, "You cannot say you have thoroughly seen anything until you have got a photograph of it, revealing a lot of points which otherwise would be unnoticed, and which in most cases could not be distinguished."[2]

In the years between the perfection of the "witch machine," as it was often called by the press in the 1880s, and World War I, a second generation of photographers came to maturity. They accepted the existence of photography as a matter of course, but questioned its meaning and use to a degree not previously known. Cogent and highly influential aesthetic theories were formulated to defend critical positions. And new ways of looking at and thinking about the world through

photography evolved during these decades—methods of seeing, thinking, and photographing that would propel the field into the modern era. At the same time it was a period of intense commercialization as large manufacturing interests began to exert extraordinary pressure to standardize and control the burgeoning new market. And it was a time of conservatism and retrenchment as many photographers, threatened by the armies of hand camera enthusiasts, attempted to regain some of the lost mystery, magic, and conspicuous artistry of the medium.

This period resists easy, simplifying categorization. But despite the turmoil and diversity, it saw the evolution of a common understanding of photography as a very personal tool. In part because it was so easy and cheap, in part because it became the ubiquitous companion of modern life, photography and the camera came to be seen almost as extensions of the hand and eye.[3] No longer an exotic profession practiced in elaborate and remote studios, photography entered the home and became both commonplace and intimate. As such, its primary use during this time was not on a public scale to define issues of national character or relevance, but on a very personal one. For many it was a delightful way to record intimate scenes of friends and family; for others it was a tool enlisted in personal crusades to document social conditions or dying cultures; and for still others it became a means of self-expression. It is this use of photography for personal ends that distinguishes this generation of workers from their predecessors. Whereas an earlier era reveled in seeing how the world looked when it was photographed, this generation was concerned with doing it themselves, with seeing, knowing, and defining their personal, social, and emotional life through the rectangular frame of the little black box.

In 1887 when Alexander Black wrote in *The Century* of "that gentle madness" of the "enthusiastic amateur . . . who has succumbed to the curious contagion of the camera," he was, in actuality, witnessing not only the revolution of photographic practice, but also the establishment of a vernacular tradition.[4] Photography had begun to approach this state before with the highly popular and inexpensive *cartes-de-visite* and tintypes of the 1860s and 1870s. Although they oc-

casionally contained some of the whimsy, irreverence, and spontaneity that came to be associated with the hand camera, these images were most often controlled and convention-bound, composed in studios under the direction of professional photographers. As cameras became smaller, lighter, and less expensive, culminating at the turn of the century with the introduction of the Brownie camera costing one dollar, it was possible for everyone of almost every economic class and occupation to make photographs: by 1900 it was estimated that four million people, or one out of ten in the entire population of Great Britain, owned a camera.[5] Children and grandparents, royalty and soldiers, farmers and urban dwellers, reformers and artists all became photographers, and the medium came to be dominated by amateurs. These new practitioners were distinctly different from their predecessors. They were not professionals influenced by external, economic dictates—no project supervisor or client told them what to photograph or how to do it—instead they were free to record whatever they wanted in whatever manner they chose. Nor were they like earlier amateurs, for example Cameron, who aspired to creative expression; they had no such lofty ambitions. Largely untrained, most of the new amateurs did not bring to their practice of photography a strong heritage of the other fine arts. With few pictorial conventions on which to rely, they experimented widely, often blundered, and occasionally excelled.

They did, however, bring new ideas of what to photograph. Before the 1880s the business of photography had consisted largely of *cartes-de-visite*, stereos, cabinet cards, and tintypes of landscapes, buildings, monuments, and celebrities, as well as portraits made in studios. Although a few itinerant photographers went door-to-door recording mundane scenes, this was not financially lucrative. But these were precisely the scenes the new amateurs wanted to document—a group of friends on a picnic, a favorite dog, the family house, a new bicycle. Characterized by an intensely personal point of view and a freedom of observation, their photographs showed family and friends in relaxed, familial settings. Taking their cameras out-of-doors, on trips and outings, they depicted the inconsequential subjects, the commonplace incidents and highly personal details of modern life, in a casual, off-

hand manner. Unconcerned with posterity or the public, the amateurs' only frame of reference was themselves. When they recorded people or things they did so in a manner that emphasized their personal, not public, meaning. On vacation, they were far more concerned with documenting their presence and that of their family than they were with making a record of the buildings and places they saw. Thus when the future Queen of England, Princess Alexandra, took her Kodak No. 1 on board the royal yacht, she did not record a naval inspection, but a family outing (cat. 117). Or, when the Washington amateur Uriah Hunt Painter went to the White House, he did not document the building, but rather, his companion standing in front of it (cat. 119).[6] Occasionally the amateurs' images appear to be carefully conceived visual inventories of all that they owned or was dear to them, as if by recording these objects they could halt the passage of time. Tables and chairs, babies and animals are depicted with equanimity, with no more emphasis or interest placed on one than another. Other photographs are so personal, the sitters unknown, the subjects and references so vague, that we can only guess at their meaning or relevance (cat. 116). Removed from the time and emotions that produced them and pasted into family albums or framed on the mantelpiece, the amateurs' photographs functioned less as concise literal documents of visual facts and more as selected details to stir the memory of the maker. In total they formed vast private archives that recorded the family, friends, events, and posessions of the amateur.

With the development of the hand camera, a new relationship began to emerge between photographers and their sitters. These amateurs were not hired to document an occasion; they did not arrive, line everyone up, ingratiate themselves to gain cooperation, take the photograph, and leave, for they were not outsiders. Because the exposures were so fast, the subject often did not even know that a photograph was being taken. There was no chance for primping, for the assumption of a pose or attitude, as the photograph was achieved within a fraction of a second, and finished before most knew it was happening. Because the camera was now a normal object of everyday family life and not an exotic instrument, when people did know of its presence, they often paid little attention either to it or to the photographer. With

little awe for the process or the photographer, they continued to talk, gesture, and move, frequently walking in or out of the photograph as it was being made. When amateurs did group their friends, they were not voyeurs trying to ascertain relationships or personalities, but intimately related to the event being recorded, and their subjects reacted accordingly (cat. 118). They put on their camera smiles, confident that their silly antics and unstudied countenances were for private consumption, not public display. By getting out of the studio into the real world, by removing the psychological barriers between photographer and sitter, and by making the photographer a privileged insider, these images are often endowed with a vivacity and immediacy not previously known in photography.

This sense of privileged intimacy informs several photographs by Thomas Eakins and Edgar Degas. The new ease of the process led many painters to make photographs at the turn of the century. As a group they probably did not adopt the hand camera with any more enthusiasm than others, but because they were famous artists, their photographs have often been more carefully collected and preserved, making a systematic examination possible.[7] Although Eakins and Degas often photographed the same familial scenes as other amateurs, neither exploited the advantages of the new processes; instead the majority of their photographs retain conventions of an earlier time.[8] Despite Eakins' interest in motion, his work with Eadweard Muybridge at the University of Pennsylvania in 1884, and his own motion studies made in 1884 and 1885 (cat. 112), many of his other photographs, and particularly his portraits, are still and clearly posed. Classically restrained and controlled, often without props and occasionally without background details, they elicit the same psychological intensity Eakins sought in his paintings. This too was Degas' aim in his portrait of *Paul Poujaud, Mme. Arthur Fontaine, and Degas* (cat. 114). Taken at night with the light of gas lamps and a long exposure, it also was artfully staged, far from the instantaneous snapshot celebrated by the new amateurs. Both Eakins and Degas did occasionally take a camera on family outings and it was then that they made some of their more casual images. When Eakins visited his sister's farm in Avondale, Pennsylvania, in 1883, he photographed

his fiancée Susan Macdowell and several of his nieces and nephews playing in a stream (cat. 113). The vantage point, the distance separating the photographer from his subject, the action and gestures of the children, and the slight blurring of the edges of the image all combine to give this bucolic scene an unrehearsed quality that was rare in Eakins' photographs or paintings, and rarer still in photographs in general made before the 1880s.

More typical of the new subjects and the new vision of the hand camera workers are the photographs of two other amateurs: the painter Edouard Vuillard and the child Jacques-Henri Lartigue. Vuillard began photographing in the late 1890s, when his reputation as an artist was well established; Lartigue, on the other hand, made his first photographs in 1900, when he was six years old.[9] Both delighted in recording their affluent French families amusing themselves in the waning years of the Belle Époque shortly before World War I. Their unself-conscious, effervescent photographs describe an undeniably charmed existence of summer holidays, motorcar trips, languid afternoons, dear friends, and childish games.

It is not so much what was photographed, however, as how it was done that unites the work of this visually sophisticated artist and visually innocent child, and demonstrates the new pictorial structure that emerged with the invention of the hand camera. Smaller and less cumbersome, cameras were not only more portable, but also more flexible, and could be put in many new situations. Lartigue made one of his early photographs by placing his camera on his bedroom floor to photograph his toy cars (cat. 125). It was a simple, expedient way to record his beloved playthings: in order to see them properly, Lartigue felt he had to photograph them on their level.[10] For the child who sat or lay on the floor playing and who was used to seeing bureaus and tables assume monumental proportions as they loomed above him, this ant's-eye perspective undoubtedly seemed quite natural. But it was hardly a point of view an adult would often consider, nor was it a traditional vantage point for photographs. In another, more conscious attempt to create what he called a "nonsensical" photograph of himself and a toy helicopter in his bathtub, Lartigue balanced his camera on a piece of wood stretched

across the tub[11] (cat. 126). The resulting photograph shows his head floating above the surface of the water, his expression clearly displaying his excitement and anticipation. With difficulty, these photographs could have been made before the invention of the hand camera, but it was the ease and cheapness of photography that encouraged such visual experimentation and financial risk.

Vuillard pursued a quieter, less flamboyant, more systematic, but equally innovative investigation of photography. He too used the camera as a way of seeing the world from different points of view; he looked down from second-story windows, he looked up along garden paths, and he looked over the tops of cars.[12] Like Lartigue, Vuillard seems not to have been troubled by blurred or out-of-focus objects caused by fixed focus lenses, slow shutters, or movement, for he was not striving for technically perfect images. In fact, neither had much technical knowledge at all: Vuillard's negatives were developed by his supplier and printed by his mother and in his youth Lartigue's early photographs were developed by his father. Both evidenced a willful disregard and healthy skepticism of the guidelines issued by manufacturers on how to take photographs: Lartigue recalled how he was always told not to photograph someone in front of the sun, but found that he could.[13] Not interested in the technique of photography, the child and the painter were intrigued with the act of taking photographs and the joy of discovering what their world looked like when photographed. Vuillard's nephew recalled his uncle's method: "Vuillard owned a camera, a Kodak. It was an ordinary model, one of the bellows type. It was part of Vuillard's household. Its place was on the sideboard in the dining room. Sometimes, during a conversation, Vuillard would go to get it and resting it on some furniture or even the back of a chair, oblivious of its view finder, would point the lens in the direction of the image he wished to record: he would then give a brief warning, 'Hold it please' and we could hear the clic . . . clac of the time exposure. The camera was then returned to its place, and Vuillard walked back to his seat."[14]

This casual approach of not even looking through the view finder resulted in equally casual images. At times chaotic, often fragmented and scattered, these snapshots by

Fig. 2. Édouard Vuillard, *Amfréville–Driveway*, 1905, silver bromide print, 8.5 x 8.5 (3⁵⁄₁₆ x 3⁵⁄₁₆), M. Antoine Salomon (cat. 121)

Vuillard and Lartigue, as well as much hand camera work in general, are radically different from the tightly integrated, ordered, and composed photographs made earlier in the century. While the latter photographs reflect the great effort entailed in setting up, exposing, and developing the wet plate collodion negative, these are indicative of photography's new-found simplicity. Concerned with quality and finish, earlier photographs most often have serious aspirations to define issues of character, locale, and culture; occasionally humorous, frequently mundane, and obscure, later photographs wish only to record visual data in a very basic fashion. Photographs from the first few decades after the invention of the process were usually described as views, landscapes, compositions, or portrait studies—indicating their completeness of both intent and execution. Newer images were called "snapshots," after the hunting term for a hurried shot taken without deliberate aim at a rapidly moving animal.[15]

Both Lartigue and Vuillard, as well as countless other amateurs, delighted in the ability of their cameras to make "snapshots" and record instantaneous slices of time. Vuillard, who was older and more sedentary than his younger counterpart, used the camera not so much to freeze motion as to fragment time and explore the meaning of the ephemeral. He studied glances or actions that passed too quickly for careful scrutiny but could summarize an individual, mood, or event. He looked for gestures, posture, facial expression, layerings of space and pattern, to render, as Baudelaire had suggested in *The Painter of Modern Life*, "the stroke that could sum up a character"[16] (cat. 124). Lartigue froze motion, for his was a world of movement, of automobiles, airplanes, gliders, bicycles, and games, and he made countless photographs of people running, racing, jumping, swimming, and flying. But these images, like the photographs of another twelve-year-old, the American Leonard Dakin, and those of the painter Pierre Bonnard, do not examine the study of motion analytically[17] (cats. 129, 130). It was not the photographers' intention to expose the clumsiness of their friends or children, for they were too intimately a part of the games and action. But rather in fragmenting time and freezing motion, they showed the fluidity and grace of the ephemeral. Even though both Lartigue and Dakin photographed people running and jumping from several different angles and even though Lartigue often grouped these photographs into sequences in his albums, these are not motion studies. There is no scientific interest to synthesize the various parts of the movement to describe its process or wholeness, only a desire to see a frozen cut of time. Made in a fraction of a second, these photographs freely admit their transitory nature. We know that the jumper suspended in midair was in actuality rapidly descending to earth in the constant flux of time. Not stabile or eternal, these photographs are but one second in an endless succession of seconds, a section ripped from a much larger whole.

Fractured and disjointed, without traditional compositional structure, and with people looking and moving in several different directions, snapshots from the turn of the century often seem on the verge of pulling themselves apart. The edges of the frame sever arms and legs from the rest of the body,

Fig. 3. Jacques-Henri Lartigue, *Oléo*, 1908, gelatin silver print, 15.9 x 11 (6¼ x 4⅜), Association des Amis de J.-H. Lartigue, Paris, Copyright Association des Amis de Jacques-Henri Lartigue, Paris (cat. 128)

rendering them useless and bizarre; parts of objects are separated from the whole and dangle in space without meaning or function. It is true that these properties had appeared in photographs before, but never to such an extent. In part this kind of cropping and framing was the result of the primitive view finders of many early hand cameras, which were not much more than point-and-shoot contraptions that did not

allow for careful pre-visualization. In part, too, the early Ko-daks, whose circular format was difficult for the untrained amateur to handle, exacerbated these characteristics. But it was largely the result of the attitude of the amateur who casually pointed his camera in the direction of his intended subject and often caught a lot of unintended, peripheral information in the bargain. These extraneous details were of little concern to the amateur, however, whose sole aim was to record his world, not define it or extract its meaning, but simply to preserve a record of it.

Much hand camera work from the turn of the century has been overlooked and what has been examined can be attributed to other reasons: Vuillard and Bonnard because they were painters; Princess Alexandra because she later became Queen of England. The anonymous amateur photographers from the turn of the century—the Uriah Hunt Painters, Leonard Dakin, and countless others—have been dismissed as pictorially inconsequential and of no particular influence on more sophisticated, self-consciously artistic photographers.[18] This is not entirely accurate. To be sure, much of their work is banal and the more visually interesting portion was largely unknown at the time, buried in family archives and only resurrected when the patina of history had endowed it with further charm and nostalgia, or when it became critically fashionable. It would be foolish to argue that Lartigue or Dakin, who were after all just children, understood the implications of their new subjects and radical compositions, for they had no conscious desire to create a new artistic language. Nor did they comprehend the parallels that might be seen between their investigations of time and motion and, for example, William James' "specious present," and "stream of consciousness," or Henri Bergson's *la durée*, both of which celebrated fluency, change, and movement as the dominant characteristics of modern life. That Lartigue's photograph of a racing car with elliptical wheels from 1912 seems to be the proof of Einstein's 1905 theory "On the Electrodynamics of Moving Bodies," which argued that moving forms do change their shape in reference to a stationary reference point, is simply coincidental.[19] But Vuillard, Lartigue, Dakin, Painter, Bonnard, and Princess Alexandra are symptomatic of their time. The same culture, the same period

that witnessed the invention of the electric light, the cinema, the telephone, the automobile, the bicycle, and the airplane, that experienced the world-wide regulation of time with the establishment of the Greenwich zero meridian—all of which profoundly affected the basic understanding of time and space—produced both the amateurs and the philosophers.[20] That Lartigue and Dakin reached the same conclusion as James that the conceptual world was a kind of cut, excerpt, or selection from a flux or continuum which was reality, points to the currency of the idea.[21] That these photographers manifest similar concerns, though of vastly different degrees of intellectual sophistication, must be admitted.

It must also be recognized that the subjects of these amateur photographs and their methods of pictorial construction were so characteristic of hand camera work in general that any visually sensitive person growing up at the turn of the century was exposed to their influence. Such images were seen daily in family albums, newspapers, magazines, even school books. The style and subject matter of the amateur's snapshots became so commonplace that they faded into the general fabric of modern middle-class life, but they were there. It was many years before the photographic vanguard had the self-confidence to embrace these mundane incidents of modern life as worthy subjects or appreciate their lessons of pictorial structure, but hand camera work from this time did serve, as Mallarmé wrote of Manet's art, to "educate the public eye" and if nothing else to demonstrate "the graces which exist in the bourgeoisie as worthy models in art."[22]

Late in 1890 the Danish-born American police reporter Jacob Riis published *How the Other Half Lives: Studies among the Tenements of New York*. Including forty-three illustrations and fifteen halftone reproductions, it was the result of several years of investigation in the depths of New York's slums. It was not the first study of urban life to include photographs: daguerreotypes by Richard Beard had been used as studies for the illustrations in Henry Mayhew's 1851 publication *London Labour and London Poor*, and John Thomson's photographs accompanied his 1877 work with Adolphe Smith, *Street Life in London*. But even though the latter contained

Fig. 4. Jacob Riis or Richard Hoe Lawrence, *A Downtown Morgue*, 1887, albumen print, 9.4 x 12.0 (3¹¹⁄₁₆ x 4¾),
Jacob Riis Collection, Museum of the City of New York (cat. 395)

woodburytype reproductions (an early method of reproducing photographs in facsimile in ink), it has none of the horror, passion, commitment, or authenticity of Riis' work. Without question, Riis' book can be said to have initiated a new era in urban and social documentary photography, but it also signaled a new understanding of how photography could be used.

Riis, who himself arrived in New York as an impoverished immigrant, had many friends in the New York City Health Department whom he accompanied on midnight forays into the slums to investigate suspected violations and collect evidence. It was on these trips, he recalled in his autobiography, that "the wish kept cropping up in me that there was some way of putting before the people what I saw there . . . A drawing might have done it, but it would not have been evidence of the kind I wanted."[23] He did not immediately seize upon photography as the obvious solution; he lectured to middle-class audiences in the New York area using graphs and maps but found that his presentations lacked the authority of proof.[24] When he read about the 1887 discovery of *Blitzlichtpulver*, a flashlight powder, he realized, as he later wrote, that it was "the thing I had been looking for all those years," for now it was possible to photograph at night or in darkened rooms.[25]

Riis is typical of the many turn-of-the-century crusaders who used photography as a tool to provide visual proof for their ideas. They were not, on the whole, commercial photographers; although some may have made money from their photographs, financial gain was not their primary motivation. Often they were not particularly interested in photography; it was only a means to an end. Something else was their passion—social reform or cultural history, for example. Nor were they particularly concerned about technique and only learned enough to enable them to record their data successfully. They picked the camera up because it was cheap, simple, and portable, because its images could easily be reproduced, and because they and their audience still believed it was an objective recorder, a transparent window on the world. For them photography was an empirical tool, and they used it as they would have used any other mechanical aid, to provide data to augment their spoken and written words, their charts and statistics. Photography became a way for these men and women to organize, classify, symbolize, and, perhaps most important, understand issues such as urban growth, ethnic diversity, cultural change, and industrialization, which otherwise were unknown, fearsome, and seemingly out of control.

The ability to make photographs, however, coupled with an idea of what to photograph, did not automatically endow these crusaders with an understanding of how to use photography most effectively or even with a clear notion of what their photographs should look like. They had few photographic precedents on which to rely. Before the perfection of the hand camera in the late 1880s many aspects of human life, particularly its more unpleasant sides, had not been shown in photography. With a few notable exceptions, the effects of poverty, crime, violence, and industrialization on Western European and American society had rarely been photographed because there was little economic incentive to do so. When they were, for example, by such English Victorian photographers as H. P. Robinson or O. G. Rejlander, the scenes were so cleaned-up, so sentimentalized or heroized, as to make the condition seem faintly charming and certainly acceptable.[26] None of the true brutality of the situation was conveyed, no moral outrage was provoked. But this is precisely what Riis wanted to do.

The process of photography was not an act of discovery for Riis. After many years of experience with the area, he approached his project to document the horrors of New York's slums with a set program and fixed ideas about his subject, and its nature, cause, and solution: specifically, that poverty caused crime, filth, moral degradation, and corruption, and neglect; its cure would be found in government and social organizations that provided structure, order, education, and middle-class values. Originally designed to illustrate lectures, each photograph tells a very obvious and compelling story. The boy in the photograph *In the Sweat Shop* sits at work surrounded by several idle and threatening men (cat. 132). His bruised eye, apprehensive expression, and busy hands are in sharp contrast to the authoritative and menacing looks and poses of the men. In *Lodgers in a Crowded Bayard Street Tenement: Five Cents a Spot* Riis showed a room jammed

with people and their possessions (cat. 135). Boots, bags, pots, hats, clothes, bedding, and people are stuffed in every corner and hung from the ceiling, and intrude from the edges of the image. They speak more forcefully than any verbal description Riis could have given of the extreme overcrowding in the slums. The floors and ground in Riis' photographs are covered with stains, dirt, water, litter, and garbage; the walls and ceilings are often sagging and covered with peeling paint, plaster, or wallpaper; windows are dark, bare, or broken; tables and chairs are overflowing with tattered possessions. It is this relentless, unabashed accumulation of horrifying details, intensified by the blinding light of the flash powder, that provided Riis with the facts he needed to build his case. In addition, these horrifying details are the source of the power of Riis' photographs, for scenes like these of the underside of American life, presented in such a stark manner, had never before been so objectively depicted.

While Riis was a reformer, he was also a "producer" who carefully manipulated his audiences to elicit a desired response. As has recently been demonstrated, his lantern slide lectures were precisely orchestrated events using music, lights, and slides; his books were carefully constructed to show first the evils of the situation and then its cures.[27] Perhaps realizing, as O. Henry wrote, that "optical gluttons feast on the misfortunes of others," he played upon the voyeurism and curiosity of the middle class about this unknown world to entice them to hear his lectures or read his books; once he had snared his audience he played on their values of home, family, religion, and cleanliness to convince them of the pressing need for reform.[28] His goal was reform; how he accomplished it, whether through playing sentimental music or using other people's photographs as illustrations for his ideas, mattered little. In point of fact, Riis did not make all of the photographs usually attributed to him. In good nineteenth-century fashion, he appropriated and published as his own images by Richard Hoe Lawrence and Dr. Henry G. Piffard; in his later years he even used some of Lewis Hine's photographs.[29] Untroubled by issues of authorship or the sanctity of artistic creation, Riis needed photographic images to prove his points and he, and his audience, did not particularly care who had made the photographs. This mul-

tiple authorship accounts for the varying style of "Riis" photographs, from the posed, conventional, almost picturesque *Bandit's Roost* or *Home of the Italian Rag Picker*, often called *Slum Madonna* (both of which clearly recall European, particularly Italian, nineteenth-century genre traditions) to the stark, confrontational, and brutal quality of *Interior of an Arab Boarding House, Washington Street, New York* (cat. 133).[30] It should be remembered that Riis, in exploring the uses of photography for social change, was pioneering a new field. He did not know which kind of image, one that recalled a fine art tradition or one that visually assaulted the viewer, would have more impact on his audience. And further, it could be argued that he needed both kinds of photographs, conventional and sensational, to evoke differing responses from his audience.

In light of the differing authors of "Riis" photographs, Riis himself cannot be credited with much artistic intent, and it is risky to suggest that he consciously pursued certain formal qualities—such as cropping, darkness, blinding light, or compression of space—to intensify the impact of his photographs.[31] What Riis did master and where his importance lay was in his ability not to make creative photographs, but to use photography creatively. When presented with a random group of images, some his own, some made under his direction, and some by others, he was able to recognize the expressive potential of diverse images, and to use them effectively to his own advantage and ultimately that of his cause.

Despite Riis' genuine moral outrage over the conditions of life in the slums, evidenced by his lifetime commitment to social reform, his empathy and his compassion for his fellow man are less apparent. Although his objective was to make the New York slums a known quantity, he treated them as if they were a somewhat foreign and exotic land. He described his first session photographing with Lawrence, Piffard, Dr. John T. Nagle, and a policeman or two as a "raiding party [that] invaded the East Side by night" armed "with big pistols which they shot off recklessly."[32] His first article on the subject, which included wood engravings made from photographs, was titled "Flashes from the Slums . . . the Poor, the Idle, and the Vicious." Some of this phrasing can be attributed to Riis' years as a journalist and his tendency to

sensationalize, but some of this disdain is also felt in the photographs he used: adults, particularly men, are often threatening, sinister, and idle; women and children usually work in sweatshops while men drink.[35] His sympathy was reserved for the children who had not yet been corrupted by their environment. In his lantern slide shows he included before and after photographs of children when they were "taken from their hovels, and cruel and wretched parents, and after they were cleaned and cared for by Mr. E. Gerry's 'Society for the Prevention of Cruelty to Children.'"[34] In both his choice of words and photographs there is a sense of confrontation between one class and its values of home, family, morality, and cleanliness and another's instinct for survival. There is, too, a sense of invasion, of something being taken without cooperation or consent. Riis purposely photographed at night so that people would be caught unaware with no time to prepare themselves or "fix up" for the camera.[35] That he succeeded is evident in the startled and horrified looks of the women in *Interior of an Arab Boarding House*.

With the invention of the hand camera in the 1880s, an uneasy, at times confrontational and adversarial, relationship between the photographer and the public began to develop. When small cameras were first introduced, any instrument that could be hand-held, as well as any one that was concealed, was called a "detective camera." This implied that its primary use was to search out hidden and perhaps intentionally concealed secrets.[36] While the manufacturers were delighted that "surreptitious negatives" could now be made "without attracting the attention of the curious," others wondered whether these "obnoxious" photographers who were "annoying" the public were not "abusing a new found privilege."[37] In 1902 *The New York Times* complained of the enormous invasion of privacy caused by "Kodakers lying in wait" to photograph the unsuspecting public, and another, earlier reviewer noted that "as there is every probability of Detective Cameras becoming very popular, it would be interesting to know if the use (or *abuse*) of them is legal."[38]

This uneasy relationship between the photographer and the subject is present in some of the photographs made in the 1890s by E. Alice Austen, an amateur photographer who lived on Staten Island. In 1896 the Albertype Company published a portfolio of photographs of the street people of New York's Lower East Side by Austen. It was an adventurous undertaking for a genteel, middle-class woman, whose previous photographs consisted almost exclusively of family portraits, to wander the streets of New York's infamous slums, and her photographs evidence some of her own hesitancy about the project. Although they are sympathetic portraits, made *in situ* and not in a studio, the realities of street life—its hunger, disease, and danger—rarely intrude on the viewer of Austen's photographs. She always maintained a

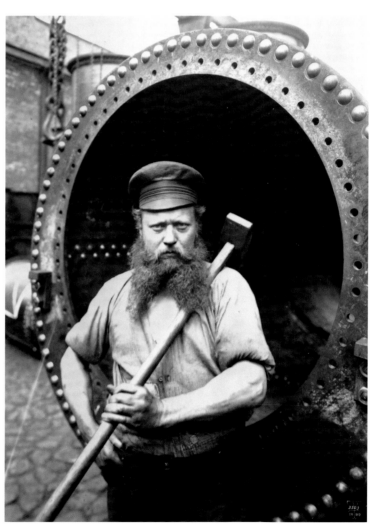

Fig. 5. Waldermar Franz Herman Titzenthaler, *Boiler Maker: Types of German Workers*, c. 1900, gold-toned silver print, 27.8 x 21 (11 x 8¼), Carpenter Center for the Visual Arts, Harvard University

distance from her subjects, both physically and psychologically. The subjects eye the photographer warily, not quite certain what to make of her, and she, in turn, saw them not as individuals, but as representative types: *The Rag Carts, Bootblacks* (cat. 137, 138), *The Organ Grinder, The Immigrant and the Pretzel Vendor.* Working at approximately the same time in Germany, Waldermar Franz Herman Titzenthaler pursued a course similar to Austen's. Although his images are more carefully composed and structured than hers, he too used the camera as a means of examining and documenting types and classes of people.

The use of photography as a tool to aid in the classification of people and things was widespread in the 1880s and 1890s. In part it was stimulated by the growth of the nineteenth-century field of sociology, a discipline that had been established by Auguste Comte in 1838, one year before the announcement of photography. In part, too, it was motivated by a *fin-de-siècle* nostalgia for the past, coupled with an awareness of the profound social transformations caused by a century of industrialization. Photography had been used as an empirical tool for much of its history, but in the 1880s and 1890s, perhaps as a direct response to the huge increase in the number of photographers and photographs, systems were proposed to regularize its productions. A writer in *The British Journal of Photography* in 1889, noting that it was an age of "increasing criticism and self-examination," proposed that a society be formed to preserve "a record as complete as it can be made . . . of the present state of the world."[39] He envisioned this society preserving both details and generalities: it should include photographs of specific buildings, animals, and places, portraits of rich and poor alike, as well as images documenting "the social relations of the classes." And it should also include "records of types" of people made by composite photographs.

In point of fact, both kinds of specific and general records already were being produced. In France, Alphonse Bertillon organized a statistically based filing system for the Paris Prefecture of Police using cards with photographic portraits and physical descriptions of criminals. Between 1883 and 1893 he documented 100,000 individuals with his system.[40] National photographic surveys formed another extensive,

although ineffectively organized, system of social and cultural documentation. In 1897 Sir Benjamin Stone founded the National Photographic Record Association to "obtain photographic records of all objects and scenes of interest in the British Isles."[41] Noting that such a national record would have enormous value to historians, artists, scientists, and politicians, in addition to its commercial, legal, and civic ramifications, Stone issued instructions on what subjects to photograph, how to compose the images, what kind and size of prints to make, and how to mount them. Encouraged by the growing nationalism of the late nineteenth century, other photographic surveys were founded in Prussia, France, Germany, scattered cities in the United States, and Brussels, where the images were classified by the decimal system.

Whereas Stone and Bertillon were concerned with the individual and specific, and Bertillon with constructing a system that would allow for statistical comparisons between individuals, the Englishman Francis Galton used photography to construct physiognomic types. Galton's *Inquiries into Human Faculty*, first published in 1883, included composite photographs made by precisely aligned multiple exposures of types of individuals such as criminals or consumptives.[42] Highly influential, Galton's work touched many responsive chords: it fed directly into the literary and painterly tradition of the picturesque type, a subject stripped of limiting details to reveal its universal characteristics of class or profession, and equally it exploited racial and cultural stereotypes. Numerous composite photographic portraits appeared in the 1890s as this became a form of popular amusement with newspapers, for example, predicting "The Picture of Posterity: How the Future New Yorker Will Look."[43] The term "composite portrait" came to stand for any study that emphasized typical attributes at the expense of individuality. Considerable speculation surrounded the question of which kind of document, specific or general, produced the more valid description. It is against this background, not just of the massive accumulation and systematizing of photographic documents, but also the investigation of how those documents should be formulated, that much photography from the turn of the century must be examined.[44]

One of the most ambitious private archives of photographs

to be constructed at this time was Eugène Atget's. In a little less than thirty years, Atget made approximately eighty-five hundred images of Paris and its environs. He clearly thought of himself as a documentary photographer and made his living by selling photographs to artists, craftsmen, private individuals, and institutions interested in old Paris. Because of the nature of his business and the varied demands of his clients, Atget devised an elaborate system of classification with subject headings divided into major, and some minor, series of "Picturesque Paris," "Old France," and "Environs," for example, and a numbering system that allowed for easy retrieval (by Atget, at least—it took scholars many years to crack his code).[45] He was, as his business card from the turn of the century announced, both a creator and purveyor of photographic views, able to form multiple groupings of images to suit the needs of his business.

Atget's photographs contain a nostalgia, longing, and isolation that, in many ways, is similar to the work of some of his contemporaries. Just as the Englishman Frederick Evans found his inspiration not in the art and culture of his day, but in the distant and seemingly grander past of England's Norman and Gothic cathedrals, so too did Atget seek to record not Paris at the dawn of the twentieth century, or even its recent nineteenth-century history, but a much older city (cats. 148, 152). Both consistently avoided references to their present: street cars, automobiles, or people in contemporary dress rarely appear in their photographs. That Atget, who seems at times to have photographed every street and corner in Paris, was able to avoid the Eiffel Tower is quite extraordinary, but only slightly more radical than Evans' insistence that all Victorian fixtures and additions be removed before he photographed the cathedrals.[46] And just as Peter Henry Emerson or Frank M. Sutcliffe's studies of English fishing people recorded a way of life that was rapidly becoming obsolete, so too did Atget in his *petits métiers* series, one of his few groups of photographs of people, focus on a dying relic of another time (cat. 147).

But Atget's photographs are significantly different from those by Evans, Emerson, or Sutcliffe in several respects. Whereas they generalized and summarized, Atget was specific. Evans was well versed in the history of the Norman and

Gothic cathedrals, and Emerson and Sutcliffe were deeply involved in the life of the people they photographed; Emerson documented in his numerous books their methods and habits of work, patterns of speech, living conditions, and politics. However, their photographs betray little interest in their subjects' individuality. Through their compositions, their emphasis on monumentality, they sought representative types expressing the universal characteristics of church or peasant, to allude to the authority of one and the heroicism of the other. Atget, like Stone or Bertillon, was very much concerned with details; the demands of his clients necessitated that he be so. At the turn of the century there was a strong movement in Paris to record its past, which was rapidly being destroyed, and Atget's photographs served that movement. As the Bibliothèque Nationale or the Musée Carnavalet formed their archives of documents of Paris arranged street by street, one *arrondissement* after another, they needed photographs of specific buildings or architectural elements. And Atget obliged, photographing not just a courtyard or staircase, but the staircase of *91, rue de Turenne, Folie Thoinard*, and the staircase of *9, rue Coq-Héron*, and that of *7, rue de l'Estrapade*, and on and on. It is in this insistent accumulation of detail in a vast corpus of photographs, made year after year for more than a quarter of a century, and in his recognition of the need to construct a filing system to relate the detail to the whole and give order and meaning to his project, that one sees a very different sensibility at work. Like Riis, Atget was passionately committed to something beyond the practice of photography, and to using photography to structure and define an issue of pressing importance to his time. Far from being merely a purveyor of images, as he called himself, Atget wanted to construct an image not just of the topography of Paris and its environs, but of its culture. It is this ambition to tackle such an enormous, almost endless subject and to see it not in generalities, but in all its multiplicity and diversity, that ultimately distinguishes Atget's work from that of Evans, Emerson, or Sutcliffe, or most of his contemporaries.

This dichotomy between the general and the specific, the summary and the insistent, the desire to reveal the universal qualities of a subject as opposed to its individual character-

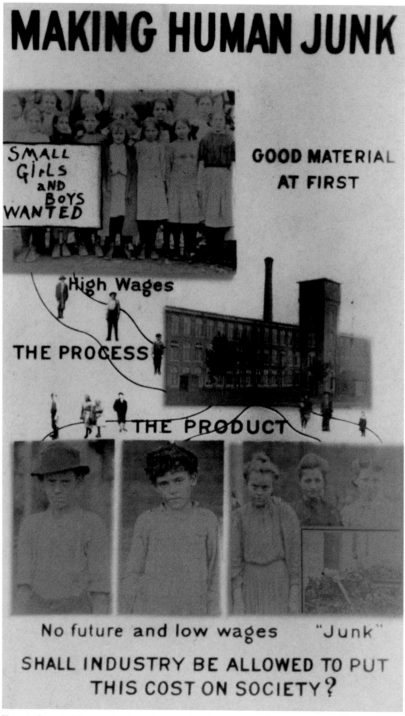

MAKING HUMAN JUNK

SMALL GIRLS AND BOYS WANTED

GOOD MATERIAL AT FIRST

High Wages

THE PROCESS

THE PRODUCT

No future and low wages    "Junk"

SHALL INDUSTRY BE ALLOWED TO PUT THIS COST ON SOCIETY?

Fig. 6. Lewis Hine, *Making Human Junk*, c. 1915, photographic collage, Library of Congress, Prints and Photographs Division

istics, continues in the photographs of Lewis Hine. A graduate of Columbia University's sociology department, Hine began to photograph immigrants at Ellis Island in 1904. In much the same way as Emerson or Sutcliffe, he saw them as representative types. His use of light to isolate and monumentalize figures, his pyramidal compositions, and his titles—*A Young Russian Jewess*, or *The Ellis Island Madonna*—clearly indicate his desire to evoke a fine art tradition to ennoble and empower his subjects (cat. 143). These are not documents of individuals, but emblems of an event in American history. Hine's work after 1907, beginning with his photographs made for the Pittsburgh Survey in 1907 and most particularly those for the National Child Labor Committee (NCLC) from 1908 to 1918, are very different, however. The titles alone reveal the change: *Lacy, twelve years old, and Savannah, eleven years old, Gastonia, North Carolina, November 1908; Mrs. A. J. Young and her nine children, five of whom work with her in Tifton, Georgia, cotton mill, 1909; Danny Mercurio, 150 Scholtes Alley, Washington, D.C., 1912.* The simple act of naming the people, of locating them in time and place, removes the images from the realm of emblems and gives them individual character and distinctive presence. Like Atget's clients, Hine's employer, the NCLC, needed facts, not generalities, multiple instances of abuse, not representative examples, in order to convince the public of the need for protective legislation for children in the workplace. Along with other investigators, Hine was sent to mills, factories, mines, and farms to collect data on the extent and nature of child labor. Hine supplied the NCLC with thousands of photographs of children in or near their places of work; in his first year alone he made more than 800 images.[47] Because Hine was frequently unwelcome, he often had to make his photographs quickly, with little time for careful focusing, composition, or lighting. Whether intended or not, his camera caught all the details of the scene: the clutter of machines, dirt, and debris and the small, poorly clad children (cats. 141, 142). The result is a group of images that are far more immediate than his consciously artistic constructions. Because they are without artifice, they also appear to be more objective records of fact.

Hine, like Bertillon, accumulated additional, relevant in-

formation: he noted the age of the children, height, nature of job, how long they had been working, and job-related injuries, for this further data would, as he wrote, "refute those who, either optimistically or hypocritically, spread the news that there is no child labor."[48] Recognizing that a pointed selection of images and words together would have far more power than either one alone, he developed methods of merging visual and written data for exhibition and publication. He made montage posters that showed, for example, how the greed of industry turned healthy children into "Human Junk," and he pioneered something that he called "Time Exposures," a combination of photographs, often collaged images, and extensive texts to present a subject from several different points of view. All of this he did in an effort to provide not simply a descriptive analysis of the nature and cause of these social problems, but an interpretive one.

It has been said that in his photographs made for the Pittsburgh Survey and the NCLC, Hine humanized social documentary photography; it would be more to the point to say that he specified it. By abandoning his references to the other fine arts, by seeing his subjects not as generic types, but as individuals, each of whom must be recognized, acknowledged, and understood in relation to a larger whole, he brought both himself and his viewers into closer contact with the people depicted, and he capitalized on the ability of photography to differentiate. During these years he refused to obfuscate through generalities and thus gave his photographs an authenticity that is lacking in both his earlier and later work. This dichotomy between the universal and the specific, between a tradition of generalities borrowed from the fine arts and a more uniquely photographic ability to distinguish details, continued well into the 1930s with such photographers as Dorothea Lange, on the one hand, focusing on the monumental, heroic qualities of *The Migrant Mother* (cat. 284), while Walker Evans, on the other, accumulated the insistent details of his *Subway Series* (cats. 287–289).

In 1889, fifty years after Talbot's and Daguerre's announcements, Emerson published *Naturalistic Photography for Students of the Art*, one of the most widely read and controversial works of its generation.[49] Although it proscribed rigid rules for the construction of photographic pictures, the primary contribution of *Naturalistic Photography* was its separation of camera vision from human vision. Noting that the eye does not see everything in sharp detail at one time but selectively focuses on individual objects according to their inherent interest, color, or prominence, Emerson urged photographers to transcend their machine and its mechanical transcription of nature and incorporate into their work an understanding of the way the viewer actually sees reality. By relegating camera vision to a secondary position, by stressing the importance of physiological and psychological realities, and by imploring photographers to produce not a literal description of nature, but an impression of it, Emerson separated photography from the slavish representation of visual facts and placed it at the service of personal sentiment.

*Naturalistic Photography* inaugurated the movement of pictorialism. On one level, pictorialism sought to demonstrate that photography was capable of subjective expression, that it was not merely a mimetic device but could reveal the personality of the maker and construct images resonant of universal themes. On another level, pictorialism was an attempt to develop a larger program for photography, not simply to infuse it with the aspirations of the other fine arts, but to give it validity, prestige, and perhaps most important, definition, by precisely limiting the nature of its art. In the minds of many pictorialists, before 1889 photography had evolved in an unthinking, inchoate manner; that is not to say that there were not great photographers or important works written about the subject, but photographers did not seem to share a common goal, nor did they band together into schools to prove the merit of their approach, and no journals or exhibitions were devoted to elucidating their cause. Pictorialism was the first widespread, cogently formulated theory to define the conventions of photographic picture-making and it was also the first consciously adopted international movement in photography. As a movement, pictorialism came to be as much about politics and the establishment of a structure to defend a theory, as it was about art. Its politics have clouded recent assessments of the movement, but far more important are the questions pictorialism raised about the nature of the art of photography, the relationship of photog-

144

Fig. 7. Edward Steichen, *The Pool—Evening: A Symphony to a Race and to a Soul*, 1898, gum bichromate-platinum print, 21.0 x 16.2 (8¼ x 6⅜), Royal Photographic Society (cat. 389)

raphy to the depiction of the external world, and the role of science in the practice of the medium.[50] With these questions, and with the answers it posed, pictorialism ushered photography into the polemics of modern art.

Pictorialism developed in the late 1880s for a variety of reasons related both to external pressures and to internal changes in the technique and practice of photography. In part it was a result of the invention of the hand camera. Since 1839 people had questioned whether photography was capable of artistic expression, but the early critics' concerns were obviated by the wonder of the process itself, its elaborate technique, and a fascination with seeing the world photographed. As that initial infatuation diminished, and as the technique became so easy anyone could take photographs, the question of artistic expression returned with added urgency. The legions of Sunday snapshooters altered the definition of who the photographer was and cast grave doubt on what skill, intelligence, and sensitivity were needed to make a photograph. In the public's mind, the photographer was demoted from the status of magician to someone of only marginal competence. As the photographer's prestige was profoundly eroded, more serious amateurs, along with some professionals, who saw a dramatic reduction in the business of portrait photography in the 1880s and 1890s, consciously sought to set themselves apart from the snapshooters by declaring the artistic nature of their work.

The impetus behind the development of pictorialism as a movement, however, was due far less to a desire to regain lost stature and self-esteem than to a crisis of faith experienced by all the arts in the late 1880s and 1890s. Pictorialism, like symbolist art and literature, was a direct result of a waning belief in the power of science, positivism, and empiricism, and a disenchantment with the dominant materialist ethos of the nineteenth century. G.-A. Aurier succinctly summarized the situation in 1892, noting that "after having proclaimed the omnipotence of scientific observation and deduction for eighty years with child-like enthusiasm, and after asserting that for its lenses and scalpels there did not exist a single mystery, the nineteenth century at last seems to perceive that its efforts have been in vain, and its boast puerile. Man is still walking about in the midst of the same enigmas, in the same formidable unknown. . . . A great many scientists and scholars today have come to a halt discouraged."[51] For this generation, art could no longer be, as Aurier continued, "the simple imitation of material things."[52] Instead of being the copy of nature, art must cultivate the imagination, search for "the mysterious center of thought," as Maurice Denis wrote, and become "the subjective deformation of nature."[53] Artists of the 1880s and 1890s came to believe that their work, through the expression of subjective and abstract states of being, could reveal a higher and more universal reality than that which could be discovered by any scientific method of investigation. This faith in the ability of art to make known the "formidable unknown" unites the work of both symbolist and art nouveau painters and sculptors with that of the pictorial photographers. In an age that saw the invention of X-rays and with that the ability of photography to reveal things invisible to the human eye, it was, perhaps, not too large a step to the assumption that the camera could not only show man's bones, but also his psyche.[54]

For photography, however, a lack of confidence in science cut to the heart of the medium and seemed to contradict much of what had been understood to be essential to the process. Photography had been perceived to be, as Alfred Stieglitz wrote in 1899, the bastard child of art and science; as such, the attributes of science, including accuracy, precision, and most of all verisimilitude, had been considered to be inherent characteristics.[55] As photographers began to refute the scientific heritage of the medium, so too did they deny these attributes and call into question the whole notion of "intrinsic properties." Emerson had begun to question the verisimilitude of photography by separating scientific truth from artistic truth. He noted that the photographers should be faithful not to objective, scientific facts, but to the appearance of reality. By the late 1890s, however, truth in pictorial photography was understood to be not a fixed or quantifiable entity, but something relative and subjective; it was defined as "the verification of all things through human consciousness, and their statement through human feeling."[56] As truth took a secondary role to the expression of personal sentiment, photographs could no longer be accepted as *a priori* statements of visual facts. "Something more is re-

quired than truth to nature," wrote William Murray in 1898 in the American publication *Camera Notes*, and A. Horsely Hinton went so far as to state that photographers could willfully distort the truth in order to express more forcefully their idea: "the photograph *may even be less pleasing to the public, less truthful to nature, and at the same time be more a work of art* . . . I would rather have the photograph not just exactly as the scene was, *but as the artist would have liked it to be, or imagined it might be.*"[57]

A loss of faith in science also meant that pictorial photographers sought to banish from their art all references to scientific objectivism and literalness. The line was clearly drawn: As Emerson noted, when a work presented facts, it was a science; when it presented ideas, it was an art.[58] Also clear was the understanding that facts were precise whereas art was suggestive. This desire to be suggestive and elusive accounts for the indistinct and at times blurred quality of pictorial photographs. It has often been assumed that the pictorialists' softly focused images were an attempt to make their photographs look less like photographs and more like paintings or the other graphic arts, but while this may have been the result, it was not the intention. Believing that the aim of their art was "not to copy nature, but to appeal to the imagination," the pictorialists, like the symbolist artists and writers, thought that the imagination was most profoundly stimulated by suggestion rather than delineation. "It may be given as a principle," wrote Hinton in 1900, "that the feelings prompted by nature are more perfectly re-created by something which suggests than by accurate representation."[59] "To *name* an object," Stéphane Mallarmé had written only a few years before, "is to suppress three-quarters of the enjoyment to be found in the poem . . . suggestion, that is the dream."[60]

For these reasons, the pictorialists chose subjects that were not clearly linked to a specific time, event, or place in the external world, but were vague and elusive, like Leonard Misonne's *Untitled (Landscape)* (cat. 154) or Edward Steichen's *The Pond, Moonrise* (cat. 172). They sought the nameless view, the anonymous model on which to project their ideas and associations. Even their titles—*A Study, Landscape—Morning, Pastoral*—gave few clues about who, what, or where they were photographing. Avoiding the use of estab-

lished symbols whose references were understood rationally, the pictorialists tried to construct a more immediate art that relied on universal experiences to convey meaning. They played on photography's ability to recall memories and associations, yet they also recognized that such memories are rarely sharply defined but more often dreamlike and indistinct, composed of nothing more than a small incident or passing glance. As in Steichen's *The Pond, Moonrise*, they built their compositions around the expressive potential of light and form, noting that these entities in their purest state often evoked the strongest emotions. And they made an effort to understand the meanings of line and light in order, as Aurier wrote of the symbolist painters, to use those elements "like letters of an alphabet to write poems of their dreams and ideas."[61]

The pictorialists envisioned an emotive photography that would appeal not to reason or the intellect, which were the properties of a scientific inquiry, but to intuition. Defying discursive explanation, this photography would engender experience and symbolically communicate "the abstract thoughts and subtle feelings which language is inadequate to express."[62] In this way, the pictorialists thought they would become truly creative artists, for their images would not simply revive corresponding thoughts and memories in the mind of the viewer, but create new ones; they would employ "the image of concrete things to create abstract ideas."[63] For practically the first time in photography, the specificity and individuality of the objects in front of the camera were of no importance, but were only a vehicle for the expression of an idea. By divorcing photography from its scientific heritage, pictorial photographers also divorced it from reality.

Working with the more plastic world of allusion rather than the sharp truths of reality, the pictorialists freely manipulated their prints. They favored printing processes such as carbon, platinum, gum-bichromate, and bromoil, as well as exotic combinations, which either in their initial application or in development allowed for considerable reinterpretation of the negative. To intensify the expressive and tactile quality of their images, they often hand-coated their own paper, which had been carefully selected for its size, weight, and tooth. The pictorialists' manipulation of their prints was one of the

most controversial aspects of the movement and it served many purposes. First, and most obviously, the size, tonal scale, print quality, and variety, even the texture, clearly separated pictorial work from that of the Sunday snapshooter. But the pictorialists' photographs also represented a rebellion against the growing standardization of photography by large, commercial manufacturers. Like other participants in the arts and crafts movement, pictorial photographers were faced with an increasingly mechanized and regularized industry. To reassert their integrity and craftsmanship and to reclaim their field from commercial control, the pictorialists resurrected older processes that allowed for more individualistic expression. Reinforcing the idea of a singular masterpiece, they manipulated their images so extensively in the darkroom that, often, the result was a unique image that could not be duplicated.[64]

The pictorialists' prints attacked on other fronts too. With their ability to suppress unwanted details, intensify others, alter tonal scale, even add color, and combine negatives, the "automatism of the procedure," to use the words of the French pictorialist E. J. Constant Puyo, was broken, and photography became synthetic.[65] As was clearly expressed by Steichen in his *Self-Portrait with Brush and Palette* (cat. 173), the act of translation became just as important as that of composition. No longer obligated to construct a window on the world or render a depiction of external, scientific truths, the pictorialists continually interjected their presence, their individuality, between the viewer and the original scene, further negating the importance of what was in front of the camera. These large, manipulated prints were not just an attempt to construct more beautiful, elaborate, or even painterly images, but to unite form and content, to make style the "physiognomy of the spirit."[66] In this way, the very substance of the photograph— its surface, color, and form—is its subject. The pencil of nature became the pencil of man as pictorial photographers, according to the English pictorialist George Davison, fulfilled "the literal meaning of the word photography—to draw or paint by light."[67]

As photography's first movement to break radically with its past and to defy assumptions about what photographs could and could not be, pictorialism had to be both militant

and elitist to differentiate itself, and the pictorialists prided themselves on these qualities. The whole movement of pictorialism was a self-conscious act of separation: of the art of photography from its science; of the artist-photographer from the scientist, technician, professional, or amateur; of photography's creative capacity from its mimetic and mnemonic ability. While present-day critics may question his terminology, Stieglitz correctly summarized the fervor of the pictorialists when he noted that "progress has been accomplished only by reason of the fanatical enthusiasm of the revolutionist, whose extreme teaching has saved the mass from utter inertia."[68] Throughout the 1890s and early 1900s pictorial photographers allied themselves, not with other photographers, but with artists, particularly those associated with the secessionist and arts and crafts movements. They were included in several of the large exhibitions of the aesthetic movement, including those in Milan in 1894, Munich in 1898, Glasgow in 1901, Turin in 1902, and Dresden in 1909.

The most effective exponents of the pictorialist movement, however, were the splinter groups that broke away from the older, more established photographic organizations. Although these groups ostensibly sought to improve the quality of the average amateur's work, they did so by example, not by direct participation in their organizations. The Linked Ring is a case in point. In 1892 a group of photographers including Hinton, Davison, and Alfred Maskell split from the Royal Photographic Society, which they considered riddled with scientists, technicians, and hobbyists, to form "an inner circle, a kind of little bohemian club . . . enveloped in a certain kind of mystery."[69] Consisting only of members elected by unanimous vote, the Linked Ring came to include most of the major English, French, German, Austrian, and American pictorial photographers. In formulating the organization, Maskell recognized that even a small group, if it included the leading international workers, could yield considerable influence and could "make or smash any exhibition."[70] The Linked Ring did not often use its power in this way, but its annual "salons" of members' work were purposely timed to coincide with the exhibitions of the Royal Photographic Society to demonstrate the difference

between pictorial photographs and all other kinds. Because its members were influential members of their communities, the Linked Ring was able to command attention for its efforts in local publications, thus extending its influence well beyond the confines of any one region.

Similar orgnizations with similar agendas included the Photo Club de Paris, the Vienna Camera Club, the Association Belge de Photographie, the Gesellschaft zur Förderung der Amateur Photographie of Hamburg, and the Photo-Secession of New York. Forming a tight, international community of pictorial photographers, they exhibited in each others' annual salons and published in each others' lavish periodicals. Because of these efforts, large exhibitions of photographs in art museums became relatively commonplace by the turn of the century.

Despite the closeness of the pictorialist community and the insular, self-perpetuating quality of their exhibitions and publications, both individual and regional differences of subjects and style existed. Rebelling against what they considered to be the anonymous character of much nineteenth-century photography, the first generation of pictorial photographers believed that it was extremely important to cultivate a distinctive look so that their work would, as the American F. Holland Day phrased it, boldly stand forth and declare, "Behold it is I."[71] Hinton, Davison, and J. Craig Annan were celebrated for their softly focused, emotive landscapes, Heinrich Kühn and Hugo Erfurth for their large and intense psychological studies, and Oscar and Theodore Hofmeister and Hugo Henneberg for their highly charged, empty vistas. It is not, of course, coincidental that their subjects and styles were very similar to those of their country's leading painters, including Whistler and Turner, Franz von Stück, and Arnold Böcklin, for as much as the pictorialists sought to create photographs reflective of their emotional state, they looked to the other arts to provide visual models.

Without doubt the most influential organization after the turn of the century was the Photo-Secession, in large part because it was also the most militant and elite. Founded by Stieglitz in 1902, the Photo-Secession was under his unquestioned direction for the fifteen years of its existence; its impact must be credited not only to his organizational skill

and political acumen, but also to his ability to attract and encourage creative individuals. Admission into the Photo-Secession was determined not by the whole group, as it was with the Linked Ring, but by Stieglitz alone. He admitted some because of the excellence of their photographs, others because their critical writings and theories furthered the cause, and still others because their sympathies were in accord with his own. Unlike most of the other splinter groups, the Photo-Secession frequently acted as a unit. Although individual members were free to exhibit independently, Stieglitz most often determined the exhibitions in which they participated. In return, he demanded that all photographs submitted by the Photo-Secession had to be exhibited, without submission to a jury, and hung as a group. Although the Photo-Secession's images were greatly revered and emulated, frequent squabbles erupted with other photographic organizations because of its separatist attitude. In 1905 Stieglitz, who was weary of the arguments, retrenched even further from the extreme "inertia of the masses" and founded his own gallery, the Little Galleries of the Photo-Secession, later known simply as 291, from its address on Fifth Avenue in New York City.

291 and Stieglitz's publication *Camera Work* provided a way out of the dead end in which pictorialism found itself after the turn of the century. In the 1890s pictorialism had called into question a battery of commonly accepted generalities about photography; specifically, it cast doubt on the assumption that photography was an anonymous, styleless, transparent, and truthful record of external reality with inherent, inviolate properties such as an all-over, sharp focus. But in their enthusiastic attempt to suppress the science of photography in favor of its art, pictorialists had often wholeheartedly, and sometimes rather unthinkingly, adopted both the subject matter and the pictorial devices of the other arts. Defending his portrayal of the crucifixion, Day explained the logic behind these photographs, noting that "if art may be produced with the camera" and "if the painter and sculptor are permitted to portray such subjects, there is no reason why . . . [the photographer] should not have the same privilege."[72] In addition, the pictorialists, threatened by a rapidly modernizing world, had attempted to create an

alternative, and they believed in a superior reality, one dominated by the mind and soul, not the crass concerns of mundane life. However, lacking the visionary or mystic underpinnings to propel their art to another level of intensity, what many pictorialists often succeeded in constructing was a hermetic existence, where the photographer and ultimately the viewer were divorced from the world. Although their photographs are filled with atmospheric effects—clouds, mists, and rain—the scenes are often so unreal and dreamlike that they appear, at times, devoid of air and human life. The range of subjects, even though quite nominal to the photographer's expression, was limited—empty landscapes, wistful women, portraits of each other—as was the range of moods they conveyed. Particularly in the hands of the lesser exponents, pictorialism had a tendency to become repetitive and incestuous.

291 and *Camera Work* provided two avenues out of this conundrum. Although ideas discussed in *Camera Work* were eagerly adopted by many American pictorialists working after the turn of the century, they were not directed specifically at them, for the 291 and *Camera Work* audience quickly came to consist of a wide range of individuals, including painters, writers, critics, and photographers. The first path proposed was theoretical. The *Camera Work* writers emphasized both the idea of correspondence and an analogy between art and music. Such frequent contributors as Hinton, J. T. Keiley, Charles H. Caffin, and Sadakichi Hartmann urged readers to search for hieroglyphic objects in the real world that corresponded to the spiritual realm; to interpret "spirit through matter," as Caffin wrote, and illuminate "matter with spirit."[73] At the same time, they asserted that the artist, whether a painter or photographer, should embody in his work the non-mimetic expression of feeling that music evoked. By subordinating photography's narrative or descriptive aspects and by stressing its abstract and decorative qualities, these critics believed that photographers could achieve the same emotive quality in their work that is found in music. "The concrete thing, expressible in words and suggesting them, draws the mind of the spectator from the more abstract qualities of beauty," Caffin explained in 1905, and he continued, "music, because of its appeal being uninterrupted

by the concrete, is capable of deeper and farther reaching expression."[74] Just as the musician worked with rhythm and harmony, so, too, were the *Camera Work* readers encouraged to explore the expressive potential of pure color, line, and form to construct an image that would evoke abstract states of being and create what Arthur W. Dow called "visual music."[75]

As they searched for correspondences, for the auras and spiritual qualities of an object, the *Camera Work* photographers began to strip away distracting details to reduce an object to its essence. In so doing, they also simplified their photographs, achieving something very close to formal studies. As can be seen in George Seeley's 1909 *Winter Landscape* or Clarence H. White's 1907 *Untitled (Woman in Bed)*, many of the devices that had previously been used to obscure reality and impart a mood—shadows, dusk, mists, reflections, or smoke, for example—began to take on a more purely formal quality (cats. 181, 182). Light, which was frequently used in the 1890s to express an emotion, as in Edward Steichen's 1898 *The Pool—Evening: A Symphony to a Race and to a Soul*, was now used to reveal form, design, or pattern, as in Baron de Meyer's 1912 *Hydrangea* or Alvin Langdon Coburn's 1911 *Grand Canyon* (cats. 180, 183). By the beginning of the second decade of the twentieth century, a concern for constructing pictures that could be accepted as works of art had grown into a concern for constructing pictures photographically, using the basic elements of light and form. Thus the significant mood of the pictorialist evolved into the "significant form" of the English theoretician Clive Bell.

Subject matter, in particular the iconography of the modern city, provided another avenue out of the dead end of pictorialism. It was not a phenomenon limited either to photography or New York; artists working in other mediums and in other cities experienced a similar rejuvenation when confronted with rapidly developing metropolises, but it was a subject that American photographers, in particular, successfully exploited. It began quite fortuitously, perhaps as much a result of the location of 291 within a major American metropolis as it was of any theoretical justification or promotion. As the second generation of pictorialists exhausted the subject matter

of their predecessors, they increasingly turned their attention to the urban life around them. Photographing a city, even New York, did not, of course, in and of itself, constitute a new expression. Coburn had made some very elegant, but very Whistlerian, studies of London shortly after the turn of the century. while Stieglitz and Steichen also had relied heavily on picturesque conventions in their photographs of New York from the late 1890s and early 1900s. But by 1910 it was difficult to see New York in those terms. The city engendered a very different experience, not just the result of its burgeoning skyline, which seemed to change almost daily with the appearance of a new skyscraper, but also its exploding population, its compactness, and most of all its pace. The quiet, *fin-de-siècle* world of the pictorialists, with their carefully composed and contained images, stood in stark opposition to this new city. Whereas the pictorialists sought stable and eternal subjects out of which they could construct a singular masterpiece, the essence of the modern city was its change, multiplicity, variety, and impermanence; though the pictorialist wanted to impose an order and harmony on a contemplative, closed environment, the city was a chaotic and intrusive jumble; and though the pictorialist cultivated private, internal subjects, the city was a decidedly public one.

Around 1910 American pictorialists increasingly began to adopt New York as their subject. As they did, they also adapted both their ways of photographing and their understanding of the aims of their art. Sadakichi Hartmann, who as early as 1900 had urged photographers to consider the picturesque possibilities of New York, in 1910 in an article in *Camera Work* proposed the new pictorial structure these photographs might take.[76] Noting that photographic illustration was so common as to be a "new kind of writing," Hartmann argued that because the seemingly casual, haphazard snapshots of the amateur were being repeatedly transmitted, they would inevitably suggest new methods of composition. He also recognized that many of the new subjects of modern life were not compatible with the old compositional laws: "the main thoroughfare of a large city at night, near the amusement center, with its bewildering illumination of electrical signs, must produce something to which the accepted laws of com-

position can be applied only with difficulty." An acquaintance with various styles of the past would only be prejudicial, he believed, for the new laws would come from the "amateur who by sheer necessity will work unconsciously in the right direction." From his work, the artist would find more "varied, subtle and modern (though not necessarily more perfect) states of development."[77]

Working with a hand camera, Stieglitz had begun to move in this direction shortly after the turn of the century in his photographs of *The Flat Iron* and *Going to the Post, Morris Park* (cats. 185, 188). But by 1910 he, Coburn, and Pierre Dubreuil,

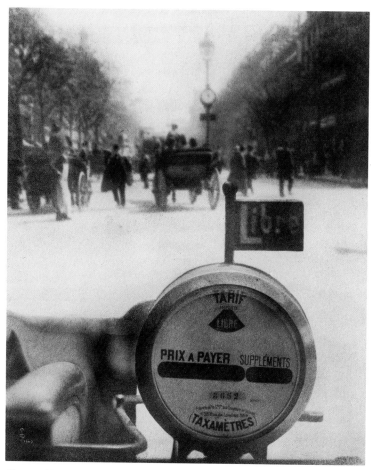

Fig. 8. Pierre Dubreuil, *The Boulevards*, 1909, oil print, 23.5 x 19.7 (9¼ x 7¾), Metropolitan Museum of Art, Ford Motor Company Collection, Gift of the Ford Motor Company and John C. Wadell, 1987, All rights reserved, The Metropolitan Museum of Art (cat. 396)

working in Paris, had embraced the new subject matter of the modern city and, although they would never conclusively abandon all vestiges of the "prejudicial old styles" under which they had been laboring, they did adopt some of the compositional devices suggested by the vernacular snapshot.[78] In such 1910 works as Stieglitz's *Old and New New York*, Coburn's *The Octopus, Williamsburg Bridge*, or *Pittsburgh Smoke Stacks*, or Dubreuil's *The Boulevards*, they composed their pictures right up to and beyond the edge of the picture frame (cats. 187, 189). They cut off buildings and smokestacks, emphasizing the fragmentary nature of their photographs. These are not closed, composed pictures, neatly contained within the confines of the frame, but isolated fragments of a passing, transitory scene that continues beyond its edges. In an attempt to negate the pretentious quality of much recent photography, Stieglitz even called these photographs not studies or pictures, but "snapshots," emphasizing both their common heritage and ephemeral quality.

In a country that had few outlets for new ideas, 291 became a haven for the intellectual vanguard. After 1910 Stieglitz sought to apply the same questions to all the arts that he had once asked of photography; that is, he examined the nature of their relationship to science, photography, and external reality. He did this by exhibiting Picasso, Braque, Cézanne, Matisse, Picabia, and Severini along with the American painters Marin, Dove, Hartley, Weber, and Walkowitz, and by devoting both *Camera Work* and his experimental publication *291* to an examination of these issues. Between 1910 and the close of 291 in 1917 Stieglitz showed very few photographs: he exhibited his own work at the time of the Armory Show in 1913 to demonstrate the differences between painting and photography and in 1916 he gave the young Paul Strand an exhibition. In addition, he devoted the final issue of *Camera Work* to Strand's photographs, reproducing such works as the *Photograph, New York (Blind Woman)* and *New York (Wall Street)* (cats. 194, 195).

The 1915–1916 photographs by Stieglitz, Strand, Charles Sheeler, and Karl Struss in many ways mark the end of pictorialism (cats. 191, 192, 193, 196). They build on a study of the formal qualities of Cézanne, Picasso, and Braque to search for what Marius de Zayas in his theory of pure photography

Fig. 9. Alvin Langdon Coburn, *Pittsburgh Smoke Stacks*, 1910, platinum print, 21.0 x 29.0 (8¼ x 11⁷⁄₁₆), Janet Lehr, Inc., New York (cat. 190)

called the "objectivity of form . . . the pure expression of the object."[79] Approaching their work with the zeal of redemptive saviors, these photographers sought to purge the medium from what they perceived to be the heresy of pictorialism. They reasserted the belief that photography was a gift of science to the arts, that it was an art of selection, not translation, that its basic property of "unqualified objectivity" demanded a purity of application. Photography's ability to reveal truth was still an important issue, but it became a fixed truth rooted in an external, not internal, reality.[80] This new formulation could not have been achieved, however, were it not for pictorialism—the questions it had asked, the theories it had proposed, and the battles it had fought. Pictorialism provided these photographers with the confidence that a photograph was not merely a mechanical transcription, not simply the result of nature impressing itself on the photographic plate,

but an expression of creative intelligence. This was the legacy of pictorialism.

Strand's photographs, particularly those of *Photograph, New York (Blind Woman)* and *Chair Abstract, Twin Lakes, Connecticut*, point to issues not broached by pictorialism (cat. 195). *Blind Woman* is a photograph of a scene Strand happened upon in 1916 while walking about the streets of New York's Lower East Side, where Riis and Strand's teacher, Hine, had photographed only a few years before. Without the consent or knowledge of the blind woman, Strand took her photograph and within the context of 291 and *Camera Work* declared it to be a work of art. The other photograph, made the same year at a summer house in Connecticut, is an image that has been painstakingly constructed. In much the same way as Lartigue lay on his bedroom floor to photograph his toy cars, so too did Strand have to put his camera on, or very close to, the seat of the chair, tilting it at a 45-degree angle to render this unusual perspective.

The first is a scene chanced upon in the real world. It has been taken, appropriated in much the same way that another 291 artist, Marcel Duchamp, after careful consideration, took a urinal and exhibited it as a work of art at 291 in 1917. For their presentation as art, both Strand's photograph and Duchamp's urinal were given accurate but evocative titles: *Photograph, New York* and *The Fountain*. Strand's photograph appropriates the subject matter and the direct, confrontational style of documentary photography. It is, in a very real sense, a record of something that actually existed and its connection with the real world is clear. But, like Duchamp's urinal, within its new context as art, its meaning and function are less than clear. The other Strand photograph, while certainly constructed out of elements from the real world, is decidedly fabricated. It is made, not taken. After much scrutiny we can recognize its component parts and see that it is a chair, which, like the blind woman, has been stripped of its individuality and its functional use and removed from its original context. Devoid of emotional content, it is patently art, but its meaning is, again, less than clear. Pictorialism had conclusively proved that photographs could be art, but how they were to be made or taken, what their "intrinsic" properties were, if any, and what their function was, were issues that had yet to be resolved.

1. Charles Baudelaire, "The Modern Public and Photography," in *The Mirror of Art*, Jonathan Mayne, ed. and trans. (New York, 1956), 232.
2. Emile Zola, "Zola's New Hobby," *Photo-Miniature* 2 (December 1900), 396.
3. J. Craig Annan in "Picture Making with the Hand-Camera," *The Amateur Photographer* 23 (27 March 1896), 275, noted that the hand camera was so easy for the amateur to operate that it became "second nature with his hands to prepare the camera while his mind and eyes are fully occupied with the subject before him."
4. Alexander Black, "The Amateur Photographer," *The Century* 34 (September 1887), 722.
5. Helmut and Alison Gernsheim, *The History of Photography from the Camera Obscura to the Beginning of the Modern Era* (New York, 1969), 425.
6. I am grateful to Mary Ison of the Library of Congress for her tentative attribution of these images to Uriah Hunt Painter and for information about him.
7. Since the invention of photography, painters had, of course, used photographs, either commissioning or simply buying them, and many painters abandoned their professions to become photographers: Daguerre, Fenton, or Le Gray, to name but a few. But with the ease of the hand camera, a new group of actively practicing painters began to use the camera at the turn of the century. The point in examining their images here is not to find photographic sources for their paintings, but to see how these artists used the camera. For a discussion of the use of photography by painters, printmakers, and sculptors, see Aaron Scharf, *Art and Photography* (London, 1968 and 1974); Van Deren Coke, *The Painter and the Photograph* (Albuquerque, 1964 and 1972); Erika Billeter, *Malerei und Photographie im Dialog* (Zurich, 1977 and 1979); and Marina Vaizey, *The Artist as Photographer* (London, 1982). For an alternative viewpoint refuting the influence of photography on nineteenth-century painting, see J. Kirk Varnedoe, "The Artifice of Candor," *Art in America* 68 (January 1980), 66–78.
8. Eugenia Parry Janis in "Edgar Degas' Photographic Theater," in *Degas: Form and Space*, Maurice Guillard, ed. (Paris, 1985), 468, has noted that "whether consciously or not, Degas pursued effects resembling older, more primitive manifestations of camera work: a subject's potential stillness; the controllable art of posing, and most interesting of all, perhaps, the strange unearthly illumination of the daguerreotype and calotype."
9. Although most of Vuillard's surviving images are from after the turn of the century, Bonnard photographed Vuillard holding a camera in Venice in 1899: see plates 36 and 37 in *Pierre Bonnard Photographe* by Françoise Heilbrun and Philippe Néagu (Paris, 1987). Lartigue's father, an amateur photographer, allowed his son to use his cameras to make his earliest photographs from 1900. When Jacques-Henri was seven his father gave him his own camera.
10. Jacques-Henri Lartigue, *Mon Livre de Photographie* (Paris, 1977), unpaginated.

11. Lartigue, *Mon Livre de Photographie*, unpaginated.

12. Demonstrating the shared subjects and styles of the new amateurs, Lartigue also photographed out the front window of a moving car while sitting in the back seat, producing an image remarkably similar to Vuillard's; see *Trip to Auvergne in Automobile 22HP Peugeot*, 1910, repro. in *Jacques-Henri Lartigue*, intro. by Jacques Damade (Paris, 1986), pl. 28.

13. Jacques-Henri Lartigue album of photographs, 1908 to 1910, page 12, preserved at the Association des Amis de Jacques-Henri Lartigue. J. Craig Annan in "Picture Making with the Hand-Camera," *The Amateur Photographer* 23 (27 March 1896), 277, wrote that "rules regarding hand-camera work can only be made to be broken."

14. Jacques Salomon, *Vuillard and His Kodak* [exh. cat. The Lefevre Gallery] (London, 1964), 2–23; repr. in *L'Oeil* 100 (April 1963), 14–25, 61.

15. *Oxford English Dictionary* (Oxford, 1933), vol. 9, 308. Herschel was the first to apply this hunting term to photography, writing in the *Photographic News* 11 (13 May 1860) of the "possibility of making a photograph, as it were by a snap-shot—of securing a picture in a tenth of a second of time." For a discussion of the use and implications of the nineteenth-century term "view" see Rosalind Krauss, "Photography's Discursive Spaces: Landscape/View," *Art Journal* 42 (winter 1982), 311–319.

16. Charles Baudelaire, *The Painter of Modern Life and Other Essays*, Jonathan Mayne, trans. and ed. (Greenwich, Conn., 1964), 1–40.

17. Leonard Dakin's photographs are reproduced in Oliver Jensen, "Windows on Another Time," *American Heritage* (March 1968), 51.

18. Labeling the Kodak a "Pandora's box," Helmut and Alison Gernsheim in *The History of Photography*, 414–415 and 422–425, lamented the invention of the hand camera and suggested that it was not only responsible for "the evils from which photography is suffering today," but also marked the end of serious photography.

19. Despite their similarity, Lartigue's photographs of elongated wheels on racing cars are not proof of Einstein's theory because the distortion in Lartigue's image was caused by a shutter moving across the film surface. Thus the point of reference was not fixed.

20. For a discussion of the changes in the perception of both time and space at the end of the nineteenth century, see Steven Kern, *The Culture of Time and Space, 1880–1918* (Cambridge, Mass., 1983).

21. William James, *Some Problems of Philosophy* (New York, 1911).

22. Stéphane Mallarmé, "The Impressionists and Edouard Manet," 1876, repr. in *The New Painting: Impressionism 1874–1886* [exh. cat. The Fine Arts Museums of San Francisco] (San Francisco, 1986), 30.

23. Jacob Riis, *The Making of an American* (New York, 1901, 1937), 173.

24. Peter B. Hales, *Silver Cities: The Photography of American Urbanization, 1839–1915* (Philadelphia, 1984), 169.

25. Riis, *The Making of an American*, 174.

26. See, for example, O. G. Rejlander, *Poor Jo*, repro. in Valerie Lloyd, *The Camera and Dr. Barnardo* [London, n.d.], 23, for a picturesque rendition of poverty, or Alexander Gardner's *Home of the Rebel Sharpshooter* (cat. 92) for a heroic rendition of war, and Robert Howlett's *Leviathan: Side View of the Hull* (cat. 68) for a monumental image of industry.

27. Maren Stange in "Gotham's Crime and Misery: Ideology and Entertainment in Jacob Riis's Lantern Slide Exhibitions," *Views* 8 (Spring 1987), 7–11.

28. O. Henry quoted by M. Braive, *The Era of the Photograph* (London, 1965), 219.

29. Recent scholarship is beginning to unravel the mysteries of who actually made the photographs formerly attributed to Riis. For an important study see Stange, "Gotham's Crime," 7–11, and Hales, *Silver Cities*, 163–217.

In addition, many of the lantern slides in the Jacob Riis Collection at the Museum of the City of New York are signed by either Piffard or Lawrence, and the "Riis" collection of photographs also in the Museum of the City of New York includes at least one unattributed Hine print, *A Carrying-in-Boy in Virginia Glass Factory, Alexandria, Virginia* (cat. 141).

30. The Riis Collection at the Museum of the City of New York also contains several hand-colored lantern slides of such images as *Bandit's Roost* and *Saluting the Flag in the Mott Street Industrial School*. The coloring makes the scenes far more picturesque, almost sentimental. However, it is not known who painted the slides, or when.

31. Riis did not have the luxury to compose his images carefully. As he recalled in his autobiography, he raced into dark, dangerous basements or tenements in the middle of the night, fired his flashgun (which was at first, quite literally, a gun), and made his exposure just as his subjects "bolted through windows and down fire-escapes" (Riis, *The Making of an American*, 174–175.) Many of the formal qualities Riis has recently been applauded for using—ragged, radically cropped edges; crowded, claustrophic scenes; and darkness—were facts of the places he was photographing. For example, when photographing *Lodgers in a Crowded Bayard Street Tenement: Five Cents a Spot* (cat. 135), it would have been extremely difficult for him to eliminate the clutter, just as it would have been hard for him not to have bodies and objects intrude into the edges of his photograph: those things were there in that darkened room.

32. Riis, *The Making of an American*, 174–175.

33. "Flashes from the Slums: Pictures Taken in Dark Places by the Lightning Process," *The New York Sun*, 12 February 1888, repr. in Beaumont Newhall, *Photography: Essays and Images* (New York, 1980), 155–157.

34. *The Photographic Times and American Photographer* 18 (3 February 1888), 59.

35. Riis, "Flashes from the Slums," repr. in Newhall, *Photography: Essays and Images*, 156.

36. See Eaton S. Lothrop, Jr., "Time Exposure," *Popular Photography* 70 (January 1972), 171. Stange points out in "Gotham's Crime" that shortly after the invention of photography the police used photographs as a way of apprehending criminals. This application explains the suspicion that many people had with the camera.

37. Lothrop, "Time Exposure," 171.

38. *The New York Times*, 1902, quoted by Steven Kerns, *The Culture of Time and Space*, 187; Lothrop, "Time Exposure," 171.

39. Cosmo I. Burton, "The Whole Duty of the Photographer," *The British Journal of Photography* 36 (11 October and 18 October 1889), 667–668, 682.

40. For an excellent discussion of Bertillon, Galton, and the "universal language" photography provided to nineteenth-century empiricists, see Allan Sekula, "The Body and the Archive," *October* 39 (winter 1986), 3–64.

41. Quoted by Colin Ford in *Sir Benjamin Stone, 1838–1914* [exh. cat. National Portrait Gallery] (London, 1974), 10. Stone's organization was not very successful because it was based on voluntary contributions. The National Photographic Record Association was disbanded in 1917 in favor of local surveys, which were scattered and even less well organized. See also H. D. Gower, *The Camera as Historian* (London, 1916), 5.

42. For further discussion, see Sekula, "The Body and the Archive."

43. "The Picture of Posterity: The Camera Shows How the Future New Yorker Will Look," *The New York Journal*, 10 November 1895.

44. See, for example, Frederic Taber Cooper, "The Creation of Types and Some Recent Novels," *The Bookman* 24 (October 1906), 115–120, or Charles DeKay, "Painting Racial Types," *The Century Magazine* 60 (June 1900), 165–169; see Sekula, "The Body and the Archive."

45. Maria Morris Hambourg deciphered Atget's code, thus significantly expanding our understanding of his aims and accomplishments. She published her results with John Szarkowski in *The Work of Atget*, 4 vols. (New York, 1981–1985).

46. Although Atget did make at least one photograph that includes the Eiffel Tower, it was never the intended subject of any of his photographs.

47. Alan Trachtenberg, "Ever—the Human Document," *America and Lewis Hine: Photographs 1904–1940* (Millerton, New York, 1977), 129.

48. Quoted in Trachtenberg, *America and Lewis Hine*, 133.

49. Emerson's book was extensively reviewed in the photographic press. See, for example, "Naturalistic Photography for Students of the Art," *The Amateur Photographer* 9 (29 March 1889), 209–210; "Litteratur," *Photographische Mittheilungen* 29 (April 1889), 13; Graham Balfour, "Naturalistic Photography," *The British Journal of Photography* 36 (23 August 1889), 563; L. Schrank, "Naturalistic Photography for Students of the Art," *Photographische Correspondenz* 26 (1889), 241–243.

50. Ulrich Keller, "The Myth of Art Photography: A Sociological Analysis," *History of Photography* 8 (October–December 1984), 249–275, and "The Myth of Art Photography: An Iconographic Analysis," *History of Photography* 9 (January–March 1985), 1–38.

51. G.-A. Aurier, *Les peintures symbolistes*, as quoted by H. R. Rookmaaker, *Gauguin and Nineteenth Century Art Theory* (Amsterdam, 1972), 1.

52. Aurier, as quoted by Rookmaaker, *Gauguin*, 340.

53. Maurice Denis, *Theories*, as quoted by Rookmaaker, *Gauguin*, 307.

54. During the 1890s many people thought photography could be used in conjunction with psychic investigations. In "The Image Had Vanished," *The New York Sun*, 22 December 1894, 7, it was reported that the eyes of a murder victim were being examined to see if the last image she had seen was preserved on the retina. This article quoted Alfred Stieglitz as saying that he believed it was possible—revealing his strong belief that eyes were not only a "window on the soul," but also functioned like a camera.

55. "Pictorial Photography," *Scribner's* 26 (1899), 528.

56. Dallett Fuguet, "Truth in Art," *Camera Notes* 3 (April 1900), 190.

57. William Murray, "Picturesque Tonality in Photographic Work," *Camera Notes* 2 (October 1898), 6, and A. Horsley Hinton, "A Blind Leader of the Blind," 1895, as quoted in Peter Bunnell, *A Photographic Vision: Pictorial Photography, 1889–1923* (Salt Lake City, 1980), 28.

58. See Emerson, "Science and Art," 1889, repr. in Bunnell, *A Photographic Vision*, 9–12. The symbolists laid the presentation of facts at the feet of photography: "The short-sighted copy of social anecdotes, the imbecile imitation of the warts of nature, the flat observation of optical illusion, the glory of being as faithful and vulgarly exact as a daguerreotype"; Aurier, *Les peintures symbolistes*, as quoted by Rookmaaker, *Gauguin*, 281.

59. A. Horsley Hinton, "Some Further Considerations of The New School and Its Critics," *The Amateur Photographer* 32 (16 November 1900), 385.

60. As quoted by Edward Lucie-Smith, *Symbolist Art* (London, 1972), 59.

61. Aurier, as quoted by Rookmaaker, *Gauguin*, 323.

62. J. F. Strauss, "Symbolism," *Camera Notes* 5 (July 1901), 28.

63. A. Horsley Hinton, *Practical Pictorial Photography* (London, 1900), vol. 1, 13.

64. Steichen manipulated his gum-bichromate prints so extensively that they were unique. In order to duplicate them, he made copy negatives of the gum-bichromate originals, which he then printed as gelatin-carbon or gelatin silver prints. For further discussion of this, see Weston Naef, *The Collection of Alfred Stieglitz* [exh. cat. The Metropolitan Museum of Art] (New York, 1978), 452–453.

65. E. J. Constant Puyo, "Synthetic Photography," 1904, repr. in Bunnell, *A Photographic Vision*, 168.

66. Schopenhauer, as quoted by Rookmaaker, *Gauguin*, 290.

67. Davison, 1898, quoted in Weston Naef, *The Collection of Alfred Stieglitz* (New York, 1978), 70–71.

68. Alfred Stieglitz, "Photo-Secession," *Bausch and Lomb Lens Souvenir* (Rochester, N. Y.), 3.

69. Alfred Maskell to unknown recipient, dated 24 April 1892, in the collection of the Royal Photographic Society, Bath.

70. Maskell, 1892.

71. Report of a lecture given by F. Holland Day in "Pictorial Photography from America," *The Amateur Photographer* 32 (12 October 1900), 283.

72. F. Holland Day as quoted in "Mr. Day and His Work," *The Boston Herald*, 17 January 1899, 8.

73. Charles H. Caffin, "Symbolism and Allegory," *Camera Work* 17 (April 1907), 21.

74. Charles H. Caffin, "Of Verities and Illusion," *Camera Work* 12 (October 1905), 25.

75. Arthur W. Dow, *Composition* (Boston, 1899), 5.

76. Sadakichi Hartmann, "A Plea for the Picturesqueness of New York," 1900, repr. in *The Valiant Knights of Daguerre*, Harry W. Lawton and George Knox, eds. (Berkeley, 1978), 56–63; and "New Pictorial Laws," *Camera Work* 3 (April 1910), 23–26.

77. Hartmann, "New Pictorial Laws," 23–26.

78. Keller in "The Myth of Art Photography" points out that popular illustrators and commercial photographers of this time were also attracted to New York as a subject and depicted many scenes similar to those of the pictorial photographers. While it is undeniably true that such people as the Brown Brothers photographed New York looking down from the tops of skyscrapers and up from the street level, what distinguishes their photographs from those by Stieglitz, Coburn, Struss, Dubreuil, and others, is not just the subject, but also pictorial construction. The pictorial photographers' use of the crop and fragment and their exploration of the new vision suggested by snap-shots differs radically in both intent and look from those of the commercial photographers.

79. Marius de Zayas, "Photography and Artistic Photography," *Camera Work* 42/43 (April–July 1913), 14.

80. Paul Strand, "Photography," *Camera Work* 49/50 (April–June 1917), 3.

110. ÉTIENNE-JULES MAREY
*Vibrations d'une verge élastique*, 1886
salted paper print, 7.0 x 17.5 (2¾ x 6⅞)
Private collection

111. EADWEARD MUYBRIDGE
*Movement of the hand, drawing a circle*
(Plate XXX from *Animal Locomotion*), 1887
collotype, 19.4 x 38.8 (7⅝ x 15⅜)
The Art Institute of Chicago,
Ryerson Library

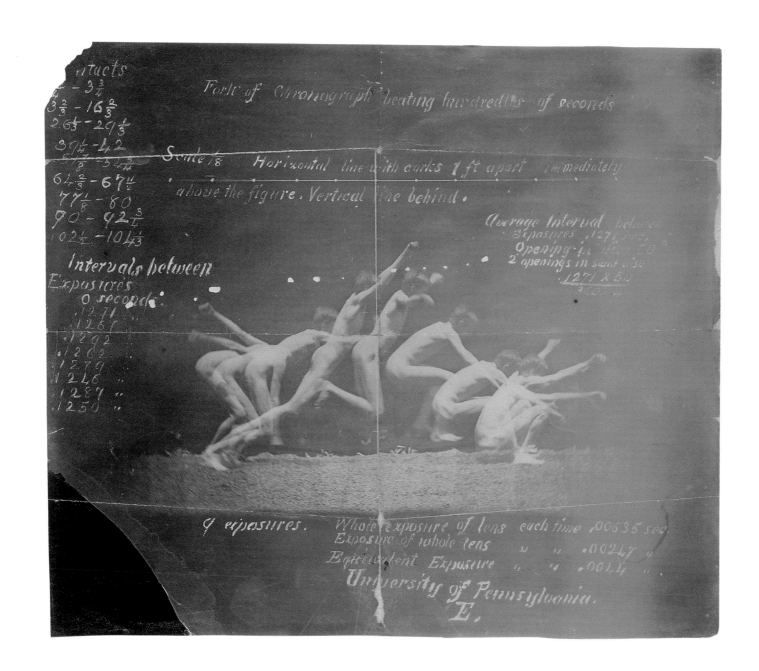

112. Thomas Eakins
*Nude Broad Jumping*, 1884–1885
albumen print, 24.0 x 28.2 (10 x 11)
The Library Company of Philadelphia

113. THOMAS EAKINS
Untitled, c. 1885
gelatin silver print, 13.0 x 18.0 (5⅛ x 7⅛)
Janet Lehr, Inc., New York

114. EDGAR DEGAS
*Paul Poujaud, Madame Arthur Fontaine, and Degas*, c. 1895
gelatin silver print, 29.4 x 40.5 (11⅝ x 15⅞)
The Metropolitan Museum of Art, The Elisha Whittelsey Collection,

115. PHOTOGRAPHER UNKNOWN
*Untitled (Two Men and Two Women)*, c. 1889
gelatin silver print, 8.0 diam. (3¾₆)
International Museum of Photography at George Eastman House
Gift of George B. Dryden

116. PHOTOGRAPHER UNKNOWN
*S.S. Central Viaduct*, c. 1889
matte collodion, 9.2 diam. (3⅝)
International Museum of Photography at George Eastman House
Museum Collection

117. QUEEN ALEXANDRA
*The Prince of Wales and Unknown Person on the Racing Yacht Aline*, 1891
gelatin silver print, 6.8 diam. (2¹¹⁄₁₆)
Gernsheim Collection, Harry Ransom Humanities Research Center,
University of Texas at Austin

118. QUEEN ALEXANDRA
*Princess Victoria with Her Uncle Prince Waldemar of Denmark on the Osborne*, 1889
gelatin silver print, 6.9 diam. (2¹¹⁄₁₆)
Gernsheim Collection, Harry Ransom Humanities Research Center,
University of Texas at Austin

119. URIAH HUNT PAINTER
*Untitled (On White House Grounds)*, c. 1889
gelatin silver print, 6.5 diam. (2⁹⁄₁₆ diam.)
Library of Congress, Prints and Photographs Division

120. URIAH HUNT PAINTER
*Untitled (Child)*, c. 1889
gelatin silver print, 6.5 diam. (2⁹⁄₁₆)
Library of Congress, Prints and Photographs Division

121. ÉDOUARD VUILLARD
*Amfréville–Driveway*, 1905
silver bromide print, 8.5 x 8.5 (3⁵⁄₁₆ x 3⁵⁄₁₆)
M. Antoine Salomon

122. ÉDOUARD VUILLARD
*Trip in Brittany*, 1906
silver bromide print, 8.5 x 8.5 (3⅜ x 3⅜)
M. Antoine Salomon

123. ÉDOUARD VUILLARD
*Annette Roussel, Niece of Vuillard, at Saint-Tropez*, 1904
silver bromide print, 8.4 x 8.2 (3⁵⁄₁₆ x 3⁵⁄₁₆)
M. Antoine Salomon

124. ÉDOUARD VUILLARD
*Madame Hessel and Mademoiselle Aron*, 1905
silver bromide print, 8.4 x 8.4 (3⁵/₁₆ x 3⁵/₁₆)
M. Antoine Salomon

166

127. JACQUES-HENRI LARTIGUE
*George Boucard During the Race,* 1911
gelatin silver print, 1988, 14.0 x 17.0 (5½ x 6¹¹⁄₁₆)
Association des Amis de J.-H. Lartigue, Paris
Copyright Association des Amis de Jacques-Henri Lartigue, Paris

128. Jacques-Henri Lartigue
*Oléo*, 1908
gelatin silver print, 1988, 15.9 x 11.1 (6¼ x 4⅜)
Association des Amis de J.-H. Lartigue, Paris
Copyright Association des Amis de Jacques-Henri Lartigue, Paris

168

129. PIERRE BONNARD
*Jean and Charles Wrestling*, 1898
silver printing-out-paper print, 3.5 x 5.8 (1⅜ x 2⁵⁄₁₆)
Musée d'Orsay, Paris, Promised gift of Antoine Terrasse,
his brothers and sister
Copyright Réunion des Musées Nationaux, Musée d'Orsay

130. PIERRE BONNARD
*Charles and a Nurse*, 1898
silver printing-out-paper print, 3.9 x 5.1 (1⅜ x 2⁵⁄₁₆)
Musée d'Orsay, Paris, Promised gift of Antoine Terrasse
Copyright Réunion des Musées Nationaux, Musée d'Orsay

131. Jacob Riis, or Henry G. Piffard, or Richard Hoe Lawrence
*Bandits Roost*, 1887
albumen print made by Chicago Albumen Works, 1988, from original
lantern slide, 6.8 x 7.4 (2¹¹⁄₁₆ x 3)
Jacob Riis Collection, Museum of the City of New York

132. JACOB RIIS(?)
*In a Sweatshop—12-Year-Old Boy at Work Pulling Threads*, c. 1890
albumen print made by Chicago Albumen Works, 1988, from
original glass negative, 7.0 x 5.8 (2¾ x 2⁵⁄₁₆)
Jacob Riis Collection, Museum of the City of New York

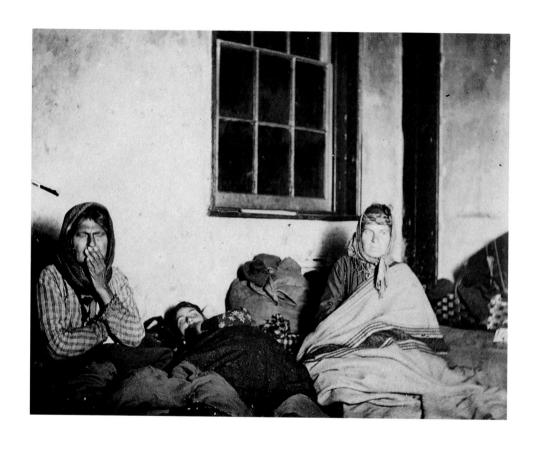

133. Richard Hoe Lawrence
*Interior of an Arab Boarding House, Washington Street, New York*, 1887
albumen print made by Chicago Albumen works, 1988, from original
lantern slide, 8.1 x 10.2 (3 3/16 x 4)
Jacob Riis Collection, Museum of the City of New York

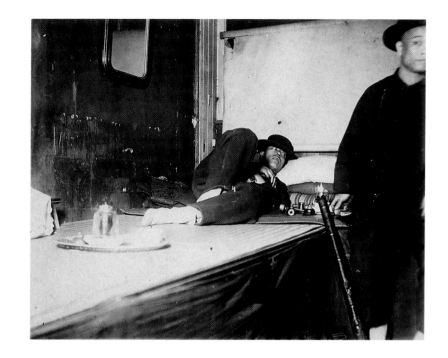

134. RICHARD HOE LAWRENCE
*A Chinese Opium Joint*, 1887
albumen print made by Chicago Albumen Works, 1988,
from original lantern slide, 9.4 x 12.0 (3¹¹⁄₁₆ x 4¾)
Jacob Riis Collection, Museum of the City of New York

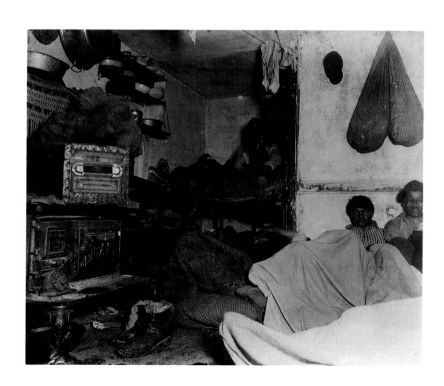

135. JACOB RIIS(?)
*Lodgers in a Crowded Bayard Street Tenement: Five Cents A Spot*, 1887
albumen print made by Chicago Albumen works, 1988,
from original glass negative, 6.8 x 7.4 (2¹¹⁄₁₆ x 3)
Jacob Riis Collection, Museum of the City of New York

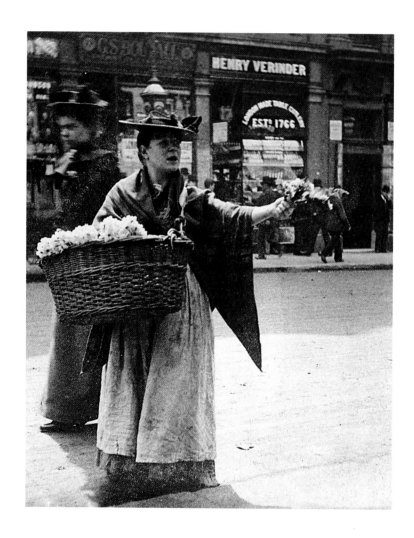

136. Paul Martin
*The Cheapside Flower Seller*
platinum print, 7.4 x 6.1 (2⁵⁄₁₆ x 2⁷⁄₁₆)
Gernsheim Collection, Harry Ransom Humanities Research Center,
University of Texas at Austin

137. ALICE AUSTEN
*Bootblacks*, 1896
gelatin silver print, 9.4 x 11.1 (3¹¹⁄₁₆ x 4³⁄₈)
Library of Congress, Prints and Photographs Division

138. ALICE AUSTEN
*Rag Carts*, 1896
gelatin silver print, 9.2 x 11.2 (3⁵⁄₈ x 4⁵⁄₈)
Library of Congress, Prints and Photographs Division

175

139. Frances Benjamin Johnston
*Snow Hill Institute*, 1902
cyanotype, 18.5 x 23.8 (7¼ x 9⅜)
Library of Congress, Prints and Photographs Division

140. Arnold Genthe
*Chinatown #4*, c. 1905
gelatin silver print, 23.1 x 32.6 (9⅛ x 12⅞)
The Art Institute of Chicago, Acquired through exchange with the Library of Congress

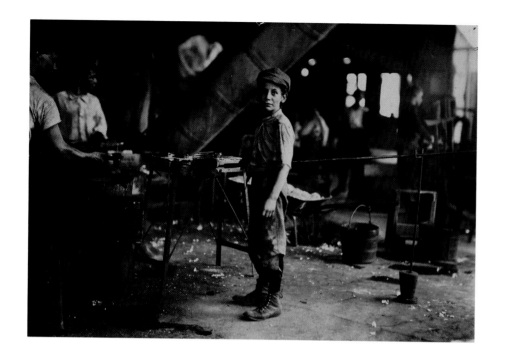

141. LEWIS HINE
*A Carrying-in-Boy in Virginia Glass Factory, Alexandria, Virginia:*
*Works in Day Shift One Week and Night Shift Next.*
*He Works All Night Every Other Week*, June 1911
gelatin silver print, 11.8 x 17.1 (4⅝ x 6¾)
Jacob Riis Collection, Museum of the City of New York

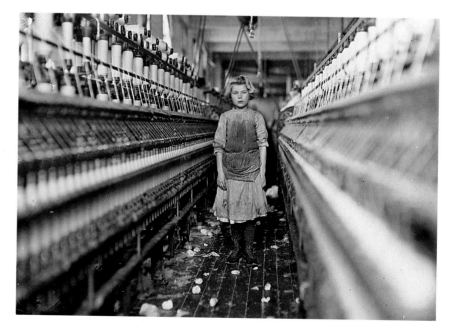

142. LEWIS HINE
*Little Spinner in Mill, Augusta, Georgia.*
*Overseer Said She Was Regularly Employed*, 1909
gelatin silver print, 11.8 x 16.8 (4⅝ x 6⅝)
International Museum of Photography at George Eastman House,
Gift of the Photo League, New York,
ex-collection, Lewis Wickes Hine

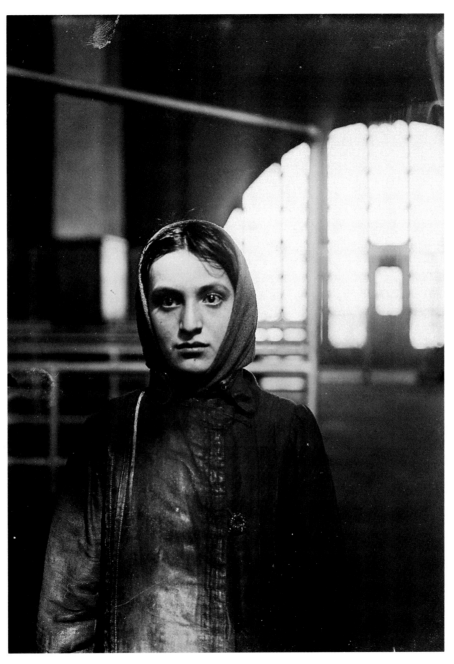

143. Lewis Hine
*Young Russian Jewess*, 1905
gelatin silver print, 17.7 x 12.7 (7 x 5)
International Museum of Photography at George Eastman House.
Gift of the Photo League, New York, ex-collection Lewis Wickes Hine

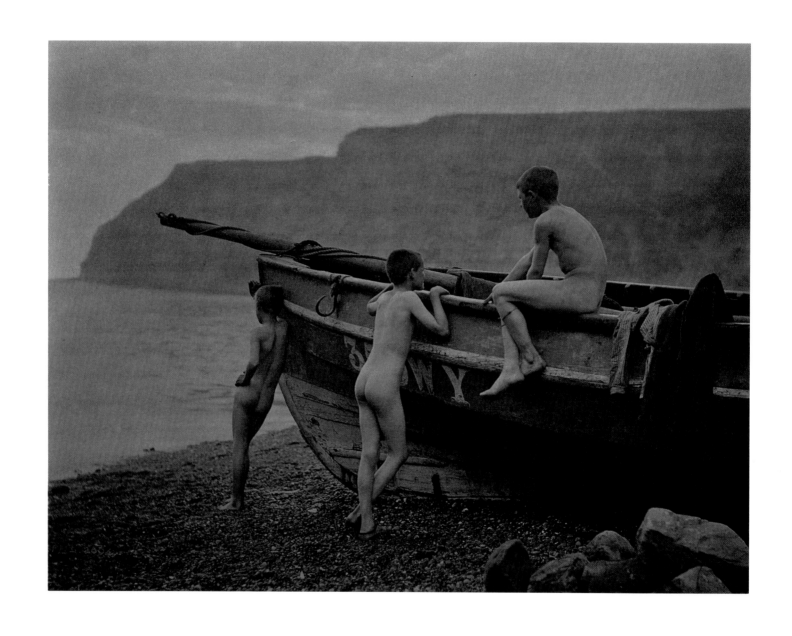

144. Frank Sutcliffe
*Natives*, 1895
carbon print, 22.5 x 29.2 (9 x 11½)
The J. Paul Getty Museum

145. Peter Henry Emerson
*Poling the Marsh Hay*, 1886
platinum print, 23.2 x 28.9 (9⅛ x 11⅜)
Gilman Paper Company Collection

146. ALFRED STIEGLITZ
*Venetian Gamin*, 1894
platinum print, 16.4 x 13.2 (6⁷⁄₁₆ x 5³⁄₁₆)
National Gallery of Art, Alfred Stieglitz Collection

147. Eugène Atget
*Ragpicker*, 1899–1900
albumen print, 20.5 x 15.0 (8¹⁄₁₆ x 5⅞)
Collection, The Museum of Modern Art, New York,
Abbott-Levy Collection, Partial Gift of Shirley C. Burden

148. Eugène Atget
*Window*, 1913
albumen print, 21.6 x 17.5 (8½ x 6⅞)
Gilman Paper Company Collection

184

149. Eugène Atget
*Fontaine, rue Garancière*, 1900
albumen print, 25.0 x 17.0 (9⅞ x 6¹¹⁄₁₆)
Collection, The Museum of Modern Art, New York, Abbott-Levy Collection,
Partial Gift of Shirley C. Burden

150. FREDERICK EVANS
*Ely Cathedral: Grotesque Sculpture in Triforium,*
c. 1898
platinum print, 23.5 x 18.4 (9¼ x 7¼)
Kent and Marcia Minichiello

151. FREDERICK EVANS
*In the Attics: Kelmscott Manor*, 1896
platinum print, 15.3 x 20.0 (6¹/₁₆ x 7⅞)
Museum of Fine Arts, Boston, Gift of Mr. Ralph W. Morris

152. FREDERICK EVANS
*York Minster: Into the North Transept*, c. 1902
platinum print, 26.0 x 18.3 (10¼ x 7³/₁₆)
Museum of Fine Arts, Boston, Horatio Greenough Curtis Fund

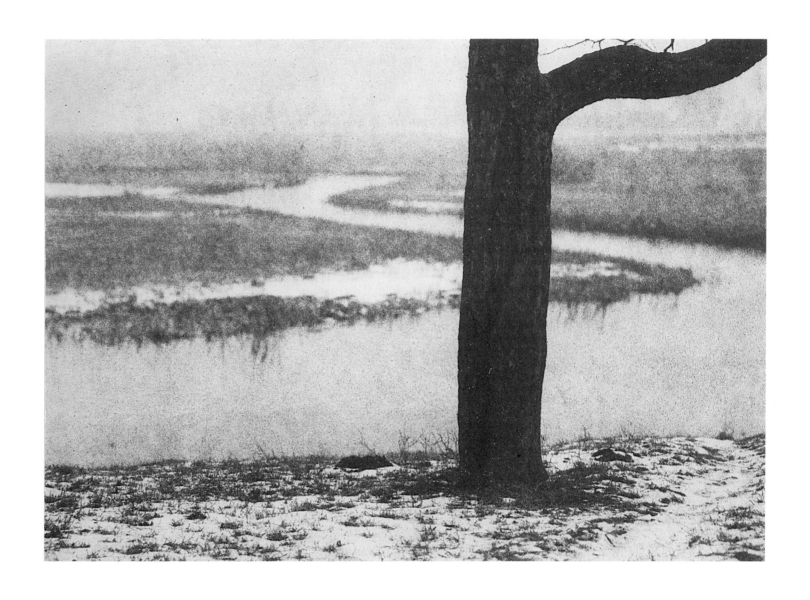

153. Frederick Behrens
*Untitled (Landscape)*, 1898
gum bichromate print, 11.9 x 16.9 (4$^{11}$/$_{16}$ x 6$^{11}$/$_{16}$)
Agfa Foto-Historama

154. LEONARD MISONNE
*Untitled (Landscape)*, c. 1900
silver bromide print, 8.3 x 11.1 (3¼ x 4⅜)
Provinciaal Museum voor Fotografie, Antwerp

155. ALFRED HORSLEY HINTON
*Beyond*, 1903
photogravure, 14.0 x 18.5 (5½ x 7⁵⁄₁₆)
Provinciaal Museum voor Fotografie, Antwerp

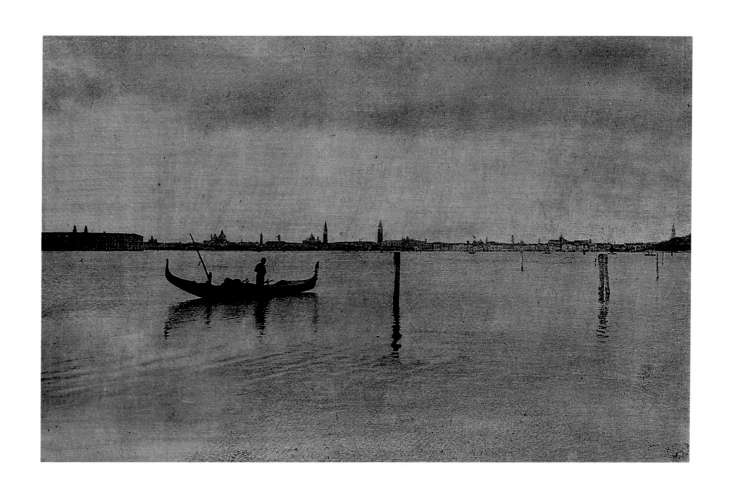

156. James Craig Annan
*Venice from the Lido,* c. 1896
photogravure, 9.6 x 15.0 (3¾ x 5⅞)
National Galleries of Scotland, Portrait Gallery

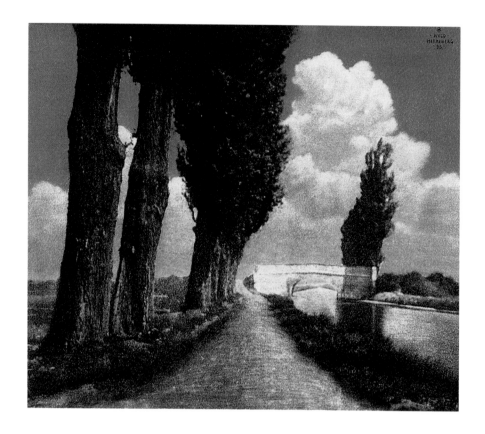

157. Hugo Henneberg
*On the Canal*, 1898
gum bichromate print, 46.0 x 55.8 (18⅛ x 22)
Museum für Kunst und Gewerbe, Hamburg

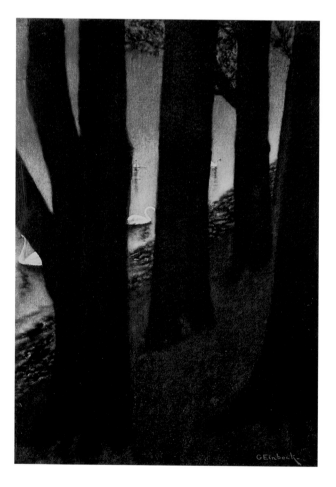

158. George Einbeck
*The Swan*, 1898
gum bichromate print, 45.5 x 33.1 (18 x 13⅛)
Museum für Kunst und Gewerbe, Hamburg

159. THEODOR AND OSKAR HOFMEISTER
*The Siblings*, c. 1901
gum bichromate print, 62.5 x 79.5 (24⅝ x 31⅜)
Museum für Kunst und Gewerbe, Hamburg

HEINRICH W. MÜLLER
*Landscape*, c. 1901
gum bichromate print, 15.0 x 79.5 (6 x 31⅜)
Museum für Kunst und Gewerbe, Hamburg

160. HUGO ERFURTH
*Wolfgang Erfurth*, c. 1905
gum bichromate print, 28.8 x 36.5 (11⅜ x 14⅜)
Agfa Foto-Historama

161. HUGO ERFURTH
*Girl*, 1910
carbon print, 20.8 x 32.7 (8³⁄₁₆ x 12⅞)
Royal Photographic Society

162. Heinrich Kühn
*Walter Kühn*, c. 1905
gum bichromate print, 62.6 x 50.2 (24⅝ x 19¾)
Museum Folkwang, Essen

163. Heinrich Kühn
*Still Life*, c. 1904
gum bichromate print, 26 x 38 (10¼ x 15)
Gilman Paper Company Collection

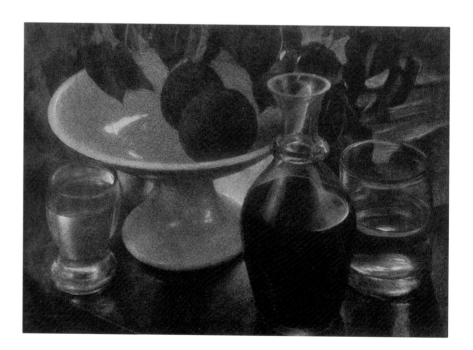

164. Heinrich Kühn
*Still Life*, c. 1904
bromoil transfer print, 21.1 x 29.5 (8⁵⁄₁₆ x 11⁹⁄₁₆)
Marjorie and Leonard Vernon

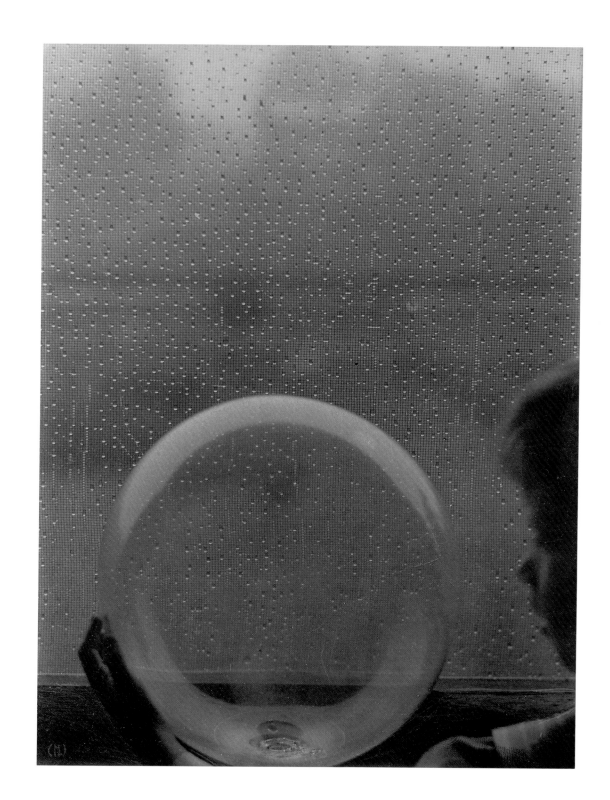

165. CLARENCE H. WHITE
*Raindrops*, 1902
platinum print, 20.6 x 16.0 (8⅛ x 6⁵⁄₁₆)
Royal Photographic Society

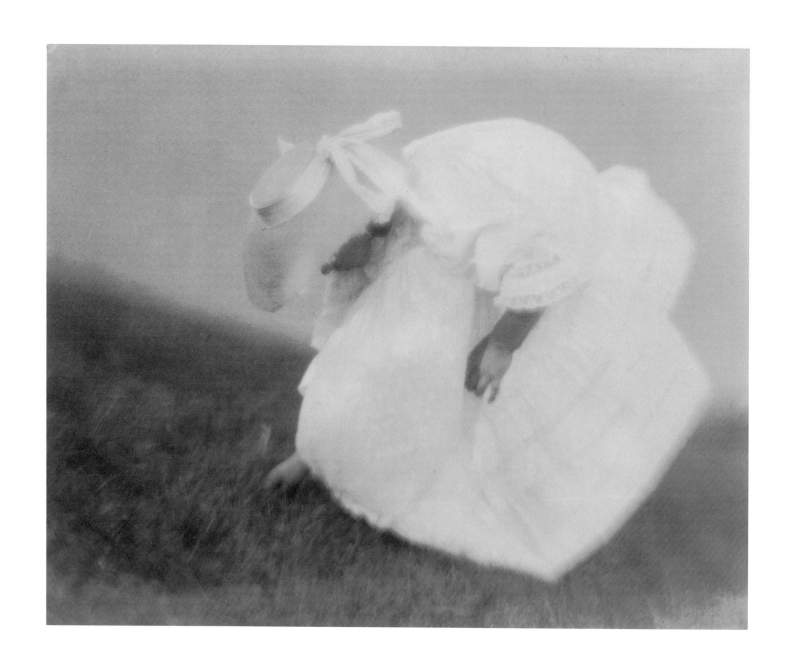

166. Heinrich Kühn
*On the Hillside*, 1910
gum bichromate print, 23.3 x 29.1 (9 9/16 x 11 1/2)
Gilman Paper Company Collection

196

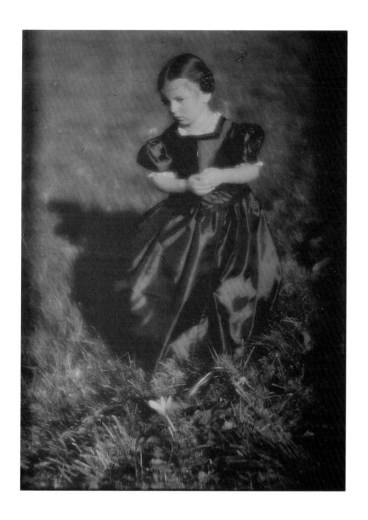

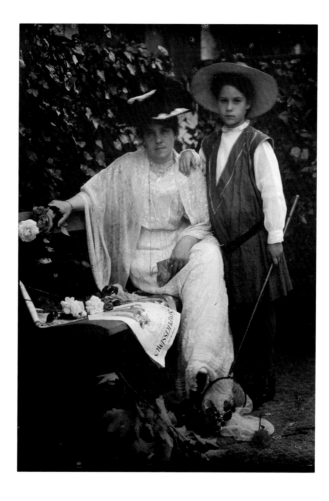

167. HEINRICH KÜHN
*Lotte*, c. 1907
Autochrome, 23.1 x 17.2 (9⅛ x 6¾)
The Art Institute of Chicago, Restricted gift of William Mares

168. FRANK EUGENE
*Emmy and Kitty–Tutzing, Bavaria*, 1907
Autochrome, 16.8 x 11.7 (6⅝ x 4⅝)
The Metropolitan Museum of Art, The Alfred Stieglitz Collection, 1955

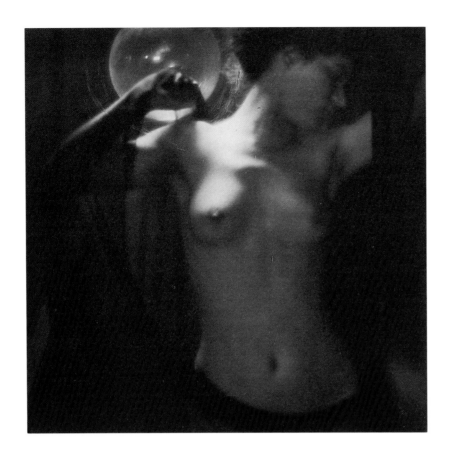

169. CLARENCE H. WHITE
*Untitled (Nude Study)*, 1906–1909
platinum print, 17.5 x 18.0 (6⅞ x 7⅛)
Royal Photographic Society

170. EDWARD STEICHEN
*Untitled (Nude Study)*, c. 1902
platinum print, 10.4 x 14.1 (4⅛ x 5⁹⁄₁₆)
Royal Photographic Society

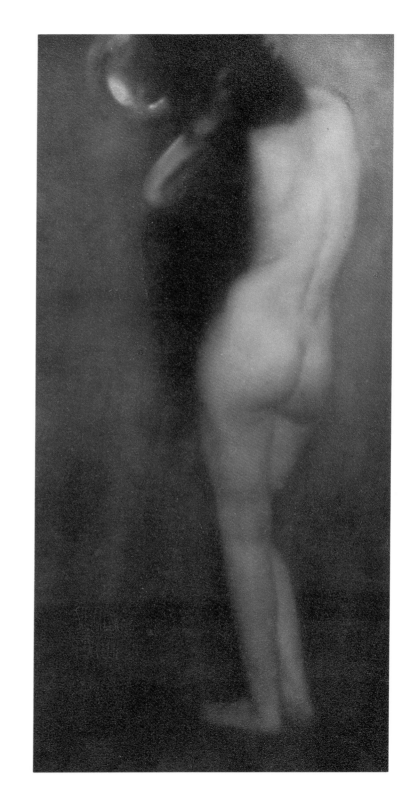

171. EDWARD STEICHEN
*The Little Round Mirror*, 1902
gum bichromate-platinum print, 41.3 x 21.3 (16¼ x 8⅜)
Royal Photographic Society

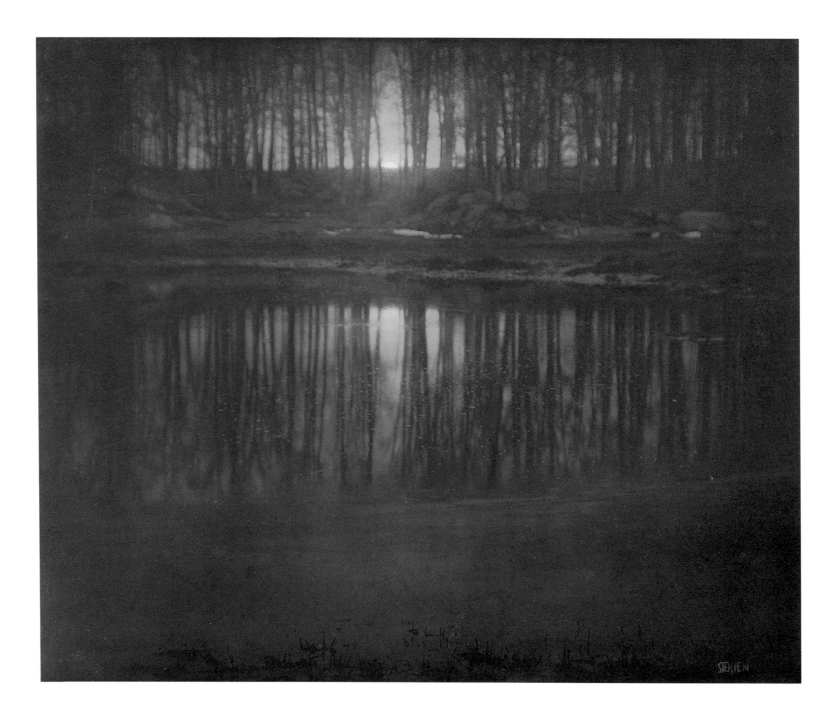

172. Edward Steichen
*The Pond, Moonrise*, 1903
platinum print toned with yellow and blue-green pigment, 39.7 x 48.2 (15⅝ x 19)
The Metropolitan Museum of Art, The Alfred Stieglitz Collection, 1933

173. Edward Steichen
*Self-Portrait with Brush and Palette*, 1902
gum bichromate print, 26.7 x 20.0 (10½ x 7⅞)
The Art Institute of Chicago, The Alfred Stieglitz Collection

201

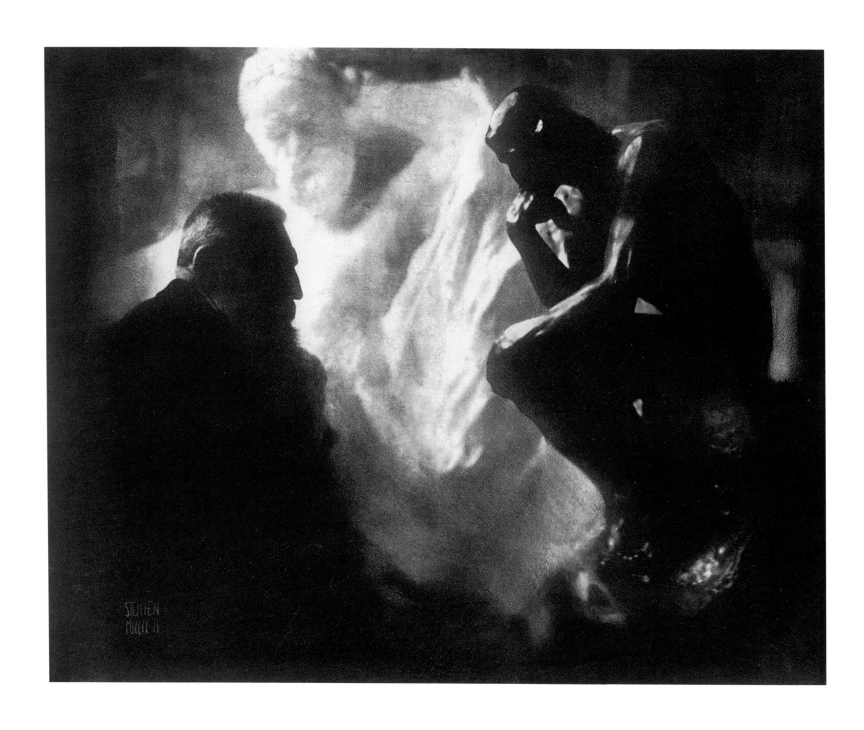

174. Edward Steichen
*Rodin–The Thinker*, 1902
gum bichromate print, 40.3 x 50.0 (15⅞ x 19⅞)
Gilman Paper Company Collection

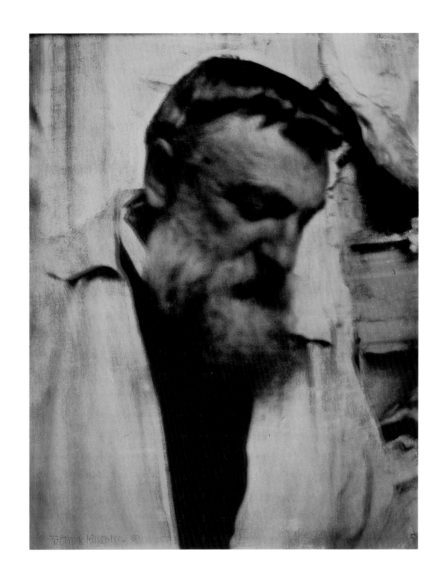

175. GERTRUDE KÄSEBIER
*Portrait of Auguste Rodin*, 1906
gum bichromate print, 33.8 x 26.5 (13¼ x 10⁷⁄₁₆)
The Art Museum, Princeton University, Gift of the Estate of Mina Turner

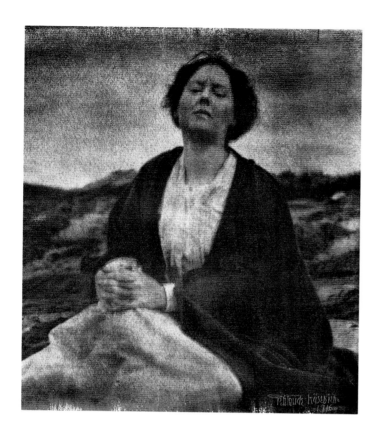

176. GERTRUDE KÄSEBIER
*The Heritage of Motherhood*, c. 1905
gum bichromate print, 1916 27.0 x 24.9 (10⅝ x 9⅛)
Collection of the International Museum of Photography
at George Eastman House, Gift of Hermine Turner

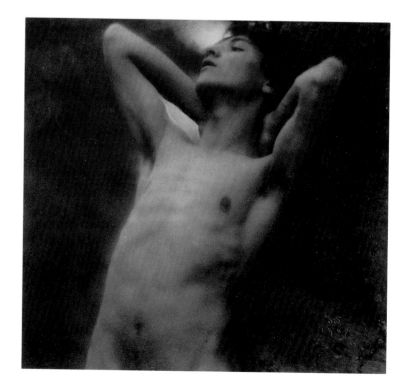

177. F. HOLLAND DAY
*Boy*, 1907
platinum print, 17.3 x 18.5 (6¹³/₁₆ x 7⁵/₁₆)
Janet Lehr, Inc., New York

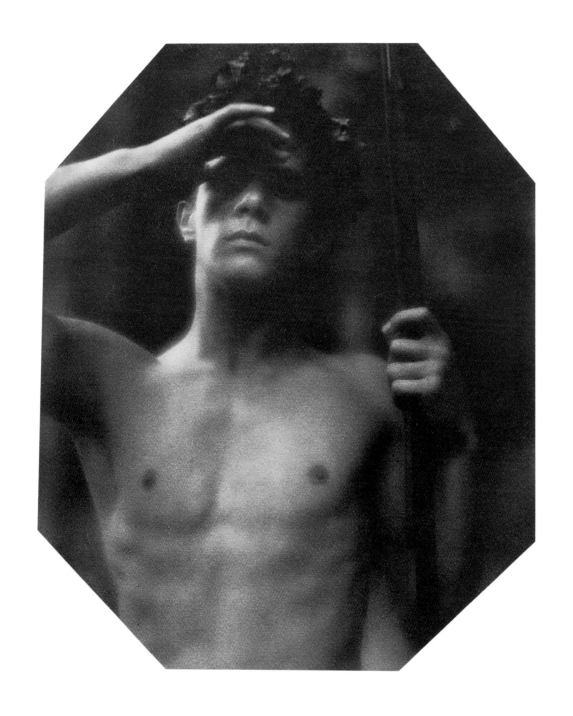

178. F. Holland Day
*Torso*, 1908
platinum print, 23.7 x 19.3 (9⁹⁄₁₆ x 7⅝)
Royal Photographic Society

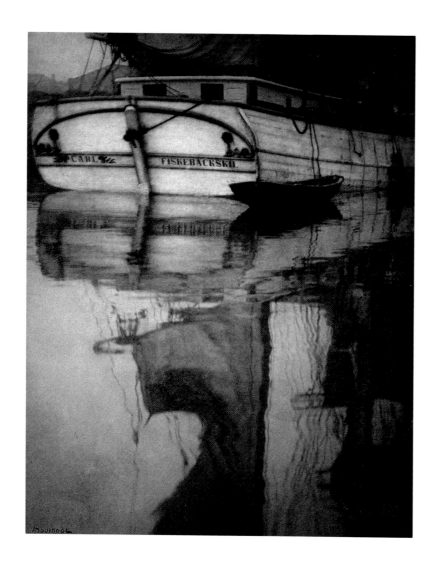

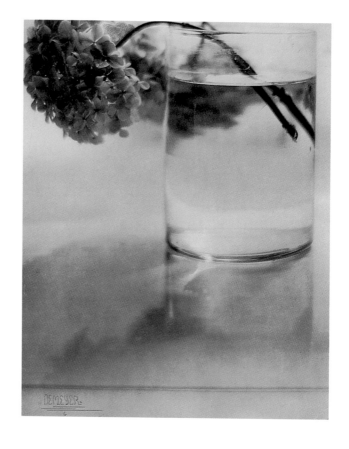

179. MALCOLM ARBUTHNOT
*Reflections*, 1909
gum bichromate-platinum print, 32.9 x 26.7 (13 x 10½)
Royal Photographic Society

206

180. BARON ADOLF DEMEYER
*Hydrangea*, c. 1908
platinum print, 33.3 x 27.5 (13⅛ x 10¹³⁄₁₆)
Royal Photographic Society

181. CLARENCE H. WHITE
*Untitled (Woman in Bed)*, c. 1907
gum bichromate-platinum print
20.4 x 15.07 (8 x 6⁵⁄₁₆), Musée d'Orsay
Copyright Réunion des Musées Nationaux,
Musée d'Orsay

182. GEORGE SEELEY
*Untitled (Winter Landscape)*, 1909
gum bichromate print, 43.8 x 53.3 (17¼ x 21)
The Baltimore Museum of Art

183. Alvin Langdon Coburn
*Grand Canyon*, 1911
platinum print, 31.5 x 41.0 (12$\frac{7}{16}$ x 16$\frac{1}{8}$)
Janet Lehr, Inc., New York

184. Edward Steichen
*Flatiron*, 1907
blue pigment gum bichromate-platinum print
24.0 x 19.2 (9$\frac{7}{16}$ x 7$\frac{9}{16}$)
The Metropolitan Museum of Art,
The Alfred Stieglitz Collection, 1933

185. ALFRED STIEGLITZ
*Flatiron*, 1902
photogravure, 32.7 x 16.7 (12⅞ x 6⁹⁄₁₆)
National Gallery of Art, Alfred Stieglitz Collection

186. ALFRED STIEGLITZ
*The Steerage*, 1907
photogravure, 32.0 x 25.7 (12⅝ x 10⅛)
National Gallery of Art, Alfred Stieglitz Collection

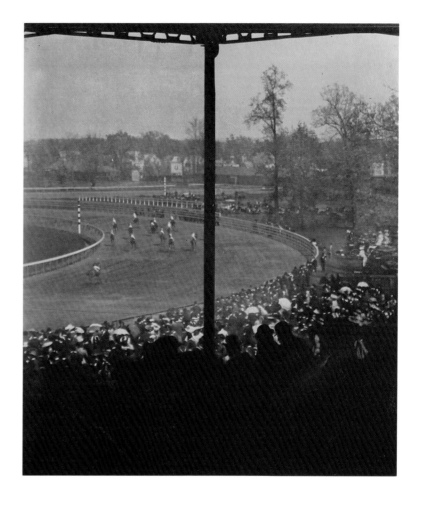

187. ALFRED STIEGLITZ
*Old and New New York*, 1910
photogravure, 33.3 x 25.7 (13⅛ x 10⅛)
National Gallery of Art, Alfred Stieglitz Collection

188. ALFRED STIEGLITZ
*Going to the Post, Morris Park*, 1904
photogravure, 30.8 x 26.4 (12⅛ x 10⅜)
National Gallery of Art, Alfred Stieglitz Collection

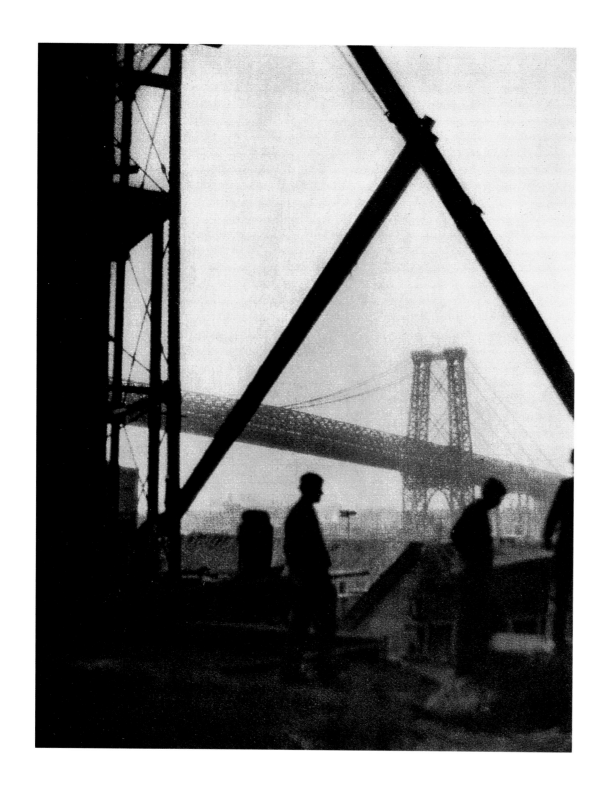

189. ALVIN LANGDON COBURN
*Williamsburg Bridge*, 1909
photogravure, 19.2 x 15.3 (7$\frac{9}{16}$ x 6$\frac{1}{16}$)
Gernsheim Collection, Harry Ransom Humanities
Research Center, University of Texas at Austin

190. ALVIN LANGDON COBURN
*Pittsburgh Smoke Stacks*, 1910
platinum print, 21.0 x 29.0 (8¼ x 11⁷⁄₁₆)
Janet Lehr, Inc., New York

191. Karl Struss
*New York Building*, c. 1911
gelatin silver print, 13.0 x 10.0 (5⅛ x 4)
Stephen White Collection

192. Alfred Stieglitz
*From the Back-Window—291*, 1915
platinum print, 25.0 x 20.0 (9⅞ x 7⅞)
National Gallery of Art, Alfred Stieglitz Collection

193. CHARLES SHEELER
*Doylestown House–Stairs from Below*, 1917
gelatin silver print, 21.1 x 15.0 (8⅜₆ x 5⅞)
The Metropolitan Museum of Art,
The Alfred Stieglitz Collection, 1933

194. Paul Strand
*New York (Wall Street)*, 1915
platinum print, 24.8 x 32.3 (9¾ x 12¾)
Collection Centre Canadien d'Architecture/Canadian Centre for Architecture, Montréal
Copyright 1971, Aperture Foundation, Inc., Paul Strand Archive

219

195. Paul Strand
*Photograph, New York (Blind Woman)*, 1916
platinum print, 33.7 x 25.6 (13¼ x 10⅟₁₆)
The Metropolitan Museum of Art, The Alfred Stieglitz Collection, 1933

196. Paul Strand
*Chair Abstract, Twin Lakes, Connecticut,* 1916
satista print, 33.7 x 25.3 (13¼ x 9¹⁵/₁₆)
San Francisco Museum of Modern Art, Purchase,
Copyright 1985, Aperture Foundation, Inc.,
Paul Strand Archive

# III
## 1919–1945

Fig. 1. Manuel Alvarez Bravo, *Laughing Mannequins*, gelatin silver print, c. 1932, 18.6 x 24.1 (7⁵/₁₆ x 9⁹/₁₆), The Art Institute of Chicago, Julien Levy Collection, Gift of Jean Levy and the Estate of Julien Levy (cat. 397)

# Ephemeral Truths

## THE MODERN WORLD

On 29 May 1919 a set of photographs was taken that helped to change our perception of the world. The photographs did not depict the aftermath of saturated artillery bombardment or civilian casualties suffered during the Great War. They were photographs of a solar eclipse taken by the Royal Astronomer, Sir Frank Dyson, on the island of Principe off West Africa, in conjunction with Arthur Eddington working in Sobral, Brazil. The photographs confirmed, after several months of analysis, that a ray of light grazing the surface of the sun was deflected by twice the angle that Newtonian physics predicted, thus supporting the general theory of relativity that Albert Einstein had published in 1916.[1] Other photographic confirmations of Einstein's predictions were to follow, and, like the images of Dyson and Eddington, did not need to be seen, but only measured.

Around the same time, in Buenos Aires, another observer produced a different perception of the world with photographs that were to confirm or prove nothing, and that were not even taken by the observer. They consisted simply of a pair of stereoscopic views showing a featureless stretch of ocean with the outline edges and axes of an octahedron drawn in on both halves to stereographic effect. They did, however, need to be seen (through a stereoscope) and contemplated as a picture to be understood at all.

The difference between the astronomers' scientific measurements and Marcel Duchamp's appropriation and subsequent alteration of an existing image may be said to set the extreme limits of twentieth-century photography. The first example can be thought of as the proof of a theory about reality, and the other as the conceptual shell into which a meaning supplied by the viewer is to be placed. The one establishes a reality out of an existing concept, and the other makes a concept out of an existing reality.

That the medium of photography had a role, at all, on the intellectual gameboard defined by these two Cartesian axes of fact and concept is due to its special status in the first half of the century. Photography was the most expedient and objective way to record the visual data of a wide range of subjects from astronomical observations to the day-to-day events featured in the illustrated press, or from the atrocities of war to conceptual art. In addition, it went to work for advertising, and formed the basis of the cinema. Until television news broadcasts and commercials became widespread and electronic information storage a matter of course, photography was *the* medium in ascendancy.

To the photographs defined by fact and concept may be added a third type, that which has become a reality unto itself, the work of art. During the period between the World Wars three new factors affecting photography's aesthetic potentiality came into play. The first was the idea that an artist's personal intentions should be subordinated to the viewer's perception of the work itself. Any technique that, like photography, removed the artist's personal touch was bound to be explored and exploited for its untapped picturemaking possibilities. Duchamp wrote later that his aim was to "reduce the idea of aesthetic consideration to the choice of the mind, not to the ability or cleverness of the hand. . . ."[2] Thus, his out-of-context manipulation of a stereograph, or the signing of a bottle-drying rack, a snow shovel, or a urinal posited by example that nothing is a work of art unless perceived as one.

Fig. 2. Marcel Duchamp, *Handmade Stereopticon Slide*, cut-and-pasted stereopticon slide, and pencil on black paper-surfaced cardboard, c. 1918–1919, 6.7 x 17.2 (2⅝ x 6¾), Collection, The Museum of Modern Art, New York, Katherine S. Dreier Bequest

The second factor was a trend toward replacing the historic and traditional with the fundamental. Avant-garde artists, rejecting past cultural habits and themes, did not want to salvage what was left to them after the Great War but to build a new world from the ground up. In reducing each medium to what it could do best, artists sought a universal language that would define and validate their work. Examples are abundant in every field. In his paintings Mondrian discarded everything except a few primary-colored shapes that were determined by the rigidity of an asymmetrical grid. Brancusi, too, found a simple geometry of curves and solids to be adequate for his sculpture. The 1917 *Vortograph* of Alvin Langdon Coburn (cat. 205)—produced by the refracted and reflected light of prisms and mirrors—tried to shatter the perspectives of conventional pictorial views and piece together a picture by abstracting the medium of photography to an art of pure optical effects.

The third factor, which led to a new understanding of photography as the art of an observer, had an invigorating effect on the arts of the new century: the consciousness of time as a dimension of perception. "Every form is the frozen instantaneous picture of a process. Thus a work is a stopping-place on the road of becoming and not the fixed goal,"[3] is how El Lissitzky put it, being careful to indicate that works of art were only parts in a larger dynamic process of being and making. Or as the French philosopher Henri Bergson wrote in 1907: "form is only a shapshot view of transition."[4]

Beginning in the 1920s, the recognition of the photographic moment as the complement of the photographic object brought about the rediscovery of the tool that had once obsessed the inventive genius of William Henry Fox Talbot. In their curiosity to know the essense of the photographic medium, artists and photographers often turned away from what was in front of the camera and made the process of creating a photographic picture its own subject. As Talbot had described in his first publication, photography became once again an art of fixing shadows, but now even more appreciated for the optical and mechanical character of its impersonal approach. During the economic and political turmoil of the next decade, however, photography's objective eye be-

gan to turn back to the world around it. In the 1930s, when photographers registered evidence for science, commerce, publicity, sociology, and history, they did so for the first time with a confidence that it was something in and of itself. This, in turn, led photographers beyond their quest for the perfect copy or the frozen moment, to a recognition of the unrivaled ability of photography to reveal what the writer Pierre Bost termed the "ephemeral truth."

## LEAVING THE PAST BEHIND

In art and photography, the Great War did not cause a break with the past, it finalized it. Before the outbreak of hostilities, a few artists were already challenging tradition in the most radical way by undermining the necessity of the artist's immediate presence: Duchamp with his "readymades" and Picasso with his collages. The tendency toward representing the world in abstract shapes was becoming common enough so as to preoccupy such pictorialists as Coburn, Karl Struss, and George Seeley. The factor of time was beginning to assert itself as a moment's souvenir in amateur snapshots. Despite all the interest among artists and photographers in technology and new ideas, it was still a little early for true collaboration.

A mere two months after Anton Giulio Bragaglia had advertised the publication of his 1913 book *Fotodinamismo futurista*, it was set upon by assassins. In no uncertain terms, the painters of the futurist movement led by Umberto Boccioni repudiated the photographer's implied affiliation with their own innovation, *plastic dynamism*.[5] They wanted to have nothing to do with either Bragaglia or photography. Unfortunately, the parochial measures taken by the painters quashed Bragaglia's singular, if peculiar, attempt to align the aesthetics of speed and motion with photographic technology.

Having begun working in his father's pioneering film company in Rome as a teenager in 1906, Bragaglia acquired early on a sense of the movement of objects and the interpenetration of forms. He was the first futurist whose understanding of these things proceeded strictly from technology itself. Yet at the same time he was more than casually attracted to the occult and paranormal occurrences, which lent an aura of the charlatan to his efforts. Nevertheless, F. T. Marinetti,

the poet-founder and intellectual spirit of the futurist movement, encouraged the young recruit and his brothers, Arturo and Carlo Lucovico, by helping to finance some of their first photodynamic experiments.

Bragaglia was not interested in breaking up or freezing movement and then analyzing it, as the scientist Étienne-Jules Marey had done. As an artist, Bragaglia involved himself only in the area of movement that produced sensation. He avoided "the precise, mechanical, glacial reproduction of reality,"[6] in accordance with the philosophy of Bergson, whose ideas undoubtedly came via Marinetti.[7] Had he had ever seen Bragaglia's photographs, Bergson might have found them a quirky offspring of his philosophy, but in many of his experiments Bragaglia expressed a feeling for duration ("la durée") like few others in the futurist move-

Fig. 3. Anton Giulio Bragaglia, *The Cellist*, gelatin silver print, 1913, 11.7 x 13.8 (4⅝ x 5⁷⁄₁₆), Courtesy of Werner Bokelberg, Hamburg

ment and respected Bergson's objection to the scientific fragmentation of the "perpetual flux of things." For both the philosopher and the photographer, time could be the scientific measure of motion, if it first served the mind as a dimension of perception.

For all the artistic experimentation in the years to follow Bragaglia's photodynamism, time as an element of photographic perception was not to receive a second thought before more than a decade had run its course. It retreated along with Bragaglia into film and the performing arts. By the time Anton Bragaglia re-entered the still photography arena with another wave of futurists in the late 1920s, the redefinition of the medium that was underway made many of his innovations seem like standard stuff.

In America, the 1913 Armory Show of modern American and European painting and sculpture was the clearest sign of the break with the past. One of the exhibitors, Francis Picabia, who had studied under Pissarro but since 1909 had been associated with many of the various avant-garde movements in Paris, came to New York to see the exhibition. After his return, Picabia sent an anonymous manifesto to Alfred Stieglitz proposing something called amorphism:

War on form!
Form is the enemy!

. . . .

Light is all we need. Light absorbs objects. Objects have value only through the light which bathes them. Matter is only a reflection and an aspect of universal energy. From the relationship of this reflection to its cause, which is luminous energy, is born what we improperly call objects, and thus we arrive at the nonsense called form.[8]

Perhaps Picabia, after improvising an exhibition of pictures of mechanical fantasies at Stieglitz's 291 gallery, sent the tract as a courtesy, knowing his new photographer friend, passionately enamored of form, would enjoy reading that light had attained a redemptive quality in Europe, if only theoretically. Since Picabia did not include the last page of the manifesto containing the signature of the author, Victor Meric,[9] this friendly act was as much a prank as a communi-

Fig. 4. Christian Schad, *Untitled*, printing-out paper Schadograph, 1918, The Museum of Fine Arts, Houston, Museum purchase with funds provided by Isabell and Max Herzstein, Mary Ryerson Library

cation, a parting *boutade* to agitate the overly serious New Yorkers—a bit of pure Picabia. Within a few years Picabia, in the company of Duchamp, was back in New York seeking refuge from the war. With Stieglitz as sympathizer and occasional promoter, the two Europeans formed an anti-art movement that later became known as an early branch of dada.

Unlike Stieglitz in New York, there were no photographers among those artists in Zürich in 1916 who banded together for the duration of the war in a local cabaret to demonstrate their discontent with the broken hopes of a once rational world. They satirized and attacked any and every convention of art and christened their attitude—since they had no particular artistic style—with the nonsense word "dada." But as the

war ended, a sudden interest in appropriating photographic images took hold of them. Christian Shad pieced together small scraps of newspaper and printed matter and then used the temporary assemblage as a negative from which to make a photographic print. In 1918, the same year the *schadograph* appeared in Zürich, Raoul Hausmann and John Heartfield, along with Hannah Höch, Johannes Baader, Georg Grosz, Kurt Schwitters, and Max Ernst, re-invented the lost technique of photocollage in Germany.[10] Dadaists did not need to be photographers themselves to function as *photomonteurs*; they used anyone's photographs (or photomechanical reproductions) scattered in a visual ruckus of seemingly irrelevant wood engravings, stray maps, spasmotic typography, and self portraits in order to dissociate the artist from the traditional role as the originator of the images and to upset the viewer's pictorial conventions. It was the perfect retort to the insanity of a world torn to pieces by war and revolution.

The perfidious dadaists reveled in everything about the photography that had embarrassed the pictorialists of the previous generation: its mechanical reproduction of appearances, its selection divorced from conception, and its inability to idealize a subject. The capacity of a photograph to convey sentiment or personality was not a matter of concern for dada artists, who assumed that the meaning of individual pieces of photographic reproduction, like singular words, could have an additive function. This attitude can be deduced from André Breton's introduction to a 1921 Max Ernst exhibition that incorporated photographic images in several montages: "The invention of photography has given a deadly blow to the old modes of expression, in painting as in poetry where automatic writing, discovered at the end of the nineteenth century, is a true photography of thought."[11] Photography was, in the opinion of those who sought to use it as a source for readymade images, just one impersonal and mechanically reliable step away from reality. This view would dominate most critical discussions of photography for the next two decades.

The leaders of the dada movement thought little of *making* photographs, as opposed to *using* them. By dissembling the authorship of the assembled images they attacked the notion that what was valuable about them was the artist's intention.

Using and appropriating finished photographs made them more conscious of the role of the medium in perceiving the world, but not of the role of the photographer in making the picture to begin with. If a redefinition of the attitudes about creating photographic images was to occur, it would have to come from the photographers themselves.

At the same time, Stieglitz's understanding of photography as an art was beginning to change under the influence of the European avant-garde artists whose work he had been exhibiting in 291, and in concert with Marius de Zayas' notion of "pure photography."[12] In making photographs, Stieglitz had been practically dormant from around 1911 until 1915 (coincidentally the year Picabia and Duchamp returned to New York and Stieglitz's protégé, Paul Strand, began to come into his own). Although Stieglitz contributed an inadvertent double-exposure portrait of Dorothy True in 1919 to his own

Fig. 5. Alfred Stieglitz, *Fountain and Buddha of the Bathroom*, from *The Blind Man*, no. 2, May 1917, The Art Institute of Chicago, Mary Reynolds Collection

magazine *MSS*, the few photographs he made that can be associated with dada were limited to portraits he took of dada artists and a reproduction of Duchamp's notorious *Fountain* of 1917.[13] Because he was not basically a revolutionary and had developed his own vision over a long career, Stieglitz was always more of a sideline collaborator than an active leader in the movement.

None of the elite cluster of young photographers who gathered around Stieglitz in New York during the war or just after could muster the same degree of irony or detachment from values that the visiting dadas sustained in their exile. Because Americans were not suffering from a vast war on their own soil perpetrated without righteous cause, they experienced none of the disillusionment with their own cultural history that was the basis of the dada attitude. Charles Sheeler, Strand, and later Edward Weston fought another enemy: the sentimental proclivities and commercial mentality of their native philistines. Thus the new kind of photography emanating from Stieglitz and his circle did not represent a break with the past as much as an adjustment. If any of the new American photographers were iconoclastic, it was only in momentary fits and starts. Even Edward Steichen and Paul Outerbridge, who were soon to become commercial photographers, chose subjects that they respected, even revered, and presented them in a matter-of-fact way that equated the continuity of what light revealed with "the material truth of form" (cat. 221).[14] The new American photographers were now deaf to any whispering muse of romantic sentiment, as well as the practice of manipulating prints, instead deferring to the sanctity of pure photographic rendition. Although they did not abandon meticulous printing practices, their photographs were to be "straight" regardless of the subject.[15] If intimate views of their lovers were achieved with an objective technique similar to that used to make an aerial photograph, a detail of a film still, or an industrial illustration, so much the better. They sought meaning more in what de Zayas' had termed the "search for the pure expression of the object,"[16] rather than attempted to create a novel thought for an object, as Duchamp had done with his *Fountain*. They wanted to see if they could retain a faint trace of mood and symbolism while at the same time allowing the

object to speak for itself. This is not to say that Stieglitz or his followers eliminated any of the metaphysical properties they had been building into their work. Under Stieglitz's leadership, in reducing technique to the representation of an object directly seen, metaphysics was all that was left to justify photography as an art.

Although the 291 gallery was a crucible for artists as well as visitors stimulated by modernist art, its centrality and uniqueness diminished. During the war, when Stieglitz began again to photograph with regularity, he kept within the gallery itself, making portraits of visiting friends or views from the windows. In the summer of 1918, he no longer needed avant-garde art to inspire him, for his photography was reinvigorated by a series of portraits and nudes of the young artist Georgia O'Keeffe, with whom he had fallen in love. By the summer of 1922 the gallery had no particular hold on him as far as his photography was concerned, and he made a kind of escape by photographing clouds at his family's country home in Lake George. The first few photographs of this series were actually landscapes. But soon the element of landscape became tangential as the sphere of ethereal abstractions of the changing cloud formations became source and firmament. As if he wanted to demonstrate that these images were more than just photographs of clouds, his first titles had musical references, such as *Music: A Sequence of Ten Cloud Photographs, No. 1*, 1922 (cat. 210), or for a 1923 series, *Songs of the Sky*.

When Stieglitz had removed all traces of the landscape from his photographs, an underlying transcendental quality kept the cloud abstractions from being a mere play of shapes that amused many a supine cloud gazer on late summer afternoons. Outside and distant, Stieglitz's clouds were still symbolic and subjective. The cloud photographs did not answer quite so well to de Zayas' search for an external "material truth of form" as they did to the internal discovery of the artist's soul that Stieglitz had admired in Kandinsky's *On the Spiritual in Art*.[17] His later cloud photographs after 1925 were titled *Equivalents*, to keep the metaphysical reference. They were meant not only to be abstract, but spiritual, a combination that had not been easy to nurture in the nihilistic atmosphere of the dada occupation during the war.

While American photographers were pondering the nature of *things*, Man Ray left New York for Paris to catch up with his new friends Picabia and Duchamp and their *ideas*. Only loosely attached to the 291 circle, Man Ray was like none of its photographers.[18] He was rather the perfect dada conspirator: a renegade painter for whom photography was not yet a serious pursuit, and somewhat beholden to Picabia and Duchamp for encouraging him toward a conceptual approach to art. Man Ray combined commercial experience as a graphic designer and cartographic draftsman with an anarchistic abandon. Other American artists entered the avant-garde by a different route—such as Charles Sheeler, who had studied with the fashionable painter William Merritt Chase and whose personal inclinations were toward precision, order, and architecture.[19] For Sheeler, as William Carlos Williams later postulated, there were "no ideas except in things."[20]

But for Man Ray there were only fugitive situations; the perfect example being the photograph he took in 1920 for Duchamp of dust collecting on the *Large Glass*. Some of the dust was actually destined to be glued to the glass as part of the lasting work. The remaining accumulation, fascinating as it was, could only be fixed as a photograph. Duchamp's later title for the photograph, *Élevage de poussière* (Dust Breeding) (cat. 199), was a finishing touch to what was initially a glimpse of a work in progress. Later, Man Ray was responsible for a second metamorphosis when he published it in 1922 as *Vue prise en aéroplane* (View Taken from an Airplane).[21] But whose work of art was it? As the idea of dust breeding remained Duchamp's, and the actual photographic view Man Ray's, the photograph had separate authors and separate meanings. It also had its own inherent contradiction: when perceived as one, it was a work of art itself; otherwise it was a document belonging to something else.

Although he spoke no French, introductions from both Picabia and Duchamp allowed Man Ray to join the literary circle of young dadaists (Louis Aragon, André Breton, Philippe Soupault, Tristan Tzara) in Montmartre when he arrived in Paris in 1921. Near the end of his first year there, while making fashion prints for a Paul Poiret, he found that one of the sheets of paper in his developing tray was unexposed. Rather than waste it, he put several darkroom objects at hand on its surface and turned the lights on. The technique of the photogram, which had first been employed by Talbot in his scientific investigations of light-sensitive materials, was new to Man Ray, and he dubbed it the Rayogram (cat. 226). It was new to Tristan Tzara, as well, who declared it pure dada, and made much more of the accident than the modest photographer had at first.[22]

The Rayogram freed photography from being defined by camera images alone and reduced the definition of the medium to the registration of light. The technique separated what went on in front of the camera from what happened on the chemically prepared surfaces inside. The optical component now clearly related to the consistent spatial representation of single-point perspective, something most avant-garde painters were trying to avoid, while the light-sensitive surfaces, exposed to whatever fugitive images raced across them, were vaguely related to time.

The opportunity that the Rayogram provided to investigate time as a dimension of perception, however, was overshadowed by the Rayogram's strange abstraction of objects to silhouette or translucent forms set adrift as if in a timeless void. But if the Rayogram did not deal with the investigation of time as the fourth dimension or as the measure of motion, the medium of film was beginning to do so. Man Ray whimsically experimented with film, but more serious filmmakers were graduating from the simple reproduction of motion and the theatrical format to the art of sequencing. Films created the illusion of both endured time and simultaneity through the compression and reordering of past and present in montage effects.

Because of the emergence of the cinema, the paths that led toward the future of still photography skirted time's field. Not surprisingly, the one blazed by the young Man Ray bordered on the fugitive. The other, charted by the well-seasoned Stieglitz, surprisingly took no notice of Bergson, the flood of futurist manifestos, or the wit of the best dada protagonists. Stieglitz's path, it turned out, had nothing to do with the temporary, but everything to do with the eternal.

Gertrude Stein relates that when Picabia was searching for a way to keep his painting from looking like painting, he considered first if it should be like music and then became fascinated with photographs because, "the difference between a painting and a photograph is that a painting looks like something and a photograph does not."[23] She meant that a photograph is more an image than a thing itself. That the photograph had become important as an image is best illustrated by the appropriation through reproduction of the photographs of Eugène Atget by the surrealists in their official journal *La Révolution surréaliste*. For the surrealists, as had been true of the dadaists, perceiving kew meaning for an image (or eliminating the intended one) was as permissible as finding one (or eliminating one) for an object.

When Eugène Atget was "discovered" by Man Ray, who was living on the same street, the elder photographer was unaffected by the new factors of perception, abstraction, and time that his younger contemporaries were incorporating in their own photography, and occasionally trying to affix to his. Resistant though he was to such radical change, he did not try to force the tradition he admired on the new era, but rather respectfully asked through his pictures what his own time had done to its inheritance. Like a man tending a dying garden, his quiet, distant affections were indicative of the concerns that troubled the older generation during the period following the war (cats. 243, 244).

Atget and another photographer, Karl Blossfeldt, who had also been "discovered" in the 1920s, were no strangers to the "straight" photography being made by the Americans, for they still photographed with an attitude compatible with that of the nineteenth-century photographers Charles Marville and Charles Aubry. Nor were Atget and Blossfeldt concerned with the status of photography as an art or an anti-art. By the end of the decade, they would become models of the kind of photographer still capable of depicting the objective poetry of an external reality. While most photographers reacted to the new directions of the 1920s by displaying a consciousness, if not of themselves, then of their medium, Atget and Blossfeldt were set in their ways of accumulating empirical observations for their vast personal archives of what was still marvelous to look at and worth saving exactly as it was.

Fig. 6. Eugène Atget, *Les Dernières Conversions*, from *La Révolution Surréaliste* 2, no. 7, 15 June 1926

Because the Great War in Europe had finally destroyed the notion that civilization was capable of progressing toward rationality, prosperity, and peace, such steadfast survivors were needed to prove that the inherent order in nature had been and was still available to man.

Society, man's own order, was the subject of August Sander, another photographer whose analytic typology of the German people was congruent with Blossfeldt's recording of buds,

flowers, leaves, and stems (cats. 203, 204). Sander came to the notion of depicting the German social order after developing and then rejecting a fashionable pictorial portrait style that gave both the sitter and the photographer airs of distinction.

Despite the many intrafraternal honors Sander received in salon competitions, a few years after he opened a portrait studio in Cologne in 1909 he found himself forced to pedal an old bicycle into the Westerwald countryside on Sundays seeking new clients among landed peasantry. These excursions liberated him not only from interior studio work but eventually from his old printing style as well. The farmers did not require fancy printing techniques and were satisfied with photographs printed on modest portrait papers, mounted conventionally on card stock. Some years later, as Sander began to sort through his numerous farm-family portraits during the period of slack business after the war, he showed samples of these photographs to Franz Seiwert, Heinrich Hoerle, and other friends he had made among the young progressive painters in Cologne. Their interest was piqued all the more because the enlargements Sander presented to them were on glossy paper usually used for technical illustrations and architectural work. They argued that the merit of such prints was that in reducing to personal interpretation what remained was an inexorable love of truth resulting from simplicity of medium.[24] Sander, after twenty years of flattering sitters, had convinced himself that rendering the world by this new objective manner was really the photographer's true and special role.

Sander took a further and more radical step when he categorized and grouped his portraits into a structured sociological map of the German people. Around 1924, when the German currency was reformed and the portrait business was picking up, he added new categories: tradesmen at work, occupations of the urban middle-class, artists, and even society's outcasts. Sander would meet his subjects halfway, preserving the seriousness of their own projected self images as part of his study. Further, his formal exposures settled the momentary expressions of their faces and postures into summary ones.[25] Like the work of the famed geneticist Gregor Mendel, each recorded trait of pea or portrait helped to fill in and define the pattern of a larger system.

But Sander's dispassionate eye did not make him a heartless fact-finder or statistician. By recording the sturdy glory of a peasant, the pride of a police officer (cat. 202), and the dignity of a street beggar (cat. 276) Sander revealed his respect for those who were fulfilled by their occupation or heroic under adverse conditions, as he was. These values were ones he had acquired during his youth, spent in the country close to his family, and which gave him a certain old-fashioned view of society that he felt was fundamental to all civilization. The fact that he felt compelled to preserve his ideals in photographs indicates that he saw them disappearing with the past.[26]

Sander, as well as Atget and Blossfeldt, believed in a reality separate from his own existence. For the next half century, Atget, Blossfeldt, and Sander became, through the subordination of their personalities to their subjects, the models of the objective approach for the increasing number of photographers dedicated to a documentary style. The faith in photography as a truthful witness and a humanely scientific tool was reinforced by their emergence and discovery. With the increase of technology and urbanization, primary contact with the world and with nature decreased and photographers such as Atget, Blossfeldt, and Sander became surrogates for experience in the first era that began to search actively for authenticity.

Until 1927, the year of Atget's death, those interested in the practical extremes that photography had achieved as document or dada could visit one tiny Parisian street, the rue Campagne-Première, and meet both Atget and Man Ray. Although Paris would continue during the next decade to be a locus for the development of the art of photography, many of the innovative uses of the medium would come from central and eastern Europe, from Berlin and Moscow.

## The New Order and Disorder

Because dada was a movement of divergent, iconoclastic passions fueled primarily by the war, it was, as a group activity, living on borrowed time once peace arrived. The lingering impasse of anti-art would soon begin to be unblocked by a few organized strategies charting a return to order that sprouted

across Europe. In 1917, a movement directed toward pure abstraction, De Stijl, was formed in Holland. Amid the political and economic chaos in Germany, Walter Gropius founded the Bauhaus in Weimar, in 1919, as a school that integrated the disciplines of art and design. And in 1920 a movement created by Le Corbusier and Amedée Ozenfant through the publication *L'Esprit nouveau* attracted international contributors. This time the new order was founded or strongly influenced by the rationality of architects, rather than the impetuosity of poets. As *L'Esprit nouveau* declared: "The spirit of construction is as necessary for creating a picture or a poem as for building a bridge."[27] About five years later it could have listed photography as well. The emphasis on building together with a belief in a technological Utopia defenestrated any resident nihilism. This positive revolution in the arts was perhaps the most evident in Soviet Russia.

The first exhibition of Soviet avant-garde art in the West, held at the van Diemen Gallery in Berlin in 1922, was installed by a new kind of artist. El Lissitzky had studied engineering and architecture; worked alongside one of the leading abstract painters, Kasimir Malevich; developed a fusion of non-objective painting and architecture, which he called Proun; had talents in typography, graphic art, and exhibition installation; and was, in addition, a teacher. He had made or would soon make photograms, photomontages, and photographs. He referred to himself as a "constructor," which was a more forceful term than "designer." Like-talented contemporaries such as the Russian Alexander Rodchenko and the Hungarian László Moholy-Nagy also came to photography not from the ranks of practiced amateurs but as "constructors," first using the photographs of others for photomontages or layouts, and then taking their own photographs for reproductions, montages, and portraits.

As revolutionary artists of a new social order, El Lissitzky and Rodchenko considered metaphysics a penchant of German thinking that was unnecessary and opposed to the production of objects that had purpose and use. Rodchenko's first photographic enterprise was the production of propaganda posters with the leading poet of constructivism, Vladimir Mayakowsky, and then photomontages for a book of his partner's poems in 1923, *Pro Eto* (About This). Although

Lissitzky may have made photograms early on, his first datable photographic work was in 1924: advertisements for Pelican pens, a double-exposure portrait of Hans Arp, and his own famous self portrait, *The Constructor*.

In El Lissitzky's self portrait, one of the seminal images of the period, we see the delicate, serious-faced designer in perfect equilibrium. His eye is superimposed on his open hand. His hand, in turn, balances between its fingers a drafting compass that inscribes a circle. The circle intersects a line of the letters "XYZ" stenciled onto graph paper bearing the designer's letterhead graphics that point to his initials. If any photographic work can represent the extension of the revolution of modernist art into a further realm of the utilitarian and make it seem the work of a genius, it is this one. More introspective and self-referential than any of El Lissitzky's other works, it is still in concert with the lecture on the new Russian art that he had delivered in Berlin, Amsterdam, and Hanover. "We have suddenly realized that the plastic art of our time is not created by the artist, but by the engineer."[28] Mayakowsky in his poem to the Brooklyn Bridge was more succinct: "here's a fight/for construction/instead of style."[29]

The Soviet faith in production implied a respect for the potential of tools as well as workers. Rodchenko became obsessed with a hand camera that he bought in Paris in 1925 because it was free of any earth-binding tripod. Tilting his new camera up or down became a kind of sport for him, resulting in what became known in Moscow as "Rodchenko perspectives" (cats. 215, 254). This mobility intoxicated him with the possibility of what the documentary filmmaker Dziga Vertov had described as taking real life "by surprise."[30] But, in 1928, Rodchenko began to come under fire from his comrades, not only for his continuing repetition of vertiginous views but for inching away from the utilitarian and productivist function of an artist.[31] Rodchenko began to declare that *how* one photographed was more important than *what*. He found himself trying to grasp a new aesthetic for photography that superseded the photomontage. "We are discovering all the miracles of photography as if in some wonderful fantasy, and they are becoming a staggering reality."[32] The medium had become its own study and its own reality.

In many respects Moholy-Nagy was a Central European mirror of Rodchenko. They admired each other's work and corresponded from their respective teaching positions in the metal workshops at the Bauhaus and the Vkhutemas. In 1924, both had started to make photographic portraits of friends with the camera (Moholy-Nagy had made photograms with his wife, Lucia Moholy, as early as 1922). Moholy-Nagy, too, made his first vertiginous perspective photographs during a visit to Paris in 1925 to see the International Exposition of Decorative Arts and Modern Industry, which premiered Vertov's *Kino-auge* (cat. 213).[33] But there were differences: Moholy-Nagy, the theorist, wrote about photography in advance of his accomplishments; Rodchenko, the empiricist, wrote in order to clarify or defend how he photographed.[34] The former, thus, saw photography and its particular aesthetic as a pedagogical research tool for contructivism, and the latter for its practical application.

During Moholy-Nagy's tenure at the Bauhaus (1923–1928), there were no formal photographic courses, nor did he teach special courses on the side. Photography, nevertheless, was well discussed, practiced, and attended to among the faculty (Josef Albers, Herbert Bayer, Georg Muche, Hannes Meyer, Joost Schmidt) and students.[35] In 1925, Moholy-Nagy's first book, *Malerei, Fotographie, Film* (Painting, Photography, Film), was issued as the eighth in a series of Bauhaus books treating contemporary art.[36] The first edition—written and assembled in the summer of 1924 before his familiarity with the camera—reproduced only one camera photograph by Moholy-Nagy and was essentially a notion of the medium that had been developed by someone who was not primarily a photographer. His notion concerned itself exclusively with how the functional mechanisms operated in directing images from the outside in. It was not a projection of the photographer onto the world from the inside out. "Everyone will be compelled to see that which is optically true, is explicable in its own terms, is objective, before he can arrive at any possible subjective position."[37]

Among the more progressive professional photographers in Germany, like Sander or Helmar Lerski who both became known for an objective approach, Albert Renger-Patzsch (cat. 264) is the one most often cited as the photographic

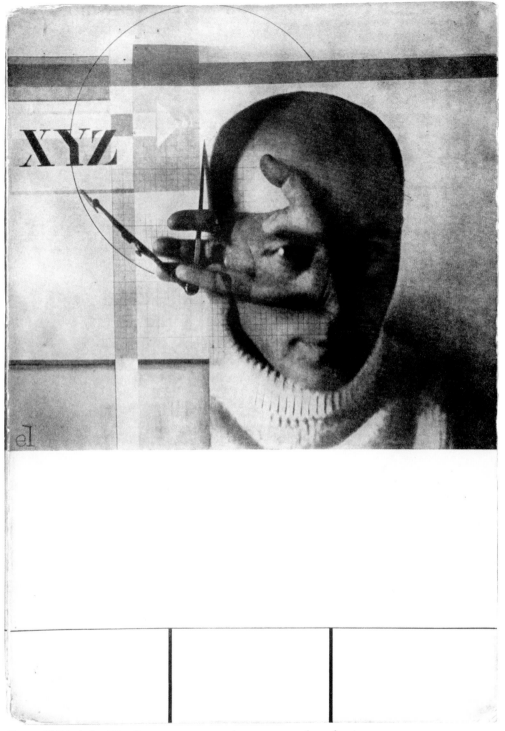

Fig. 7. El Lissitzky, *The Constructor*, 1924, photomontage, from front cover of *Foto-Auge*, 1929, 26.0 x 20.0 (10¼ x 7⅞), Private collection

parallel of a movement in painting called *Die Neue Sach-lichkeit* (New Objectivity).[38] Renger-Patzsch's photographs, however, were generally antithetical to the feeling of social malaise that the painters in the movement, such as Christian Schad, expressed. Renger-Patzsch's influential book, *Die Welt ist Schön* (The World Is Beautiful) was not first and foremost a critique of society or an intellectual work, like *Malerei, Fotographie, Film*, expounding an idea about photography. It was a picture book that implied through its sequencing that natural plant forms, animals, industrial products, and details of cathedrals and factories related to each other through an inherent, god-given geometry and order.

Although the objectivity of photographic rendition became nearly a goal unto itself in Germany from the mid-1920s on, Moholy-Nagy's view was that photography as a medium should be primarily concerned with the plastic manipulation of light and secondarily with objectivity. He dissected the German word for serious photography, *Lichtbild*, into its literal meanings: "light picture," and referred to himself by coining the term *Lichtner*: one who deals with light. Using printing-out paper that darkened slowly on its own during exposure to light as the material for his early photograms, he constructed an image by moving objects or by manipulating the light itself during the time of exposure. Or, in his camera photographs, by applying his unique sense of graphic chiaroscuro, he rendered light not as atmosphere or volume but as flat, geometric pieces.

That photography was understood so well as a medium in Europe by those "constructors" who had not apprenticed as professionals or begun as amateurs should not seem surprising. Photography as a medium was now being seriously studied and practiced by artists of the highest rank. Outsiders who were able to see it from enough distance recognized many of its unique properties and potentials *vis-à-vis* other modes of artistic expression.

What photography was to those who saw it as a tool rather than as a profession was summed up in a 1929 exhibition devoted to the explanation of the medium, *Film und Foto*, which toured Europe and Japan.[39] The accompanying catalogue stated that an attempt had been made to represent and articulate systematically three territories belonging to

the photographic process: the document, the fixing of motion, and the conscious modeling of light and shadow. The exhibition did not claim that the photographs were works of fine art, but in avoiding the issue that had plagued the pictorialists for decades, the organizers of the exhibition, of whom Moholy-Nagy was one,[40] cleverly kept the question of *what* kind of art it was before the viewer's imagination.

The "new photography" that had begun to flourish around the mid-1920s from Paris to Prague, in New York, California, and Japan, and which was consolidated in *Film und Foto*, had no particular emotional or philosophical ground and was based more on experimental technique rather than an ideal. And as far as it had an aesthetic, it was one based on the function of photographic materials and cameras. The "new photography," by allowing any *optical* manipulation or distortion of light, was a functionally self-conscious expansion of the American notion of "straight" photography. Because the medium had become its own subject, if the "new photography" had a style it was of tautological simplicity: its pictures must look photographic.

The "constructors" of central and eastern Europe and the photographers who followed their lead in the glorification of machine production and abstraction sought to reduce both processes and shapes to fundamental elements and eliminate any trace of manual intervention. In reconstituting the elemental into a new world, the optical objectivity of photography was compatible with the genius of the rational, architectural mind. But the genius of the era was not wholly dominated by rationality. Moholy-Nagy, in saying that photography compelled one to see what was objectively true, avoided the whole issue of illusionary perceptions, which put him at odds with the surrealist vision of the world that had developed out of dada and an appreciation for Freud. In surrealism there was a more consistent aesthetic role for photography to play in showing that the world was *not* what it rationally appeared to be. As Breton later warned: "Let us not forget that in this epoch it is reality itself that is in question."[41]

Curiously, the faith in the objectivity of photographic rendition was part of Breton's appreciation of it. Certain photographs—whether anonymous, by Atget, or by Man Ray—hinted that the optically recordable world was equally

fantastic as any that could be constructed or created by the imagination. The poetry mined from such photographs depended on perception alone, just as Breton and his circle perceived the poetic potential in the technique of automatic writing by which they attempted to mine their own subconsciousnesses. For the surrealists, Atget's photographs of boulevard shop windows advertising their merchandise became stores of curiosities, making daily life a kind of carnival display. Of course, to understand Atget only as the surrealists did would be to deny most of his intentions. But to fail to understand him as they did would be to misinterpret a period that was beginning to believe that anything was a work of art if only perceived as one.

Breton reproduced photographs throughout the issues of the journal *La Révolution surréaliste*, though none was intended to illustrate to the surrounding verbiage. Work by Atget or Man Ray stood in complete isolation, asking the viewer to understand its inclusion in the journal as the confirmation of the idea that photographers were uniquely able to witness to some incidents that simultaneously evoked dual meanings: the one redundant with fact and the other, "while not existing, is yet as intense as that which does exist."[42] Everything was brought into question and nothing was clarified by the inclusion of these photographs, nor was it meant to be.

For Breton, the pencil of nature was not prescribing an antidote for the egocentric excesses of artists, but mechanically jotting down coded signals intelligible to an inner self. The true function of thought, free of all rational, aesthetic, or moral preoccupations that the founder of surrealism had defined in his 1924 manifesto, was not exclusively a poetic concern. Any medium that could operate as a "disinterested play of thought" was worth tolerating under a watchful eye—as was any homologue of automatic writing, or any medium that suggested a reality for dreams. And if, like photography, it actually verified the marvelous, all the better.

Besides the Rayogram, Man Ray's darkroom yielded another technique that brought optical reality into question. As the Rayogram was an expression of the irrational relationship of inanimate objects, the "solarized" photograph became Man Ray's graceful expression of his disaffection with nature's yet libidinous beauty of face (cat. 228), figure,

or flower. Although the "Sabbatier effect," as it was properly called, had been long known to technical researchers, it too was to have an accidental rebirth in the arts: while developing negatives in the darkroom, Man Ray's assistant Lee Miller inadvertently turned on the lights. Ever wanting to make the best of a ruined situation, Man Ray printed the negative to discover a partial reversal of tones. Part of the picture appeared as a positive and part as a negative. The incestuous implication with the parent negative made the offspring more bewitching. Like a forbidden liaison, the technique of solarization was kept secret and only made known in working detail around 1932, when Man Ray broke off his amorous relationship with Miller. So between 1929 and the publication of *La solarization* by Maurice Tabard in 1933,[43] the technique was exclusively Man Ray's artistic property.

Photography, at the time, was full of other tricks, as well. Multiple exposures, which confused time, place, gravitational collimation, interior and exterior, human and mechanical, or any number of other ingredients, implied simultaneous realities, and as such they could lead to psychic discoveries or represent dreams. Other photographs printed as negative images were sometimes successful as surrealist pursuits. But all of these tricks and techniques had to be shared either with amateur gimmickry, which dissembled the seriousness of artistic investigation, or with constructivism, and as such deflected the surrealistic purpose of marveling at perception itself. Only Man Ray's "solarization" was born of surrealism with a perfect pedigree.

The disorder that surrealism was meant to bring to the rational perception of reality was an outgrowth of its dada origins. However, as the term "surreal" became less specifically associated with Breton and entered the language, it became synonymous with terms such as "curious," "fantastic," and "weird." Surrealism in photography needed a Freudian tone or a poetic imagination associated with chance to make it something other than a stylistic appliqué of an artist's prodigal dissipation or half-hearted mysticism. Few photographers intuitively understood—as Man Ray did of objects and Henri Cartier-Bresson would later of time—that it was photography's anchor in reality that gave the medium an entrée to surrealism at all, and allowed it to retain a cer-

tain order amidst the new disorder that Breton was imposing on the world around him.

## THE RIGHT MOMENT

When the child photographer Jacques-Henri Lartigue grew up, he remained an amateur. He kept his rompish demeanor, proving over and over again with his camera that, even after the Great War, a boundless spunk survived. He resumed in "les folles années" what had begun for him as a child at the end of "la belle époque." Lartigue's photograph capturing his small son's exuberant companion leaping over a sand castle on the beach at Royan in the summer of 1924 (cat. 235) is a marvel of picture-making invention. Years of recording his life through snapshots, judged only by the spontaneity of the passing fancy they conveyed, made the unconventional act of composing a vertical panorama child's play. No preparatory manifesto, theoretical argument, or revolutionary world view was needed to tilt the camera ninety degrees—just a photographer's reflex.

A little of the insouciance of the twenties in Paris was evident by the middle of the decade in Berlin as well, if the work of the amateur Friedrich Seidenstucker or the photojournalist Martin Munkacsi is any indication. For Seidenstucker, the pleasure of the incidental moment usually associated with family outings or celebrations appeared on streets full of strangers. For Munkacsi, who had begun his career as a sports photographer, the curiosity of freezing time at the moment of climax was sufficient for a personal style and for the amusement of a new readership that expected both to be informed and entertained by photographs in magazines (cat. 234).[44]

Despite a continuing abundance of "isms" and manifestoes during the 1920s, the recognition of time as a dimension of perception in photography came from the personal and practical, rather than the theoretical, side of the medium. Because snapshot photographers kept their photographs in private albums—Lartigue's work was not published until the 1960s—their work had little influence on other photographers at the time it was made. It is therefore necessary to take a closer look into the field of photojournalism in order to understand how the photographic moment became an equal complement of the photographic object.

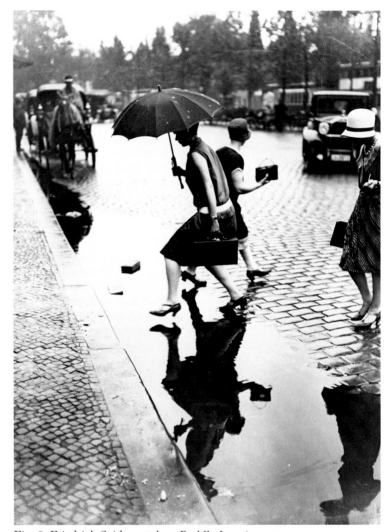

Fig. 8. Friedrich Seidenstücker, *Puddle Jumping*, 1925

In the early 1920s publishers of fashion magazines were willing to take on photographers, such as Edward Steichen, for stylish portraits and product illustration. By the end of the decade, newspapers and magazines were hiring photographers as journalists, occasionally allowing them to create their own assignments and attend to the research, editing, and captioning of their stories.[45] Thus, with the encouraging responses of editors like Stephen Lorant of the *Münchner Illustrierte Zeitung*, the photo-essay was born. The sequencing of images, like an abbreviated newsreel, together with the em-

phasis on graphic layout and introduction of high-speed ro-
togravure presses, combined to revolutionize print journalism.
Photographers received picture credits as writers received by-
lines, and some gained modest fame. But the non-committal
politics, economic machinery, and distribution of the publi-
cations of large circulation were beyond the photographers'
and the editors' control. Such circumstances were less trou-
bling for Soviet photographers or for those who needed to
hold on to their jobs during the high unemployment of the
1930s. But, for the few photographers who earnestly thought of
the medium as an artistic expression, there was bound to be
frustration.

The new photojournalists were usually self-taught pho-
tographers, who had pursued some other career in art or lit-
erature. In this regard, André Kertész, perhaps the best
among them, was an exception in that he had always wanted
to be a photographer. Before he began to contribute to a
handful of literary journals and German magazines in 1927,
or to Lucien Vogel's *Vu* magazine in 1928, he had been an
amateur photographer in Budapest for thirteen years and
had spent a year and a half on his own in Paris. Through his
compatriot Lajos Tihanyi, a modern painter, and the Belgian
poet/painter Michel Seuphor, both of whom had settled in
Paris, Kertész was introduced around town and began to see
the city with new eyes. Borrowing from his friends' modernist
attitudes, as well as from the serenity of Mondrian's abstract
compositions, Kertész harnessed his energetic Hungarian
mettle without abandoning all of his romantic sentiment.
Through the clarity of form that he achieved, objects and
people fit effortlessly into the elegant still lifes, and in his
photograph titled *Satiric Dancer* (cat. 242) even the un-
tamed, the world of time and motion, registered a simple
Euclidian order.

From his first day in Paris, Kertész prowled the streets
with a small hand camera. But he was not the only one intui-
tively searching out the city's genii, daemons, characters,
and oddities. André Breton too had rummaged through the
flea market of Saint-Quen or roamed the streets in the heart
of Paris in search of chance encounters, and might have been
mistaken for a photographer if he had carried a camera. In
examining reality as if it were a perspicuous disguise, the
same state of anticipation for the unexpected that animated
the eyes of photographers served the poet. The belief that
revelation was spontaneous was common to both. The trick
was to encounter, through an accident of time, not what was
suspected but what was unforeseen.[46]

Errant photographers of this discipline and purity were
rare. Still, the young free-lance photojournalists were on
their own much of the time, as they were seldom fully em-
ployed. What they had created through their photographic
habits was described by the writer Pierre Mac Orlan as the
work of *révélateurs*[47] in two critical discussions of photography
in 1928 and 1929:

> At its present stage of growth, photographic art can be
> divided into two classes which more or less define the
> poles of all human artistic creation. There is plastic
> photography and documentary photography. This second
> category is unwittingly literary, for it is nothing other
> than an observation of contemporary life apprehended
> at the right moment by an artist capable of seizing it.
> Sometimes he must wait ten hours for the unique in-
> stant when life can be caught, you might say, in the very
> act.[48]

> It is through the mediation of photography that we
> are permitted to seize the unreal forms of life, which
> demand, at least, one second of motionlessness in order
> to be perceptible. . . . The greatest field of photography,
> for the literary interpretation of life, consists, to my
> mind, in its latent power to create, as it were, death for a
> single second. Anything or person is, at will, made to
> die for a moment of time so immeasurably small that
> the return to life is effected without consciousness of the
> great adventure.[49]

Mac Orlan's idea of "the right moment" did not cogently
express what he was trying to say about the "documentary"
photographs by Kertész. Unlike Munkacsi's fascination
with frozen climaxes or Breton's *explosante-fixe*, Kertész's
extractions from the flux of time were pauses meant to en-
gage the viewer's imagination and then be continued by it
like the portentous paragraphs of a mystery novel.

Pierre Bost, another writer, described the philosophical

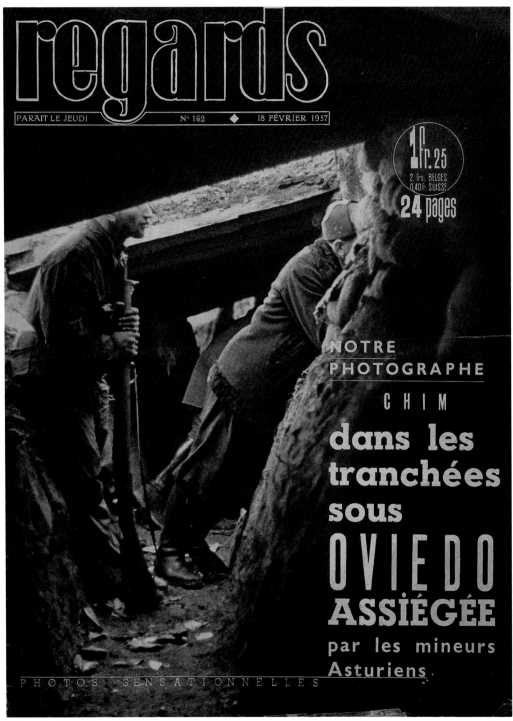

allure that the unexpected held for the street photographers by linking it with the objective record for which the medium had been celebrated elsewhere. In introducing a gravure portfolio of photographs by Kertész, Germaine Krull, Eli Lotar, Roger Parry, Maurice Tabard, and Emmanuel Sougez, among others, he coined a phrase that reconciled the truthfulness of the optical record with the moment of revelation inherent in the photographic exposure:

> No one thought these images stolen from the world, these formulas snatched from their inventor, were anything other than documents—useful but not beautiful. We have since discovered that all truth, no matter how fleeting, should be respectfully considered. Ephemeral truth? Indeed, this is at once photography's special attribute and its handicap. Photography cannot pretend to fix more than the instantaneous—that term so speedily and aptly appropriated by the medium.[50]

Photography now was seen as locating its revelatory truth not only in objects but in a suspension of time. Bost understood that the photographic truth was not an absolute one, as "the medium creates a realm which we cannot wisely deem true or false. . . . "[51] This relativistic attitude, though not compatible with Moholy-Nagy or even Breton's faith in the objectivity of photographic rendition, was closer to the photographer's own experience with the medium. Further, it matched the epoch in which it was born and the notion of time that Einstein had provoked. Whatever truth photographers retained through their witnessing was only as believable as any witness is against another of equal persuasion.

Because photographs were seen as a confirming proof of specific situations, witnessing as a metaphor for photographing became increasingly common beginning with the photojournalists of the late 1920s and continuing on through the social documentary photographers of the 1930s. Witnessing and photographing was an apt comparison, for with the rise of the illustrated press followed by books comprised entirely of a single photographer's work, the photographer more and more acted as a surrogate eye for tens of thousands of viewers. As the appetite for the unusual increased, the seeking of dangerous, concealed, or forbidden situations became a chal-

Fig. 9. Chim, *Photograph of Spanish Soldiers in the Trenches*, from *Regards* magazine, 18 February 1937, Private collection

lenge to photographers since their work had to be done on the spot rather than in the shelter of the imagination. Before Robert Capa and David Seymour (Chim) made themselves known in 1936 during the Spanish Civil War, the photographer with the greatest daring was Brassaï.

In photographing the hoodlums, prostitutes, transvestites, opium dens, and cheap music halls of Paris, as well as the better-known boulevards and attractions of the nocturnal city, Brassaï came to know the city inside out, as Henry Miller remarked in describing their meandering together in his 1934 novel the *Tropic of Cancer* (cats. 245, 246, 247).[52] The exploration of the Parisian *demi-monde* as a massive communal subconscious was not initially a photographic endeavor, but one present in Mac Orlan's literary idea of the "social fantastic," in which the erotic and threatening was situated out of easy view "where man is in the habit of disposing of undesirable or harmful elements that threaten his existence."[53] Before Brassaï learned from his compatriot Kertész that photography at night was possible, he roamed the streets at night with friends, such as the poet Léon-Paul Fargue. The publication of Brassaï's book *Paris de nuit* (Paris by Night) in 1933 had been preceded, by a year, by Fargue's celebrated *Le piéton de Paris* (The Pedestrian of Paris), an account of his wanderings about the city in search of its residual soul, which in turn followed Louis Aragon's 1926 novel *Le paysan de Paris* (The Peasant of Paris).

Brassaï's camera, tripod, and lighting equipment required him to be bold rather than inconspicuous if he were to show Paris in the mood of the city through its walls and deserted streets and the activities they concealed. His passion was not for the pure photographic rendition of static objects or in the split-second exposures that uncovered the interior of the moment. Rather, his aspiration was to be a kind of recording secretary to the act of living. His photographs were frank and, like Sander's, convincing, for he too secured the confidence and cooperation of his subjects, treating them as if they were actors and actresses playing their own roles.

For the photographer who desired to record life surreptitiously, the small 35mm camera known as the Leica was unsurpassed.[54] Many hand cameras had to be reloaded with another small glass plate or sheet of film after each exposure.

Thus, it was common for photographers to plant themselves and await the movement of the subject to resolve itself within the frame. The Leica allowed them a new agility in the flux of the changing situation itself. Beside the convenience of having several dozen exposures loaded in the camera, the quality that set the Leica apart from other cameras was its ability to serve as a true extension of the eye. The Leica viewfinder allowed the picture to be framed and taken almost exactly from the position of the photographer's eye. As the photographer's head turned, looked up or down, the camera responded immediately.

Although invented and perfected by a German engineer of the Leitz company, who was an amateur photographer and a hiking enthusiast, the Leica became more famous as the traveling accessory of one chronically footloose, disaffected youth rebelling from the bourgeois life of his family. When Henri Cartier-Bresson acquired his first Leica in 1932, it would have been hard to predict he would eventually become a professional photographer. After four years in the constant company of the Leica, this would still not have been a certain guess, even for him.

Cartier-Bresson came to the Leica, not with conventional amateur enthusiasms, but as a culturally precocious young man still in the rut of adventure's lure. As a teenager, he had already read Rimbaud, Mallarmé, Lautréamont, Proust, Joyce, Dostoevsky, and fed on the ideas of Marx and Freud. Several painting instructors (one of whom, André Lhôte, had a respectable name among the less radical modernists) had tried to channel his epigenetic talent into the quiet practice of easel painting. But he was too restless and soon was attending livelier intellectual pursuits at the Montmartre cafe gatherings of the youthful literati around Breton, and came under the spell of surrealism.

His first photographs, beyond the casual snapshots of his boyhood, were still-lifes of randomly packed moving carts and the discarded remains of slaughterhouses—exemplifying the kind of distress of a surrealistic "encounter." The repulsiveness of such objects may have symbolized the disgust he had for the moribund spirit of bourgeois society, yet such subjects did not express his own need for the rush of life, nor did they reflect the vagabond pattern he was setting for him-

self. With the Leica as his companion, he could see the world with his own eyes, and judging from the originality of his early Leica pictures, one might assume that his seemingly unpatterned travel was structured by a pursuit of novel subjects for his photographs. But more than likely he was still just restless, and the camera was witness rather than protagonist in what the poet Rimbaud would have described as a senseless voyage of discovery.

Julien Levy, who organized the first exhibition of Cartier-Bresson's photographs in 1933, anticipated that the work might not be understood, even by the most progressive New York photographers. The introductory wall text and mailing announcement reproduced a letter from a Peter Lloyd (Levy's pseudonym) in Paris preparing the viewer for something new:

> I myself am 'emballé' by the vigour and importance of Cartier-Bresson's idea, but an essential part of that idea is such a rude and crude, such an unattractive presence, that I am afraid it must invariably condemn itself to the superficial observer—as if a Della Robbia should be cast in gold before it might be appreciated. If Cartier-Bresson were more the propagandist and could efficiently promote some theory or another to excuse his work— but you know how he is sincere and modest. . . . You have two exhibition rooms in your Gallery. Why don't you show the photographs of Cartier-Bresson in one, and the innumerable, incredible, discreditable, profane photographs that form a qualifying program for his idea, show those in the other room? . . . Septic photographs as opposed to the mounting popularity of the anti-septic photograph? Call the exhibition amoral photography . . . equivocal, ambivalent, anti-plastic, accidental photography. Call it anti-graphic photography.[55]

Cartier-Bresson's early photographs (cat. 250) exude spontaneity, intuition, and revolt by adding a measure of Breton's "convulsive beauty" to every measure of André Lhôte's more predictable abstract geometry.[56] Beyond this peculiar amalgam, they speak directly of chance events and the cinematic nature of his vision. If the Leica were held horizontally, it presented the photographer with a viewfinder scene in almost the same aspect ratio of a motion-picture projection. His selection and reflex could then record the world in its flux (cat. 237). In his intuitive understanding of the medium, Cartier-Bresson took photography into the dimension of time, beyond Lhôte's compositional formulas and Breton's inspirational but possesive definitions of art. There spontaneity had a higher order of meaning than the simple juxtaposition of one object against another. By situating photographic objects within a disjunctive, yet admissible, situation, Cartier-Bresson contrasted them with a situation or an event suspended in time. What had previously been an entertaining comparison of objects freed from their cloying backgrounds by a frozen moment now hinted at a future possibility of figuring one *event* against another, where time would be the primary dimension of perception.

That Cartier-Bresson was not labeled a surrealist was due to the fact that few of his photographs were exhibited, published, or critically examined before 1936, when he became a photojournalist, taking daily assignments, along with Robert Capa, for the communist newspaper *Ce Soir* founded by the surrealist poet-turned-political activist Louis Aragon.[57] Civil war in Spain, fascism in Italy, and Hitler in Germany - forced larger issues to the fore. The politically minded Cartier-Bresson began to temper his whimsical pursuit of what the Leica could do with a different sense of realism.

In speaking at a 1936 symposium organized by the Maison de la Commune, a communist cultural organization in Paris, Aragon took contemporary painters to task for having nothing human left in their canvases. In urging them to take social realism as the standard of supreme good and beauty, as they had once taken nature, Aragon turned to the cinema and the legitimization it gave to the kind of photography that had grown out of the snapshot as the best example.

> It has happened that, thanks to the technical perfection of the camera, photography, in its turn, has abandoned the studio and lost its static, academic character—its fixity. It has mixed into life; it has gone everywhere taking life by surprise; and once again it has become more revealing and more denunciatory than painting. . . . The strange part of this rediscovery is that, suddenly, when timid painting has long since renounced daring compo-

sitional arrangements, photography reproduces at ran-
dom, in the streets or anywhere, the earliest audacities
of painters. . . . And here I have especially in mind the
photographs of my friend Cartier.[58]

Photographic art and propaganda took on new meaning
with the advent of worldwide economic depression and the
rise of fascism in Europe. The neglected field of social docu-
mentation now attracted photographers ranging from Man
Ray's apprentices to leftist politicoes totally uninitiated in
photography. During the 1930s, photography split in two
camps. One responded to the realities that surrounded and
threatened them from the outside and the other looked further
within the medium and themselves for an aesthetic solution
to the impending changes of the modern world. Because
photographers of both the documentary and the plastic per-
suasion, to use Mac Orlan's terms, believed in the medium's
consistent, internal accuracy of rendering the world by wit-
nessing or optical registration, the field did not come apart
under the decade's strain. The two decades between the
wars formed a relativistic period that began to see not only
art, but truth, as a matter of perception, and photography as
an objective vehicle to either one.

## Spiritual Equivalents

Edward Weston, for one, found it hard to give in to the idea
that nature was not the standard of supreme good and beauty.
He summed up the attitude toward photography that was
developing in America among the generation of photogra-
phers who followed Stieglitz in a statement he wrote for the
1929 *Film und Foto* exhibition:[59]

> The finished print is previsioned on the ground glass
> while focussing. . . the shutter's release fixes forever
> these values and forms. . . . Not to interpret in terms of
> personal fancy, transitory and superficial moods, but
> present with utmost exactness,—this is the way of pho-
> tography. . . . Vision, sensitive reaction, the knowing of
> life, all are requisite in those who would direct through
> the lens forms from out of nature,—maybe only a frag-
> ment, but indicating or symbolizing life rhythms.

Although El Lissitzky believed Weston's idea of an artist
to be hopelessly bourgeois and reactionary, a tentative com-
patibility still existed among the freshmen "new photogra-
phers": they had unanimously rejected pictorialism and
adopted an optically objective technique. Weston had his
own doubts about the avant-garde. In his private *Daybooks*,
Weston, convinced of the inanity in Moholy-Nagy's and
Man Ray's experimental photography,[60] expressed his own
dissatisfaction with the many progressive ideas he had been
absorbing second-hand through publications:

> September 4 [1926]. A copy of Spring *Little Review* at
> hand. . . . I used to eagerly await it—to devour it. Now I
> find myself impatient, irritated or indifferent to most of
> its contents. I feel but an attempt to force attention by
> bizarrerie, or a fierce, puerile effort at being intellec-
> tual.[61]

Weston made this diary entry near the end of his second
extended stay in Mexico, where, through his artist friend Jean
Charlot, his allegiance to symbolic expression survived in a
purely functional approach to photography.[62] Stieglitz, too,
had refused to abandon symbolic expression in his *Equiva-
lents* (cats. 255–257). When Weston and Stieglitz had met in
1922, the young photographer had the good fortune to meet
the rejuvenated master rather than the one who by his own
admission would have had little to show some four years earli-
er. The ever-outspoken Stieglitz criticized the photographs
by Weston that others generally praised, all the while forti-
fying the young photographer's recent resolve to leave his
former pictorial indulgences behind and set out in a direc-
tion all his own. As Stieglitz had, Weston was at the time
about to separate from his wife and family and begin a new
life. Disenchanted with his declining portrait business, in
1923 he pulled up roots and set sail for Mexico, enthralled
by the country's exotic promise and the impulsive coaxing of
his younger mistress, model, and soon-to-be-photographer,
Tina Modotti.[63]

Weston brought to Mexico the desire for a new start as a
photographer. In his mind, he also brought with him what
he had seen firsthand of Stieglitz's nudes and portraits of
O'Keeffe, and whatever Strand had shown him. The pho-

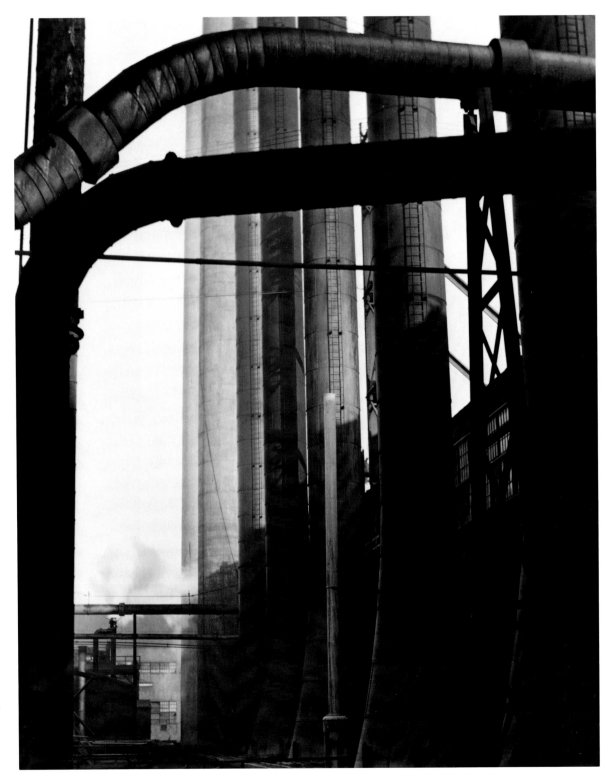

Fig. 10. Edward Weston, *Armco Steel, Ohio*,
gelatin silver print, 1922, San Francisco
Museum of Modern Art, Copyright 1981,
Arizona Board of Regents, Center for
Creative Photography

tographs that he had admired, Sheeler's architectural views, stayed with him as persistently as any others. Of Weston's own work, the New Yorkers roundly admired his first attempts at an industrial subject, the Armco Steel plant. Once in Mexico, the idea that machines and articles of manufacture could have a photographically sensual character affected Weston even more deeply, and he carried the idea further than any of the photographers he had met in New York. New subjects, such as his porcelain toilet bowl and a simple metal wash basin stored under his sink (cat. 263), asserted themselves as he wasted hours every week waiting for portrait business in his studio.[64] Part of this new enchantment was still with the new sense he gave to form, but, as the Mexican painter David Alfaro Siqueiros wrote, part was with the seductive clarity of photographic rendition: ". . . Weston and Modotti create TRUE PHOTOGRAPHIC BEAUTY. Material qualities of things and of objects that they portray could not be more EXACT; what is rough is rough; what is smooth, smooth; what is flesh, alive; what is stone, hard."[65]

The photograph that rendered an object so exactly as to mimic its physical properties exhilarated Weston to such an extent that he neglected other characteristics of the medium, especially the emotional intensity of suspended moments in time that he had captured in several 1924 portrait heads (cat. 206) with his Graphlex camera. What emerged first from his obsession with precise rendition was a pursuit of what he called "the thing itself,"[66] and what developed from this notion was the gradual replacement of one sense of form by another: the architectonic-sometimes-planar by the organic-sometimes-volumetric. With the end of his Mexican sojourn and his return to California in 1926, the latter sense of form became evident in his famous studies of the exquisite and erotic shapes of shells and vegetables.

Weston had not been the first photographer to discover the inherent geometry of natural forms, whether architectonic or organic. It had occupied Blossfeldt's entire career and had appealed, as well, to Steichen, who for a brief period immediately after World War I had given up almost everything for gardening. In Steichen's attempt to deal with Einstein's perception of the world through a series of 1920 time/space continuum compositions, natural forms agreed more readily

Fig. 11. Edward Steichen, *Triumph of the Egg*, c. 1921, warm-toned gelatin silver print, 24.0 x 19.1 (9⁷⁄₁₆ x 7½), The Art Institute of Chicago, Bequest of Edward Steichen by direction of Johanna T. Steichen and George Eastman House

with mathematics than with anything to do with time. In his search for a new vision of nature, Steichen was one of the first to adopt "straight" photography as fundamental to the medium's inherent scientific rationality.

Imogen Cunningham, who had also come out of the pictorialist tradition, is still another example of the irresistible lure "straight" photography and the abstract forms of nature had for photographers seeking a break with the past. Her graphic studies of plant and animal forms (cat. 260)—a selection of which was chosen by Weston for the *Film und*

Fig. 12. Edward Weston, *Mount Lassen National Park*, gelatin silver print, 1937 printed by Brett Weston, The Art Institute of Chicago, Gift of Max McGraw, Copyright 1981, Arizona Board of Regents, Center for Creative Photography

*Foto* exhibition—were as much in tune with current German photography as with the photography in California.[67] The approach of the "new photography" was clearly international in character.

Cunningham, Adams, Willard Van Dyke, and a handful of other photographers in the San Francisco Bay area formed a casual association in 1932 for the promotion of "straight" photography and natural subjects. Their name, F.64—the smallest aperture of most view camera lenses, producing sharp focus with the greatest depth of field—underscored their objection to the optically soft moodiness of pictorial photography. Weston was a member, as well, but not because he sought encouragement from the others. The understanding

of the medium and vision of the world that he had reached independently served the group more as a model than as a compatible emerging expression. Beyond the still life views of nature that had become common, the F.64 photographers and others began to grapple with the representation of distance and atmosphere through various motifs. The abstract chiaroscuro patterns of vast stretches of sand dunes, indicating distance, and the luminous expanses of clouds over a darkened ground, indicating atmosphere, were two of Weston's solutions in the mid-1930s. The radiance of a sunburst by Laura Gilpin (cat. 261) and a hacienda doorway by Strand (cat. 262) opening onto the most subtle play of light that his film could record were other steps that made use of the architectonic compositions of the 1920s. Step by step, landscape photographers found a balance between the familiar, enclosed, formal compositions and the open structure of radiant light and atmosphere, equating luminosity with spirituality.

The shift that Weston made away from active composition in the studio to a more passive and respectful observance of the landscape in the 1930s was not an act of obeisance to a superior force. Despite his respect for nature, Weston sought to possess what he saw to such an extent that he often compressed his subject in the view finder, sometimes confusing its true scale. Ansel Adams, on the other hand, saw man as subservient to nature and chose subjects that magnified its grace and power (cats. 265–267). When the maturity of his vision matched the virtuosity of his technique, the photographs that Stieglitz had shown at his American Place gallery in 1936 became more sophisticated and began to incorporate other factors of his awareness, as well as a sense of time. Adam's 1940 sequence of abstract designs of waves on a surf-smoothed beach, for all its possibilities for showing age, erosion, and the irreversibility of time, presented nature, like Stieglitz's *Equivalents*, as cyclic, renewable, and eternal. He had already photographed a moonrise and an eclipse, showing that nature's fleeting moments were determined by forces beyond man's control. Even the disruptive moment of awe that he portrayed as a clearing storm in the Yosemite valley was unthreatening and magnificent, allowing man a sheltered safety in nature as a humble viewer.

At the same time, Weston's vision of nature was becoming

246

Fig. 13. Ansel Adams, *Clearing Winter Storm, Yosemite National Park, California*, gelatin silver print, 1944, 18.7 x 22.9 (7⅜ x 9), Center for Creative Photography, University of Arizona, Copyright 1980, the Trustees of The Ansel Adams Publishing Rights Trust, All rights reserved

unsettled within him. At Point Lobos—once Weston's bound-less source for images of natural order and design—nature became a darker, moodier place entangled with gloom and glory (cats. 268, 269, 271). Unlike Adams, who could accept nature as a supreme force, Weston still struggled to possess it on his own terms, which is what his architectonic compo-sitions as a pictorialist and a modernist photographer had taught him to do. Weston was not simply repeating his earlier successes; he felt that physical order produced rather than resolved the spiritual mystery within his perception. Any-thing could contain everything, and Point Lobos became the ground of both paradise and hell in Weston's last views of his most beloved subject.

By the time Weston had begun his final series of Point Lobos in 1938, Stieglitz was no longer able to photograph. Stieglitz's photographs, unlike the contrasts that animated the rocks, cypresses, and waters of Point Lobos, had come to embody a quiet resignation. As he photographed the dying poplar trees on his family's Lake George property or the subtlety of light raking over a humble patch of grass, Stieglitz felt alone in an age that was abandoning spiritual values. He characterized the photography of the troubled decade of the 1930s in a letter to Weston in September 1938 as having "So little vision.—So little true *seeing*.—So little *inness* in any print," knowing Weston, if anyone, could still understand what inness was.[68]

At the end of their careers, great artists who step beyond their own virtuosity encounter a world more demanding of their genius than any struggle with youth's identity or the style of middle age. Unable to start over, they are forced to finish the person they have become. Thus Stieglitz marked the tributary that led to mysticism for succeeding generations to explore. He had no cause to follow it to its source, having already found the course from the secular to the spiritual with his agnosticism intact. As they aged, Stieglitz and Weston made fewer testimonials about the medium's inherent ob-jectivity, as they had come to believe that both photography and nature now had to satisfy an inner sense of truth rather than supply one. Still, they did not entirely abandon nature for the expression of their own voices, for their photographs made the viewer feel as if nature were speaking of itself.

## IMPINGING REALITIES

When Dorothea Lange left her career as a San Francisco portrait photographer to devote herself to social documentary in the mid-1930s, she pinned a quotation by the English es-sayist Francis Bacon over her darkroom door. It was to become her own motto: "The contemplation of things as they are, without substitution or imposture, without error or confusion, is in itself a nobler thing than a whole harvest of invention."[69] Neither the clever photographic discoveries of Man Ray nor the spiritual qualities of Stieglitz's photographs could dis-tract her from the sense of mission she felt in showing to the rest of the nation the destitute faces of the homeless and her concern for their care.

Although she was not a member of the F.64 group, the first appreciation of her early documentary work came from Weston who suggested to Van Dyke that an exhibition of her work be organized under their auspices. Photography was not so divided in its goals that the landscape photographers could not feel a kinship with those making social docu-ments. Van Dyke recognized that Lange's special talents as a portrait photographer were being brought to bear on the country's great social crisis. In comparing her work to that of Mathew Brady during the Civil War, he wrote: "Dorothea Lange has turned to the people of the American scene with the intention of making an adequate photographic record of them. These people are in the midst of great changes—con-temporary problems are reflected in their faces, a tremendous drama is unfolding before them, and Dorothea Lange is photographing it through them."[70]

If a single image of the effect of the American Depression on the face of any individual stands out from the tens of thousands taken for the government during the 1930s, it is Lange's portrait of the *Migrant Mother* (cat. 284) huddled with her children in a makeshift canopy home, where the fami-ly subsisted on birds and the remains of a frost-decimated pea crop in Nipomo, California. The portrait was the final com-position of five exposures, each progressively closer to the fam-ily group. Instead of sending her film to Washington, as the Farm Security Administration (FSA), which employed her, required, Lange's heart and sense of the urgency of the situ-

ation compelled her to act on her own.[71] She gave two of the photographs to the San Francisco *News* and within days of their publication, 20,000 pounds of food was sent to feed the starving migrant workers. For the most part, however, the FSA photographs in the early years of the project were used to illustrate government reports.

The photographer as social observer was more common in the decade of the Great Depression than in the "roaring twenties" or "les folles années".[72] In Europe the 1930s saw the rise of fascism, which awakened the dormant social and political consciousness of many artists and photographers. Even Man Ray, in introducing a retrospective book of his photography in 1934, felt the need to defend having dealt with individual emotions now that the world faced "the problem of the perpetuation of a race or class and the destruction of its enemies."[73] In Aragon's opinion, however, more than a few, apologetic words were needed, and he used Man Ray's book to illustrate the kind of studio art that, detached from life, showed only "beautiful human faces that are without defect and without misery."[74] But even the psychological darkening among the work of the surrealists or the occasional transference of the sexual fetishism of an artist like Hans Bellmer (cat. 281) to a political subject was too oblique a response to the threat of fascism. The political montages of John Heartfield in Germany (and later in Czechoslovakia) (cat. 280) or the photographs of the Spanish Civil War by Robert Capa and David Seymour were more what Aragon had in mind.

In England, Bill Brandt, a former assistant in Man Ray's studio, was facing off against the brutality of a world headed toward war, as if he had heard Aragon's call. In brooding photographs, showing weary, blackened coal miners (cat. 275) and scavengers, he both made use of and began to undermine the formalist and surrealistic approaches, with which he had begun his career only a few years earlier. Although not a committed socialist, as was his contemporary George Orwell, he did share the same outrage at his country's complicity in the continued exploitation of its human resources. They also shared the dilemma of the artist's eye, as Orwell worded it: "A belching chimney or a stinking slum is repulsive chiefly because it implies warped lives and ailing children. Look at it from a purely aesthetic standpoint and it may have

a certain macabre appeal. I find anything outrageously strange ends by fascinating me even when I abominate it."[75]

In America, at least one major socially conscious photographer maintained a presence in the 1920s: Lewis Hine. No social surrealism pestered his vision, for he had come to photography as a social reformer and not as an artist. After the Great War, his attitude about photographing only what needed to be corrected had shifted in the new spirit of optimism, to include that which needed to be appreciated. His series on American workmen exemplified his new direction, culminating in spectacular photographs glorifying the human effort in the construction of the Empire State Building (cat. 272) in 1931. In the late 1930s, however, Hine, being less compliant than most photographers about control of his negatives and proper credit, only occasionally found work among the various government agencies that hired documentary photographers.

The photographers who worked for the Resettlement Administration (later the Farm Security Administration) were a generation younger than Hine. Their job under the direction of Roy E. Stryker was to illustrate the situation of sharecroppers and tenant farmers who had been forced off the land by the government's new policy of paying land-owning farmers not to grow crops. The photographs were also used as propaganda to help justify the large appropriations Roosevelt and the Democrats made to resettle these unemployed workers and combat conservative politcal opposition.[76]

Among the first group of photographers hired or consolidated from other agencies in the summer and fall of 1935 were Lange, Arthur Rothstein, Carl Mydans, and Walker Evans.[77] One of the unofficial members of the team was Ben Shahn, who had been hired as a painter in another division. As Stryker began to figure out his agency's goals, three of the photographers had already established their own distinctive styles: Shahn's candid photographs of people on the street (cat. 283), taken with a Leica equipped with a right-angle viewer; Evans' straightforward, austere 8 × 10″ view camera contact prints (cat. 279); and Lange's compassionate reportage of the human condition.[78] Without any experience as a photographer himself, Stryker's view of the alliance of artist and government, understandably, favored the admin-

istration's needs, and most of his photographers tried to accommodate their work to his program and to the larger archive he was assembling. Only Walker Evans refused to give in at all to anything he considered bureaucratic hackwork and propaganda. Evans' singular vision of his subjects and his eye of veiled pessimism and clinical precision lent to his photographs a poignancy unequalled in American photography of the period.

Walker Evans could be called a late arrival to Gertrude Stein's "lost generation." He had gone off to Paris, like many writers and artists, but wrote nothing, only visiting Sylvia Beach's famous bookshop Shakespeare and Company, and auditing classes at the Sorbonne. On his return from a year abroad in 1927, he found that his private dissatisfaction with the crassness and mercantile character of the United States was in sympathy with the poetry and writing of William Carlos Williams and John Dos Passos, or of Hart Crane and James Agee, both of whom he came to know during his bohemian life in Greenwich Village. Like many others seeking their own *métier*, Evans came to photography as a not-so-famous failure in another field who had somehow acquired a camera and tested his indeterminate skills privately against a fomenting or amused reaction to the world outside. Owing nothing to a master teacher's style or to a magazine's public, Evans was usually the odd man out of any group.[79] He was perseverant, and in the course of pursuing his own goals during his twenty-month tenure with the FSA Evans disappeared for weeks at a time. Even Stryker could not tell exactly where in the South his chief photographer would be or if he would be shooting what was of immediate need.

Evans had been able to maintain his identity as an artist in working for the FSA because his straight, objective photographs rang true to the decade in which change and decay spared neither the resistant nor the indigenous strains of American culture. Through his puritanical eye, ordinary things and scenes—the most neglected and perishable of subjects—survived in the solitary and extended moment of the photograph (cats. 277–279). His sense of time was not Stieglitz's spiritual "forever," but was closer to Brady's historical freeze. As he had removed sentiment, commercial involvement, and almost the photographer himself from his photographs, the images read like eloquent depositions of cynical detachment of a subject from which he could not quite release his affection.

Other photographers made use of the dispassionate photographic eye to show the world as it was. Although Berenice Abbott had been an assistant to Man Ray, her inspiration was Atget, whom she admired and whose archive she had brought back with her in 1929. After seven years in Paris (and part of a year in Berlin), she felt she was ready to establish herself as a portrait photographer in New York. Although the Wall Street crash ruined her prospects for a flourishing business, it did not diminish her urge to document the street and buildings of the city. She began to take Wednesdays off from her meager studio business to roam the city, making casual and elegant notes with a small hand camera (cat. 238). In 1932, she followed these up with proper view camera exposures. She tried to raise money from museums and private sources for her documentation project without success. It was only when she secured funding through the Federal Arts Project (FAP) in the summer of 1935 that she could hire assistants and immerse herself in what was one of the few government-sponsored photographic documentation projects of an urban center.

Not only did Abbott spend four years on a project larger than any single person could handle, but she also promoted the work of Atget throughout the 1930s and of Hine at the end of the decade. In 1939, the same year that *Changing New York*, a book of her FAP photographs, was published, she helped arrange with the critic Elizabeth McCausland a retrospective exhibition of the work of Hine at the Riverside Museum in New York, one year before his death. Thus, by the end of the decade, she had done as much as anyone to bring great works of documentary photography to the attention of her profession and the public.

Hine's archives were willed to an organization of photographers in New York known as the Photo League. Founded in 1936, the league was dedicated to teaching photography, mounting modest exhibitions in their quarters, and organizing social documentary projects relating to the urban environment. It expressed its goals in a 1938 manifesto printed in its *Photo Notes*: "Upon the photographer rests the responsibility

and duty of recording a true image of the world as it is today."[80] To ground their idealism, League members took as their model the work of the FSA photographers and the traditions set by Stieglitz, Strand, Abbott, and Weston. This amalgam of the two divergent aspects of photography (Mac Orlan's documentary and plastic categories) came about through their gradual veneration of Strand.

Stieglitz's protégé Strand, it must be remembered, had been interested in photography before he came to 291, where his work was first exhibited. His was introduced to photography through the classes taught by Lewis Hine at the Ethical Culture School in 1908, and it was Hine who took him to see Stieglitz's gallery. In the 1920s, Strand alternated as a freelance cinematographer and an advanced disciple of "straight" photography. In the 1930s, his social concerns, ever emersal to his aesthetic consciousness, began to surface again in his photographs and films, especially of Mexico and its peasants. In 1936, his organization of Frontier Films splintered off from the New York Film and Photo League, the radical communist organization that had preceded the Photo League. Thus, with Strand becoming an ever stronger model through the late 1930s and 1940s, many photographers felt themselves to be members of a fraternity of truth seekers. Although there were arguments about the different purposes photography should serve, the Photo League, in having Beaumont Newhall of The Museum of Modern Art, Margaret Bourke-White, and Dorothea Lange as advisors, and later exhibiting the work of Cartier-Bresson, proved that there continued to be a common ground between the attitudes of socially and aesthetically-minded camps of photographers.

In Europe things were considerably less pacific, but for different reasons. National Socialism in Germany caused many of the established and most promising photographic talents to flee. Robert Capa and many other photojournalists went to Paris, as did Ilse Bing, who would take her first photographs there. Lisette Model, already in the city, took up photography as a potential profession in 1937 in case her family's Viennese real estate fortune was confiscated by the Nazis, which it was. John Heartfield, Felix Man, and several others ended up in London, as did László Moholy-Nagy, who ventured to establish a school of design in Chicago

based on the Bauhaus model in 1937. Although John Gutmann landed in San Francisco from Berlin, most of the photographers who left Europe for America settled in New York, including those who fled Paris after its occupation in 1940.

When Lisette Model arrived in New York she was hardly an experienced photographer, but she was treated as a genius. In January 1941, Ralph Steiner, picture editor of the Sunday edition of the weekly newspaper *PM*, featured a cover and six full-page reproductions of her 1937 satirical views of the wealthy French lounging on the Riviera and grotesque street types of Nice. The picture story was supported only by one-

Fig. 14. Lisette Model, *Greed*, from *PM* magazine, 19 January 1941, Private collection

line captions, the questioning headline title *Why France Fell*, and the answering individual rubrics: Weariness, Boredom, Underprivilege, Greed, Cynicism, and Self-Satisfaction.[81] These were to be some of the underlying themes she continued to photograph in New York for *PM*.

Another discovery whom *PM* had put on a retainer was a tabloid photographer of the victims of fire, drowning, and murder named Arthur Fellig, but credited as Weegee. He had come to the United States in 1909 at the age of ten from Central Europe, but from the extreme opposite end of the social scale from Model. Unlike Model, who had studied music with Arnold Schönberg in Vienna, Weegee was poor and left his Lower East Side home in his teens without an education or a promising future. He had wanted to be a photographer early in life and after a stint in the flophouses of the Bowery he landed a job in the darkroom of the Acme photo agency in the mid-1920s. Around 1935, he finally worked himself into the business of providing sensational photographs of the sorry side of a city's day by tagging after the police between midnight and sunrise, or later by responding to calls on a police radio. Without pity or a reformer's heart, he exposed in the split-second timing of his raw flash a cruel world of characters and deeds (cats. 285, 286). In one sense, his photographs served as a moral emetic for the lurid scenes in front of him, and in another sense they were merely a cheap, vicarious thrill for his readers.

The underbelly of the city and the thin veneer of society in the 1930s became themes for photographers of every social status. The pampered upbringing of Brandt and Model, the bohemian existence of Brassaï, and the down-and-dirty life of Weegee all gravitated toward Mac Orlan's "social fantastic," but without the sweet grace of someone like Kertész. The agile, playful, and magical photography which came to maturity in Europe in the 1920s was born of an optimism that was supposed to take care of everything; the sturdy, serious, and sardonic photography of the 1930s was born of disillusionment and impending doom that surrealism or constructivism could not cure.

Photographically, Aragon would have found Model's and Brandt's style and approach to be right for the decade ahead, even though they were not communists. Weegee, on the other

hand—a misfit stumbling in at the right time and place— would have been too quirky and self-indulgent for faithful service to the cause of social realism. Free of a propagandist's purpose, Weegee's realism was undeniable, but vulgar. In America, this proved to be no handicap, for that was what sold the tabloid newspapers, titillated the readers of *PM*, and amused the visitors to The Museum of Modern Art or the Photo League, where Weegee lectured and his photographs were exhibited.

There were, nevertheless, small and delightful measures of capricious honesty to be recovered between the subject and the camera of sophisticated photographers. The natural and unguarded ease of life that was shielded by self-involvement from global concerns or civic disorder was there to see between static poses and the predictable rigidities of climactic expression. Time melded its instants, ever inchoate to the development of another moment, and showed them to the photographer in the graceful accidents of chance. But that is the languourous pleasure of a subject watched, while the subject taken by camera is a choice of one of many observations. Yet keeping the moment fluid and concise was, as James Agee described it, a lyrical art that required not intellection but the "simple liveliness of soul and talent."[82] A certain beginner's luck and childlike vision, like Kertész's or Lartigue's, unsoiled by worry or audacity, was what was required first. No metaphysics of time, no history to continue past the present, no rational program to follow nor employer's shooting script needed to be consulted. The simultaneity of objects and events forming pictures on the street was pure photographic territory.

The photographer whom Agee was describing was not Evans, whose work he characterized as rich in "meditativeness," but a young New York woman who had come to admire it. Helen Levitt (cat. 292) had also admired the work of Cartier-Bresson. She was not insistent or vain or obsessed with mission. But by 1943 her photographs of children in the slums were hanging on the walls of The Museum of Modern Art and she had restored a certain innocence to the camera's eye.

Concerned or comic, lyric or dejected, none of the young street photographers emerging at this time reached the sobriety achieved in a series of subway portraits taken by Evans in

1938 and 1941 (cats. 287, 288, 289). Shahn's faces of resignation or Strand's 1916 portraits of despair are the only examples to approach the candid testimonial stare of Evans' hidden camera. Sander's portraits in Germany relate to Evans' in their quiescence, but they show little of the bitter edge of Evans' psychological incision. Further, the surreptitiousness of Evans' concealed contax, like the right-angle lenses of Strand and Shahn, recorded not a face created by the sitter and the photographer but one that was authentically public. Evans need not have characterized himself as "a penitent spy and an apologetic voyeur" when he published the portraits in *Harper's Bazaar* for the first time in 1962,[83] for these were the faces that each prepared for all to see. He was only guilty of slicing off an image by stealth and leaving the scene in which it was discovered as it was.

The solemnity of Evans' impassive sitters covertly recorded in the purgatory of a subterranean ride was in strange accord with the innocent play of children and passersby on the sidewalks above. In Levitt's photographs there was a graceful new coherence of aggregate motion out in the open. The same give-and-take reflexes as those his young admirer was developing had already been touched upon by Evans in the exploration of the casual fact in his street photographs of 1929 and his work in Havana in 1932. Now he was drawn back to them but with a will stripped of any sense of sport or accomplishment. For Evans, photographic timing was more than a fascination with the simultaneity of the scene. His vision, which had grown more and more deliberate through the 1930s, was compatible with the unrushed procedures of the view camera and the consideration of time as waiting, endurance, and history.

The beauty of the unaltered moment reduced from the chaos that held it in thrall was something that Evans, Shahn, and Levitt shared with other street photographers, but not for the sake of politics. Shahn's work for the FSA was not shaped by its directives, nor were Evans and Levitt gathering propaganda for a cause. When Levitt's work was shown at the Photo League, the political commentary of the members did not improve or diminish it one bit. Neither were any of the three gorgonizing the readers of the contemporary press as Model and Weegee were in *PM*. It was in vernacular affairs that Evans, Shahn, and Levitt found a residual truth and a concerned naturalism that was as lyrical as it was literal and as quiet as it was humane.

Naturalism, in whatever form, could only survive as an escape in a world that would tear itself apart for a second time with a savagery and level of atrocity unkown to the history of civilization. During the time of the conflict, the effects of World War II appeared so cataclysmic that cycling back to any previous, happier moment in time seems to have been precluded.

Early in April 1944 Gertrude Stein lectured to the American soldiers, who had helped to liberate Paris, on their deportment in France.[84] She asked them to be more friendly and smile. From the previous war, the French remembered that the faces of American soldiers were supposed to be fresh, and they were supposed to come back from the lines to Paris to get drunk and be very gay. With all due respect for the great and perplexing writer, one soldier reminded her that after the European operation another war awaited them in the Pacific. Nevertheless, she insisted that they should smile.

A measure of days later, the American General George S. Patton had forced some twelve hundred citizens of Weimar—home of Johann Wolfgang von Goethe and the Bauhaus—to visit the Nazi concentration camp Buchenwald, situated on the outskirts of their enlightened city. Accompanying him were war correspondents and photographers from *Life* magazine. Bourke-White's photographs were not the most gruesome ones printed by the magazine—her subjects were alive. The other photographs by George Rodger and William Vandivert of charred remains and piles of emaciated corpses in the camps at Belsen and Gardelegen, where the Nazis had had a few days to murder the occupants, were unbelievable horrors of an order of magnitude unknown in the previous war. The vision that the futurists had promoted of World War I as a great aesthetic adventure of hectic speed and invigorating violence seemed centuries gone. The American and Allied soldiers would find less and less to smile about as they uncovered or learned of further atrocities. But if Stein may have been wrong about asking the soldiers to smile, she was right when she said, "in this horrible war we're in danger of losing our humanity."[85]

Fig. 15 a

Fig. 15 b

Fig. 15 c

Fig. 15 d

Fig. 15 e

Fig. 15 f

Fig. 15. From "Atrocities," *Life* Magazine (7 May 1945), 32–37: photographs by a. George Rodger, b. George Rodger with Margaret Bourke-White, c. William Vandivert, d. William Vandivert, e. Johnny Florea, f. George Rodger

Over and over again, the photographers who covered the war found their best pictures not to be of action, but of the cost in human terms, especially when it concerned children, prisoners, or civilians. Robert Capa, after nearly being blown to bits on the front line by a Nazi mortar barrage with the U.S. 45th Infantry Division in Italy, wrote in a note to the editors of *Life* that the lack of action in the resulting photographs "prove again the old truth that in the most dangerous situations you get the least exciting pictures."[86] It was not as if he had never succeeded, for it was Capa who had taken the famous photograph during the Spanish Civil War of a Loyalist soldier falling an instant after being killed, and who would take the most famous photographs of the Normandy invasion. But those heroic photographs seemed to abstract their subjects from suffering and death. Capa even remarked about the Normandy landing that the gray water and the gray sky made the little men, dodging under the "surrealistic" anti-invasion obstacles, "very effective."[87]

As many times as Capa risked his life for a few exposures of action, his most effective photograph was not taken on the front lines. During the 1943 Italian campaign, as Capa was going back to his hotel in Naples, he came upon a local funeral being held for twenty teenagers who with stolen rifles had fought the Nazis fourteen days before the liberation of the city. "I took my hat off and got out my camera. I pointed the lens at the faces of the prostrated women, taking pictures of their dead babies, until finally the coffins were carried away. Those were my truest pictures of victory, the ones I took at that simple schoolhouse funeral (cat. 294)."[88] In this picture Capa stepped out of the role of adventuring reporter and hero to look at the anguish on the faces of those powerless to fight back.

Innocence abused became the overpowering theme of W. Eugene Smith, the great war photographer in the Pacific. At the outbreak of the war, Smith had been invited by Steichen to join his photographic unit, but was refused by the Navy as not having sufficient education. Smith eventually reached the Pacific as a war correspondent and, like Capa, then shifted his employment to *Life* magazine. Up to the landing on Saipan in June 1944, the war he witnessed was between soldiers. Saipan was the first American objective in the Pacific with a sizable civilian population. It was on Saipan that the war

came home for Smith (cat. 293). There he identified with the victims, as few other photographers were capable of doing. As the father of two children and one expected, he wrote home on 3 September 1944: ". . . a few of the pictures made on Saipan were close to being the best I have ever made. . . . I do not believe I could have reached this close without my family. For these people of the picture were my family—and I saw my daughter, and my wife, and my mother, and my son, reflected in the tortured faces of another race. Accident of birth, accident of home—damn the rot of men that leads to war. The bloody dying child I held momentarily in my arms while the life fluid seeped away and through my shirt and burned my heart into flaming hate—that child was my child. . . . "[89] His experience on Saipan galvanized Smith, making him into a great photographer who decided to look past patriotism and a crusader whose every exposure was a condemnation of war.

Although Smith might be characterized as an outraged romantic, Capa as a fearless adventurer, or Bourke-White as a mass-media illustrator, the fact that each used the camera was a primary factor in the perceived plausibility of their images. During the 1930s, and especially during World War II, photography gained further credibility as a faithful witness because of the risks photographers took to become part of the scenes they recorded. The objectivity of the medium had become a well-celebrated faith. In an address to the French Academy on the centenary of photography in 1939, the aged poet Paul Valéry described its objectivity as if it were good medicine for visual dreamers needing to be awakened to new realities: "Thanks to photography, the eye grew accustomed to anticipate what it should see, and to see it; and it learned not to see nonexistent things which, hitherto, it had seen so clearly."[90] Nevertheless, truth was always a larger issue than accuracy, for as dada, advertising, and propaganda had demonstrated, photography's on-the-spot honesty was relative to the context from which the photograph was taken and the new context into which it was put.

Most of the photographers between the wars for whom an objective approach to the medium had become a form of self expression would not quite have agreed with Valéry, for they believed that they saw things that no one else saw. Brassaï was later fond of saying that he invented nothing but imagined

everything, which is what Mac Orlan was getting at when he called Abbott, Kertész, and Krull *révélateurs*, or what Breton meant when he said that perceptual "encounters" could free objects from their cloying environments. As Gertrude Stein told an assembly of American soldiers: "an artist sees something else and tries to create it. The rest of us see it and are subject to it."[91]

In order that photographers were not dominated by the world—Weston by its beauty, Evans by its anonymity, or Smith by its brutality—they kept a distance between their idea of form and the idea that demanded a form.[92] For instance, in Model's photograph of a window display memorial to the dead Franklin Roosevelt (cat. 296) all the self-explanatory symbols are in place—the official portrait, the unlit bulb, the toy cannon, and the spade. No single item hints at either the absurdity or the naïveté of the aggregate. The case is much the same in Joseph Cornell's penny arcade box of Lauren Bacall (cat. 297). The difference is that Cornell deliberately constructed his arrangement of chance objects and Model found hers by roaming the streets searching for what would strike her as a picture and not necessarily a tribute to the fallen president. Once the still life in the window was encountered, she needed do nothing more than adjust her point of view and dutifully record it with her camera.

Looking back now on the photographs of the subway riders, we can imagine Evans, unlike Model, placing himself *within* a situation wholly created by the subject and letting it dictate what would happen in the camera. The factors of light and point of view having been predetermined, the only variable under the photographer's complete control is when to make the exposure. Although in their frame of reference the subway riders are relatively slow-moving, they are not immobile as Model's still life. One second after Model's exposure, the picture is still there; one second after Evans', there is already a variation. The "when" of the photograph is now a factor of the composition consciously made equal to that of the point of view. Thus, in anticipating the unexpected, Evans begins and finishes his photograph at the onset of perception, which is photography's special privilege.

After the end of World War II, the alienation and despondency that Evans' New York subway riders suggested were

real and unavoidable, especially in Europe. The holocausts of the Allied fire bombing of Hamburg and Dresden; the Nazi death camps of Buchenwald, Auschwitz, and Dachau; and finally Hiroshima and Nagasaki gave no quarter to innocence or compassion. The world was in danger of losing its humanity. Things and individuals seemed to count for nothing. An order distinctly less optimistic than Corbusier's or El Lissitzky's began to dominate European thought after World War II. Photographers like Cartier-Bresson, who had spent three years in a Nazi labor camp, were inextricably caught in the despair that brought a new, sobering awareness of being human.

Cartier-Bresson's 1946 portrait of Sartre on the north end of the Pont des Arts depicting the stilled and bitter anguish of the philosopher was the photographer's way of dealing with the situation at hand: representing both Sartre and the mood of the period itself. Sartre's idea that "existence precedes essence" could be understood as analogous to the developing habits of the street photographer where time as a dimension of perception preceded the rendition of "the thing itself." Mostly, however, we find the two philosopher's categories in balance among photographers. Cartier-Bresson's portrait is still composed with a geometry reminiscent of his earlier work. But, unlike the bicycle rider at Hyères or the children in the rubble of Seville, his portraits of the French intelligentsia at the time were not fleeting images taken on the run, *images à la sauvette* as the photographer later termed them.[93] The Sartre portrait is rather an open moment, like that of Evans' subway portraits, that has brought the existence of the photographer back into a balance with the spirit and essence of the subject.

At this point, if one thinks back on Bergson and Bragaglia, one recalls an infinitely happier time when existence could be described in terms of the fluidity of time. With such a philosophy, form could be a snapshot view of transition and a photograph a kind of second reality capable of proving a thesis or just playing with any stray concept that it attracted. If one thinks back on Atget, Blossfeldt, or Sander, one recalls the belief that the essence of things could be known by empirical observation. Photography began its self-discovery as a medium during that optimistic period when photographers were confident enough of photographic rendition to believe

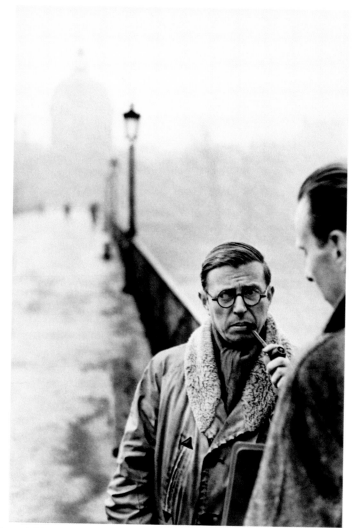

Fig. 16. Henri Cartier-Bresson, *Jean-Paul Sartre, Pont des Arts, Paris*, gelatin silver print, 1946, 36.2 x 24.1 (14⅛ x 9⅜), The Richard Sandor Collection (cat. 398)

that the medium had, through its technical objectivity, some link to truth. But the realities of the Depression, fascism, and war created a crisis of existence in many photographers. For them photography became more than a technique, more than the optical registration of light or a conceptual shell in to which meaning was to be put. It became a human record intimately bound with a moment of perception, desperate to prove its faith that some connection with truth still existed, even if it were ephemeral, at best.

1. Stephen W. Hawking, *A Brief History of Time, from the Big Bang to Black Holes* (New York, 1988), 32, notes that "later examinations of the photographs taken on that expedition showed the errors were as great as the effect they were trying to measure."

2. Marcel Duchamp in a 1953 interview with Harriet, Sidney, and Carroll Janis. Quoted in Anne d'Harnoncourt and Kynaston McShine, *Marcel Duchamp* (New York, 1973), 275.

3. Quoted in Sophie Lissitzky-Küppers, *El Lissitzky, Life, Letters, Texts* (Greenwich, Conn., 1967), 347.

4. Henri Bergson, *Creative Evolution*, Arthur Mitchel, trans. (1911 repr., Lanham, Md., 1983), 302.

5. Bragaglia's advertisement appeared in the July 1913 issue of *Lacerba*, the organ of the futurist movement. The refutation by Boccioni and others followed in the October 1913 issue.

6. Anton Bragaglia, "Futurist Photodynamism 1911," Caroline Tisdall, trans., in Umbro Apollonio, ed., *Futurist Manifestos* (New York, 1973), 38.

7. In *Creative Evolution* (first published in 1907), Bergson obliges the comparison with a photographic metaphor: "That life is a kind of mechanism I cordially agree. But is it the mechanism of parts artificially isolated within the whole universe, or is it the mechanism of the real whole? The real whole might well be, we conceive, an indivisible continuity. The systems we cut out within it would, properly speaking, not be *parts* at all; they would be *partial views* of the whole. And, with these partial views put end to end, you will not make even a beginning of the reconstruction of the whole, any more than, by multiplying photographs of an object in a thousand different aspects, you will reproduce an object itself." See Bergson, *Creative Evolution*, 31.

8. Victor Meric, "Vers L'Amorphisme," *Camera Work*, Special Number (June 1913), 57. Repr. in Jonathan Green, ed., *Camera Work, A Critical Anthology* (Millerton, New York, 1973), 234–263.

9. Victor Meric was an anarchist and obscure editor about whom little is known. The text of the manifesto was discovered to be by Meric by Dickran Tashjian, *Skyscraper Primitives* (Middletown, Conn., 1975), 235. According to Tashjian, it was not titled "Men of the Hour" but appeared in a publication *Les Hommes du Jour* 276 (May 1913), 8–10.

10. Photographic collages were not uncommon in nineteenth-century Victorian family photographic albums.

11. André Breton, "Max Ernst," Ralph Manheim, trans., repr. in Max Ernst, *Beyond Painting* (New York, 1948), 177.

12. The term "pure photography" occurs in Marius de Zayas, "Photography and Artistic-Photography," *Camera Work* 42/43 (1913), repr. in Green, *Camera Work: A Critical Anthology*, 267–268.

13. Stieglitz's photograph of Duchamp's *Fountain* was reproduced on page 4 of the second number (May 1917) of the dada publication *The Blind Man*. It illustrated responses by Louise Norton and Charles Demuth to the refusal of the Society of Independent Artists to display the urinal signed "R. Mutt, 1917" in an unjuried exhibition.

14. The phrase "the material truth of form" occurs in Marius de Zayas, "Photography," *Camera Work* 41 (1913), repr. in Green, *Camera Work: A Critical Anthology*, 263–266.

15. The use of the term "straight" appears as early as 1904 in Sadakichi Hartmann, "A Plea for Straight Photography," *American Amateur Photographer* 16 (1904), 101–109, cited in Beaumont Newhall, *The History of Photography, from 1839 to the Present* (New York, 1982), 167.

16. The phrase "pure expression of the object" occurs in de Zayas, "Photography and Artistic-Photography," repr. in Green, *Camera Work: A Critical Anthology*, 267–268.

17. *Über das Geistige in der Kunst* was first translated into English in 1914. Stieglitz, however, published a translated excerpt in *Camera Work* 38 (July 1912), 34.

18. Man Ray was loosely associated with 291 in that Stieglitz casually hung a few paintings in the gallery.

19. Sheeler was a friend of Duchamp and allowed him to use seven photographic reproductions he had made of avant-garde painting and sculpture in a dada book titled *Some French Moderns Says McBride* in 1922.

20. William Carlos Williams, "Paterson," *The Collected Poems of William Carlos Williams*, vol. 1, 1909–1939 (New York, 1986), 263.

21. Published as "Vue prise en aéroplane par Man Ray," in *Littérature* (15 October 1922), 10.

22. A limited edition book of 12 Rayograms, *Les Champs délicieux*, with Man Ray as author and an introduction by Tzara, was published at the end of the year. Rayograms were introduced into dada exhibitions and the technique was even applied as an experiment to part of a short film Man Ray made in 1923, *Retour à la raison*.

23. Gertrude Stein, *Everybody's Autobiography* (1937 repr., New York, 1964), 58.

24. In Robert Kramer, *August Sander, Photographs of an Epoch, 1904–1959* (Millerton, New York, 1980), 23, the author relates that Sander's use of a hard, glossy paper may have been because he had run out of his usual portrait paper, and "Seiwert was quick to point out that he had in fact made an important aesthetic breakthrough, and encouraged Sander to continue with the technique."

25. The matter-of-fact procedure he employed was not just an intellectual position, for it related to a mixture of the fascination for the antique daguerreotypes and *cartes-de-visite* he collected, his training as a portrait photographer, and his comprehension that each element of his larger system would relate to other elements if the photographer's own feelings sided on neutrality.

26. A selection of his portraits in his own arrangement was included in 1927 in an exhibition of modern art by the Cologne Art Association, where he formally titled his project, *Men of the Twentieth Century*. Two years later, *Anlitz der Zeit* (Face of the Time) was published. It was to be the only book of his portraits published during his lifetime. But its sixty portraits were far from Sander's ultimate goal. The complete work—forty-five portfolios of twelve photographs each—was intended to show a cycle of mankind from the earthbound, to the functional, to the intellectual, and around to the degenerate.

27. Quoted from the opening article, "*L'Esprit nouveau*," of the premier issue (no. 1) of *L'Esprit nouveau* (Paris, 1920), 3.

28. Lissitzky-Küppers, *El Lissitzky*, 333.

29. Vladimir Mayakowsky, "Brooklyn Bridge," in *The Bedbug and Selected Poetry*, Patricia Blake, ed., Max Hayward and George Reavey, trans., 177.

30. The term "by surprise" by Vertov is cited in Selim O. Khan-Magonedov, *Rodchenko, The Complete Work* (Cambridge, Mass., 1986), 215.

31. In the spring of 1928, the editors of *Sovetskoe foto* (Soviet Photography) reproduced on the left-hand side of a page photographs by D. Martin, Albert Renger-Patzsch, and Moholy-Nagy opposite similar subjects taken from similar extreme points of view by Rodchenko. The text hinted that one side had plagiarized the other and left it to the readers to decide. See Khan-Magonedov, *Rodchenko, The Complete Work*, 215, 219, for reproduction of the page and a translation of the accompanying text. By the end of 1928 Rodchenko had found disfavor with the new editors of *Novyi Lef*, the organ of constructivism cofounded by Mayakowsky in 1923.

32. Alexander Rodchenko, "Photography—Art," repro. in Galerie Gmurzynska, *Alexander Rodchenko, Possibilities of Photography* (Cologne, 1982), 28.

33. Rodchenko showed his photomontages for *Pro Eto*, as well as an installation for a worker's club at the exposition.

34. In 1927–1928, Rodchenko wrote about photography in *Novyi Lef*.

35. Photography was not taught at the Bauhaus as a course until 1929 when Walter Peterhans was hired as an instructor. A few of the Bauhaus students engaged in photography or who became photographers were: Marianne Brandt, Andreas Feininger, T. Lux Feininger, Werner Feist, Walter Funkat, Heinz Loew, Florence Henri, Gyula Pap, and Umbo. For an excellent discussion of photography among the teachers and students of the Bauhaus, see: Susan E. Pastor, "Photography and the Bauhaus," *The Archive* 21 (March 1985), 4–25.

36. The second edition, which appeared in 1927, was titled *Malerei, Fotographie, Film* and reproduced, for the first time, camera photographs by Moholy-Nagy.

37. Moholy-Nagy, *Painting, Photography, Film* (Cambridge, Mass., 1969), English repr., 28.

38. The movement took its name from a 1925 exhibition organized by G. F. Hartlaub for the Mannheim Kunsthalle. Franz Roh also helped to organize the exhibition but in his later writings he recorded his dislike for the term "neue Sachlichkeit."

39. The *Film und Foto* exhibition was organized by the Deutscher Werkbund, a professional association of artists, craftsmen, and manufacturers dedicated to bridging the gap between inventor, producer, and consumer. Among the members were the photographers Hugo Erfurth and Albert Renger-Patzsch. For an excellent discussion of the *Film und Foto* exhibition and related photography exhibitions in Germany, see Ute Eskildsen, "Innovative Photography in Germany Between the Wars," in *Avant-Garde Photography in Germany: 1919–1939* [exh. cat. Fine Arts Museums of San Francisco, 1980], 35–40.

40. Moholy-Nagy arranged the first room of *Film und Foto* to show the viewer what photography was. What had become his typical concoction—X-rays, aerial photographs, animals, close-up portraits, sports photos, with the addition of historical photographs from the collection of Erich Stenger and several studies labeled as coming from the field of parapsychology—was meant to impress the viewer with the *functional* brotherhood of the medium if used objectively.

41. André Breton, *What is Surrealism?* (London, 1936), 12.

42. Breton, *What is Surrealism?*, 14.

43. Maurice Tabard, "La Solarization," *Arts et métiers graphique*, 7:38 (15 November 1933), 30–33.

44. Munkacsi's career had begun in Budapest around 1921, but by 1927, he was working for the prestigious Berlin publisher Ullstein, which owned the *Berliner Illustrierte Zeitung*, for which Munkacsi was a staff photographer in Berlin. Seidenstücker began working for Ullstein in 1930.

45. For a discussion of the photographer's role in the creation of the photo essay, see: Tim N. Gidal, *Modern Photojournalism, Origin and Evolution, 1910–1933*, 15–28.

46. As Breton put it some years later: "Those who prefer to take no account of the moment when they expect the least to happen seem to me to lack that mysterious aid which to my mind is the only aid of any importance" (Breton, *What is Surrealism?*, 19.)

47. In French the term *révélateur* is used for the developing agent that brings out the picture in the darkroom.

48. Pierre Mac Orlan, "L'Art littéraire d'imagination et la photographie," *Les Nouvelles littéraires* (19–22 September 1928), photocopy in the files of the Department of Photography, The Art Institute of Chicago.

49. Pierre Mac Orlan, "La photographie et le fantastique social," *Les Annales* (1 November 1928), 414.

50. Pierre Bost, *Photographies modernes* (Paris, 1930), unpaginated.

51. Bost, *Photographies modernes*.

52. Brassaï is described by Miller in *Tropic of Cancer* (New York, 1961), 171.

53. Mac Orlan, "La Photographie et le fantastique social," 413.

54. The Leica had originally been conceived in 1914 by Oskar Barnack as an instrument for duplicating the exposure and lens setting of motion-picture cameras. By developing the film from this instrument, the cinematographer could judge his exposure accurately. Early in 1925, the first Leica with an f3.5 lens, a focal plane shutter with speed between 1/5 and 1/500 of a second, appeared at a trade fair in Leipzig. It was made expressly for amateurs. Despite unfavorable trials in the previous two years due to the initial incompatibility of the motion-picture film stock for enlarging, it was destined to continue the revolution in the kind of street photography pioneered by Kertész, Krull, Seidenstucker, Munkacsi, and the German photo reporters.

55. Republished in Julien Levy, *Surrealism* (repr. 1968, New York, 1936), 61.

56. See Peter Galassi, *Henri Cartier-Bresson: The Early Work* (New York, 1987), 12, for a discussion of Breton's influence.

57. It was at this time that Cartier-Bresson began work in film with Jean Renoir.

58. Louis Aragon, "Painting and Reality," *transition* 25 (Paris, 1936), 98–99.

59. Weston was asked to make selections for the exhibition from the West Coast photographers and Steichen for the East Coast.

60. The spring 1926 issue of the *Little Magazine* reproduced Moholy-Nagy's work on which Weston commented in the same *Daybook* entry: "The photographs by Zwaska are trivial mannerisms, the center one least offensive. I would quite as soon have a dark smudge by Genthe. The 'N.Y.' done by Charles Sheeler, had a genuine grandeur,—nobility—these photographs by Zwaska are an effort to be smart. Neither do I contact with the photography by Moholy-Nagy—it only brings a question—why?"
Weston's *Daybook* entry for September 6 attacks the work by Man Ray that he had seen in a German magazine: "I suppose it was a laudatory review, but not being able to read German I was spared. This photographer has been much praised and why, I wonder? The photographs reproduced show nothing beyond the usual,—even the best of them—and the worst are what one might expect from anyone of a hundred commercial photographers in New York,—theatrical postures and soft focus 'effects'—Picasso done in a blur—well, well, how funny!" The magazine was most likely the 1926 June issue of *Das Kunstblatt* (pages 227–231) where four photographs were reproduced: a 1924 out-of-focus view of two pylons of the Eiffel Tower, the nude with curtain shadows from *Retour à la raison* of 1923, and two Rayograms. The text by Tzara "Man Ray und die Fotografie von der Kehrseite" was a German translation of his introduction to *Les Champs délicieux*. Weston's remarks, not surprisingly, show a total lack of understanding for the surrealist approach, which was not to find an expression in photography in Mexico until Manuel Alvarez-Bravo several years later and Cartier-Bresson in 1934.

61. Edward Weston, *The Daybooks of Edward Weston* (George Eastman House, 1961), Nancy Newhall, ed., vol. 1: Mexico, entry for 4 September 1924, 190.

62. See Mike Weaver, "Curves of Art," in *EW:100, Centennial Essays in Honor of Edward Weston*, from series *Untitled* 41 (Carmel, Calif., 1986), 84–86, 89–90, for a discussion of the influence of Jean Charlot on Weston.

63. Modotti introduced Weston to Diego Riviera and the Mexican muralists and arranged for the 1923 exhibition in a centrally located store, the Aztec Land Gallery, and another in 1925 in Guadalajara. She became a photographer in her own right, dealing with the native people on the street or working, in addition to themes typical of Weston.

64. The negatives of the Armco plant, the toilet bowl, and the sink are all labeled with an "M" designating the category "mechanical or manufacture, belonging to our machine age." See Amy Conger, "Edward Weston's Toilet," in *Perspectives on Photography, Essays in Honor of Beaumont Newhall*, Peter Walsh and Thomas Barrow, eds. (Albuquerque, 1986), 167.

65. David Alfaro Siqueiros, "A Transcendental Photographic Work: The Weston-Modotti Exhibition," trans. in *Edward Weston Omnibus*, Beaumont Newhall and Amy Conger, eds. (Salt Lake City, 1984), 19. The review was of an exhibition held in Guadalajara in 1925.

66. Weston often used the term "the thing itself" taken from Kant's "das Ding an sich." His daybook entry for 10 March 1924 reads: " . . . the camera should be used for a recording of *life*, for rendering the very substance and quintessence of the *thing itself*, whether it be polished steel or palpitating flesh," in *Daybooks*, vol. 1: Mexico, 55.

67. It should be noted that Cunningham studied photographic chemistry from 1909 to 1910 at the Technische Hochschule, Dresden.

68. Letter from Stieglitz to Weston, 3 September 1938, quoted in Sarah Greenough and Juan Hamilton, *Alfred Stieglitz, Photographs and Writings* [exh. cat. National Gallery of Art, Washington, 1983], 218.

69. The Bacon quote first appeared on her change of address announcement and later on her Christmas card.

70. Quoted in Milton Meltzer, *Dorothea Lange, A Photographer's Life* (New York, 1978), 84, from an article in *Camera Craft* (October 1934), 461–467.

71. For the story of the *Migrant Mother* photograph, see Meltzer, *Dorothea Lange, A Photographer's Life*, 132–136.

72. Outside Soviet Russia, politically committed photographers in the 1920s were scarce. Modotti in Mexico was an exception. A movement to create worker-photographers in Germany through the communist magazine *Arbeiter Illustrierte Zeitung* (Worker's Illustrated Newspaper) produced no steady source of documentary photographs of publishable quality, and the editors commonly resorted to montages based on photographs from outside sources or edited those supplied by picture agencies to suit their needs.
An affiliated publication, *Der Arbeiter Fotograf* (The Worker Photographer), begun in 1926, helped to instruct and encourage amateur political photography of the extreme left, but with little lasting consequence.
See Ute Eskildsen, "Germany: the Weimar Republic" in Jean-Claude Lemagny and André Roille, eds., *A History of Photography, Social and Cultural Perspectives* (Cambridge, Mass., 1986), 147–148, for a discussion of the worker-photographer. See also David Mellor, ed., *Germany, The New Photography, 1927–33* (London, 1978), 44–53.

73. Man Ray, "The Age of Light," quoted in Alan Trachtenberg, ed., *Classic Essays on Photography* (New Haven, 1980), 167.

74. Louis Aragon, "Painting and Reality: A Discussion," published in *transition* 25 (1936), 97.

75. George Orwell, *The Road to Wigan Pier* (New York, 1958), 109 (first American ed.).

76. Stryker was head of the Historical Section under John Franklin Carter, head of the Information Division, who in turn was under Rexford Tugwell, head of the Resettlement Administration and simultaneously Assistant Secretary of Agriculture. For a complete history of the formation of the FSA, see F. Jack Hurley, *Portrait of a Decade, Roy Stryker and the Development of Documentary Photography in the Thirties* (Baton Rouge, 1972).

77. Several adjustments to the initial team were necessary. Budget cuts ended Theo Jung's employment in May 1936 and Mydans left that summer to work for Henry Luce's new publishing venture, *Life*. In Mydans' place Stryker hired Russell Lee.
Paul Carter was also on staff by the end of 1935, but only for a brief time. For a history of the hiring of various photographers by Stryker, see Hank O'Neal, *A Vision Shared, A Classic Portrait of America and its People 1935–1943* (New York, 1976), and Hurley, *Portrait of a Decade*.

78. Stryker's vast understanding of the farm economy and its history better informed and often structured the work of his photographers in the field. Once his sense of mission congealed, briefings, suggestions, pleading, and even shooting scripts were part of his way of getting what he thought would benefit the overall program.

79. Evans' first photographs were snapshot discoveries of accidental patterns of found urban structures, which he dutifully showed to Stieglitz in 1929 without success, and sent off as examples of "new photography" in 1930 to an exhibition in Munich, *Das Lichtbild* (The Photograph), from June through September 1930, to which 228 photographers, agencies, or industrial firms submitted work. The other American photographers were Cunningham, Weston, and a photographer listed as Sheril (perhaps Sheril Schell).

80. Quoted in Beverly Moore Bethune, *The New York Photo League: A Political History* (Ann Arbor, 1979), 17.

81. Lisette Model, "Why France Fell," *PM's Weekly*, Sunday Edition, Section Two, 19 January 1941, cover and 34–39.

82. James Agee, intro. to Helen Levitt, *A Way of Seeing* (New York, 1965), vii. The Agee essay was written in 1946, but remained unpublished until 1965.

83. Walker Evans, "Walker Evans: The Unposed Portrait," *Harper's Bazaar* (March 1962), 120–125. In 1966, Evans issued a book of the subway portraits with an introduction by James Agee, entitled *Many Are Called*.

84. Percy Knauth, "Gertie & the G.I.s," *Time* 45:16 (16 April 1945), 26–27. See also Percy Knauth, *Life* 18:16 (16 April 1945), 14–18.

85. Quoted in Percy Knauth, "A War Is A War Is A War, Gertrude Stein gives GIs a lecture on deportment," *Life* 18:16 (16 April 1945), 14.

86. Robert Capa as quoted by Richard Whelan, *Robert Capa, A Biography* (New York, 1985), 203.

87. Robert Capa, *Slightly Out of Focus* (New York, 1947), 146.

88. Capa, *Slightly Out of Focus*, 104.

89. Quoted in William Johnson, "W. Eugene Smith: 1938–1951," in *The Archive* 12 (July 1980), 14.

90. Paul Valéry, "The Centenary of Photography," in Alan Trachtenberg, ed., *Classic Essays on Photography* (New Haven, 1980), 192.

91. Stein in Knauth, *A War Is A War Is A War*, 17.

92. This notion of the artist's idea of form occurs in Paul Valéry, "Leonardo and the Philosophers," Anthony Bower, trans., in *Paul Valéry, Selected Writings* (New York, 1964), 113. "The philosopher cannot easily comprehend that the artist passes, almost with indifference, from form to content and from content to form; that form comes to the artist with the meaning that he wishes to give it, nor that the idea of form is the same thing to him as the idea which demands a form."

93. Cartier-Bresson's first book of his photographs published in 1952 was titled *Images à la sauvette*, which was translated as *The Decisive Moment*.

197. AMERICAN EXPEDITIONARY FORCES UNDER THE DIRECTION OF EDWARD STEICHEN
*Aerial View of Battlefield with Soldiers and Trenches*, c. 1918
gelatin silver print, 34.0 x 48.7 (13⅜ x 19⅛)
San Francisco Museum of Modern Art, Arthur W. Barney Bequest Fund Purchase

LE MASSACRE DES INNOCENTS                                    MAX ERNST

198. Max Ernst
*Massacre of the Innocents*, 1920
photocollage with brush and ink, gouache, and watercolor, 21.3 x 28.9 (8⅜ x 11⅜)
Mrs. Edwin A. Bergman

199. MAN RAY
*Dust Breeding (on Duchamp's Large Glass)*, 1920
gelatin silver print, 20.0 x 26.0 (7⅞ x 10¼)
Jedermann Collection, N.A.

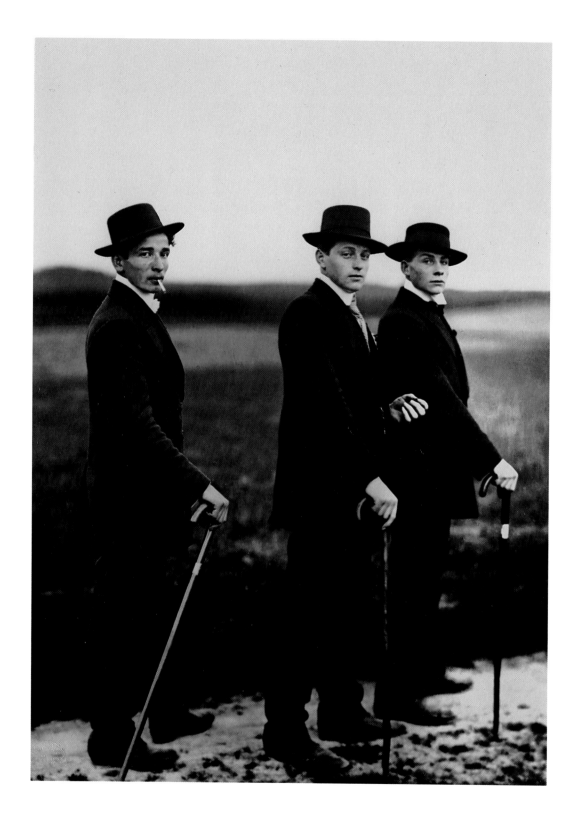

200. AUGUST SANDER
*Young Peasants on Their Way to a Dance,*
*Westerwald, 1913–1914*
gelatin silver print, 1927, 26.0 x 20.0 (10¼ x 7⅞)
Mr. and Mrs. Richard L. Menschel

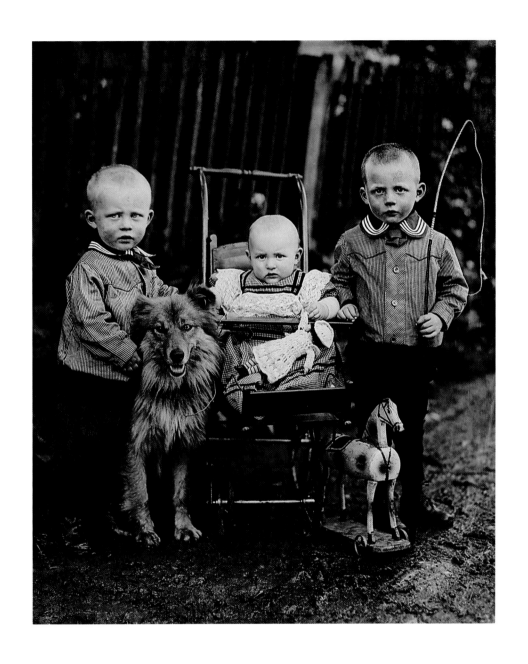

201. AUGUST SANDER
*Group of Children, Westerwald,* 1920
gelatin silver print, 27.5 x 22.6 (10¾ x 8⅞)
The J. Paul Getty Museum

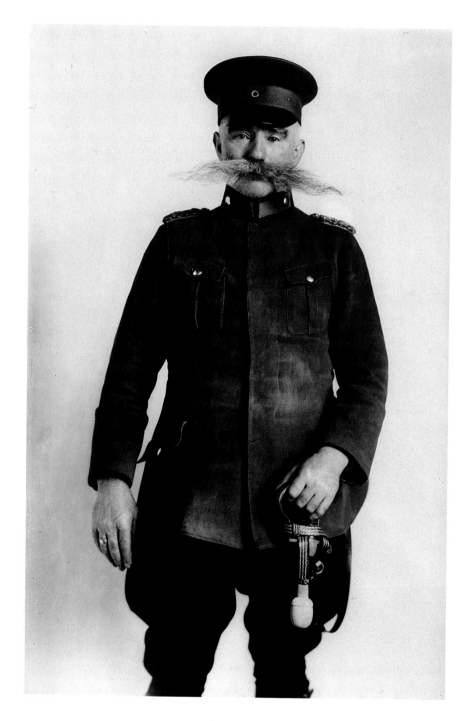

202. AUGUST SANDER
*Police Officer*, 1925
gelatin silver print, 29.6 x 19.5 (11 11/16 x 7 11/16)
Collection, The Museum of Modern Art, New York, Gift of the Photographer

266

203. KARL BLOSSFELDT
*Silphium lacinatum*, 1915–1925
gelatin silver print, 30.1 x 24.0 (11⅞ x 9⁷⁄₁₆)
Hochschule der Künste, Berlín

204. Karl Blossfeldt
*Balsamine impatiens*, 1915–1925
gelatin silver print, 30 x 24 (11 13/16 x 9 7/16)
Hochschule der Künste, Berlin

205. ALVIN LANGDON COBURN
*Vortograph*, 1917
gelatin silver print, 22.1 x 27.0 (8¹¹⁄₁₆ x 10⅝)
The Art Institute of Chicago, Harold L. Stuart Endowment

206. Edward Weston
*Tina Modotti Reciting Poetry*, 1922
platinum print, 23.5 x 19.2 (9¼ x 7⁹⁄₁₆)
Jedermann Collection, N.A.
Copyright 1981, Arizona Board of Regents,
Center for Creative Photography

207. Alfred Stieglitz
*Georgia O'Keeffe*, 1920
palladium print, 24.4 x 19.7 (9⅝ x 7¾)
National Gallery of Art, Alfred Stieglitz Collection

208. PAUL STRAND
*Rebecca*, 1923
platinum print, 19.3 x 24.0 (7⅝ x 9⁷⁄₁₆)
The J. Paul Getty Museum, Copyright 1981, Aperture Foundation, Inc., Paul Strand Archive

209. Alfred Stieglitz
*Georgia O'Keeffe*, 1918
palladium print, 23.6 x 19.3 (9⁹/₁₆ x 7⁵/₈)
National Gallery of Art, Alfred Stieglitz Collection

210. ALFRED STIEGLITZ
*Music: A Sequence of Ten Cloud Photographs, No. 1, 1922*
gelatin silver print, 19.4 x 24.0 (7⅝ x 9⅜)
National Gallery of Art, Alfred Stieglitz Collection

211. László Moholy-Nagy
*Untitled (Photogram)*, 1922
photogram on gelatin silver printing-out-paper,
13.9 x 8.9 (5½ x 3½)
The Art Institute of Chicago, Julien Levy Collection,
Special Photography Acquisitions Fund

212. Georg Muche
*Self Portrait*, c. 1925
gelatin silver print, 15.8 x 12 (6⁵⁄₁₆ x 4⅝)
The Art Institute of Chicago,
Mary L. and Leigh B. Block Endowment

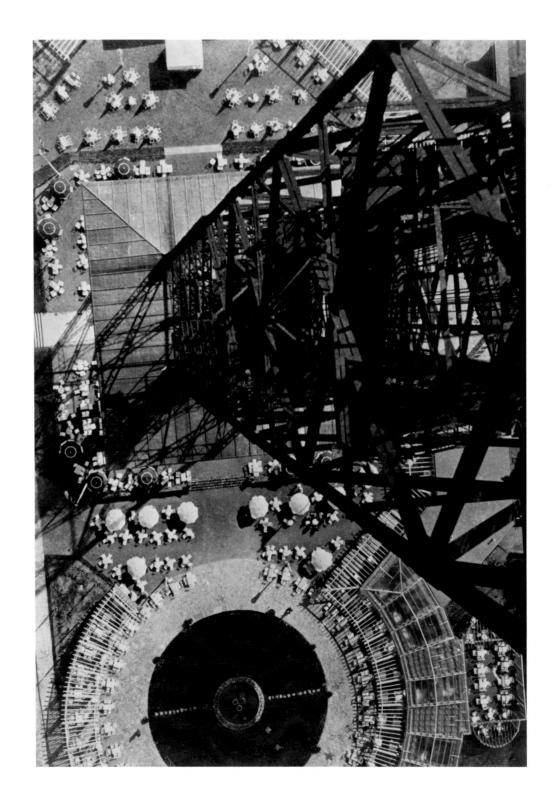

213. László Moholy-Nagy
*Berlin Radio Tower*, c. 1928
gelatin silver print, 36.0 x 25.5 (14¼ x 10¹⁄₁₆)
The Art Institute of Chicago, Julien Levy Collection,
Special Photography Acquisitions Fund

214. László Moholy-Nagy
*Oskar Schlemmer, Ascona*, 1926
gelatin silver print, 29.2 x 21.2 (11½ x 8⅜)
The Art Institute of Chicago, Julien Levy Collection,
Gift of Jean and Julien Levy

215. ALEXANDER RODCHENKO
*At the Telephone*, 1928
gelatin silver print, 39.4 x 29.0 (15½ x 11⁷/₁₆)
Collection, The Museum of Modern Art, New York,
Mr. and Mrs. John Spencer Fund

216. GERMAINE KRULL
*Shadow of the Eiffel Tower, Paris*, c. 1928
gelatin silver print, 22.2 x 15.3 (8¾ x 6¹⁄₁₆)
The Art Institute of Chicago, Photography Purchase Account

217. ELSE THALEMANN
*Waiting Passersby*, c. 1930
gelatin silver print, 12.2 x 17.1 (4¹³⁄₁₆ x 6¾)
The Art Institute of Chicago, Arnold H. Crane Endowment

218. Franz Roh
*Untitled (Pedestrians)*, c. 1928
negative gelatin silver print
23.4 x 18.5 (9¼ x 7³⁄₁₆)
The Art Institute of Chicago,
Restricted Gift of the Rice Foundation
in Memory of Dan and Ada Rice

279

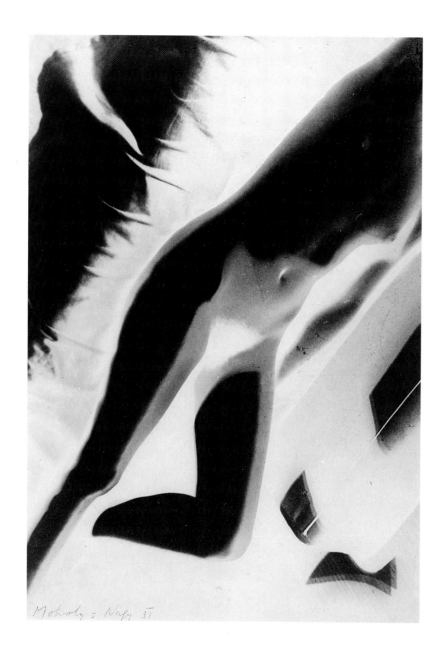

219. László Moholy-Nagy
*Nude (positive and negative)*, 1931
gelatin silver prints, 38.0 x 27.0 (15 x 10⅝) each
Jedermann Collection, N.A.

220. Yasuzo Nojima
*Untitled (Standing Nude)*, 1931
bromoil print, 39.5 x 26.9 (15⅝ x 10⅝)
The Nojima Collection, Courtesy of
The National Museum of Modern Art, Kyoto

221. Paul Outerbridge
*Advertisement for George P. Ide Co.*, 1922
platinum print, 12.3 x 9.5 (4⅞ x 3¾)
Museum of Fine Arts, Houston, Museum Purchase
with Funds Provided by Target Stores, Inc.
Copyright G. Ray Hawkins Gallery, Los Angeles

222. JAROMIR FUNKE
*Untitled (Shadows of Bottles)*, c. 1927
gelatin silver print, 29.2 x 23.5 (11½ x 9¼)
San Francisco Museum of Modern Art, Purchase

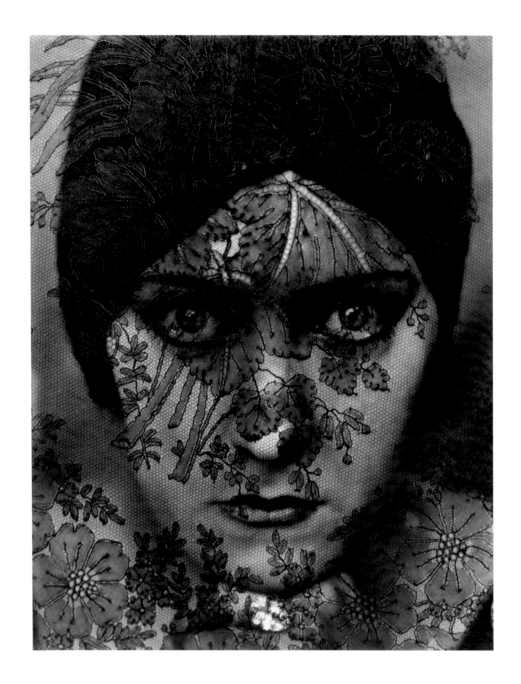

223. EDWARD STEICHEN
*Gloria Swanson*, 1924
gelatin silver print, 24.1 x 19.1 (9½ x 7½)
The Richard Sandor Collection

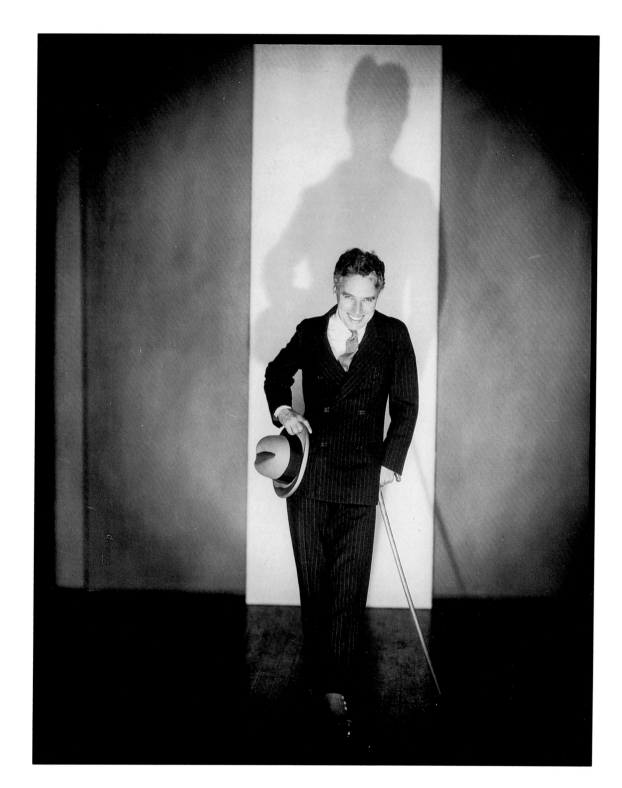

224. EDWARD STEICHEN
*Charles Chaplin*, 1925
gelatin silver print, 25.1 x 20.1 (9⅞ x 7⅞)
International Museum of Photography
at George Eastman House,
Bequest of Edward Steichen
by Direction of Joanna T. Steichen

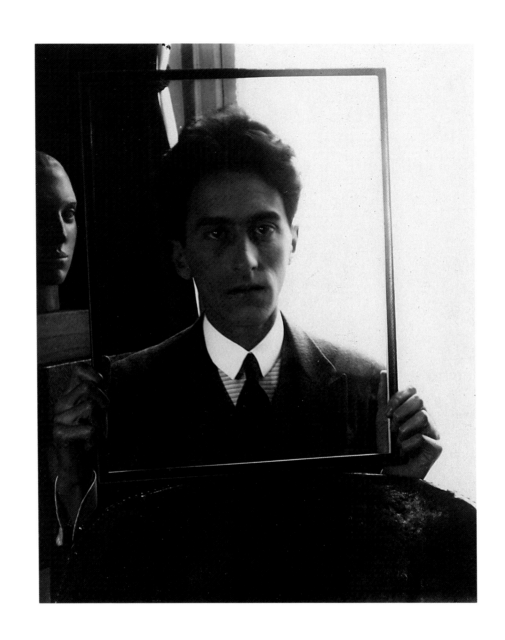

225. Man Ray
*Portrait of Jean Cocteau*, 1922
gelatin silver print, 11.9 x 9.8 (4¹¹⁄₁₆ x 3⅞)
The J. Paul Getty Museum, Copyright 1924, Man Ray Trust/ADAGP-Paris/ARS-USA

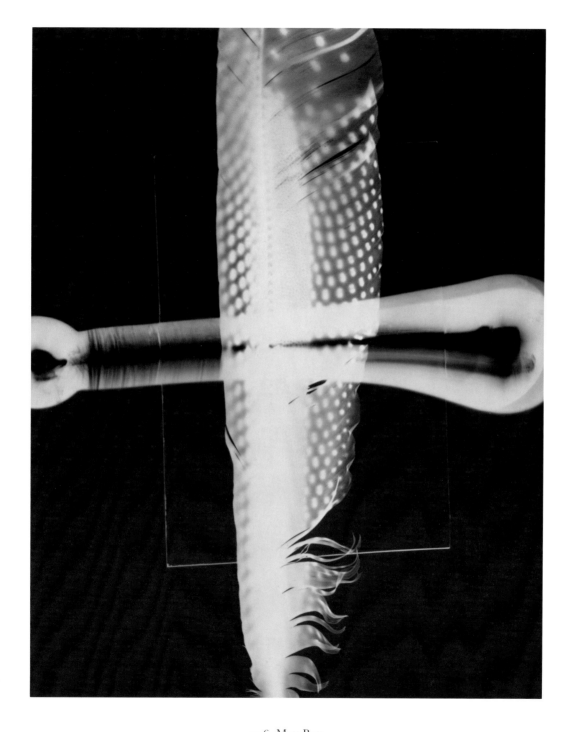

226. Man Ray
*Untitled (Photogram)*, 1923
photogram, 29.6 x 23.8 (11 11/16 x 9 3/8)
The Art Institute of Chicago, Julien Levy Collection, Special Photography Acquistions Fund

227. MAN RAY
*Rétour à la Raison*, 1923
gelatin silver print from a motion picture
negative, 18.7 x 13.9 (7⅜ x 5½)
The Art Institute of Chicago,
Julien Levy Collection,
Special Photography Acquisitions Fund

288

228. MAN RAY
*Mrs. Henry Rowell*, c. 1929
gelatin silver print from solarized negative, 21.9 x 16.8 (8⅝ x 6⅝)
The Art Institute of Chicago, Julien Levy Collection, Special Photography Acquisitions Fund

229. Jaroslav Rössler
*Portrait of a Woman*, 1931
gelatin silver print, 17.8 x 17.8 (7 x 7)
The Richard Sandor Collection

230. Tato
*Mechanical Portrait of Remo Chiti*, 1930
gelatin silver print, 23.8 x 17.8 (9⅜ x 7)
San Francisco Museum of Modern Art, Byron Meyer Fund Purchase

231. EUGÈNE ATGET
*Store, Avenue des Gobelins*, 1925
gelatin silver printing-out-paper print, 22.8 x 17.8 (9 x 7)
International Museum of Photography at George
Eastman House, Museum Purchase,
ex-collection Man Ray

232. UMBO
*Untitled (Mannequin Legs and Slippers)*, 1928
gelatin silver print, 29.6 x 20.9 (11 11/16 x 8 1/4)
The Art Institute of Chicago, The Julien Levy
Collection, Gift of Jean and Julien Levy

233. EUGÈNE ATGET
*Fête du Trône de Géant*, 1925
gelatin printing-out-paper print, 17.9 x 22.5 (7⅟₁₆ x 8⅞)
The Art Institute of Chicago, The Julien Levy Collection,
Special Photography Acquisitions Fund

234. Martin Munkacsi
*Motorcycle Rider*, c. 1923
gelatin silver print, 33.9 x 26.9 (13½ x 10⅝)
The J. Paul Getty Museum

294

235. Jacques-Henri Lartigue
*Gerard Willemetz and Dani*, 1926
gelatin silver print, 1988, 30.2 x 17.2 (11⅞ x 6¾)
Association des Amis de J.-H. Lartigue, Paris
Copyright Association des Amis de Jacques-Henri Lartigue, Paris

236. Ilse Bing
*Horses Jumping through Fire, New York Circus, Paris*, 1936
gelatin silver print 19.6 x 28.5 (7¾ x 11¼)
Gilman Paper Company Collection

237. Henri Cartier-Bresson
*Hyères, France*, 1932
gelatin silver print, 19.8 x 29.5 (7¹⁵⁄₁₆ x 11⅝)
The Art Institute of Chicago, Julien Levy Collection,
Gift of Jean and Julien Levy

238. Berenice Abbott
*El at Columbus and Broadway, New York City*, 1929
gelatin silver print, 16.2 x 22.2 (6½ x 8¹⁵⁄₁₆)
The Art Institute of Chicago, Julien Levy Collection,
Gift of Jean and Julien Levy

296

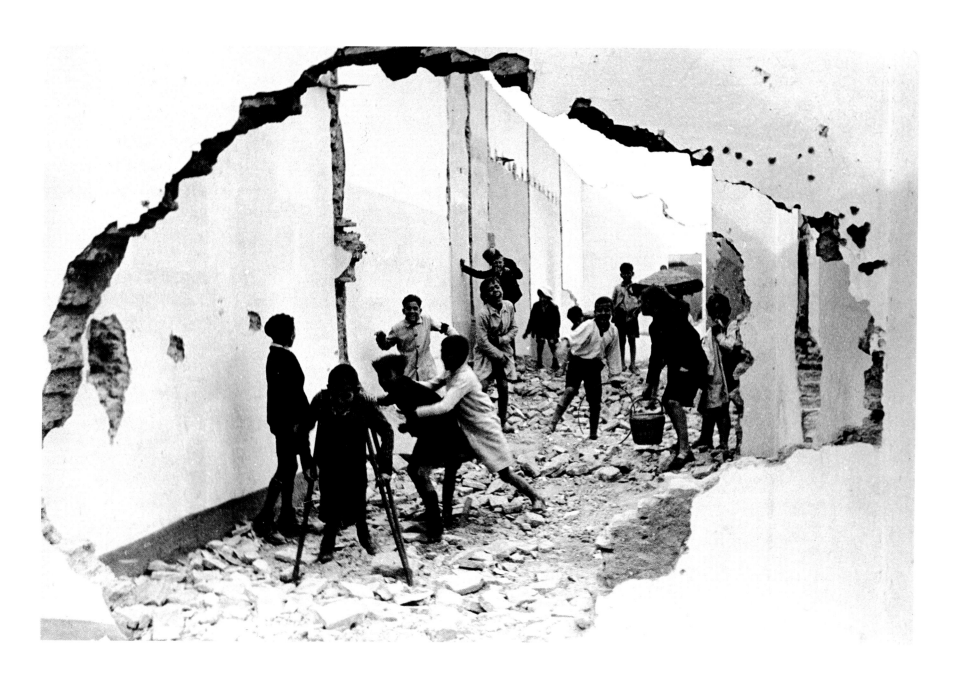

239. HENRI CARTIER-BRESSON
*Seville, Spain,* 1933
gelatin silver print, 19.3 x 29.0 (7⅝ x 11⅜)
The J. Paul Getty Museum

240. André Kertész
*Chez Mondrian*, 1926
gelatin silver print, 10.8 x 7.9 (4¼ x 3¹/₁₆)
The Art Institute of Chicago, Julien Levy Collection,
Gift of Jean and Julien Levy

241. André Kertész
*Chairs, The Medici Fountain*, 1926
gelatin silver print, 16.4 x 18.5 (6⁷/₁₆ x 7⁵/₁₆)
Museum of Fine Arts, Houston, Museum Purchase
with Funds Provided by the Sarah Campbell Blaffer Foundation

242. André Kertész
*Satiric Dancer*, 1926
gelatin silver print, 9.6 x 7.9 (3¹⁵⁄₁₆ x 3¹⁄₁₆)
Collection of Nicholas Pritzker

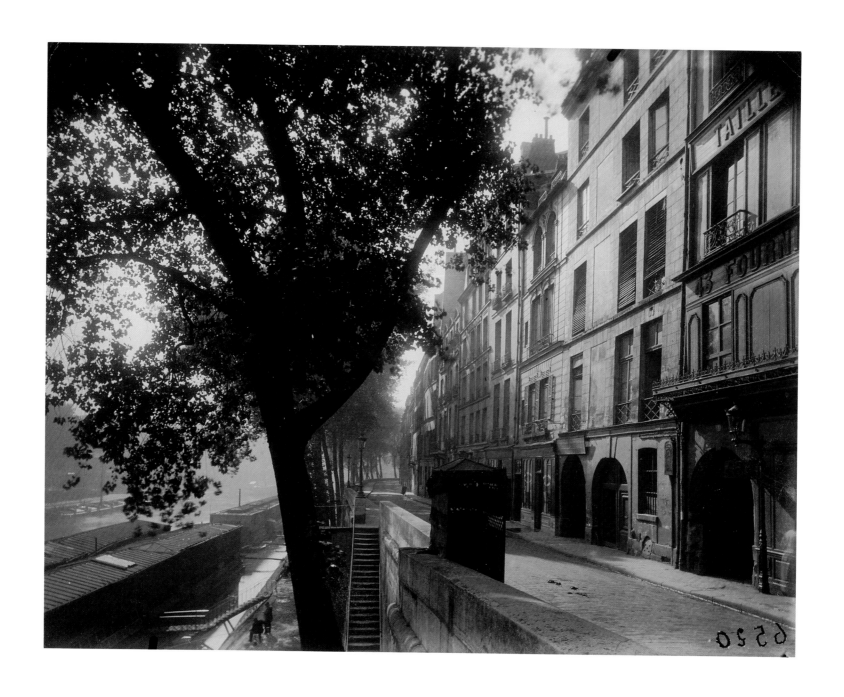

243. Eugène Atget
*Quai d'Anjou, 6 am, 1924*
arrowroot print, 17.8 x 22.8 (7 x 9)
Gilman Paper Company Collection

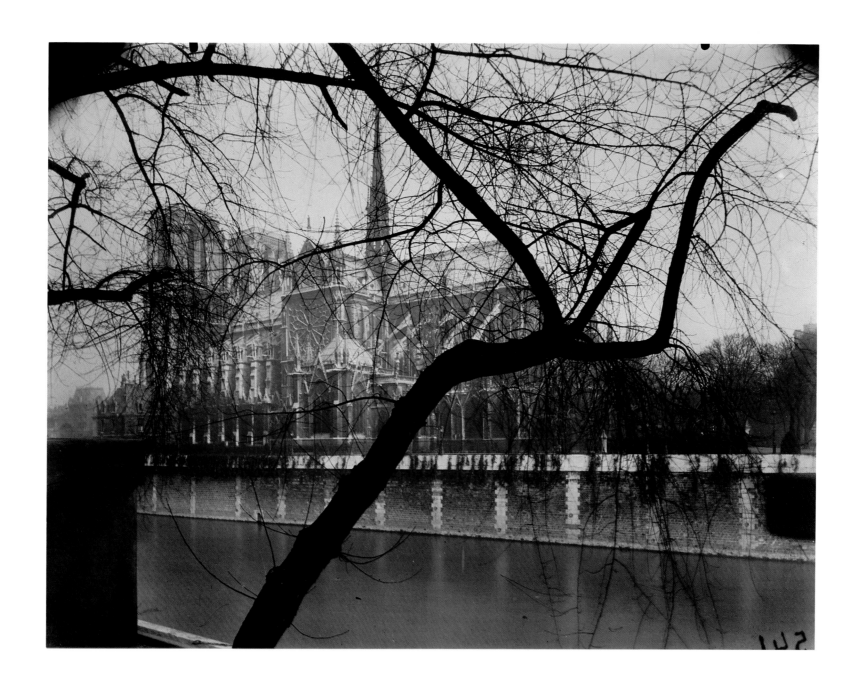

244. Eugène Atget
*Notre Dame (6541)*, 1925
albumen print, 16.6 x 22.0 (6⁹⁄₁₆ x 8⅝)
Collection, The Museum of Modern Art, New York, Abbott-Levy Collection,
Partial Gift of Shirley C. Burden

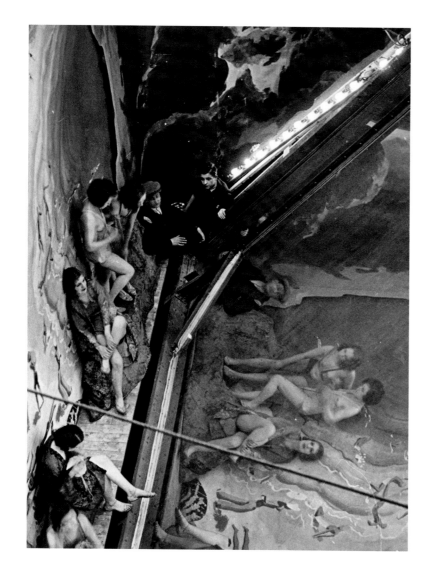

245. Brassaï
*Backstage at the Folies-Bergère*, 1932
gelatin silver print, 23.7 x 17.8 (9⁵⁄₁₆ x 7)
The Art Institute of Chicago, Restricted Gift of Leigh B. Block

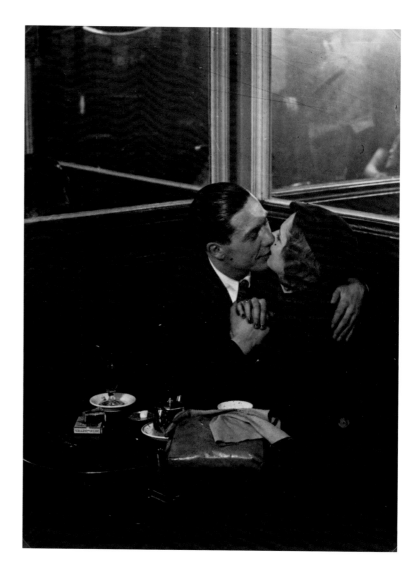

246. Brassaï
*Lovers in a Bistro*, 1932–1933
gelatin silver print, 23.2 x 17.2 (9⅛ x 6¾)
Collection of Nicholas Pritzker

247. Brassaï
*Chez "Suzy,"* 1932–1933
gelatin silver print, 22.2 x 17.5 (8¼ x 6⅞)
Collection of Nicholas Pritzker

248. Henri Cartier-Bresson
*Martigues, France, 1932–1933*
gelatin silver print, 24.7 x 16.6 (9⅝ x 6⅞)
Collection of Nicholas Pritzker

249. Henri Cartier-Bresson
*Italy, 1933*
gelatin silver print, 28.8 x 20.8 (11⅜ x 8³⁄₁₆)
The Art Institute of Chicago, Julien Levy Collection, Gift of Jean and Julien Levy

250. Henri Cartier-Bresson
*Alicante, Spain*, 1933
gelatin silver print, 16.3 x 23.7 (6⁷⁄₁₆ x 9⁹⁄₁₆)
The Art Institute of Chicago, Julien Levy Collection, Special Photography Acquisition Fund

251. CHARLES SHEELER
*Self-Portrait at Easel*, 1931–1932
gelatin silver print, 24.5 x 18.7 (9⅝ x 7⅜)
The Art Institute of Chicago,
Ada Turnbull Hertle Endowment

252. Michel Seuphor
*Portrait of Enrico Prampolini*, 1929
gelatin silver print, 16.3 x 12.3 (6⁷⁄₁₆ x 4⁷⁄₈)
The Art Institute of Chicago, "In Chicago" Portfolio Fund

253. FLORENCE HENRI
*Self-Portrait*, 1937
gelatin silver print, 23.9 x 27.8 (9⁷⁄₁₆ x 10¹⁵⁄₁₆)
The J. Paul Getty Museum

254. ALEXANDER RODCHENKO
*Toilette*, 1934
gelatin silver print, 39.7 x 29.5 (15⁹⁄₁₆ x 11⅝)
The J. Paul Getty Museum

255. ALFRED STIEGLITZ
*Equivalent, Set C2, No. 3,* 1929
gelatin silver print, 11.6 x 9.2 (4⅝ x 3⅝)
National Gallery of Art, Alfred Stieglitz Collection

256. ALFRED STIEGLITZ
*Equivalent, Set C2, No. 4,* 1929
gelatin silver print, 11.8 x 9.1 (4⅝ x 3⁹/₁₆)
National Gallery of Art, Alfred Stieglitz Collection

257. ALFRED STIEGLITZ
*Equivalent, Set C2, No. 5,* 1929
gelatin silver print, 11.7 x 9.2 (4⅝ x 3⅝)
National Gallery of Art, Alfred Stieglitz Collection

258. ALFRED STIEGLITZ
*Grass, Lake George,* 1933
gelatin silver print, 18.9 x 24.3 (7⁷⁄₁₆ x 9⁹⁄₁₆)
National Gallery of Art, Alfred Stieglitz Collection

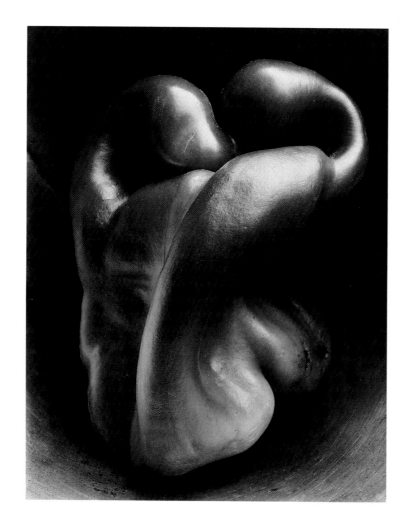

259. EDWARD WESTON
*Pepper*, 1930
gelatin silver print, 24.2 x 19.0 (9½ x 7½)
The Los Angeles County Museum of Art, Anonymous Gift
Copyright 1981, Arizona Board of Regents,
Center for Creative Photography

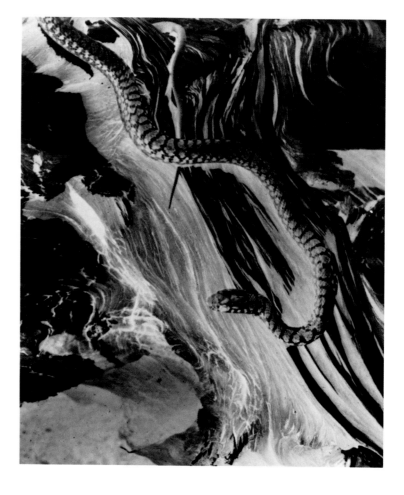

260. IMOGEN CUNNINGHAM
*Snake*, 1929
negative gelatin silver print, 19.7 x 16.6 (7¾ x 6⁹⁄₁₆)
The Art Institute of Chicago, Julien Levy Collection,
Gift of Jean and Julien Levy

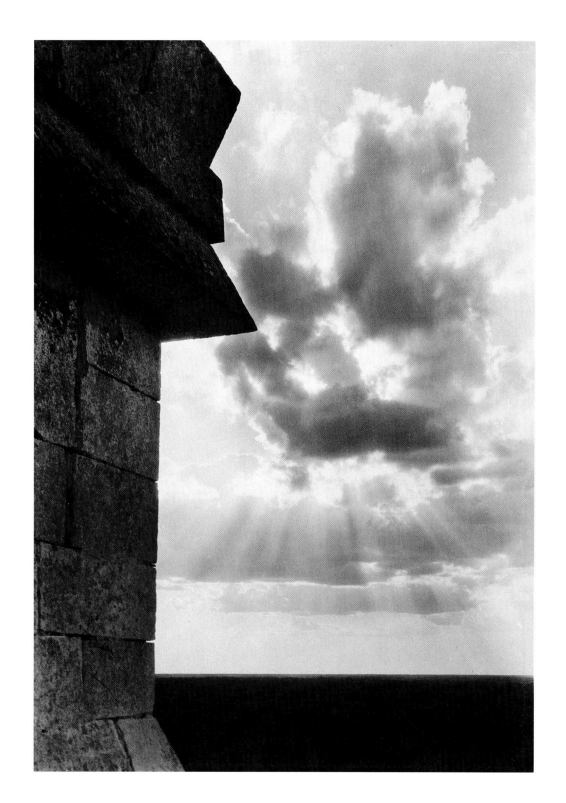

261. Laura Gilpin
*Sunburst, the Castillo, Chichen Itza*, 1932
silver bromide print on Gevaluxe paper,
35.6 x 25.2 (14 x 10)
Amon Carter Museum, Fort Worth, Texas,
Copyright 1981, Laura Gilpin Collection

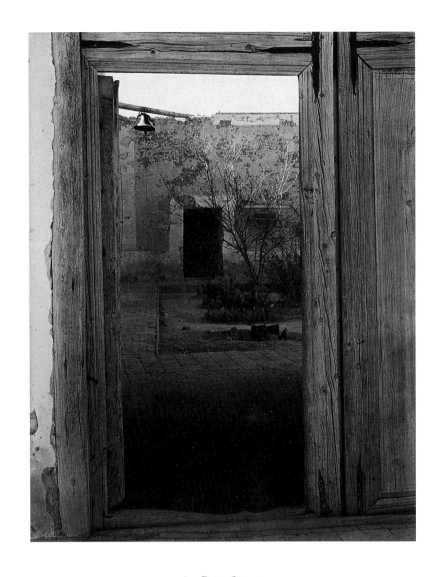

262. PAUL STRAND
*Hacienda, Saltillo, Mexico,* 1932
gelatin silver print, 24.6 x 19.2 (10 x 7⁹⁄₁₆)
The J. Paul Getty Museum, Copyright 1986, Aperture Foundation, Inc.,
Paul Strand Archive

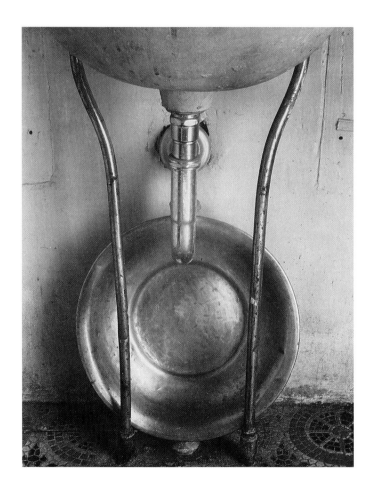

263. EDWARD WESTON
*Washstand,* 1925
platinum print, 24.5 x 18.9 (9⁹⁄₁₆ x 7⁷⁄₁₆)
The Art Institute of Chicago, Harold L. Stuart Endowment
Copyright 1981, Arizona Board of Regents,
Center for Creative Photography

264. ALBERT RENGER-PATZSCH
*Little Tree*, 1929
gelatin silver print, 38.1 x 28.3 (15 x 11⅛)
Museum für Kunst und Gewerbe, Hamburg

265, 266, 267. Ansel Adams
*Surf Sequences: #1, #2, #4*, 1940
three gelatin silver prints, 20.8 x 26.0 (8³⁄₁₆ x 10¼)
Philadelphia Museum of Art, Gift of Mr. and Mrs. Robert Hauslohner, Centennial Gift
Photographs by Ansel Adams, Copright 1981,
The Trustees of The Ansel Adams Publishing Rights Trust, All rights reserved

268. Edward Weston
*Dry Salt Pool, Point Lobos*, 1939
gelatin silver print, 19.4 x 24.0 (7⅝ x 9⁷⁄₁₆)
The Art Museum, Princeton University, Gift of David H. McAlpin
Copyright 1981, Arizona Board of Regents, Center for Creative Photography

269. EDWARD WESTON
*China Cove, Point Lobos,* 1940
gelatin silver print
24.3 x 19.2 (9⁹⁄₁₆ x 7⅝)
The Art Institute of Chicago,
Gift of Max McGraw
Copyright 1981,
Arizona Board of Regents,
Center for Creative Photography

270. Frederick Sommer
*Arizona Landscape*, 1943
gelatin silver print, 19.5 x 24.0 (7¹¹⁄₁₆ x 9⁷⁄₁₆)
Mr. and Mrs. Richard L. Menschel

271. EDWARD WESTON
*Point Lobos, North Dome*, 1946
gelatin silver print, 24.1 x 19.3 (9½ x 7⅝)
The Art Institute of Chicago,
Peabody Purchase Fund
Copyright 1981, Arizona Board of Regents,
Center for Creative Photography

272. Lewis Wickes Hine
*Empire State Building*, 1930–1931
warm-toned gelatin silver print, late 1930s,
49.0 x 39.6 (19⅜ x 15⅝)
The Art Institute of Chicago, Mary L. and
Leigh B. Block Endowment

273. Tina Modotti
*Workers, Mexico*, 1924
gelatin silver print, 17 x 21.0 (6¹¹⁄₁₆ x 8¼)
Amon Carter Museum, Fort Worth

322

274. Helmar Lerski
*Untitled*, c. 1930
gelatin silver print, 26.0 x 20.0 (10¼ x 7⅞)
Museum für Kunst und Gewerbe, Hamburg

275. BILL BRANDT
*Coal Searcher Going Home to Jarrow*, 1937
gelatin silver print, 22.9 x 19.8 (9 x 7¹⁵⁄₁₆)
The Art Institute of Chicago, Gift of Noya Brandt
Copyright Estate of Bill Brandt, Courtesy of Noya Brandt

276. AUGUST SANDER
*Unemployed Man*, 1928
gelatin silver print, 29.6 x 22.7 (11 $^{10}$/$_{16}$ x 8 $^{15}$/$_{16}$)
Collection, The Museum of Modern Art, New York, Gift of the Photographer

277. WALKER EVANS
*Maine Pump*, 1933
gelatin silver print, 20.0 × 14.9 (7⅞ × 5⅞)
Exchange National Bank of Chicago

278. WALKER EVANS
*View of Railroad Station, Edwards, Mississippi*, 1936
gelatin silver print, 19.7 × 24.5 (7¾ × 19¹¹⁄₁₆)
San Francisco Museum of Modern Art, Gift of Theo Jung

279. WALKER EVANS
*A Child's Grave, Hale County, Alabama,* 1936
gelatin silver print, 8.3 × 23.1 (3¼ × 9¹⁄₁₆)
The Art Institute of Chicago,
Restricted Gift of Lucia Woods Lindley and Daniel A. Lindley, Jr.

280. JOHN HEARTFIELD
*Little German Christmas Tree*, 1934
rotogravure print, 26.0 × 20.0 (10½ × 7⅞)
The Metropolitan Museum of Art, The Horace W. Goldsmith Foundation Gift, 1987

281. Hans Bellmer
*Machine Gun in a State of Grace*, 1937
gelatin silver print with oil and
watercolor, 64.8 × 64.8 (25½ × 25½)
San Francisco Museum of Modern Art.
Gift of Foto Forum
Copyright ARS N.Y./ADAGP, 1988

282. RUSSELL LEE
*Child of Migrant Worker in Car, Oklahoma*, 1939
gelatin silver print, 25.0 × 33.3 (9⅞ × 13⅛)
Museum of Fine Arts, Houston, Museum Purchase
with Funds Provided by The Mundy Companies

283. BEN SHAHN
*Three Men with Iron Pilaster, New York*, 1934
warm-toned gelatin silver print, 15.2 × 23.5 (6 × 9¼)
San Francisco Museum of Modern Art, Purchase

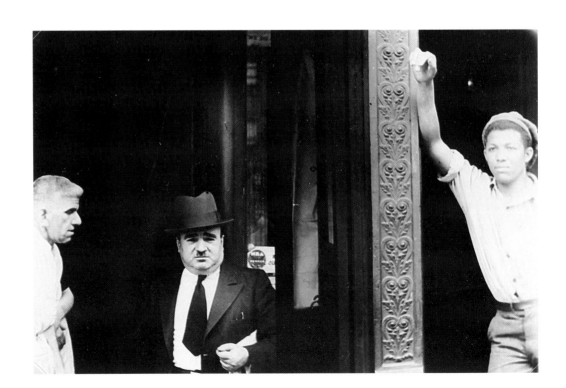

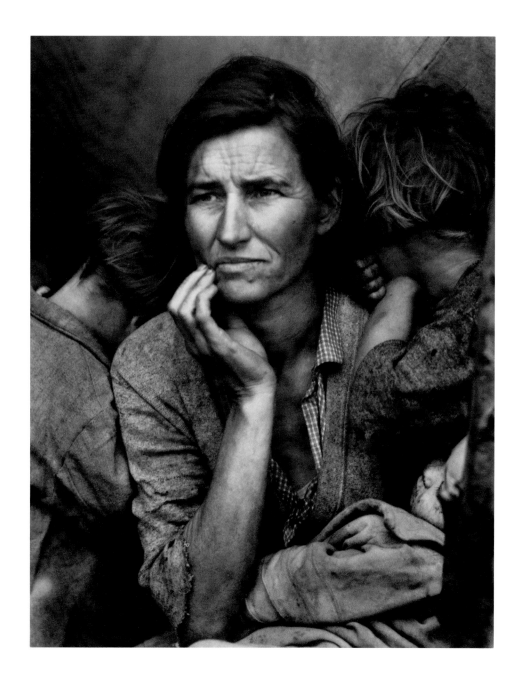

284. DOROTHEA LANGE
*Migrant Mother, Nipomo, California, 1936*
gelatin silver print, 50.0 × 39.4 (19⅝ × 15½)
Exchange National Bank of Chicago, Courtesy of the Dorothea Lange Collection
Copyright The City of Oakland, The Oakland Museum

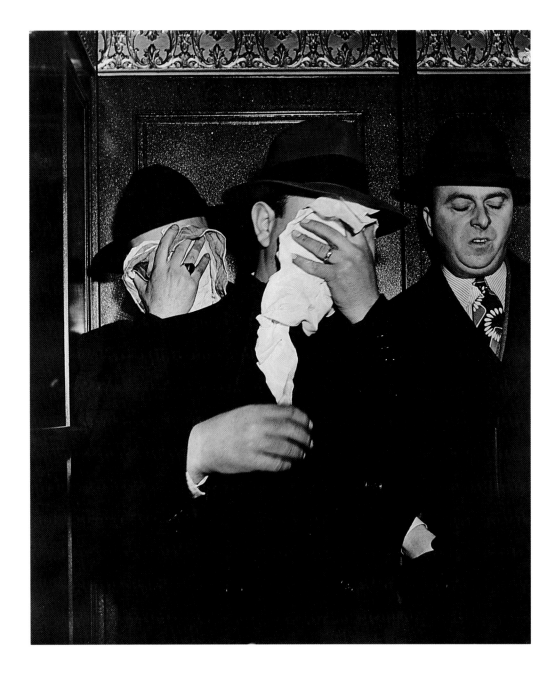

285. WEEGEE
*Arrested for Bribing Basketball Players*, 1942
gelatin silver print, 30.7 × 25.9 (12⅛ × 10³⁄₁₆)
The J. Paul Getty Museum

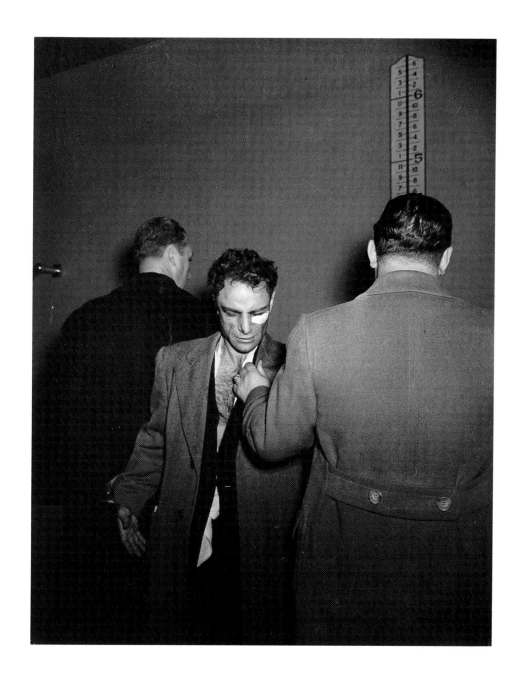

286. WEEGEE
*Booked on Suspicion of Killing a Policeman*, 1939
gelatin silver print, 34.5 × 27.0 (13⅝ × 10¹¹⁄₁₆)
San Francisco Museum of Modern Art, Members' Accession Fund Purchase

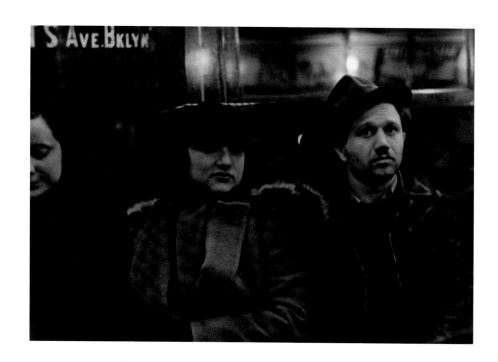

287. WALKER EVANS
*Untitled (Subway Portrait)*, 1938–1941
gelatin silver print, 12.6 x 19.3 (5 x 7⅝)
The Art Institute of Chicago, Gift of Arnold H. Crane

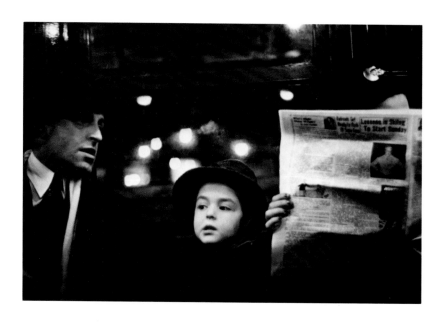

288. WALKER EVANS
*Untitled (Subway Portrait)*, 1938–1941
gelatin silver print, 12.4 x 19.1 (4⅞ x 7½)
Kent and Marcia Minichiello

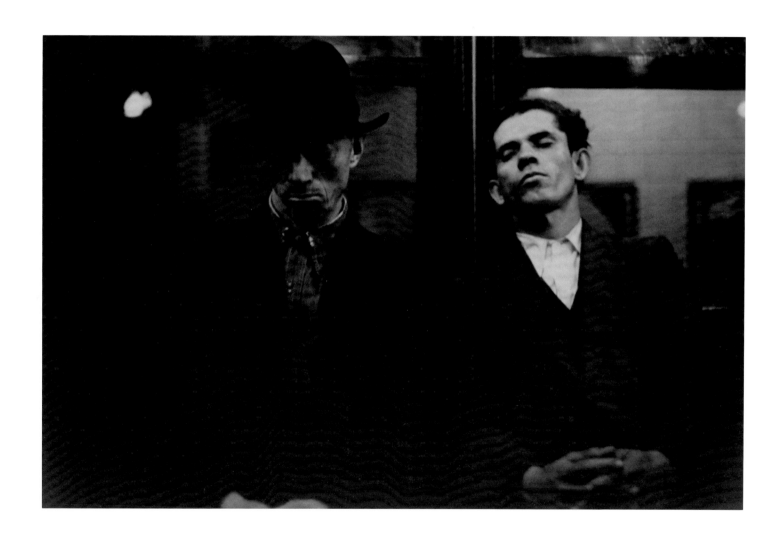

289. WALKER EVANS
*Untitled (Subway Portrait)*, 1938–1941
gelatin silver print, 12.8 x 19.3 (5 x 7⅝)
National Gallery of Art, John Wilmerding Fund

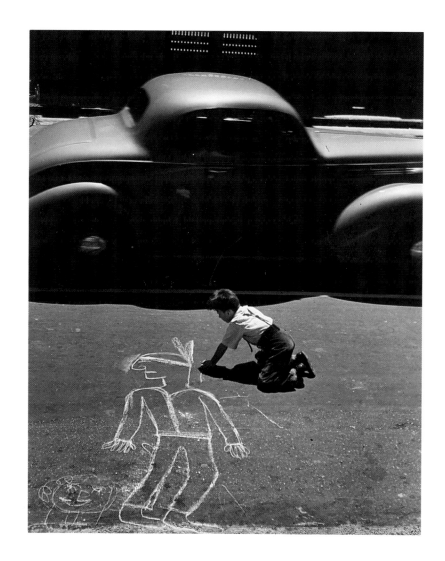

290. JOHN GUTMANN
*The Artist Lives Dangerously*, 1938
gelatin silver print, 23.5 × 19.1 (9¼ × 7½)
San Francisco Museum of Modern Art, Gift of Foto Forum

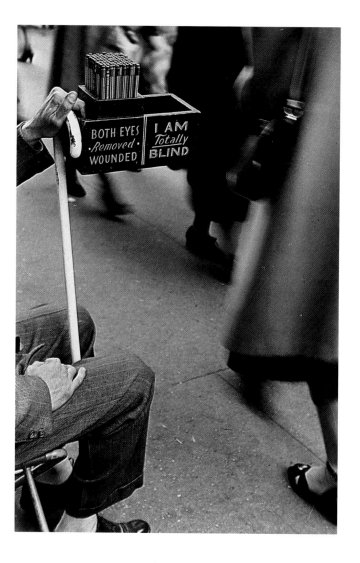

291. LOUIS FAURER
*Philadelphia*, 1937
gelatin silver print, 33.8 × 22.4 (13⅜ × 8⅞)
San Francisco Museum of Modern Art, Fund of the '80s Purchase

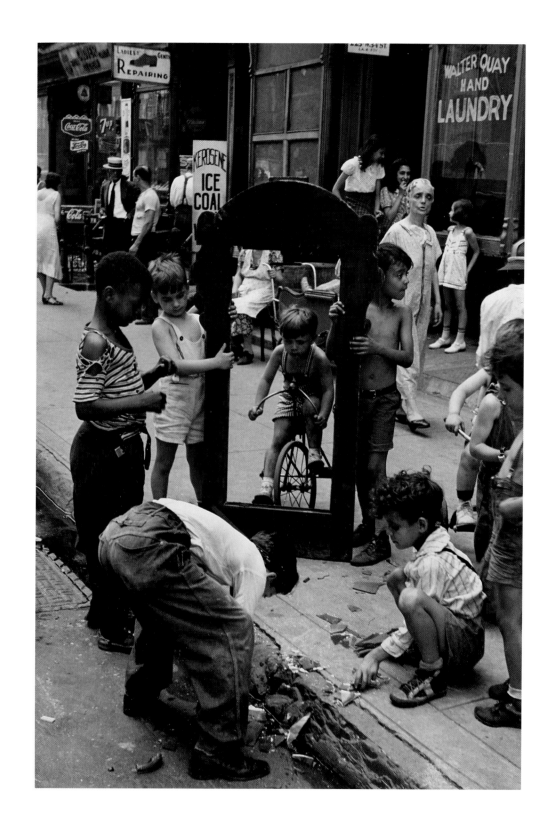

292. HELEN LEVITT
*New York*, c. 1945
modern gelatin silver print, 27.0 × 18.4 (10⅝ × 7¼)
Courtesy of the Photographer, Fraenkel Gallery,
San Francisco, Laurence Miller Gallery, New York

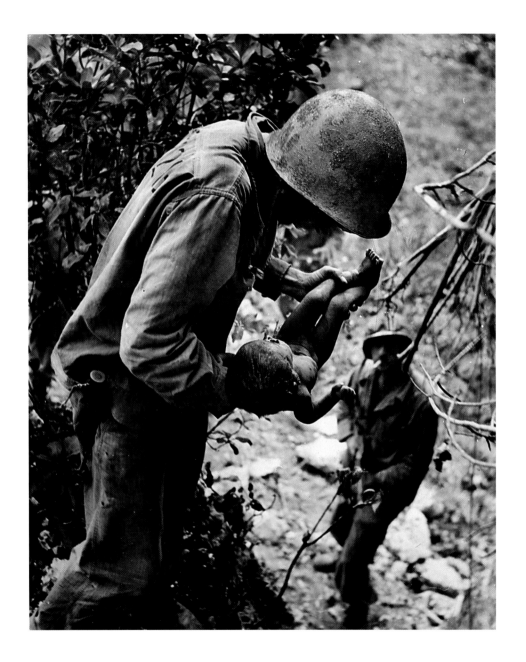

293. W. Eugene Smith
*Wounded, Dying Infant Found by American Soldier in Saipan Mountains*, 1944
gelatin silver print, 33.0 × 26.7 (13 × 10½)
Center for Creative Photography, University of Arizona
Copyright Heirs of W. Eugene Smith, photo courtesy of Black Star

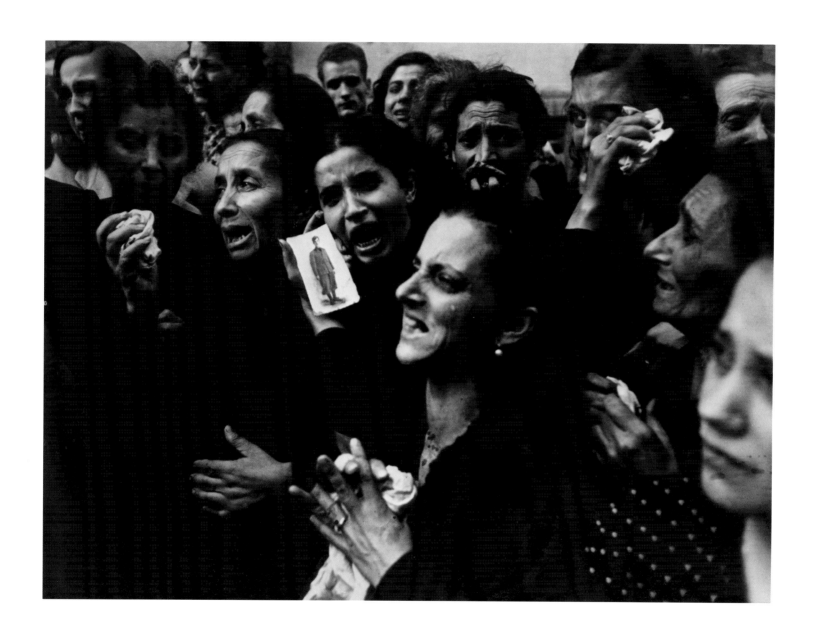

294. Robert Capa
*Naples*, 1943
gelatin silver print, 25.8 × 34.5 (10⁵⁄₁₆ × 13⁵⁄₈)
The Art Institute of Chicago, Restricted Gift of Mr. and Mrs. Morris Kaplan

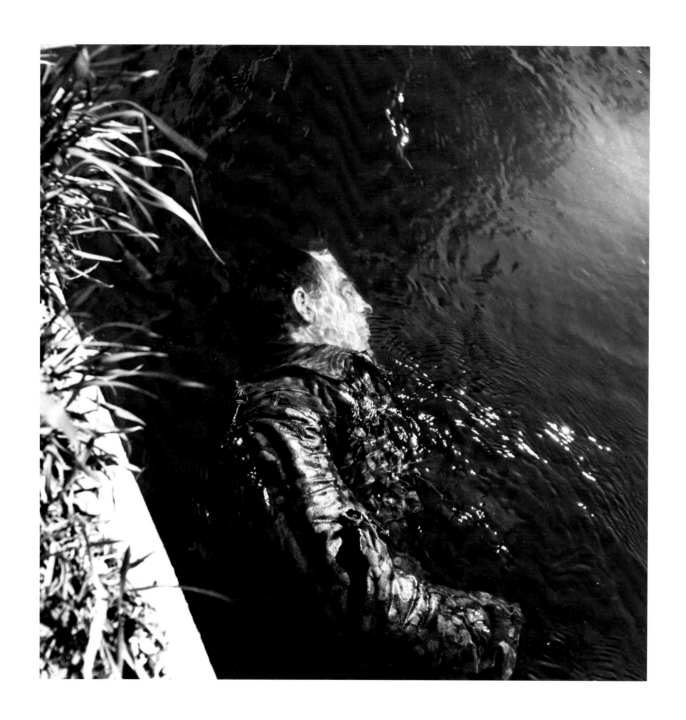

295. LEE MILLER
*Dead German Guard in Canal*, 1945
modern gelatin silver print,
1988, 23.0 × 23.0 (9¹⁄₁₆ × 9¹⁄₁₆)
Copyright Lee Miller Archives, England

296. LISETTE MODEL
*We Mourn Our Loss*, 1944
gelatin silver print, 32 × 26.9 (12⅝ × 10⅝)
The Art Institute of Chicago, Mary L. and
Leigh B. Block Endowment

297. Joseph Cornell
*Untitled (Penny Arcade Portrait of Lauren Bacall)*, 1945–1946
gelatin silver photographs in box construction, 53.4 × 41.0 × 9.2 (20⅝ × 16⅛ × 3⅝)
Mrs. Edwin A. Bergman

# IV
## 1946–1989

Fig. 1. *Jay, New York*, from Robert Frank, *The Americans* (Paris, 1958; New York, 1959 (cat. 399)

# Beyond the Photographic Frame

COLIN WESTERBECK

## THE LANDSCAPE TRADITION

In the early 1940s, Ansel Adams made a number of photographs that were to be among his best known ever. It was the period in which he produced *Moonrise, Hernandez, New Mexico* (1940), *Clearing Winter Storm, Yosemite National Park* (1944), and *Mount Williamson, Sierra Nevada, from Manzanar, California* (1945). Also included in the series should be *Winter Sunrise, The Sierra Nevada, from Lone Pine, California* (1944) (cat. 298), which is in many respects the apotheosis of his vision both then and later. The impressive clarity of this photograph is due not only to the mountain air and sharp focus, but to the rationality of the image. It is lucid in both senses of the word.

As the eye advances from the tiny detail of the horse in the foreground to the vast panorama of the distant mountain peaks, it finds a perfect order in nature, a logical progression. The black horse relates to a patch of sunshine as the hills in shadow do to the snow-covered range beyond. The syllogism that is writ large in this landscape leads to the irrefutable conclusion that all of nature is one, that its unity is inviolable. The photograph's composition equates light—which is, especially as seen here, the most fleeting and ethereal aspect of nature—with mountains, which are the most solid and permanent. The synthesis thus achieved reaches from the domesticated animal on the valley floor to the wild, primordial conditions above the cloud line. A uniquely American transcendentalism informs this image. Reason abides in nature and is manifest there. The macrocosm is but an elaboration of the principles that the microcosm contains.

Adams' work during this period draws upon an American landscape tradition that goes back to the nineteenth-century photographer Carleton Watkins and has included Adams as well as contemporary figures such as William Clift. Adams' *Winter Sunrise* and other pictures like it were the culmination of more than a decade of landscape work done in association with the Group f/64 and Edward Weston. Yet Adams' imagery was also undergoing something of a transformation in the early 1940s. The quiet corners and intimate views of the natural world that had been prominent in his 1936 exhibition at Alfred Stieglitz's gallery An American Place were less frequently seen in the early forties, when photographs with the panoramic sweep of *Winter Sunrise* began to dominate Adams' work. In the following decade, his prints too would change, becoming much larger than they had been before.

In order to see how Adams arrived at the vision represented by *Winter Sunrise*, the viewer must consider the particular historic moment when these images were made. Like *Mount Williamson*, *Winter Sunrise* was taken in the vicinity of Manzanar, California, at the time that Adams was documenting conditions there in one of the "relocation centers" where the federal government had interned all West Coast Nisei, or second-generation Japanese-Americans. The beauty and seeming tranquility of *Winter Sunrise* give the impression that it is a timeless image—that it was made at a great enough remove from the terrors of World War II not to have been affected by them. But the truth is that it was made very much in the shadow of world events, of which Adams was, at that moment, painfully aware.

"As I write this," he stated in *Born Free and Equal*, the book in which his photography of the Manzanar center was published late in 1944, "men are dying and destruction roars in almost every part of the globe." He saw the relocation

camps as yet another "tragic problem" in a world already suffering from "human catastrophes such as the destruction of Rotterdam, the annihilation of Lidice, the rape of Nanking, or the decimation of the Jews."[1] Such reflections impart to photographs like *Mount Williamson* or *Winter Sunrise* a special poignancy and significance—as if Adams were trying to look beyond the sordidness of Manzanar, scanning the mountains above the camp in search of some higher truth. He was striving to recapture the high moral ground to which photography had always led him before.

If Adams' vision remained altered forever, despite the fact that he was far removed from the conflict, the impact of the times on those photographers who were directly involved in the war was much greater. Minor White, while on active duty in the Phillipines at around the same time Adams was documenting Manzanar, wrote,

If battle gives me time
It is my will
To cut away all dear insanities
I get in War
Or if I live
To amputate the pain
I've seen endured.[2]

In 1947, White reproduced this verse in a portfolio that combined portraits of soldiers with photographs of nature under the title *Amputations*. Despite this declaration of intent, however, he never was able to leave the effects of the war entirely behind. Throughout the next several decades he continued to edit and alter the sequence of the images.

Cutting away the "insanities" of war meant for White, as for Adams, getting back to the rationality of Edward Weston and Alfred Stieglitz. Stieglitz, whom White met in 1946, had made a series of cloud studies entitled the *Equivalents* that appealed to White because they turned photography from a medium of literal description into one of poetic metaphor. Nevertheless, the agenda White had for his own photography was something new and very different. In the *Equivalents*, Stieglitz had hoped to reveal "what [he] had learned in forty years about photography."[3] The subject White felt he was exploring was not photography *per se*, but himself.

He said, in 1955, "I photograph not that which is, but that which I AM."[4] For White, the *Equivalents* turned out to be a point of departure, a place where he could touch earth briefly and get his footing before taking that leap in the dark that was necessary in order to explore his own feelings.

White's photographs show that what he felt was disorientation. In early postwar views of the Pacific Ocean such as *Pacific, Devil's Slide, California* (cat. 299), we can hardly tell where the water ends and the sky begins. *Bullet Holes, Capitol Reef, Utah* (cat. 312), done in 1961, almost a decade and a half later, appears to be a photograph of a starry night in the desert, until we notice the title and realize that we have completely mistaken both the scale and the nature of the image. In photographs such as these, it seems that the four elements—earth, air, water, and even the distant fire of the stars—have lost their distinctness and blended uncertainly together. The suggested sense of topsy-turvy in nature is demonstrated most dramatically by the 1947 image *Surf, Vertical, San Mateo County, California* (cat. 300), in which White turned on its side a picture of sea foam spreading up a beach. These photographs all follow in different ways the lead of the *Equivalents*, of a few highly illusionary studies of natural scenes made by Weston, and of some inverted pictures done by Moholy-Nagy. But even in Stieglitz's horizonless, omnidirectional images, we never lose our bearings in nature to the extent that we frequently do in White's work, which can make it all but impossible for us to tell up from down, little from big, or foreground from background.

Another verse of White's from the war years reads,

When there is no further
Down to go
The bottom
Drops out on up.[5]

The last line, especially, seems to give voice to the disorientation of the photographs. This verse is included just before *Amputations* in White's 1969 book *Mirrors Messages Manifestations*. The anxiety of war left White no place further down to go, and, after the fighting was over, he could not escape the existential angst that the war had instilled.

The world war became a cold war that found its way into White's photography in the peculiar mid-sixties images symbolic of the bomb entitled *Sand Dune, Eel Creek, Oregon* and *Essence of Boat*, or in the 1951 *Fog over City* suggesting a descending radiation cloud, which was included in the 1953 portfolio *Intimations of Disaster*. "And man will invent atomic fires," White wrote at the war's end and also included in *Amputations*. This concern remained with him in 1969 when he did a sequence for *Mirrors* in which his most Adams-like landscape, *Grand Tetons* (1959), is followed by a photograph of a mound of burning tires and rubbish. In the second picture the natural beauty of the first one appears to have been incinerated in some manmade cataclysm.

After the war, White turned his sense of disorientation into an aesthetic basis for his work. The photography became a way to salvage spiritual value and clarity from chaos. His conversion to Catholicism in 1943 was only the first step in a quest that led him to explore a variety of Oriental and occult systems of belief. He went from traditional Christianity through the *I Ching* and Esalen to Gurdjieff, and he arrived at the wisdom that he must photograph "that which I AM" as a result of reading Evelyn Underhill's book *Mysticism*.

White achieved the light-headedness of a mystic living ascetically at high altitudes where the rarefied atmosphere causes him to see visions. The disorientation that he experienced became, in the end, the sort felt by someone who ritualistically chants a mantra over and over to the point of hyperventilation. White was capable of going into a contemplative's trance, sitting for hours watching snow fall in the yard, ice crystals gather on windowpanes, or wax drip from candles. The experience of photographing was like "hypnosis," he said; it was a "melting together, bliss or fear mounting to terror."[6]

The course that White's vision took after the war followed a pattern that was repeated, and can be seen even more clearly perhaps, in the careers of other photographers. Consider the work of Denis Brihat, who was a member of a small group that came together in France in the late 1940s and in the early 1960s would form a movement called Expression Libre, which was in many respects a European Group f/64, a photographic fellowship that strove, as Weston, Adams,

Fig. 2. Denis Brihat, *Coupe d'un choux rouge*, 1950, gelatin silver print, 39.5 x 23.5 (15⅝ x 9¼), Bibliothèque Nationale (cat. 400)

and others had in the 1930s, for a consensus on aesthetic matters. In the still life studies for which Brihat is best known, the debt he owes to Edward Weston is obvious. From his choice of subject for an early postwar image—a green pepper—to his 1972 treatment of a single pear, which he invested with an unmistakably anthropomorphic, female quality, he seems to have built his entire career around an explicit recovery and reaffirmation of Weston's aesthetic of the thirties. Weston's vision, in which all of nature was informed by a ubiquitous sexual potency and energy, naturally appealed to a generation of photographers trying to revive their spirits after the war.

What is most interesting in Brihat's early photographs, however, is the absence of Eros from nature. Among his more evocative images is one of a red cabbage cut in half, *Coupe d'un choux rouge* (1950), a picture that invites comparison to Weston's studies of both a single leaf of cabbage and a cut head of kale. The latter picture, *Kale Halved* (1930), is closest to Brihat's; yet even it is very different in spirit because of the phallic power that it suggests. The leaves radiate as if they were bolts of electricity being generated by the stalk, which they at the same time enclose in a protective, womblike field. In like manner, Weston's cabbage leaf is sensuous and free as a form, a metaphor for water flowing over stone or a woman's hair blowing in the wind, or for muscle under skin and vessels engorged with blood.

Brihat's cut cabbage, by contrast, makes a pattern so involuted and compacted that it suggests total paralysis. It looks like an image of a dissected brain, as though the photographer were searching in vegetable nature for some clue to the inner workings of human nature. The brain that is exposed in his picture seems to have imprinted on it a new postwar gestalt, an unmistakable image here and there of human bodies writhing and straining in a fit of desperation, or even suffocation. It as is if the pictures that were published after the war of the corpses of concentration camp victims frozen in their death agony had forever impressed themselves on the human imagination—as if, beyond being a permanent scar, an ineradicable memory, such imagery had become a part of the structure of the mind itself.

One reason Brihat's work retains its interest for us is that it was part of an intellectual and artistic crisis that many photographers, including White, were going through. Like White, Brihat wanted to reach back over the war—over the millions of soldiers and civilians killed, over the Holocaust and the atomic bomb, over the rise of Nazism and Stalinism— to link up yet again with some kind of aesthetic order that made sense to him. But Brihat could not entirely cut away the insanities or amputate the pain of war any more than White could. The plight of these photographers was similar to that of trauma victims who try at first to believe that they have not been hurt. They attempt to go back to the last moment at which the world was still normal, to go on as if everything

were fine. But their actions become an eerie variation on the theme of their earlier behavior. White, Brihat, and many other photographers did go back to the pre-war traditions; they picked up where photography had left off. But because of the new conditions that had been generated by the war, what these photographers created was a deflection and transformation, not just a continuation or recovery, of earlier photographic aesthetics.

## SUBJECTIVE PHOTOGRAPHY

The disorientation found in White's imagery is a common phenomenon among postwar photographers. Material that achieves comparable effects ranges from the splayed and flattened Italian hillsides of Mario Giacomelli to Jan Dibbets' vertiginous overhead panoramas of courtyards, churches, and other atrium spaces (cat. 381). Both photographers' works seem intended to make the viewer's head spin. In color pictures in the *Glen Canyon* series by Eliot Porter (cat. 314), the spatial ambiguities result from reflections in water. In Bill Brandt's landscapes and interiors with nudes, from in the 1950s (cats. 309, 310), an aura of hallucination is instilled by the use of a police evidentiary camera because the extreme distortion that it creates imparts a warped perspective.

Even the street photography from the postwar years is often characterized by confusion and distortion. Callahan was seeing double in the series of Detroit street scenes that he shot during the war (cat. 305); and the tilting of the camera in Robert Frank's 1954 image from New York (cat. 352), as in many of those that Garry Winogrand made a decade or two later (cat. 355), suggests that the photographer was off-balance. In like manner, the wide-angle lens preferred by street photographers makes their subjects pitch and yaw crazily in the frame. This is particularly noticeable in the 1950s work of William Klein or that done in the 1960s by Josef Koudelka. In Koudelka's picture from Utekac, Czechoslovakia (cat. 354), the girl seems to float free from the earth in a way that gives the image a hallucinatory quality shared by Bill Brandt's nudes. In Roy De Carava's 1965 photograph of a man passed out in a New York subway entrance (cat. 365), it is hard to tell whether we are standing at the

top of the stairs or the bottom, just as, in Lee Friedlander's images shot through windows in the 1960s and 1970s (cats. 362, 363), foreground and background are indistinguishable. The play of light on glass in Friedlander's work can create illusions as dizzying as those sometimes caused by light on water in Porter's imagery.

A similarly disconcerting group of landscapes was made in Germany by members of the *fotoform*, a collective for photographic amateurs and artists founded in 1949. The image *Die Tiefe* (1950) by Toni Schneiders (cat. 301) employs a formalist strategy similar to that White used in *Surf, Vertical*: Schneiders turned his image, blistered tar or moonlight reflecting in bubbles on a beach, upside down. It thus becomes a vision of intergalactic space. Like White in *Bullet Holes, Capital Reef, Utah*, where we see a starry desert night in a piece of vandalized rock or wood, Schneiders has caught a glimpse of the cosmos in a small, dark, perhaps damaged corner of nature. Not all similarities between American photographers and their German counterparts are as pointed as this, but throughout the decade of the fifties there are in the *fotoform* work many instances, like Peter Keetman's 1958 image *Schnee-Inseln* (cat. 303), which cause the viewer to skate on the thin ice of visual illusion.

The war was unquestionably a presence in the work of European photographers who either belonged to or exhibited with the *fotoform* group. Keetman, who served in the German military from 1940 to 1944, had been so badly injured that he was unable to work until 1947. Scenes of winter like his *Schnee-Inseln* evoke feelings of drift in nature, and of a numbness induced by cold, that are common in European postwar photography. Such frigid imagery may well reflect memories of the severe fuel rationing of the war years. The high-contrast print of a snow scene made in the early 1950s by Norwegian photographer Christer Strömholm, who joined *fotoform* in 1951, depicts a world equally featureless, bleak, and locked in ice (cat. 302).

There is a parallel between this European imagery and some of the work of American photographers whose experiences were far removed from the war. Harry Callahan's most often reproduced snow scene (cat. 306) was done in Chicago around the time that Schneiders made *Schnee-Inseln*. It's even possible, since Callahan's work was included in later

Fig. 3. Mario Giacomelli, *Countryside*, from the series *Paessaggio*, 1971, gelatin silver print, 30.0 x 40.3 (11 5/16 x 15 7/8), The J. Paul Getty Museum (cat. 401)

*fotoform* exhibitions, that he inspired European photographers for whom the chilly beauty in some of his images had associations and potential meanings that he could never have imagined.

A more decisive factor in the similarity between certain German and American artists, however, was the influence that the heritage of the Bauhaus had on both. When *fotoform* members in the late forties wanted to reach back over Nazism and the war to recover a viable photographic tradition, the one to which they naturally turned was that established at the Bauhaus in the 1920s by László Moholy-Nagy. In Chicago too, the predominant influence was Moholy's, because it was to this city that he had come in the late thirties, when he fled Europe, in order to found a "New Bauhaus."

349

By the mid-1950s, after the school he started had gone through several reincarnations and finally become the Institute of Design, Harry Callahan was running the photography program (Moholy had died in 1946) and had hired Aaron Siskind as an instructor. Just as Callahan's spare winter scenes from between 1940 and 1955 have their counterparts in *fotoform* photography, so too do Siskind's abstract closeups of peeling paint and weathered walls (cat. 304). What the imagery of Strömholm, Schneiders, Keetman and other members of the *fotoform* shares with that of Callahan, Siskind, and their students at the Institute of Design is an impulse toward reductionism that has its origins in Moholy's work.

Where both this Chicago photography and the similar work done in Europe differ from the Bauhaus aesthetic is in the frame of mind in which the imagery was created. The photographic culture of the twenties in Germany was allied with a larger movement in the arts, particularly painting, known as *die Neue Sachlichkeit* (the new objectivity). Photog-

raphy was used at the Bauhaus as a tool for the exploration and celebration of external realities upon whose principles this utopian arts collaborative hoped to rebuild society. But the intention of the *fotoform* was to sponsor what its founder Dr. Otto Steinert called, in the title that he gave to three exhibitions mounted in the 1950s, *Subjektive Fotographie*.

The new premise for photographic art that this phrase suggested was not limited to Germany alone. The global decimation caused by the war and the threat of even worse calamities posed by the bomb, which appeared to symbolize the destructive potential not only of man, but of nature, made impossible a return to either utopian aspirations for art or the idealization of objective reality. To artists working in a great many different countries and media, the self appeared to be the last refuge of human sensibility.

The disorientation that characterizes so much photography since the war is one form that subjectivity has taken. From the landscapes of White or Keetman to the tilted street photographs of Winogrand, photographers have sought ways to make imagery about not just the scene itself, but their experience of it. Pictures like Siskind's might also be thought of as belonging to this postwar style of images made, one might say, in an abstracted state of mind. Siskind's career offers an especially graphic illustration of the tendency to turn inward. Although, in the late 1930s, Siskind had run the most successful and complete of the documentary projects of the Photo League (the New York cooperative for socially concerned photography), in 1942 he began to make the abstract closeups that have dominated his work since then.

Abstraction was not new to photography, but like other postwar trends that had prewar precedents, this one was rather different in intention from what had gone before. Paul Strand, whose work and ideas had a great impact at the Photo League, had done abstractions inspired by cubism in 1915, and Siskind's imagery was influenced by the early stages of abstract expressionist painting. But where cubism was a means of analyzing external realities, abstract expressionism was a means of exploring internal ones, and the photography that followed from it had a like purpose. Actually, the effect of Siskind's photography on the painting of the day was as crucial as that of the painting on him, for his work was shown at

Fig. 4. Josef Sudek, *Untitled*, from the series *Easter Reminiscences*, c. 1952, gelatin silver prints, 29.5 x 23.0 (9¹/₁₆ x 6⁷/₈), Uměleckoprůmyslové Muzeum (cat. 402)

the Egan Gallery in New York several years before Franz Kline, who also exhibited there, began making paintings that closely compare to Siskind's photographs.

Otto Steinert and other members of the *fotoform* created their own type of photographic action painting by making light drawings and then negative prints of the expressionistic swirls, streaks, and squiggles that resulted. In Steinert's work, even when he did confront and document the reality of postwar Germany, as in the photograph entitled *Appel* (cat. 350), the image was dominated by the subjective experience—the apparition or hallucination—that the shadow figure looming in the foreground represents. A line can sometimes be imagined at the closest point where a camera's lens goes into focus. Everything beyond that line is assumed to be out there, in reality, while the indeterminate forms on the near side of the line seem to be a purely personal vision existing in the eye of the beholder alone.

Disorienting points of view and bare scenes of winter might be thought of as distinctive visual themes or motifs that are widespread in postwar photography. Themes like these, which transcend national boundaries and cultural differences, point toward underlying concerns and attitudes that characterize the period. One motif expressing the new, insular consciousness of the postwar years—the desire to withdraw into the self—was that of the world in a small room. *Worlds in a Small Room* is the title that Irving Penn gave to his 1974 book of portraits made on location around the globe in a portable studio. In this series, which Penn began at a local studio in Cuzco, Peru, in 1948 (cat. 339), each of the peoples represented is isolated in a stark, featureless rooms. A setting like this appears in a great deal of work other than Penn's, though. More typical than the photographer who transported a room all over the world were those who retreated into their own rooms, and tried to create a world there. The small room gives visible, symbolic form to a frequent desire expressed in the title of Minor White's touring exhibition of 1959: *Sequence 13/Return to the Bud*.

Callahan contributed to this motif in the late forties and early fifties with his nude studies of his wife Eleanor—sometimes by herself, at other times with their daughter—in the bedroom of their Chicago apartment (cat. 307). The nuclear family is the bud of life to which these pictures, made in a space as anonymous as Penn's portable studio, return. In one series, Eleanor's back faces us as Callahan projects on it slides of outdoor scenes, thus implying a condensation of the whole world into her body and their intimacy. The pictures suggest that only the private emotions this room contains have validity now. Even the room itself is reduced, a space with curtainless windows, pictureless walls, and a minimum of generic, functional furniture.

In 1945, Bill Brandt began photographing nudes in a rather spare Victorian parlor of his own. Like Callahan's nude studies, Brandt's were made outdoors as well as in, as he sought a reconciliation of the private and human with the natural world. In another respect, this postwar series made Brandt's career comparable to Siskind's, for Brandt was also turning away from documentary work toward more personal projects. During the thirties and the early forties, he had done ever more newsworthy kinds of reportage—beginning with a study of the social life of the different classes in London, then spending a period looking at living conditions in England's mining region, and finally photographing the effects of the Blitz. By switching to the pictures of nudes after the war, Brandt was deciding to, as Cyril Connolly put it, "remain a poet,"[7] which is to say, a lyric singer of the self.

For no photographer of the postwar period did the actuality of a small room merge more completely with its symbolism than for Josef Sudek in Czechoslovakia. The position of the exile seeking refuge in the self became very real for him when, during the Nazi occupation, he was forced to restrict his photographic activities primarily to his studio and garden in Prague. He was compelled to live his imaginative life in secret, recording it in his studies of the condensation on the studio windows, the garden outside, and the studio itself as seen from the garden. This private point of view was one that Sudek continued to maintain under the communist regime of the postwar years (cat. 308).

Sudek's work gains its poignancy from the way that its internal aesthetic conflict between romanticism and modernism appears to reflect a larger struggle within Czechoslovakian history. The alternative ways of looking at the world characteristic of his photography are epitomized by a modest still

life from which he made a pair of experimental prints late in his career. The darker one makes the subject into a romantic artifact, while the lighter renders it as a modernist abstraction, an object in the international style rather than a relic of Central Europe. The utter simplicity of the statement made by the two prints demonstrates how, as the photographer's sphere of action became reduced to his studio alone, the themes in the work became more nearly universal.

Like the theme of disorientation, that of the small room was extensively used in postwar photography. It appears in the images of a younger Czechoslovakian photographer, Jan Saudek, who works mostly in a basement studio (cat. 331), and in the imagery of contemporary Americans such as Lucas Samaras and Duane Michals. The former's *Photo-Transformations* show us the photographer as a demonic presence sequestered in his tiny Manhattan apartment (cat. 335). Michals' photonarratives are also set in modest, spare rooms similar to Samaras' apartment, or Callahan's. In the 1972 sequence of photographs entitled *Things Are Queer* (cat. 333), the inward-turning quality of so much postwar photography seems to be summarized perfectly. The image is, in effect, swallowed up by itself.

## PHOTOJOURNALISM

Interpretive landscapes and the sometimes cloistered art photography discussed so far were not the only kinds of imagery being made during the postwar period. The humanist photojournalism that had emerged in Europe in the 1920s and 1930s in the work of André Kertész, Henri Cartier-Bresson, Robert Capa, and others continued through the 1940s and into the 1950s. Yet even in this essentially documentary tradition, among certain younger talents who established their reputations after the war and in bodies of work that were original to that time, a newly subjective element emerged. Robert Doisneau's 1951 *M. et Mme. Garfino* (cat. 347), demonstrates why this photographer achieved tremendous popularity in the late forties. The *clochards* who are his subjects are the very image of Gallic dignity, battered and tattered in the war's aftermath, yet surviving undaunted. More than a record of present realities, the photograph appeals to

the memory of an earlier day. The picture's authenticity lies in its sympathy for French life and in a sense of humor preserved by Doisneau himself as much as the subjects he chooses.

Doisneau had grown up in the working-class *banlieus* whose bistros and street scenes he photographed after the war, and he had acquired there the attitude toward life that is evident in photographs like that of the Garfinos or his 1953 *Fox Terrier on the Pont des Arts* (cat. 343). This image pokes fun at art, looking upon the pretentions of the artist with a curious incredulity, and in so doing it relies upon a kind of earthy, slightly ribald sense of humor. The photograph provides an insight into Doisneau's personality that reveals something not only about him, but about Paris itself. The artisans' work rooms and walk-up flats, the summer street dances, and the dingy but lively cafés were for Doisneau the same sort of haven in a heartless world that America's national parks were for Ansel Adams.

The strength of Doisneau's documentation derives from a subjectivity that is the result of the photographer's actual, direct experience of the world he photographed. Just as Doisneau was a part of working-class Paris, Manuel Alvarez Bravo lived and worked in peasant Mexico. A student of the modernist tradition in the 1930s, Alvarez turned in the 1940s and 1950s more and more insistently to experiences of his youth and of the time of the Mexican Revolution. "I was born in the city of Mexico, behind the Cathedral, in the place where the temples of the ancient Mexican gods must have been built," he wrote to Nancy Newhall in 1943.[8] This was the year after he made the photograph *How Small the World Is* (cat. 345), in which laundry flutters brilliantly over a gray street. Images such as this one represent Alvarez's attempt to return, via an imaginative route, to the primal origins of his culture. He came to see the world through the eyes of his peasant subjects, and his work began to be informed by a kind of animism through which everything from a statue to a dress on a chair, or some laundry, seems to take on a life of its own. Even the humblest object or scene is inhabited by spirits made visible by Alvarez's photographs.

Alvarez had been exposed before the war to the influence of Cartier-Bresson, who had lived and worked in Mexico City in 1934, and whose imagery had inspired photographers

with hand cameras on both sides of the Atlantic. His style was less reliant on the distinct character of the photographer than Alvarez's or Doisneau's was. His work drew its strength not from his own personality but from a clear, long-held conviction about the nature of photography. He saw in the medium a capacity to exploit chance in the spirit of surrealism and thereby to create symbolic juxtapositions with poetic meanings. The results seemed to reveal a universal law about photography, a potential inherent in the medium itself rather than in the talent of any one practitioner. Many photographers in the postwar generation followed his lead.

In Elliott Erwitt's 1964 image from Poland, the postures of the women who incline to one another in the background mock the priest hearing confession in the foreground. This little drama of sacred and profane speech, truth and confession, absolution and relapse, depends on just the kind of aesthetic playing off of one element against another used by Cartier-Bresson. Marc Riboud's 1958 picture of a photographers' convention in Japan (cat. 344) seems almost a parody of the way that disciples and imitators of Cartier-Bresson have crowded the field since the war.

Both Erwitt and Riboud are members of Magnum, the photocooperative founded in 1946 by Cartier-Bresson, Robert Capa, David Seymour (known as "Chim"), and two other photojournalists. It would not be accurate to speak of a Cartier-Bresson school of photography, since he has never taught and always discouraged people who would revere him as a master. Yet Magnum did institutionalize the influence that Cartier-Bresson and the cooperative's other founders exercised on the history of photojournalism. Magnum's innovations were organizational and commercial, not aesthetic. In Cartier-Bresson's 1952 book, *The Decisive Moment*, the images are about equally divided between prewar work and his Magnum photography of the postwar era. But all are the product of an idea of the medium that he had realized fully by the mid-1930s.

Magnum constituted a new insight into world politics rather than photography. The original members of Magnum were convinced that much of postwar history would be made in the developing nations then struggling to emerge from colonial status. Cartier-Bresson, Capa, and the others de-

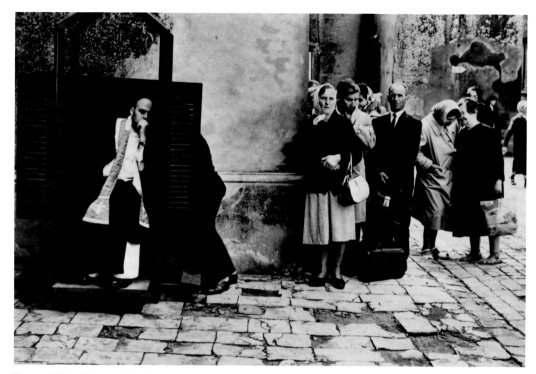

Fig. 5. Elliott Erwitt, *Confessional—Czestochowa, Poland*, 1964, gelatin silver print, 20.3 x 25.2 (8 x 10), The Art Institute of Chicago, on extended loan from Mr. Lawrence Schafran (cat. 403)

sired to work in the remote corners of Asia, Africa, or South America unfettered by the need to return constantly to Paris or New York to sell their pictures. It was essential that their sojourns should be long enough to permit them to work in the candid, invisible way that Cartier-Bresson had in European cities, or that Capa had in the front lines of wars in Spain, France, and elsewhere.

Although documentary photography and photojournalism were by definition types of work that looked outward rather than inward, even in this field some key figures eventually found themselves sequestered in a small room. André Kertész and Sid Grossman, for example, had very different backgrounds and commitments to photography; yet both found themselves in a cul de sac of this sort in New York after the war. Grossman was the director of education at the Photo League from the late 1930s until 1949, when he had to give up his association with the cooperative because he was named as a

Communist during an investigation of the League's alleged subversive activities. By the time this happened, he had already become somewhat estranged from others at the League. His estrangement was the result of a subtle shift in the League's photographic ideals that occured when Paul Strand began to put new emphasis on personal creativity. Strand's ideas carried great weight with the League members, and Grossman was made uneasy by the fear that the new goals meant an abandonment of the socially committed photography for which Lewis Hine, who had become a kind of patron saint of the League in the late 1930s, had stood.

After the war, Grossman continued to do the kind of documentary photography in which he believed, most notably at Coney Island in 1947 and an Italian street festival in 1948. After he left the League in 1949, he continued to teach, offering private classes in his apartment. But the sense of persecution he felt as a consequence of being branded a Communist and cut off from the League took its toll. One of his former students says that his paranoia became so great that he would lock the doors when his class met and not let anyone enter or leave until the session was finished, no matter how late that might be.[9] Nor did he go out himself to photograph in New York after 1949, for he had become afraid to show himself on the streets that had once been his prime subject matter. He died in 1955 of a heart attack, at the age of forty-two.

Kertész, too, felt isolated in New York without the support of the community of artists and bohemians to which he had belonged in Paris before the war. After being stranded in New York by the outbreak of the war, he felt he had no choice but to remain. Yet he never was able to feel comfortable in New York or to photograph in the city as he had in Paris. He had always been attracted to a point of view that looked down from a window above the street or a park, but in New York, as the years passed, and especially after he moved in the early 1950s into a highrise building where his balcony overlooked Washington Square, views from the sanctuary of his apartment became the predominant part of his work. Eventually, his gaze turned back into the apartment itself where he created, as his one new project in his old age, a series of views of objects of *virtu* and mementoes evocative of his past.

W. Eugene Smith was yet another photojournalist who

suffered a fate similar to that of Kertész and Grossman in the 1950s. Like Grossman, Smith became alienated from the institution that had fostered his career. He resigned from *Life* magazine in the mid-1950s and thereafter spent a crucial period photographing in and from a room that he was loath to leave. Smith had established himself as a war correspondent in the Pacific theater. But after the war, while Chim photographed the Arab-Israeli conflict, David Douglas Duncan went to Korea, and Cartier-Bresson covered China and Russia, Smith retreated from this kind of front-line reporting. He did his most famous postwar features for *Life* on places time had forgotten: rural North Carolina (*Folk Singers*, 20 October, 1947); rural Spain (*Spanish Village*, 9 April 1951); a small Colorado town (*Country Doctor*, 20 September 1948); and a leper colony in equatorial Africa where the world's most famous humanitarian, Dr. Albert Schweitzer, had set up a clinic (*A Man of Mercy*, 15 November 1954).

A common thread throughout Smith's photographs is his view of life as a mixture of brutality and tenderness. This view permeates his work, from his 1944 photograph of the Marine holding a dead baby on Saipan (cat. 293) to his image from the late 1950s of a shapely woman in a white dress glimpsed through the jagged opening of a broken darkroom window (cat. 351). Although the two photographs were made only ten to fifteen years apart, a lifetime of anguish and conflict separates them. By the late 1950s, after having left both *Life* and his family, Smith was living in a loft on Sixth Avenue in New York, heavily addicted to amphetamines and alcohol. Since his beginnings as a photojournalist working in the heat of battles that literally decided the fate of the world, Smith had become a recluse in a small room, trying to create imagery out of his personality alone.

During this period he made the photograph of the woman in the white dress as part of a series he called *As From My Window I Sometimes Glance*. In an unfinished 1957 letter, Smith offered a gloss on this title: "I glance from my window, but I cannot go out; I cannot go out!"[10] He did in fact go out again, completing two of the major projects of his career—the photographic essays on Pittsburgh (1958) and the effects of industrial pollution at Minamata, Japan (1971–1975). Still, the sense of exile within himself persisted as the views

from his window gave way after 1958 to a new experimental series. Some of the images it contains, in particular a group in which children's toys are backlit by the window, combine with the original views of the street below to make this passage of Smith's late career seem very like the housebound one that Kertész was also to experience.

After Smith moved to the loft, his prints of his classic images began to grow darker. At times his pictures are virtually indistinguishable from those of Robert Frank, the young Swiss photographer who had come to New York from Paris in 1947 and begun to establish a reputation in fashion photography at *Harper's Bazaar.* Frank's 1952 picture of a lonely fiddler cheering himself with his music on a darkened street might have been Smith's, just as Smith's image of *Dream Street* in Pittsburgh (cat. 349), or that of a Welsh miner trudging up a hill past some row houses (cat. 346), might easily have been made by Frank. Frank was inspired by Smith's 1950 photo-essay on Wales for *Life* to travel there himself to photograph. The two men had a show together in 1951, and for a while Frank thought of following in Smith's tracks at *Life.* Conversely, Smith's freelance Pittsburgh project, begun in 1955 and published in 1959, might have been the counterpart in his career to Frank's book *The Americans,* whose realization spanned roughly the same period.

While Smith, like Minor White, wanted to use photography to restore the moral order of the universe, Frank entirely lacked not only Smith's certainty that photographs could make a profound difference in the world, but confidence in the righteousness of photography itself as a vocation, a calling. Frank represented a way of thinking about the medium that was unique to the postwar period, though he did not invent this conception of photography all by himself. On the contrary, the new aesthetic grew from a number of sources almost simultaneously and, often, independently. Frank was significant because it was in his work that this aesthetic became intense enough to have an historic impact.

STREET PHOTOGRAPHY

"Your photographs speak too much," an American editor once told Kertész after he had relocated to New York.[11] If we remove the judgmental "too" from this statement, it becomes an indisputable one. Moreover, the quality that the editor was identifying in Kertész's work is the same one that Cartier-Bresson was thinking of when he referred to Kertész as "my poetic source."[12] The qualities that Kertész employed in his personal photojournalism in the late 1920s—visual counterparts to conceit, meter, formal control, and other aspects of prosody—were brought by Cartier-Bresson in the early 1930s to a kind of perfection that no one would ever surpass. In Cartier-Bresson's imagery, elegance became a form of eloquence.

Frank recognized the power of Cartier-Bresson's accomplishment in the medium, but he had no desire to emulate it. He wanted only to find a way around it. In 1948, when Frank left New York and a flourishing commercial career to go to Peru, he discovered his "style"[13] while traveling in the Andes by native transport. It was a trip during which he sometimes went for weeks without speaking to anyone because he could not understand local dialects. That experience was what he wanted his photography to capture. He relished his incomprehension and the total otherness of the world he had entered in Peru. The kind of photograph it made him want to take was literally a dumb picture, one that does not speak.

In a sense, the result was a simplification to the point where the uniqueness of photography as a medium was all that was left. Frank wanted to see whether anything lay on the other side of Cartier-Bresson's artistically self-sufficient masterpieces. What Frank discovered was the one property unique to the medium: its multiplicity, the endless number of pictures that the camera, by its facile, mechanical nature, made possible. The ideal of the masterpiece required that everything except the one perfect frame be discarded. Frank wanted to arrange intuitive pictures into sequences that would have a wholeness and power no single photograph could achieve.

When Frank returned to New York from Peru, he turned the pictures he had taken there into a hand-made book, the

first of several. By the time he published *The Americans* in France (1958), he had developed his ability to sequence images into a talent that would later lead him into filmmaking. The book progresses by symbolic montage. The plates follow each other by a kind of protean process through which an incidental detail in a picture—a look, a gesture, a fixture on a wall, a peculiarity of the light or the shadows—appears again, transformed somehow, in subsequent images.

The resultant complex, layered relationships among the pictures have a precedent in Walker Evans' *American Photographs*, a book from which Frank learned a lot. (In fact, Evans helped Frank get the Guggenheim grant that enabled him to produce *The Americans*.) *American Photographs* appeared two decades before *The Americans*; a decade later, another likeminded book that also used sequences was published by Minor White—*Mirrors, Messages, Manifestations.* Surprising as it may seem, a statement White once made about grouping pictures describes as well as any explanation Frank

himself has ever given how *The Americans* is constructed. "The meaning appears in the space between images," White said, "in the mood they raise in the beholder. The flow of the sequence eddies in the river of his associations as he passes from picture to picture."[14]

The difference between Frank and White was ultimately a matter not of their sense of their medium, but of the state of awareness in which each worked. Where White's was heightened, Frank's was depressed. Frank's vision could descend into the lower spiritual depths of the postwar world. His photographs were not meant as an affirmation of an individual consciousness, a rarefied sensibility. They were, rather, the expression of a new collective unconscious, a libido, an anonymous self as opposed to a transcendent one.

Frank's imagery stands apart from that development described earlier by which photographic aesthetics from before the war was transformed in the process of being recovered. The rough, graceless kind of picture Frank made was not

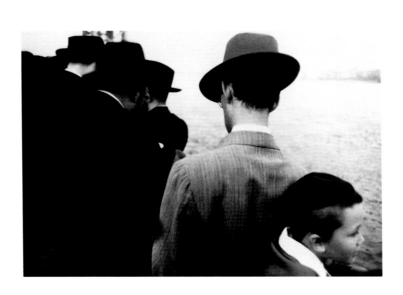
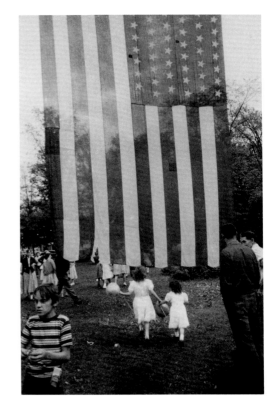

Fig. 6. Page sequence from Robert Frank, *The Americans* (Paris, 1958; New York, 1959) (cats. 404–407)

even considered within the pale of aesthetics in the prewar world. In the face of the barbarism of the war, there had been a movement toward a stylistically raw and violent art. If art were still possible at all, then it must be an art that explored primal emotions. Abstract expressionism, and in particular action painting, reflected the impulse to work in this direction.

A like tendency can be seen in the adoption by museums and into the medium's official history of photographers whose work had been considered unaesthetic before. Jacob Riis' photographic plates, which he had made in an intentionally crude way so that their content would be all the more shocking to his turn-of-the-century audiences, were recovered during the war, reprinted, and later exhibited in both historical museums and art museums. A similar interest in new types of imagery became apparent near the war's end at the Museum of Modern Art, where the tabloid photojournalist Weegee (Arthur Fellig) lectured and exhibited his work. The work of European emigré Lisette Model was celebrated also at the

Museum of Modern Art. All three photographers made vulgar, offensive work that would have been considered artless before. Many photographers were ineluctably drawn to imagery of this type, until it reached its full potential in Frank's *The Americans*.

With the publication of Frank's book, this antiaesthetic strain of postwar photography became an aesthetic in its own right. Frank sometimes made photographs, probably including the one from 1954 of a legless man scuttling along a rainy sidewalk (cat. 352), without even putting his camera to his eye. While this way of training his instincts as a photographer was only an occasional practice, all his imagery had a comparable quality, a look of mere gesture enhanced by motion blur and grainy prints. (Although Siskind may have captured the look of action painting, Frank was the photographer who truly worked in the spirit of this new art.) Because Frank's work had such a harsh look to it, *The Americans* was very controversial when it appeared. A few individuals in the

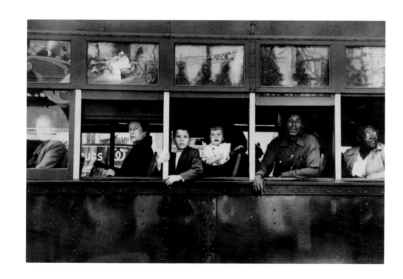

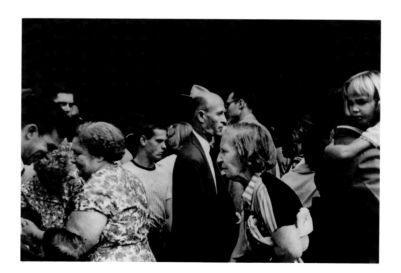

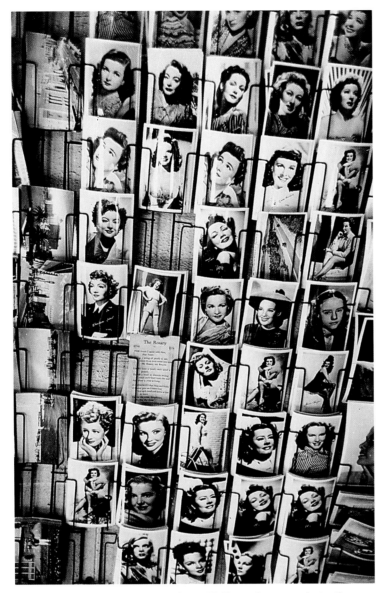

Fig. 7. Robert Frank, *Stationery Store, Hollywood, 1955*, gelatin silver print, 33.0 x 22.0 (13 x 8⅝), The Richard Sandor Collection (cat. 408)

disturbing not because it failed at what it tried to do, but because it succeeded. It created a vision of contemporary reality that no longer owed a debt to the prewar years.

Frank was certainly not the only photographer, nor even necessarily the first, to make use of a dark, rough, blurry, or grainy image. Yet his work established a context in which a lot of other imagery of this type finally made sense. Among the New York photographers already working in that way were Roy DeCarava and Bruce Davidson. DeCarava's desire was to bear witness to the life of black people living in dim places. Images such as his 1965 photograph of a man lying in a subway station (cat. 365) force the viewer to feel his way in the shadows. The photographer's hope was that eventually our eyes would become accustomed to the darkness and we too would be able to see both the pain and beauty that he finds there.

Davidson, working on the verge of the sixties, felt the mixture of discontent and passion that was gathering, especially among the young. In his c. 1960 picture from New York (cat. 366), several teenagers have assembled in a children's room, with marionettes and clowns on the wallpaper, that they have now outgrown. Some of them sit sociably along a wall, on the opposite side of which two others kiss hungrily in the shadows. Davidson gives us a glimpse into the dark recesses and frustrated desires of the time.

William Klein, an American photographer who also was a contemporary of Frank's, published in 1956 a provocative photography book entitled *Life Is Good and Good for You in New York: Trance Witness Revels*. After he was mustered out of the army, Klein left for Paris at about the time that the European Frank sailed for New York. The two photographers' paths crossed in 1954 when each was sent by a different fashion magazine to cover the same society ball; each photographer produced out of the night's shooting one picture for use in his book. Klein's photograph of a man with a cigarette in his mouth (cat. 353) is the epitome of his work. The murky, stutter-frame quality of this print suggests how far Klein wanted to push the medium, to "abuse" the equipment, as he himself said, and to "break all the rules" of photographic aesthetics.[16]

The tendency toward gritty, high-contrast prints in the postwar era can be seen in work ranging from Frank's and

photographic establishment, most notably Hugh Edwards at The Art Institute of Chicago, had unreserved praise for the book. But when *Popular Photography* polled its editors, all except one responded negatively.[15] Frank's imagery was

Klein's to Bill Brandt's, Mario Giacomelli's, Josef Koudelka's, and Eikoh Hosoe's. It is a look in photography that is made to serve the greatest possible variety of moods or intentions—both the dour realism of Frank and the extreme expressionism of Klein, the poetic surrealism of Brandt or Giacomelli and the Zen ritual of Hosoe. Yet even photographers as geographically and culturally removed as Giacomelli and Hosoe seem to have in common, besides a similar printing style, that each produced a series dealing with the experience of the war. In both cases the series played a key part in the development of the photographer's style. What Hosoe did in his 1969 *Kamaitachi*, a group of images recalling the time when, at age eleven, he was evacuated to the Japanese countryside, Giacomelli did in an early project documenting the war victims at Lourdes. A veteran of the Italian army, Giacomelli was perhaps also creating a metaphor for the brutality of the war with his series of slaughtered animals. In the end, however, all that is cruel is reabsorbed into the Italian landscape. Even the faintly dirty quality of his prints, their speckled coarseness, seems to be one with the benevolent earthiness of Giacomelli's subject matter.

While Frank's stylistic innovations may have resonated in sympathy with the work of photographers all over the world, the direct, immediate impact of *The Americans* was felt most strongly in New York, where the book opened the way for the imagery of Garry Winogrand and other street photographers of the 1960s. In a 1960 show that Winogrand had at The Image Gallery in New York, the influence of Frank's dour subjects and dark printing style was already apparent. (Winogrand was later to reprint some of those negatives in a lighter manner that makes the imagery unmistakably his rather than Frank's.) Joel Meyerowitz was inspired to take up photography in the early 1960s as a result of watching Frank at work, and others were liberated by Frank's vision to pursue their own.

The possibilities that Frank created for later photographers were not stylistic so much as psychological, amounting to a kind of license for a reflex behavior with the camera that came from their most instinctive needs and emotions. The power of Frank's work emboldened others to dive ever deeper into the self for their imagery, while at the same time exploring

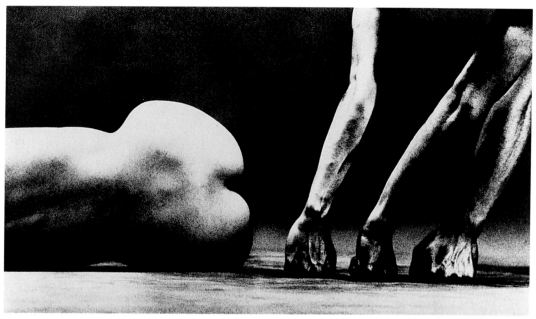

Fig. 8. Eikoh Hosoe, *Man and Woman #24*, 1960, gelatin silver print, 26.7 x 54.4 (10½ x 21½), Center for Creative Photography, University of Arizona (cat. 409)

the behavior of those on the margins of society, as Danny Lyon did in his book *The Bikeriders* (cat. 367).

Although Garry Winogrand photographed steadily throughout the 1950s, his style was not fully formed until the 1960s. In the middle of the decade, he roamed the country fitfully, like a man who did not know what to do with himself (except photograph). When he was on the street, prowling for subjects, he concentrated totally on his work because his attention had to extend to the edges of his peripheral vision and the limits of his consciousness. Only then could he see the things he wanted to photograph. They were so fleeting and tentative that he had to catch them out of the corner of his eye.

Winogrand surpassed Frank in his willingness to make images whose occasion is tenuous and peculiar—is dumb, as it were—to the point where the viewer is unsure whether he sees it or not. A photograph like the one Winogrand took in an airport in 1964 is interesting, but there is no salient

359

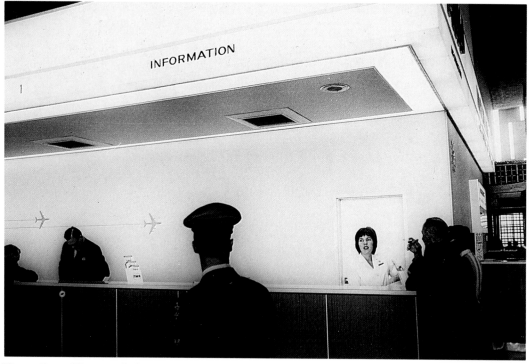

Fig. 9. Garry Winogrand, *San Francisco*, 1964, gelatin silver print, 22.8 x 34.2 (9 x 13½), Center for Creative Photography, University of Arizona (cat. 410)

kind of hot, muscular, impulsive photographs. Friedlander's work was always more self-conscious than theirs, as his 1970 book *Self-Portrait* demonstrates by showing us either him, his shadow, or his reflection in every picture.

The featureless silhouette, expressionless face, or headless body that we see in each picture, as in *Colorado* (1967) (cat. 362), is a motif intended to make the viewer see in the photographer an impassive being as neutral as his medium. Friedlander also shows us his self-consciousness by the nature of his compositions. His visions along the American Main Street, such as an image made in a revolving door in 1972 (cat. 363), are given to optical illusions, compartmentalization of the space, and a cool, analytical way of seeing. Moreover, as his *American Monuments* project of the 1970s (cat. 364) makes clear, through its careful assimilation of the influences of Eugène Atget and Walker Evans, the consciousness Friedlander has of himself as a photographer is also an effort to be aware of his place in the medium's history.

Such an acute sense of photographic tradition may well be what distinguishes Friedlander's generation and the succeeding one from earlier photographers. The landscape photographer Robert Adams is about the same age as Friedlander (they were born a few years apart in the mid-1930s), and his work has also been powerfully shaped by remote historical influences, especially that of the nineteenth-century photographer Timothy O'Sullivan. The most important photography exhibition of the 1950s, Edward Steichen's *The Family of Man* at The Museum of Modern Art, was markedly ahistorical in nature. But since that time, major museums as well as and smaller ones devoted exclusively to photography have fostered among photographers a stronger awareness of themselves as both a part and a product of photographic history. This history continues to be affected by figures who have come from other backgrounds and taken up the medium for their own purposes. But even that type of influence is perhaps being assimilated into photographic tradition more quickly now because of a new, historical consciousness among photographers themselves.

element or unusual subject that makes obvious why this is so. While the aesthetics of this sort of photography become increasingly refined in his work, the sentiment tends toward a certain bluntness and crudeness. Joel Meyerowitz recalls that when he and Winogrand would look at each other's contact sheets in the early 1960s, their highest accolade, the one they reserved for the pictures that they agreed were great, was "crazy, wow, that's really crazy!" they would say looking at an image like Winogrand's backlit 1969 view of Hollywood Boulevard[17] (cat. 357).

Although Lee Friedlander was included with Winogrand and one other photographer in a 1967 exhibition at The Museum of Modern Art entitled *New Documents*, Friedlander was actually something of an odd man out in New York. While he had been on the streets there with Winogrand and Meyerowitz, he had never lived in the city. Nor did he make the same

The landscape tradition that emerged from Group f/64 and Ansel Adams' work and was filtered through Minor White's influence has continued right up to the present. Adams' direct heritage can be seen in the work of Eliot Porter and others. Porter, like Adams, may well have been affected by the experience of the war. While working in the Radiation Laboratory at Massachusetts Institute of Technology in the early 1940s (he had both engineering and medical degrees from Harvard, where he had done research in biochemistry throughout the thirties), he began to make color nature photography. Just as Adams was expanding his vision of nature during this period in a way that suggests a need to compensate for the horror of the war, so was Porter feeling the need to dwell on the truth of nature with the greater fidelity that color made possible. Porter had already found through his color photographs that, as the title of a book he published in 1962 says, *In Wilderness Is the Preservation of the World.*

Adams had an almost spiritual significance for American postwar lanscapists, but in the 1950s and 1960s, even his influence on younger photographers was superseded by that of Minor White, spread not only through his art, but through the magazine *Aperture* (which he co-founded in 1952) and, especially, through his teaching (which spanned almost thirty years). When White was a professor at Rochester Institute of Technology in 1957–1958, among his students and protégés were both Paul Caponigro and Jerry Uelsmann. Uelsmann's fantasy worlds, created through a seamless combination of multiple negatives, as in his untitled 1969 image of trees floating above a lake (cat. 313), are an original extension of White's search for revelation in the landscape and his need to make private worlds visible. The love of illusion and ambiguous space in Caponigro's work, including his 1968 *Redding Woods, Redding, Conn.* (cat. 315), suggests that that photographer owes White a lasting debt too.

The imagery of other landscapists, who worked independently of White and the group for which he served as mentor also tended toward abstract and disorienting effects. Frederick Sommer was one of these. His *Arizona Landscape* (cat. 270), where the cutting-off of the horizon reduces the scene to a uniform surface, seems to anticipate the still more obscure imagery of his photographs of smoke on cellophane, made twenty years later (cat. 311). The terrain of these abstractions seems to be a microscopic interior one, inside the tissue or the nerve and muscle fiber of the human body, recalling the image by Denis Brihat discussed earlier. Sommer, inspired by the surrealists during their wartime stay in America, began creating imagery with analogies not only in the work of White and his students, but in that of Siskind, Callahan, and their students at the Institute of Design.

Where Frank's gestural, intuitive way of working makes his street photography comparable to action painting, the sparse, simple look of photographs by Callahan and some of his students like Ray Metzker parallels an alternative version of abstract expressionism, the side beginning with color field painting and ending with minimalism in the 1970s. The flat, confrontational images of building facades produced routinely by Callahan and Siskind's students were exercises in continuous field imagery that led, in the end, to masterpieces like Metzker's 1964 *Composites: Philadelphia* (cat. 380). A minimalist impulse was obvious early in Callahan's photographs, such as the one of tree trunks in the snow against Lake Michigan, and it has persisted through the Cape Cod series of the 1970s (cat. 316) up to more recent projects. The tendency toward such imagery was extended as well by Art Sinsabaugh, another photographer at the Institute of Design.

This line of development that leads from Callahan through his students has perhaps never had the popular appeal enjoyed by the work of Ansel Adams, White, and followers of theirs like Uelsmann. But in addition to having done work that is significant in its own right Callahan and Sinsabaugh are important because they have provided a crucial groundwork for the landscape photography of the 1970s and 1980s known as "new topographics." This group of photographers, among whom are Robert Adams and Lewis Baltz, has created a look in landscape that is original and unique to the postwar period in the same way that the street photography of Frank and Winogrand is.

The work of these new topographers is inconceivable without the taciturn, unsentimental model provided by Frank's work and that of some of the photographers who fol-

lowed his lead. In Friedlander's landscapes and townscapes, there is a vacant feeling that fits in with images by Robert Adams or Baltz. In the work of the new topographers, the somber mood of Frank's photography is synthesized with an aesthetic that has passed through Sinsabaugh's imagery. Sinsabaugh's photographs, such as the 1961 *Midwest Landscape #24* (cat. 317), in which the use of a panoramic camera allows the image to hug the ground, conforming to the low prairie landscape, were clearly a precedent for both Adams and Baltz. A lesson to be learned from Sinsabaugh's pictures— that life is spread thin in this part of the country—becomes a more severe truth in Adams' work. Sinsabaugh's spareness of both horizon and artistry foreshadows the vibrant blankness of the frame in Baltz's.

*New Topographics* was the title of a 1975 exhibition at the International Museum of Photography at George Eastman House in Rochester, New York.[18] Although this may be an inappropriate, catch-all term, it has continued in use because the exhibition did identify a new attitude toward landscape that had appeared in photography by the early 1970s. There is no question that an image like Robert Adams' 1977 *Missouri River, Clay County, South Dakota* (cat. 318) is both photographically and geographically a long way from the work of Ansel Adams. Robert Adams has picked a middling time of year in which all the forces of nature have nullified each other. The landscape itself is an in-between one, flat and featureless, with none of the mountain gloom and mountain glory, the romantic ultimacy of both the terrain and the weather, characteristic of Ansel Adams' work. Robert's vision is a secular, maybe even an agnostic one. The tonal range of the *Missouri River* print is as flat as the topography. It is a powerfully negative picture depicting a vast and empty landscape with limited possibilities.

And then there is the beer can lying on the river bank in the lower left corner of the frame. A ragtag sign of man's presence like this a kind of signature in Robert Adams' work. The beer can is as forlorn a detail as the flickering lights of the carnival in a 1982 picture from the *Summer Nights* series. At the same time that Adams' work harks back to the aesthetic of O'Sullivan and other nineteenth-century photographers who explored the West, his imagery is so removed from that of his immediate predecessors in landscape that it seems to emerge from potwar literary traditions rather than photographic ones. The West and Midwest Adams photographs are those of Wright Morris' *Ceremony in Lone Tree* and Truman Capote's *In Cold Blood*. They are the setting in which Gary Gillmore lives in Norman Mailer's *The Executioner's Song*. Adams, a college English teacher before he took up photography full-time, seems to invite such comparisons. His imagination has a literary bent, as is evident from the book of essays on photography that he published in 1981. Although his photographs show an unblinking view of the landscape, he still finds, as the title of his book says, *Beauty in Photography*.[19]

While Adams photographs in the part of the West that is shutting down, closing up, losing steam, Lewis Baltz photographs in the part that is forging ahead. Although Adams did show pictures from subdivisions in the *New Topographics* exhibition, this is the subject with which Baltz has since become associated. The industrial parks and housing developments that he has documented in work like the 1979 image *Park City #95* (cat. 320) are part of an even more desolate and alien landscape than the ones Adams frequents. Yet like Adams, Baltz has managed to wrest from a despoiled subject matter an exact beauty, as his *Industrial Parks #51* (1977) (cat. 321) demonstrates. He somehow redeems in the photograph what is lost in reality. In the process, he also draws solace, as Adams and others have, from the history of his medium.

The emergence in the 1970s of Baltz, Adams, and other new topographers extended an American hegemony in photography that began with Winogrand, Friedlander, and Meyerowitz in the 1960s. Yet in America itself, despite the strength of the legacy of the 1960s, street photography seems now to be in a quiescent phase. The reason may be that this genre is more dependent than others on the social conditions in which it is practiced. The explosion of street photography twenty-five years ago happened not only because Frank had shown the way aesthetically, but because the subject was appropriate for the time. The society was entering an era of turmoil and extroversion when the streets were, as the saying of the day put it, "where the action was." The subject matter begged to be photographed.

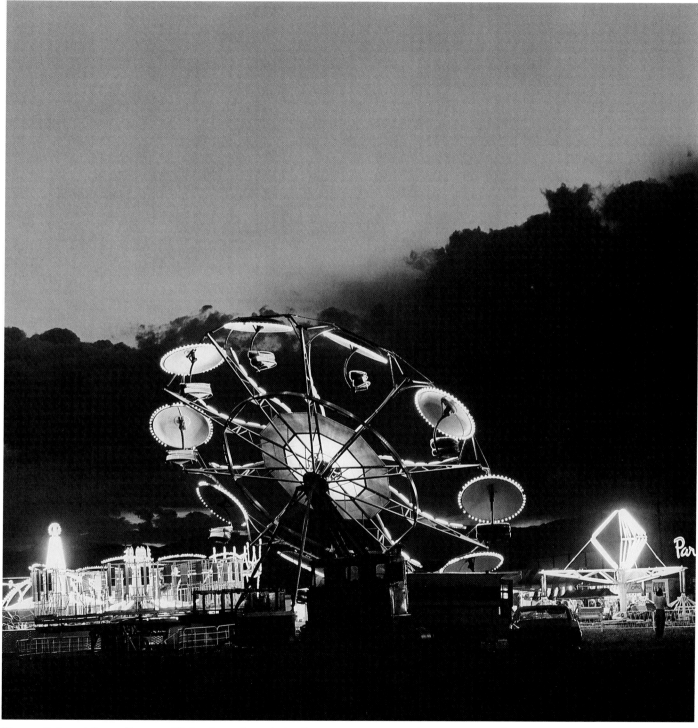

Fig. 10. Robert Adams, *Summer Nights #2*, 1982, gelatin silver print, 37.0 x 37.0 (14½ x 14½), Hallmark Photographic Collection,
Hallmark Cards Inc., Kansas City, Missouri, Copyright Robert Adams (cat. 411)

Today, in countries where a sharp, visible contrast exists between an underground culture and an official one, or between old ways and new, street photography continues to be a predominant art form. Jindrich Streit, just by taking photographs in the little Czechoslovakian town where he lives (cat. 369), makes a social statement that gives his images an urgency and significance rare among photographs of everyday life in the American streets. In a developing nation like Mexico, where common signs of change irresistibly take on symbolic meaning, as in the 1979 photograph *Mujer angel* by Graciela Iturbide (cat. 368), the photographer who documents ordinary life commands attention as an artist that her contemporary American counterpart cannot achieve. Talented newcomers still continue to make street photography in this country, but for its own sake. Such individuals keep alive a discipline in a culture where neither the subject of the photograph nor the viewer response to it is as compelling as it was a couple of decades ago.

This is not to suggest that either the influence or the careers of all former street photographers in America are now finished. But a lot of the energy generated by that tradition, and by landscape too, has been drawn off in recent years by yet another kind of photography—color. Color photography is currently functioning as a separate genre. Just as the influence of some 1960s street photography and a certain earlier strain of landscape were melded in new topographics, so have street photography and new topographics both been absorbed in the color work of the last fifteen years. On the one hand, although he began as a black and white street photographer, Joel Meyerowitz did not gain widespread recognition until he switched to color landscape work in the mid-1970s. On the other hand, early recognition was accorded to Stephen Shore's color landscapes when, at around the same time, his photographs were included in the otherwise black and white *New Topographics* exhibition. In both cases, what had been until then essentially black and white traditions were providing support and a context for a kind of photography that might rightly be called, on the analogy of new topographics, new color.[20]

## NEW COLOR

An earlier color landscape tradition had been established by Eliot Porter, drawing its sustenance from the black and white photography of Ansel Adams. Porter had originally made black and white work himself in the thirties under the tutelage of Adams, whose compositional devices Porter adopted rather directly for his work in color. Porter's achievement is unique because relatively few photographers had even tried to work in color before the early 1970s, and those who did experiment with it—among them Walker Evans and Joel Meyerowitz—seldom showed the work at the time.

Part of the reason for the reluctance serious photographers felt about working in color was that it was very much the province of advertising agencies and fashion magazines. Only such commercial concerns could afford color technology (though Porter had an independent income that permitted him to work with dye-transfer printing, which was beyond the means of most individual photographers), and their preeminence in the field of color made its effects seem rather meretricious. Their use of color, together with the chemical instability of most color processes and the tendency of color prints to deteriorate with time, reinforced the belief that color was not a suitable medium for any artist who hoped to be capable of truths that were timeless.

Such truths are suggested by Ansel Adams' black and white photography. It is no mere coincidence that his work achieved its greatest popularity, and that he himself became a public figure, only after the profound social changes of the 1960s had liberated public mores and made a new hedonism permissible in American life. Adams' California-pioneer transcendentalism may be traced back to New England. The enormous success that came to Adams late in life was the result of his being a benevolent reminder of the somber America that existed before everything from toilet paper to electronically altered prints of old movies burst into glorious color—the America whose values had been formed before the war. Adams made his black and white vision of nature into a repository for the stern rectitudes of that time.

Moreover, Eliot Porter, even though he photographed in color, shared in the heritage that Adams represented. Like

Adams' work, Porter's derives its authority and authenticity from the force of character of the photographer. Porter gave his vision credibility by approaching color photography with the same care, dedication, and reverence with which he approached nature itself. His integrity as a naturalist and a scientist gave validity to a beauty in his work that might have seemed fraudulent in other hands.

Color has always been a troublesome aspect of perception in Western culture. In metaphysical philosophy, it has usually been taken to be a secondary attribute, one that cannot be supposed to inhere in external realities, but is, rather, something that the mind imposes on such reality. Only in the context of the greater subjectivism that has characterized postwar photography, perhaps, could color eventually come to seem viable as an art form. Though an increased legitimacy for color work may have been the result of a gradual, long-term shift of postwar attitudes toward photography, it was not until after the psychedelic rainbows of the 1960s that color gained wide acceptance. Yet even then, color remained a kind of forbidden magic that could only be approached obliquely. When a native photographer works in an exotic land with a more colorful culture than our own, as Raghubir Singh has in India (cat. 376), we accept the lushly picturesque results with a readiness that we would not have for such imagery made here. American photographers working at home have had to employ more complex aesthetic strategems.

Like Porter, more recent color photographers owe their success partly to force of character. In order to handle color without being tainted by it, they have needed to have the right temperament and humor for the job. This is why a number of those who have been able to convince us with their visions, or at least disarm our resistance, have emerged from the street tradition. The instinct for odd moments, poetic juxtapositions, and a somewhat zany view of life, all found in the color work of photographers such as Helen Levitt and Joel Meyerowitz, keeps that work from seeming saccharine.

Notice how a certain idea about picture-making carries over from one phase of Meyerowitz's career to the next in three different images. In a black-and-white from 1969 (cat. 370), a boy leaps off both a footbridge and the side of the photograph itself. In a 35mm color picture from 1973 (cat. 371), a

quirky, spindly desert weed rises, luminous, above the rim of the Grand Canyon. During a long view-camera exposure at night for the 1977 *Porch, Provincetown*, a lightning bolt is imprinted on the outside of a porch column. All three pictures are, in effect, the same picture. That aberrant weed, its greenness as electric as the lightning flash, contradicts the picture-book pastels of nature in the background. In the Cape Cod image, the lightning itself has a similar effect. Its unexpectedness pokes a hole in the romantic bubble, the calendar-art cliché, into which the photograph might otherwise fall. Although plenty of more conventionally pretty views may be found among Meyerowitz's Cape pictures, they are an indulgence the photographer has earned. They are meant to be viewed in the context of many images that have surprising, off-beat subjects, or that pit the acidic colors of neon and fluorescent light against the pastels of a sunset.

While Meyerowitz has displaced what he learned on the street into landscape photography, Helen Levitt has remained a street photographer in New York. In an image like her 1978 one of two men chatting by the side of a truck (cat. 372), the mentality of the black and white photographer seems to have been adapted to color. The sense of an event and the feel for the shape of the frame are familiar from a great deal of black-and-white street photography, including Levitt's own. The difference here is that instead of two gestures or forms answering each other from opposite edges of the picture, it is two patches of color that do so. The beatific smile on the face of the man to one side is an element that would work equally well in black-and-white. Being placed off-center, as he is, gives this subject the treatment that is classic for street photography. Yet the playing-off of the blue peninsula of jacket sleeve on the right against the blue arm sticking out of the truck window on the other side of the picture is something that could work only in color. The two areas of blue against the red of the truck become, as much as the kindly smile that flickers across the subject's face, the event that is the subject of the picture.

Joel Sternfeld, like Meyerowitz and Levitt, is from New York, and he has brought to his color view camera work a street-photographer's eye. He too tends to put out on the edges or into the background the one curiosity in each photograph

that transforms an otherwise banal scene into something amusing, or even astonishing. The most salient characteristic of a body of 8 x 10 work he has produced over the last decade is a group of images that are what might be called page-six news stories. They are photographs of the sort of minor events that a newspaper would use on the inside as filler, a photographic counterpart to the human-interest story, as in an image Sternfeld made in McLean, Virginia, in 1978 (cat. 373).

Sternfeld might be compared to Weegee, who made a career out of fires, ambulance calls, and small-time disasters. Sternfeld enjoys working out on the edges not only of the photographic frame, but of the profession of photojournalism as well. Because his subject matter is, at least as news, practically beneath notice, the viewer is forced to scan the image for some other meaning, some more compelling reason for its existence. In this way Sternfeld enhances the power of mere detail in the photographs.

Among Sternfeld's images, and even among Meyerowitz's, are some with the visual terseness of new topographical work. Conversely, some street shots are found among Stephen Shore's work. But his photographs are best considered in the context of recent landscape. His ruminative, laconic nature is evident in his pictures, which illustrate the obliqueness of approach that working in color requires more graphically than the work of any other photographer. His images of small-town America such as *Meeting Street, Charleston, South Carolina, 3 August 1975* (cat. 375) are circumspect in the most literal way. He often enters by the side streets, it seems, driving around in back of the subjects he decides upon, photographing the buildings from across and empty parking lot. Having selected his rather scrappy, spare subject matter, he then chooses the least advantageous point of view. Moreover, in his handling of the color, he demands from himself a commensurate restraint, a modesty of vision. The tones are as thin and subdued as the landscape is bare. His photographs deprive color film of its sensuous, cheerful quality. They dampen its effects, removing all trace of the Pollyanna brightness to which color photography too often yields.

A number of other color photographers who have recently come to prominence also seem to play upon the conventions of the new topographical landscape. The New South where William Eggleston photographs yields subjects similar to Shore's—empty fields, tract housing, a boarded-up filling station (cat. 374)—though people appear more often in Eggleston's work. He explores the human and social landscape directly, not just as it is reflected in a topographical one. But he, too, uses muted colors, usually the drab earth tones of rusted shed roofs, brown lawns, and faded paint.

Even John Pfahl's work has a place in the new landscape tradition. In his *Altered Landscapes*, he littered scenes of nature with bits of tin foil, string, and other odds and ends that we might find lying about in a Robert Adams picture. The difference is that Pfahl has carefully placed these materials in a way that makes a comment on photography rather than society. The lush, saturated colors in his pictures of power plants are, likewise, a reflection on aesthetic issues as much as ecological ones. In his *Trojan Nuclear Plant, Columbia River, Oregon, October 1982* (cat. 377), style and content contaminate each other. The subject matter is inappropriate for such a romantic treatment, with the result that both aspects of the picture are called into question. The viewer is challenged to think about a kind of artistic pollution in addition to an environmental one. Like other photographers of the last decade or so, Pfahl handles color gingerly, keeping an intellectual distance through wit and irony. In fact, because of the archness of his work, the way in which it is intended as a clever critique of the conventions of his own medium, Pfahl's photography spills over into yet another newly emergent tradition, conceptualism.

A certain look established in the postwar period by Frank, Friedlander, and other street photographers who came together in New York in the late 1950s or early 1960s fed into the new topographical landscape photography in the West in the succeeding decades. Those two traditions—new topographics and the street—contributed in turn to the new color work that began to be seen in the early and mid-1970s. At the same time that this convergence of photographic traditions was occuring, an even more significant integration, that of the history of photography and the other pictorial arts, was taking place. The adoption of photography as a primary medium by the conceptualists in the 1960s and 1970s

was one indication of this. Another sign, which overlapped with the development of conceptual art to some extent, was the practice among painters of borrowing or quoting imagery from photographic sources.

## CONCEPTUALISM

Two European photographers who were included in the *New Topographics* exhibition, Hilla and Bernhard Becher, are indicative of the sort of crossover influences that were developing between photography and the visual arts in general. Bernhard, originally a painter, at first made photographs of industrial structures only as a form of visual notes. But since the mid-1950s when he began collaborating with his wife, Hilla, documentation like their series on repair sheds (1975–1985) (cat. 322) has been their life's work and has led to their publication of a number of monographs.

Their standardized, repetitious views fit into the history of photography as a variation on the theme of the dumb picture. Their work pushes the minimalism of the new topographics to new limits. No historical archive could be more literal-minded than this work, no evidentiary file more mechanical. And yet, for that very reason, their imagery is somehow ennobling and philosophical. These properties first caused the Bechers' work to be discussed in *Artforum*, in an article by the conceptualist/minimalist artist Carl André.[21] He saw in their endless rows of prints a spirit kindred to that of the lines of metallic squares in his own sculpture.

The word "conceptual" does not necessarily mean cerebral. On the contrary, conceptual work is often visceral in intention, a gut reaction against pretentiousness and idealization in the arts. It is an attempt to be clear-headed, not high-minded. It might better be called "perceptual" art, for it often deals with our visual habits, with how we see the world, and how our idea of art is thus formed and informed. Far from being an elitist, the conceptual artist is often a lover of vulgarity or at least someone very aware of the effects on popular imagination of movies, television, advertising, photojournalism, and other types of mass media. The frequent invention of altogether new art forms—new concepts of what art should be— is what has earned this kind of work its name. Vito Acconci,

Fig. 11. Robert Cumming, *Quick Shift of the Head Leaves Glowing Stool Afterimage Posited on Pedestal*, 1978, gelatin silver print, 19.5 x 25.0 (7¹¹⁄₁₆ x 9⅞), The Art Institute of Chicago, Restricted Gift of Society for Contemporary Art (cat. 412)

Robert Cumming, William Wegman, and John Baldessari are all conceptual artists, and in a larger sense figures ranging from pop artists like Andy Warhol to postmodernists like Sherrie Levine or Ciny Sherman are also involved in this movement toward an art that challenges our assumptions about art.

That the raw vitality found in Frank's images or Klein's is also an aim of conceptual art is apparent in the work of Vito Acconci. His photo pieces combine Frank's gestural, motion-blurred kind of photography with the insistent, mechanical repetition characteristic of the Bechers' work. The results are hardly monotonous, though, since taking photographs has obviously amused and stimulated Acconci, as is apparent

in the 1969 piece *Twelve Pictures*.[22] Acconci created this sequence by walking sideways across a stage and after each step making a snapshot of the audience. Some people look melodramatically bored or distracted. One man used his own camera to photograph Acconci back every time Acconci photographed him. A woman in the front row seems to have fallen dead asleep, and another behind her puts on sunglasses as protection against Acconci's flash. In the back of the theater, a man does a handstand so that among all the heads, a pair of feet sticks up.

The man's gesture seems to be, like that of the person taking pictures of Acconci, a perfect symbol of the inversion this piece entails. The audience becomes the actors, the man on the stage a passive spectator, in this bit of theater. The relationship established in the performance piece, where Acconci provides the entertainment for the audience by doing a comically mechanical dance across the stage, is reversed in the photo piece, where the audience entertains him, and us, by performing for his camera. Photography has led him to create a work so suffused with the mystery of paradox that it threatens to become high art all over again. The reason that an effect so unexpectedly rich results from such meager materials is that the piece is actually being created in two media simultaneously—performance and photography—and the interaction between them has a power greater than either is capable of alone.

Conceptual artists like Acconci gravitated toward performance in the late 1960s and early 1970s because part of the point of making art out of mere concepts was to insulate it from the increasingly materialistic market created by the triumph of abstract expressionism and the boom in pop art. Having been a poet first, Acconci did not think of art as a way to make money. Art that existed only as a bright idea had the appeal of not being subject to commodification as readily as a painting. These were the motives that prompted artists to take up performance, which was at first done only privately for a few friends, or even completely alone. Acconci's first attempts were, in his own words, "activities in the street . . . that only I knew I was performing."[23]

The same might have been said of Robert Frank's activities in the street, or of those of any street photographer who practiced the kind of invisibility that allowed him to take close, candid pictures of which nobody else, not even the subject, was aware. Frank actually played a role in the development of performance art, for he photographed at least one of the early pieces—proto-happenings—by Allen Kaprow in the late 1950s.[24] (The line that goes from action painting to performance art passes through Frank's photography.) The appeal of performance art lay in its being yet another conclusion to be drawn from the reductionist-minimalist argument that modern art was making. A performance was a work so ephemeral that it produced no physical object at all, except perhaps a snapshot or two. Photographs were the one form of permanence, the only by-product, that was permissible. Like the performances themselves, photography seemed safe from conspicuous consumption by the art world because it was a medium without much status among dealers and collectors.

Photography was the essential element in Acconci's performance pieces because of the emphasis they put on the point-of-view shot. Part of the paradox the pictures create is that while they are a work of documentation, an objective record of something the artist did, the action itself was an insistently subjective one. An act of perception, how he saw the world at certain moments, was all that the performance was. Aside from the taking of the picture, there was no event, or at least none except the totally private, unobservable kind that constituted Acconci's first pieces.

A variation on Acconci's use of the medium of photography can be seen in the work of Hamish Fulton, who has taken walks, mostly in rural settings, and photographed certain prospects with which his routes have presented him. Fulton's work done in England in the early 1970s has much the same feeling of uniformity and standardization of views that is a part of the Bechers' work. Fulton almost always chose a standpoint from which a solitary path led across the moors or foothills toward a low horizon. Only in recent pieces such as his 1986 diptych (cat. 384) does he interpret the landscape with a freer, more eclectic imagery.

William Wegman's Polaroids of his dog Man Ray (or now, his successor Fay), seem to have been made not by a visual diarist but by a cartoonist. His art is like Robert Cumming's in

this regard. What gives a number of his photographic pieces and even more of his video work its distinctly conceptual feel is the way repetition is used to imply a methodical exhausting of all the possibilities inherent in any premise. Just as Acconci will hold his camera overhead, then upside down at his knees, then to his right and to his left, so Wegman will systematically explore the obverse, converse, and reverse of every situation to which the dog will submit. Having persuaded the dog to sit still for *Leopard/Zebra*, Wegman has him pose for *Zebra/Leopard* (cat. 325). The diptychs, especially, have that familiar conceptualist feeling of rationality and logic run mad.[25]

What many performance pieces entailing photography have in common is that they have been conceived not as public events, but only as publishable ones. They are art works distinct from legitimate theater because, like those early Acconci pieces, they have been done privately, and indeed, like other postwar photography, they are about the privatization of experience. Gilbert and George began by creating in public places living sculpture in which they themselves would pose, immobilized, for hours. But over the two decades that they have been collaborating, their daily lives have become their art, and the photo pieces they have made, such as *The Decorators* (1978) (cat. 382), are a memorial to the way they live. Their living sculpture was in a sense photographic to begin with, since Gilbert and George were real people in suspended animation, and the photo pieces, which are both monumental and monochromatic, might be thought of as sculpture. Photography is an integral part of their conceptual art, not just a means of documenting it.

The same can be said of the work of many artists in recent years who have performed for the camera, particularly Arnulf Rainer and Lucas Samaras, who each began making photographic self-portraits in 1969, or Holger Trülzsch and Vera Lehndorff, who have worked together since 1970. The illusions created when Trülzsch paints on Lehndorff's nude body (cat. 332) exist only from the camera's monocular point of view. Likewise, the histrionic self-portraits by Rainer (cat. 336) and gothic posturings of Samaras (cat. 335) exist solely as photographic pieces, since the marking or defacing of the surface of the print is crucial to the art of each. In both men's

work, the violence done to the image merges with the violence or menace inherent in it. The parallel between what the artist does with himself in his performance and with his image in the photograph establishes an aesthetic equivalence, an inseparability, between them.

In Helen Chadwick's 1984 installation piece *Ego Geometria Sum* (cat. 334), a performance was photographed, and life-size prints were turned into photo-sculpture with which the artist interacted in a second performance; then the documentation from it was framed and hung around the walls of a gallery on whose floor the photo sculptures were displayed. Thus has Chadwick given a mannerist twist to the treatment of subjectivity, self-absorption, and narcissism in photography. Her imagery has, like that of Duane Michals in *Things Are Queer*, been reabsorbed into itself. One way or another, Samaras, Rainer, Lehndorff, Acconci, Fulton, Chadwick, Gilbert and George, and many other artists involved in photo performances are all dramatizing their own subjectivity. If they have not created their own world in a small room, like Samaras or Gilbert and George, then they have made themselves—their eyes, bodies, gestures, and postures—into either the sole subject matter or the one, urgent vantage point from which their photographs are made.

The relationship between conceptualism and pop art has been an ambivalent one. On the one hand, conceptualists have for the most part rejected the consumer-goods approach to the production of art that led Andy Warhol to call his studio The Factory. On the other hand, conceptualists like Gilbert and George have made their public personalities the center of their art in the same sense that Warhol did, living their lives as a kind of parody of English respectability much as Warhol lived his as a parody of bohemianism. Among the tendencies that conceptualists have shared with pop artists is their fascination with popular culture, whose imagery Warhol, Robert Rauschenberg, Jasper Johns, Roy Lichtenstein, James Rosenquist, Tom Wesselman, and others all incorporated into their work.

From the photo historian's viewpoint, Warhol is the key figure here. He was the one whose uses of the medium followed, however unintentionally, from the history of photography itself. His early adoption of photographic imagery

into painting exploits this history in a way that shows he also understood it on some intuitive level. For in the early-1960s series entitled *Disasters*, which reproduces sensationalistic imagery from the tabloid press—automobile accidents, murders, suicides, five-alarm fires, riots—Warhol brought into the mainstream of painting exactly the same sort of pictures that had entered the mainstream of photographic history a decade and a half earlier when Weegee had been shown at The Museum of Modern Art. A few years later, when Warhol began the *Jackie* series, which came to focus on wire-service and magazine shots of Mrs. Kennedy at the time of the president's assassination and funeral, he expanded his use of the concept that had formed the basis of the *Disasters* series.

Warhol developed a style intended to match the content of the photographs. In the examples that are most characteristic of his approach, such as the 1965 *Sixteen Jackies* (cat. 323), the photograph has been reproduced on canvas directly from a newspaper or magazine by use of the silk-screen process. The resultant image is, intentionally, only a very crude, vestigial version of the original. In fact, Warhol's technique as a printmaker—or rather, his systematic lack of technique—was a counterpart to the blurry, grainy, gestural style of shooting and printing employed by William Klein or Robert Frank. Like Acconci, Warhol combined the roughness of an image by Klein or Frank with repetitions like the Bechers'.

Conceptualists such as John Baldessari began making their work into a commentary on mass media not long after Warhol and other pop artists had done so. Baldessari planned to be an art critic before becoming an artist, and his work has always had a strong intellectual and theoretical bias. Having made himself a student of all the major writers who have speculated on the structure of language, he was particularly influenced by the writings of the French semiotician Roland Barthes. A relevant way to look at Baldessari's own work, in so far as he was inspired by Barthes, is as a process of translating cognitive systems. Although the rationales he uses for combining images may be esoteric, the imagery is mundane, having been drawn mostly from a file of old movie stills and other stock-photo sources. His photographs are put together in a fashion that often makes his work into a parody of the formalism—the tendency toward abstracted

and highly patterned uses of shapes—that is inherent in so much modern art. In his 1986 *Eye lid (with log)* (cat. 326), the three vaguely similar curves of a twig, a palm tree, and a log are juxtaposed. It is as if the verbal technique of free association were being applied to visual material.

Baldessari's way of working is not unlike that of Robert Heinecken, who also puts into novel, provocative combinations images he has snagged almost at random from popular culture. His 1986 jetgraph print of network news personality Connie Chung (cat. 342) was made by pressing a sheet of color photographic paper to a television screen and flicking the set on and off. Earlier works were created by superimposing or in some way eliding photographic reproductions gleaned from the enormous number of magazines that he peruses. Perhaps the fact that Baldessari and Heinecken live in the Los Angeles area, where film and television are major industries, accounts for their focus on media imagery. Baldessari's work raises with special force an issue that has become central to the conceptual art of the last decade. His big montage pieces are "blasted allegories"—a phrase he used as the title for a 1978 series—of contemporary culture. They portray the contemporary world as a random mix of disparate images, an environment so dominated by pictures from media, movies, or our own hands (the separately framed element in *Eye lid* is a snapshot of Baldessari's daughter), that the culture as a whole begins to take on the properties of a visual fiction, a work of art.

## POSTMODERNISM

The practice of borrowing from photography that developed among artists in the sixties and seventies, beginning with the pop art of Warhol and continuing through the conceptualism of Baldessari, has led to a new movement in the eighties—postmodernism. The implications for the history of photography itself are particularly strong in the work of the group known loosely as image recyclers, which includes Sherrie Levine, Victor Burgin, Hans Haacke, Richard Prince, and Cindy Sherman. For these artists, photography is not the medium of choice so much as a target of opportunity. They

have appropriated photography much as Warhol and Baldessari did, and like the latter, they have been impressed with the ideas of Barthes and of certain other French intellectuals, especially Jean Baudrillard and Jacques Derrida.[27]

These thinkers have instilled in contemporary artists a concern that second-hand experiences are the only kind of which people in advanced technological societies are now capable. Living in a media-saturated environment has made us dependent on simulacra, vague images that replace reality and diminish our capacity for an original response to life. Originality as an aesthetic ideal, a basis of modernism, is no longer viable since artists are as susceptible as everyone else to contamination by mass culture. Its effects are, like those of air pollution, indiscriminate. In order to confront this new reality, the postmodernists and conceptualists like Baldessari work primarily in recycled imagery. Although trained in other art forms, they prefer photography because it is a much degraded medium. Its attraction lies in its ubiquity, in its history of application for everything from modernist masterpieces to kitsch, journalism, and advertising. To undermine any one aspect of the use of photography is to call all into question.

Since they have adopted photography as a means of challenging both the authority that modernism has with us and the effect that mass culture has upon us, postmodernists should not, strictly speaking, permit themselves to become too interested in the medium. If they do, they are, in a very real sense, not being true to their own principles and insights into our society. A series that Sherrie Levine has been working on since 1980, rephotographing from books or other easily accessible sources reproductions of pictures by famous painters or by photographers such as Edward Weston, Alexander Rodchenko, and Walker Evans, comprises the most stringent critique of modernism's role in contemporary culture.

Levine is the most conceptually oriented of all the postmodernists using photography. She has thought through the implications of her work more clearly than anybody else. The rigid literalness of her approach leaves no room for aesthetic play, nor for any artistic redemption of the material of the sort to which modernism always seems to lead. The only

Fig. 12. Sherrie Levine, *After Walker Evans*, 1981, gelatin silver print, 20.3 x 25.4 (8 x 10), Courtesy Mary Boone Gallery, New York (cat. 413)

backsliding of which Levine is in danger is that Evans' photography, when reproduced by her in prints that are as flat and alike as those from the Fotomat, might begin to take on the same sort of pathos that steel mills do in the work of the Bechers. The point Levine is making about Evans' photographs is that, like the steel mills, they are at once obsolete and noble.

In the work of a number of other postmodernists, the limits upon the aesthetic aspirations are defined by a social ideology such as Marxism or feminism. Only by upsetting the viewer's expectation of being delighted visually do Victor Burgin or Hans Haacke believe they can break the hold that a modernism now hidebound and conservative, from their point of

view, has on the art world. These artists want to use the gallery and museum as a forum where they can raise the art lover's political consciousness, which for them has priority over all aesthetic considerations. By doing pieces based on the public-relations photographs of politicians or on corporate advertising campaigns, Haacke has attempted to heighten what he sees as the contradictions between art and capitalism. Burgin, in works like the nine-panel installation entitled *Lei Feng* (1974) (cat. 328), tries to make us see in promotional material a facet of our culture as deeply engrained as the use of language and as highly propagandistic as parables of worker heroism in Communist China's society.

Feminism is a concern of comparable importance in the work of Barbara Kruger or Cindy Sherman. Over the course of a decade, Sherman has tried on for size, as it were, a variety of myths, stereotypes, and media images of women. She enacts each role she takes on, but does so rather inadequately in order to distance herself from it at the same time. The rear-projection backdrops she employs are obvious, the wigs cheap, the melodrama exaggerated, the special effects and makeup theatrical. In each photograph, Sherman creates a very vague and generalized situation because she wants it to be clear that these are generic images of womanhood.

Beginning with the series *Untitled Film Stills*, she has been writing a critique of each female character she assumes, or deconstructing it. Yet even as early as *#56* in that series (cat. 327), it became apparent that Sherman has a flair for photography equal to any need she feels to vitiate the effects of the medium's misuse by others. In this 1980 image, the interplay between reflection and shadow gives the woman gazing into her mirror only a small, circumscribed space where she can see herself clearly. Through the use of this carefully constructed compositional device, a photograph ostensibly about narcissism communicates a sense of the loneliness and isolation of its female subject. In the process of weakening the female images she parodies, purposely making them less compelling than they were in the movies or advertisements from which she drew them, Sherman finds an opportunity—indeed, a necessity—to assert herself as an artist. In order to make clear the disparity between the view of women inherent in each stereotype she takes on and her own point of view,

she has to be an imaginative, effective photographer.

Postmodernism is as preoccupied with the presence of media imagery in our lives today as some earlier photographers were with World War II or the atomic bomb. Like a global conflict or the threat of nuclear annihilation, the media are, in advanced societies, a ubiquitous, inescapable condition of life. They are, from the postmodernist's point of view, part of the constant background hum of modern civilization, an incessant white noise that can have a disconcerting, debilitating effect on our state of mind even when we think that we are paying no attention to it. Perhaps the reason that photography seems an exceptionally attractive, potent means of expression for artists who want to deal with this sort of elemental consciousness is that the medium is all-pervasive, like the human problems they would address. The memory of the war is among the concerns that photography has permitted contemporary artists working with postmodernist techniques to braoch with a new directness.

For his current *Lycée Chases* series (cat. 341), the French conceptualist Christian Boltanski has blown up individual faces that he rephotographed from a class picture taken at a Jewish school in Austria in 1931. As always in his work, the extreme enlargenent imparts to the series the feeling of a surveillance photograph in a classified report, a file being kept on political undesirables, future deportees. In one version of the series, Boltanski has placed window screening over these portraits framed in tin biscuit boxes from whose tops goose-neck lamps have been hung. The lamps function the way a picture light would on a painting, except that they are bent over the photograph so far that they obscure rather than illuminate the image and shine into the faces like interrogation lamps. Thus do the methods of the totalitarian state merge with the forms of a high culture.

The window screening in place of glass also has a provocative effect. It can be interpreted as the wire mesh on the detention cell or as the screen on the half-tone plate by means of which a photograph is reproduced. These young Jews are imprisoned in photography, in the reduction of human beings to data that the mug shot makes possible. "The Holocaust is terrifying," Boltanski has said, "because people were actually turned into objects."[28] Photographs, too, turn people

into objects, pieces of paper as easily disposable as the manifest sheets and lading bills for a train being routed across Germany to an unspecified destination in Poland.

Anselm Kiefer's photographic albums, such as his 1987 *Schweres Wasser* (cat. 385), resting on their lecterns like great books of the dead, evoke a similarly elegiac mood. He has recreated in miniature, in his studio, the German landscape, battles, and other historic events from World War II. Occasionally he recycles imagery, heavily overprinted. Saturated with photo chemistry, sometimes striped with silver solder, his photographs are then laid on the studio floor to be walked or bicycled over, after which they may be coated with paint, pitch, clay, glue, or sand. The photograph has been buried under layers of rubble or sediment like the past under a crushing new reality. The image all but disappears, as if it were a memory obscured by forgetfulness and the passage of time—a memory of which Kiefer now reminds us, one that he would like to disinter with his work.

Although conceptualists and postmodernists on both sides of the Atlantic use the medium of photography and even take pictures themselves, they have often been reluctant to be thought of as photographers. They have tried to stay aloof from photographic history. Nonetheless, their work does follow from that history in basic ways and will affect its future course. To established modernist views not only of photography, but of the visual arts in general, postmodernism has presented a challenge that younger artists taking up the medium cannot ignore or dismiss even if they want to. One possibility that postmodernism raises is that it has come into existence as a kind of end-game, a final phase, or phase-out, of the history of photography as an art.

From its invention up through World War II, the history of photography was primarily an affirmation of both the medium and the subject matter. But at the end of the war, a disaffection with the subject set in. In Minor White's relationship to nature, in Robert Frank's to the American people, and in that of Robert Adams or Lewis Baltz to the American landscape, there is an ambiguity that amounts at times to an ambivalence. A certain disorientation in the landscape tradition is succeeded by a new alienation in both landscape and street photography. And then, beginning in the 1970s, the mood becomes one of disaffection not just with the subject, but with photography itself. One way to define postmodernists would be as photographers who are disenchanted with their own medium. The longer the history goes on, the more the options seem to be closed off. The subjectivism found in painting and photography since the war is seen in the postmodernist critique as an attempt to escape from political and social realities into art. In Sherrie Levine's work it appears that all the medium's potential has been exhausted at last. What new elaboration, or reduction, could exist beyond her recycled images?

Yet as we have already seen in the postmodernist work of Cindy Sherman, photography has as an art form an extraordinary resilience and adaptability that continue to allow it to renew itself. The way in which Boltanski or Kiefer can use their photography to both redress and redeem the past might suggest the same thing. Even with the rather limited perspective that it is now possible to have on postmodernism, it is obvious that this movement has been, at least within the context of photographic history, only part of a larger development. It has been a kind of crystallization of a longer, more extensive, and varied process by which the medium has gradually been coming to an historical consciousness of itself. The present moment is just an elaboration of past ones when influences were being felt, acknowledged, and adopted in the normal way. The only difference now is that this process of assimilation has itself become a subject matter and even a style in photography. From the portraiture of Richard Avedon to that of Chuck Close, and in the photographic art of Paolo Gioli, Mark Klett, or Joel-Peter Witkin, issues that postmodernism has raised for the medium are resolved in ways that leave the door open to the future.

## BEYOND THE PHOTOGRAPHIC FRAME

The nature of celebrity and fame in the late twentieth century is one issue that is implicit not only in work ranging from Warhol to Sherman, but in that of William Wegman as well. The artist first began to experiment with his dog as a subject when, in the course of making an early videotape, he

Fig. 13. Richard Avedon, *Marilyn Monroe, actress, New York City 5/6/57*, 1957, gelatin silver print, 35.5 x 27.9 (14 x 11), Mr. Richard Avedon, Copyright 1957 by Richard Avedon Inc., All rights reserved (cat. 414)

was repeatedly interrupted by the dog because it was attracted to the lights, the camera, and the impression of excitement they created. Many of the videos and photographs that followed are meditations on the power of the media over the dog, which will, like a game-show contestant, submit to any indignity, or act in any sit-com scene no matter how silly, in order to be on camera. The dog becomes a parody of the celebrity, just as Cindy Sherman does in her photographs.

Long before conceptualists and postmodernists became fascinated with celebrity, photographic portraiture had made itself into a study of the subject even as it was creating the celebrities themselves. The question of the relationship of photography's place among the fine arts to its place among the mass media is central to the work of Richard Avedon (cats. 337, 338, 414) and Irving Penn. They have had to think about this problem upon which their images inevitably become a commentary. Through the 1920s and 1930s, portraitists almost always glamorized famous subjects, but by the time the war was over, this had changed. In the work of Penn and, even more, of Avedon, a dyspeptic, adversarial relationship between photographer and subject began to develop. From his 1954 photograph of Marilyn Monroe, characteristically, Avedon banished every trace of the erotic charm and effervescence for which the actress was celebrated. She appears here crestfallen. Behind the beautiful face, her spirits sag as gravely as the body beneath the sequined dress. Avedon's portrait has turned his subject from a star into a mere mortal.

Avedon published this image in his 1964 book *Nothing Personal* with the caption, "Marilyn Monroe, Actress," as if she were someone unknown, an example of a social type like the subjects labeled only by their professions in the 1920s work of August Sander (to which Avedon was, quite consciously, making allusion). With its simplified, unvarying format, Avedon's portraiture suggests an ethnographic study, a documentation of the common humanity of anonymous people. That is what his 1985 exhibition and book *In the American West* really was, and what Penn's earlier *Worlds in a Small Room* was as well. Penn's project has been much criticized for treating primitive subjects like fashion models and celebrities, but perhaps the point was just the opposite:

that the famous celebrities seemed a doomed ethnic group, a "tribe" that sacrificed itself to popular culture in the late twentieth century.

Avedon's work suggests again what has already been demonstrated elsewhere—that it is as a mere document that a photograph is capable of having its most profound aesthetic impact. Documentation is the common ground on which the functions of photography as art and as news can meet to be reconciled. In order to give his portraiture the modesty and dignity of serious work, Avedon treats it collectively as a routine documentation, an on-going project not so different from the Bechers'.

Nicholas Nixon's annual pictures of his wife and her sisters, begun in 1975 (cat. 340) also give to portraiture a feeling of seriality. Where Avedon would reduce a famous subject to ordinary mortality, Nixon would elevate ordinary subjects to a universal theme. Despite the care with which Nixon makes and prints these group portraits, they function on one level as snapshots for the family album, a personal photographic ritual that might occur on any Fourth of July. Yet by making essentially the same, expressionless picture, year in and year out, so that small variations take on tremendous import, Nixon creates a larger, impersonal truth about growing older and the nature of change.

Avedon's conversion of illustrious personages into unknown soldiers, of celebrity into anonymity, has ramifications that reach far into contemporary photography. These can be felt in one way in Nixon's work and in another in the collaboration between Holger Trülzsch and Vera Lehndorff. The body art that they achieve when they paint her nude figure into a run-down corner of an abandoned factory or rag warehouse gains its poignancy as a performance piece from the fact that that body was at one time very famous. For in the 1960s Lehndorff worked as a model under the name Veruschka. Because of her height and her extraordinary beauty, no cover girl was more instantly recognizable or had a wider public exposure than she. It is as a comment on the existence she had then, one constantly celebrated in photographs, that she makes her art now by literally vanishing under shady circumstances, disappearing into a characterless background.

The striving for anonymous humanity that typifies much

of the celebrity portraiture of the post-war period imparts to this genre an aura of paradox. Avedon's best work is self-deconstructing in a way that might disarm postmodernist criticisms of it. It undoes the very illusion of fame that it would create. It turns head shots of the sort that models and actors distribute to their fans into photo documentation such as one might find mounted on an identity card. Perhaps portraiture at the highest level became a succession of grim, wary, almost anonymous faces because the ideal of the celebrated individual seemed too ironic when so many millions of unknown people had perished.

The post-modernist architectural historian Charles Jencks has suggested that a precise day, date, and even minute can be designated for the end of modernism in his field. (It was the moment at which an abandoned housing project in St. Louis was demolished with dynamite.) If there was a comparable last moment for the modernist era in photography, it was 29 December 1972, when the last weekly issue of *Life* magazine was published. *Life* failed as a news magazine because television had pre-empted photography and the press as the primary information medium. The magazine's passing marked the end of photography's power as a mass medium and of that partnership between journalism and art that had made possible modernist careers in photography like Cartier-Bresson's or Erwitt's. Once a medium is no longer essential as a culture's source of information, it turns into an art form. It is not mere coincidence that the decline of photography as a mass medium was accompanied by the rise in photography galleries, history courses, art-school degrees, and auction prices for vintage prints. This historical consciousness with which the medium is now appreciated has contributed, moreover, to the intense historical self-consciousness of the new photography of the 1980s.

This self-consciousness is apparent in the density of the historical allusions made by photographers as diverse as Mark Klett, Paolo Gioli, Joel-Peter Witkin, and Joan Fontcuberta. Witkin's work has provoked the most comment, often because of the obscene nature of its content; yet, that content is in truth just another aspect of a reflection on photographic history made by his style. The composition of Witkin's 1982 *Canova's Venus* (cat. 330) evokes not only the sculpture from

375

which the title is borrowed, but a famous calotype that William Henry Fox Talbot made of his wife (fully clothed) on a similar couch. Witkin's picture also suggests the early days of the medium by its toned, stained surface and darkening edges. By putting such salacious, contemporary subject matter into what appear to be venerable old prints, Witkin makes the shocking proposal that his outlaw imagery should be considered part of the mainstream of photographic history.

Mark Klett's career began with *The Re-Photographic Survey*, a project for which he and some colleagues scoured the western United States, trying to locate the exact vantage points from which the original camera exploration of that part of the country was done in the 1860s and 1870s. This tracking of historic references is the background that has led Klett to more recent images such as the 1987 panorama of Toroweap Point (cat. 383), which begins and ends with recreations of views made 100 years ago by John K. Hillers, the first person to photograph the Grand Canyon. In work such as this, Klett has elided the pictorial history of the West with later commercial developments by manipulating dye-transfer color prints to achieve the tinted look of nineteenth- and early twentieth-century postcards.

The critic J. Hoberman once called Klett, correctly, "a deadpan conceptualist."[29] By terse inscriptions or titles that Klett writes on his prints, and by little flourishes such as throwing his bandana-banded sun hat into one of the frames of *Toroweap Point*, Klett has been subtly creating a persona for himself as a throw-back to the tough, old sourdough explorer-photographer of yesteryear. He makes us sense this fictitious presence in the landscape, hovering just outside the big view camera's frame, fussing with the screws and knobs to get the picture true. Although Klett works essentially within the mainstream of photographic tradition, he is re-examining—as the conceptualists or John Pfahl have—the question of how we make art and what it is.

Paolo Gioli in Italy and Joan Fontcuberta in Spain are both recycling photography's past into a new future for the medium as well. Gioli reaches far back into the nineteenth century for imagery from both painting and photo history to incorporate into his peeled-apart Polaroids, such as the 1982 image of Cardinal d'Amboise from the *Homage to*

*Niépce* series (cat. 329), which reproduces a photochemical copy that Nicéphore Niépce made of an engraving in 1826. Fontcuberta goes back to the early 1900s, to the plant studies of Karl Blossfeldt, which he parodies with his fabricated flora and fauna. The most prominent young photo historian in Spain in addition to being a photographer himself, Fontcuberta uses a postmodernist technique not just to deconstruct an historical precedent, but to decolonize Spanish photography from such northern European influences.

While none of these photographers has allied himself with postmodernism, all are preoccupied with the same aesthetic and historical concerns that postmodernists have addressed. An awareness of photography's role in the mass media exists in the work of many photographers far removed from postmodernism in both time and temperament. Even Garry Winogrand's 1977 book *Public Relations* might be thought of in this way. Winogrand attended various media events—receptions, openings, news conferences—along with the rest of the press corps. But unlike most of his colleagues, he took a step back, thereby creating a whole new sense of what the subject was to be photographed. While others were photographing a politician or an athlete, Winogrand was taking pictures of the photo opportunity itself. Their imagery was a part of the media; his is a commentary on it. By enlarging his field of vision, Winogrand expanded the viewer's historical consciousness of the medium.

Photography in the postwar period has extended beyond the photographic frame in the sense that it has made a concerted effort to exceed the traditional limits of the medium, to find new ways of conceiving of it that lie beyond the uses to which it had been put before. In the work of Robert Frank, there was literally an attempt to go beyond the single image to multiple frames that draw upon the power of seriality and montage in photography. Frank made inspirationally simple pictures—an antiformalist, unaesthetic imagery—that opened the way for a variety of new attitudes toward the medium. *The Americans* operated as a kind of symbolic film made up of stills; after its publication ever greater emphasis was placed on books, extended projects, and series work. A group of photographs by the Bechers framed to look like gang prints emphasizes the same potential in the medium, as does

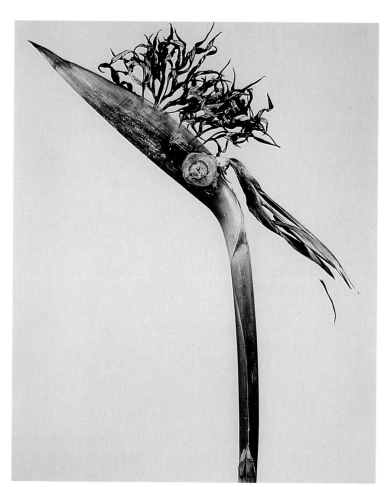

Fig. 14. Joan Fontcuberta, *Giliandria escoliforcia* (from the series *Herbarium*), 1984, gelatin silver print, 27.0 x 22.0 (10⅝ x 8⅝), Courtesy Zabriskie Gallery, New York (cat. 415)

ever more austere, constrained, negative image until finally, in postmodernism, it seemed that the only option left was repetition of images already in existence. Yet even in the process of recycling itself this way, photography seems to have opened up new possibilities that extend the life and the promise of the medium. The visions of photographers and artists alike continue to be fed not only by the most remote, arcane reaches of photographic history and the most vulgar, mindless excesses of mass media, but by the burgeoning new technologies in image-making that have developed in the past twenty years.

Consider the impact that the digitized, computer-generated imagery of space exploration has had on photographers and artists in recent years. Not since the Mercator projections were published four centuries ago have images of new worlds held such fascination for the Western imagination. Even this kind of composite photograph is not completely without forerunners in the medium's history, Ray Metzker's composite series being among them (cat. 380). But the recent spate of this kind of multiple photography has more to do with the excitement that images such as the Jet Propulsion Laboratory's 1977 *Southern Latitudes of Mars* (cat. 379) have held for visual artists of all types. Having been created in the esoteric realms of science, such pictures soon became a universally recognized part of mass culture. Whoever imitates their form now is engaged in an act of recycling just as surely as Cindy Sherman is.

Such celestial visions as *Southern Latitudes* have influenced new works ranging from single images like Robert Mapplethorpe's 1981 *Cedric* (cat. 378) (which shows us, as in an astronomical photograph, a picture of a new world rising) to serial extravaganzas like David Hockney's 1986 *Pearblossom Highway* (cat. 387), which contains hundreds of Ektacolor prints. Whether it was inspired by NASA and Jet Propulsion images or not, this kind of photography functions in art exactly the way it does in space technology, as a form of mapping. The multiple images of the Starn Twins draw a kind of cultural map for us. Hockney's are a social map. Chuck Close's are in effect a map of intimacy, an exploration of the experience of nearness to nude flesh, the centers of flowers, and one's own or somebody else's face (cat. 386).

the mechanical logic that attempts to exhaust all possibilities and combinations in many conceptual pieces.

At the same time that the use of the photographic medium by artists expanded, and the uses to which it was put by traditional photographers became more varied, there also developed, ironically, a growing sense that the possibilities of photography were being increasingly diminished. The reductionist aesthetic inherent in modernism demanded an

Because he works in a monumental scale befitting the study of planets, but documents only the most commonplace details of everyday life, Close reinvests what is ordinary with a newly heroic stature. The nearly grainless results of working in Polaroid material of this size compel the viewer to examine what is familiar with the same attention and expectation of discovery as scientists poring over an enhanced, high-resolution imaging of a landscape where man has never set foot. Close's multi-part study of his own face might be looked at as a photographer's escape into the self magnified to an extreme degree, although, at the same time, the impassivity and sheer scale of the image also make it the ultimate objectification of the self. His portraits are correctly thought of as the latest variation on an aesthetic that reaches from Nadar to Avedon.

In like manner, Hockney's *Pearblossom Highway* transforms a vision of the American landscape that is as old as O'Sullivan's work over a century ago and as recent as Robert Adams'. The America Hockney has chosen as his subject here is the one of litter, highway signs, and desolate space, a muzzy, dishevelled terrain with which our photography has

by now made us all too familiar. Whereas scientists are concerned with obtaining images that are as true and as nearly seamless as they can be, Hockney has understood that the possibilities for art lie in displacement and interruption. As Close and most of the others who have been drawn to multiple or serial imagery have also realized, the disparities and discrepancies between the pictures are chinks in the wall of reality through which beauty can seep into an otherwise closed subject.

Hockney's antic landscape is, in effect, a two-dimensional version of a sculpture by Red Grooms where all the objects lurch and sway comically in the space. As has so often been the case in postwar photography, the effect is dizzy, though in a rather exhilarating way. It is a bright, clear desert morning. The sky is blue and vast, and Hockney's whimsy cannot help but put us in a good mood. Up ahead is an intersection with roads turning off to the right and left and one leading straight into the distance as far as the eye can see. Which way will the photographer go?

1. Ansel Adams, *An Autobiography* (Boston, 1985), 263.
2. Minor White, *Mirrors Messages Manifestations* (New York, 1969), 33.
3. Dorothy Norman, *Alfred Stieglitz: An American Seer* (New York, 1960), 143.
4. White, *Mirrors*, 186.
5. White, *Mirrors*, 31.
6. White, *Mirrors*, 163.
7. Bill Brandt, *Bill Brandt: Shadow of Light* (New York, 1966), 11.
8. Manuel Alvarez Bravo, letter to Nancy Newhall (5 July 1943).
9. Helen Gee, conversation with the author (October 1980).
10. Ben Maddow, "The Wounded Angel," in *Let Truth Be the Prejudice W. Eugene Smith: His Life and Photographs* (New York, 1985), 59.
11. Weston Naef, "André Kertész: The Making of an American Photographer," in *André Kertész of Paris and New York* (Chicago, 1985), 104.
12. Henri Cartier-Bresson, conversation with the author (November 1980).
13. Robert Frank, conversation with the author (October 1980).
14. White, *Mirrors*, 63.
15. *Popular Photography* 46 (May 1960), 104–106.
16. Centre Georges Pompidou, *William Klein photographe etc.* (Paris, 1983), 14.
17. Joel Meyerowitz, conversation with the author (October 1987).
18. *New Topographics: Photographs of a Man-altered Landscape* included work by Robert Adams, Lewis Baltz, Bernhard and Hilla Becher, Joe Deal, Frank Gohlke, Nicholas Nixon, John Schott, Stephen Shore, and Henry Wessel, Jr. In a brief introduction to the catalogue (Rochester, 1975), Eastman House's assistant curator of twentieth-century photography, William Jenkins, who organized the exhibition, spoke of the photographic books by conceptual artist Ed Ruscha, such as *Some Los Angeles Apartments* (1965), as a source of inspiration for the work in his own exhibition. The connection between new topographics and conceptualism is explored more fully in a later section of this essay.
19. This book (Millerton, New York, 1981) is a collection of *Essays in Defense of Traditional Values*, as its subtitle says. Adams' desire to reconcile the contemporary American landscape with certain traditional aesthetic and religious concerns he has leads him to reject the ambiguous scale in Minor White's photography, which creates, he feels, "a frightening alienation from the world of appearances" (98). Adams is also dissatisfied, however, with more conventional postwar wilderness photography, claiming that "unspoiled places sadden us because they are, in an important sense, no longer true" (14). This observation made in the volume's opening essay, "Truth and Landscape," returns in the final one, where he says that only a landscape photography that is able "to encompass our mistakes" can help us "to endure our age of apocalypse" (107).
20. This phrase was used by editor-critic Sally Eauclaire in the titles of two books, *The New Color Photography* (New York, 1981) and *New Color/New Work: Eighteen Photographic Essays* (New York, 1984), that attempted to survey early activity in this emerging field of photography.
21. Carl André, "A Note on Hilla and Bernhard Becher," *Artforum* (December 1972), 59–61.
22. In an issue of the avant-garde art journal *Avalanche* devoted to Acconci—*Avalanche* 6 (fall 1972)—this photo piece was published in another format, four rows of three pictures with a separate text that differed from the

one now accompanying the imagery. Unfortunately, Acconci kept no records of it either when the piece was first exhibited or when he put it in its present form, although he believes this was in the early 1970s.

23. Vito Acconci, "Notes on My Photographs 1969–1970," in *Vito Acconci: Photographic Works 1969–1970* (New York, 1988), unpaginated.

24. One of the images in a collage Frank has done of his own snapshots of the "10th Street Painters" shows Kaprow and Aristodemus Kaldis at this early happening, which was performed outdoors. The collage is reproduced in The Museum of Fine Arts, Houston, *Robert Frank: New York to Nova Scotia* (Houston, 1986), 52–53.

25. The videotapes by Wegman and some of the other conceptual artists discussed here are also marked by the tendency to try all the possible combinations and permutations of any action. An untitled Wegman video performance with Man Ray from between 1970 and 1972, for example, has four scenes: first, the artist goes to his front door with the dog, and both go out; second, they go to the door, and he lets the dog out but remains inside himself; third, *he* goes out and leaves the dog behind; and fourth, they both come to the door in anticipation, but neither goes out. Vito Acconci's *Pryings* (1971), John Baldessari's *I Will Not Make Any More Boring Art* (1971), Bruce Nauman's *Revolving Upside Down* (1968), and many other video pieces from this era are similarly repetitious in structure.

26. In some notes on the phrase Blasted Allegories, which he adopted from Nathaniel Hawthorne, Baldessari explained, "An allegory is a useful device in the rich meanings it can generate but its very blessing is a curse in the multiplicity of meanings that can be generated, thus the possibility of confusion. An allegory can mean so many things, it can mean anything and nothing. . . . But the phrase can also mean 'exploded,' pieces and bits of meaning floating in the air, their transient syntax providing new ideas" (Van Abbemuseum, Eindhoven, *John Baldessari* [Eindhoven, 1981], 49). Although he paid homage a bit later in the text to the methodology of the French structuralist Claude Lévi-Strauss, the emphasis on multiplicity of meanings suggests that Baldessari is indebted as well to Jacques Derrida's concept of deconstruction, which describes the process whereby conflicting meanings within a work reveal, because of the disparities or contradictions between possible interpretations, different ideological and cultural assumptions that the work contains. Roland Barthes has been an important writer for Baldessari and other conceptual or postmodernist artists, such as Sherrie Levine, interested in this very inaccessible school of French thought, for Barthes has acted as a proselytizer and apologist for both the structuralists and deconstructionists.

27. See in particular Jean Baudrillard, "The Precession of the Simulacra," in *Simulations* (New York, 1983).

28. Lynn Gumpert, lecture on Boltanski, the Museum of Contemporary Art, Chicago (10 May 1988).

29. J. Hoberman, *The Village Voice* (24 December 1982), 62.

298. ANSEL ADAMS
*Winter Sunrise, Sierra Nevada, from Lone Pine, California,* 1944
gelatin silver print, 37.0 x 49.4 (14½ x 19½)
Center for Creative Photography, University of Arizona
Copyright 1981, The Ansel Adams Publishing Rights Trust

299. Minor White
*Pacific, Devil's Slide, California*, 1947
gelatin silver print, 16.8 x 20.8 (6⅝ x 8³⁄₁₆)
Collection, The Museum of Modern Art, New York, Gift of David H. McAlpin,
Reproduction courtesy The Minor White Archive, Princeton University
Copyright 1982, the Trustees of Princeton University

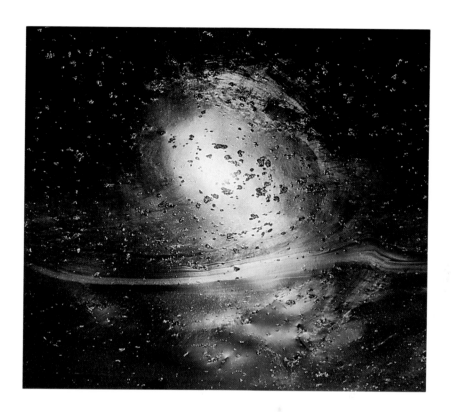

301. Toni Schneiders
*Die Tiefe*, 1950
gelatin silver print, 17.3 x 19.9 (6$^{13}/_{16}$ x 7$^{7}/_{8}$)
Museum Folkwang, Essen

300. Minor White
*Surf Vertical, San Mateo County, California*, 1947
gelatin silver print, 12.0 x 9.5 (4$^{3}/_{4}$ x 3$^{3}/_{4}$)
The Art Institute of Chicago, Restricted gift of Photo Gallery,
Reproduction courtesy The Minor White Archive, Princeton University
Copyright 1982, the Trustees of Princeton University

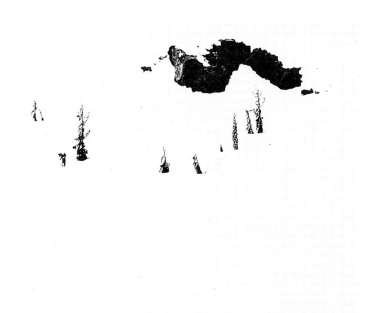

302. CHRISTER STRÖMHOLM
*Landscape*, c. 1950
gelatin silver print, 10.7 x 19.8 (4¼ x 7¹³⁄₁₆)
Museum Folkwang, Essen

303. PETER KEETMAN
*Schnee-Inseln*, 1958
gelatin silver print, 23.2 x 28.8 (9⅛ x 11⅜)
Museum Folkwang, Essen

304. AARON SISKIND
*Los Angeles 49*, 1949
gelatin silver print, 25.5 x 32.5 (10 x 12¹³⁄₁₆)
Monsen Collection

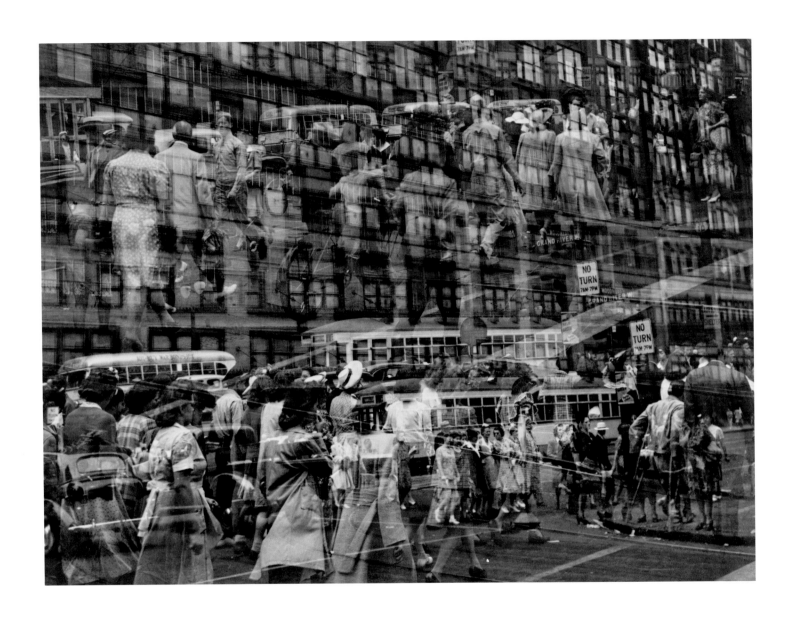

305. Harry Callahan
*Detroit Street Scene*, 1943
gelatin silver print, 20.0 x 28.0 (7⅞ x 11¹⁄₁₆)
The Art Institute of Chicago, Gift of Mrs. Katherine Kuh

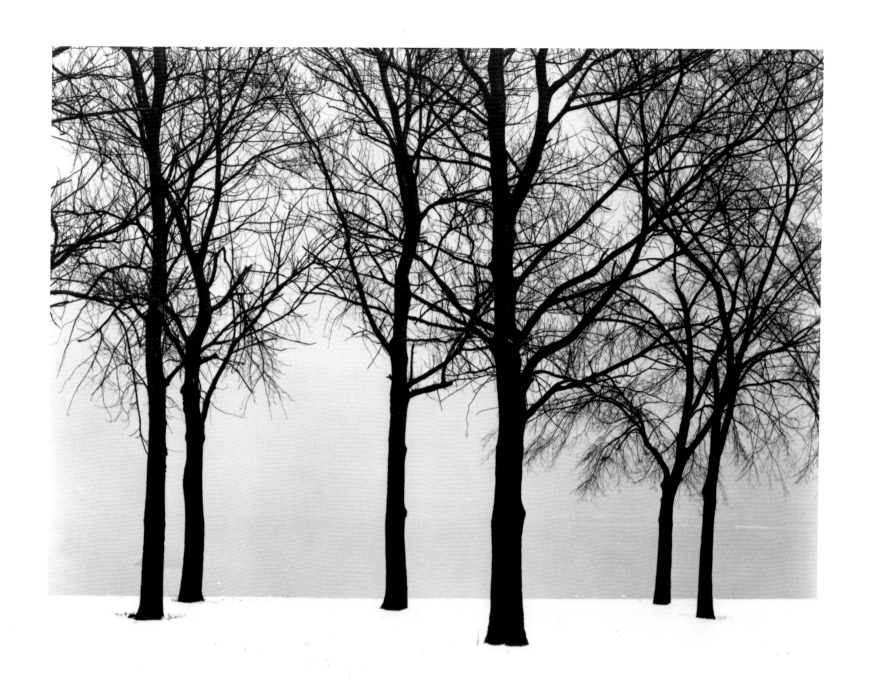

306. Harry Callahan
*Chicago*, c. 1950
gelatin silver print, 19.2 x 24.2 (7⁹/₁₆ x 9⁹/₁₆)
The Art Institute of Chicago, Mary L. and Leigh B. Block Endowment

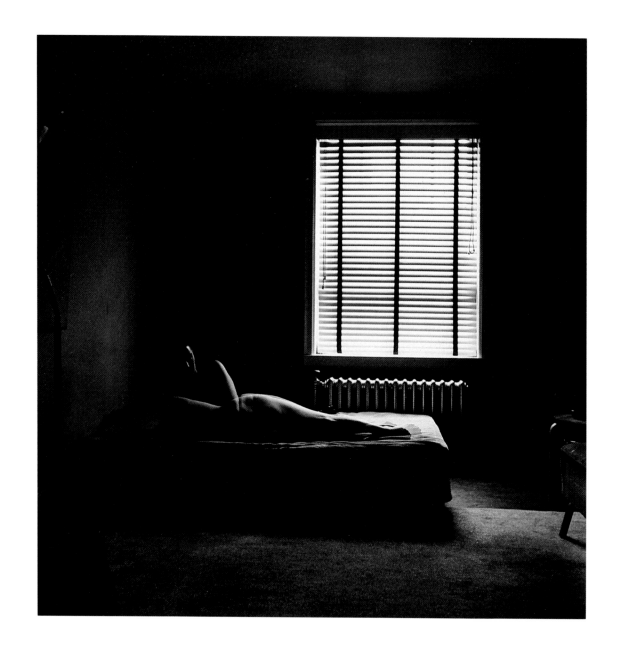

307. HARRY CALLAHAN
*Eleanor, Chicago*, 1954
gelatin silver print, 18.2 x 17.5 (7⅛ x 6⅞)
Center for Creative Photography, University of Arizona

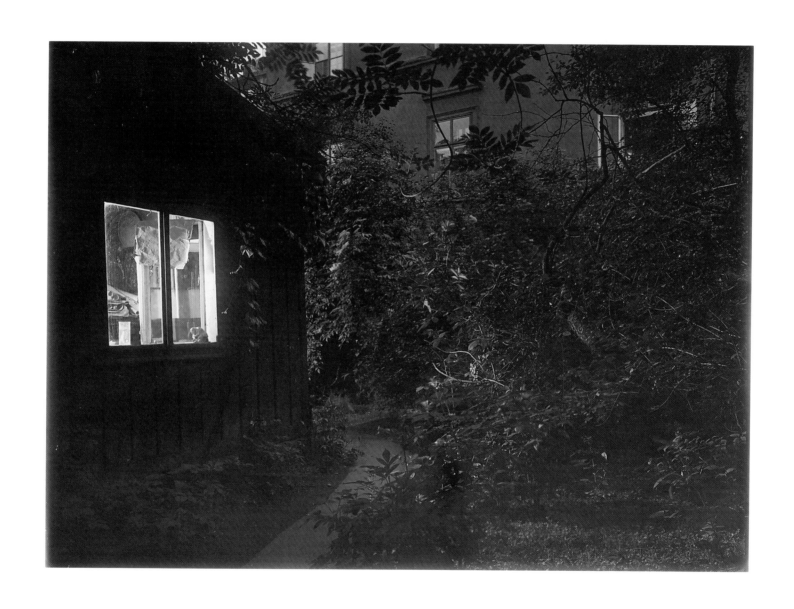

308. Josef Sudek
*Untitled*, c. 1950
gelatin silver print, 18.0 x 24.0 (7⅛ x 9⁷⁄₁₆)
Kicken-Pauseback Galerie, Cologne

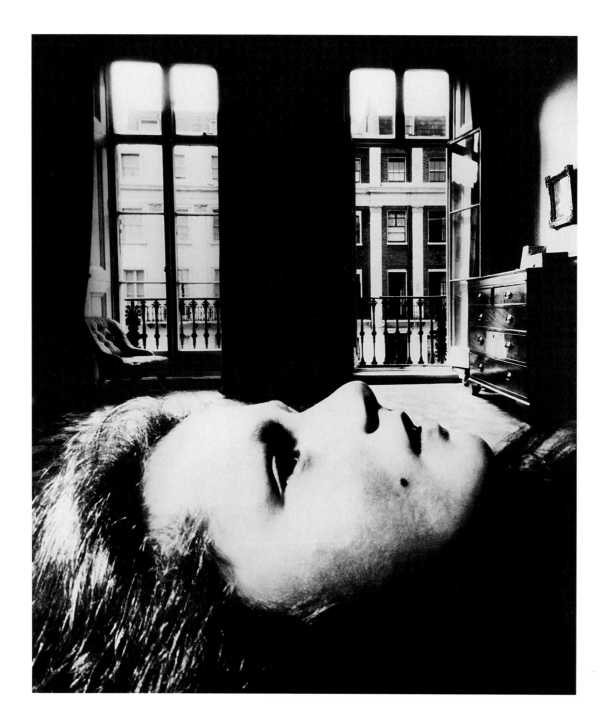

309. BILL BRANDT
*Portrait of a Young Girl, Eaton Place, London*, 1955
gelatin silver print, 43.0 x 37.5 (17 x 14¾)
Collection, The Museum of Modern Art,
New York, Purchase

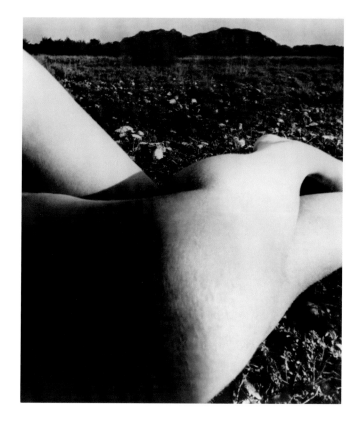

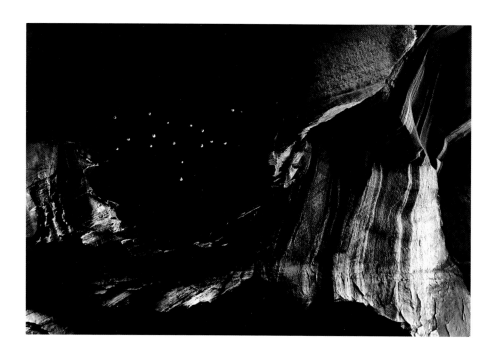

312. MINOR WHITE
*Bullet Holes, Capitol Reef, Utah*, 1961
gelatin silver print, 21.5 x 29.5 (8½ x 11⅝)
The Art Museum, Princeton University, The Minor White Archive,
Reproduction courtesy The Minor White Archive, Princeton University
Copyright 1982, the Trustees of Princeton University

313. JERRY N. UELSMANN
*Untitled*, 1969
gelatin silver print, 26.9 x 32.2 (10⅝ x 12¹¹⁄₁₆)
The Art Institute of Chicago, Restricted gift of The People's Gallery

314. ELIOT PORTER
*Dark Canyon, Glen Canyon*, 1965
dye transfer print, 25.9 x 20.0 (10³⁄₁₆ x 7⁷⁄₈)
The Art Institute of Chicago, Anonymous gift
in honor of Hugh Edwards

315. Paul Caponigro
*Redding Woods, Redding, Connecticut*, 1968
gelatin silver print, 19.6 x 26.7 (7¾ x 10½)
The Art Institute of Chicago, Gift of the Joseph and Helen Regenstein Foundation

316. Harry Callahan
*Cape Cod*, 1972
gelatin silver print, 24.4 x 24.8 (9⅝ x 9¾)
Monsen Collection

317. Art Sinsabaugh
*Midwest Landscape #24*, 1961
gelatin silver print, 6.6 x 49.0 (2⅝ x 19⅜)
The J. Paul Getty Museum

318. ROBERT ADAMS
*Missouri River, Clay County, South Dakota*, 1976
gelatin silver print, 22.2 x 28.3 (8¾ x 11⅛)
Collection, The Museum of Modern Art, New York, Purchase, Copyright Robert Adams

319. ROBERT ADAMS
*Colorado Springs*, before 1974
gelatin silver print, 15.2 x 15.2 (6 x 6)
Nebraska Art Association, Sheldon Memorial Art Gallery, University of Nebraska-Lincoln
Copyright Robert Adams

320. Lewis Baltz
*Park City #95*, 1979
gelatin silver print, 14.0 x 21.5 (5½ x 8½)
Monsen Collection

321. LEWIS BALTZ
*Industrial Parks #51*, 1977
gelatin silver print, 15.0 x 22.0 (5⅞ x 8⅝)
Monsen Collection

322. HILLA AND BERNHARD BECHER
From the series *Industrial Façades*, 1975–1985
six gelatin silver prints, each 30.0 x 40.0
(11¹³⁄₁₆ x 15¾)
Hilla and Bernhard Becher

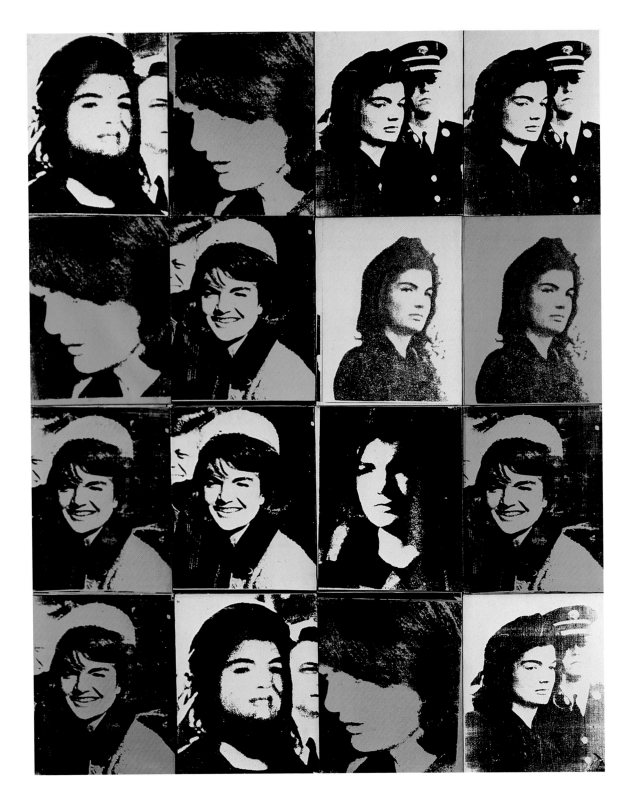

323. ANDY WARHOL
*Sixteen Jackies*, 1964
acrylic and silkscreen ink on sixteen joined canvases,
203.2 x 162.6 (80 x 64)
Mr. and Mrs. David Pincus

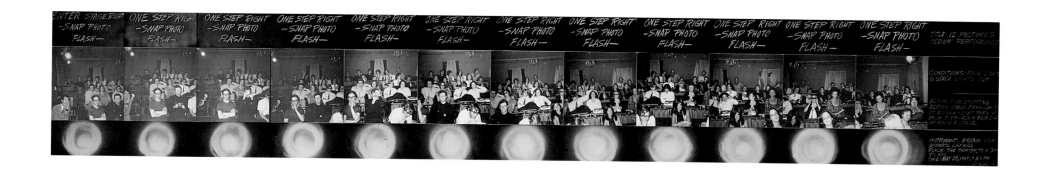

324. VITO ACCONCI
*Twelve Pictures*, 1969
gelatin silver prints mounted on foamcore with text panels executed
in chalkboard spray, chalk, and marker
99.0 x 670.0 (39 x 260)
Peter Brams and Rhona Hoffman Gallery

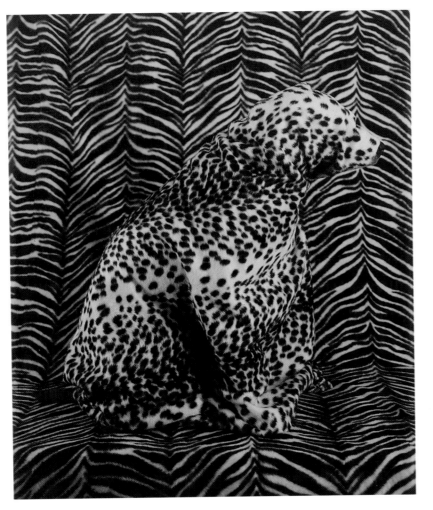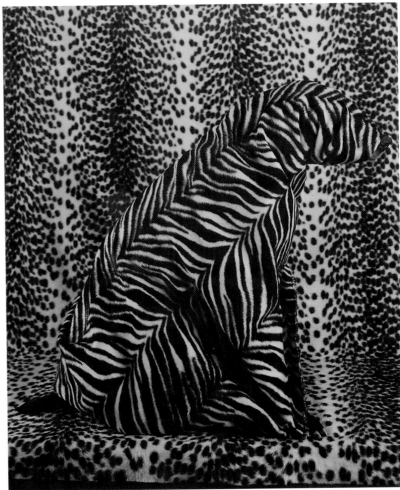

325. William Wegman
*Leopard/Zebra – Zebra/Leopard*, 1981
dye diffusion transfer prints, each 61.0 x 52.4 (24 x 20⅝)
Sherry and Alan Koppel

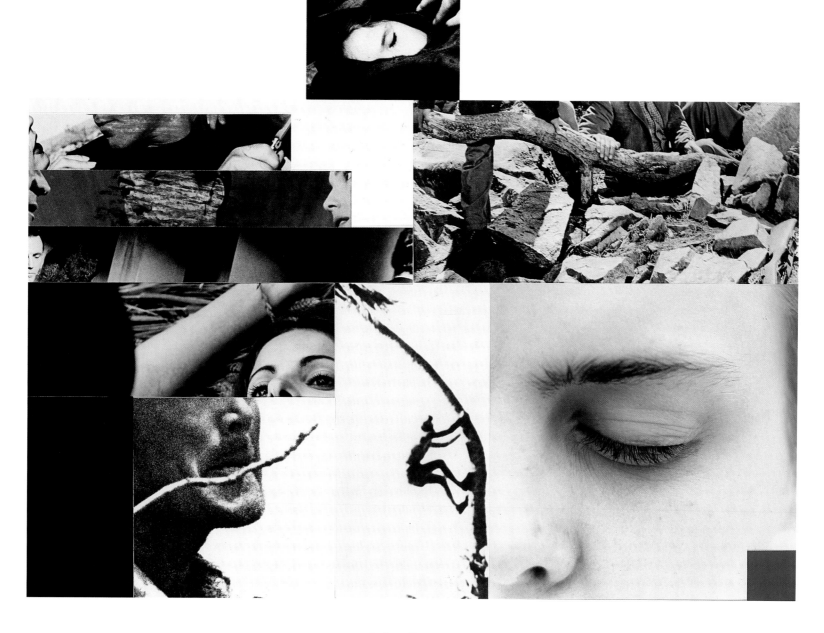

326. John Baldessari
*Eye lid (with log)*, 1986
gelatin silver prints, chromogenic color prints, and color paper,
26.0 x 31.0 (10¼ x 12³⁄₁₆), 97.0 x 153.0 (38¼ x 60¼)
Monsen Collection

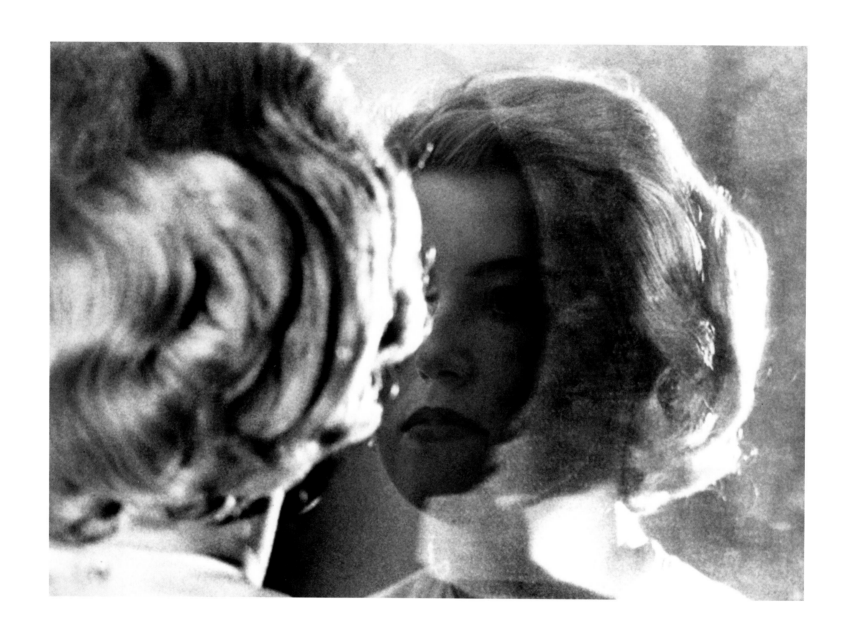

327. Cindy Sherman
*Untitled Film Still #56*, 1980
gelatin silver print, 20.3 x 25.2 (8 x 10)
The Art Institute of Chicago, Restricted gift of Allen Turner

The *recognition seme* cannot be said to belong to an equivalent level of articulation to that of the phoneme as it has, by definition, intrinsic meaning. It must therefore be decomposed into atomic constituents of expression which have no counterpart on the content plane. The difference between recognition semes and semantic markers is illustrated in their respective decompositions. Katz says that each of the concepts represented by the semantic markers in his analysis of the sense of "chair" may itself be decomposed. For example, he writes, "…the concept of an object represented by '(Object)' might by analysed as an *organisation of parts that are spatio temporally contiguous which form a stable whole having an orientation in space.*"

A recognition seme might be decomposed as follows. Consider the example of two silhouette heads which are identical in all features except the nose, one is "aquiline", the other "retrousse". The *gestalt* in this case is "head" which may be decomposed into the recognition semes (throat), (chin), (lips), (nose), (brow), (crown), (nape). We are accustomed to seeing the seme (nose) rendered schematically (via another iconic interpretant) as two lines. One line is horizontal, the other, about twice the length of the first, meets one end of this horizontal line at an angle of about 60°. The seme (nose) in this example may thus be decomposed into "lines" (more accurately, perhaps, "changes in direction and segmentation of line") and the other semes might be similarly dealt with. *These lines have no intrinsic meaning.* The change of significance from "aquiline" to "retrousse" is thus brought about by the modification of an expression element which has no counterpart in the content plane.

Once commutation is established paradigms follow. In "Identikit" pictures a great many tokens of the type "face" are generated by combining recognition semes drawn from paradigms established through changes in a small number of expression elements (lines, shadings, and their relations) which in themselves have no significance. Although the argument at this point concerns iconic signs of a different type from that of photographs the implications for the photographic sign should be clear.

**In the Service of the People** was written by Mao in memory of the soldier Zhang Si-de. Lei-Feng knows the essay perfectly and does not understand why he must return to it now.

328. Victor Burgin
From the sequence *Lei Feng*, 1974
silver gelatin print, 50.8 x 76.2 (20 x 30)
MJS Collection, Paris

329. Paolo Gioli
From the series *Homage to Niépce*, 1982
dye diffusion transfer print with silk insertion, graphite and color pencil on paper,
15.3 x 16.5 (6¹⁄₁₆ x 6½)
The Art Institute of Chicago, Photography Purchase Account

330. JOEL-PETER WITKIN
*Canova's Venus*, 1982
manipulated gelatin silver print,
37.2 x 37.7 (14⅝ x 14⅞)
Courtesy Pace/MacGill Gallery, New York,
and Fraenkel Gallery, San Francisco
Copyright Joel-Peter Witkin

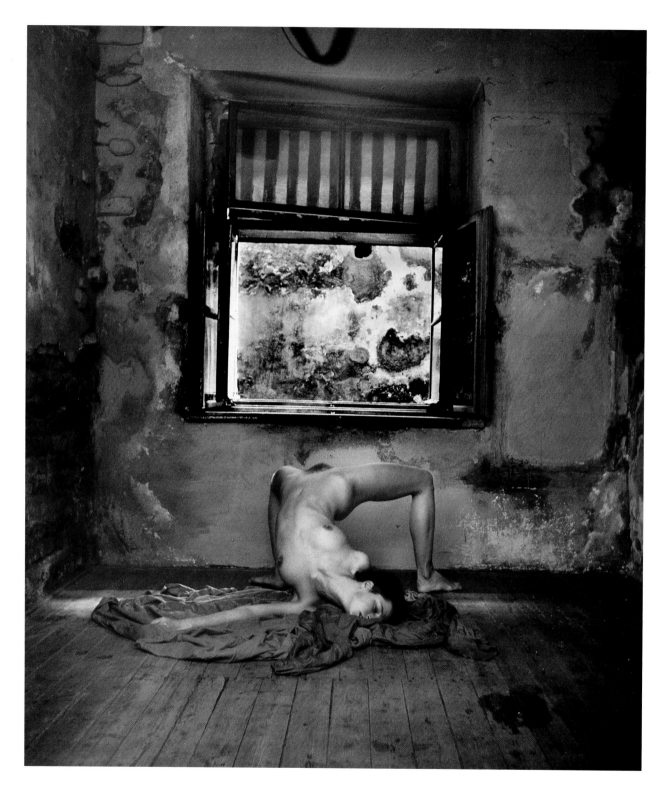

331. Jan Saudek
*Untitled*, 1986
toned, hand-colored gelatin silver print,
39.5 x 30.0 (15 x 11⁷⁄₁₆)
Uměleckoprůmyslové Muzeum

332. HOLGER TRÜLZSCH AND VERA LEHNDORFF
*Sirius VII*, 1987
chromogenic color print, 159.4 x 128.9 (63¾ x 50¾)
John L. Stewart

333. DUANE MICHALS
*Things Are Queer*, 1972
nine gelatin silver prints, each 12.9 x 17.9 (5 1/16 x 7 1/16)
San Francisco Museum of Modern Art, Gift of Marcia Weisman

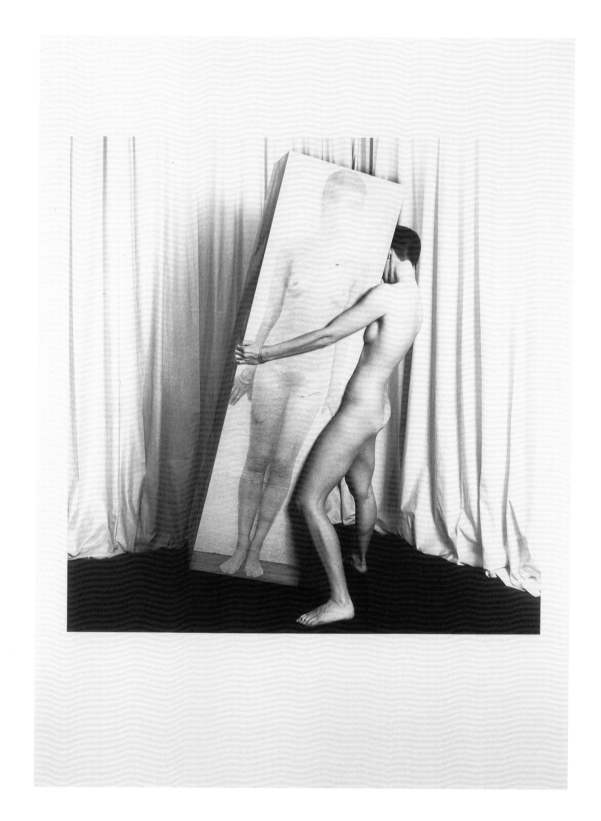

334. Helen Chadwick
*Ego Geometria Sum: The Labors X*, 1984
toned gelatin silver print
122.0 x 91.0 (48 x 35⅞)
Helen Chadwick and Mark Pilkington

335. Lucas Samaras
*Photo-Transformation, 12/28/73*
manipulated internal dye diffusion-transfer
print, 8.5 x 8.5 (3⅜ x 3⅜)
International Polaroid Corporation

336. ARNULF RAINER
*Untitled*, 1973
gelatin silver print with hand markings, 17.8 x 24.2 (7 x 9½)
Joshua P. Smith

337. RICHARD AVEDON
*Oscar Levant, pianist, Beverly Hills, California, 4/12/72*
gelatin silver print, 116.9 x 116.9 (46 x 46)

338. RICHARD AVEDON
*Juan Patricio Lobato, carney, Rocky Ford, Colorado, 8/23/80*
gelatin silver print, 143.5 x 114.3 (56½ x 45)
Mr. Richard Avedon, Copyright 1985, Richard Avedon Inc., All rights reserved

339. IRVING PENN
*Mother and Daughter, Cuzco, Peru*, 1948
gelatin silver print, 31.1 x 26.3 (12¼ x 10⅜)
Collection, The Museum of Modern Art,
New York, Gift of Condé Nast Publications

340. Nicholas Nixon
*The Brown Sisters*, 1976, 1978
gelatin silver prints, each 19.4 x 24.4 (7⅝ x 9⅝)
Monsen Collection

341. CHRISTIAN BOLTANSKI
*Monument, La Fête du Pourim*, 1988
gelatin silver prints, lamps, electrical wire, and biscuit boxes containing clothing,
235.0 x 50.0 x 23.0 (92⁷⁄₈ x 19⁵⁄₈ x 9¹⁄₁₆) per column
Private collection

342. Robert Heinecken
*Jetgraph Proof (Connie Chung)*, 1986
jetgraph print, 55.5 x 66.0 (21⅞ x 26)
The Metropolitan Museum of Art, Purchase, Charina Foundation, Inc., Gift, 1986

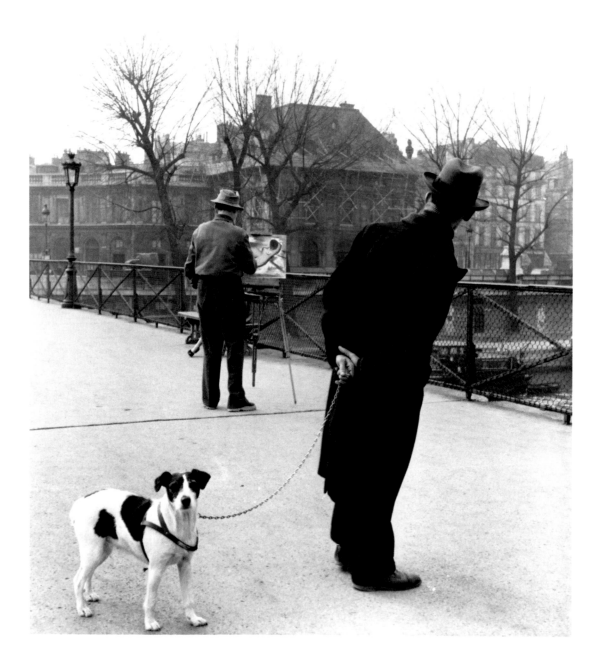

343. ROBERT DOISNEAU
*Fox Terrier on the Pont des Arts*, 1953
gelatin silver print, 35.0 x 29.5 (13¾ x 11⅝)
Courtesy The Witkin Gallery, Inc.

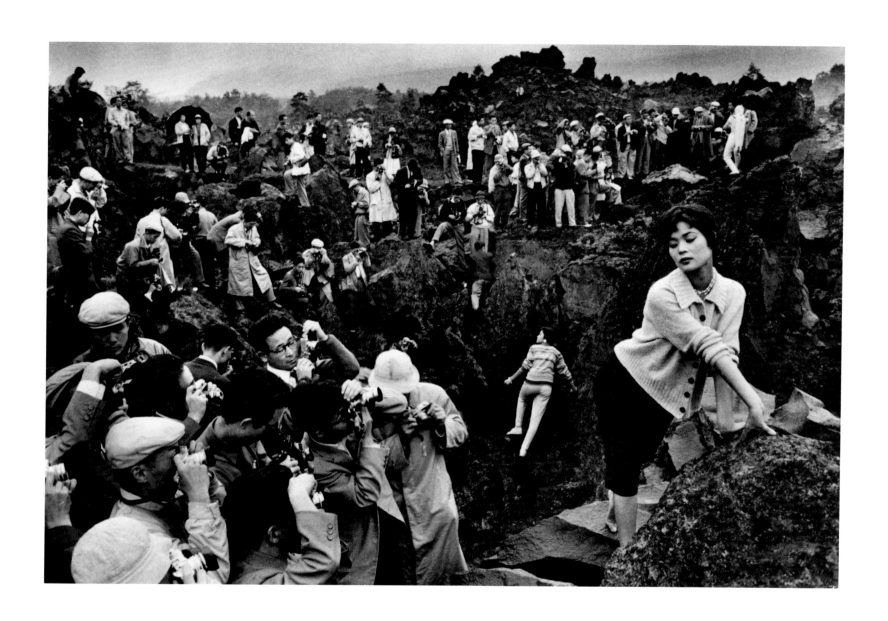

344. Marc Riboud
*Photographers' Convention, Japan*, 1958
gelatin silver print, 30.5 x 40.5 (12¹/₁₆ x 16)
Courtesy, Magnum Photos, Copyright Marc Riboud/Magnum Photos

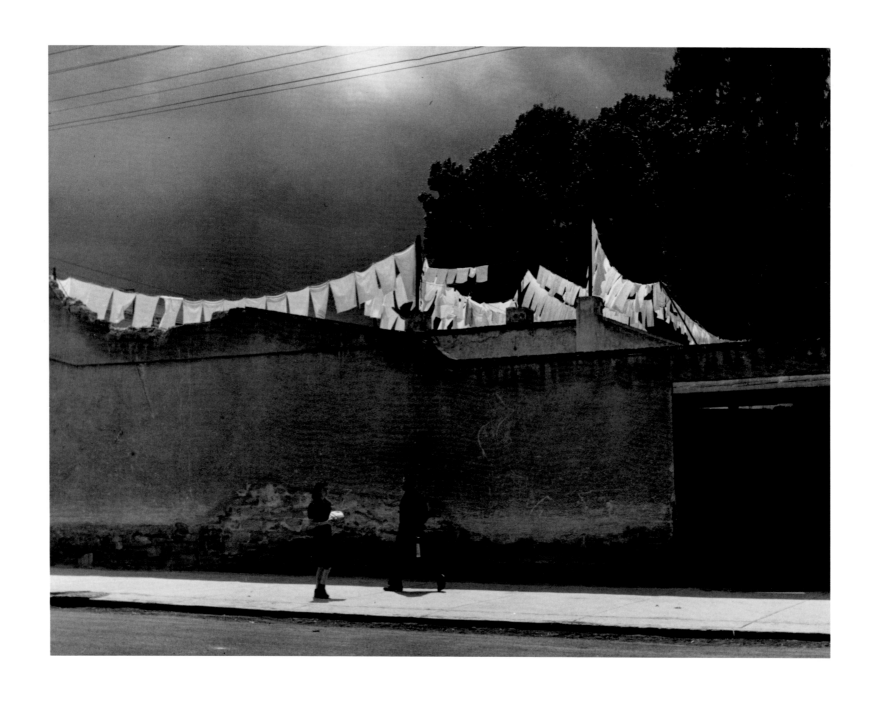

345. MANUEL ALVAREZ BRAVO
*How Small the World Is*, 1942
gelatin silver print, 18.6 x 24.3 (7⁵⁄₁₆ x 9½)
Center for Creative Photography, University of Arizona

346. W. Eugene Smith
*Untitled*, 1950
gelatin silver print, 19.4 x 34.2 (7⅝ x 13½)
Center for Creative Photography, University of Arizona

347. ROBERT DOISNEAU
*M et Mme Garfino, Vagabonds,* 1951
gelatin silver print, 30.0 x 20.0 (11¹³⁄₁₆ x 7⅞)
Bibliothèque Nationale, Paris

348. ROBERT FRANK
*Untitled,* 1949
gelatin silver print, 27.5 x 18.0 (10¹³⁄₁₆ x 7⅛)
The Art Institute of Chicago, Mary L. and Leigh B. Block Endowment

349. W. Eugene Smith
*Untitled*, 1955–1956
gelatin silver print, 26.3 x 39.2 (10⅜ x 15½)
Center for Creative Photography, University of Arizona

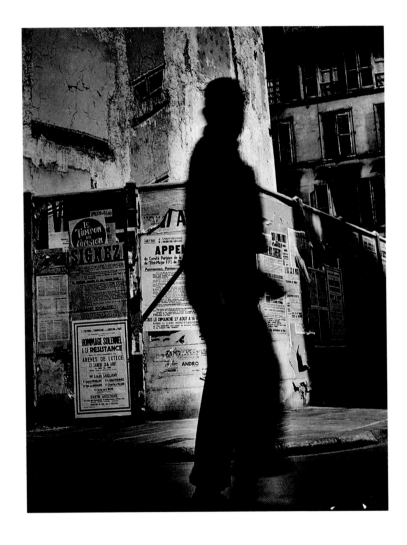

351. W. Eugene Smith
From the series *As From My Window*
*I Sometimes Glance*, 1957–1958
gelatin silver print, 34.4 x 26.2 (13⅝ x 10⁵⁄₁₆)
The Art Institute of Chicago, Photography Purchase Fund

350. Otto Steinert
*Appell*, 1950
gelatin silver print, 39.2 x 29.7 (15½ x 11¹¹⁄₁₆)
Kicken-Pauseback Galerie, Cologne

352. ROBERT FRANK
*New York City*, 1954
gelatin silver print, 25.4 x 34.5 (10 x 13⁹⁄₁₆)
San Francisco Museum of Modern Art, Gift of Foto Forum

353. WILLIAM KLEIN
*The Toy Ball of Elsa Maxwell, in the Waldorf,* 1954–1955
gelatin silver print, 27.8 x 36.0 (11 x 14¼)
Collection Stedelijk Museum, Amsterdam

354. JOSEF KOUDELKA
*Utekac*, 1963
gelatin silver print, 30.5 x 40.5 (12 x 16)
Courtesy, Magnum Photos, Copyright Josef Koudelka/Magnum Photos

355. GARRY WINOGRAND
*Untitled*, c. 1965
gelatin silver print, 22.8 x 34.2 (9 x 13½)
Center for Creative Photography, University of Arizona

356. GARRY WINOGRAND
*Utah*, 1964
gelatin silver print, 22.6 x 34.2 (8⅞ x 13⅜)
Center for Creative Photography, University of Arizona

357. GARRY WINOGRAND
*Los Angeles*, 1969
gelatin silver print, 28.0 x 35.5 (11 x 14)
Joshua P. Smith

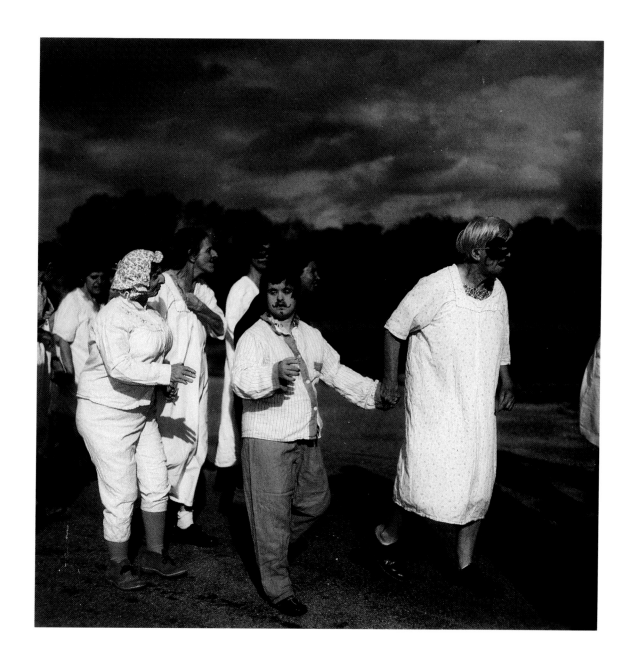

358. DIANE ARBUS
*Untitled #7*, 1970–1971
gelatin silver print, 38.1 x 38.1 (15 x 15)
Robert Miller Gallery, New York
Copyright Estate of Diane Arbus 1972

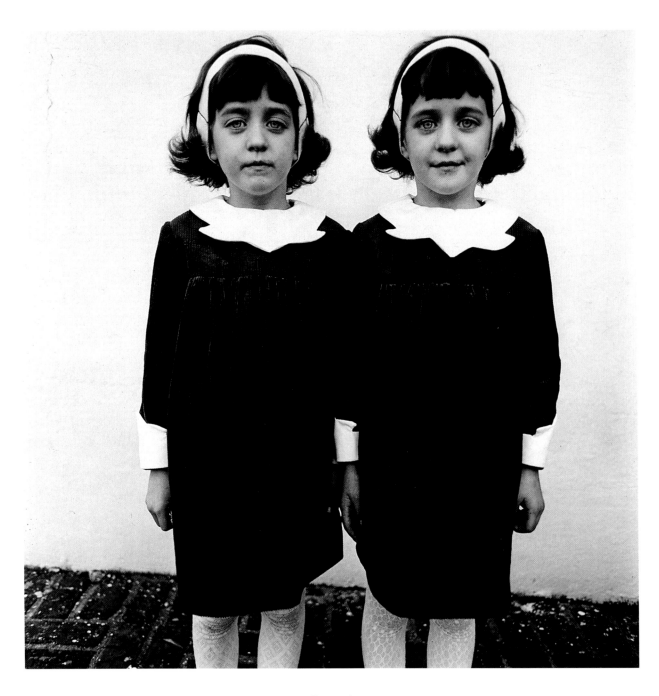

359. DIANE ARBUS
*Identical Twins, Roselle, New Jersey, 1967*
gelatin silver print, 37.4 x 37.9 (14¾ x 14⅞)
Center for Creative Photography, University of Arizona
Copyright Estate of Diane Arbus

436

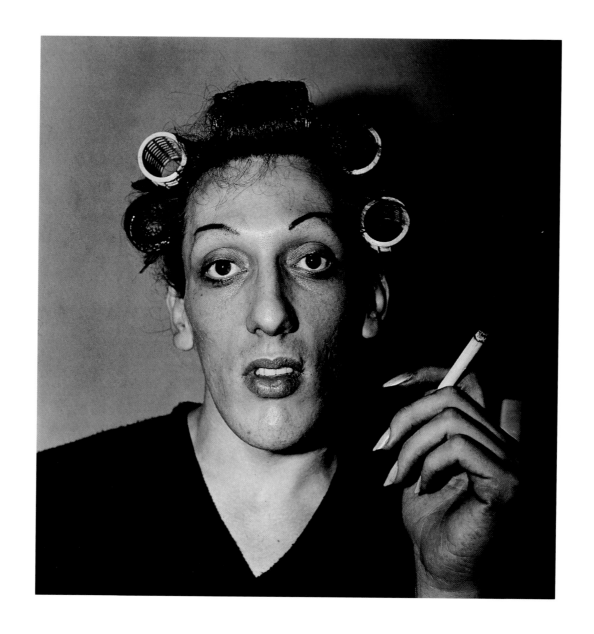

360. DIANE ARBUS
*A Young Man in Curlers at Home on West 20th Street, NYC*, 1966
gelatin silver print, 39.4 x 37.9 (15½ x 14⅞)
Center for Creative Photography, University of Arizona
Copyright Estate of Diane Arbus 1966

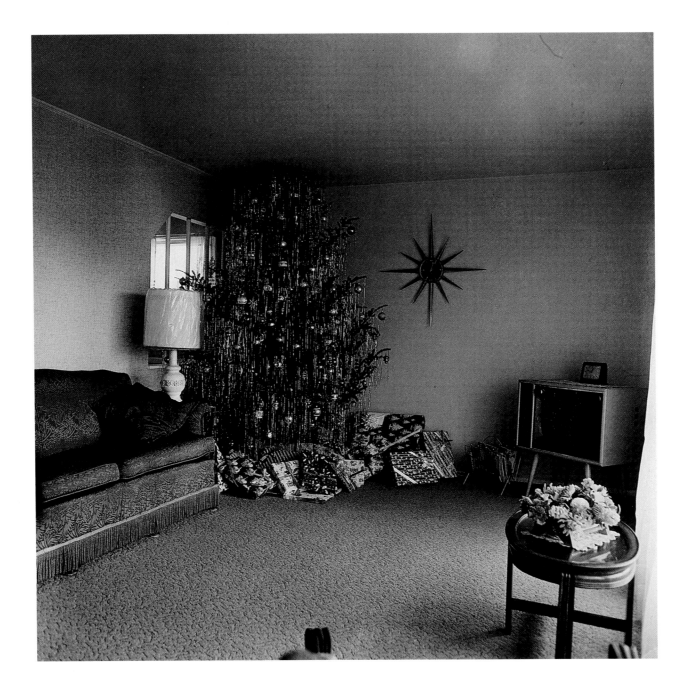

361. DIANE ARBUS
*Xmas Tree in a Living Room, Levittown, NY, 1963*
gelatin silver print, 36.5 x 37.3 (14⅜ x 14⅝)
Center for Creative Photography, University of Arizona
Copyright Estate of Diane Arbus

362. LEE FRIEDLANDER
*Colorado*, 1967
gelatin silver print, 19.0 x 28.0 (7½ x 11¹/₁₆)
Monsen Collection

363. LEE FRIEDLANDER
*Untitled*, 1972
gelatin silver print, 27.9 x 35.6 (11 x 14)
Courtesy Zabriskie Gallery, New York

364. LEE FRIEDLANDER
*Commodore John Paul Jones, West Potomac Park,*
*Washington, D.C.,* 1973
gelatin silver print, 35.6 x 27.9 (14 x 11)
Courtesy Zabriskie Gallery, New York

365. ROY DE CARAVA
*Untitled*, 1965
gelatin silver print, 35.0 x 28.0 (13⅞ x 11⅟₁₆)
Edwynn Houk Gallery, Chicago

366. BRUCE DAVIDSON
*Untitled*, c. 1960
gelatin silver print, 24.0 x 35.0 (9⁷/₁₆ x 13⁷/₈)
The Art Institute of Chicago,
Photography Gallery Restricted Fund

367. DANNY LYON
*Crossing the Ohio, Louisville*, 1966
gelatin silver print, 22.0 x 33.0 (8⁵/₈ x 13)
The Art Institute of Chicago, Gift of
Frederick M. and Elizabeth L. Myers

368. Graciela Iturbide
*Mujer angel*, 1979
gelatin silver print, 20.4 x 30.3 (8 1/16 x 12)
Center for Creative Photography, University of Arizona

369. JINDRICH STREIT
*TV: A Part of Our Lives*, c. 1978
gelatin silver print, 38.2 x 28.5 (10¹⁄₁₆ x 11¹⁄₁₆)
Uměleckoprůmyslové Muzeum, Prague

445

370. JOEL MEYEROWITZ
*Untitled*, 1969
gelatin silver print, 27.8 x 41.4 (10$^{15}$/$_{16}$ x 16¼)
Private collection

371. JOEL MEYEROWITZ
*Grand Canyon*, 1973
dye transfer print, 25.0 x 20.0 ( 21⅛x16½ )
Joel Meyerowitz

372. HELEN LEVITT
*New York*, 1978
chromogenic color print, 22.8 x 34.1 (9 x 13⅜)
Courtesy Laurence Miller Gallery, New York

373. JOEL STERNFELD
*McLean, Virginia,* 1978
chromogenic color print, 34.0 x 43.0 (13⅜ x 17)
Courtesy Pace/MacGill Gallery, New York, Copyright Joel Sternfeld

449

374. WILLIAM EGGLESTON
*Tallahatchie County, Mississippi*, 1972
dye transfer print, 33.6 x 49.5 (13¼ x 19½)
Collection, The Museum of Modern Art, New York, Gilman Foundation Fund

375. STEPHEN SHORE
*Meeting Street, Charleston, South Carolina, 3 August 1975*
chromogenic color print, 20.3 x 25.2 (8 x 10)
Courtesy Pace/MacGill Gallery, New York, Copyright Stephen Shore

376. Raghubir Singh
*Farmer Dredging Dal Lake, Kashmir, India*, 1980
dye-transfer print, 24.6 x 37.2 (9¹¹⁄₁₆ x 14⅝)
Courtesy Pace/MacGill Gallery, New York
Copyright 1989 by Raghubir Singh

377. JOHN PFAHL
*Trojan Nuclear Plant, Columbia River, Oregon, October 1982*
chromogenic color print, 34.0 x 46.5 (13⅜ x 18⅜)
The Art Institute of Chicago, Restricted gift of Gordon Lee Pollack

453

378. Robert Mapplethorpe
*Cedric*, 1981
gelatin silver print, 76.0 x 76.0 (30 x 30)
Robert Miller Gallery, New York

379. VIKING ORBITER 2
*The Southern Latitudes of Mars at the Time of the Spring Equinox,* 1977
silver gelatin print, 1988, 101.6 x 127.0 (40 x 50)
NASA's Regional Planetary Image Facilities

380. RAY METZKER
*Composites: Philadelphia*, 1964
sixty-three gelatin silver prints mounted on
plexiglass, 86.2 x 84.5 (34 x 33¼)
The Art Institute of Chicago,
Gift of Dirk Lohan

381. Jan Dibbets
*Untitled*, 1983
collage of chromogenic color prints and graphite on paper, 72.7 x 79.8 (28⅝ x 31⅜)
David C. and Sarajean Ruttenberg, Through the Courtesy of the Ruttenberg Arts Foundation

382. GILBERT AND GEORGE
*The Decorators*, 1978
silver gelatin and toned silver gelatin prints
241.3 x 200.7 (95 x 79)
Morton G. Neumann Family Collection

458

383. MARK KLETT
*Around Toroweap Point Just before and after Sundown Beginning and Ending with*
*Views by J. K. Hillers over 100 years ago, Grand Canyon, 1986*
dye transfer prints on silver gelatin paper, 51.0 x 205.0 (20⅛ x 80¾)
Mark Klett

459

384. HAMISH FULTON
*A Sixteen Day Walking Journey from the Ship at Nachi Katsura to the Train at Horyoji Travelling by Way of Nara, Japan, early 1986*
gelatin silver print diptych, 101.5 x 74.4 (40 x 29½)
The Art Museum, Princeton University, Museum purchase,
Gift of the Horace W. Goldsmith Foundation

385. ANSELM KIEFER
*Schweres Wasser*, 1987
handmade book of gelatin silver prints, lead, clay, silver, and pencil mounted on cardboard,
56.6 x 50.0 x 5.5 (22¼ x 19⅝ x 2⅛)
Stefan T. Edlis Collection

386. CHUCK CLOSE
*Self-Portrait/Composite/Sixteen Parts*, 1987
silver gelatin transfer print
233.7 x 193 (92 x 76)
Courtesy Pace/MacGill Gallery, New York,
Copyright Chuck Close

387. David Hockney
*Pearblossom Hwy., 11–18 April 1986, #2*
photo collage of chromogenic color prints, 198.0 x 280.0 (78 x 111)
Courtesy of the Artist

List of Works Exhibited

Artists' Bibliographies

Bibliography

Glossary

Index

# List of Works Exhibited

*(Numbers in parentheses are catalogue numbers)*

BERENICE ABBOTT
*El at Columbus and Broadway, New York City,* 1929
gelatin silver print
16.2 x 22.2 (6½ x 8¹³⁄₁₆)
The Art Institute of Chicago, Julien Levy Collection,
    Gift of Jean and Julien Levy (238)

VITO ACCONCI
*Twelve Pictures,* 1969
gelatin silver prints mounted on foamcore, with text
    panels executed in chalkboard spray, chalk, and
    marker
99.0 x 670.0 (39 x 260)
Peter Brams and Rhona Hoffman Gallery (524)

ANSEL ADAMS
*Surf Sequence: #1,* 1940
gelatin silver print
20.8 x 26.0 (8³⁄₁₆ x 10¼)
Philadelphia Museum of Art, Gift of Mr. and Mrs.
    Robert Hauslohner, Centennial Gift (265)

ANSEL ADAMS
*Surf Sequence: #2,* 1940
gelatin silver print
20.8 x 26.0 (8³⁄₁₆ x 10¼)
Philadelphia Museum of Art, Gift of Mr. and Mrs.
    Robert Hauslohner, Centennial Gift (267)

ANSEL ADAMS
*Surf Sequence: #4,* 1940
gelatin silver print
20.8 x 26.0 (8³⁄₁₆ x 10¼)
Philadelphia Museum of Art, Gift of Mr. and Mrs.
    Robert Hauslohner, Centennial Gift (266)

ANSEL ADAMS
*Winter Sunrise, Sierra Nevada, from Lone Pine,
    California,* 1944
gelatin silver print
37.0 x 49.4 (14½ x 19½)
Center for Creative Photography, University of
    Arizona

ROBERT ADAMS
*Missouri River, Clay County, South Dakota,* 1976
gelatin silver print
22.2 x 28.3 (8¾ x 11⅛)
Collection, The Museum of Modern Art, New York,
    Purchase (318)

ROBERT ADAMS
*Colorado Springs,* before 1974
gelatin silver print
15.2 x 15.2 (6 x 6)
Nebraska Art Association, Sheldon Memorial Art
    Gallery, University of Nebraska-Lincoln (319)

ROBERT ADAMS
*Summer Nights #2,* 1982
gelatin silver print
37.0 x 37.0 (14½ x 14½)
Hallmark Photographic Collection, Hallmark Cards
    Inc., Kansas City, Missouri (411)

MANUEL ALVAREZ BRAVO
*How Small the World Is,* 1942
gelatin silver print
18.6 x 24.3 (7⁵⁄₁₆ x 9½)
Center for Creative Photography, University of Arizona
    (345)

MANUEL ALVAREZ BRAVO
*Laughing Mannequins,* c. 1932
gelatin silver print
18.6 x 24.1 (7⁵⁄₁₆ x 9⁹⁄₁₆)
The Art Institute of Chicago, Julien Levy Collection,
    Gift of Jean Levy and the Estate of Julien Levy (597)

PIERRE AMEDÉE
*See under Eugène-Napoleon Varin*

JAMES CRAIG ANNAN
*Venice from the Lido,* c. 1896
photogravure
9.6 x 15.0 (3¾ x 5⅞)
National Galleries of Scotland, Portrait Gallery (156)
*Exhibited in Washington only*

DIANE ARBUS
*Identical Twins, Roselle, N.J., 1967*
gelatin silver print
37.4 x 37.9 (14¾ x 14⅞)
Center for Creative Photography, University of Arizona
    (359)

DIANE ARBUS
*Untitled (7), 1970–1971*
gelatin silver print
38.1 x 38.1 (15 x 15)
Robert Miller Gallery, New York (358)

DIANE ARBUS
*Xmas Tree in a Living Room, Levittown, L.I., 1963*
gelatin silver print
36.5 x 37.3 (14⅜ x 14⅝)
Center for Creative Photography, University of Arizona
    (361)

DIANE ARBUS
*A Young Man in Curlers at Home on West 20th Street,
    N.Y.C., 1966*
gelatin silver print
39.4 x 37.9 (15½ x 14⅞)
Center for Creative Photography, University of Arizona
    (360)

MALCOLM ARBUTHNOT
*Reflections,* 1909
gum bichromate-platinum print
32.9 x 26.7 (13 x 10½)
Royal Photographic Society (179)

FREDERICK SCOTT ARCHER
*Ante Room of Great Hall,* 1851
albumen print from wet collodion negative
21.9 x 17.5 (8⅝ x 6⅞)
Royal Photographic Society (52)

EUGÈNE ATGET
*Fête du Trône de Géant,* 1925
gelatin printing-out-paper print
17.9 x 22.5 (7¹⁄₁₆ x 8⅞)
The Art Institute of Chicago, Julien Levy Collection,
    Special Photography Acquisitions Fund (233)

EUGÈNE ATGET
*Fontaine, rue Garancière,* 1900
albumen print
25.0 x 17.0 (9⅞ x 6¹¹⁄₁₆)
Collection, The Museum of Modern Art, New York,
    Abbott-Levy Collection, Partial Gift of Shirley C.
    Burden (149)

EUGÈNE ATGET
*Notre Dame (6541),* 1925
albumen print
16.6 x 22.0 (6⁹⁄₁₆ x 8⅝)
Collection, The Museum of Modern Art, New York,
    Abbott-Levy Collection, Partial Gift of Shirley C.
    Burden (244)

EUGÈNE ATGET
*Parc de Sceaux (68)*, 1925
albumen print
17.6 x 22.5 (7 x 8⅞)
Collection, The Museum of Modern Art, New York,
    Abbott-Levy Collection, Partial Gift of Shirley C.
    Burden (390)

EUGÈNE ATGET
*Quai d'Anjou, 6 am*, 1924
arrowroot print
17.8 x 22.8 (7 x 9)
Gilman Paper Company Collection (243)

EUGÈNE ATGET
*Ragpicker*, 1899–1900
albumen print
20.5 x 15.0 (8¹/₁₆ x 5⅞)
Collection, The Museum of Modern Art, New York,
    Abbott-Levy Collection, Partial Gift of Shirley C.
    Burden (147)

EUGÈNE ATGET
*Store, Avenue des Gobelins*, 1925
gelatin silver printing-out-paper print
22.8 x 17.8 (9 x 7)
International Museum of Photography at George
    Eastman House, Museum Purchase, ex-collection
    Man Ray (231)

EUGÈNE ATGET
*Window*, 1913
albumen print
21.6 x 17.5 (8½ x 6⅞)
Gilman Paper Company Collection (148)

CHARLES AUBRY
*A Study of a Leaf (heracoeum longefolium)*, c. 1864
albumen print from wet collodion negative
47.0 x 39.1 (18⅝ x 15⅜)
By Courtesy of Fraenkel Gallery, San Francisco (73)

E. ALICE AUSTEN
*Bootblacks*, 1896
gelatin silver print
9.4 x 11.1 (3¹¹/₁₆ x 4⅜)
Library of Congress, Prints and Photographs Division
    (137)

E. ALICE AUSTEN
*Rag Carts*, 1896
gelatin silver print
9.2 x 11.2 (3⅝ x 4⅝)
Library of Congress, Prints and Photographs Division
    (138)

RICHARD AVEDON
*Juan Patricio Lobato, carney, Rocky Ford, Colorado,
    8/23/80*, 1980
gelatin silver print

143.5 x 114.3 (56½ x 45)
Mr. Richard Avedon (338)

RICHARD AVEDON
*Marilyn Monroe, actress, New York City 5/6/57*, 1957
gelatin silver print
35.5 x 27.9 (14 x 11)
Mr. Richard Avedon (414)

RICHARD AVEDON
*Oscar Levant, pianist, Beverly Hills, California, 4/12/72*,
    1972
gelatin silver print
116.9 x 116.9 (46 x 46)
Mr. Richard Avedon (337)

JOHN BALDESSARI
*Eyelid (with log)*, 1986
gelatin silver prints, chromogenic color prints, and
    color paper
26.0 x 31.0 (10¼ x 12³/₁₆), 97.0 x 153.0 (38¼ x 60¼)
Monsen Collection (326)

ÉDOUARD-DENIS BALDUS
*Cloister of St. Trophine, Arles*, c. 1855
dilute albumen print from paper negative
33.9 x 43.0 (13⅜ x 17)
Collection Centre Canadien d'Architecture/Canadian
    Centre for Architecture, Montréal (28)

ÉDOUARD-DENIS BALDUS
*Le Moine*, c. 1853
dilute albumen print from paper negative
32.0 x 40.7 (12⅝ x 16)
Exchange National Bank of Chicago (37)

ÉDOUARD-DENIS BALDUS
*Train Station, Toulon*, c. 1859
albumen print from wet collodion negative
27.0 x 43.2 (10⅝ x 17)
Mr. C. David Robinson (65)

LEWIS BALTZ
*Industrial Parks #51*, 1977
gelatin silver print
15.0 x 22.0 (5⅞ x 8⅝)
Monsen Collection (521)

LEWIS BALTZ
*Park City #95*, 1979
gelatin silver print
14.0 x 21.5 (5½ x 8½)
Monsen Collection (320)

HIPPOLYTE BAYARD
*Montmartre, Windmills*, 1839
direct positive print
9.5 x 11.0 (3¾ x 4⁵/₁₆)
Gilman Paper Company Collection (392)

HILLA AND BERNHARD BECHER
*Industrial Façades*, 1975
six gelatin silver prints
each 30.0 x 40.0 (11¹³/₁₆ x 15¾)
Hilla and Bernhard Becher (322)

FREDERICK BEHRENS
*Untitled (Landscape)*, 1898
gum bichromate print
11.9 x 16.9 (4¹¹/₁₆ x 6¹¹/₁₆)
Agfa Foto-Historama (153)

WILLIAM BELL
*Grand Canyon of the Colorado*, 1872
albumen print from wet collodion negative
27.2 x 19.8 (10¹¹/₁₆ x 7¹³/₁₆)
Gilman Paper Company Collection (100)

HANS BELLMER
*Machine Gun in a State of Grace*, 1937
gelatin silver print with oil and watercolor
64.8 x 64.8 (25½ x 25½)
San Francisco Museum of Modern Art, Gift of Foto
    Forum (281)

ILSE BING
*Horses Jumping through Fire, New York Circus, Paris*,
    1936
gelatin silver print
19.6 x 28.5 (7¾ x 11¼)
Gilman Paper Company Collection (236)

LOUIS DÉSIRÉ BLANQUART-ÉVRARD
*Phare de Lantern des Mortes de l'ancien cimetière de
    Bayeux*, c. 1851–1855
dilute albumen print from paper negative
25.9 x 20.2 (10³/₁₆ x 8)
International Museum of Photography at George
    Eastman House, Gift of Eastman Kodak Company,
    Vincennes, via the French Society of Photography,
    ex-collection Henri Fontan (33)

KARL BLOSSFELDT
*Balsamine impatiens*, 1915–1925
gelatin silver print
30 x 24 (11¹³/₁₆ x 9⁷/₁₆)
Hochschule der Künste, Berlin (204)

KARL BLOSSFELDT
*Silphium laciniatum*, 1915–1925
gelatin silver print
30.1 x 24.0 (11⅞ x 9⁷/₁₆)
Hochschule der Künste, Berlin (203)

CHRISTIAN BOLTANSKI
*Monument, La Fête du Pourim*, 1988
gelatin silver prints, lamps, electrical wire, and biscuit
    boxes containing clothing
235.0 x 50.0 x 23.0 (92⅞ x 19⅝ x 9¹/₁₆) per column
Private collection (341)

PIERRE BONNARD
*Charles and a Nurse*, 1898
silver printing-out-paper print
3.9 x 5.1 (1⅜ x 2⁵/₁₆)
Musée d'Orsay, Paris, Promised gift of Antoine
    Terrasse (130)

PIERRE BONNARD
*Jean and Charles Wrestling*, 1898
silver printing-out-paper print
3.5 x 5.8 (1⅜ x 2⁵/₁₆)
Musée d'Orsay, Paris, Promised gift of Antoine
    Terrasse, his brothers and sister (129)

MATHEW B. BRADY
*Thomas Cole*, c. 1845
half-plate daguerreotype
13.8 x 10.4 (5⁷/₁₆ x 4⅛)
National Portrait Gallery, Smithsonian Institution,
    Gift of Edith Cole Silberstein (15)

BILL BRANDT
*Coal Searcher Going Home to Jarrow*, 1937
gelatin silver print
22.9 x 19.8 (9 x 7¹³/₁₆)
The Art Institute of Chicago, Courtesy of Noya Brandt
    (275)

BILL BRANDT
*Eygalières, France*, 1953
gelatin silver print
33.4 x 28.7 (13⅛ x 11⁵/₁₆)
The Art Institute of Chicago, Gift of Helen Harvey
    Mills (310)

BILL BRANDT
*Portrait of a Young Girl, Eaton Place, London*, 1955
gelatin silver print
43.0 x 37.5 (17 x 14¾)
Collection, The Museum of Modern Art, New York,
    Purchase (309)

BRASSAÏ
*Backstage at the Folies-Bergère*, 1932
gelatin silver print
23.7 x 17.8 (9⁵/₁₆ x 7)
The Art Institute of Chicago, Restricted Gift of Leigh
    B. Block (245)

BRASSAÏ
*Chez "Suzy,"* 1932–1933
gelatin silver print
22.2 x 17.5 (8¼ x 6⅞)
Collection of Nicholas Pritzker (247)

BRASSAÏ
*Lovers in a Bistro*, 1932–1933
gelatin silver print
23.2 x 17.2 (9⅛ x 6¾)
Collection of Nicholas Pritzker (246)

DENIS BRIHAT
*Coupe d'un choux rouge*, 1950
gelatin silver print
39.5 x 23.5 (15⅝ x 9¼)
Bibliothèque Nationale (400)

VICTOR BURGIN
From the sequence *Lei Feng*, 1974
silver gelatin print
50.8 x 76.2 (20 x 30) each
MJS Collection, Paris (328)

HARRY CALLAHAN
*Cape Cod*, 1972
gelatin silver print
24.4 x 24.8 (9⅝ x 9¾)
Monsen Collection (316)

HARRY CALLAHAN
*Chicago*, c. 1950
gelatin silver print
19.2 x 24.2 (7⁹/₁₆ x 9⁹/₁₆)
The Art Institute of Chicago, Mary L. and Leigh B.
    Block Endowment Fund Income (306)

HARRY CALLAHAN
*Detroit Street Scene*, 1943
gelatin silver print
20.0 x 28.0 (7⅞ x 11¹/₁₆)
The Art Institute of Chicago, Gift of Mrs. Katherine
    Kuh (305)

HARRY CALLAHAN
*Eleanor, Chicago*, 1954
gelatin silver print
18.2 x 17.5 (7⅛ x 6⅞)
Center for Creative Photography, University of Arizona
    (307)

JULIA MARGARET CAMERON
*The Astronomer: Sir John Herschel*, 1867
albumen print from wet collodion negative
30.2 x 23.2 (11⅞ x 9⅛)
Royal Photographic Society (90)

JULIA MARGARET CAMERON
*Call, I follow, I follow, let me die!*, c. 1867
carbon print from wet collodion negative
36.3 x 28.0 (14¼ x 11¹/₁₆)
Royal Photographic Society (89)

JULIA MARGARET CAMERON
*May Prinsep*, c. 1865
carbon print from wet collodion negative
22.5 x 20.5 (8⅞ x 8¹/₁₆)
The Metropolitan Museum of Art, Harris Brisbane
    Dick Fund, 1941 (87)

JULIA MARGARET CAMERON
*Pomona*, 1872

albumen print from wet collodion negative
34.6 x 26.9 (13⅝ x 10⁹/₁₆)
Royal Photographic Society (88)

ROBERT CAPA
*Naples*, 1943
gelatin silver print
25.8 x 34.5 (10⁵/₁₆ x 13⅝)
The Art Institute of Chicago, Restricted Gift of Mr.
    and Mrs. Morris Kaplan (294)

PAUL CAPONIGRO
*Redding Woods, Redding, Connecticut*, 1968
gelatin silver print
19.6 x 26.7 (7¾ x 10½)
The Art Institute of Chicago, Gift of Joseph and Helen
    Regenstein Foundation (315)

ÉTIENNE CARJAT
*Charles Baudelaire*
albumen print from wet collodion negative
23.2 x 18.1 (9⅛ x 7⅛)
Collection of Mr. and Mrs. Harry H. Lunn, Jr. (76)

HENRI CARTIER-BRESSON
*Alicante, Spain*, 1933
gelatin silver print
16.3 x 23.7 (6⁷/₁₆ x 9⁹/₁₆)
The Art Institute of Chicago, Julien Levy Collection,
    Special Photography Acquisition Fund (250)

HENRI CARTIER-BRESSON
*Hyères, France*, 1932
gelatin silver print
19.8 x 29.5 (7¹³/₁₆ x 11⅝)
The Art Institute of Chicago, Julien Levy Collection,
    Gift of Jean and Julien Levy (237)

HENRI CARTIER-BRESSON
*Italy*, 1933
gelatin silver print
28.8 x 20.8 (11⅜ x 8³/₁₆)
The Art Institute of Chicago, Julien Levy Collection,
    Gift of Jean and Julien Levy (249)

HENRI CARTIER-BRESSON
*Jean-Paul Sartre, Pont des Arts, Paris*, 1946
gelatin silver print
36.2 x 24.1 (14⅛ x 9⅜)
The Richard Sandor Collection (398)

HENRI CARTIER-BRESSON
*Martigues, France*, 1932–1933
gelatin silver print
24.7 x 16.6 (9⅝ x 6⁷/₁₆)
Collection of Nicholas Pritzker (248)

HENRI CARTIER-BRESSON
*Seville, Spain*, 1933
gelatin silver print

19.3 X 21.0 (7⅝ X 11⅜)
The J. Paul Getty Museum (239)

HELEN CHADWICK
*Ego Geometria Sum: The Labors X*, 1984
toned gelatin silver print
122.0 X 91.0 (48 X 35⅞)
Helen Chadwick and Mark Pilkington (334)

CHARLES CLIFFORD
*Interior, Mosque of Cordova*, 1862
albumen print from wet collodion negative
38.8 X 28.7 (15⁵⁄₁₆ X 11⁵⁄₁₆)
The J. Paul Getty Museum (54)

CHARLES CLIFFORD
*Puente del Diablo, Martorell*, c. 1856
albumen silver print from glass negative
31.0 X 42.3 (12³⁄₁₆ X 16⅝)
The Metropolitan Museum of Art, Purchase, Joyce
   and Robert Menschel Gift, 1988 (53)

CHUCK CLOSE
*Self-Portrait*, 1987
black and white Polaroid
183.0 X 157.5 (72⅛ X 62)
Courtesy Pace/MacGill Gallery, New York (386)

ALVIN LANGDON COBURN
*Grand Canyon*, 1911
platinum print
31.5 X 41.0 (12⁷⁄₁₆ X 16⅛)
Janet Lehr, Inc., New York (183)

ALVIN LANGDON COBURN
*Pittsburgh Smoke Stacks*, 1910
platinum print
21.0 X 29.0 (8¼ X 11⁷⁄₁₆)
Janet Lehr, Inc., New York (190)

ALVIN LANGDON COBURN
*Vortograph*, 1917
gelatin silver print
22.1 X 27.0 (8¹¹⁄₁₆ X 10⅝)
The Art Institute of Chicago, Harold L. Stuart En-
   dowment (205)

ALVIN LANGDON COBURN
*Williamsburg Bridge*, 1909
photogravure
19.2 X 15.3 (7⁹⁄₁₆ X 6¹⁄₁₆)
Gernsheim Collection, Harry Ransom Humanities
   Research Center, University of Texas at Austin (189)

ALBERT COLLARD
*Arcades des Lisses, A l'amont du chemin rural de Cor-
   beil à Arpajon*, 1874
albumen print from wet collodion negative
29.4 X 42.5 (11⁹⁄₁₆ X 16¾)
Musées de la Ville de Paris, Musée Carnavalet (109)

ALBERT COLLARD
*Arche du Pont de Grenelle, Paris*, 1874
albumen print from wet collodion negative
32.0 X 42.0 (12⅝ X 16⅝)
École Nationale des Ponts et Chaussées, Paris (107)

ROBERT CORNELIUS
*Self-Portrait*, 1839
daguerreotype
12.0 X 9.4 (4¾ X 3¹¹⁄₁₆)
Private Collection (8)

JOSEPH CORNELL
*Untitled (Penny Arcade Portrait of Lauren Bacall)*, 1945
gelatin silver photographs in box construction
53.4 X 41.0 X 9.2 (20⅝ X 16⅛ X 3⅝)
Mrs. Edwin A. Bergman (297)

ROBERT CRAWSHAY
*Study in a Turkish Bath*, c. 1855
quarter-plate ambrotype
10.5 X 7.9 (4⅛ X 3⅛)
By courtesy of the Board of Trustees of the Victoria
   and Albert Museum (81)

ROBERT CUMMING
*Quick Shift of the Head Leaves Glowing Stool After-
   image Posited on Pedestal*, 1978
gelatin silver print
19.5 X 25.0 (7¹¹⁄₁₆ X 9⅞)
The Art Institute of Chicago, Restricted Gift of Society
   for Contemporary Art (412)

IMOGEN CUNNINGHAM
*Snake*, 1929
negative gelatin silver print
19.7 X 16.6 (7¾ X 6⁹⁄₁₆)
The Art Institute of Chicago, Julien Levy Collection,
   Gift of Jean and Julien Levy (260)

ADELBERT CUVELIER
*Forest at Fontainebleau*, c. 1860
salted paper print from wet collodion negative
16.2 X 14.5 (6⅜ X 5⁹⁄₁₆)
Gilman Paper Company Collection (40)

EUGÈNE CUVELIER
*View of Fontainebleau Forest in the Mist*, 1859–1862
salted paper print from wet collodion negative
19.6 X 25.6 (7¾ X 10¹⁄₁₆)
The Metropolitan Museum of Art, The Howard Gilman
   Foundation and Joyce and Robert Menschel Gifts,
   1988 (55)

LOUIS JACQUES MANDÉ DAGUERRE
*Première Épreuve fait par Daguerre devant ses Collegues
   des Beaux-Arts*, 1839
full-plate daguerreotype   14.5 X 19.3 (5¹¹⁄₁₆ X 7⅝)
Musée National des Techniques du CNAM–Paris (2)
*Exhibited in Washington only*

BRUCE DAVIDSON
*Untitled*, c. 1960
gelatin silver print
24.0 X 35.0 (9⁷⁄₁₆ X 13⅞)
The Art Institute of Chicago, Photography Gallery
   Restricted Fund (366)

F. HOLLAND DAY
*Boy*, 1907
platinum print
17.3 X 18.5 (6¹³⁄₁₆ X 7⁵⁄₁₆)
Janet Lehr, Inc., New York (177)

F. HOLLAND DAY
*Torso*, 1908
platinum print
23.7 X 19.3 (9⁹⁄₁₆ X 7⅝)
Royal Photographic Society (178)

ROY DE CARAVA
*Untitled*, 1965
gelatin silver print
35.0 X 28.0 (13⅞ X 11¹⁄₁₆)
Edwynn Houk Gallery, Chicago (365)

EDGAR DEGAS
*Paul Poujaud, Madame Arthur Fontaine, and Degas*,
   c. 1895
gelatin silver print
29.4 X 40.5 (11⅝ X 15⅞)
The Metropolitan Museum of Art, The Elisha
   Whittelsey Collection, The Elisha Whittelsey Fund
   (114)

PHILIP HENRY DELAMOTTE
*Evening*, 1856–1857
albumen print from wet collodion negative
21.0 X 17.0 (8¼ X 6¹¹⁄₁₆)
The Metropolitan Museum of Art, David Hunter
   McAlpin Fund, 1952 (57)

PHILIP HENRY DELAMOTTE
*Storeroom with Artisans and Plaster Casts, Crystal
   Palace*, 1852
albumen print from wet collodion negative
23.0 X 28.0 (9¹⁄₁₆ X 11¹⁄₁₆)
The Metropolitan Museum of Art, David Hunter
   McAlpin Fund, 1952 (63)

PHILIP HENRY DELAMOTTE
*The Upper Gallery, Crystal Palace*, 1852–1853
albumen silver print from wet collodion negative
23.0 X 28.0 (9¹⁄₁₆ X 11¹⁄₁₆)
The Metropolitan Museum of Art, David Hunter
   McAlpin Fund, 1952 (62)

HYACINTHE CÉSAR DELMAET & LOUIS-EMILE
   DURANDELLE
*Apollo Group (Construction of the Paris Opera)*, c. 1865
albumen print from wet collodion negative

33.5 x 28.3 (13¼ x 11⅛)
International Museum of Photography at George
    Eastman House, Gift of Eastman Kodak Company:
    ex-collection Gabriel Cromer (66)

HYACINTHE CÉSAR DELMAET & LOUIS-EMILE
    DURANDELLE
*Draped Columns*, c. 1865
albumen print
26.2 x 38.1 (10⁵⁄₁₆ x 15)
International Museum of Photography at George
    Eastman House, Gift of Eastman Kodak Company:
    ex-collection Gabriel Cromer (67a)

BARON ADOLF DEMEYER
*Hydrangea*, c. 1908
platinum print
33.3 x 27.5 (13⅛ x 10¹⁵⁄₁₆)
Royal Photographic Society (180)

JAN DIBBETS
*Untitled*, 1983
chromogenic color prints and graphite on paper
72.7 x 79.8 (28⅝ x 31⅜)
David and Sarajean Ruttenberg, through the Courtesy
    of the Ruttenberg Foundation (381)

ROBERT DOISNEAU
*Fox Terrier on the Pont des Arts*, 1953
gelatin silver print
35.0 x 29.5 (13¾ x 11⅝)
Courtesy The Witkin Gallery, Inc. (343)

ROBERT DOISNEAU
*M et Mme Garfino, Vagabonds*, 1951
gelatin silver print
30.0 x 20.0 (11¹³⁄₁₆ x 7⅞)
Bibliothèque Nationale, Paris (347)

PIERRE DUBREUIL
*The Boulevards*, 1909
oil print 23.5 x 19.7 (9¼ x 7¾)
The Metropolitan Museum of Art, Ford Motor
    Company Collection, Gift of the Ford Motor
    Company and John C. Wadell, 1987 (396)

MAXIME DUCAMP
*Égypte*, 1851
salt paper print from waxed paper negative
16.5 x 21.0 (6½ x 8¼)
Gilman Paper Company Collection (42)

THOMAS EAKINS
*Nude Broad Jumping*, 1884–1885
albumen print
24.0 x 28.2 (10 x 11)
The Library Company of Philadelphia (112)

THOMAS EAKINS
*Untitled*, c. 1885

gelatin silver print
13.0 x 18.0 (5⅛ x 7⅛)
Janet Lehr, Inc., New York (113)

WILLIAM EGGLESTON
*Tallahatchie County, Mississippi*, 1972
dye transfer print
33.6 x 49.5 (13¼ x 19½)
Collection, The Museum of Modern Art, New York,
    Gilman Foundation Fund (374)

GEORGE EINBECK
*The Swan*, 1898
gum bichromate print
45.5 x 33.1 (18 x 13⅛)
Museum für Kunst und Gewerbe, Hamburg (158)
*Exhibited in Chicago and Washington only*

PETER HENRY EMERSON
*Poling the Marsh Hay*, 1886
platinum print
23.2 x 28.9 (9⅛ x 11⅜)
Gilman Paper Company Collection (145)

HUGO ERFURTH
*Girl*, 1910
carbon print
20.8 x 32.7 (8³⁄₁₆ x 12⅞)
Royal Photographic Society (161)

HUGO ERFURTH
*Wolfgang Erfurth*, c. 1905
gum bichromate print
28.8 x 36.5 (11⅜ x 14⅜)
Agfa Foto-Historama (160)

MAX ERNST
*Massacre of the Innocents*, 1920
photocollage with brush and ink, gouache, and water-
    color
21.3 x 28.9 (8⅜ x 11⅜)
Mrs. Edwin A. Bergman (198)

ELLIOTT ERWITT
*Confessional – Czestochowa, Poland*, 1964
gelatin silver print
20.3 x 25.2 (8 x 10)
The Art Institute of Chicago, on extended loan from
    Mr. Lawrence Schafran (403)

FRANK EUGENE
*Emmy and Kitty – Tutzing, Bavaria*, 1907
autochrome
16.8 x 11.7 (6⅝ x 4⅝)
The Metropolitan Museum of Art, The Alfred Stieg-
    litz Collection, 1955 (168)

FREDERICK EVANS
*Ely Cathedral: Grotesque Sculpture in Triforium*,
    c. 1898

platinum print
23.5 x 18.4 (9¼ x 7¼)
Kent and Marcia Minichiello (150)

FREDERICK EVANS
*In the Attics: Kelmscott Manor*, 1896
platinum print
15.3 x 20.0 (6¹⁄₁₆ x 7⅞)
Museum of Fine Arts, Boston, Gift of Mr. Ralph W.
    Morris (151)

FREDERICK EVANS
*York Minster: Into the North Transept*, c. 1902
platinum print
26.0 x 18.3 (10¼ x 7³⁄₁₆)
Museum of Fine Arts, Boston, Horatio Greenough
    Curtis Fund (152)

WALKER EVANS
*A Child's Grave, Hale County, Alabama*, 1936
gelatin silver print
8.3 x 23.1 (3¼ x 9¹⁄₁₆)
The Art Institute of Chicago, Restricted Gift of Lucia
    Woods Lindley and Daniel A. Lindley, Jr. (279)

WALKER EVANS
*Maine Pump*, 1933
gelatin silver print
20.0 x 14.9 (7⅞ x 5⅞)
Exchange National Bank of Chicago (277)

WALKER EVANS
*Untitled (Subway Portrait)*, 1938–1941
gelatin silver print
12.4 x 19.1 (4⅞ x 7½)
Kent and Marcia Minichiello (288)

WALKER EVANS
*Untitled (Subway Portrait)*, 1938–1941
gelatin silver print
12.8 x 19.3 (5 x 7⅝)
National Gallery of Art, John Wilmerding Fund (289)

WALKER EVANS
*Untitled (Subway Portrait)*, 1938–1941
gelatin silver print
11.8 x 17.5 (4⅝ x 6⅞)
The Art Institute of Chicago, Gift of Arnold H. Crane
    (289)

WALKER EVANS
*View of Railroad Station, Edwards, Mississippi*, 1936
gelatin silver print
19.7 x 24.5 (7¾ x 19¹¹⁄₁₆)
San Francisco Museum of Modern Art, Gift of Theo
    Jung (278)

LOUIS FAURER
*Philadelphia*, 1937
gelatin silver print

33.8 x 22.4 (13⅜ x 8⅞)
San Francisco Museum of Modern Art, Fund of the
'80s Purchase (291)

ROGER FENTON
*The Double Bridge on the Machno*, 1857
albumen print from wet collodion negative
40.3 x 33.6 (15⅞ x 13¼)
Royal Photographic Society (60)

ROGER FENTON
*The Long Walk, Windsor*, 1860
albumen print from wet collodion negative
30.6 x 43.3 (12¹/₁₆ x 17⅛)
Royal Photographic Society (388)

ROGER FENTON
*Salisbury, The Bishop's Gardens*, c. 1858
albumen print by Francis Frith from wet collodion
    negative
34.2 x 41.3 (13½ x 16¼)
Royal Photographic Society (50)

ROGER FENTON
*Valley of Death*, 1856
albumen print from wet collodion negative
27.2 x 36.4 (10¹¹/₁₆ x 14⅜)
The Art Institute of Chicago, Photography Gallery,
    Restricted Gifts Fund (91)

ROGER FENTON
*View on the Ribble*, 1858–1859
albumen print from wet collodion negative
28.4 x 39.9 (11³/₁₆ x 15⅝)
Royal Photographic Society (59)

JOAN FONTCUBERTA
*Giliandria escoliforcia* (from the series *Herbarium*), 1984
gelatin silver print, soft selenium toned
27.0 x 22.0 (10⅝ x 8⅝)
Courtesy Zabriskie Gallery, New York (415)

ROBERT FRANK
*The Americans*, 1958
book
19.0 x 21.5 x 2.0 (7½ x 8½ x ¾)
Courtesy, Larry Frankel (399)

ROBERT FRANK
*The Americans*, 1958
book
19.0 x 21.5 x 2.0 (7½ x 8½ x ¾)
Joel Meyerowitz (404)

ROBERT FRANK
*The Americans*, 1958
book
19.0 x 21.5 x 2.0 (7½ x 8½ x ¾)
The Art Institute of Chicago, Restricted Gift of the
    Photo Gallery (405)

ROBERT FRANK
*The Americans*, 1958
book
19.0 x 21.5 x 2.0 (7½ x 8½ x ¾)
Courtesy Pace/McGill Gallery, New York (406)

ROBERT FRANK
*The Americans*, 1958
book
19.0 x 21.5 x 2.0 (7½ x 8½ x ¾)
The Art Institute of Chicago, Photography Collection
    Archive (407)

ROBERT FRANK
*Stationery Store, Hollywood*, 1955
gelatin silver print
33.0 x 22.0 (13 x 8⅝)
The Richard Sandor Collection (408)

ROBERT FRANK
*New York City*, 1954
gelatin silver print
25.4 x 34.5 (10 x 13⁹/₁₆)
San Francisco Museum of Modern Art, Gift of Foto
    Forum (352)

ROBERT FRANK
*Untitled*, 1949
gelatin silver print
27.5 x 18.0 (10¹³/₁₆ x 7⅛)
The Art Institute of Chicago, Mary L. and Leigh B.
    Block Endowment (348)

LEE FRIEDLANDER
*Colorado*, 1967
gelatin silver print
19.0 x 28.0 (7½ x 11¹/₁₆)
Monsen Collection (362)

LEE FRIEDLANDER
*Commodore John Paul Jones, West Potomac Park,
    Washington, D.C.*, 1973
gelatin silver print
35.6 x 27.9 (14 x 11)
Courtesy Zabriskie Gallery, New York (364)

LEE FRIEDLANDER
*Untitled*, 1972
gelatin silver print
35.6 x 27.9 (14 x 11)
Courtesy Zabriskie Gallery, New York (363)

FRANCIS FRITH
*Fallen Colossus*, c. 1858
albumen print from wet collodion negative
38.1 x 48 (15 x 18⅞)
Janet Lehr, Inc., New York (49)

HAMISH FULTON
*Sixteen-Day Walking Journey from the Ship at Nachi
    Katsura to the Train at Horyoji Traveling by Way of
    Nara, Japan*, 1986
gelatin silver diptych print
101.5 x 74.4 (40 x 29½)
The Art Museum, Princeton University, Museum Pur-
    chase, Gift of the Horace W. Goldsmith Foundation
    (384)

JAROMIR FUNKE
*Untitled (Shadows of Bottles)*, c. 1927
gelatin silver print
29.2 x 23.5 (11½ x 9¼)
San Francisco Museum of Modern Art, Purchase (222)

ALEXANDER GARDNER
*Home of a Rebel Sharpshooter, Gettysburg, 1863*, 1866
albumen print from wet collodion negative
30.4 x 39.8 (12 x 15⅝)
Library of Congress, Prints and Photographs Division
    (92)

ARNOLD GENTHE
*Chinatown #4*, c. 1905
gelatin silver print
23.1 x 32.6 (9⅛ x 12⅞)
The Art Institute of Chicago, Acquired through ex-
    change with the Library of Congress (140)

MARIO GIACOMELLI
*Countryside*, from the *Paessaggio* series, 1971
gelatin silver print
30.0 x 40.3 (11⁵/₁₆ x 15⅞)
The J. Paul Getty Museum (401)

GILBERT AND GEORGE
*The Decorators*, 1978
sixteen panels of silver gelatin prints, eight of them
    toned
241.3 x 200.7 (95 x 79)
Morton G. Neumann Family Collection (382)

LAURA GILPIN
*Sunburst, the Castillo, Chichen Itza*, 1932
silver bromide print on Gevaluxe paper
35.6 x 25.2 (14 x 10)
Amon Carter Museum, Fort Worth, Texas (261)

PAOLO GIOLI
From the series *Homage to Niépce*, 1982
dye diffusion transfer print with silk insertion, graphite
    and color pencil on paper
15.3 x 16.5 (6¹/₁₆ x 6½)
The Art Institute of Chicago, Photography Purchase
    Account (329)

JOHN BEASELY GREENE
*The Nile*, 1853–1854

developed-out salted paper print by Blanquart-Évrard
    from waxed paper negative
23.1 x 27.9 (9⅛ x 11)
Gilman Paper Company Collection (45)

JOHN BEASELY GREENE
*Pyramid, Egypt*, 1853–1854
developed-out salted paper print by Blanquart-Évrard
    from waxed paper negative
22.9 x 28.5 (9½ x 11⅝)
Janet Lehr, Inc., New York (48)

JOHN BEASELY GREENE
*Statue, Egypt*, 1854
developed-out salted paper print by Blanquart-Évrard
    from waxed paper negative
29.6 x 21.5 (11¹¹⁄₁₆ x 8½)
Janet Lehr, Inc., New York (46)

JEAN-BAPTISTE-LOUIS GROS
*East Façade of the Propylaea, the Acropolis, Athens,*
    *1850*
daguerreotype
15.0 x 23.0 (5¹⁵⁄₁₆ x 9¹⁄₁₆)
Collection Centre Canadien d'Architecture/Canadian
    Centre for Architecture, Montréal (29)

JOHN GUTMANN
*The Artist Lives Dangerously*, 1938
gelatin silver print
23.5 x 19.1 (9¼ x 7½)
San Francisco Museum of Modern Art, Gift of Foto
    Forum (290)

LADY CLEMENTINA HAWARDEN
*Two Girls – Hand to Bosom*, c. 1862
albumen print from wet collodion negative
24.0 x 27.5 (9⁷⁄₁₆ x 10¹³⁄₁₆)
By courtesy of the Board of Trustees of the Victoria
    and Albert Museum (82)

LADY CLEMENTINA HAWARDEN
*Girl at Mirror*, c. 1862
albumen print from wet collodion negative
22.2 x 24.2 (8¾ x 9⁹⁄₁₆)
By courtesy of the Board of Trustees of the Victoria
    and Albert Museum (83)

LADY CLEMENTINA HAWARDEN
*Two Women on Porch*, c. 1862
albumen print from wet collodion negative
23.1 x 21.3 (9¹⁄₁₆ x 8⅜)
By courtesy of the Board of Trustees of the Victoria
    and Albert Museum (85)

JOSIAH JOHNSON HAWES
*See under Albert Sands Southworth*

JOSIAH JOHNSON HAWES
*Albert Sands Southworth*, c. 1848

half-plate daguerreotype
14.0 x 10.7 (5½ x 4¼)
Collection of the International Museum of Photography
    at George Eastman House, Gift of Alden Scott
    Boyer (20)

JOHN HEARTFIELD
*Little German Christmas Tree*, 1934
rotogravure print
26.0 x 20.0 (10½ x 7⅞)
The Metropolitan Museum of Art, The Horace W.
    Goldsmith Foundation Gift, 1987 (280)

ROBERT HEINECKEN
*Jetgraph Proof (Connie Chung)*, 1986
jetgraph print
55.5 x 66.0 (21⅞ x 26)
The Metropolitan Museum of Art, Purchase, Charina
    Foundation, Inc., Gift, 1986 (342)

HUGO HENNEBERG
*On the Canal*, 1898
gum bichromate print
46.0 x 55.8 (18⅛ x 22)
Museum für Kunst und Gewerbe, Hamburg (157)
*Exhibited in Chicago and Los Angeles only*

FLORENCE HENRI
*Self-Portrait*, 1937
gelatin silver print
23.9 x 27.8 (9⁷⁄₁₆ x 10¹⁵⁄₁₆)
The J. Paul Getty Museum (253)

DAVI OCTAVIUS HILL AND ROBERT ADAMSON
*Alexander Rutherford, William Ramsay, and John Liston,*
    c. 1844–1845
salted paper print from calotype negative
18.2 x 14.0 (7³⁄₁₆ x 5½)
Royal Photographic Society (24)

DAVID OCTAVIUS HILL AND ROBERT ADAMSON
*East Gable of the Cathedral and St. Rule's Tower,*
    *St. Andrews*, 1846
salted paper print from calotype negative
19.4 x 14.0 (7⅝ x 5½)
Hochberg-Mattis Collection (27)

DAVID OCTAVIUS HILL AND ROBERT ADAMSON
*Highland Guard*, c. 1844–1845
salted paper print from calotype negative
15.3 x 19.4 (6¹⁄₁₆ x 7⅝)
Royal Photographic Society (23)

DAVID OCTAVIUS HILL AND ROBERT ADAMSON
*James Drummond*, c. 1846
salted paper print from calotype negative
14.0 x 20.0 (5½ x 7⅞)
National Galleries of Scotland, Portrait Gallery (25)
*Exhibited in Washington only*

DAVID OCTAVIUS HILL AND ROBERT ADAMSON
*John Henning and Female Audience*, c. 1844
salted paper print from calotype negative
15.6 x 20.2 (6⅛ x 8)
Royal Photographic Society (26)

DAVID OCTAVIUS HILL AND ROBERT ADAMSON
*Life Study, Dr. George Bell*, c. 1845
salted paper print from calotype negative
14.0 x 20.0 (5½ x 7⅞)
National Galleries of Scotland, Portrait Gallery (21)
*Exhibited in Washington only*

LEWIS WICKES HINE
*A Carrying-in-Boy in Virginia Glass Factory, Alexandria,*
    *Virginia: Works in Day Shift One Week and Night*
    *Shift Next. He Works All Night Every Other Week,*
    *June* 1911
gelatin silver print
11.8 x 17.1 (4⅝ x 6¾)
Jacob Riis Collection, Museum of the City of New
    York (141)

LEWIS WICKES HINE
*Empire State Building*, 1930–1931
warm-toned gelatin silver print, late 1930s
49.0 x 39.6 (19⅜ x 15⅝)
The Art Institute of Chicago, Mary L. and Leigh B.
    Block Endowment Fund (272)

LEWIS WICKES HINE
*Little Spinner in Mill, Augusta, Georgia. Overseer Said*
    *She Was Regularly Employed*, 1909
gelatin silver print
11.8 x 16.8 (4⅝ x 6⅝)
International Museum of Photography at George
    Eastman House, Gift of the Photo League, New
    York, ex-collection, Lewis Wickes Hine (142)

LEWIS WICKES HINE
*Young Russian Jewess*, 1905
gelatin silver print
17.7 x 12.7 (7 x 5)
International Museum of Photography at George
    Eastman House, Gift of the Photo League, New
    York, ex-collection Lewis Wickes Hine (143)

ALFRED HORSLEY HINTON
*Beyond*, 1903
photogravure
14.0 x 18.5 (5½ x 7⁵⁄₁₆)
Provinciaal Museum voor Fotografie, Antwerp (155)

DAVID HOCKNEY
*Pearblossom Hwy., 11–18 April 1986, #2*
photo-collage of chromogenic color prints
198.0 x 280.0 (78 x 111)
Courtesy of the Artist (387)

THEODOR AND OSKAR HOFMEISTER
*The Siblings*, c. 1901
gum bichromate print
62.5 x 79.5 (24⅝ x 31⅜)
Museum für Kunst und Gewerbe, Hamburg (159)
*Exhibited in Chicago and Los Angeles only*

EIKOH HOSOE
*Man and Woman #24*, 1960
gelatin silver print
26.7 x 54.4 (10½ x 21½)
Center for Creative Photography, University of Arizona
(409)

ROBERT HOWLETT
*In the Valley of the Mole*, 1856
albumen print from wet collodion negative
20.0 x 26.2 (7⅞ x 10⁵⁄₁₆)
The Metropolitan Museum of Art, Purchase, Harrison
    D. Horblitt and Harriette and Noel Levine Gifts
    and David Hunter McAlpin Fund, 1988 (58)

ROBERT HOWLETT
*Leviathan: Side View of the Hull*, c. 1857
albumen print from wet collodion negative
28.6 x 35.9 (11¼ x 14⅛)
International Museum of Photography at George
    Eastman House, Museum Purchase (68)

GRACIELA ITURBIDE
*Mujer angel*, 1979
gelatin silver print
20.4 x 30.3 (8¹⁄₁₆ x 12)
Center for Creative Photography, University of Arizona
(368)

WILLIAM HENRY JACKSON
*The Royal Gorge, Grand Canyon of the Arkansas*,
    c. 1882
albumen print from wet collodion negative
52.0 x 40.0 (20½ x 15¾)
Janet Lehr, Inc., New York (106)

FRANCES BENJAMIN JOHNSTON
*Snow Hill Institute*, 1902
cyanotype
18.5 x 23.8 (7¼ x 9⅜)
Library of Congress, Prints and Photographs Division
    (139)
*Exhibited in Washington only*

REVEREND CALVERT RICHARD JONES
*Scottish Clansmen*, c. 1845
salted paper print from calotype negative
17.0 x 21.0 (6¹¹⁄₁₆ x 8¼)
Lacock Abbey Collection (22)

GERTRUDE KÄSEBIER
*The Heritage of Motherhood*, c. 1905
gum bichromate print

27.0 x 24.9 (10⅝ x 9⅛)
Collection of the International Museum of Photography
    at George Eastman House, Gift of Hermine Turner
    (176)

GERTRUDE KÄSEBIER
*Portrait of Auguste Rodin*, 1906
gum bichromate print
33.8 x 26.5 (13¼ x 10⁷⁄₁₆)
The Art Museum, Princeton University, Gift of the
    Estate of Mina Turner (175)

PETER KEETMAN
*Schnee-Inseln*, 1958
gelatin silver print
23.2 x 28.8 (9⅛ x 11⅜)
Museum Folkwang, Essen (303)

ANDRÉ KERTÉSZ
*Chairs, The Medici Fountain*, 1926
gelatin silver print
16.4 x 18.5 (6⁷⁄₁₆ x 7⁵⁄₁₆)
Museum of Fine Arts, Houston, Museum Purchase
    with Funds Provided by the Sarah Campbell Blaffer
    Foundation(241)

ANDRÉ KERTÉSZ
*Chez Mondrian*, 1926
gelatin silver print
10.8 x 7.9 (4¼ x 3¹⁄₁₆)
The Art Institute of Chicago, Julien Levy Collection,
    Gift of Jean and Julien Levy (240)

ANDRÉ KERTÉSZ
*Satiric Dancer*, 1926
gelatin silver print
9.6 x 7.9 (3¹³⁄₁₆ x 3⅛)
Collection of Nicholas Pritzker (242)

ANSELM KIEFER
*Schweres Wässer*, 1987
handmade book of gelatin silver prints, lead, clay, silver,
    and pencil mounted on cardboard
56.6 x 50.0 x 5.5 (22¼ x 19⅝ x 2⅛)
Stefan T. Edlis Collection (385)

WILLIAM KLEIN
*The Toy Ball of Elsa Maxwell in the Waldorf*, 1954–
    1955
gelatin silver print
27.8 x 36.0 (11 x 14¼)
Collection Stedelijk Museum, Amsterdam (353)

MARK KLETT
*Around Toroweap Point Just before and after Sundown
    Beginning and Ending with Views by J. K. Hillers
    over 100 years ago, Grand Canyon*, 1986
dye transfer print in five parts
51.0 x 205.0 (20⅛ x 80¾)
Mark Klett (383)

JOSEF KOUDELKA
*Utekac*, 1963
gelatin silver print
30.5 x 40.5 (12 x 16)
Courtesy Magnum Photos (354)

GERMAINE KRULL
*Shadow of the Eiffel Tower, Paris*, c. 1928
gelatin silver print
22.2 x 15.3 (8¾ x 6¹⁄₁₆)
The Art Institute of Chicago, Photography Purchase
    Account (216)

HEINRICH KÜHN
*Lotte*, c. 1907
autochrome
23.1 x 17.2 (9½ x 6¾)
The Art Institute of Chicago, Restricted Gift of William
    Mares (167)

HEINRICH KÜHN
*On the Hillside*, 1910
gum bichromate print
23.3 x 29.1 (9³⁄₁₆ x 11½)
Gilman Paper Company Collection (166)

HEINRICH KÜHN
*Still Life*, c. 1904
gum bichromate print
29.5 x 39.1 (11⅝ x 15⅜)
Gilman Paper Company Collection (163)

HEINRICH KÜHN
*Still Life*, c. 1904
bromoil transfer print
21.1 x 29.3 (8⁵⁄₁₆ x 11⁹⁄₁₆)
Marjorie and Leonard Vernon (164)

HEINRICH KÜHN
*Walter Kühn*, c. 1905
gum bichromate print
62.6 x 50.2 (24⅝ x 19¾)
Museum Folkwang, Essen (162)

DOROTHEA LANGE
*Migrant Mother, Nipomo, California*, 1936
gelatin silver print
50.0 x 39.4 (19⅝ x 15½)
Exchange National Bank of Chicago, Courtesy of the
    Dorothea Lange Collection (284)

JACQUES-HENRI LARTIGUE
*George Boucard during the Race*, 1911
gelatin silver print, 1988
14.0 x 17.0 (5½ x 6¹¹⁄₁₆)
Association des Amis de J.-H. Lartigue, Paris (127)

JACQUES-HENRI LARTIGUE
*Gerard Willemetz and Dani*, 1926
modern gelatin silver print, 1988

30.2 x 17.2 (11⅞ x 6¾)
Association des Amis de J.-H. Lartigue, Paris (235)

JACQUES-HENRI LARTIGUE
*In My Room: Collection of My Racing Cars*, 1905
gelatin silver print, 1988
13.7 x 17.8 (5⅜ x 7)
Association des Amis de J.-H. Lartigue, Paris (125)

JACQUES-HENRI LARTIGUE
*My Hydroglider with Propeller*, 1904
gelatin silver print, 1988
13.3 x 17.0 (5¼ x 6¹¹⁄₁₆)
Association des Amis de J.-H. Lartigue, Paris (126)

JACQUES-HENRI LARTIGUE
*Oléo*, 1908
gelatin silver print, 1988
15.9 x 11.1 (6¼ x 4⅜)
Association des Amis de J.-H. Lartigue, Paris (128)

RICHARD HOE LAWRENCE
*See under Jacob Riis*

RICHARD HOE LAWRENCE
*A Chinese Opium Joint*, 1887
albumen print made by Chicago Albumen Works, 1988,
   from original lantern slide
9.4 x 12.0 (3¹¹⁄₁₆ x 4¾)
Jacob Riis Collection, Museum of the City of New
   York (134)

RICHARD HOE LAWRENCE
*Interior of an Arab Boarding House, Washington
   Street, New York*, 1887
albumen print made by Chicago Albumen Works, 1988,
   from original lantern slide
8.1 x 10.2 (3³⁄₁₆ x 4)
Jacob Riis Collection, Museum of the City of New
   York (133)

GUSTAVE LE GRAY
*Cloister of Moissac*, 1851
dilute albumen print from waxed paper negative
23.0 x 34.3 (9⅛ x 13½)
Musée d'Orsay (51)
*Exhibited in Washington only*

GUSTAVE LE GRAY
*Tree, Forest of Fontainebleau*, c. 1856
albumen print from wet collodion negative
31.9 x 41.6 (12⁹⁄₁₆ x 16⅜)
The Art Institute of Chicago, Laura T. Magnuson
   Fund; Edward E. Ayer Fund in Memory of Charles
   L. Hutchinson by his great friend and admirer, Ed-
   ward E. Ayer; Maurice D. Galleher Fund; Went-
   worth Green Field Memorial Fund and the Samuel
   P. Avery Fund (56)

GUSTAVE LE GRAY
*Railroad Yard, Tours*, c. 1851
dilute albumen print from waxed paper negative
25.2 x 34.8 (10 x 13¾)
Collection Centre Canadien d'Architecture/Canadian
   Centre for Architecture, Montréal (64)

HENRI LE SECQ
*Carrière en Forêt cadré verticalement*, c. 1852
dilute albumen print from waxed paper negative
50.8 x 37.8 (19⅞ x 14⅞)
Bibliothèque des Arts Décoratifs, Paris (36)

HENRI LE SECQ
*Ruisseau en Forêt cadré horizontalement*, c. 1852
dilute albumen print from waxed paper negative
37.9 x 51.3 (14⅞ x 20¼)
Bibliothèque des Arts Décoratifs, Paris (38)

RUSSELL LEE
*Child of Migrant Worker in Car, Oklahoma*, 1939
gelatin silver print
25.0 x 33.3 (9⅞ x 13⅛)
Museum of Fine Arts, Houston, Museum Purchase
   with Funds Provided by The Mundy Companies
   (282)

NOEL-MARIE PAYMAL LEREBOURS
*Hôtel-de-Ville de Paris*, c. 1841–1843
hand-colored photomechanical print from engraved
   daguerreotype plate
13.7 x 19.1 (5⅜ x 7½)
Collection of the International Museum of Photography
   at George Eastman House, Gift of Eastman Kodak
   Company, ex-collection Gabriel Cromer (13)

HELMAR LERSKI
*Untitled*, c. 1930
gelatin silver print
26.0 x 20.0 (10¼ x 7⅞)
Museum für Kunst und Gewerbe, Hamburg (274)

SHERRIE LEVINE
*Untitled (after Walker Evans)*, 1981
gelatin silver print
20.3 x 25.4 (8 x 10)
Courtesy Mary Boone Gallery (413)

HELEN LEVITT
*New York*, c. 1945
modern gelatin silver print
27.0 x 18.4 (10⅝ x 7¼)
Courtesy of the Photographer, and Fraenkel Gallery,
   San Francisco; and Laurence Miller Gallery, New
   York (292)

HELEN LEVITT
*New York*, 1978
chromogenic color print

22.8 x 34.1 (9 x 13⅜)
Courtesy Laurence Miller Gallery, New York (372)

DANNY LYON
*Crossing the Ohio, Louisville*, 1966
gelatin silver print
22.0 x 33.0 (8⅝ x 13)
The Art Institute of Chicago, Gift of Frederick M. and
   Elizabeth L. Myers (367)

ROBERT MacPHERSON
*Grotto of Egeria*, c. 1855
dilute albumen print from wet collodion negative
31.0 x 40.2 (12¹³⁄₁₆ x 15⅞)
Hochberg-Mattis Collection (61)

MAN RAY
*Dust Breeding (on Duchamp's Large Glass)*, 1920
gelatin silver print
20.0 x 26.0 (7⅞ x 10¼)
Jedermann Collection, N.A. (199)

MAN RAY
*Mrs. Henry Rowell*, c. 1929
gelatin silver print from solarized negative
21.9 x 16.8 (8⅝ x 6⅝)
The Art Institute of Chicago, Julien Levy Collection,
   Special Photography Acquisitions Fund (228)

MAN RAY
*Portrait of Jean Cocteau*, 1922
gelatin silver print
11.9 x 9.8 (4¹¹⁄₁₆ x 3⅞)
The J. Paul Getty Museum (225)

MAN RAY
*Rétour à la Raison*, 1923
gelatin silver print from a motion picture negative
18.7 x 13.9 (7⅜ x 5½)
The Art Institute of Chicago, Julien Levy Collection,
   Special Photography Acquisitions Fund (227)

MAN RAY
*Untitled (rayograph)*, 1923
photogram
29.6 x 23.8 (11¹¹⁄₁₆ x 9⅜)
The Art Institute of Chicago, Julien Levy Collection,
   Special Photography Acquisitions Fund (226)

ROBERT MAPPLETHORPE
*Cedric*, 1981
gelatin silver print
76.0 x 76.0 (30 x 30)
Robert Miller Gallery, New York (378)

ÉTIENNE-JULES MAREY
*Vibrations d'une verge élastique*, 1886
salted paper print
7.0 x 17.5 (2¾ x 6⅞)
Private collection (110)

475

PAUL MARTIN
*The Cheapside Flower Seller*, 1894
platinum print
7.4 x 6.1 (2⁵/₁₆ x 2⁷/₁₆)
Gernsheim Collection, Harry Ransom Humanities
    Research Center, University of Texas at Austin (136)

CHARLES MARVILLE
*Cul de sac at the Horse Market*, 1860–1870
albumen print from wet collodion negative
26.2 x 37.2 (10⁵/₁₆ x 14⁵/₈)
The J. Paul Getty Museum (70)

CHARLES MARVILLE
*No. 3, Urinoir (Système Jennings), Plateau de
    l'Ambiguë*, 1865–1875
albumen print from wet collodion negative
26.6 x 36.2 (10¹/₂ x 14¹/₄)
Musées de la Ville de Paris, Musée Carnavalet (72)

CHARLES MARVILLE
*Rue de l'Épée de Bois de la rue Mouffetard*, 1865–1875
albumen print from wet collodion negative
30.4 x 27.1 (12 x 10¹¹/₁₆)
Musées de la Ville de Paris, Musée Carnavalet (71)

RAY METZKER
*Composites: Philadelphia*, 1964
sixty-three gelatin silver prints mounted on plexiglass
86.2 x 84.5 (34 x 33¹/₄)
The Art Institute of Chicago, Gift of Dirk Lohan (380)

JOEL MEYEROWITZ
*Grand Canyon*, 1975
dye transfer print
25.0 x 20.0 (16¹/₂ x 21¹/₈)
Joel Meyerowitz (371)

JOEL MEYEROWITZ
*Provincetown Porch*, 1977
chromogenic color print
50.8 x 61.0 (20 x 24)
Joel Meyerowitz (391)

JOEL MEYEROWITZ
*Untitled*, 1969
gelatin silver print
27.8 x 41.4 (10¹⁵/₁₆ x 16¹/₄)
Private collection (370)

DUANE MICHALS
*Things Are Queer*, 1972
nine gelatin silver prints
each 12.9 x 17.9 (5¹/₁₆ x 7¹/₁₆)
San Francisco Museum of Modern Art, Gift of Marcia
    Weisman (333)

LEE MILLER
*Dead German Guard in Canal*, 1945
modern gelatin silver print, 1988

23.0 x 23.0 (9¹/₁₆ x 9¹/₁₆) sheet 40.6 x 30.5 (16 x 12)
Lee Miller Archives, England (295)

LEONARD MISONNE
*Untitled (Landscape)*, c. 1900
silver bromide print
8.3 x 11.1 (3¹/₄ x 4⁵/₈)
Provinciaal Museum voor Fotografie, Antwerp (154)

LISETTE MODEL
*We Mourn Our Loss*, 1944
gelatin silver print, 32 x 26.9 (12⁵/₈ x 10⁵/₈)
The Art Institute of Chicago, Mary L. and Leigh B.
    Block Endowment (296)

TINA MODOTTI
*Workers, Mexico*, 1924
gelatin silver print
17 x 21.0 (6¹¹/₁₆ x 8¹/₄)
Amon Carter Museum, Fort Worth (273)

LÁSZLÓ MOHOLY-NAGY
*Berlin Radio Tower*, c. 1928
gelatin silver print
36.0 x 25.5 (14¹/₄ x 10¹/₁₆)
The Art Institute of Chicago, Julien Levy Collection,
    Special Photography Acquisitions Fund (213)

LÁSZLÓ MOHOLY-NAGY
*Nude (positive and negative)*, 1931
gelatin silver prints
38.0 x 27.0 (15 x 10⁵/₈) each
Jedermann Collection, N.A. (219)

LÁSZLÓ MOHOLY-NAGY
*Oskar Schlemmer, Ascona*, 1926
gelatin silver print
29.2 x 21.2 (11¹/₂ x 8³/₈)
The Art Institute of Chicago, Julien Levy Collection,
    Gift of Jean and Julien Levy (214)

LÁSZLÓ MOHOLY-NAGY
*Untitled (Photogram)*, 1922
photogram on gelatin silver printing-out-paper
13.9 x 8.9 (5¹/₂ x 3¹/₂)
The Art Institute of Chicago, Julien Levy Collection,
    Special Photography Acquisitions Fund (211)

GEORG MUCHE
*Self Portrait*, c. 1925
gelatin silver print
16.0 x 11.8 (6⁵/₁₆ x 4⁵/₈)
The Art Institute of Chicago, Mary L. and Leigh B.
    Block Endowment (212)

HEINRICH W. MÜLLER
*Landscape*, c. 1901
gum bichromate print
15.0 x 79.5 (6 x 31³/₈)

Museum für Kunst und Gewerbe, Hamburg (159)
*Exhibited in Chicago and Los Angeles only*

MARTIN MUNKACSI
*Motorcycle Rider*, c. 1923
gelatin silver print
33.9 x 26.9 (13¹/₂ x 10⁵/₈)
The J. Paul Getty Museum (234)

EADWEARD MUYBRIDGE
*Movement of the Hand, Drawing a Circle* (Plate xxx
    from *Animal Locomotion*), 1887
collotype
19.5 x 38.9 (7⁵/₈ x 15³/₈)
The Art Institute of Chicago, Ryerson Library, Gift of
    the Friends of The Art Institute (111)

NADAR
*Charles Baudelaire*, c. 1855
salted paper print from wet collodion negative
21.0 x 18.5 (8¹/₄ x 7¹/₄)
Marie-Thérèse and André Jammes (77)

NADAR
*Théophile Gautier*, c. 1855
dilute albumen print from wet collodion negative
25.6 x 19.7 (10¹/₁₆ x 7³/₄)
The J. Paul Getty Museum (75)

NADAR
*Paul Legrand, Mime*, c. 1855
salted paper print from wet collodion negative
24.0 x 17.7 (9⁷/₁₆ x 7)
Marie-Thérèse and André Jammes (80)

NADAR
*Auguste Luchet*, c. 1855
salted paper print from wet collodion negative
21.5 x 15.5 (8¹/₂ x 6)
The J. Paul Getty Museum (78)

NADAR
*Auguste Vacquerie*, 1855
salted paper print from wet collodion negative
26.5 x 20.5 (10⁷/₁₆ x 8¹/₁₆)
The J. Paul Getty Museum (79)

CHARLES NÈGRE
*Chartres Cathedral, South Porch*, c. 1856
heliogravure
51.8 x 72.0 (20³/₈ x 28³/₈)
Marie-Thérèse and André Jammes (51)

JOSEPH NICÉPHORE NIÉPCE
*Cardinal D'Amboise*, c. 1827
heliographic print from original engraving
19.3 x 12.8 (7⁵/₈ x 5¹/₁₆)
Royal Photographic Society (1)

NICHOLAS NIXON
*The Brown Sisters*, 1976, 1978
gelatin silver prints
each 19.4 x 24.4 (7⅝ x 9⅝)
Monsen Collection (340)

YASUZO NOJIMA
*Untitled (Standing Nude)*, 1931
bromoil print
39.5 x 26.9 (15⅝ x 10⅝)
The Nojima Collection, Courtesy of The National
   Museum of Modern Art, Kyoto (220)

TIMOTHY O'SULLIVAN
*Black Canyon, Colorado River, From Camp 8, Looking
   Above*, 1871
albumen print from wet collodion negative
20.1 x 27.6 (8 x 10⅞)
The J. Paul Getty Museum (101)

TIMOTHY O'SULLIVAN
*Field Where General Reynolds Fell*, 1863
albumen print from wet collodion negative
17.8 x 22.9 (7 x 9)
The Art Institute of Chicago, Gift of Mrs. Everett Kovler
   (94)

TIMOTHY O'SULLIVAN
*Fissure Vent of Steamboat Springs*, 1867
albumen print from wet collodion negative
21.6 x 27.9 (8½ x 11)
Records of the Office of the Chief Engineers, No. 77-
   KS-3-1-29, National Archives (394)
*Exhibited in Washington Only*

TIMOTHY O'SULLIVAN
*Sand Dunes, Carson Desert*, 1867
albumen print from wet collodion negative on glass
21.5 x 28.0 (8½ x 11¹⁄₁₆)
Records of the Office of the Chief Engineers, No. 77-
   KS-3-160, National Archives (98)
*Exhibited in Washington Only*

TIMOTHY O'SULLIVAN
*Vermillion Creek Canyon*, 1863
albumen print from wet collodion negative
20.3 x 26 (8 x 10¼)
Library of Congress, Prints and Photographs Division
   (99)

PAUL OUTERBRIDGE
*Advertisement for George P. Ide Co.*, 1922
platinum print
12.3 x 9.5 (4⅞ x 3¾)
Museum of Fine Arts, Houston, Museum purchase with
   Funds Provided by Target Stores, Inc. (221)

URIAH HUNT PAINTER
*Untitled (Child)*, c. 1889
gelatin silver print

6.5 diam. (2⁹⁄₁₆)
Library of Congress, Prints and Photographs Division
   (120)

URIAH HUNT PAINTER
*Untitled (On White House Grounds)*, c. 1889
gelatin silver print
6.5 diam. (2⁹⁄₁₆)
Library of Congress, Prints and Photographs Division
   (119)

IRVING PENN
*Mother and Daughter, Cuzco, Peru*, 1948
gelatin silver print
31.1 x 26.3 (12¼ x 10⅜)
Collection, The Museum of Modern Art, New York,
   Gift of Condé Nast Publications (339)

JOHN PFAHL
*Trojan Nuclear Plant, Columbia River, Oregon, October
   1982*, 1982
chromogenic color print
34.0 x 46.5 (13⅜ x 18⅜)
The Art Institute of Chicago, Restricted gift of Gordon
   Lee Pollack (377)

PHOTOGRAPHER UNKNOWN
*Martin van Buren*, c. 1845
full-plate daguerreotype
21.6 x 16.5 (5½ x 4½)
Chicago Historical Society (17)

PHOTOGRAPHER UNKNOWN
*S.S. Central Viaduct*, c. 1889
matte collodion
9.2 diam. (3⅝)
International Museum of Photography at George
   Eastman House, Museum Collection (116)

PHOTOGRAPHER UNKNOWN
*Untitled (Two Men and Two Women)*, c. 1889
gelatin silver print
8.0 diam. (3³⁄₁₆)
International Museum of Photography at George
   Eastman House, Gift of George B. Dryden (115)

HENRY G. PIFFARD
*See under Jacob Riis*

JOHN PLUMBE
*Untitled*, c. 1844
quarter-plate daguerreotype
11.0 x 8.5 (4⁵⁄₁₆ x 3⅜)
The J. Paul Getty Museum (19)

ELIOT PORTER
*Dark Canyon, Glen Canyon*, 1965
dye transfer print
25.9 x 20.0 (10³⁄₁₆ x 7⅞)

The Art Institute of Chicago, Anonymous gift in honor
   of Hugh Edwards (314)

QUEEN ALEXANDRA
*The Prince of Wales and Unknown Person on the Racing
   Yacht Aline*, 1891
gelatin silver print
6.8 diam. (2¹¹⁄₁₆)
Gernsheim Collection, Harry Ransom Humanities
   Research Center, University of Texas at Austin (117)

QUEEN ALEXANDRA
*Princess Victoria with Her Uncle Prince Waldemar of
   Denmark on the Osborne*, 1889
gelatin silver print
6.9 diam. (2¹¹⁄₁₆)
Gernsheim Collection, Harry Ransom Humanities
   Research Center, University of Texas at Austin (118)

ARNULF RAINER
*Untitled*, 1973
gelatin silver print with hand markings
17.8 x 24.2 (7 x 9½)
Joshua P. Smith (336)

WILLIAM RAU
*Main Line and Low Grade Tracks at Parkersburg*,
   c. 1890
gelatin silver print
44.0 x 54.6 (17 x 21½)
The J. Paul Getty Museum (108)

JOHN REEKIE
*A Burial Party, Cold Harbor, Virginia*, 1865
albumen print from wet collodion negative
30.4 x 39.8 (12 x 15⅝)
Library of Congress, Prints and Photographs Division
   (93)

VICTOR REGNAULT
*Sèvres et environs, bords de la Seine, usine*, c. 1852
salted paper print from paper negative
44.0 x 33.5 (17⅜ x 13¼)
Musée d'Orsay, Dépôt d'Archives de la Manufacture
   de Sèvres (35)

OSCAR G. REJLANDER
*The Poet*, 1856
albumen print from wet collodion negative
18.2 x 14.1 (7³⁄₁₆ x 5½)
Royal Photographic Society (84)

ALBERT RENGER-PATZSCH
*Little Tree*, 1929
gelatin silver print
38.1 x 28.3 (15 x 11⅛)
Museum für Kunst und Gewerbe, Hamburg (264)

MARC RIBOUD
*Photographers' Convention, Japan,* 1958
gelatin silver print
30.5 x 40.5 (12$^1$/$_{16}$ x 16)
Courtesy, Magnum Photos (344)

JACOB RIIS, OR HENRY G. PIFFARD, OR RICHARD
HOE LAWRENCE
*Bandits Roost,* 1887
albumen print made by Chicago Albumen Works, 1988,
from original lantern slide
6.8 x 7.4 (2$^{11}$/$_{16}$ x 3)
Jacob Riis Collection, Museum of the City of New
York (131)

JACOB RIIS OR RICHARD HOE LAWRENCE
*A Downtown Morgue,* 1887
albumen print
9.4 x 12.0 (3$^{11}$/$_{16}$ x 4$^3$/$_4$)
Jacob Riis Collection, Museum of the City of New
York (395)

JACOB RIIS(?)
*In a Sweatshop—12-Year-Old Boy at Work Pulling
Threads,* c. 1890
albumen print made by Chicago Albumen Works, 1988,
from original glass negative
7.0 x 5.8 (2$^3$/$_4$ x 2$^5$/$_{16}$)
Jacob Riis Collection, Museum of the City of New
York (132)

JACOB RIIS(?)
*Lodgers in a Crowded Bayard Street Tenement: Five
Cents A Spot,* 1887
albumen print made by Chicago Albumen Works, 1988,
from original glass negative
6.8 x 7.4 (2$^{11}$/$_{16}$ x 3)
Jacob Riis Collection, Museum of the City of New
York (135)

ALEXANDER RODCHENKO
*At the Telephone,* 1928
gelatin silver print
39.4 x 29.0 (15$^1$/$_2$ x 11$^7$/$_{16}$)
Collection, The Museum of Modern Art, New York,
Mr. and Mrs. John Spencer Fund (215)

ALEXANDER RODCHENKO
*Toilette,* 1934
gelatin silver print
39.7 x 29.5 (15$^9$/$_{16}$ x 11$^5$/$_8$)
The J. Paul Getty Museum (254)

JAROSLAV RÖSSLER
*Portrait of a Woman,* 1931
gelatin silver print
17.8 x 17.8 (7 x 7)
The Richard Sandor Collection (229)

FRANZ ROH
*Untitled (Pedestrians),* c. 1920
negative gelatin silver print
23.4 x 18.3 (9$^1$/$_4$ x 7$^3$/$_{16}$)
The Art Institute of Chicago, Restricted Gift of the
Rice Foundation in memory of Dan and Ada Rice
(218)

ANDREW JOSEPH RUSSELL
*Granite Canyon from the Water Tower,* c. 1863
albumen print from wet collodion negative
22.0 x 30.5 (12$^3$/$_4$ x 18$^1$/$_4$)
Janet Lehr, Inc., New York (97)

ANDREW JOSEPH RUSSELL
*Potomac Creek Bridge, Aquia Creek and Fredericksburg
Railroad, 18 April 1863*
albumen print from collodion negative
25.9 x 40.4 (10$^5$/$_{16}$ x 16)
Library of Congress, Prints and Photographs Division
(96)

ANDREW JOSEPH RUSSELL
*Stone Wall, Rear of Fredericksburg, with Rebel Dead,
3 May 1863*
albumen print from wet collodion negative
23.6 x 30.2 (9$^9$/$_{16}$ x 11$^7$/$_8$)
Library of Congress, Prints and Photographs Division
(95)

AUGUSTE SALZMANN
*Jerusalem: Anciente du Temple, Triple port romaine,*
1855
developed-out salted paper print by Blanquart-Évrard
from paper negative
22.3 x 32.0 (8$^{13}$/$_{16}$ x 12$^5$/$_8$)
International Museum of Photography at George
Eastman House, Museum Purchase (44)

LUCAS SAMARAS
*Photo-Transformation, 12/28/73*
manipulated internal dye diffusion-transfer print
8.5 x 8.5 (3$^3$/$_8$ x 3$^3$/$_8$)
International Polaroid Corporation (335)

AUGUST SANDER
*Group of Children, Westerwald,* 1920
gelatin silver print
27.5 x 22.6 (10$^3$/$_4$ x 8$^7$/$_8$)
The J. Paul Getty Museum (201)

AUGUST SANDER
*Police Officer,* 1925
gelatin silver print
29.6 x 19.5 (11$^{11}$/$_{16}$ x 7$^{11}$/$_{16}$)
Collection, The Museum of Modern Art, New York.
Gift of the photographer (202)

AUGUST SANDER
*Unemployed Man,* 1928

gelatin silver print
29.6 x 22.7 (11$^{11}$/$_{16}$ x 8$^{15}$/$_{16}$)
Collection, The Museum of Modern Art, New York,
Gift of the photographer (276)

AUGUST SANDER
*Young Peasants on Their Way to a Dance, Westerwald,*
1913
gelatin silver print
26.0 x 20.0 (10$^1$/$_4$ x 7$^7$/$_8$)
Mr. and Mrs. Richard L. Menschel (200)

JAN SAUDEK
*Untitled,* 1986
toned, hand-colored gelatin silver print
39.5 x 30.0 (15 x 11$^7$/$_{16}$)
Uměleckoprůmyslové Muzeum (331)

TONI SCHNEIDERS
*Die Tiefe,* 1950
gelatin silver print
17.3 x 19.9 (6$^{13}$/$_{16}$ x 7$^7$/$_8$)
Museum Folkwang, Essen (301)

GEORGE SEELEY
*Untitled (Winter Landscape),* 1909
gum bichromate print
43.8 x 53.3 (17$^1$/$_4$ x 21)
The Baltimore Museum of Art (182)

MICHEL SEUPHOR
*Portrait of Enrico Prampolini,* 1929
gelatin silver print
16.3 x 12.3 (6$^7$/$_{16}$ x 4$^7$/$_8$)
The Art Institute of Chicago, "In Chicago" Portfolio
Fund (252)

BEN SHAHN
*Three Men with Iron Pilaster, New York,* 1934
warm-toned gelatin silver print
15.2 x 23.5 (6 x 9$^1$/$_4$)
San Francisco Museum of Modern Art, Purchase
(283)

CHARLES SHEELER
*Doylestown House–Stairs from Below,* 1917
gelatin silver print
21.1 x 15.0 (8$^5$/$_{16}$ x 5$^7$/$_8$)
The Metropolitan Museum of Art, The Alfred Stieglitz
Collection, 1933 (193)

CHARLES SHEELER
*Self-Portrait at Easel,* 1931
gelatin silver print
24.2 x 18.6 (9$^9$/$_{16}$ x 7$^5$/$_{16}$)
The Art Institute of Chicago, Ada Turnbull Hertle
Endowment (251)

CINDY SHERMAN
*Untitled Film Still #56,* 1980

gelatin silver print
20.3 x 25.2 (8 x 10)
The Art Institute of Chicago, Restricted gift of Allen
Turner (327)

STEPHEN SHORE
*Meeting Street, Charleston, South Carolina, 3 August
1975*
chromogenic color print
20.3 x 25.2 (8 x 10)
Courtesy Pace/MacGill Gallery, New York (375)

RAGHUBIR SINGH
*Farmer Dredging Dal Lake, Kashmir, India*, 1980
dye transfer print
24.6 x 37.2 (9¹¹⁄₁₆ x 14⅝)
Courtesy Pace/MacGill Gallery, New York (376)

ART SINSABAUGH
*Midwest Landscape #24*, 1961
gelatin silver print
6.6 x 49.0 (2⅝ x 19⅜)
The J. Paul Getty Museum (317)

AARON SISKIND
*Los Angeles 49*, 1949
gelatin silver print
25.5 x 32.5 (10 x 12¹³⁄₁₆)
Monsen Collection (304)

W. EUGENE SMITH
From the series *As From My Window I Sometimes
Glance*, 1957–1958
gelatin silver print
34.4 x 26.2 (13⅝ x 10⁵⁄₁₆)
The Art Institute of Chicago, Photography Purchase
Fund (351)

W. EUGENE SMITH
*Untitled*, 1950
gelatin silver print
19.4 x 34.2 (7⅝ x 13½)
Center for Creative Photography, University of Arizona
(346)

W. EUGENE SMITH
*Untitled*, 1955
gelatin silver print
26.3 x 39.2 (10⅜ x 15½)
Center for Creative Photography, University of Arizona
(349)

W. EUGENE SMITH
*Wounded, Dying Infant Found by American Soldier in
Saipan Mountains*, 1944
gelatin silver print
33.0 x 26.7 (13 x 10½)
Center for Creative Photography, University of Arizona
(293)

FREDERICK SOMMER
*Arizona Landscape*, 1943
gelatin silver print
19.5 x 24.0 (7¹¹⁄₁₆ x 9⁷⁄₁₆)
Mr. and Mrs. Richard L. Menschel (270)

FREDERICK SOMMER
*Smoke on Cellophane #1*, 1961
gelatin silver print
26.6 x 33.7 (10½ x 13¼)
The Art Institute of Chicago, On extended loan from
John Vinci (311)

ALBERT SANDS SOUTHWORTH AND JOSIAH JOHNSON
HAWES
*Copy Daguerreotype of Mother and Child*, c. 1850
sixth-plate daguerreotype
8.2 x 7.0 (3¼ x 2¾)
Collection of the International Museum of Photography
at George Eastman House, Gift of Alden Scott
Boyer (18)

ALBERT SANDS SOUTHWORTH AND JOSIAH JOHNSON
HAWES
*Daniel Webster*, 1851
full-plate daguerreotype
21.5 x 16.6 (8½ x 6⁹⁄₁₆)
The Metropolitan Museum of Art, Gift of I. N. Phelps
Stokes, Edward S. Hawes, Alice Mary Hawes, Marion
August Hawes, 1937 (16)

ALBERT SANDS SOUTHWORTH AND JOSIAH JOHNSON
HAWES
*Marion Augusta Hawes or Alice Mary Hawes*, c. 1850
daguerreotype
10.8 x 8.3 (4¼ x 3¼)
International Museum of Photography at George
Eastman House, Gift of Alden Scott Boyer (393)

ALBERT SANDS SOUTHWORTH AND JOSIAH JOHNSON
HAWES
*Winchester Family Tomb, Mount Auburn Cemetery*,
c. 1850
full-plate daguerreotype
21.5 x 16.6 (8½ x 6⁹⁄₁₆)
International Museum of Photography at George
Eastman House, Gift of Alden Scott Boyer (30)

EDWARD STEICHEN
*Aerial View of Battlefield with Soldiers and Trenches*,
c. 1918
gelatin silver print
34.0 x 48.7 (13⅜ x 19⅛)
San Francisco Museum of Modern Art, Arthur W.
Barney Bequest Fund Purchase (197)

EDWARD STEICHEN
*Charles Chaplin*, 1925
gelatin silver print
25.1 x 20.1 (9⅞ x 7⅞)

International Museum of Photography at George
Eastman House, Bequest of Edward Steichen by
Direction of Joanna T. Steichen (224)

EDWARD STEICHEN
*Flatiron*, 1907
blue pigment gum bichromate-platinum print
24.0 x 19.2 (9⁷⁄₁₆ x 7⁹⁄₁₆)
The Metropolitan Museum of Art, The Alfred
Stieglitz Collection, 1933 (184)

EDWARD STEICHEN
*Gloria Swanson*, 1924
gelatin silver print
24.1 x 19.1 (9½ x 7½)
The Richard Sandor Collection (223)

EDWARD STEICHEN
*The Little Round Mirror*, 1902
gum bichromate-platinum print
41.3 x 21.3 (16¼ x 8⅜)
Royal Photographic Society (171)

EDWARD STEICHEN
*The Pool—Evening: A Symphony to a Race and to a
Soul*, 1898
gum bichromate-platinum print
21.0 x 16.2 (8¼ x 6⅜)
Royal Photographic Society (389)

EDWARD STEICHEN
*The Pond, Moonrise*, 1903
platinum print toned with yellow and blue-green
pigment
39.7 x 48.2 (15⅝ x 19)
The Metropolitan Museum of Art, The Alfred
Stieglitz Collection, 1933 (172)

EDWARD STEICHEN
*Rodin–The Thinker*, 1902
gum bichromate print
40.3 x 50.0 (15⅞ x 19⅞)
Gilman Paper Company Collection (174)

EDWARD STEICHEN
*Self-Portrait with Brush and Palette*, 1902
gum bichromate print
26.7 x 20.0 (10½ x 7⅞)
The Art Institute of Chicago, The Alfred Stieglitz
Collection (173)

EDWARD STEICHEN
*Untitled (Nude Study)*, c. 1902
platinum print
10.4 x 14.1 (4⅛ x 5⁹⁄₁₆)
Royal Photographic Society (170)

OTTO STEINERT
*Appell*, 1950
gelatin silver print

39.2 x 29.7 (15½ x 11¹¹/₁₆)
Kicken-Pauseback Galerie, Cologne (350)

JOEL STERNFELD
*McLean, Virginia*, 1978
chromogenic color print
34.0 x 43.0 (13⅜ x 17)
Courtesy Pace/MacGill Gallery, New York (373)

ALFRED STIEGLITZ
*Equivalent, Set C2, No. 3*, 1929
gelatin silver print
11.6 x 9.2 (4⅝ x 3⅝)
National Gallery of Art, Alfred Stieglitz Collection (255)

ALFRED STIEGLITZ
*Equivalent, Set C2, No. 4*, 1929
gelatin silver print
11.8 x 9.1 (4⅝ x 3⁹/₁₆)
National Gallery of Art, Alfred Stieglitz Collection (256)

ALFRED STIEGLITZ
*Equivalent, Set C2, No. 5*, 1929
gelatin silver print
11.7 x 9.2 (4⅝ x 3⅝)
National Gallery of Art, Alfred Stieglitz Collection (257)

ALFRED STIEGLITZ
*Flatiron*, 1902
photogravure
32.7 x 16.7 (12⅞ x 6⁹/₁₆)
National Gallery of Art, Alfred Stieglitz Collection (185)

ALFRED STIEGLITZ
*From the Back-Window–291*, 1915
platinum print
25.0 x 20.0 (9⅞ x 7⅞)
National Gallery of Art, Alfred Stieglitz Collection (192)

ALFRED STIEGLITZ
*Georgia O'Keeffe*, 1918
palladium print
23.6 x 19.3 (9⁹/₁₆ x 7⅝)
National Gallery of Art, Alfred Stieglitz Collection (209)

ALFRED STIEGLITZ
*Georgia O'Keeffe*, 1920
palladium print
24.4 x 19.7 (9⅝ x 7¾)
National Gallery of Art, Alfred Stieglitz Collection (207)

ALFRED STIEGLITZ
*Going to the Post, Morris Park*, 1904
photogravure
30.8 x 26.4 (12⅛ x 10⅜)
National Gallery of Art, Alfred Stieglitz Collection (188)

ALFRED STIEGLITZ
*Grass, Lake George*, 1933
gelatin silver print

18.9 x 24.3 (7⁷/₁₆ x 9⁹/₁₆)
National Gallery of Art, Alfred Stieglitz Collection (258)

ALFRED STIEGLITZ
*Music: A Sequence of Ten Cloud Photographs, No. 1*,
 1922
gelatin silver print
19.4 x 24.0 (7⅝ x 9⅝)
National Gallery of Art, Alfred Stieglitz Collection (210)

ALFRED STIEGLITZ
*Old and New New York*, 1910
photogravure
33.3 x 25.7 (13⅛ x 10⅛)
National Gallery of Art, Alfred Stieglitz Collection (187)

ALFRED STIEGLITZ
*The Steerage*, 1907
photogravure
32.0 x 25.7 (12⅝ x 10⅛)
National Gallery of Art, Alfred Stieglitz Collection (186)

ALFRED STIEGLITZ
*Venetian Gamin*, 1894
platinum print
16.4 x 13.2 (6⁷/₁₆ x 5³/₁₆)
National Gallery of Art, Alfred Stieglitz Collection (146)

PAUL STRAND
*Chair Abstract, Twin Lakes, Connecticut*, 1916
satista print
33.7 x 25.3 (13¼ x 9¹⁵/₁₆)
San Francisco Museum of Modern Art, Purchase (196)

PAUL STRAND
*Hacienda, Saltillo, Mexico*, 1932
gelatin silver print
24.6 x 19.2 (10 x 7⁹/₁₆)
The J. Paul Getty Museum (262)

PAUL STRAND
*New York (Wall Street)*, 1915
platinum print
24.8 x 32.3 (9¾ x 12¾)
Collection Centre Canadien d'Architecture/Canadian
 Centre for Architecture, Montréal (194)

PAUL STRAND
*Photograph, New York (Blind Woman)*, 1916
platinum print
33.7 x 25.6 (13¼ x 10¹/₁₆)
The Metropolitan Museum of Art, The Alfred
 Stieglitz Collection, 1933 (195)

PAUL STRAND
*Rebecca*, 1923
platinum print
19.3 x 24.0 (7⅝ x 9⁷/₁₆)
The J. Paul Getty Museum (208)

JINDRICH STREIT
*TV—Part of Our Lives*, c. 1978
gelatin silver print
38.2 x 28.5 (10¹/₁₆ x 11¹¹/₁₆)
Uměleckoprůmyslové Muzeum (369)

CHRISTER STRÖMHOLM
*Landscape*, c. 1950
gelatin silver print
10.7 x 19.8 (4¼ x 7¹⁵/₁₆)
Museum Folkwang, Essen (302)

KARL STRUSS
*New York Building*, c. 1911
gelatin silver print
13.0 x 10.0 (5⅛ x 4)
Stephen White Collection (191)

JOSEF SUDEK
*Untitled*, c. 1950
gelatin silver print
18.0 x 24.0 (7⅛ x 9⁷/₁₆)
Kicken-Pauseback Galerie, Cologne (308)

JOSEF SUDEK
*Untitled*, from the series *Easter Reminiscences*, c. 1952
gelatin silver print
29.5 x 23.0 (9¹/₁₆ x 6⅞)
Uměleckoprůmyslové Muzeum (402)

FRANK SUTCLIFFE
*Natives*, 1895
carbon print
22.5 x 29.2 (9 x 11½)
The J. Paul Getty Museum (144)

WILLIAM HENRY FOX TALBOT
*Cloisters, Lacock Abbey*, 1843
calotype negative
16.5 x 20.7 (6½ x 8⅛)
Royal Photographic Society (10)

WILLIAM HENRY FOX TALBOT
*Cloisters, Lacock Abbey*, 1843
salted paper print from calotype negative
16.5 x 20.7 (6½ x 8⅛)
Royal Photographic Society (11)

WILLIAM HENRY FOX TALBOT
*Courtyard Scene*, c. 1844
salted paper print from calotype negative
14.9 x 19.7 (5⅞ x 7¾)
National Museum of American History, Smithsonian
 Institution, Division of Photographic History (9)

WILLIAM HENRY FOX TALBOT
*Flowers, Leaves, and Stem*, c. 1858
photogenic drawing
22.1 x 18.1 (8¹¹/₁₆ x 7⅛)

The Art Institute of Chicago, In Memory of Charles L. Hutchinson by his great friend and admirer Edward E. Ayer (3)

WILLIAM HENRY FOX TALBOT
*Fly's Wings*
salted paper print from calotype negative
10.2 X 12.7 (4 X 5)
The National Museum of Photography, Film and Television (National Museum of Science and Industry) (417)

WILLIAM HENRY FOX TALBOT
*The Game Keeper*, c. 1843
salted paper print from calotype negative
18.1 X 14.6 (7⅛ X 5¾)
National Museum of American History, Smithsonian Institution, Division of Photographic History (6)

WILLIAM HENRY FOX TALBOT
*The Haystack*, 1844–1845
salted paper print from calotype negative
16.4 X 21.0 (6⁷⁄₁₆ X 8¼)
The National Museum of Photography, Film and Television (National Museum of Science and Industry) (12)

WILLIAM HENRY FOX TALBOT
*Ships at Low Tide*, c. 1844
salted paper print from calotype negative
16.5 X 21.6 (6½ X 8½)
National Museum of American History, Smithsonian Institution, Division of Photographic History (7)

TATO
*Mechanical Portrait of Remo Chiti*, 1930
gelatin silver print
23.8 X 17.8 (9⅜ X 7)
San Francisco Museum of Modern Art, Byron Meyer Fund Purchase (230)

ALPHONSE TERPEREAU
*Pont du Gilet sur la Dordogne*, c. 1884
albumen print from wet collodion negative
37.0 X 43.0 (14½ X 17)
École Nationale des Ponts et Chaussées, Paris (69)

FÉLIX TEYNARD
*Capital, Shafts and Architrave, Temple of Knum, Esna, Egypt*, 1852
salted print by H. de Fonteny from paper negative
25.9 X 32.5 (9⅜ X 12⁵⁄₁₆)
The J. Paul Getty Museum (43)

FÉLIX TEYNARD
*Nubie: Environs d'Ibrim*
salted paper print from paper negative
23.9 X 32.5 (9⅜ X 12¹³⁄₁₆)
Gilman Paper Company Collection (41)

ELSE THALEMANN
*Waiting Passersby*, c. 1930
gelatin silver print
12.2 X 17.1 (4¹³⁄₁₆ X 6¾)
The Art Institute of Chicago, Arnold H. Crane Endowment Fund (217)

LINNAEUS TRIPE
*The Elephant Rock, Madura*, c. 1858
dilute albumen print from paper negative
27.4 X 37.5 (10¾ X 14¾)
Royal Photographic Society (47)

HOLGER TRÜLZSCH AND VERA LEHNDORFF
*Sirius VIII*, 1987
chromogenic color print
159.4 X 128.9 (63¾ X 50¾)
John L. Stewart (332)

BENJAMIN BRECKNELL TURNER
*Pepperharrow Park, Surrey*, c. 1853
albumen print from paper negative
26.5 X 38.6 (10⁷⁄₁₆ X 15¼)
By courtesy of the Board of Trustees of the Victoria and Albert Museum (39)

BENJAMIN BRECKNELL TURNER
*Whitby Abbey: North Transept*, 1852–1854
albumen print from waxed paper negative
26.8 X 34.4 (10⁹⁄₁₆ X 13⅝)
By courtesy of the Board of Trustees of the Victoria and Albert Museum (34)

JERRY N. UELSMANN
*Untitled*, 1969
gelatin silver print
26.9 X 32.2 (10⅝ X 12¹¹⁄₁₆)
The Art Institute of Chicago, Restricted gift of The People's Gallery (313)

UMBO
*Untitled (Mannequin Legs and Slippers)*, 1928
gelatin silver print
29.6 X 20.9 (11¹¹⁄₁₆ X 8¼)
The Art Institute of Chicago, The Julien Levy Collection, Gift of Jean and Julien Levy (232)

AUGUSTE VACQUERIE
*Adele Victor Hugo's Hand*, c. 1853
dilute albumen print from wet collodion negative
9.4 X 7.1 (3¹¹⁄₁₆ X 2¹³⁄₁₆)
Musée d'Orsay (74)

PIERRE AMEDÉE AND EUGÈNE-NAPOLEON VARIN
*View of Flying Buttresses, Reims*, 1853–1854
dilute albumen print
17.0 X 13.0 (6¹¹⁄₁₆ X 5⅛)
Musée d'Orsay (32)

VIKING ORBITER 2
*The Southern Latitudes of Mars at the Time of the Spring Equinox*, 1977
silver gelatin print, 1988
101.6 X 127.0 (40 X 50)
NASA's Regional Planetary Image Facilities (379)

FREDERICK VON MARTENS
*Pont Neuf de Paris*, 1842
panoramic daguerreotype
14.0 X 50.0 (6½ X 19⅝)
Musée National des Techniques du CNAM–Paris (14)
*Exhibited in Washington only*

ÉDOUARD VUILLARD
*Amfréville—Driveway*, 1905
silver bromide print
8.5 X 8.5 (3⁵⁄₁₆ X 3⁵⁄₁₆)
M. Antoine Salomon (121)

ÉDOUARD VUILLARD
*Annette Roussel, Niece of Vuillard, at Saint-Tropez*, 1904
silver bromide print
8.4 X 8.2 (3⁵⁄₁₆ X 3³⁄₁₆)
M. Antoine Salomon (123)

ÉDOUARD VUILLARD
*Madame Hessel and Mademoiselle Aron*, 1905
silver bromide print
8.4 X 8.4 (3⁵⁄₁₆ X 3⁵⁄₁₆)
M. Antoine Salomon (124)

ÉDOUARD VUILLARD
*Trip in Brittany*, 1906
silver bromide print
8.5 X 8.5 (3⅜ X 3⅜)
M. Antoine Salomon (122)

ANDY WARHOL
*Sixteen Jackies*, 1964
acrylic and silkscreen ink on sixteen joined canvases
203.2 X 162.6 (80 X 64)
Mr. and Mrs. David Pincus (323)

CARLETON WATKINS
*Cape Horn, Columbia River, Oregon*, 1867
albumen print from wet collodion negative
52.4 X 40 (20⅝ X 15¾)
Gilman Paper Company Collection (102)

CARLETON WATKINS
*Cape Horn near Celilo*, 1867
albumen print from wet collodion negative
40.0 X 52.0 (15¾ X 20½)
Gilman Paper Company Collection (105)

CARLETON WATKINS
*Mirror View, Yosemite Valley*, c. 1866

albumen stereograph from wet collodion negatives
each 7.9 x 7.9 (3¹⁄₁₆ x 3¹⁄₁₆)
The Art Institute of Chicago, Restricted gift of
Kunstadter Family Foundation (104)

CARLETON WATKINS
*Multnomah Falls, Columbia River*, c. 1870
albumen stereograph from wet collodion negatives
each 8.0 x 7.8 (3⁵⁄₁₆ x 3¹⁄₁₆)
The Art Institute of Chicago, Gift of Harold Allen (103)

WEEGEE
*Arrested for Bribing Basketball Players*, 1942
gelatin silver print
30.7 x 25.9 (12¹⁄₈ x 10³⁄₁₆)
The J. Paul Getty Museum (285)

WEEGEE
*Booked on Suspicion of Killing a Policeman*, 1939
gelatin silver print
34.5 x 27.0 (13⁵⁄₈ x 10¹¹⁄₁₆)
San Francisco Museum of Modern Art, Members' Ac-
cession Fund Purchase (286)

WILLIAM WEGMAN
*Leopard/Zebra—Zebra/Leopard*, 1981
dye diffusion transfer prints
61.0 x 52.4 (24 x 20⁵⁄₈)
Sherry and Alan Koppel (325)

EDWARD WESTON
*China Cove, Point Lobos*, 1940
gelatin silver print
24.3 x 19.2 (9⁹⁄₁₆ x 7⁵⁄₈)
The Art Institute of Chicago, Gift of Max McGraw (269)

EDWARD WESTON
*Dry Salt Pool, Point Lobos*, 1939
gelatin silver print
19.4 x 24.0 (7⁵⁄₈ x 9⁷⁄₁₆)
The Art Museum, Princeton University, Gift of David H.
McAlpin (268)

EDWARD WESTON
*Pepper*, 1930
gelatin silver print
24.2 x 19.0 (9¹⁄₂ x 7¹⁄₂)
The Los Angeles County Museum of Art, Anonymous
Gift (259)

EDWARD WESTON
*Point Lobos, North Dome*, 1946
gelatin silver print
24.1 x 19.3 (9¹⁄₂ x 7⁵⁄₈)
The Art Institute of Chicago, Peabody Purchase Fund
(271)

EDWARD WESTON
*Tina Modotti Reciting Poetry*, 1922
platinum print
23.5 x 19.2 (9¹⁄₄ x 7⁹⁄₁₆)
Jedermann Collection, N.A. (206)

EDWARD WESTON
*Washstand*, 1925
platinum print
24.3 x 18.9 (9⁹⁄₁₆ x 7⁷⁄₁₆)
The Art Institute of Chicago, Harold L. Stuart
Endowment (263)

CLARENCE H. WHITE
*Raindrops*, 1902
platinum print
20.6 x 16.0 (8¹⁄₂ x 6⁵⁄₁₆)
Royal Photographic Society (165)

CLARENCE H. WHITE
*Untitled (Nude Study)*, 1906
platinum print
17.5 x 18.0 (6⁷⁄₈ x 7¹⁄₈)
Royal Photographic Society (169)

CLARENCE H. WHITE
*Untitled (Woman in Bed)*, c. 1907
gum bichromate-platinum print
20.4 x 15.07 (8 x 6⁵⁄₁₆)
Musée d'Orsay (181)

MINOR WHITE
*Bullet Holes, Capitol Reef, Utah*, 1961
gelatin silver print
21.5 x 29.5 (8¹⁄₂ x 11⁵⁄₈)
The Art Museum, Princeton University, The Minor
White Archive (312)

MINOR WHITE
*Pacific, Devil's Slide, California*, 1947
gelatin silver print
16.8 x 20.8 (6⁵⁄₈ x 8¹⁄₁₆)

Collection, The Museum of Modern Art, New York,
Gift of David H. McAlpin (299)

MINOR WHITE
*Surf Vertical, San Mateo County, California*, c. 1947
gelatin silver print
12.0 x 9.5 (4³⁄₄ x 3³⁄₄)
The Art Institute of Chicago, Restricted gift of Photo
Gallery (300)

GARRY WINOGRAND
*Los Angeles*, 1969
gelatin silver print
28.0 x 35.5 (11 x 14)
Joshua P. Smith (357)

GARRY WINOGRAND
*San Francisco*, 1964
gelatin silver print
22.8 x 34.2 (9 x 13¹⁄₂)
Center for Creative Photography, University of Arizona
(410)

GARRY WINOGRAND
*Untitled*, c. 1965
gelatin silver print
22.8 x 34.2 (9 x 13¹⁄₂)
Center for Creative Photography, University of Arizona
(355)

GARRY WINOGRAND
*Utah*, 1964
gelatin silver print
22.6 x 34.2 (8⁷⁄₈ x 13³⁄₈)
Center for Creative Photography, University of Arizona
(356)

JOEL-PETER WITKIN
*Canova's Venus*, 1982
gelatin silver print
37.2 x 37.7 (14⁵⁄₈ x 14⁷⁄₈)
Courtesy Pace/MacGill Gallery, New York, and
Fraenkel Gallery, San Francisco (330)

DAVID WILKIE WYNFIELD
*G. F. Watts, O.M., R.A.*, 1862
albumen print from wet collodion negative
21.3 x 16.2 (8³⁄₈ x 6³⁄₈)
Royal Academy of Arts (86)

# Artists' Bibliographies

BERENICE ABBOTT
1898 Springfield, Ohio–

O'Neil, Hank, *Berenice Abbott, American Photographer* (New York, 1982)

VITO ACCONCI
1940 Bronx, New York–

Kirshner, Judith Russi, *Vito Acconci: A Retrospective: 1969–1980* [exh. cat., Museum of Contemporary Art, Chicago] (1980)
*Vito Acconci, Photographic Works 1967–1970* [exh. cat., Rhona Hoffman Gallery and Brooke Alexander Gallery] (Chicago, 1988)

ANSEL ADAMS
1902 San Francisco–1984 Monterey

Adams, Ansel, with Mary Street Alinder, *Ansel Adams, An Autobiography* (Boston, 1985)
Adams, Ansel, *Ansel Adams: Letters and Images, 1916–1984*, Mary Street Alinder and Andrea Gray Stillman, eds. (Boston, 1988)
Gray, Andrea, *Ansel Adams, An American Place, 1936* (Tucson, 1982)

ROBERT ADAMS
1937 Orange, New Jersey–

Adams, Robert, *From the Missouri West* (Millerton, New York, 1980)
————, *Beauty in Photography: Essays in Defense of Traditional Values* (Millerton, New York, 1981)
*To Make It Home. Photographs of the American West* [exh. cat., Philadelphia Museum of Art] (Millerton, New York, 1989)

ROBERT ADAMSON
1821 Burnside, St. Andrews, Scotland–1848 Burnside

Bruce, David, *Sun Pictures: The Hill-Adamson Calotypes* (Greenwich, England, 1973)
Ford, Colin, ed., *An Early Victorian Album: The Hill/Adamson Collection* (London, 1974)
Stevenson, Sara, *David Octavius Hill and Robert Adamson: catalogue of their calotypes taken between 1843 and 1847 in the collection of The Scottish National Portrait Gallery* (Edinburgh, 1981)

QUEEN ALEXANDRA
1844 Denmark–1925 London

Dimond, Frances, and Roger Taylor, *Crown and Camera: The Royal Family and Photography, 1842–1910* (London, 1987)
Gernsheim, Helmut and Alison, *Edward VII and Queen Alexandra* (New York, 1962)

MANUEL ALVAREZ BRAVO
1902 Mexico City–

Alvarez Bravo, Manuel, *Manuel Alvarez Bravo* (Millerton, New York 1987)
Livingston, Jane, *M. Alvarez Bravo* (Boston, 1978)
Parker, Fred R., *Manuel Alvarez Bravo* [exh. cat., Pasadena Art Museum] (Pasadena, 1971)

JAMES CRAIG ANNAN
1864 Hamilton, Scotland–1946 Glenbank, Lenzie, England

Annan, J. Craig, "Picture-Making with the Hand Camera," *The Amateur Photographer* 23 (27 March 1896), 275–277
————, "Painters Who Have Influenced Me," *Anthony's Photographic Bulletin* 30 (November 1899), 345, 348
Hinton, A. Horsely, "Photographic Technique of James Craig Annan," *Magazine of Art* 27 (July 1903), 461–464
Keiley, Joseph T., "J. Craig Annan," *Camera Work* 8 (October 1904), 17–18
Touchstone [pseud.], "Photographers I Have Met— J. Craig Annan," *The Amateur Photographer* 53 (10 January 1911), 34

DIANE ARBUS
1923 (born Diane Nemerov) New York–1971 New York

Arbus, Diane, *Diane Arbus* (Millerton, New York, 1972)
*Diane Arbus: Magazine Work* (Millerton, New York, 1984)

MALCOLM ARBUTHNOT
1874 Suffolk, East Anglia–1968 La Houle, Isle of Jersey

Arbuthnot, Malcolm, "The Gum-Bichromate Process," *The Amateur Photographer* 43 (6 and 13 March 1906), 118–190, 211–213
————, "A Plea for Simplification and Study in Pictorial Work," *The Amateur Photographer* 49 (12 January 1909), 34–35

"The Late Malcolm Arbuthnot," *Magnet Magazine* (19 December 1973), 5, 22
Portrait Lens [pseud.], "Some Professional Picture Makers and Their Work: Malcolm Arbuthnot," *The Amateur Photographer* 63 (13 June 1916), 476

FREDERICK SCOTT ARCHER
1813 Bishops Stortford, Hertfordshire, England–1857 London

Newhall, Beaumont, *The History of Photography* (New York, 1964)

EUGÈNE ATGET
1856 Libourne, near Bordeaux, France–1927 Paris

Abbott, Berenice, *The World of Atget* (New York, 1964)
MacOrlan, Pierre, *Eugène Atget* (Paris, 1930)
Szarkowski, John and Maria Morris Hambourg, *The Work of Atget*, 4 vols. [exh. cat., The Museum of Modern Art] (New York, 1981–1985)

CHARLES AUBRY
France–

Seguin, Jean-Pierre, and Weston J. Naef, *After Daguerre, Masterworks of French Photography (1848–1900) from the Bibliothèque Nationale* (New York, 1980)

E. ALICE AUSTEN
1866 Staten Island, New York–1952

Humphries, Hugh, and Regina Benedict, "The Friends of Alice Austen: With a Portfolio of Historical Photographs," *Infinity* (July 1967), 4–51
Novotny, Ann, *Alice's World: The Life and Photography of an American Original: Alice Austen, 1866–1952* (Old Greenwich, Connecticut, 1976)
"Alice Austen's America," *Holiday* (September 1952), 66–71
"The Newly Discovered Picture World of Alice Austen: Great Woman Photographer Steps Out of the Past," *Life* (24 September 1951), 137–144

RICHARD AVEDON
1923 New York–

*Richard Avedon, Portraits* (1976)
————, *Avedon Photographs 1947–1977* (1978)
————, *In the American West* (1985)

————, *Nothing Personal* (1964)
————, *Observations* (1959)
————, "The Family," *Rolling Stone* (21 October 1976)

**JOHN BALDESSARI**
1931 National City, California–

*John Baldessari* [exh. cat., The New Museum] (New York, 1981)

**ÉDOUARD-DENIS BALDUS**
1813 Westphalia, Germany–1882 Paris

Pare, Richard, *Photography and Architecture, 1839–1939* (New York, 1982)

**LEWIS BALTZ**
1945 Newport Beach, California–

Baltz, Lewis, ed., *Contemporary American Photographic Works* [exh. cat., The Museum of Fine Arts, Houston] (1977)
————, *San Quentin Point* (Millerton, New York, 1986)
————, and Gus Blansdell, *Park City* (Albuquerque, 1980)

**HIPPOLYTE BAYARD**
1801 Breteuil-sur-Noye, France–1887 Nemours

Gautrand, Jean-Claude, and Michel Frizot, *Hippolyte Bayard: Naissance de l'image photographique* (Paris, 1986)
Jammes, André, *Hippolyte Bayard, Ein bekannter Erfinder und Meister der Fotografie* (Lucerne and Frankfurt, 1975)

**BERNHARD AND HILLA BECHER**
Bernhard Becher: 1931 Siegen, West Germany–
Hilla Becher (born Hilla Wobeser): 1934 Potsdam, West Germany–

André, Carl, "A Note on Hilla and Bernhard Becher," *Artforum* 11 (December 1972), 59–61
Becher, Hilla and Bernhard, *Anonyme Skulpturen Eine Typologie Technischer Bauten* (1970)

**FRIEDRICH BEHRENS**
1866 Germany–

Buerger, Janet E., "Art Photography in Dresden 1899–1900: An Eye on the German Avant-Garde at the Turn of the Century," *Image* 27, no. 2 (June 1984), 1–24
————, *The Last Decade: The Emergence of Art Photography in the 1890s* [exh. cat., International Museum of Photography at George Eastman House] (Rochester, 1984)

**WILLIAM BELL**
United States (active 1840s through late 1870s)

Snyder, Joel, and Douglass Munson, eds., *The Documentary Photograph as a Work of Art* [exh. cat., Smart Gallery, University of Chicago] (Chicago, 1976)

**HANS BELLMER**
1902 Katowice, Silesia (now Poland)–1975 Paris

Sayag, Alain, *Hans Bellmer, Photographe* [exh. cat., Centre Georges Pompidou] (Paris, 1983)

**ILSE BING**
1898 Frankfurt-am-Main–

Barrett, Nancy C., *Ilse Bing: Three Decades of Photography* [exh. cat., New Orleans Museum of Art]
Barrett, Nancy C., *Ilse Bing, Paris 1931–1952* [exh. cat., Musée Carnavalet] (Paris, 1987)

**LOUIS-DÉSIRÉ BLANQUART-EVRARD**
1802 Lille–1872 Lille

Blanquart-Évrard, Louis-Désiré, *La Photographie: Ses Origines, Ses Progrès, Ses Transformations* (Lille, 1870)
Jammes, Isabelle, *Blanquart-Évrard et Les Origines de l'Edition Photographique Française* (Geneva, 1981)

**KARL BLOSSFELDT**
1865 Schielo, Germany–1932 Berlin

Blossfeldt, Karl, *Karl Blossfeldt, 1865–1932, Das Fotografische Werk* (Munich, 1981)
————, *Karl Blossfeldt, Urformen der Kunst* (Dortmund, Harenberg, 1982)

**CHRISTIAN BOLTANSKI**
1944 Paris–

Boltanski, Christian, *Classe Terminale du Lycée Chasses en 1931* (Düsseldorf, 1987)
*Christian Boltanski: Lessons of Darkness* [exh. cat., Museum of Contemporary Art, Chicago] (Chicago, 1988)

**PIERRE BONNARD**
1867 Fontenay-aux-Roses, France–1947 Le Cannet

Chevrier, François, *Bonnard photographe* (Paris, 1984)
Heilbrun, Françoise and Philippe Néagu, *Pierre Bonnard Photographe* (Paris, 1987)
Newman, Sasha, et al., *Bonnard. The Late Paintings* [exh. cat., National Gallery of Art] (Washington, 1984)

**MATHEW B. BRADY**
1823 Lake George–1896 New York

Horan, James D., *Mathew Brady: Historian with a Camera* (New York, 1955)
Taft, Robert, *Photography and the American Scene* (New York, 1938)

**BILL BRANDT**
1904 Hamburg–1983 London

Brandt, Bill, *Bill Brandt, Behind the Camera: Photographs, 1928–1983* (Millerton, New York, 1985)

**BRASSAÏ** (Gyula Hàlsz)
1899 Brasso, Transylvania–1984 Nice

Brassaï, *Camera in Paris* (London, 1949)
————, *The Secret Paris of the 30s*, Richard Miller, trans. (New York, 1976)
————, *The Artists of My Life*, Richard Miller, trans. (New York, 1982)
Durrell, Lawrence, *Brassaï* [exh. cat., The Museum of Modern Art] (New York, 1968)
Sichel, Kim and Gilberte Brassaï, *Brassaï, Paris le jour, Paris la nuit* [exh. cat., Musée Carnavalet] (Paris, 1988)

**DENIS BRIHAT**
1928 Paris–

Dieuzaide, Jean, *Denis Brihat: Photographies 1947–80* (Toulouse, 1980)
Estienne, Charles, *Denis Brihat: Photographies* (Paris, 1965)

**VICTOR BURGIN**
1941 Sheffield, Yorkshire–

Burgin, Victor, *Between* (London, 1986)
————, *The End of Art Theory, Criticism and Postmodernity* (Atlantic Highlands, New Jersey, 1986)
————, ed., *Thinking Photography: Essays in the Theory of Photographic Representation* (London, 1981)

**HARRY CALLAHAN**
1912 Detroit–

Callahan, Harry, intro. by John Szarkowski, *Callahan* (Millerton, New York, 1976)
————, *The Multiple Image, Photographs by Harry Callahan* (Chicago, 1961)
Shaw, Louise E., *Harry Callahan and His Students: A Study in Influence* (Atlanta, 1983)

**JULIA MARGARET CAMERON** (Julia Margaret Pattle)
1815 Calcutta–1879 Kalatura, Ceylon

Cameron, Julia Margaret, *Victorian Photographs of Famous Men and Fair Women*, intro. Virginia Woolf and Roger Pry (Boston, 1973)
Gernsheim, Helmut, *Julia Margaret Cameron, Her Life and Photographic Work* (London, 1948; revised Millerton, New York, 1975)
Hill, Brian, *Julia Margaret Cameron, A Victorian Family Portrait* (New York, 1973)
Lukitsh, Mary, *To Secure for Photography the Character and Uses of High Art: The Photography of Julia Margaret Cameron, 1864–1879*, Ph.D. diss., University of Chicago (Ann Arbor, Michigan, 1987)
Ovenden, Graham, *A Victorian Album: Julia Margaret Cameron and Her Circle* (New York, 1975)
Weaver, Mike, *Whisper of the Muse* [exh. cat., J. Paul Getty Museum] (Malibu, California, 1986)

ROBERT CAPA (André Friedmann)
1913 Budapest–1954 Thai-Binh, Indochina

Capa, Robert, *Slightly Out of Focus* (New York, 1947)
Whelan, Richard, *Robert Capa, a Biography* (New York, 1985)

PAUL CAPONIGRO
1932 Boston–

Caponigro, Paul, *Landscape: Photographs by Paul Caponigro* (New York, 1975)
———, *Paul Caponigro* (Millerton, New York, 1967)
———, *Seasons: Photographs and Essays* (Boston, 1988)
———, *The Wise Silence: Photographs* (Boston, 1983)
Mellor, D. W., and Peter C. Bunnell, *Paul Caponigro Photography: 25 Years* (Philadelphia, 1981)

ÉTIENNE CARJAT
1828 Fareins, France–1906 Dubois

*Étienne Carjat, 1828–1906, Photographe* (Paris, 1982)
Nadar, *Quand j'étais photographe* (Paris, 1900)

HENRI CARTIER-BRESSON
1908 Chanteloup, France–

Cartier-Bresson, Henri, *The Decisive Moment* (New York, 1952)
———, *Henri Cartier-Bresson, Photographer* (Boston, 1979)
———, *The Photographs of Henri Cartier-Bresson* [exh. cat., The Museum of Modern Art] (New York, 1947)
———, *The World of Cartier-Bresson* (New York, 1968)
Galassi, Peter, *Henri Cartier-Bresson, The Early Work* [exh. cat., The Museum of Modern Art] (New York, 1987)

HELEN CHADWICK
1953 Croydon, England–

Chadwick, Helen, *Ego Geometria Sum* (London, 1985)
———, *Of Mutability* (London, 1986)

CHARLES CLIFFORD
c. 1800 Great Britain–1863 Madrid

Bierile, R., Roy Flukinger, Nancy Keeler, and Sydney Mallet Kelgore, *Paper and Light: The Calotype in France and Great Britain 1839–1870* (Boston, 1984)
Fontanella, Lee, *La Historia de la Fotografie en España desde sus origenes hasta 1900* (Madrid, 1981)

CHUCK CLOSE
1940 Monroe, Washington–

Lyons, L., and M. Friedman, *Close Portraits* [exh. cat., Walker Art Center] (Minneapolis, Minnesota, 1980)
*Chuck Close Photographs* [exh. cat., California Museum of Photography, University of California] (Riverside, 1982)

ALVIN LANGDON COBURN
1882 Boston–1966 Colwyn Bay, North Wales

Coburn, Alvin L., "The Relation of Time to Art," *Camera Work* 36 (October 1911), 72–73
———, "The Future of Pictorial Photography," *Photograms of the Year* (1916), 23–24
Helmut, Edward, and Alison Gernsheim, ed., *Alvin Langdon Coburn, Photographer, An Autobiography* (London, 1966)
Weaver, Mike, *Alvin Langdon Coburn. Symbolist Photographer 1882–1966* (New York, 1986)

ALBERT COLLARD
before 1838 France–after 1887

Seguin, Jean-Pierre, and Weston J. Naef, *After Daguerre, Masterworks of French Photography (1848–1900) from the Bibliothèque Nationale* (New York, 1980)

ROBERT CORNELIUS
1809 Philadelphia–1893 Philadelphia

Stapp, Will, *Robert Cornelius: Portraits from the Dawn of Photography* (Washington, 1983)
Wistar, C., *Philadelphia: Three Centuries of American Art* (Philadelphia, 1976)

JOSEPH CORNELL
1903 Nyack, New York–1972 Flushing

Ashton, Dore, ed., *A Joseph Cornell Album* (New York, 1974)
McShine, Kynaston, ed., *Joseph Cornell* [exh. cat., The Museum of Modern Art] (New York, 1980)

ROBERT CRAWSHAY
Great Britain–active 1850s

ROBERT CUMMING
1943 Worcester, Massachusetts–

Cumming, Robert, *A Training in the Arts* (Toronto, 1973)
Cumming, Robert, *Robert Cumming, Photographs* [exh. cat., Friends of Photography] (Carmel, California, 1979)
Hagen, C., "Robert Cummings Subject Object," *Artforum* 21, no. 10 (June 1983), 36–41
*Three on Technology*, by Robert Cumming, Lee Friedlander, Jan Groover [exh. cat., List Visual Arts Center, Massachusetts Institute of Technology] (Cambridge, Massachusetts, 1988)

IMOGEN CUNNINGHAM
1883 Portland, Oregon–1976 San Francisco

Cunningham, Imogen, *Imogen Cunningham, Photographs, 1910–1973* (Seattle, 1974)
Dater, Judy, *Imogen Cunningham* (Boston, 1979)

ADELBERT CUVELIER
Arras, France (active 1850s)

Glassman, Elizabeth, *Cliché-verre, Hand-drawn, Light-printed* (Detroit, 1980)
Heilbrun, Françoise, *Les Paysages des Impressionistes* (Paris, 1986)

EUGÈNE CUVELIER
c. 1830, Arras, France–1900 Paris

Glassman, Elizabeth, *Cliché-verre, Hand-drawn, Light-printed* (Detroit, 1980)
Heilbrun, Françoise, *Les Paysages des Impressionistes* (Paris, 1986)

LOUIS JACQUES MANDÉ DAGUERRE
1787 Cormeilles-en-Parisis, France–1851 Bry-sur-Marne

Gernsheim, Helmut and Alison, *L. J. M. Daguerre* (London, 1956)
Kravits, T. P., ed., *Documenty po istorii izobreteniya fotografii* (Moscow, 1949)
Pontinée, George, *The History of the Discovery of Photography*, trans. Edward Epstein (New York, 1946)

BRUCE DAVIDSON
1933 Oak Park, Illinois–

Davidson, Bruce, *East 100th Street* (Millerton, New York, 1970)
———, *Subway* (Millerton, New York, 1986)
*Bruce Davidson Photographs* (New York, 1978)

FREDERICK HOLLAND DAY
1864 Norwood, Massachusetts–1933 Norwood

Clattenburg, Ellen Fritz, *The Photographic Work of F. Holland Day* [exh. cat., Wellesley College Art Museum] (Wellesley, Massachusetts, 1975)
Coburn, Alvin Langdon, "American Photographs in London," *Photo-Era* 6 (January 1901), 209–215
Day, F. Holland, "The New School of American Photography," *British Journal of Photography* (20 November 1900), 759
———, "Sacred Art and the Camera," *The Photogram* 6 (February 1899), 97–99
Hartmann, Sadakichi, "The Salon Club and the First American Photography Salon at New York," *Valiant Knights of Daguerre* (Berkeley, 1978), 118–127

ROY DeCARAVA
1919 New York–

DeCarava, Roy, *Photographs* [exh. cat., Friends of Photography] (Carmel, California, 1981)
———, and L. Hughes, *The Sweet Flypaper of Life* (1955; reprint, Washington, 1984)

EDGAR DEGAS
1834 (born Hilaire-Germain-Edgar de Gas) Paris–1917 Paris

Boggs, Jean Sutherland, ed., *Degas* (New York, 1988)
Guillard, Maurice, ed., *Degas: Form & Space* (Paris, 1985)
Terrasse, Antoine, *Degas et la Photographie* (Paris, 1983)
Varnedoe, J. Kirk, "The Ideology of Time: Degas & Photography," *Art in America* 68 (summer 1980), 96–110

PHILIP HENRY DELAMOTTE
1820 London–1889 London

Auer, Michèle, *Encyclopédie Internationale des Photographes de 1839 à nos Jours* (Hermance, Switzerland, 1985)
Seiberling, Grace, *Amateurs, Photography, and the Mid-Victorian Imagination* (Chicago and London, 1986)

HYACINTHE CÉSAR DELMAET
1828 Roubaix, France–1862 Paris

BARON ADOLF DE MEYER
1868 Paris–1946 Hollywood

Brandau, Robert, *De Meyer* (New York, 1976)
Caffin, Charles H., "The De Meyer and Coburn Exhibition," *Camera Work* 27 (July 1909), 29–30
De Meyer, Baron Adolf, *Sur le Prélude à l'Après-Midi d'un Faune* (Paris, 1914)
Haviland, Paul, "The Art of Baron de Meyer," *International Studio* 46 (April 1912), 43–44

JAN DIBBETS (Gerardus Johannes Maria Dibbets)
1941 Weert, Netherlands–

*Jan Dibbets* [exh. cat., Walker Art Center] (Minneapolis, 1987)

ROBERT DOISNEAU
1912 Gentilly, France–

Chevrier, Jean-François, *Robert Doisneau* (Paris, 1983)
Doisneau, Robert, *Instantanés de Paris* (Paris, 1955)
———, *Three Seconds from Eternity: Photographs* (Boston, 1980)
Giraud, Robert, and Michel Ragon, *Les Parisiens tels qu'ils sont* (Paris, 1954)

PIERRE DUBREUIL
1872 Lille, Belgium–1946 Brussels

Dubreuil, Pierre, "Le Deuxième Salon International d'Art Photographique," *Photographie Moderne* (15 May 1928), 25
Guest, Anthony, "The Work of M. Pierre Dubreuil at the A. P. Little Gallery," *The Amateur Photographer* (18 March 1912), 295
Jacobson, Tom, and Alain Sayag, *Pierre Dubreuil Photographies 1896– 1935* (San Diego, 1987)

MAXIME DuCAMP
1822 Paris–1894 Baden-Baden

Sobieszek, Robert, *French Primitive Photography* (New York, 1970)

LOUIS-ÉMILE DURANDELLE
1839 Verdun, France–1917

Auer, Michèle, *Encyclopédie Internationale des Photographes de 1839 à nos Jours* (Hermance, Switzerland, 1985)

THOMAS EAKINS
1844 Philadelphia–1916 Philadelphia

Goodrich, Lloyd, *Thomas Eakins* (Washington, D.C., 1982)
Hendricks, Gordon, *Thomas Eakins: His Photographic Works* (Philadelphia, 1969)
Johns, Elizabeth, *Thomas Eakins: The Heroism of Modern Life* (Princeton, 1983)

WILLIAM EGGLESTON
1939 Memphis–

Szarkowski, John, *William Eggleston's Guide* [exh. cat., The Museum of Modern Art] (New York and Cambridge, Massachusetts, 1976)

GEORGE EINBECK
1871 Hamburg–

Buerger, Janet E., "Art Photography in Dresden 1899–1900: An Eye on the German Avant-Garde at the Turn of the Century," *Image* 27 (June 1984), 1–24
———, *The Last Decade: The Emergence of Art Photography in the 1890s* [exh. cat., International Museum of Photography at George Eastman House] (Rochester, New York, 1984)

PETER HENRY EMERSON
1856 La Palma, Cuba–1936 Falmouth, England

Emerson, Peter H., *Life and Landscape on the Norfolk Broads* (London, 1886)
———, *Naturalistic Photography for Students of the Art* (London, 1889)
Newhall, Nancy, *P. H. Emerson: The Fight for Photography as a Fine Art* (New York, 1975)
Turner, Peter, and Richard Wood, *P. H. Emerson, Photographer of Norfolk* (London, 1974)

J. C. ENSLEN
Great Britain–active 1839

HUGO ERFURTH
1874 Halle, Germany–1948 Gaienhofen am Bodensee, Germany

Schardt, Hermann, et al., *Hugo Erfurth Sechsunddreissig Künstler-bildnisse* (1960)

MAX ERNST
1891 Brühl, Germany–1976 Paris

Werner Spies, ed., *Max Ernst, Oeuvre-Katalog* (Houston, 1975)

ELLIOTT ERWITT
1928 Paris–

Erwitt, Elliott, *Personal Exposures* (New York, 1988)
———, John Szarkowski, and Sam Holmes, *Photographs and Anti-Photographs* (Greenwich, Connecticut, 1972)
———, and Wilfred Sheed, *Recent Developments* (New York, 1978)
———, and P. G. Wodehouse, *Son of a Bitch* (New York, 1974)

FRANK EUGENE
1865 (born Frank Eugene Smith) New York–1936 Leipzig

Hartmann, Sadakichi, "Portrait Painting and Portrait Photography," *Camera Notes* 3 (July 1899), 3–21
Smith, Frank Eugene, "Extract from a Letter," *Camera Work* no. 49/50 (June 1917), 36
W. R., "Photographien von Frank Eugene Smith," *Dekoratif Kunst* 12 (October 1908), 1–8

FREDERICK EVANS
1853 London–1945 London

Anderson, A. J., "Mr. Evans' Exhibition of Multiple Mounting," *The Amateur Photographer* 47 (11 February 1908), 140
Evans, Frederick H., "The Cult of Vagueness," *The Amateur Photographer* 39 (4 February 1904), 83
Hinton, A. Horsley, "Mr. Frederick Evans—A 'Romanticist' in Photography," *Magazine of Art* (June 1904), 372–377
Newhall, Beaumont, *Frederick H. Evans* (Rochester, New York, 1963; reprint, Millerton, New York, 1973)

WALKER EVANS
1903 St. Louis–1975 New Haven

Evans, Walker, *American Photographs* [exh. cat., The Museum of Modern Art] (New York, 1938)
———, *Walker Evans at Work* (New York, 1982)
———, *Walker Evans, Photographs for the Farm Security Administration, 1935–1938* (New York, 1973)
Szarkowski, John, *Walker Evans* [exh. cat., The Museum of Modern Art] (New York, 1971)

LOUIS FAURER
1916 Philadelphia–

Tonelli, Edith A., and John Gossage, eds., *Louis Faurer: Photographs from Philadelphia and New York, 1937–1973* (College Park, Maryland, 1981)

ROGER FENTON
1819 Bury, Lancashire, England–1869 Mount Grace, Little Heath Potter's Bar

Hannavy, John, *Roger Fenton of Crimble Hall* (London, 1975)
Lloyd, Valerie, *Roger Fenton, Photographer of the 1850s* (London, 1988)

JOAN FONTCUBERTA
1955 Barcelona, Spain–

*4 Spanish Photographers* [exh. cat. Tucson Museum of Art] (Tucson, 1988)
Fontcuberta, Joan, *Contemporary Spanish Photography* (Albuquerque, 1987)
———, *Dr. Ameisenhanfen's Fauna* (Göttingen, West Germany, 1988)

ROBERT FRANK
1924 Zurich, Switzerland–

Alexander, Stuart, *Robert Frank, A Bibliography, Filmography, and Exhibition Chronology, 1946–1985* (Tucson, 1986)
Arnaud, G., *Indiens pas Morts* (Paris, 1956)
Frank, Robert, *The Americans* (New York, 1959)

———, *The Lines of My Hand* (Tokyo, 1971)
*Robert Frank: New York to Nova Scotia* [exh. cat., The Museum of Fine Arts, Houston] (Houston, 1986)

LEE FRIEDLANDER
1934 Aberdeen, Washington–

Friedlander, Lee, *Factory Valleys: Ohio and Pennsylvania* (New York, 1982)
———, *Lee Friedlander: Photographs* (New York, 1978)
———, *Lee Friedlander Portraits* (Boston, 1985)
———, *Like a One-eyed Cat: Photographs by Lee Friedlander 1956–1987* (New York, 1989)
———, *Self-Portrait* (New York, 1970)
———, and Jim Dine, *Work from the Same House* (London and New York, 1969)
———, and Leslie Katz, *The American Monument* (New York, 1976)

FRANCIS FRITH
1822 Chesterfield, Derbyshire, England–1898 Reigate, Surrey

Browne, Turner, and Elaine Partnow, *Photographic Artists and Innovators* (New York, 1983)
Jay, Bill, *Victorian Cameraman: Francis Frith's Views of Rural England, 1850–1898* (Newton Abbott, 1973)
Pare, Richard, *Photography and Architecture 1839–1939* (New York, 1982)
Seiberling, Grace, *Amateurs, Photography, and the Mid-Victorian Imagination* (Chicago and London, 1986)

HAMISH FULTON
1946 London–

Chevrier, François, Jean-Marc Poinsot, and Michèle Chomette, *Construire les Paysages de la Photographie* [exh. cat.] (Metz, 1984)
Fulton, Hamish, *Artist and Camera* [exh. cat.] (London, 1980)
———, *Coast to Coast Walks* (London, 1985)
———, *Roads and Paths* (Munich, 1978)

JAROMIR FUNKE
1896 Skutev, Czechoslovakia–1945 Prague

Dufek, Antonin, et. al., *Ceska Fotografie 1918–1938* [exh. cat., Moravian Gallery] (Brno, Czechoslovakia, 1981)
Dvorakova, Nina, *Jaromir Funke* [exh. cat., Moravian Gallery] (Brno, Czechoslovakia, 1979)
Soucek, Ludvik, *Jaromir Funke, Fotografie* (Prague, 1970)

ALEXANDER GARDNER
1821 Paisley, Scotland–1882 Washington

Browne, Turner, and Eliane Partnow, *Photographic Artists and Innovators* (New York, 1983)
Naggar, Carole, *Dictionnaire des Photographes* (Paris, 1982)

ARNOLD GENTHE
1869 Berlin–1942 New York

Genthe, Arnold, *As I Remember* (New York, 1936)
———, *Pictures of Old Chinatown* (New York, 1913)
*Arnold Genthe, 1869–1942* [exh. cat., Staten Island Museum] (New York, 1975)

MARIO GIACOMELLI
1925 Senigallia, Ancona, Italy–

Crawford, Alistair, *Mario Giacomelli: A Retrospective 1955–1983* (Cardiff, Wales, 1983)
Schwarz, Angelo, *Mario Giacomelli* (Carmel, California, 1983)
*Mario Giacomelli, fotografie* (Parma, 1980)

GILBERT AND GEORGE
Gilbert, 1943 Dolomites, Italy–
George, 1942, Totnes, Devon, England–

*Gilbert and George, 1968–1980* [exh. cat., The Municipal Jan Abbemuseum] (Eindhoven, The Netherlands, 1980)
*Gilbert and George: The Complete Pictures 1971–1985* (New York, 1986)
Richardson, Brenda, *Gilbert and George* [exh. cat., The Baltimore Museum of Art] (1984)

LAURA GILPIN
1891 Colorado Springs–1979 Santa Fe

Sandweiss, Martha A., *Laura Gilpin, An Enduring Grace* [exh. cat., Amon Carter Museum of Western Art] (Fort Worth, 1986)

PAOLO GIOLI
1942 Sarzano di Rovigo, Italy–

*Paolo Gioli, Monografia Fotografia* (Milan, 1977)
*Paolo Gioli, Autoanotomie* [exh. cat., Musée Reattu] (Arles, 1987)
Gioli, Paolo, *Hommage à Niépce* (Châlon-sur-Saône, 1983)

JOHN BEASELY GREENE
c. 1832 Paris–1856 Egypt

Jammes, Bruno, "John B. Greene, an American Calotypist," *History of Photography* 4 (1981)
Pare, Richard, *Photography and Architecture, 1839–1939* (New York, 1982)

BARON JEAN-BAPTISTE-LOUIS GROS
1793 France–1871 Ivry-sur-Seine

Pare, Richard, *Photography and Architecture 1859– 1939* (New York, 1982)
Seguin, Jean-Pierre, and Weston J. Naef, *After Daguerre, Masterworks of French Photography (1848– 1900) from the Bibliothèque Nationale* (New York, 1980)

JOHN GUTMANN
1905 Breslau, Germany (now Poland)–

Gutmann, John, *The Restless Decade, John Gutmann's Photographs of the Thirties* (New York, 1982)

LADY CLEMENTINA HAWARDEN
1822 Cumberweald House, near Glasgow–1865 London

Haworth-Booth, Mark, *The Golden Age of British Photography 1839– 1900* (New York, 1984)
Ovenden, Graham, *Clementina, Lady Hawarden* (London, 1974)

JOSIAH JOHNSON HAWES
1808, Crawford Notch, New Hampshire–1908, East Sudbury, Massachusetts

Newhall, Beaumont, *The Daguerreotype in America* (New York, 1961)
Sobieszek, Robert A., and Odette M. Appel, *The Spirit of Fact: The Daguerreotypes of Southworth & Hawes, 1843–1862* (Boston, 1976)

JOHN HEARTFIELD (Helmut Herzfeld)
1891 Berlin–1968 Berlin

Heartfield, John, *Photomontages of the Nazi Period* (New York, 1977)
Herzfeld, Wieland, *John Heartfield, Leben und Werk* (Dresden, 1962, 1971)
Roland Marz, ed., *Der Schnitt entlang der Zeit* (Dresden, 1981)

ROBERT HEINECKEN
1931 Denver–

Enyeart, J. L., *Heinecken* (Carmel, California, 1980)
Heinecken, Robert, *A Case Study in Finding an Appropriate TV Newswoman (A CBS Docudrama in Words and Pictures)* (New York, 1984)
————, *He/She* (Chicago, 1980)
Huginin, J., "Robert Heinecken's Phenomenology of Sex," *Dumb Ox* no. 6– 7 (fall 1977–spring 1978), 28 and 32
Porter, D., "An Interview with Robert Heinecken," *Journal: A Contemporary Arts Magazine* no. 3–10 (September–October 1981), 49–55

HUGO HENNEBERG
1863 Vienna–1918 Vienna

Henneberg, Hugo, "Praktische Mitteilungen für Landschafts—photographen," *Wiener Fotografische Blätter* (2 May 1895), 89–95
Matties-Masuren, "Hugo Henneberg," *Fotografisches Zentralblatt* 5 (September 1899), 357–360

FLORENCE HENRI
1895 New York–1982 Compiègne, France

Marcenaro, Giuseppe, *Florence Henri, aspetti di un percorso, 1910–1940* (Genoa, 1979)
Molderings, Herbert, *Florence Henri, Aspekte der Photographie der 20er Jahre* [exh. cat., Westfälischer Kunstverein] (Münster, 1976)

DAVID OCTAVIUS HILL
1802 Perth, Scotland–1870, Edinburgh

Bruce, David, *Sun Pictures: The Hill-Adamson Calotypes* (Greenwich, England, 1973)
Ford, Colin, ed., *An Early Victorian Album: The Hill/ Adamson Collection* (London, 1974)
Schwarz, Heinrich, *David Octavius Hill, Master of Photography*, trans. Helene E. Fraenkel (New York, 1931)
Stevenson, Sara, *David Octavius Hill and Robert Adamson: catalogue of their calotypes taken between 1843 and 1847 in the collection of The Scottish National Portrait Gallery* (Edinburgh, 1981)

LEWIS HINE
1874 Oshkosh, Wisconsin–1940 Hastings-on-Hudson, New York

Gutman, Judith Mara, *Lewis W. Hine and the American Social Conscience* (New York, 1967)
————, *Lewis W. Hine, 1874–1940: Two Perspectives* (New York, 1974)
Hine, Lewis W., *Men at Work. Photographic Studies of Modern Men and Machines* (New York, 1932; reprint, 1977)
Kaplan, Daile, *Lewis Hine in Europe: The Lost Photographs* (New York, 1988)
Pose ver Curtis, Kerna, and Stanley Mallach, *Photography and Reform: Lewis Hine and the National Child Labor Committee* (Milwaukee, 1984)
Rosenblum, Walter, ed., *America & Lewis Hine. Photographs 1904–1940* (New York, 1977)

ALFRED HORSLEY HINTON
1863 London–1908 Essex, England

"A Conversation with A. Horsley Hinton," *The Photographer* 1 (1 May 1904), 18–20
Hinton, A. Horsley, *Practical Pictorial Photography* (London, 1898)
————, "Naturalism in Photography," *Camera Notes* (4 October 1900), 83–91

Maskell, Alfred, "A. Horsley Hinton and the Photographic Salon," *The Amateur Photographer* 47 (10 March 1908), 220–221

DAVID HOCKNEY
1937 Bradford, Yorkshire, England–

David Hockney, *Cameraworks* (New York, 1984)
*David Hockney photographs* [exh. cat., Centre Georges Pompidou] (Paris, 1982)
*David Hockney: A Retrospective* [exh. cat., Los Angeles County Museum of Art] (Los Angeles, California, 1988)
*Photographs by David Hockney* [exh. cat., International Exhibitions Foundation] (Washington, 1986)

OSKAR AND THEODOR HOFMEISTER
Oskar Hofmeister: 1869 Hamburg–1937 Hamburg
Theodor Hofmeister: 1865 Hamburg–1943 Hamburg

Juhl, Ernst, "Some Notes on the Work of Theodor and Oskar Hofmeister," *The Amateur Photographer* 34 (20 September 1901), 231–233
————, "Theodor and Oskar Hofmeister of Hamburg," *Camera Work* 7 (July 1904), 18–20
Matthies-Masuren, F., ed., *Gummidrucke von Hugo Henneberg, Wien, Heinrich Kühn, Innsbruck, und Hans Watzek, Wien* (Halle, 1902)

EIKOH HOSOE
1933 Yonezawa, Yamagata, Japan–

Hosoe, Eikoh, *Ba-ra-kei—Ordeal by Roses: Photographs of Yukio Mishima* (New York, 1985)
————, *Eikoh Hosoe* (Carmel, California, 1986)
————, *Embrace* (Tokyo, 1977)
*Black Sun: The Eyes of Four, Roots and Innovations in Japanese Photography* [exh. cat., The Philadelphia Museum of Art] (Philadelphia, 1986)

ROBERT HOWLETT
1831–1858 Kensington, England

Hardwich, F., "Remarks on the Death of Mr. Howlett," *Journal of the Photographic Society* 5 (December 1858), 111

GRACIELA ITURBIDE
1942 Mexico City–

Iturbide, Graciela, *Suenos de papel* (Mexico City, 1985)
Pitts, Terence, and Rene Verdugo, *Contemporary Photography in Mexico: 9 Photographers* [exh. cat., Center for Creative Photography] (Tucson, 1978)

WILLIAM HENRY JACKSON
1843 Keesville, New York–1942 New York

Hales, Peter B., *William Henry Jackson and the Transformation of the American Landscape* (Philadelphia, 1988)
Jackson, William H., *Time Exposure: The Autobiography of William Henry Jackson* (New York, 1940)

FRANCES BENJAMIN JOHNSTON
1864 Grafton, West Virginia–1952 New Orleans

Daniel, Pete, and Raymond Smock, *A Talent for Details: The Photographs of Miss Frances Benjamin Johnston 1889–1910* (New York, 1974)
Kirstein, Lincoln, *The Hampton Album* (New York, 1966)
Szarkowski, John, *Looking at Photographs* (New York, 1973)
Tucker, Ann, ed., *The Woman's Eye* (New York, 1973)

REV. CALVERT RICHARD JONES, JR.
1804 Wales–1877 Wales

Kraus, Hans P., Jr., *Catalogue Four Sun Pictures. The Harold White Collection of Historical Photographs from the Circle of Talbot* (New York, 1987)

GERTRUDE KÄSEBIER (Gertrude Stanton)
1852 Des Moines, Iowa–1934 New York

Bunnell, Peter, "Gertrude Käsebier," *Arts in Virginia* 16 (fall 1975), 2–15
Caffin, Charles H., "Gertrude Käsebier and the Artistic Commercial Portrait," *Photography as a Fine Art* (New York, 1901; reprint, Hastings-on-Hudson, New York, 1971), 51–81
Homer, William Innes, *A Pictorial Heritage, The Photographs of Gertrude Käsebier* [exh. cat., University of Delaware and Delaware Art Museum] (Newark, 1979)
Käsebier, Gertrude, "To Whom It May Concern," *Camera Notes* 3 (January 1900), 121–122
Tighe, Mary Anne, "Gertrude Käsebier Lost and Found," *Art in America* 65 (March–April 1977), 94–98

PETER KEETMAN
1916 Wuppertal-Elberfeld, Germany–

Eskildsen, Ute, *Subjektive Fotografie: Images of the 50s* [exh. cat., Museum Folkwang] (Essen, West Germany, 1984)

ANDRÉ KERTÉSZ
1894 Budapest–1985 New York

Phillips, Sandra S., David Travis, and Weston J. Naef, *André Kertész: Of Paris and New York* [exh. cat., The Art Institute of Chicago] (Chicago, 1985)
Szarkowski, John, *André Kertész, Photographer* [exh. cat., Museum of Modern Art] (New York, 1964)

ANSELM KIEFER
1945 Donaueschingen, West Germany–

Rosenthal, Mark, *Anselm Kiefer* [exh. cat., The Art Institute of Chicago] (Chicago and Philadelphia, 1987)

WILLIAM KLEIN
1928 New York–

Klein, William, *Life Is Good and Good for You in New York: Trance Witness Reveals* (Paris, 1956)
———, *Moscow* (New York, 1964)
———, *Rome* (London, 1960)
———, and John Heilpern, *William Klein: Photographs* (Millerton, New York; London, and Paris, 1981)
*William Klein photographe etc.* [exh. cat., Centre Georges Pompidou] (Paris, 1983)

MARK KLETT
1952 Albany, New York

Klett, Mark, Ellen Manchester, and JoAnn Verburg, *Second View: The Rephotographic Survey Project* (Albuquerque, 1984)
———, *Traces of Eden: Travels in the Desert Southwest* (Boston, 1986)

JOSEF KOUDELKA
1938 Boskovice, Moravia, Czechoslovakia–

Koudelka, Josef, *Gypsies* (Millerton, New York, 1975)
*Exiles: Photographs by Josef Koudelka* [exh. cat., Centre National de la Photographie, Paris, in association with the International Center of Photography, New York] (New York, 1988)

GERMAINE KRULL
1897 Wilda-Poznan, Poland–1985 Wetzlar, West Germany

Bouqueret, Christian, *Germaine Krull, Photographie, 1924–1936* [exh. cat., Musées d'Arles] (Arles, 1988)
Krull, Germaine, *Germaine Krull, Autobiografische Erinnerungen einer Fotografin aus der Zeit zwischen den Kriegen*, introduction by Klaus Honnef [exh. cat., Rheinisches Landesmuseum] (Bonn, 1977)
Mac Orlan, Pierre, *Germaine Krull* (Paris, 1931)

HEINRICH KÜHN
1866 Dresden–1944 Birgitz-bei-Innsbruck, Austria

Eskildsen, Ute, *Heinrich Kühn 1866–1944* [exh. cat., Museum Folkwang] (Essen, 1978)
Kühn, Heinrich, "Neue Erfahrungen im Gummidruck," *Wiener Fotografische Blätter* 3 (1896), 181–193
Matthies-Masuren, F., "Heinrich Kühn," *Fotografisches Zentralblatt* (5 April 1899), 161–166

Pollock, Elizabeth, *An Exhibition of One Hundred Photographs by Heinrich Kühn* [exh. cat.] (Munich, 1981)
Sobieszek, Robert, "Heinrich Kühn," *Image* 14 (1971) 16–18
Weiermair, Peter, *Heinrich Kühn (1866–1944) Fotografien* (Innsbruck, 1978)

DOROTHEA LANGE
1895 Hoboken–1965 Marin County

Ohrn, Karin Becker, *Dorothea Lange and the Documentary Tradition* (Baton Rouge, 1980)
Lange, Dorothea, *Dorothea Lange, Photographs of a Lifetime* (Millerton, New York, 1982)

JACQUES-HENRI LARTIGUE
1894 Courbevoie, France–1986 Nice

Avedon, Richard, *Diary of a Century* (New York, 1970)
Damade, Jacques, *Jacques-Henri Lartigue* (New York, 1986)
Frizot, Michel, *Le Passé composé, Les 6 x 13 de Jacques-Henri Lartigue* [exh. cat., Centre National de la Photographie] (Paris, 1984)
Guichard, *Boyhood Photos of J.-H. Lartigue. The Family Album of a Gilded Age* (New York, 1966)
Szarkowski, John, *The Photographs of Jacques-Henri Lartigue* [exh. cat., The Museum of Modern Art] (New York, 1963)
Tounier, Michel, *J.-H. Lartigue. Mémoires sans Mémoire* (Paris, 1975)

RICHARD HOE LAWRENCE

Stange, Maren, "Gotham's Crime and Misery: Ideology and Entertainment in Jacob Riis' Lantern Slide Exhibitions," *Views* 8 (1987), 7–11
———, *Symbols of Ideal Life: Social Documentary Photography in America, 1890–1950* (Cambridge, Massachusetts, 1988)

GUSTAVE LE GRAY
1820 Viliers-le-Bel, France–1882 Cairo, Egypt

Janis, Eugenia Parry, *The Photography of Gustave Le Gray*, 1987

HENRI LE SECQ
1818 Paris–1882 Paris

Janis, Eugenia Parry, *Henri Le Secq, Photographe de 1850 à 1860* (Paris, 1986)
Néagu, Philippe, *La Mission héliographique. Photographies de 1851* (Paris, 1980)

RUSSELL LEE
1903 Ottawa, Illinois–1986 Austin, Texas

Hurley, F. Jack, *Russell Lee, Photographer* (Dobbs
    Ferry, New York, 1978)

NOEL-MARIE-PAYMAL LEREBOURS
1807 Neuilly, France–1873 Neuilly

HELMAR LERSKI (Israël Schmoklerski)
1871 Strasbourg, France–1956 Zurich

Eskildsen, Ute, and Jan-Christopher Horak, *Helmar
    Lerski, Lichtbildner, Fotografien und Filme, 1910–
    1947* [exh. cat., Museum Folkwang] (Essen, 1982)

SHERRIE LEVINE
1947 Hazleton, Pennsylvania–

Crimp, Douglas, *Pictures: An Exhibition of the Work
    of Sherrie Levine* (New York, 1972)
———, "The Photographic Activity of Postmodern-
    ism," *October* 15 (winter 1980), 91–102
Marzorati, Gerald, "Art in the (Re)Making," *Artnews*
    85 (May 1986), 90–99
*Sherrie Levine, Art at the Edge* [exh. cat., High Muse-
    um of Art] (Atlanta, 1988)

HELEN LEVITT
1918 New York–

Hellman, Roberta, and Robert Hoshino, *Helen Levitt:
    Color Photographs* [exh. cat. Grossmont College
    Gallery] (El Cajon, California, 1980)
Levitt, Helen, *In the Street, Chalk Drawings and Mes-
    sages, New York City, 1938–1948* (Durham, North
    Carolina, 1987)
———, *A Way of Seeing* (New York, 1965; reprint,
    1981)
Soby, James T., "The Art of Poetic Accident: The
    Photographics of Henri Cartier-Bresson and Helen
    Levitt," *Minicam* (March 1943)

DANNY LYON
1942 Brooklyn–

Lyon, Danny, *The Bikeriders* (New York, 1968)
———, *Conversations with the Dead* (New York, 1971)
———, *Pictures from the New World* (Millerton, New
    York, 1981)

ROBERT MACPHERSON
1811 Scotland–1872 Scotland

Haworth-Booth, Mark, *The Golden Age of British
    Photography 1839–1900* (New York, 1984)
Pare, Richard, *Photography and Architecture, 1839–
    1939* (New York, 1982)

MAN RAY (Emmanuel Rudnitsky)
1890 Philadelphia–1976 Paris

Baldwin, Neil, *Man Ray, American Artist* (New York,
    1988)
Man Ray, *Self Portrait* (Boston, 1963)
Martin, Jean-Hubert, et al., *Man Ray Photographs*
    (New York, 1982)
*Perpetual Motif, The Art of Man Ray* [exh. cat., Na-
    tional Museum of American Art, Smithsonian Insti-
    tution] (Washington and New York, 1988)

ROBERT MAPPLETHORPE
1946 New York–1989 New York

Mapplethorpe, Robert, *Certain People: A Book of Por-
    traits* (Pasadena, California, 1985)
———, *Lady: Lisa Lyon* (New York, 1983)
———, *The Black Book* (Munich, 1986)
*Robert Mapplethorpe* [exh. cat., Whitney Museum of
    American Art] (New York, 1988)
*Robert Mapplethorpe, 1970–1983* [exh. cat., Institute
    of Contemporary Art] (London, 1983)

ÉTIENNE-JULES MAREY
1830 Beaune, France–1904 Paris

Frizot, Michel, "Le Grand Oeuvre de l'Oeil," *Chron-
    iques de l'art Vivant*, 44 (November 1973), 7–9
———, *Etienne Jules Marey* (Paris, 1984)
Jammes, André, "E.-J. M.," *Charactères* (Noel,
    France, 1965)

FREDERICK VON MARTENS
c. 1809 Germany–1875 Paris

Berger, Levrault, *Regards sur la Photographie en
    France au XIXe Siècle* (Paris, 1980)

PAUL MARTIN
1864 Herbeuville, France–1944 London

Flukinger, Roy, et al., *Paul Martin, Victorian Photog-
    rapher* (Austin, Texas, and London, 1977)
Jay, Bill, *Victorian Candid Camera: Paul Martin,
    1864–1944* (Newton Abbot, 1973)
Martin, Paul, *Victorian Snapshots* (London, 1939)

CHARLES MARVILLE
1816 Paris–c. 1879 Paris

Hambourg, Maria Morris, *Charles Marville, Photo-
    graphs of Paris 1852–1878* (New York, 1981)
Jammes, Isabelle, *Blanquart-Évrard et les origines de
    l'édition photographique française, catalogue raison-
    né des albums photographiques édités, 1851–1855*
    (Paris and Geneva, 1981)

RAY METZKER
1931 Milwaukee–

Metzker, Ray, and Hugh Edwards, *My Camera and I
    in the Loop* (Chicago, 1959)
———, *Sand Creatures* (Millerton, New York, 1979)
———, and Anne W. Tucker, *Unknown Territory:
    Photographs by Ray Metzker* [exh. cat., Museum of
    Fine Arts, Houston] (Millerton, New York, 1984)

JOEL MEYEROWITZ
1938 New York–

Meyerowitz, Joel, Clifford S. Ackley, and Bruce K.
    Macdonald, *Cape Light: Color Photographs by Joel
    Meyerowitz* [exh. cat., Museum of Fine Arts, Bos-
    ton] (Boston, 1978)
———, *A Summer's Day* (New York, 1985)
———, *Wild Flowers* (Boston, 1983)
———, and James N. Wood, *St. Louis and the Arch*
    [exh. cat., St. Louis Art Museum] (Boston, 1981)

DUANE MICHALS
1932 McKeesport, Pennsylvania–

Bailey, Ronald H., *Duane Michals: The Photographic
    Illusion* (Los Angeles, 1975)
Michals, Duane, *Sequences* (New York and Milan, 1970)
*Duane Michals: Photographs, Sequences, Texts 1958–
    1984* [exh. cat., The Museum of Modern Art] (Ox-
    ford, 1984)
———, *Real Dreams* (Danbury, New Hampshire, and
    Paris, 1977)
——— (under pseudonym Stefan Mihal), *Take One
    and See Mount Fujiyama and Other Stories* (New
    York, 1976)

LEE MILLER
1907 Poughkeepsie, New York–1977 Sussex, England

Livingston, Jane, *Lee Miller, Photographer* (New York,
    1989)
Penrose, Anthony, *The Lives of Lee Miller* (New York,
    1985)

LÉONARD MISSONE
1870 Gilly, near Charleroi, Belgium–1943 Gilly

Association Belge de Photographie, *Tableaux Photo-
    graphiques* (Brussels, 1927)
———, *Twenty-four Photographs* (Brussels, 1934)
Missone, Maurice, *Introduction à l'Oeuvre Photogra-
    phique de Léonard Missone* (Brussels, 1971)

LISETTE MODEL (Elise F. Amélie Seybert)
1906 Vienna–1983 New York

Model, Lisette, *Lisette Model* (Millerton, New York,
    1979)

TINA MODOTTI (Assunta Adelaide Luigia Modotti)
1896 Udine, Italy–1942 Mexico City

Barckhausen, Christiane, *Auf dem Spuren vin Tina Modotti* (Cologne, 1988)
Caronia, Maria, *Tina Modotti, Photographs* (Westbury, New York, 1981)
Constantine, Mildren, *Tina Modotti: A Fragile Life: An Illustrated Biography* (New York, 1983)

LÁSZLÓ MOHOLY-NAGY (László Nagy)
1895 Bacsborsod, Hungary–1946 Chicago

Andreas, Haus, *Moholy-Nagy: Photographs and Photograms* (New York, 1980)
Hight, Eleanor M., *Moholy-Nagy: Photography and Film in Weimar Germany* [exh. cat., Wellesley College Museum] (Wellesley, Massachusetts, 1985)
Moholy, Lucia, *Moholy-Nagy, Marginal Notes* (Krefeld, 1972)
Moholy-Nagy, László, *Painting, Photography, Film*, trans. Janet Seligman (Cambridge, Massachusetts, 1967)
Passuth, Kristina, *Moholy-Nagy* (New York, 1985)
Rice, Leland, and David W. Steadman, eds. *Photographs of Moholy-Nagy from the collection of William Larson* [exh. cat., Galleries of the Claremont Colleges] (Claremont, California, 1975)
Verre, Philip, and Julie Saul, *Moholy-Nagy, Fotoplastiks: The Bauhaus Years* [exh. cat., The Bronx Museum of the Arts] (New York, 1983)

GEORG MUCHE
1895 Querfort, Germany–

Pastor, Suzanne, "Photography and the Bauhaus," *The Archive* no. 21, 1984

HEINRICH MÜLLER
1859 Hamburg–1933 Hamburg

Buerger, Janet E., "Art Photography in Dresden 1899–1900: An Eye on the German Avant-Garde at the Turn of the Century," *Image* 27 (June 1984), 1–24
———, *The Last Decade: The Emergence of Art Photography in the 1890s* [exh. cat., International Museum of Photography at George Eastman House] (Rochester, New York, 1984)

MARTIN MUNKACSI (Martin Marmorstein)
1896 Kolozsvar, District of Munkacsi, Hungary (now Rumania)–1963 New York

Hoghe, Raimund, *Martin Munkacsi* (Düsseldorf, 1980)
Munkacsi, Martin, *Style in Motion, Munkacsi Photographs* (New York)

EADWEARD MUYBRIDGE (Edward Muggeridge)
1830 Kingston-upon-Thames–1904 Kingston-upon-Thames

Haas, Robert B., *Muybridge: Man in Motion* (Berkeley, 1976)
Muybridge, Eadweard, *Animal Locomotion* (Philadelphia, 1887)

NADAR (Gaspard Félix Tournachon)
1820 Paris–1910 Paris

Nadar, *Quand j'étais photographe*, trans. Thomas Repensek, *October 5 Photography: A Special Issue* (summer 1978) (Paris, 1900)
Néagu, Philippe, Jean-François Bory, and Jean-Jacques Poulet-Allamagny, *Nadar*, vol. 1 (Paris, 1979)
Gosling, Nigel, *Nadar* (New York, 1976)
Greaves, Roger, *Nadar ou le paradoxe vital* (Paris, 1980)

CHARLES NÈGRE
1820 Grasse, France–1880 Grasse

Borcomon, James, *Charles Nègre 1820–1880* (Ottawa, 1976)
Heilbrun, Françoise, *Charles Nègre 1820–1880, Das Photographische Werk* (Munich, 1988)
———, *Charles Nègre Photographe, 1820–1880* (Paris, 1980)
Jammes, André, *Charles Nègre, photographe, 1820–1880* (Paris, 1963)

JOSEPH NICÉPHORE NIÉPCE
1765 Chalon-sur-Saône–1833 Gras, St. Loup de Varennes, near Chalon

Fouque, Victor, *La Vérité sur L'invention de la Photographie: Nicéphore Niépce; Sa Vie, Ses Essais, Ses Travaux, d'Aprés Sa Correspondance et Autres Documents Inédits* (New York, 1935; reprint, 1973)
Jay, Paul, *Niépce, Genese d'une invention* (Chalon-sur-Saône, 1988)
Kravits, T. P., ed., *Dokumenty po istorii izobreteniya fotografii* (Moscow, 1949)
Nadar, *Quand j'étais photographe* (Paris, 1900)
Niépce, Isidor and Victor Foque, *Nicéphore Niépce, sa vie, ses essais, ses travaux* (Paris, 1987)
Pontonnée, Georges, *The History of the Discovery of Photography*, trans. Edward Epstein (New York, 1946)

NICHOLAS NIXON
1947 Detroit, Michigan–

Nixon, Nicholas, *Nicholas Nixon: Photographs from One Year* (Carmel, California, 1983)
*Nicholas Nixon, Photographs 1977–1988* [exh. cat., The Museum of Modern Art] (New York, 1988)

YASUZO NOJIMA
1889 Urawa, Japan–1964 Hayama Ishiki, Japan

TIMOTHY O'SULLIVAN
1840 Staten Island, New York–1882 Staten Island

Dingus, Rick, *The Photographic Artifacts of Timothy O'Sullivan* (Albuquerque, 1982)
Snyder, Joel, *American Frontiers, the Photographs of Timothy H. O'Sullivan, 1867–1874* (New York, 1982)

PAUL OUTERBRIDGE, JR.
1896 New York–1958 Laguna Beach, California

Dines, Elaine, ed., *Paul Outerbridge, A Singular Aesthetic, Photographs and Drawings, 1921–1941* [exh. cat., Laguna Beach Museum of Art] (Laguna Beach, 1981)
Howe, Graham, and Jacqueline Markham, *Paul Outerbridge, Jr.: Photographs* (New York, 1980)

URIAH HUNT PAINTER
1837–1900

National Union Catalog Manuscripts, Entry No. 61-1129
Documents on Uriah Hunt Painter in Westchester Historical Society, Westchester, Pennsylvania

IRVING PENN
1917 Plainfield, New Jersey–

Penn, Irving, with text by Alexander Liberman, *Moments Preserved: 8 Essays in Photographs and Words* (New York, 1960)
———, *Worlds in a Small Room* (New York, 1974)
Szarkowski, John, *Irving Penn* [exh. cat., The Museum of Modern Art] (New York and Boston, 1984)

JOHN PFAHL
1939 New York–

Pfahl, John, *Altered Landscapes* (Carmel, California, 1981)
———, *Picture Windows* (Boston, 1987)

JOHN PLUMBE, JR.
1809 Wales–1857 Dubuque, Iowa

Newhall, Beaumont, *The Daguerreotype in America* (New York, 1961)

ELIOT PORTER
1901 Winnetka, Illinois–

Porter, Eliot, *In Wilderness Is the Preservation of the World* (San Francisco, 1962)

———, *The Place No One Knew: Glen Canyon on the Colorado* (San Francisco, 1963)
*Eliot Porter* [exh. cat., Amon Carter Museum of Art] (Dallas, 1987)

ARNULF RAINER
1929 Baden, Austria–

*Arnulf Rainer* [exh. cat., Stedelijk von Abbemuseum] (Eindhoven, The Netherlands, 1980)
*Arnulf Rainer, Death Masks and Hand Paintings* [exh. cat., Gallery Thaddaeus Ropac] (Salzburg, Austria, 1986)
*Arnulf Rainer Self-Portraits* [exh. cat., Ritter Art Gallery, University of Florida] (Boca Raton, 1986)

WILLIAM HERMAN RAU
1865 Philadelphia–1920 Philadelphia

Pare, Richard, and Phyllis Lambert, *Photography and Architecture, 1839–1939* [exh. cat., Centre Canadien d'Architecture] (Montréal, 1982)
Rau, William H., "How I Photograph Railroad Scenery," *Photo Era*, vol. 36, no. 6 (June 1916)

HENRI-VICTOR REGNAULT
1810 Aachen–1878 Paris

Jammes, André, and Robert Sobieszek, *French Primitive Photography* (New York, 1970)
Jammes, André, *V. Regnault Calotypist*, trans. Robert Sobieszek (New York, 1975)

OSCAR G. REJLANDER
1813 Sweden–1875 London

Browne, Turner, and Elaine Pratnow, *Photographic Artists and Innovators* (New York, 1983)
Jones, Edgar Y., *The Father of Art Photography: O. G. Rejlander, 1813–1875* (Newton Abbot, England, 1973)

ALBERT RENGER-PATZSCH
1897 Würzburg–1966 Wamel bei Soest, Germany

Honnef, Klaus, *Industrielandschaft, Industriearchitektur, Industrieprodukt: Fotografien, 1925–1960 von Albert Renger-Patzsch* (Cologne, 1977)
Thoma, Dieter, *Albert Renger-Patzsch, Ruhrgebiet-Landschaften, 1927–1935* (Cologne, 1982)
*Albert Renger-Patzsch, 100 Photographs* [exh. cat., Galerie Schurmann & Kicken] (Cologne, 1979)

MARC RIBOUD
1923 Lyons, France–

Riboud, Marc, *The Face of North Vietnam* (New York, 1970)
———, *Visions of China* (New York, 1981)

*Jean-Philippe Charbonnier/Marc Riboud: Reporters-Photographes* [exh. cat.] (Stockholm, 1974)

JACOB AUGUST RIIS
1849 Ribe, Denmark–1914 Barre, Massachusetts

Alland, Alexander, *Jacob A. Riis, Photographer & Citizen* (Millerton, New York, 1974)
Hales, Peter B., *Silver Cities: The Photography of American Urbanization, 1839–1915* (Philadelphia, 1983)
Stange, Maren, "Gotham's Crime and Misery. Ideology and Entertainment in Jacob Riis's Lantern Slide Exhibitions," *Views* 8 (spring 1987), 7–11

ALEXANDER RODCHENKO
1891 St. Petersburg, USSR–1956 Moscow

Elliott, David, ed., *Rodchenko and the Arts of Revolutionary Russia* (New York, 1979)
Hubertus, Gassner, *Rodchenko Fotografien* (Munich, 1982)
Nikolaevich Lavrentiev, Alexandr, and Varvara Fedorovna Stepanova, *Alexander Rodchenko: Möglichkeiten der Fotografie/Possibilities of Photography* [exh. cat., Galerie Gmurzynska] (Cologne, 1982)
Selim Omarovich, Khan-Magomedov, *Rodchenko, The Complete Work*, ed. Vieri Quilici (Cambridge, Massachusetts, 1987)
Weiss, Evelyn, ed., *Alexander Rodtschenko, Fotografien, 1920–1938* (Cologne, 1978)

JAROSLAV RÖSSLER
1896 Skutec, Czechoslovakia–1945 Prague

Kirchner, Zdenek, and Antonin Dufek, *Photographes Tcheques* [exh. cat., Centre Georges Pompidou] (Paris, 1983)

FRANZ ROH
1890 Apolda, Thüringen, Germany–1965 Munich

Roh, Franz, and Julianne Roh, *Franz Roh* (Düsseldorf, 1981)

ANDREW JOSEPH RUSSELL
1830–1902

Andrews, Ralph W., *Picture Gallery Pioneers, 1850 to 1875* (Seattle, 1964)
Taft, Robert, *Photography and the American Scene* (New York, 1938)

AUGUSTE SALZMANN
1824 Ribeauvillé, Alsace–1872 Paris

Heilbrun, Françoise, "Photographes de la Terre Sainte par August Salzmann," *F. de Saulcy et la Terre Sainte* (Paris, 1982)

LUCAS SAMARAS
1936 Kastoria, Macedonia–

Levin, Kim, *Lucas Samaras* (New York, 1975)
Samaras, Lucas, *The Photographs of Lucas Samaras* (Millerton, New York, 1987)
*Lucas Samaras Objects and Subjects 1964–1986* [exh. cat., Denver Art Museum] (New York, 1988)

AUGUST SANDER
1876 Herdof am Sieg, Germany–1964 Cologne

Sander, August, *August Sander, Citizens of the Twentieth Century, Portrait Photographs, 1892–1952* (Cambridge, Massachusetts, 1980)
———, *Men Without Masks, Faces of Germany, 1910–1938* (Greenwich, Connecticut, 1971)
Kramer, Robert, *August Sander, Photographs of an Epoch, 1904–1959* (Millerton, New York, 1980)
Sauwen, Rik, Germain Viatte, and Michel Seuphor, *Seuphor* (The Hague, 1976)

JAN SAUDEK
1935 Prague, Czechoslovakia–

Saudek, Jan, *Die Welt des Jan Saudek/The World of Jan Saudek* (Millerton, New York, 1983)
Travis, David, *The World of Jan Saudek* [exh. cat., The Art Institute of Chicago] (Chicago, 1979)

TONI SCHNEIDERS
1920 Koblenz, Germany–

Eskildsen, Ute, *Subjektive Fotografie: Images of the 50s* [exh. cat., Museum Folkwang] (Essen, 1984)

GEORGE SEELEY
1880 Stockbridge, Massachusetts–1955 Stockbridge

Caffin, Charles H., "An Exhibition of Prints by George H. Seeley," *Camera Work* 23 (1908), 8–10
Edgerton, Giles, "The Lyric Quality in the Photo-Secession Art of George Seeley," *The Craftsman* 13 (1907), 298–303
Seeley, George H., "Photography: An Estimate," *Photographic Times* 37 (1905), 99–101

MICHEL SEUPHOR (Fernand Louis Berckelaers)
1901 Anvers, Belgium–

Berckelaers, Ferdinand Louis, *Tout homme/Michel Seuphor* (Paris, c. 1978)

BEN SHAHN
1898 Kovno, Lithuania–1969 New York

Pratt, Davis, *The Photographic Eye of Ben Shahn* (Cambridge, Massachusetts, 1975)
Rodman, S., *Portrait of the Artist as an American: Ben Shahn. A Biography with Pictures* (New York, 1951)

Weiss, Margaret R., *Ben Shahn, Photographer: An Album from the Thirties* (New York, 1973)

CHARLES SHEELER
1883 Philadelphia–1965 Irvington-on-Hudson

Fitz, W. G., "A Few Thoughts on the Wanamaker Exhibition," *The Camera* 22 (1918), 201–207
Friedman, Martin, Bartlett Hayes, and Charles Millard, *Charles Sheeler* [exh. cat., National Collection of Fine Arts] (Washington, 1968)
Stebbins, Theodore E., and Norman Keyes, Jr., *Charles Sheeler: The Photographs* [exh. cat., Museum of Fine Arts] (Boston, 1987)

CINDY SHERMAN
1954 Glen Ridge, New Jersey–

Krauss, Rosalind, "A Note on Photography and The Simulacrul," *October 31* (Winter 1984), 49–68.
Schjeldahl, Peter, and Lisa Phillips, *Cindy Sherman* [exh. cat., Whitney Museum of American Art] (New York, 1987)
*Cindy Sherman* (New York, 1984)
*Cindy Sherman, Photographien* [exh. cat., Westfälischer Kunstverein] (Münster, 1985)

STEPHEN SHORE
1947 New York–

Kozloff, Max, "Photography: The Coming of Age of Color," *Artforum* (January 1975)
Ratcliff, Carter, "Route 66 Revisited," *Art in America* (January 1976)
Rewald, John, *The Gardens at Giverny: A View of Monet's World* (New York, 1983)
Shore, Stephen, *Uncommon Places* (Millerton, New York, 1984)

RAGHUBIR SINGH
1942 Jaipur, India–

Singh, Raghubir, *Calcutta: The Home and the Street* (London and New York, 1988)
———, *Kashmir: Garden of the Himalayas* (London, 1983)
———, *Rajasthan: India's Enchanted Land* (London and New York, 1981)

ART SINSABAUGH
1924 Irvington, New Jersey–1983 Chicago

Sinsabaugh, Art, and Sherwood Anderson, *6 Mid-American Chants/11 Midwest Landscapes* (Highlands, North Carolina, 1964)
Thornton, Gene, "Art Sinsabaugh's Landscapes," *Camera* (April 1979)

AARON SISKIND
1903 New York–

Chiarenza, Carl, *Aaron Siskind: Pleasures and Terrors* (Boston, 1982)
Siskind, Aaron, *Harlem Document: Photographs 1932–1940* (New York, 1981)
———, *Terrors and Pleasures of Levitation* (New York, 1972)

W. EUGENE SMITH
1918 Wichita, Kansas–1978 Tucson, Arizona

Johnson, William S., ed., *W. Eugene Smith, Master of the Photographic Essay* (Millerton, New York, 1981)
Smith, W. Eugene, *W. Eugene Smith, His Photographs and Notes* (Millerton, New York, 1969)
———, and Aileen M. Smith, *Minamata* (New York, 1975)
*Let Truth be the Prejudice. W. Eugene Smith: His Life and Photographs* [exh. cat., The Philadelphia Museum of Art] (Millerton, New York, 1985)

FREDERICK SOMMER (Fritz Sommer)
1905 Angri, Italy–

Glenn, Constance W., and Jane K. Bledsoe, *Frederick Sommer at Seventy-five: A Retrospective* [exh. cat., The Art Museum and Galleries of California State University] (Long Beach, 1980)
Sommer, Frederick, "An Extemporaneous Talk at the Art Institute of Chicago, October, 1979," *Aperture* 16 (1971)
———, with Stephen Aldrich, *The Poetic Logic of Art and Aesthetics* (Prescott, Arizona, 1972)
Weiss, John, *Venus, Jupiter and Mars: The Photographs of Frederick Sommer* [exh. cat., University of Delaware] (Newark, 1980)

ALBERT SANDS SOUTHWORTH
1811 West Fairlee, Vermont–1894 Charlestown, Massachusetts

Newhall, Beaumont, *The Daguerreotype in America* (New York, 1961)
Sobieszek, Robert A., and Odette M. Appel, *The Spirit of Fact. The Daguerreotypes of Southworth & Hawes, 1843–1862* (Boston, 1976)

EDWARD STEICHEN (Eduard Steichen)
1879 Luxembourg–1979, West Redding, Connecticut

Gallatin, A. E., "The Paintings of Eduard J. Steichen," *International Studio* 40 (1910), xl–xliii
Homer, William Inness, "Eduard Steichen as Painter and Photographer, 1897–1908," *The American Art Journal* 6 (1974), 45–55
Juhl, Ernst, "Eduard Steichen," *Photographische Rundschau* 16 (1902), 127–129

Longwell, Dennsi, and Steichen, *The Master Prints 1895–1914. The Symbolist Period* [exh. cat., The Museum of Modern Art] (New York, 1978)
Steichen, Edward, *A Life in Photography* (New York, 1963)
Steichen, Edward J., "The American School," *The Photogram* 7 (1901), 3–9
———, "Painting and Photography," *Camera Work* 23 (1908), 3–5

OTTO STEINERT
1915 Saarbrücken, West Germany–1978 Essen-Werden, West Germany

Eskildsen, Ute, *Subjective Fotografie: Images of the 50s* [exh. cat., Museum Folkwang] (Essen, 1984)
Steinert, Otto, Franz Roh, and J. A. Schmoll, *Subjektive Fotografie* (Bonn, 1952)
———, *Subjective Fotografie 2* (Munich, 1955)

JOEL STERNFELD
1944 New York–

Eauclaire, Sally, *The New Color* (New York, 1981)
Sobieszek, Robert A., *Color as Form: A History of Color Photography* (Rochester, 1982)
Sternfeld, Joel, *American Prospects* (Houston, 1987)

ALFRED STIEGLITZ
1864 Hoboken, New Jersey–1946 New York

Frank, Waldo, et al., eds., *America and Alfred Stieglitz: A Collective Portrait* (1934; reprint, Millerton, New York, 1979)
Greenough, Sarah, and Juan Hamilton, *Alfred Stieglitz: Photographs & Writings* [exh. cat., National Gallery of Art] (Washington, 1983)
Homer, William Inness, *Alfred Stieglitz and the American Avant-Garde* (Boston, 1977)
Lowe, Sue Davidson, *Stieglitz: A Memoir/Biography* (New York, 1983)
Naef, Weston J., *The Collection of Alfred Stieglitz: Fifty Pioneers of Photography* [exh. cat., The Metropolitan Museum of Art] (New York, 1978)
Norman, Dorothy, *Alfred Stieglitz: An American Seer* (New York, 1973)

PAUL STRAND
1890 New York–1976 Orgeval, France

Strand, Paul, "Photography," *Seven Arts* 2 (1917), 524–525
———, "Photography and the New God," *Broom* 3 (1922), 252–258
———, and Nancy Newhall, *Time in New England* (reprint, New York, 1950)
*Paul Strand: A Retrospective Monograph, the Years 1915–1946* and *Paul Strand: A Retrospective Monograph, the Years 1950–1968* (New York, 1971)
*Strand: 60 Years of Photographs* (New York, 1976)

JINDRICH STREIT
Czechoslovakia (active 1970s and 1980s)

CHRISTER STROMHOLM
1928 Stockholm–

Eskildsen, Ute, *Subjective Fotografie: Images of the 50s* [exh. cat., Museum Folkwang] (Essen, West Germany, 1984)

KARL STRUSS
1886 New York–1981 Los Angeles

Harvitt, Susan, and John Harvitt, *Karl Struss: Man with a Camera* [exh. cat., Cranbrook Academy of Art Museum] (Bloomfield Hills, Michigan, 1976)

JOSEF SUDEK
1896 Koline nad Labem, Czechoslovakia–1976 Prague

Bullaty, Sonya, and Anna Farova, *Sudek* (New York, 1978)
Kirschner, Zdenek, *Josef Sudek* (Prague, 1982 and 1986)
Linhart, Lubomir, *Josef Sudek: Fotografie* (Prague, 1956)

FRANK MEADOW SUTCLIFFE
1853 Headingly, Leeds–1941 Whitby, Yorkshire

Hiley, Michael, *Frank Sutcliffe, Photographer of Whitby* (London, 1974)
Shaw, Bill E., *Frank Meadow Sutcliffe, Hon. F.R.P.S.: Whitby and Its People* [exh. cat., Sutcliffe Gallery] (Whitby, 1974)

WILLIAM HENRY FOX TALBOT
1800 Melbury, Dorset, England–1877 Lacock Abbey, Wiltshire

Arnold, Harry, *William Henry Fox Talbot: Pioneer of Photography and Man of Science* (London, 1977)
Buckland, Gail, *Fox Talbot and the Invention of Photography* (Boston, 1980)
Lassam, Robert, *Fox Talbot, Photographer* (Tisbury, England, 1979)

TATO (Guglielmo Sansoni)
1896 Bologna–1974 Rome

Lista, Giovanni, *Photographie futuriste italienne* [exh. cat., Musée d'art Moderne de la Ville de Paris] (Paris, 1981)

ALPHONSE TERPEREAU

Seguin, Jean-Pierre, and Weston Naef, *After Daguerre, Masterworks of French Photography (1848–1900) from the Bibliothèque Nationale* (New York, 1980)

FÉLIX TEYNARD
1817 St. Martin, France–1892

Seguin, Jean-Pierre, and Weston Naef, *After Daguerre, Masterworks of French Photography (1848–1900) from the Bibliothèque Nationale* (New York, 1980)

ELSE THALEMANN
German (active late 1920s and early 1930s)

LINNAEUS TRIPE
1822 Davenport–1902 Davenport

Pare, Richard, *Photography and Architecture 1839–1939* (New York, 1982)

HOLGER TRÜLZSCH
1939 Munich–

Lehndorff, Vera, and Holger Trülzsch, *"Veruschka" Trans-figurations* (Boston, 1986)

BENJAMIN BRECKNELL TURNER
1815 London–1894 England

Bierile, R., Roy Fluckinger, Nancy Keeler, Sydney Mallet Kelgore, *Paper and Light: The Calotype in France and Great Britain 1839–1870* (Boston, 1984)
Pare, Richard, *Photography and Architecture, 1839–1939* (New York, 1982)
Seiberling, Grace, *Amateurs, Photography, and the Mid-Victorian Imagination* (Chicago and London, 1986)

JERRY N. UELSMANN
1934 Detroit–

Enyeart, James L., *Jerry N. Uelsmann: Twenty-Five Years, A Retrospective* (Boston, 1982)
*Jerry N. Uelsmann* [exh. cat., The Philadelphia Museum of Art] (Millerton, New York, 1970)

UMBO (Otto Umbehr)
1902 Düsseldorf–1980 Hannover

Reinhardt, Georg, *Umbo, Fotografien, 1925–1933* (Hannover, 1979)

AUGUSTE VACQUERIE
1819 France–1895 France

PIERRE AMEDÉE AND EUGÈNE-NAPOLÉON VARIN
France (active 1850s)

ÉDOUARD VUILLARD
1868 Cuiseaux, Saône-et-Loire–1940 La Baule, France

Preston, Stuart, *Édouard Vuillard* (New York, 1972)

Roger Marx, Claude, *Vuillard et son temps* (Paris, 1946)
Salomon, "Vuillard and His Kodak," *L'Oeil* 61 (April 1963), 14–25

ANDY WARHOL
1928 McKeesport, Pennsylvania–1987 New York

Koch, Stephen, *Andy Warhol Photography* (New York, 1987)
Ratcliff, Carter, *Andy Warhol* (New York, 1983)
*Andy Warhol, Death and Disasters* [exh. cat., The Menil Collection] (Houston, 1988)

CARLETON E. WATKINS
1829 Oneonta, New York–1916 California

Alinder, James, ed., *Carleton E. Watkins: Photographs of the Columbia River and Oregon* (Carmel, California, 1979)
Palmquist, Peter E., *Carleton E. Watkins, Photographer of the American West* (Albuquerque, 1983)
Pare, Richard, *Photography and Architecture 1839–1939* (New York, 1982)

WEEGEE (Usher, later "Arthur" H. Fellig)
1899 Zioczew, Poland (now Austria)–1969 New York

Fellig, Usher H., *Weegee by Weegee* (New York, 1961)
Martin, Peter, *Weegee* [exh. cat., San Francisco Museum of Modern Art] (San Francisco, 1984)
Stettner, Louis, *Weegee* (New York, 1977)

WILLIAM WEGMAN
1942 Holyoke, Massachusetts–

Wegman, William, *Man's Best Friend* (New York, 1983)

EDWARD WESTON
1886 Highland Park, Illinois–1958 Carmel, California

Conger, Amy, *Edward Weston in Mexico, 1923–1926* (Albuquerque, 1983)
Maddow, Ben, *Edward Weston: Fifty Years* (Millerton, New York, 1979)
Newhall, Beaumont, *Supreme Instants: The Photography of Edward Weston* (Boston, 1986)
———, and Amy Conger, eds., *Edward Weston Omnibus: A Critical Anthology* (Salt Lake City, 1984)
Newhall, Nancy, *The Photographs of Edward Weston* [exh. cat., The Museum of Modern Art] (New York, 1946)
Weston, Edward, *The Daybooks of Edward Weston* 2 vols. (Millerton, New York, 1973)
———, *Edward Weston on Photography*, ed. Peter Bunnell (Salt Lake City, 1983)

CLARENCE H. WHITE
1871 West Carlisle, Ohio–1925 Mexico City

Bicknell, George, "The New Art in Photography: The Work of Clarence H. White," *The Craftsman* 9 (January 1906), 495–510

Bunnell, Peter C., "The Significance of the Photography of Clarence Hudson White (1871–1925) in the Development of Expressive Photography," Master's thesis, Ohio University, 1961

Caffin, Charles H., "Clarence H. White," *Camera Work* 3 (July 1903), 15–17

Dickson, Edward R., "Clarence H. White: A teacher of Photography," *Photo-Era* (January 1913), 3

White, Clarence H., "Old Masters in Photography," *Platinum Print* 7 (February 1915), 4–5

———, "The Progress of Pictorial Photography," *Pictorial Photographers of America* (New York, 1918)

White, Maynard P., Cathleen A. Branciaroli, and William Innes Homer, *Symbolism of Light: The Photographs of Clarence H. White* [exh. cat., Delaware Art Museum] (Wilmington, 1977)

MINOR WHITE
1908 Minneapolis–1976 Boston

Hall, James Baker, *Minor White: Rites and Passages* (New York, 1978)

White, Minor, *Mirrors, Messages, Manifestations* (New York, 1970)

GARRY WINOGRAND
1928 New York–1984 Tijuana, Mexico

Szarkowski, John, *Winogrand: Figments from the Road* [exh. cat., The Museum of Modern Art] (New York, 1988)

Winogrand, Garry, *The Animals* [exh. cat., The Museum of Modern Art] (New York, 1969)

———, *Stock Photographs: The Fort Worth Fat Stock Show and Rodeo* (Austin, Texas, 1980)

*Garry Winogrand. Public Relations* [exh. cat., The Museum of Modern Art] (New York, 1977)

*Garry Winogrand. Women Are Beautiful* (New York, 1975)

JOEL-PETER WITKIN
1939 Brooklyn–

*Joel-Peter Witkin, Forty Photographs* [exh. cat., San Francisco Museum of Modern Art] (1985)

DAVID WILKIE WYNFIELD
1837–1887

Coke, Van Deren, *Nineteenth-Century Photographs from the Collection* [exh. cat., University Art Museum, University of New Mexico] (Albuquerque, 1976)

Lucie-Smith, Edward, *The Invented Eye, Masterpieces of Photography, 1839–1914* (New York, 1975)

# Bibliography

## GENERAL

Baier, Wolfgang, *Quellendarstellungen zur Geschichte der Photographie* (Halle, 1965; reprint, Munich, 1977)

Barthes, Roland, *Camera Lucida* (New York, 1981)

Beaton, Cecil, and Gail Buckland, *The Magic Image, The Genius of Photography from 1839 to the Present Day* (Toronto and Boston, 1975)

Billeter, Erika, *Malerei und Photographie im Dialog* (Zurich, 1977; reprint, Bern, 1979)

Braive, Michel F., *The Photograph, A Social History* (Toronto, New York, 1966)

Coe, Brian, and Paul Gates, *The Snapshot Photograph* (London, 1977)

Coke, Van Deren, *The Painter and the Photograph from Delacroix to Warhol* (Albuquerque, 1964)

Crawford, William, *The Keepers of Light: A History & Working Guide to Early Photographic Processes* (Dobbs Ferry, New York, 1979)

Daval, Jean-Luc, *Photography, History of an Art* (New York, 1982)

Diamondstein, Barbaralee, *Visions and Images: American Photographers on Photography* (New York, 1981)

Eder, Josef Maria, *History of Photography*, trans. Edward Epstean (New York, 1945, 1972; reprint, 1978)

Freund, Gisele, *Photography & Society* (Boston, 1980)

Gernsheim, Helmut, with Alison Gernsheim, *The History of Photography from the Camera Obscura to the Beginning of the Modern Era* (New York, 1969)

Goldberg, Vicki, ed., *Photography in Print, Writing from 1816 to the Present* (New York, 1981)

Green, Jonathan, ed., *The Snapshot* (Millerton, New York, 1974)

Hill, Paul, and Thomas Cooper, eds., *Dialogue with Photography* (New York, 1979)

Ihrke, Gerhard, *Zeittafel zur Geschichte der Photographie* (Leipzig, 1982)

Janis, Eugenia Parry, and Wendy MacNeil, eds., *Photography within the Humanities* (Danbury, New Hampshire, 1977)

Jeffrey, Ian, *Photography: A Concise History* (New York, Oxford, and Toronto, 1981)

Kozloff, Max, *Photography and Fascination* (Danbury, New Hampshire, 1979)

————, *The Privileged Eye: Essays on Photography* (Albuquerque, 1987)

Lécuyer, Raymond, *Histoire de la Photographie* (Paris, 1945)

Lemagny, Jean-Claude, and Andre Rouille, eds., *A History of Photography, Social and Cultural Perspectives* (Cambridge, 1986)

Lyons, Nathan, ed., *Photographers on Photography* (Englewood Cliffs, New Jersey, 1966)

————, *Photography in the Twentieth Century* [exh. cat. The International Museum of Photography at George Eastman House] (New York, 1967)

Malcolm, Janet, *Diana and the Nikon: Essays on the Aesthetic of Photography* (Boston, 1980)

Moholy, Lucia, *100 Years of Photography: 1839–1939* (Hammondsworth, Middlesex, 1939)

Newhall, Beaumont, *The History of Photography from 1839 to the Present* (New York, 1982)

————, ed., *Photography: Essays and Images, Illustrated Readings in the History of Photography* (Boston, 1980)

Pare, Richard, Catherine Evans Inbusch, Phyllis Lambert, and Marjorie Musterberg, *Photography and Architecture: 1839–1939* [exh. cat. Canadian Centre for Architecture, Montréal], (New York, 1982)

Petruck, Peninah R., *The Camera Viewed: Writings on Twentieth-Century Photography* (New York, 1979)

Reilly, James M., *The Care and Identification of Nineteenth-Century Photographic Prints* (Rochester, 1986)

Rosenblum, Naomi, *A World History of Photography* (New York, 1984)

Scharf, Aaron, *Art and Photography* (London, 1968)

Sobieszek, Robert A., *The Art of Persuasion: A History of Advertising Photography* (New York, 1988)

Sontag, Susan, *On Photography* (New York, 1977)

Szarkowski, John, *Looking at Photographs* (New York, 1973)

————, *The Photographer's Eye* [exh. cat. The Museum of Modern Art] (New York, 1966)

Taft, Robert, *Photography and the American Scene: A Social History, 1839–1889* (reprint, New York, 1964)

Trachtenberg, Alan, ed., *Classic Essays on Photography* (New Haven, 1980)

Travis, David, *The Art of Photography, Past and Present, from the Collection of the Art Institute of Chicago* [exh. cat. The National Museum of Art] (Osaka, 1984)

Tucker, Ann, ed., *The Woman's Eye* (New York, 1973)

Walsh, George, Colin Naylor, and Michael Held, eds., *Contemporary Photographers* (New York, 1983)

Welling, William, *Photography in America: The Formative Years, 1839–1900* (New York, 1978)

## I. 1839–1879

Bertell, Richard, with Roy Flukinger, Nancy Keeler, and Sydney Kilgore, *Paper and Light: The Calotype in Great Britain and France, 1839–1870* (Boston, 1984)

Buckland, Gail, *Fox Talbot and the Invention of Photography* (Boston, 1980)

Buerger, Janet E., *The Era of the French Calotype* [exh. cat. International Museum of Photography at George Eastman House] (Rochester, 1982)

Galassi, Peter, *Before Photography, Painting and the Invention of Photography* (New York, 1981)

Goldschmidt, Lucien, and Weston J. Naef, *The Truthful Lens: A Survey of the Photographically Illustrated Book, 1844–1914* (New York, 1980)

Haworth-Booth, Mark, ed., *The Golden Age of British Photography* [exh. cat. Philadelphia Museum of Art] (Millerton, New York, 1984)

Jammes, André, and Eugenia Parry Janis, *The Art of French Calotype* (Princeton, New Jersey, 1983)

Jammes, Isabelle, *Louis Désiré Blanquart-Évrard, 1802–1872* (Lucerne, 1978)

Lécuyer, Raymond, *Histoire de la Photographie* (Paris, 1945)

Marbot, Bernard, *Une invention du XIXe siècle, expression et technique, la photographie: Collections de la Société Française de Photographie* [exh. cat. Bibliothèque Nationale] (Paris, 1976)

Naef, Weston J., and James N. Wood, *Era of Exploration: The Rise of Landscape Photography in the American West, 1860–1885* [exh. cat. The Metropolitan Museum of Art] (New York, 1975)

Nèagu, Philippe, *La mission héliographique, photographies de 1851* (Paris, 1980)

Newhall, Beaumont, *The Daguerreotype in America* (New York, 1976, 3d rev. ed.)

———, *Latent Image: The Discovery of Photography* (Garden City, New York, 1967)

Pfister, Harold Francis, *Facing the Light: Historic American Portrait Daguerreotypes* [exh. cat. National Portrait Gallery, Smithsonian Institution] (Washington, 1978)

Potonniée, Georges, *Histoire de la découverte de la Photographie* (Paris, 1925)

Rinhart, Floyd and Marion, *The American Daguerreotype* (Athens, Georgia, 1981)

Rouillé, André, *L'Empire de la photographie, 1839–1870* (Paris, 1982)

Rudisill, Richard, *Mirror Image: The Influence of the Daguerreotype on American Society* (Albuquerque, 1971)

Scharf, Aaron, *Pioneers of Photography* (New York, 1975)

Schwarz, Heinrich, *Art and Photography* (Rochester, New York, 1985)

Seguin, Jean-Pierre, Weston Naef, and Bernard Marbot, *After Daguerre: Masterworks of French Photography 1848–1900 from the Bibliothèque Nationale* [exh. cat. The Metropolitan Museum of Art] (New York, 1980)

Seiberling, Grace, *Amateurs, Photography, and the Victorian Imagination* [exh. cat. International Museum of Photography at George Eastman House] (Chicago and London, 1986)

Snyder, Joel, and Doug Munson, *The Documentary Photograph as a Work of Art: American Photographs, 1860–1876* [exh. cat. The David and Alfred Smart Gallery, The University of Chicago] (Chicago, 1976)

Ward, John, and Sara Stevenson, *Printed Light: The Scientific Art of William Henry Fox Talbot and David Octavius Hill with Robert Adamson* (Edinburgh, 1986)

White, Minor, André Jammes, and Robert Sobieszek, *French Primitive Photography* (Philadelphia, 1969)

## II. 1880–1918

Bunnell, Peter C., ed., *A Photographic Vision: Pictorial Photography, 1889–1923* (Salt Lake City, 1980)

Caffin, Charles H., *Photography as a Fine Art* (reprint, Hastings-on-Hudson, New York, 1971)

Doty, Robert, *Photo-Secession: Stieglitz and the Fine-Art Movement in Photography* (New York, 1978)

*Fotografica Pittorica, 1889–1911* (Venice and Florence, 1979)

*French Primitive Photography* [exh. cat. Philadelphia Museum of Art] (Philadelphia, 1969)

Green, Jonathan, ed., *Camera Work: A Critical Anthology* (Millerton, New York, 1973)

Hales, Peter B., *Silver Cities: The Photography of American Urbanization, 1839–1915* (Philadelphia, 1984)

Harker, Margaret, *The Linked Ring: The Secession Movement in Photography in Britain, 1892–1910* (London, 1979)

Hartmann, Sadakichi, *The Valiant Knights of Daguerre: Selected Critical Essays on Photography and*

Profiles of Photographic Pioneers, ed. Harry W. Lawton and George Knox (Berkeley, 1978)

Homer, William Innes, *Alfred Stieglitz and the Photo-Secession* (Boston, 1983)

Keller, Ulrich F., "The Myth of Art Photography: An Iconographic Analysis," *History of Photography* 9 (January–March 1985), 1–38

Keller, Ulrich F., "The Myth of Art Photography: A Sociological Analysis," *History of Photography* 8 (October–December 1984), 249–275

*Kunstphotographie um 1900* [exh. cat. Museum Folkwang] (Essen, Germany, 1964)

Mann, Margery, *California Pictorialism* [exh. cat. San Francisco Museum of Modern Art] (San Francisco, 1977)

Naef, Weston J., *The Collection of Alfred Stieglitz* [exh. cat. The Metropolitan Museum of Art] (New York, 1978)

Panzer, Mary, *Philadelphia Naturalistic Photography, 1865–1906* [exh. cat. Yale University Art Gallery] (New Haven, Connecticut, 1982)

*La Photographie d'art vers 1900* [exh. cat. Credit Communal] (Brussels, 1983)

*Pictorial Photography in Britain 1900–1920* [exh. cat. Arts Council of Great Britain] (London, 1978)

Travis, David, *Photography Rediscovered: American Photographs, 1900–1930* [exh. cat. Whitney Museum of American Art] (New York, 1979)

## III. 1919–1945

Ades, Dawn, *Photomontage* (London, 1986)

Coke, Van Deren, Ute Eskildsen, and Bernd Lohse, *Avant-Garde Photography in Germany, 1919–1939* [exh. cat. Museum of Modern Art] (San Francisco, 1980)

Daniel, Pete, Merry A. Foresta, Maren Stange, and Sally Stein, *Official Images, New Deal Photography* (Washington, 1987)

Eskildsen, Ute, and Jan-Christopher Horak, *Film und Foto der Zwanziger Jahre, Eine Betrachtung der Internationalen Werkbundausstellung "Film und Foto" 1929* (Stuttgart, 1979)

Gidal, Tim N., *Modern Photojournalism, Origin and Evolution, 1910–1933* (New York, 1973)

Haenlein, Carl-Albrecht, *Dada Photographie und Photocollage* (Hannover, 1979)

Homer, William Innes, *Alfred Stieglitz and the American Avant-Garde* (Boston, 1977)

Hurley, F. Jack, *Portrait of a Decade, Roy Stryker and the Development of Documentary Photography in the Thirties* (Baton Rouge, 1972)

Jaguer, Édouard, *Les Mysteres de la chambre noire, le surrealisme et la photographie* (Paris, 1982)

Krauss, Rosalind, Jane Livingston, and Dawn Ades, *L'Amour fou, Photography and Surrealism* (New York, 1985)

Lista, Giovanni, *Photographie Futuriste Italienne, 1911–1939* [exh. cat. Musée d'Art Moderne de la Ville de Paris] (Paris, 1982)

Mellor, David, ed., *Germany, The New Photography, 1927–1933* [exh. cat. Arts Council of Great Britain] (London, 1978)

Moholy-Nagy, László, trans. Janet Seligman, *Painting, Photography, Film* (Cambridge, 1967)

O'Neal, Hank, *A Vision Shared: a Classic Portrait of America and its People, 1935–1943* (New York, 1976)

Pultz, John, and Catherine B. Scallen, *Cubism and American Photography, 1910–1930* [exh. cat. Sterling and Francine Clark Art Institute] (Williamstown, Massachusetts, 1981)

Roh, Franz, and Jan Tschichold, *Foto-Auge/oeil et Photo/Photo-Eye* (Tübingen, 1929; reprint, New York, 1978)

Schmied, Wieland, and Ute Eskildsen, *Neue Sachlichkeit and the German Realism of the Twenties* [exh. cat. Arts Council of Great Britain] (London, 1978)

Stott, William, *Documentary Expression and Thirties America* (New York, 1973)

Travis, David, *Photographs from the Julien Levy Collection, Starting with Atget* [exh. cat. The Art Institute of Chicago] (1976)

Willett, John, *Art And Politics in the Weimar Period, The New Sobriety, 1917–1933* (New York, 1978)

## IV. 1946–1989

Burgin, Victor, ed., *Thinking Photography* (New York, 1982)

Coleman, A. D., *Light Readings: A Photography Critic's Writings, 1968–1978* (New York, 1979)

Crimp, Douglas, and Paula Marincola, *Image Scavengers: Photography* [exh. cat. Institute of Contemporary Art] (Philadelphia, 1982)

Danese, Renato, ed., *American Images: New York by Twenty Contemporary Photographers* [exh. cat.] (Washington, D.C., 1979)

Eauclaire, Sally, *The New Color Photography* (New York, 1981)

———, *New Color/New Work: Eighteen Photographic Essays* (New York, 1984)

Eskildsen, Ute, *Subjektive Fotografie: Images of the 50s* [exh. cat. Museum Folkwang] (Essen, 1984)

Gauss, Kathleen McCarthy, *New American Photography* [exh. cat. Los Angeles County Museum of Art] (Los Angeles, 1985)

Gee, Helen, *Photography of the Fifties: An American Perspective* (Tucson, 1980)

Green, Jonathan, *American Photography: A Critical History 1945 to the Present* (New York, 1984)

Grundberg, Andy, and Kathleen McCarthy Gauss, *Photography and Art: Interactions since 1946* (New York, 1987)

Heiferman, Marvin, and Diane Keaton, eds., *Still Life* (New York, 1983)

Hoy, Anne H., *Fabrications: Staged, Altered and Appropriated Photographs* (New York, 1987)

Jenkins, William, *New Topographics: Photographs of a Man-Altered Landscape* (Rochester, 1975)

Katzman, Louise, *Photography in California, 1945–1980* (San Francisco, 1984)

Mandel, Mike, and Larry Sultan, *Evidence* (Santa Cruz, California, 1977)

Solomon-Godeau, Abigail, "Photography after Art Photography," in *Art after Modernism: Rethinking Representation* (Boston, 1984)

Steichen, Edward, *The Family of Man* (New York, 1955)

Szarkowski, John, *Mirrors and Windows: American Photography since 1960* [exh. cat. The Museum of Modern Art] (New York, 1978)

Traub, Charles, and John Grimes, *The New Vision: Forty Years of Photography at the Institute of Design* (Millerton, New York, 1981)

# Glossary

This glossary is intended to provide abbreviated definitions of a number of the technical terms used in this catalogue. For more complete information, we suggest that one of the technical references in the bibliography be consulted.

## ALBUMEN PRINT (1850–c. 1920)

A nineteenth- and early twentieth-century process for making positive prints on paper which is essentially a variation of Talbot's salted paper printing process (see below). As originally described by Louis Désiré Blanquart-Evrard, table salt was beaten into egg white and the mixture spread on sheets of paper and allowed to dry. The treated paper was sensitized with silver nitrate and dried in the dark. Printing was by contact (see below) with a negative; long exposure to daylight was required since the image was completely printed out during the exposure, rather than being developed after exposure. Blanquart-Evrard found that paper coated with the albumen-salt mixture produced prints with an objectionable luster, and accordingly, recommended diluting the albumen about fifty percent with salt water to produce prints similar in surface character to salted-paper prints (known as dilute albumen prints). By the late 1850s, however, manufacturers and photographers came to prefer lustrous prints and coated paper with the undiluted salted-albumen mixture; beginning in the mid-to-late 1860s paper was double coated in order to obtain a higher gloss on the print surface. In the 1870s an even higher gloss was achieved by bathing processed albumen prints in a castile soap solution and passing them through heated and highly polished steel rollers.

Since albumen prints fixed without chemical toning turned an unattractive brick red, the majority were processed in a toning bath after exposure to give them an acceptable hue. The procedure for the toning of albumen prints remained a highly individual preference for photographers well into the 1850s. Exhausted fixer was a popular toning bath for both salted paper and albumen prints during this time and produced a variety of tones from red, through sepia and bistre, to deep purple depending on the length of toning, which ranged from an hour or two to as long as two or three days. From the early-to-mid 1850s, the sepia brown to purple-black of many albumen prints was achieved by bathing prints in sel d'or (a mixture of fixer and gold chloride), which had originally been employed to tone and improve the contrast of daguerreotypes. While both these toners were effective in producing rich prints, they were often responsible for a pronounced yellowing and degrading of albumen prints over time. In 1855, James Waterhouse devised an improved method of toning which produced permanent prints when used with care. His toning bath of gold chloride and a mild alkali in an aqueous solution produced a variety of pleasing hues depending on the concentration of gold and the length of time the print remained in the toner. Lower concentrations of gold produced a sepia hue; higher concentrations gave purple to blue-black hues. Since the subsequent fixing bath altered the initial hue, experience and practice were necessary for exact and consistent results. This toning procedure became standard practice in the early 1860s

## AMBROTYPE

A term devised by Marcus Aurelius Root for his variation of the wet-collodion process (see below) that produced a unique positive, silvery-white image on a dark glass plate (or on a transparent plate that was painted black, or backed with dark velvet). Purposely under-exposed collodion plates were bathed in a ferrous sulfate developer to produce the positive effect when viewed by reflected light (when viewed by transmitted light, ambrotypes are under-exposed negatives). Ambrotypes were packaged in special presentation cases in imitation of daguerreotypes. The technique was not commonly used after the mid-1860s.

## AUTOCHROME

"Autochrome" was the brand name of the first commercially marketed photographic color transparency process. Introduced in 1907 by the French inventors and manufacturers, Auguste and Louis Lumière, the material was simple to use and was processed with the chemistry of black and white photography. The plates were made by dusting starch grains dyed in the three additive primary colors (green, blue and red) onto a glass plate, which formed a random pattern (called a *reseau*) of minute, translucent colored dots. These grains were then flattened under pressure and coated with a panchromatic emulsion. Exposure in the camera was made with the glass plate facing the lens (so that the light would pass through the dyed grains and then expose the film). The grains acted as filters, blocking some colors of the subject and passing others which then registered on the panchromatic film. After exposure the plate was developed as a black and white negative and then treated chemically to reverse the image into a positive. The resulting black and white transparency selectively blocked or transmitted the colors of the starch grains in such a way as to make the image appear to be in full color when viewed by transmitted light or when projected onto a screen. Within a year or two of the introduction of Autochrome plates, several members of the Photo-Secession, including Alfred Stieglitz, Edward Steichen, Alvin Langdon Coburn, and Frank Eugene experimented with, exhibited, and published their results with the new process.

## BROMOIL PRINT

A printing technique perfected by G. E. Rawling after 1904 from contributions by earlier experimenters. The basis of the technique is that gelatin mixed with potassium bichromate (now called potassium dichromate) absorbs less water when exposed to light than when unexposed. When oil-based ink is applied to the print surface it adheres better to areas less saturated with water and thus results in the differentiation between blacks, whites, and intermediate grays. The bromoil technique itself was introduced around 1907 and allowed photographers to produce this lithographic matrix on enlargements made on specially manufactured silver bromide paper. Inks could be applied by roller or more expressively by a stiff-haired brush. Often the final print was a result of the transfer of the ink from the matrix to a final support.

## CALOTYPE

The photographic process invented by William Henry Fox Talbot in September 1840, in which paper impregnated with silver iodide is sensitized by an aqueous solution containing silver nitrate, acetic acid, and gallic acid, exposed in the camera, and then developed as a negative with the same sensitizing solution. In his 1841 patent of the process, Talbot states that

the negative is fixed in a saturated solution of potassium bromide. In his 1843 patent for improvements, he specifies an after treatment of the negative in a hot bath of sodium hyposulfite (now known as sodium thiosulfate) to improve its whites and increase its permanence. Photographers soon discarded the potassium bromide bath and fixed their negatives directly in "hypo."

Talbot's development of the latent image formed by short exposure in the camera—actually a type of image intensification and technically known later as "physical" development—was a great breakthrough in his attempt to make photographs with the camera. The negatives of Talbot's early photogenic drawing process (see below) were too thin and lacked sufficient contrast to produce acceptable positive prints. Not only did development of the calotype negative greatly increase the light sensitivity of the paper, it also produced negatives that were easily printed. Although Talbot mentioned developing prints after contact exposure to the paper negative, his preferred method was to employ his photogenic drawing paper (salted paper) as the positive print material. Hot wax was often applied to negatives before printing to increase their translucency.

## CARBON PRINT

A positive printing technique similar in its chemistry to gum printing (see below). The carbon print used not only lampblack for its colorant but also other pigments. Unlike gum prints, the carbon print material was manufactured (from the 1870s on) because the thickness of the coating needed to be carefully controlled. Contact exposure was through a positive transparency made from the original negative. Development was in water until the gelatin swelled at which time the exposed carbon tissue was pressed into contact with an ordinary sheet of paper for about five minutes and then the two were immersed in a tray of lukewarm water. After the unexposed gelatin of the original carbon tissue was dissolved away, the papers were separated and the image remained on the ordinary paper. The process was devised in order to increase the permanence of positive prints and still maintain a continuous and delicate tonal range.

## CHROMOGENIC COLOR PRINT

The generic term for color print materials that make use of dyes incorporated directly into silver-gelatin emulsions in order to produce full color prints. These dyes combine with various chemical by-products produced during the development of exposed silver salts in the emulsion, which together form the coloring agents in the print. The completed chromogenic print

consists solely of these synthesized dyes suspended in gelatin; all traces of silver are removed from the print during processing. Invented by Leopold Mannes and Leopold Godowsky, the process was acquired and perfected by Kodak and first marketed under the name of Kodachrome.

## COLLOTYPE

A photo-lithographic process that produces prints in ink from a photographic image made of gelatin. Like carbon (see above) and gum-bichromate (see below) printing, the collotype process is based on the light sensitivity of dichromated colloids. When ammonium or potassium dichromate is dissolved in gelatin and allowed to dry, the mixture becomes light sensitive. Areas exposed to light lose their ability to absorb water and thus contact exposure under a positive transparency hardens the gelatin in proportion to the amount of light falling upon it. When an exposed plate is washed in water, blotted, and then rolled up with greasy ink, the plate takes up more ink where the exposure to light was greatest. This inked matrix is printed onto paper in a lithographic press. Under magnification, collotype images have a characteristic reticulated pattern from the gelatin surface.

The first successful collotypes were made by Alphonse Poitevin in 1855 using a lithographic stone coated with bichromated gelatin, a process he called "photolithographie." Various improvements quickly followed and by the 1870s there were a remarkable number of collotype processes, each with its own name: Albertype, artotype, autogravure, autotype, heliotype, hydrotype, lichtdruck, photocollographie, photogelatin, phototypie, phototype, and phototint.

## CONTACT PRINT

Usually a positive photographic print made by exposure of light through a negative placed in contact with light-sensitive paper. Contact exposure is necessary for those photographic papers that are not highly sensitive to light and therefore need exposure to the sun or another strong light source. Salted-paper prints, albumen prints, cyanotypes, gum prints, platinum prints, palladium prints, and the light-sensitive coating of the heliogravure and photogravure processes all require contact exposures.

## CYANOTYPE

Another name for blueprint. The cyanotype or ferroprussiate process was invented in 1842 by the British astronomer and chemist Sir John Herschel. It is based

on the light sensitivity of various salts of iron. Typically ferric ammonium citrate and potassium ferricyanide are mixed in an aqueous solution and applied to paper. When dry, the paper is exposed by contact to sunlight until a deep, olive gray image appears. The print is then placed in water which changes it to a rich blue. If continuous-tone prints are desired, potassium dichromate is added to adjust the contrast of the print to the character of the negative.

## DAGUERREOTYPE

The process invented by Louis Jacques Mandé Daguerre and published in September 1839. The process produced a unique camera image on a highly-polished, silvered copper plate. The silver of the plate was sensitized by the fumes of iodine to form silver iodide. After exposure in the camera, the latent image on the plate was made visible by development in the fumes of mercury and then fixed in sodium hyposulfite (now sodium thiosulfate). A whitish amalgam of silver and mercury formed where light had fallen. When the mirror-like surface of the daguerreotype reflected a dark background the image appeared as a positive; when the plate reflected a bright background the image appeared as a weak negative.

Within a year or so of Daguerre's disclosure of his methods, several improvements by scientists and photographers were incorporated into the standard daguerreotype procedure. Several independent photographers added a brief fuming of bromine to the procedure to improve sensitivity of the plate and reduce harsh contrasts. In 1840, the French physicist Armand Hippolyte Louis Fizeau invented a means of intensifying or "invigorating" daguerreotype images by the use of sel d'or, a mixture of gold chloride and ordinary photographic fixer. This chemical treatment (called "gilding") removed the surface fog, intensified the image and imparted a slight amber-rose hue to the plate. Manufacturers and photographers realized that since daguerreotypes were mostly viewed by lighting from the side a horizontal polishing and buffing of the plate improved image contrast.

Daguerre's original specifications required camera exposure from between three and thirty minutes making portraiture nearly impossible. Depending on lighting conditions, the character of the lens, and the nature of the sensitized silver surface, the improved daguerreotype procedures needed exposure times between four and sixty seconds. On the average, studio portrait exposures were ten to fifteen seconds.

Since the mercury-silver amalgam of the daguerreotype plate was extremely sensitive to abrasion, daguerreotypes were protected by metal mats and glass covers housed in frames or most commonly in small decorative cases. The daguerreotype technique became obsolete by the end of the 1860s.

## DIRECT POSITIVE PRINTS ON PAPER (BAYARD'S PROCESS)

A process invented by a French civil servant, Hippolyte Bayard, in 1839, that produced a unique positive image by exposure in the camera. The bleaching action caused by light striking silver chloride paper that had previously been darkened by exposure to sunlight and then sensitized with a weak solution of potassium iodide was the basis of the process. After an exposure that might run as long as an hour, the image was complete and the paper stabilized in a solution of potassium bromide or salt water, washed, and then dried.

It seems likely that Bayard invented the process after having first learned of the chemistry employed by Talbot for the preparation of photogenic drawing paper. The process, however, was not refined beyond its ability to supply unique positive prints.

## DRY (GLASS) PLATES

A negative process employing an emulsion of gelatin and silver bromide. The emulsion is prepared by chemically forming silver bromide in the gelatin, "ripening" the mixture by heat to increase its sensitivity, and then removing the chemical by-products by washing. This emulsion is coated onto glass and then dried. After exposure, the dry plate is developed in an alkaline developer, not in an acidic one like those used for calotypes and wet-collodion negatives. This development (called "chemical" development) converts the silver bromide particles that have been altered by exposure to light (but not reduced to elemental silver) into silver particles.

The first successful (but crude) dry silver bromide images on glass were announced by the British photomicrographer Dr. Richard Leach Maddox in 1871. Previous experiments in making a silver bromide-collodion emulsion in the mid-1860s reached a perfected stage in the late 1870s through the work of W. B. Bolton, but never achieved the sensitivity of wet-collodion plates. Although these dry collodion emulsion plates were convenient, they were less sensitive than wet-collodion plates, which also had to be prepared by the photographer. Reliable dry (gelatin) plates of a serviceable sensitivity were not available from manufacturers until 1878 when Wratten and Wainwright of London first successfully marketed their plates.

## DYE DIFFUSION TRANSFER

A generic name for the Polaroid Polacolor process. In this process the positive color image is transferred by the diffusion of dyes from a color negative to a paper support that holds the finished color print. After processing, the color print is separated from the negative, which is discarded. The first Polacolor materials were introduced in 1962.

## DYE-TRANSFER PRINT

A complex method for making color prints, in which a color transparency is photographed three times, using a different filter each time. The resulting black and white negatives contain all the necessary information for a full color image. The negatives are used to make three separate "matrixes," which are gelatin surfaces (on film) that absorb dyes in an aqueous solution in the three subtractive primary colors: yellow, magenta, and cyan. The dyes from these respective gelatin surfaces are transferred one at a time and in registration onto gelatin-coated paper. Although complicated, the technique allows for great control of hues and saturation. Dye transfer prints are among the most archivally stable of all color prints.

## GOLD TONING

A process for toning photographic images containing silver that preserves them from chemical alteration by residual processing chemicals and atmospheric pollutants. (See albumen print and daguerreotype.)

## GUM PRINT (GUM BICHROMATE PRINT)

A positive printing technique employing a coating of pigmented, light-sensitive gum arabic that allows the photographer to manipulate the printed image during development. As with other colloids, such as gelatin, gum arabic (with watercolor pigment) is sensitized by the addition of ammonium or potassium dichromate to the mixture. This mixture is brushed onto paper by the photographer and dried. Contact exposure through a negative to strong light hardens the coating differentially according to the amount of light that passes through each part of the negative. During development in water insoluble or partially soluable areas may be lightened with a brush or other abrasive techniques. The first gum prints were exhibited in 1858 by the Englishman John Pouncy, but the technique did not become popular among photographers until the last decade of the century when it was brought to high perfection by the British photographer Alfred Maskell and the French photographers A. Roulle-Ladevāze and Robert Demachy. Edward Steichen and Alvin Langdon Coburn used the gum print to great effect, often coating preliminary prints of platinum or ferro-prussiate (cyanotype) to make what were respectively called gum-platinum and gum-ferroprussiate prints.

## GUM-PLATINUM PRINT

A technique by which a layer of gum-bichromate is printed in registration over a preliminary image of platinum. See gum print and platinum print.

## HELIOGRAVURE

A type of photogravure perfected in France in the 1840s and 1850s from the initial discoveries and observations of Joseph Nicéphore Niépce that bitumen (asphalt) can be made light sensitive and used as a resist in etching a plate. In this process the resist is light sensitive as opposed to the common method perfected from Talbot's discoveries and experiments that used a layer of resist or a screen separate from the light sensitive coating. Charles Nègre and Edouard Baldus each made important contributions toward the perfection of héliogravure in the 1850s.

## INTERNAL DYE DIFFUSION TRANSFER

A generic name for the Polaroid SX-70 process of color photography. In this process, synthesized color dyes migrate from the negative image to the surface of a sealed "film unit." The residual dyes in the negative together with by-products and reagents used for development are rendered harmless and invisible once processing is complete. The SX-70 process was introduced in 1972.

## JETGRAPH

A color printing process in which sprayed dyes of the three subtractive primary colors (yellow, magenta, and cyan) and black are controlled by a computer from digitized information received from an optical scanning device.

## PALLADIUM PRINT

A positive printing technique identical to the platinum print except that the metal forming the image is palladium, which gives a palette of brown and sepia hues. See platinum print.

## PHOTOCOLLAGE

Any assembly of separate photographic images brought together to form another picture by collage.

## PHOTOGENIC DRAWING

The first name given by William Henry Fox Talbot to the photographic process that he announced in January 1839. "Superfine writing paper" was dipped in a weak bath of common salt and after blotting was brushed with a solution of silver nitrate. The light-sensitive silver chloride formed in the fibers of the paper was not highly sensitive to light, and after the photogenic drawing paper was prepared and dried it required exposure in direct sunlight from ten minutes to an hour depending on what object (leaves or lace) or image (waxed engraving) had been placed over it. Talbot fixed the resulting image, which had printed-out during exposure, in a moderately strong solution of potassium iodide or a strong solution of common salt. We would now consider these prints to be "stabilized" rather than fixed. Treatment with potassium iodide created a very pale primrose yellow hue in the highlights while common salt produced a pale lilac tint.

Photogenic drawing paper intended for camera exposures had to be more sensitive, and thus Talbot coated the paper as many times as he could, alternating between common salt and silver nitrate, before the paper would spontaneously blacken on its own. With an f/11 lens, these exposures ranged between one and two hours. The negative camera images were formed by printing-out and not by development, which was a later discovery (see calotype). As early as February 1835, Talbot had printed photogenic drawing negatives as positives (which he then called "transfers"). In order to successfully print the weak images of camera negatives, Talbot devised a negative paper in February/March 1839 that was based on silver bromide, and which was more responsive to light than even the multiply coated silver chloride paper. These new negatives of considerably greater contrast produced better positives on the original photogenic drawing paper. When the calotype process became the standard way of making camera exposures, Talbot printed these negatives on photogenic drawing paper, as well.

## PHOTOGRAM

A photograph made (without a camera) usually by laying objects directly on the light-sensitive surface. Images obtained in this way are negative silhouettes and transcriptions of the translucent areas of the objects. In the 1920s the technique was used by Man Ray (developed photograms) as a dada expression and by László Moholy-Nagy (both printed-out and developed photograms) as a constructivist technique.

## PHOTOGRAVURE

A method by which a photographic image formed in bichromated gelatin is used to control the etching of a metal plate for printing in ink. In the early 1840s several experimenters tried to etch daguerreotypes, but with limited success. In the 1850s, Talbot discovered a method of photographically controlling the rate at which the acid would etch the metal plate. Talbot coated his metal plates with gelatin mixed with potassium dichromate, dried the coating, exposed under a positive transparency (made from the original negative), developed in water, and then etched the plate. In order to provide a rough surface to hold the ink on the plate, he dusted the coated plate with acid-resistant resin or imposed a lined screen (from gauze) on the image. After later perfection by the Czech Karl Klic in 1879, the "Talbot-Klic" method became standard for the production of photogravure. Klic first dusted the plate to be etched with acid-resistant resin and then transferred a carbon print onto the plate. Iron chloride etched the plate to different depths in proportion to the tone in the picture (in reverse proportion to the thickness of the carbon tissue). The plate was inked by hand and printed in an etching press. Photogravure was a favorite printing technique of Peter Henry Emerson and Alfred Stieglitz, and was popular from the 1880s through the early 1920s. Later, etched cylinders that were mechanically screened and inked formed the basis of a process still in use, rotogravure, which prints plates at relatively high speeds.

Another technique for obtaining photographic etched plates, called héliogravure, was perfected in France. See héliogravure.

## PHOTOMONTAGE

A method of making a single photographic print by the superimposition of various negatives or copying a photocollage.

## PLATINUM PRINT

A positive printing technique that employs light-sensitive iron salts to form a provisional image that is subsequently made visible by conversion into platinum metal. The process was invented and patented by the Englishman Richard Willis in 1873. Papers supplied by the Willis Platinotype Company of London and other manufacturers contained an iron salt (probably ferric oxalate) and platinous potassium chloride. After contact exposure through a negative, the paper was developed in potassium oxalate. The dilution of the exposed iron caused the platinum salt to be reduced to pure, elemental platinum. The print was immersed in a very weak bath of hydrochloric acid,

washed, and dried. Depending on the constituents of the sensitizer or developer, platinum prints range from neutral black to warm rose-sepia hues.

Platinum paper was many times more permanent than photographs that used silver to form the image. It also was favored by photographers for its broad range of subtle gray tones and its lack of coating on the paper. After the 1920s, platinum papers were difficult to obtain outside of England, where after 1936 they were discontinued.

## PRINTING-OUT PAPER

A generic name for a photographic paper which does not need to be developed in order to make its image visible. The printed-out image darkens by itself during exposure to light. As the image darkens, it also shields the remaining light-sensitive chemicals underneath, and thus provides a control for overexposure and an adjustment to negatives of high contrast. Printing-out papers are known for their broad, delicate tonal range.

## RAYOGRAPH

The name given by Man Ray to his photograms. See photogram.

## SALTED-PAPER PRINT

A positive print made without an emulsion or thick coating, in which the light-sensitive silver salts are soaked into the paper. Talbot preferred silver chloride, but silver iodide, silver bromide, and silver oxalate were also used in combination. Sometimes the addition of starch (arrowroot) improved the color, as well as the strength of the image by preventing the silver salts from penetrating too deeply into the paper. These papers were prepared with non-light-sensitive salts and sensitized with silver nitrate shortly before use. Salted-paper prints have finely divided silver particles on their surface that are sensitive to atmospheric pollutants and humidity, and thus fade easily. See photogenic drawing.

## SATISTA PAPER

A brand name for a short-lived photographic paper marketed by the Willis Platinotype Company based on the chemistry of platinum paper, in which the final image was formed by a mixture of silver and platinum. Satista paper was produced during World War I when platinum was needed in various war industries.

## SILVER GELATIN PRINT

The generic name for the common black and white photograph employing an emulsion of light-sensitive silver salts (usually silver bromide) ripened in gelatin to form an emulsion. See description of emulsion under dry plates.

## SILVER GELATIN TRANSFER PRINT

A generic name for the instant developing black and white process devised by Edwin H. Land and first introduced in 1948 through the Polaroid Corporation. This process relies on the light sensitivity of silver halides, which after exposure in the camera are developed within a specially designed film/print sandwich (film unit) to form a negative silver image. The unexposed silver halide unaffected by development is made soluble by a special reagent and in this state migrates from its original support, through the reagent, to a new support where it is reduced to silver and forms a positive image. In Polaroid film type 55 both a film negative and a paper positive are produced. The type 55 negative can be used to make positives by conventional methods.

## SOLARIZATION

A term used to describe the phenomenon of the partial reversal of tones in a developing photographic emulsion or material after an additional exposure to light. The phenomenon is more accurately referred to as the "Sabattier effect" after the Frenchman who first observed it in 1860. This technique was accidentally discovered by Lee Miller and Man Ray in 1929.

## STEREOGRAPH

A card mount holding a pair of stereo images. The phenomenon of stereoscopic vision was discovered by the Scottish scientist Sir David Brewster in 1837. Photography proved to be a better medium for representing scenes stereoptically than drawing because of the ease in which it recorded the difference between the two points of view that each eye perceived.

## WET-COLLODION PROCESS

A negative process invented by the British photographer Frederick Scott Archer in 1851 that used collodion (a mixture of nitrocellulose dissolved in ethyl ether and ethyl alcohol) as a vehicle to hold light-sensitive silver iodide on a glass plate. Because collodion dries to be water-proof, it had to remain moist during exposure and up to the time of development. Thus, all wet-collodion plates had to be prepared in the darkroom immediately before exposure and developed immediately after. This meant that the photographer in the field had to have a portable darkroom nearby. The inconvenience of this procedure was offset by the relatively fast speed of the coating and the sharp images that could be printed from it due to the glass support. Although plagued with many problems, the wet-collodion process was the standard negative process from the mid-1850s through the 1870s.

In the process that came to be modified by photographers several years after Archer's publication, a mixture of ammonium or potassium and collodion was poured onto a glass plate, the coated plate was immersed in a bath of acidified silver nitrate for about three minutes and then withdrawn and exposed in the camera. After exposure, the plate was developed in pyrogallic acid or ferrous sulfate, rinsed in water and fixed in ordinary hypo. At times photographers used the potentially lethal potassium cyanide as a fixer because it produced negatives with absolutely transparent shadows by removing the overall fog that typically covered collodion negatives after development. After fixing, the plate was washed, dried, and then varnished to protect the fragile and easily abraded negative image.

By using the ferrous sulfate developer, the wet-collodion process was easily adapted to the production of direct positives on glass (ambrotypes) or on blackened metal (tintypes). See ambrotype.

The present glossary is based on one published by David Travis for an exhibition on the history of photography for the National Museum of Art, Osaka, in 1984, to which lengthy passages have been added from a detailed study of the history and development of nineteenth-century techniques prepared by Joel Snyder.

# Index